Deleted

ARTS & HUMANITIES
Through the Eras

Ancient Egypt

2675–332 B.C.E

Edward Bleiberg, Editor

THOMSON

GALE

Detroit • New York • San Francisco • San Diego • New Haven, Conn. • Waterville, Maine • London • Munich

THOMSON
™
GALE

Arts and Humanities Through The Eras: Ancient Egypt (2675 B.C.E.–332 B.C.E.)

Edward Bleiberg

Project Editor
Rebecca Parks

Editorial
Danielle Behr, Pamela A. Dear, Jason Everett, Rachel J. Kain, Timothy Sisler, Ralph G. Zerbonia

Editorial Support Services
Mark Springer

Indexing Services
Barbara Koch

Imaging and Multimedia
Randy Bassett, Mary K. Grimes, Lezlie Light, Daniel William Newell, Christine O'Bryan, Kelly A. Quin

Rights and Acquisitions
Margaret Chamberlain, Shalice Shah-Caldwell

Product Design
Michelle DiMercurio

Composition and Electronic Prepress
Evi Seoud

Manufacturing
Wendy Blurton

LIBRARY OF CONGRESS CATALOGING-IN-PUBLICATION DATA

Arts and humanities through the eras.
 p. cm.
 Includes bibliographical references and index.
 ISBN 0-7876-5695-X (set hardcover : alk. paper) —
 ISBN 0-7876-5696-8 (Renaissance Europe : alk. paper) —
 ISBN 0-7876-5697-6 (Age of Baroque : alk. paper) —
 ISBN 0-7876-5698-4 (Ancient Egypt : alk. paper) —
 ISBN 0-7876-5699-2 (Ancient Greece : alk. paper) —
 ISBN 0-7876-5700-X (Medieval Europe : alk. paper)
 1. Arts—History. 2. Civilization—History.

NX440.A787 2004
700'.9—dc22 2004010243

This title is also available as an e-book.
ISBN 0-7876-9384-7 (set)
Contact your Thomson Gale sales representative for ordering information.

Printed in the United States of America
10 9 8 7 6 5 4 3

CONTENTS

Contents

ABOUT THE BOOK

SEEING HISTORY FROM A DIFFERENT ANGLE. An education in history involves more than facts concerning the rise and fall of kings, the conquest of lands, and the major battles fought between nations. While these events are pivotal to the study of any time period, the cultural aspects are of equal value in understanding the development of societies. Various forms of literature, the philosophical ideas developed, and even the type of clothes worn in a particular era provide important clues about the values of a society, and when these arts and humanities are studied in conjunction with political and historical events a more complete picture of that society is revealed. This inter-disciplinary approach to studying history is at the heart of the *Arts and Humanities Through the Eras* project. Patterned in its organization after the successful *American Decades, American Eras,* and *World Eras* products, this reference work aims to expose the reader to an in-depth perspective on a particular era in history through the study of nine different arts and humanities topics:

- Architecture and Design
- Dance
- Fashion
- Literature
- Music
- Philosophy
- Religion
- Theater
- Visual Arts

Although treated in separate chapters, the connections between these topics are highlighted both in the text and through the use of "See Also" references to give the reader a broad perspective on the culture of the time period. Readers can learn about the impact of religion on literature; explore the close relationships between dance, music, and theater; and see parallel movements in architecture and visual arts. The development of each of these fields is discussed within the context of important historical events so that the reader can see history from a different angle. This angle is unique to this reference work. Most history books about a particular time period only give a passing glance to the arts and humanities in an effort to give the broadest historical treatment possible. Those reference books that do cover the arts and humanities tend to cover only one of them, generally across multiple time periods, making it difficult to draw connections between disciplines and limiting the perspective of the discipline's impact on a specific era. In *Arts and Humanities Through the Eras* each of the nine disciplines is given substantial treatment in individual chapters, and the focus on one era ensures that the analysis will be thorough.

AUDIENCE AND ORGANIZATION. *Arts and Humanities Through the Eras* is designed to meet the needs of both the beginning and the advanced history student. The material is written by subject experts and covers a vast array of concepts and masterworks, yet these concepts are built "from the ground up" so that a reader with little or no background in history can follow them. Technical terms and other definitions appear both in the

text and in the glossary, and the background of historical events is also provided. The organization of the volume facilitates learning at all levels by presenting information in a variety of ways. Each chapter is organized according to the following structure:

- Chronology covering the important events in that discipline during that era

- Brief overview of the development of that discipline at the time

- Topics that highlight the movements, schools of thought, and masterworks that characterize the discipline during that era

- Biographies of significant people in that discipline

- Documentary sources contemporary to the time period

This structure facilitates comparative analysis, both between disciplines and also between volumes of *Arts and Humanities Through the Eras*, each of which covers a different era. In addition, readers can access additional research opportunities by looking at the "Further References" and "Media and Online Sources" that appear at the back of the volume. While every effort was made to include only those online sources that are connected to institutions such as museums and universities, the web-

sites are subject to change and may become obsolete in the future.

PRIMARY DOCUMENTS AND ILLUSTRATIONS. In an effort to provide the most in-depth perspective possible, *Arts and Humanities Through the Eras* also includes numerous primary documents from the time period, offering a first-hand account of the culture from the people who lived in it. Letters, poems, essays, epitaphs, and songs are just some of the multitude of document types included in this volume, all of which illuminate some aspect of the discipline being discussed. The text is further enhanced by 150 illustrations, maps, and line drawings that bring a visual dimension to the learning experience.

CONTACT INFORMATION. The editors welcome your comments and suggestions for enhancing and improving *Arts and Humanities Through the Eras*. Please mail comments or suggestions to:

The Editor
Arts and Humanities Through the Eras
Thomson Gale
27500 Drake Rd.
Farmington Hills, MI 48331-3535
Phone: (800) 347-4253

CONTRIBUTORS

Edward Bleiberg, Editor, is associate curator in the Department of Egyptian Classical and Ancient Middle Eastern Art at the Brooklyn Museum. He earned the Ph.D. in Egyptology at the University of Toronto. He is the author of *The Official Gift in Ancient Egypt* (1996) and *Jewish Life in Ancient Egypt* (2002), and an editor of *The Oxford Encyclopedia of Ancient Egypt.* He has also written scholarly articles on the ancient Egyptian economy.

William H. Peck, Advisor, was educated at Ohio State University and Wayne State University. For many years he was the curator of Ancient Art at the Detroit Institute of Arts. He has taught Art History at the Cranbrook Academy of Art, the University of Michigan, and Wayne State University. He is currently teaching at the College for Creative Studies, Detroit. His books include *Drawings from Ancient Egypt* (Thames and Hudson, 1978), *The Detroit Institute of Arts: A Brief History* (DIA) and

Splendors of Ancient Egypt (DIA). He has published many scholarly and popular articles on Egyptian art and archaeology, especially on Egyptian painting and drawing. His excavation experience includes work at the ancient city of Mendes in the Egyptian Nile Delta and at the Temple of the Goddess Mut, Karnak. He has been responsible for a number of exhibitions at the Detroit Institute of Arts and has also lectured on art and archaeology throughout the United States and Canada.

Stephen E. Thompson is the History Chair and Dean of Students at the Donna Klein Jewish Academy in Boca Raton, Florida. He earned his Ph.D. in Egyptology from Brown University. He is the author of *A Lexicographic and Iconographic Analysis of Anointing in Ancient Egypt* (1991) and a collaborating editor on *A Dictionary of Late Egyptian* (1982-present).

ERA OVERVIEW

PROBLEM OF EVIDENCE. In a series devoted to the arts and humanities of different cultures and time periods, ancient Egypt may not seem like a ready candidate for study. Whereas more modern cultures have vast amounts of cultural evidence, from written records to art to examples of clothing, musical instruments, and architecture, artifacts from ancient Egypt are largely limited to that which could survive for millennia—largely stone reliefs, several partial structures such as pyramids and temples, and those items preserved in tombs that eluded grave robbers. While there is no doubt that ancient Egypt had a thriving culture that included the major disciplines of the arts and humanities, the evidence for its existence has largely been destroyed by the sands of time, and modern Egyptologists must piece together an understanding of that culture from the relatively small amount of evidence that is left. The paucity of surviving material has limited scholars' ability to speak conclusively about many areas of Egyptian life; indeed, there is some doubt as to whether one of the major disciplines—theater—existed at all, and the discipline of philosophy is so closely tied to that of religion that it is problematic to separate the two into separate disciplines. Nevertheless, close readings of texts and close examination of artistic evidence allows Egyptologists to describe many aspects of the arts and humanities in Egyptian culture. Scholars can study music, for example, by examining the words to songs, representations of musical ensembles on tomb walls, and archaeological examples of musical instruments. Egyptologists can study fashion by comparing artistic representations to archaeological examples of cloth. In every aspect of the arts and humanities, the Egyptians left some record of their activities.

THE DOMINANCE OF RELIGION. Egyptian religion dominated almost every aspect of the arts and humanities in Egyptian culture. Stone buildings, the best-preserved structures, were always religious structures such as temples or tombs. Knowledge of dance and music that survives through representations on tomb and temple walls are parts of religious rituals or funerals. Many of the literary genres, such as hymns, served a religious purpose. Even writers of secular literature assume the immediate presence of the gods in a way not present in modern writing. The visual arts also served religion in decorating tombs and temples but also through the belief that representation was a way of ensuring that a ritual was performed. Finally, it is nearly impossible to separate religion and philosophy, so fundamental was religion to the Egyptian point of view.

THE IMPORTANCE OF ART. Visual art assumes an added importance in the study of Egypt. Often artistic evidence survived when no other evidence is available to study some aspect of the arts and humanities. Egyptologists study dance, music, fashion, and many aspects of religion through examining sculpture, relief, and paintings preserved from tombs and temples. Artists, for example, carefully reproduced all the known steps of the funeral dance in tombs. The composition of Egyptian musical ensembles is known only from representations on tomb and temple walls. Since very few Egyptian fashions are cut and sewn, the correct way to wrap a piece of material around the body can only be seen in

sculpture. Finally, the order of rituals and the relationship between the gods and their sacred animals are just two aspects of religion that can be studied through art. Without Egyptian art, scholars would not know anything about many of these subjects. Yet interpreting the evidence of visual art is not always straightforward. The Egyptian conventions used in art lead scholars to interpret rather than merely report on what they see in visual art.

WRITING. The Egyptians were probably the first to invent writing, perhaps as early as 3500 B.C.E. This tremendous innovation, the ability to represent language graphically, allowed for accurate communication across time and space and led to a revolution in intellectual history. For the first time, it was possible to send words and thoughts formulated in one place hundreds or thousands of miles away. It was also possible to build on an intellectual heritage and accurately remember the words uttered by ancestors generations before. The Egyptians themselves recognized the importance of this accomplishment. As with anything truly important, they attributed the invention of writing to the gods. Hieroglyphs were to the Egyptians the "words of the gods." Thoth, the ibis-headed scribe of the gods, was patron for all human scribes. The Egyptians also recognized that writing had shifted the balance of power in their society. Although physical labor still had great value in Egyptian society, a new kind of power emerged with writing and the existence of the scribal class. For scribes, as the Egyptians were fond of saying, were really the people in control of everything. Certainly the scribal class played a key role in preserving ancient Egyptian heritage, for it is largely through their writings that modern scholars are able to judge and understand Egyptian accomplishments. These writings provide important evidence not only of the literature of the time, but also about the religious ceremonies and beliefs, the role of music, and even dance steps. The writings that accompany artistic representations of Egyptian life are invaluable in deciphering this visual evidence, casting a stronger light on the shadowy world of ancient Egyptian culture.

LINGUISTS. Though all Egyptologists study the Egyptian language, philologists specialize in this field. In general Egyptian philologists are familiar with the five historical dialects of Egyptian and the four ways of writing those dialects. The dialects divide the language into five historical periods closely mirroring the time when each of them was the spoken language. They include Old Egyptian, Middle Egyptian, Late Egyptian, Demotic, and Coptic. Very roughly they represent the spoken language of the Old Kingdom, Middle Kingdom, New Kingdom, Late Period, and Graeco-Roman Period. The earliest four dialects were written with hieroglyphic signs and hieratic signs, a simplified, cursive writing system. Demotic had its own writing system based on hieratic while Coptic was written with the Greek alphabet. Philologists study the grammatical systems of the dialects and are generally less interested in the writing system itself. They very often specialize in one or more of the dialects. Paleographers and epigraphers, on the other hand, specialize in the writing systems themselves. Paleographers study handwriting such as is generally found on papyrus and on limestone ostraca. Epigraphers, in contrast, are generally interested in the carved and painted hieroglyphs found on temple and tomb walls. Paleographers and epigraphers make texts available through publication for philologists to study. Historians of ancient Egypt are trained primarily as philologists.

ARCHAEOLOGISTS. Though most philologists have spent some time studying objects, archaeologists specialize in this field. A large number of specialties among archaeologists have developed in Egyptian archaeology in the years since World War II. Traditionally archaeologists studied only art and architecture. These fields remain vital and continue to make progress as new methods of analysis emerge. Other scholars concentrate on less glamorous objects such as ceramics, tools, and human, animal, and plant remains. These objects are important for understanding daily life and the lives of those ancient people who could not write. As is generally true in history, post-World War II scholars have tried to learn about all classes in the ancient world rather than concentrating only on the elite. Some archaeologists prefer to work in the field, excavating new objects for study. Others study the existing collections of Egyptian artifacts found in museums and other private and public collections. Most are involved in studying a combination of the two, both newly excavated objects and those already in collections.

THE PROBLEM OF DATES. The study of history generally deals in absolute dates, in which events are linked with concrete years and follow a specific chronology. Such methodology is more problematic when discussing ancient history, however, given the absence of precise dating systems. Ancient Egyptians used a chronology of rulers when referencing time periods, referring to events as happening in the reign of a particular king rather than in a particular year or range of years. Egyptologists have attempted to marry this rather vague dating system with actual ranges of years, but there is much disagreement regarding the exact dates of rulers' reigns or the length of certain periods of history. The disagreements that used

to separate interpretations by over 1,000 years have now narrowed to 10- to 25-year differences in dates assigned to key kings such as Ahmose, Amenhotep III, and Ramesses II. Even so, many Egyptologists refer to events as occurring in "the reign of King X" rather than in an absolute year. This allows scholars to ignore small differences in absolute dates when discussing some historical issue. Every attempt has been made to include both the name of a period or reign as well as dates when describing an event. This will allow readers to connect the information in this volume with other books about ancient Egypt. The absolute dates used in this volume were refined by the American Egyptologist William J. Murnane. They were published in *Civilizations of the Ancient Near East* in 1995 and have been adopted by many scholars. Readers might notice that a different set of dates is used in the *Oxford Encyclopedia of Ancient Egypt* published in 2001. Conflicting sets of dates stem from different ways of interpreting the data. Egyptologists generally accept that there will be minor differences of opinion on the absolute dates of ancient Egyptian history.

PERIODS OF HISTORY. Egyptologists today use a scheme of periods that can be traced to the historian Manetho who lived in Egypt in the second century B.C.E. Manetho worked from Egyptian texts to develop thirty dynasties of Egyptian kings. Manetho's work remains the framework for all current chronologies of ancient Egypt. In modern times Egyptologists have grouped the dynasties into larger periods. Recent discoveries in Abydos in central Egypt have established the existence of a royal dynasty predating the First Dynasty. It has been called Dynasty 0 for convenience. Otherwise, the period before Dynasty One has been called the Predynastic Period. Dynasties One and Two are called the Archaic or Early Dynastic Period. Dynasties Three to Six form the Old Kingdom. Dynasties Seven to Ten, a period of decentralization, are called the First Intermediate Period. That period is followed by the Middle Kingdom, Dynasties Eleven to Thirteen. Dynasties Fourteen to Seventeen, when the west Semitic people called the Hyksos ruled Lower Egypt, are called the Hyksos Period and/or the Second Intermediate Period. From Dynasties Eighteen to Twenty, when Egypt was an international power, the period is called the New Kingdom. Subperiods of the New Kingdom are the Amarna Period, when the religious radical Akhenaten ruled, and the Ramesside Period—Dynasties Nineteen and Twenty—when kings who claimed descent from Ramesses I ruled. The Third Intermediate Period includes Dynasties Twenty-one to Twenty-five. It is followed by the Late Period, Dynasties Twenty-six to Thirty. Within the Late Period are the Saite Period (Dynasty Twenty-six) and the Persian Period (Dynasty Twenty-seven). Finally, the Ptolemaic Period follows Alexander the Great's conquest of Egypt after 332 B.C.E. when kings and queens were descended from Alexander's general named Ptolemy. The Roman Period follows Cleopatra VII's defeat at Actium by the future Roman emperor Octavian.

SPELLING. The spelling of kings' names and of places in ancient Egypt also presents a problem for modern writers. The Egyptians wrote only the consonants in their language, leaving modern scholars to pursue different theories of how to add the vowels to names. The result is a variety of naming systems that can be confusing to the lay reader. Many scholars have avoided this problem by following the spellings of ancient Greek historians in reproducing the names of Egyptian kings. Thus Khufu, the Fourth-dynasty king who built the Great Pyramid, is known as Cheops, following the Greek pronunciation, in some books. This volume uses spellings based on the ancient Egyptian rather than ancient Greek, drawn specifically from the spellings established in *Civilizations of the Ancient Near East*.

EGYPTOLOGY AND EGYPTOSOPHY. This volume is a work of Egyptology. Egyptology is a modern academic discipline that grew directly from Jean-François Champollion's work on the Rosetta Stone. In 1822 Champollion published *A Letter to M. Dacier*. This letter was actually a scholarly article explaining that ancient Egyptian hieroglyphs formed a writing system that was basically phonetic and represented an ancient, but perfectly ordinary, human language. Reading this language would allow scholars to study ancient Egyptian words and to gain knowledge of this ancient culture using ordinary historical methods. Champollion's discovery was judged at the time, and in the following years to today, against a nearly 2,000-year tradition that the Egyptologist Erik Hornung called Egyptosophy. Egyptosophy regards ancient Egypt as the source of all wisdom and arcane knowledge. Egyptosophists are not a unified group, but rather among them are people who hold a variety of views about ancient Egypt. These views include the belief that the Egyptians invented usable astrology, alchemy, and magic. Among Egyptosophists are also people who believe that they have access to "hidden" Egyptian knowledge. This alternative tradition also includes the work of Rosicrucians, Freemasons, the late eighteenth-century German Romantics, nineteenth-century Theosophists, Anthroposophists, and a wide variety of Internet content providers. None of these groups and individuals rely on knowledge of the ancient Egyptian language—the Egyptians' own words—for their insights into Egyptian

culture. For that reason they represent a different kind of interest in ancient Egypt from Egyptology's concerns, and their views are thus not included in this volume except when they have relevance to our understanding of Egyptian beliefs.

PRIMARY TEXTS. This volume's authors have based their interpretations on primary texts, the ancient Egyptians' own words. The chapters contain many extracts from Egyptian texts to allow readers to form their own judgments of the interpretations offered here. These texts more than adequately demonstrate the incredible accomplishments of Egyptian culture from earliest times.

CURRENT THINKING. This volume also has tried to reflect current thinking on a wide variety of issues in Egyptology. The authors have tried to synthesize the major arguments in the field but to offer the most widely accepted views for the reader. As is true in most fields of history, the range of questions asked of the data is much broader than would have been true fifty years ago.

Great advances have been made in our understanding of the lives of ancient Egyptians outside of the elite since World War II. The fact that this volume is dedicated to the Egyptians' cultural life exclusively shows the differences from former times in the kinds of questions scholars ask today. This approach has led to a fuller and more sophisticated understanding of ancient Egypt.

ACKNOWLEDGEMENTS. This volume has benefited from the work of many people. I thank Stephen Thompson for his work on religion and William H. Peck for his crucial role as reader. Rebecca Parks has labored long and hard to bring the manuscript into conformity with the series' requirements. I thank her for her work and her patience. As always, I cannot express adequately my appreciation for the love and support I receive from my wife and son while I am working on time-consuming projects.

Edward Bleiberg
Brooklyn, New York

CHRONOLOGY OF WORLD EVENTS

By Edward Bleiberg

All dates in this chronology are approximations (c.) and occur before the common era (B.C.E.).

4400–3100 The Predynastic Period occurs in Egypt. Nothing is known of historical events during this time.

3200–3100 Dynasty 0 occurs. During this dynasty, an unknown number of kings including King Scorpion and King Narmer lay the foundations for the central government of a united Egypt.

3100–2800 The Egyptian First Dynasty consists of nine known rulers whose capital was perhaps in Abydos in central Egypt. Contemporary city-states include Nineveh in Northern Mesopotamia (Iraq), Troy in Anatolia (Turkey), and Ebla in Syria.

2800–2675 The Egyptian Second Dynasty includes five kings. The last of them, Khasekhemwy, was the subject of the first known seated statue of an Egyptian king.

2675–2170 The Egyptian Old Kingdom is established and provides central government from the capital city of Memphis.

A fully developed writing system and literature in the Sumerian language emerges in Mesopotamia, and includes the first law codes and anonymous poetry. Political organization is by city-states.

The *Ram and Tree* offering stand and *Bull's Head from a Harp* are created in the city of Ur.

2675–2625 The Egyptian Third Dynasty includes five kings. Djoser, builder of the Step Pyramid in Saqqara and subject of a life-size seated statue, is second king of the dynasty.

2625–2500 Egypt's Fourth Dynasty includes seven kings. The most famous are Khufu, builder of the Great Pyramid at Giza, as well as his son and grandson; Khafre, builder of the Great Sphinx; and Menkaure.

2500–1800 Early Minoan II culture flourishes along areas of the Aegean and Mediterranean seas. It is characterized by the earliest stone vessels, jewelry, copper daggers, imported obsidian, and textile manufacture.

2500–2200 Early Helladic II culture flourishes on the Greek mainland.

2500–2350 Egypt's Fifth Dynasty consists of eight kings. The first "Overseer of Upper Egypt" is established to deliver taxes to the court at Memphis. A second vizier for Lower Egypt is established. The first provincial governors called "nomarchs" take office.

Ebla, a city-state in Syria, develops a writing system.

The First Dynasty of Lagash, a leading Mesopotamian city-state, flourishes.

Native peoples populate permanent settlements on the Pacific coast of South America along the Andes mountain range.

2500 Early Kerma culture (Kingdom of Yeram) flourishes in Nubia. It is characterized by black and brown pottery with incised decorations found in oval-shaped burials with stone superstructures.

2350–2150 The Awan Dynasty of the Old Elamite Period flourishes on the Iranian Plateau.

2350–2170 Egypt's Sixth Dynasty includes five rulers. Egypt is involved in military or trade operations in Nubia.

2350–2193 The empire of Akkad is founded by Sargon in Mesopotamia. He organizes the military, conquers much of the Euphrates River region, and establishes trade with areas such as the Indus Valley, Crete, and the Persian Gulf. The first known published poet, Enkheduanna, daughter of Sargon, writes "Hymn to Inanna," dedicated to the goddess of love and war. The bronze sculpture "Head of an Akkadian Ruler," possibly a representation of Sargon, is created in Nineveh.

The Victory Stele of Naram-Sin, commemorating the victory of Sargon's son over a mountain tribe, is carved in Mesopotamia.

2338–2298 In the reign of the Egyptian king Merenre Pepi I, the general Weni organizes an army to fight the Bedouin in the Sinai.

2200 People who can be identified as "Greeks" arrive on the Greek mainland during the Bronze Age, establishing the the Early Helladic III Period.

2193–2100 The Gutians, tribesmen from the northeastern mountains, invade and settle in North Mesopotamia and end the Akkadian empire.

2150 Gudea becomes governor of Lagash, a leading Sumerian city-state in Mesopotamia. A series of statues of Gudea are carved.

2130–1980 The First Intermediate Period in Egypt includes the Seventh, Eighth, Ninth, Tenth, and part of the Eleventh Dynasties. Egypt lacks a strong central government, and local governors control the provinces.

2112–2004 The Third Dynasty of Ur flourishes. Ur becomes the leading Sumerian city-state. The earliest version of the Gilgamesh Epic known in the Sumerian language is written, and the Ziggurat of Ur, a three-stepped brick pyramid-like structure, is built.

2100–1900 The Shimaskhi Dynasty of the Old Elamite Period flourishes on the Iranian Plateau.

2081–2008 During the first half of the Egyptian Eleventh Dynasty four kings reign as local princes at Thebes.

2008–1938 Nebhepetre Mentuhotep II founds the Middle Kingdom by conquering Lower Egypt and reunifying the country. He is followed by Mentuhotep III and Mentuhotep IV.

2004 Amorites, a Canaanite people from the mountainous northern Jordan River region, invade Mesopotamia and end the Sumerian city-states.

2000 Amorites sack Ebla, the city-state in Syria, and establish their temple and a palace in the city.

2000–1500 An Indo-European people called the Hittites arrive in Anatolia. They establish a Middle Bronze Age city-state culture known as the Hittite Old Kingdom.

2000–1550 Palaces and cities are established on Crete during the Middle Minoan Period. The earliest Greek writing, called Linear A and B, is developed in the Aegean area and on islands in the region.

1945–1938 The Eleventh-dynasty Egyptian king Nebtawyre Mentuhotep IV builds the

first Egyptian forts to house garrisons in Nubia.

1938–1759 The Egyptian Twelfth Dynasty includes eight rulers who solidify central rule from Thebes. Senwosret I builds more forts in Nubia and occupies it, spreading Egyptian culture southward. The first extant laws concerning forced labor are compiled in papyrus records of the Great Enclosure, a prison.

1980–1630 The earliest alphabetic writing in Semitic languages occurs.

1950–1759 Independent city-states are established in Anatolia.

1900–1500 The Sukkalmakh Dynasty (ebartids) of the Old Elamite Period flourishes on the Iranian Plateau.

1900–1650 A new culture (designated C group IIA), characterized by rectangular burials with superstructures and clay figurines, flourishes in Nubia.

1900 The Assyrian trading colony of Kanash (modern Kültepe in Turkey) is active in Anatolia.

 Middle Helladic Period flourishes on the mainland of Greece. It is characterized by pottery with a soapy texture.

1894 The Old Babylonian Period, a time when several city-states vie for power, begins in Mesopotamia. The earliest known flood narrative appears in the poem *The Atrakhasis*, composed in the Akkadian language.

1836–1818 In the reign of Senwosret III provincial governors are absorbed into the central government. Local administrative councils answer directly to the central government. More forts are built in Nubia.

1813 Shamshi-Adad I, an Amorite king, conquers Ashur (Assyria).

1792–1750 The Babylonian king Hammurabi issues a written law code in Mesopotamia and has it carved on a stele.

1759–1630 The early Thirteenth Dynasty rules Egypt and gradually loses control of the Lower Egypt to the Hyksos, an Amorite people.

1700–1550 A new group of people (designated as Classic C II B), characterized by massive tumuli with chapels over graves and the use of pottery, figurines, and cattle skulls as grave offerings, flourishes in Nubia.

1630–1539 At least thirteen kings of the later Thirteenth Dynasty rule contemporaneously with the Fourteenth Dynasty in Lower Egypt. These kings are Amorites, a Semitic-speaking group. About fifteen local kings rule Upper Egypt and are called the Seventeenth Dynasty.

1630–1523 The Egyptian Fifteenth and Sixteenth Dynasties, foreign rulers called Hyksos, rule Lower Egypt.

1595–1158 The Kassite Dynasty takes control of Mesopotamia and ends the city-state period. The Kassites establish their capital at Babylon. The kingdom is a center of architectural and artistic achievements, and becomes known for trade and science.

1595 The Hittite king Murshili I conquers parts of Syria and captures Babylon, ending the Old Babylonian Period.

1550 The Indo-Iranian Mitanni Empire emerges in northern Mesopotamia and competes with Egypt for control of Syria.

 A Late Bronze Age Minoan artist creates the *Octopus Vase*, an example of the dark-on-light pottery painting in the Marine Style. The Minoans also construct the Palace of Minos on the island of Crete.

1543 The Seventeenth-dynasty king Kamose initiates a war to expel the Hyksos from Lower Egypt.

1539–1075 The Egyptian New Kingdom consists of the Eighteenth (fifteen rulers), Nineteenth (eight rulers), and Twentieth Dynasties (ten rulers) and marks the period of its greatest prosperity. Egypt conquers its eastern neighbors as far as the Euphrates River and its southern neighbors as far as

the fourth cataract of the Nile River in modern Sudan.

The Late Helladic (or Mycenean) Period flourishes on the Greek mainland. Several fortified population centers emerge, burial circles are constructed, and graves are filled with luxury items in gold.

1539–1292 Kings of the Eighteenth Dynasty create three new offices to administer Nubia: King's Son of Kush (viceroy) and Overseer of Southern Lands; Deputy of Wawat; and Deputy of Kush. They also establish the Office of Overseer of Northern Lands for administration of the Levantine possessions. The Office of Vizier divides into two separate offices for Upper and Lower Egypt.

1539–1513 The first Eighteenth-dynasty king Ahmose drives the Hyksos out of Egypt.

1530 Ugarit flourishes as a city-state on the coast of Syria. Its merchants trade with Cyprus and Greece, and its artists develop literature.

1478–1458 Hatshepsut, regent for Thutmose III, reigns as co-king.

1456 Thutmose III defeats a coalition of city-states at Megiddo.

1450 Hittite king Tudkahliya I defeats the Assuwa people of Asia Minor.

1400–1200 The Lion Gate is built in Hattusas (modern Bogazkale) in Anatolia, a Hittite religious center that was known as the City of Temples.

1400 Minoan civilization declines in the Aegean.

1390–1353 Amenhotep III makes the first attempt since the Old Kingdom to present the king as a god, perhaps as part of a political response to increased economic power of the temples. Marriage alliances with Mitanni are continued.

1353–1336 Akhenaten counters increasing political power of the temples by creating a new religion based at a new capital city in Amarna.

1332–1322 Tutankhamun reverses Akhenaten's policies and restores the cult of Amun.

1322 Tutankhamun's widow requests that the Hittite king send her a husband; her prospective groom is murdered on the way to Egypt.

1274 Troops of Ramesses II fight those of the Hittite king Muwattalli II at Qadesh in Syria.

1250 An Elamite ziggurat is built in honor of the bull-god Inshushinak at Dur Untash on the Iranian Plateau.

The Lion Gate, a tomb portal of limestone and masonry in a Mycenaean citadel and the Treasury of Atreus, a fifty-foot domed masonry tomb, are built at Mycenae.

1245 Ramesses II signs a treaty with the Hittite king Khattushili III. The two kingdoms agree to divide disputed lands, and the Egyptian king takes a Hittite princess as a wife.

1200–759 A Dark Age descends in the regions around the Aegean and Mediterranean Seas. Linear B writing disappears and there are few surviving records.

1200–1000 An early Iron Age archaeological culture emerges in Syria-Palestine.

1200 The Sea Peoples, ancestors of the Philistines, destroy the Hittite Empire in Anatolia and initiate a Dark Age in the region. Ugarit experiences a decline of power, as do the city-states of Syria-Palestine.

The Aramaeans migrate out of the Arabian peninsula and arrives in Syria-Palestine, where they establish many centers, including the city of Damascus.

1187–1156 Ramesses III, the last significant king of the New Kingdom, repulses an invasion of the Sea Peoples and settles them in Canaan. An attempt to assassinate him is thwarted.

1183 Troy, a city-state in northwest Asia Minor situated not far from the Dardanelles, is destroyed by the Greeks.

1158–1027 The Second Dynasty of Isin, an ancient city located in southern Mesopotamia, is established by Marduk-kabit-ahheshu.

1150 The Olmec of southern Mexico, living along the coast of the Gulf of Mexico, begin carving large stone heads, some as tall as nine feet, that appear to wear helmets. The Olmec also produce beautiful pottery and jewelry.

1115–1077 Assyrian king Tiglath-pileser I defeats the Mushki and the small Hurrian states of southern Armenia. He spreads Assyrian power into the lands around the Mediterranean Sea and fights against Babylonia, eventually plundering the capital.

1075–945 The Twenty-first Dynasty with a capital at Tanis in the Delta includes seven rulers. The first ruler, Smendes, sends the official of the god Amun named Wenamun to Lebanon to purchase wood for a boat for the god and meets numerous difficulties that may illustrate Egypt's decline in the world at this time.

1074–1057 King Ashur-bel-kala of Assyria, the son of Tiglath-pileser I, continues Assyrian warfare against the Aramaeans and Babylonians, although his empire is unstable.

1050–1032 Ashurnasirpal I, the brother of Ashur-bel-kala and new king, fights defensive actions against the enemies of Assyria.

1025 The Greek Geometric Period produces art based on geometric patterns on vases. They also produce bronze statues of human figures composed of triangles and rectangles.

1000–612 The Neo-Assyrian empire controls Mesopotamia.

1000 Saul, the first king of the United Monarchy of Israel and Judah, defends his lands against the Philistines. He is killed at the battle of Mount Gilboa.

1000–960 David, who succeeds Saul as king of the United Monarchy, conquers Jerusalem.

960–932 Solomon, the son of Bathsheba and David, becomes king of the United Monarchy of Israel and Judah. He makes Palestine a trading center and constructs the Temple of Jerusalem.

945–712 Ten rulers control Lower Egypt from the Delta city of Bubastis.

932–911 Jeroboam I of Israel, who had plotted against Solomon and Rehoboam, returns from exile and becomes king of the northern tribes. He makes his capital in Shechem in northern Israel.

931–915 Rehoboam, the son of Solomon, becomes king of Judah only to see Jeroboam withdraw the northern tribes. He then faces an invasion by the Egyptians.

915–913 Abijah, the son of Rehoboam, becomes the second king of Judah.

913–873 Asa, the son of Abijah, becomes king of Judah and purges his country of opposing religious cults.

911–910 Nadab, the son of Jeroboam I, becomes king of Israel.

910–887 Upon Nadab's death, Baasha becomes king of Israel and attacks Judah.

900–331 Syria-Palestine is in the sphere of influence of Assyria, Babylon, and Persia. The Napatan kings, named for the city in Sudan where the Egyptian governors ruled, control Nubia.

887–886 Elah, the son of Baasha, rules over Israel until he is assassinated in a palace coup d'état.

886–875 After defeating a rival claimant to the throne, Omri becomes the king of Israel. The Moabites, a people living around the Dead Sea, are subjugated.

886 Zimri, one of the generals who killed Elah, takes over the leadership of Israel.

883–859 The Assyrian king Ashurnairpal II rules Mesopotamia, reestablishing the former supremacy of the empire. He makes his

Arts and Humanities Through the Eras: Ancient Egypt (2675 B.C.E.–332 B.C.E.)

xxi

capital at Nimrud on the east bank of the Tigris River. Assyrian artists create the Lion Hunt relief which depicts archers in a horse-drawn chariot.

875–854 King Ahab of Israel, the son of Omri, restores alliances with Judah and other local rivals. His forces defeat an Assyrian incursion at Karkar, but he dies the following year fighting Damascus.

873–849 Jehoshaphat succeeds his father, Asa, as king of Judah. Allied with Israel, his troops fight against the Syrians.

858–824 King Shalmaneser III of Assyria rules Mesopotamia. His troops conquer the Hittites and Damascus, fight against the forces of Israel at Karkar, and defeat the opposition at Tyre and Sidon.

854–853 Ahab's son, Ahaziah, serves as king of Israel. His troops are unable to defeat a revolt in Moab.

853–842 Jehoram (or Jeram), another of Ahab's sons, succeeds Ahaziah as king of Israel. With Judean aid his troops defeat the Moabite opposition.

842 Ahaziah, son of Jeram, becomes king of Judah. Jehu, an army commander, kills Jehoram and takes the throne of Israel. He also kills Ahaziah and destroys the royal family, making Athaliah the queen of Judah. Jehu wages war against Damascus but is subservient to the Assyrians and tries to eliminate all followers of the god Baal.

838–712 The Egyptian Twenty-third Dynasty includes rival rulers in Thebes and in the north of Egypt.

836–797 Joash leads a revolt against Athaliah; he ascends the throne after her assassination.

823–811 Assyrian king Shamshi-Adad V rules in Mesopotamia. He wages war against Urartu, an emerging Armenian civilization.

815–799 Jehoahas succeeds his father, Jehu, as king of Israel.

810–783 Adad-Nirari III of Assyria serves as king of Mesopotamia. His troops will fight against the peoples to the west of his empire.

800 The Urartu in Anatolia are defeated by the Assyrians. The Olmec city of La Venta is established, becoming the most important center of Mesoamerican culture in Central America for almost four hundred years.

799–784 Jehoash succeeds his father, Jehoahas, as king of Israel.

797–769 Jehoash's son, Amaziah, serves as king of Judah. He defeats the Edomites, who occupy the hilly lands south of the Dead Sea in modern Jordan in 798 B.C.E. The Israelites capture and assassinate him.

784–744 Jeroboam II succeeds Jehoash as king of Israel. He restores the traditional borders of Israel and captures Damascus.

776 The earliest known recorded observation of a solar eclipse is documented by the Chinese.

769–741 Azariah, son of Amaziah, enjoys a prosperous reign as king of Judah. His troops defeat the Philistines. Despite his military success, the Hebrew prophets Amos and Hosea warn of an eventual downfall due to corruption.

Greek colonists expand into Italy and Sicily.

760–747 King Kashta of Kush, one in a line of hereditary Egyptianized Nubian rulers, conquers and rules Upper Egypt. He founds the Twenty-fifth Dynasty that will rule Egypt until 664 B.C.E. His rule marks the beginning of nearly continuous foreign rule in Egypt until 1952 C.E.

753 Rome is founded by Romulus, leading to the development of a monarchy in Italy. The first king and religious leader traditionally is Numa Pompilius who ascends the throne in 715 B.C.E.

750 A Neo-Hittite state emerges in Anatolia.

750–550 The Archaic Period occurs in Greece. Greeks colonize Sicily, Italy, and the Ionian coast.

747–716 King Piye of Kush controls Nubia and Egypt.

744 Zechariah succeeds Jeroboam II as king of Israel. He is assassinated by Shallum, who in turn is killed by Menachem, who ascends the throne and rules until 735 B.C.E.

744–727 Tiglath-Pileser III of Assyria rules Mesopotamia. In 743 B.C.E. he attacks the Urarteans at Arpad. He then turns his attention in 739 B.C.E. to the west, forcing Judah and Israel to submit to his authority.

743–642 The Neo-Elamite Period, in which the Elamites meddle in Babylonian affairs, occurs on the Iranian plateau.

741–726 King Jotham and King Ahaz of Judah serve as co-regents in Syria-Palestine.

735 The Assyrian king Tiglath-pileser III sends his forces against Urartu again.

734–731 Pekahiah, son of King Menachem, serves as king of Israel. Ahaz of Judah rejects an alliance with Israel and seeks support of the Assyrians. Pekah reigns as king of Israel and invades Judah in an attempt to force it into an alliance against Assyria. He dies in a conspiracy and is replaced by Hosea, who is backed by the Assyrians.

731 The Assyrian king Tiglath-pileser III is forced to return home to put down a revolt in Babylon, completed in 728 B.C.E.

726–697 King Hezekiah of Judah rules while under control of the Assyrians. He rebels unsuccessfully at least twice.

725 King Hosea of Israel rebels against the Assyrian king Shalmaneser V, who invades in response.

722 Sargon II, son of Shalmaneser V, removes Israelites to captivity in Mesopotamia.

721–705 The Assyrian king Sargon II builds the Gate of the Citadel at Khorsabad in Mesopotamia. The giant carvings depict two winged bulls with human (male) faces.

721 The Elamite king Humbanigash and the Babylonian king Merodach-baladan attack Sargon II of Assyria at Der.

720 The Chinese build a canal connecting the Huai and Yellow Rivers.

716–702 King Shabako of Kush rules in Nubia and in Egypt.

714 The Assyrian king Sargon II defeats Urartu. His forces break the alliance of the southern Palestinian states with Egypt in 712 B.C.E.

710 Babylonian king Merodach-baladan revolts against the Assyrian king Sargon II but is defeated and forced into exile. He returns in 703 B.C.E. to reclaim the throne but is again defeated by the Assyrians.

704–681 Sennacherib of Assyria rules in Mesopotamia.

702–690 King Shibitqu of Kush rules both Nubia and Egypt.

700 Celtic peoples begin settling in the Iberian Peninsula.

697–642 King Manasseh, son of Hezekiah, rules Judah.

690–664 King Taharqo of Kush rules in Nubia and Egypt.

690 Phrygia, a Thracian city-state in Asia Minor along the Black Sea, is attacked by the Cimmerians, a people who occupy most of the Crimea.

680–669 Sennacherib's son, Esarhaddon, becomes king of Assyria. He conquers Babylon, razes the Phoenician city of Sidon, and incorporates Egypt into his empire after capturing Memphis.

675 Lydia, a city-state in western Anatolia, rises in power. The Lydians are credited with inventing coins.

668–627 Ashurbanipal follows Esarhaddon as Assyrian king. He defeats the Elamites, destroying their capital at Susa in 639 B.C.E.

664–653 King Tanwetamani of Kush rules in Nubia.

664–525 Libyans found the Twenty-sixth Dynasty and expel Assyrians from Egypt.

660 The Persian prophet Zoroaster, the founder of Zoroastrianism, is born.

658 Lydian, Ionian, and Carian mercenaries join the Egyptians in their fight against the Assyrians.

653–643 King Atlanersa of Kush rules Nubia.

653 The Median king Phraortes, who conquered many of the peoples in the region, is killed in battle against the Assyrians.

650–590 A series of leaders known as "lawgivers" rule in Greece.

650 The carved limestone relief "Dying Lion," depicting the feline being pierced by three arrows, is carved in Nineveh.

643–623 King Senkamanisken of Kush reigns in Nubia.

642 Ancus Martius becomes king of Rome. A bridge is built over the Tiber River in Rome.

640 King Amon has a short reign in Judah, assassinated by his officers after two years. King Josiah of Judah reclaims the provinces of Samaria, Gilead, and Galilee from the Assyrians, who are experiencing domestic upheaval after Ashurbanipal's death. Josiah is assassinated by the Egyptian king Necho II at Megiddo.

626 Scythians, nomadic warriors from eastern Europe (Ukraine and Russia), invade Syria and Palestine.

625 The Chaldean Dynasty is established in Mesopotamia by Nabopolassar who consolidates power in the empire. This dynasty rules until 539 B.C.E.

612 The Scythians, Medes, and Babylonians capture and destroy the Assyrian city of Nineveh, and also conquer Urartu. Assyrians attempt to ally with Egypt to defeat the coalition.

609 King Jehoahaz of Judah fights Syrian and Israelite attacks on Jerusalem by turning to Assyria for help.

609–598 Josiah's son Jehoiakim serves as the king of Judah after Jehoahaz is deposed by the Assyrians.

605 Nebuchadnezzar becomes king of Babylon after defeating the Egyptian army led by Necho II of Egypt at Carchemish. He remains in power until 562 B.C.E.

600 A Phoenician fleet sails around Africa.

598 Jehoiachin becomes king of Judah and faces an invasion launched by Nebuchadnezzar of Babylon. The Babylonians conquer Jerusalem for the first time.

598–587 Nebuchadnezzar places Zedekiah on the throne of Judah. He is taken to Babylon as a captive after a failed revolt.

593–568 Aspalta becomes the first Meroitic king of Nubia.

590 The Greek tyrant Cleisthenes of Sicyon founds the Pythian Games in honor of the god Apollo. By 582 B.C.E. the games are held every four years.

587–586 Jerusalem is conquered again by Nebuchadnezzar of Babylon and the city walls razed. Judah is destroyed as a nation and the Babylonian Exile begins.

578 Rome joins the Latin League.

575 The fifteen-meter high glazed brick Ishtar gate, one of eight portals into Babylon, is built by Nebuchadnezzar.

573 Nebuchadnezzar captures the port city of Tyre after a thirteen-year siege.

568–555 King Aramatelqo of Meroe rules over Nubia.

563 Siddhartha Gautama, founder of Buddhism, is born in Kapilavastu in present-day Nepal.

560 Croesus of Lydia controls Asia Minor. The Athenian statesman and lawgiver Solon dies.

559–530 Cyrus the Great becomes king of Persia and establishes the Achaemenid (Persian) Empire which lasts until 330 B.C.E.

556 Nabonidus becomes king of Babylon and allies with Cyrus of Anshan, a small kingdom north of Babylon, against the Medes.

555–542 King Malonqen of Merore rules in Nubia.

551 The Chinese philosopher Confucius (K'ung Fu-tzu) is born.

550 Persia expands into Anatolia under the direction of Cyrus the Great. Within five years most of the Greek cities of Asia Minor provide tribute to the Persians.

Celts expand into the British Isles and Ireland.

547 Cyrus the Great conquers Lydia.

542–538 King Analmaaye of Meroe rules Nubia.

540 Mahavira (Vardhamana), the Indian religious ruler and founder of Janism, is born.

539 The Babylonian Exile ends when Cyrus the Great captures Babylon. Persia rules over Israel and Judah and dominates Mesopotamia.

538 Cyrus the Great issues an edict to rebuild the Temple in Jerusalem.

538–519 King Amani-natake-lebte of Meroe rules Nubia.

534 The Romans build the Temple of Juno.

533 Cyrus the Great conquers the Indus Valley and creates a province (satrapy).

529 Cambyses II becomes Persian king upon the death of Cyrus the Great in a battle against the Massagetae.

525 Cambyses II conquers Egypt. The Persians rule Egypt until 404 B.C.E.

522 Darius I becomes Persian king and quells revolts. He divides the empire into 22 provinces and completes a canal from the Nile River to the Red Sea.

519–510 King Karkamani of Meroe rules Nubia.

510–487 King Amaniastabarqo of Meroe rules Nubia.

509 The Roman Republic is founded. Lucius Junius Brutus and Lucius Tarquinius Collatinus are the first consuls. The Temple of Jupiter Optimus Maximus is built on the Capitoline Hill in Rome.

506 Rome and Carthage sign a non-interference treaty.

500–323 The Greek classical period on the Greek mainland marks a golden age for Greece during this period.

500 Ionian Greek city-states revolt against Persia.

Bantu peoples of Africa begin migrating throughout the continent. The Nok civilization of West Africa (Nigeria) flourishes.

496 The Romans defeat the Latins at the Battle of Lake Regillus and become the leading power in Italy.

494 Roman plebeians force political reform and additional rights from the patrician class.

490 Darius II reasserts control of Macedonia but Athens defeats the Persian Empire at the Battle of Marathon, blocking further expansion.

487–468 Siaspiqa of Meroe rules Nubia.

486 Roman consul Spurius Cassius Vecellinius, who had brokered a peace between the Romans and the Latin League in 493 B.C.E., is accused of trying to make himself the king of Rome after he tries to change agrarian laws to favor the plebeian

class. He is condemned and executed. Xerxes I (the Great) becomes king of Persia following the death of his father Darius I. He maintains Persian control over Egypt and Babylonia.

485　Lucius Quinctius Cincinnatus, a Roman consul and farmer, is declared dictator by his people in order to lead an army against the Aequi who have besieged a force led by Lucius Minucius Esquilius Augurinus. When Cincinnatus triumphs, he steps down from the position and returns to his farm.

484　The Greek dramatist Aeschylus wins his first prize in the competition for tragedy at Athens.

　　　Herodotus is born. His great work on the Greek-Persian wars leads to his reputation as the father of history.

470　The teachings of Confucius, known as the Analects, are collected by his disciples.

468–463　King Nasakhma of Meroe rules Nubia.

465–423　Artaxerxes I, son of Xerxes the Great, becomes Persian king after killing his father's assassin.

463–435　King Maloiebamani of Meroe rules Nubia.

457–445　Ezra is Persian governor of Judah.

451　The Twelve Tables, the basis of Roman law, are codified.

449　Athens and Persia negotiate the Peace of Callias.

447　Pericles begins building the Parthenon in Athens.

445–425　Nehemiah is Persian governor of Judah. He rebuilds the walls of Jerusalem.

435–431　King Talakhamani of Meroe rules Nubia.

431–404　Athens and Sparta fight the Peloponnesian War on the Greek mainland.

431–405　King Irike-Amanote of Meroe rules Nubia.

425　The Romans conclude a peace treaty with the Veii.

423–404　The Greek general Thucydides writes the history of the Peloponnesian War.

423–405　Xerxes II rules Persia.

410　The Gauls, Celtic tribes living in the German regions of Europe, begin migrations across the Alps into Italy.

409　Troops from the North African city-state of Carthage capture Sicily from its Greek colonizers. The Carthaginians are forced out in 406 because of a plague and make peace in 405 B.C.E.

405–404　Baskakeren of Meroe rules Nubia.

404–369　Harsiyotef of Meroe rules Nubia.

404–399　Amyrtaeus of Sais leads the Egyptian Twenty-eighth Dynasty.

404　Artaxerxes II follows his father Darius II as king of Persia. The Egyptian king Amyrtaeus drives Persians from Egypt.

399–381　Three kings rule successively as the Egyptian Twenty-ninth Dynasty.

390　Gauls defeat the Romans at the Battle of Allia but they fail to conquer the city of Rome.

381–343　Three kings from Sebennytos rule as the Egyptian Thirtieth Dynasty.

381　Cyprus submits to the Persians.

371　Chinese philosopher Meng-tzu, son of Confucius, is born. The Spartan king Cleobrotus is killed in battle with the Thebans.

367　Romans fight the Gauls.

359–336　Philip II becomes king of Macedon and conquers mainland Greece.

358　Artaxerxes III Ochus becomes king of Persia.

356　The first parts of the defensive fortifications, which will become the Great Wall, are constructed by the Chinese in an attempt to block invasions by the Huns.

353–340 The Noba occupy Kush and replace the kingdom of Meroe.

343–341 Rome is involved in the First Samnite War, gaining for Rome control of northern Campania.

343–332 Three Persian rulers lead the Second Persian Domination of Egypt.

340 Roman consul Titus Manlius Imperiosus Torquatus defeats the Latins in Campania and then again at Trifanum. The Latin League is disbanded and the former allies are made dependent partners in the expanding Roman empire.

340–335 King Nastasen of Meroe rules over Nubia.

336 Philip of Macedon is assassinated, and his son Alexander the Great ascends the throne.

335 Darius III ascends the Persian throne.

334 Alexander the Great defeats the Persians at the Granicus river and conquers Anatolia. His armies then capture the Phoenician cities, except for Tyre, on their way to Egypt.

332 Alexander the Great conquers Egypt.

ARCHITECTURE AND DESIGN

Edward Bleiberg

IMPORTANT EVENTS
in Architecture and Design

All dates in this chronology are approximations (c.) and occur before the common era (B.C.E.).

3800–2298 The earliest Egyptians bury their dead in oval pits in the desert and include pots, tools, and weapons.

3100–2800 The artists of the First Dynasty demonstrate a knowledge of uniform measurements called the cubit, palm, and finger.

Kings build seven mud brick enclosures at Abydos that are the first combination tombs and temples.

Egyptians add superstructures to pit tombs creating the first *mastabas*, tombs that resemble a large mud brick bench.

Architects use granite in door jambs for the first time.

2675–2625 The first preserved stone architecture built by King Djoser under Imhotep's supervision is constructed at Saqqara.

The first known architectural use of drills is in evidence at Djoser's construction at Saqqara.

2625–2585 King Sneferu's architects are unsuccessful in their attempts to build the first true pyramids, including structures at Meidum and Dahshur.

Architects building Mastaba 17 at Meidum, an early example of a noble's tomb, construct battered (inclined) walls.

2585–2560 King Khufu's architect Hemiunu builds the Great Pyramid at Giza, the largest pyramid

ever constructed. King Khufu's builders move 2,700,000 cubic meters (95,350,000 cubic feet) of stone, as engineering techniques allow for the routine moving of stone blocks up to sixty tons in weight.

Mastaba tombs are made of stone rather than the mud brick of earlier dynasties.

2585–2510 King Khafre builds his pyramid complex, including the Great Sphinx, the second pyramid complex at Giza. The valley temples from this complex are the best-preserved temples from the Fourth Dynasty.

2560–2555 King Djedefre (a.k.a. Redjedef) begins his pyramid complex at Abu Roash. It will remain unfinished, probably due to his early death.

2532–2510 King Menkaure builds his smaller pyramid complex, the third and final complex at Giza.

2508–2500 King Shepseskaf abandons Giza as the traditional resting place of kings to build his Mastabat el Fara'un in Abu Sir, returning to Djoser's earliest tomb type.

Tool marks at the Mastabat el Fara'un demonstrate that builders used saws to trim joins in masonry.

2500–2485 King Userkaf returns to Saqqara and builds a pyramid complex aligned with Djoser's complex.

King Userkaf builds the first sun temple dedicated to Re in Abu Sir.

Architects begin to construct mastaba tombs with increasingly complicated interior chapels.

2485–2472 King Sahure builds the first of the standard Fifth- and Sixth-dynasty pyramid complexes at Abu Sir.

2371–2350 King Unas includes the first known Pyramid Texts (spells recited during the royal funeral) carved inside his pyramid at Saqqara.

Skilled craftsmen working for King Unas work on statues in the quarry.

2008–1938 Nebhepetre Mentuhotep builds a tomb and temple at Deir el Bahri based on Theban temple types.

Egyptian workers at Nebhepetre Mentuhotep's temple at Deir el Bahri use benchmarks (permanent markers for the starting point) while surveying.

The Egyptians first use sandstone in construction.

1957 The vizier (prime minister) Amenemhet, serving King Mentuhotep III, leads one of the earliest quarrying expeditions into the eastern desert.

1938–1759 Twelfth-dynasty kings build pyramid complexes based on earlier traditions of the Fifth and Sixth Dynasties, but later build complexes based on the Third-dynasty tradition of Djoser.

Pictorial evidence from the time shows the Egyptians hauling heavy loads on sledges, which are sled-like devices used on sand.

1938–1909 King Amenemhet I builds a pyramid complex at Lisht based on earlier traditions of the Fourth through Sixth Dynasties.

1919–1875 King Senwosret I builds a pyramid complex at Lisht with an internal stone skeleton, like a scaffold meant to support the structure, an innovation that failed.

The workmen of King Senwosret I routinely haul blocks twice as big as the blocks at the Great Pyramid.

1836–1818 King Senwosret III builds a pyramid complex at Dahshur based on Djoser's Third-dynasty complex at Saqqara.

King Senwosret III builds an additional temple at Abydos where he is actually buried, reviving an early tradition from the First Dynasty in which the tomb is placed in Abydos in central Egypt rather than the area near Memphis.

1818–1772 King Amenemhet III builds a traditional pyramid complex at Dahshur and the Labyrinth at Hawara which follows the style of Djoser's pyramid complex at Saqqara.

1539–1292 Egyptian builders transport sandstone from Upper Egyptian quarries for use in Lower Egypt at Memphis.

The obelisk in the granite quarries of Aswan is begun and later abandoned because it cracked during the attempt to cut it from the bedrock.

1479–1425 Paintings from the tomb of the high official Rekhmire depict construction workers, including masons and brick makers.

1426–1400 King Amenhotep II restores the temple at Giza for the first time in the New Kingdom.

1400–1390 King Thutmose IV restores the temple at the Great Sphinx for the second time in two generations.

1390–1352 King Amenhotep III begins work on the Luxor Temple dedicated to the god Amun and the royal *ka* (soul).

1292–1190 The first documented use of the *shaduf*—a pole with a basket at one end and a weight that makes it easy to raise the basket at the other end—is shown in a tomb painting. A shaduf could have been used to lift construction loads as well as water.

1290–1279 King Sety I commissions a votive model of the temple he will build at Heliopolis, as a gift for the god.

Egyptians routinely move stone blocks weighing up to 1,000 tons, more than ten times as heavy as the blocks moved during the Old Kingdom.

1156–1150 King Ramesses IV commissions a presentation plan of his tomb in the Valley of the Kings. The plan is now found in the Turin Museum where it is known as Papyrus Turin 1885.

The Abbott Papyrus, now stored in the British Museum, describes tomb robberies and demonstrates that the Egyptian word *mer* ("pyramid") means any kind of tomb.

OVERVIEW
of Architecture and Design

EGYPTIAN BUILDING TYPES. Ancient Egyptian architecture falls into three categories: buildings for the living, buildings for the dead, and buildings for religious rites, i.e. temples, chapels, and shrines. The surviving architectural examples of Egypt's ancient past are from the latter two categories and are some of the most recognizable structures in the world. The Great Pyramid of Giza, for example, is one of the seven wonders of the ancient world, and one of the premier tourist attractions in Egypt today. The pyramids were tombs specifically created to be the homes of deceased kings in the afterlife, and were part of larger complexes that functioned to serve the dead king in the afterlife. These tombs include the vast pyramid complexes built for kings from the Third Dynasty until the end of the Middle Kingdom when the Egyptians abandoned pyramid building (2675–1630 B.C.E.). Kings were not the only ones to have homes in the afterlife; Egypt's elite class of individuals also built tombs called *mastabas* as permanent homes for themselves after death. The Egyptians first built mastabas for the earliest king in the First and Second Dynasties and continued to build them in Lower Egypt (northern Egypt) until the end of ancient Egyptian history (3500–30 B.C.E.) for the elite class. By the Sixth Dynasty and throughout the remainder of ancient Egyptian history, Egyptian nobles in Middle (central) Egypt and Upper (southern) Egypt carved tombs directly into the mountains that border the Nile river valley. During the New Kingdom (1539–1075 B.C.E.) the Egyptians buried kings in rock-cut tombs in the Valley of the Kings near modern Luxor and worshipped the deceased kings as gods in temples built just for that purpose.

EGYPTIAN BELIEFS. Egyptians believed their king was the incarnation of the god Horus on earth. According to the myth, Horus was a falcon, born to the god Osiris and his wife, Isis. When Osiris died he became the king of the dead. In the same way, the Egyptians believed that when the king died he became Osiris and ruled in the next world. The king's son on earth was then the new Horus. These beliefs help explain the nature of Egyptian tombs for kings. Tombs were the place where Horus became Osiris and people on earth had access to the deceased king. Egyptian belief in the afterlife was so powerful that they only used permanent building materials, such as stone, for buildings that needed to last eternally. Buildings for the living, then, made use of the relatively impermanent material of mud brick; even the king's palace was made of mud brick. The Egyptians also developed stone architecture for gods' houses which Egyptologists call temples.

ARCHITECTURE AND SOCIETY. Architecture plays a pivotal role in understanding ancient Egyptian society. In the earliest periods and as late as the end of the Old Kingdom (3500–2170 B.C.E.), architecture provides scholars with the majority of the evidence for such an analysis because so little else from the culture survived. Relying on architecture for our understanding of a culture means that only a limited range of questions can be reliably answered. Architecture can, for example, be a good indicator of where a society allocates resources. In addition, the enormous effort required to build the Great Pyramid reveals something about the government's ability to direct and organize society's energies. Changes and continuity in architectural plans also suggest developments in religion and perhaps politics. Scholars, however, have often challenged the reliability of interpretations of religion based solely on architectural changes. When texts survive to supplement the knowledge derived from architecture, a much fuller picture can emerge. This is the case for the rock-cut tombs and the temples built for kings and gods in the New Kingdom (1539–1075 B.C.E.). In this time period the texts and sculptural reliefs on the interior walls of these structures supplement our understanding of the function that the rooms served and better define when important religious changes occurred. Finally, architecture provides one of the best categories of evidence for examining a society's approach to technology. Although technologically simple when compared to modern cultures, Egypt's structural accomplishments with such simple tools once inspired theories that Egyptian monuments were actually the work of aliens. Scholars have proven, however, that such supernatural or extraterrestrial explanations are unnecessary.

RESOURCE ALLOCATION. For nearly 3,000 years the Egyptians devoted an enormous percentage of their society's efforts and energy to monumental stone architecture. Only agriculture exceeded architecture for sheer manpower and time needed. At the start of the

twenty-first century, it is difficult to imagine both the impact that Egyptian architecture made on Europeans of the eighteenth and nineteenth centuries, who were astounded by the Egyptians' accomplishments, and the difficulty of producing massive stone buildings when it is so common today. It was only in the twentieth century that architects routinely designed buildings similar in size to ancient Egyptian buildings. Unlike modern construction projects that engage a significant number of society's workers but not a majority, most able-bodied Egyptians spent some time on construction projects during a lifetime of work. The Egyptian government organized the general population into either four or five rotating work groups known individually as a *za* that Egyptologists translate with the Greek word *phyle*. These phylae produced hundreds of thousands of cubic feet of stone walls, roofs, and foundations in nearly every generation. The Egyptian government also imported hundreds of boatloads of timber from Lebanon and directed craftsmen to produce tools, including stone axes, bronze chisels and saws, and wooden mallets. Engineers designed and built wooden sledges thirty meters (98.4 feet) long and huge boats that hauled several hundred tons of stone. Workmen dragged containers of sand and Nile mud to construction sites to make bricks. At the same time, the bureaucracy organized thousands of people to do the actual construction work and hundreds more who trained, fed, and clothed the workers. Egyptian architecture represents not only the highest design principles but also an astounding degree of cooperation, organization, and control for an early society. All of these organizational feats added to the Egyptians' high reputation as engineers and architects among ancient peoples, a reputation that the Egyptians retain today. Moreover, the ability of the Egyptian government to control people's actions suggests the degree of legitimacy it enjoyed as well as its power to coerce people into performing difficult and dangerous tasks for long periods of time.

CONTINUITY AND CHANGE. Egyptian society, including architecture, was far from stagnant, though some scholars have seen conservatism as its main feature. Perhaps a fairer description of Egyptian society would emphasize a fondness for continuity coupled with an ability to meet shifting circumstances with creative solutions. These solutions often transformed new buildings in subtle ways. Certainly the period from the beginning of architecture about 3500 B.C.E. to the end of the Old Kingdom about 2170 B.C.E. was extremely creative. During this time period the Egyptians developed a vocabulary of architectural forms and plans that included the

mastaba tomb and two different plans for pyramid complexes. They also developed the first sun temples dedicated to the chief god of the Egyptian pantheon at that time, Re. There was, however, tremendous variation in the plans of individual buildings and complexes. These subtle shifts have become the basis for interpreting the relationship between Egyptian architecture and its religion and politics. Yet almost all the buildings from this time period can be classified into one of four types: mastabas, north/south pyramid complexes, east/west pyramid complexes, and sun temples.

THE IMPORTANCE OF STONE. Even among the different types of plans and buildings, there is a unity in the way that Egyptians approached stone as a material. This unity of approach supplies the clearest evidence for Egyptian conservatism in design. One of the most distinctive features of Egyptian design was the designer's insistence on translating mud brick architecture into stone, reproducing parts of buildings originally fashioned from wood, reeds, woven mats, and mud brick in stone buildings during all periods. Egyptian artisans carved stone elements to resemble building elements originally constructed from such lightweight and perishable materials. In fact, the major features of Egyptian architectural style originated in techniques more at home in these lighter architectural materials. Egyptian builders constructed battered walls at varying angles to duplicate the mud brick construction, and imitated the original reed material in their construction of the concave Egyptian cornice that projects from the tops of walls. Woven mats originally functioned as screen walls to separate the holiest part of the building from the public eye, and could be used in combination with wood to create false doors. The relatively small number of architectural forms combined with this approach to stone is one reason why the variety of Egyptian expression is sometimes muted in comparison with the more overwhelming sense of continuity conveyed by Egyptian buildings.

INTERPRETATION WITHOUT TEXTS. Because of the emphasis on continuity in Egyptian design, there is a temptation to interpret any variation in plan or location from one generation to the next as indicative of a larger cultural change. Thus Egyptologists ask why King Shepseskaf, the son of the builder of the third pyramid at Giza, never built a pyramid for himself, choosing instead to build a tomb based on the older royal tradition of building a mastaba. Clearly this change appears to be a reflection of some important change in either religious or political policy. Either Shepseskaf desired a return to an earlier attitude toward the office of king, or economic

conditions made it impossible for him to build as his father, grandfather, and great-grandfather had done. Perhaps some combination of religious and political forces was the cause, but without any corroborating evidence from texts, it is impossible to correctly interpret the king's actions. This lack of evidence points toward the fragility of some interpretations of Old Kingdom history based solely on architecture.

INTERPRETATION WITH TEXTS. Scholars were not wholly without texts, however. Written evidence and surviving decoration on the walls of a building add greatly to the reliability of interpretations of Egyptian buildings. In general Egyptologists accept that the decoration of a room in a temple or the inscriptions on the walls describe or explain the function of a room. Thus relief sculptures on the walls of a room that depict the king performing a series of ritual actions can reliably be interpreted as an illustration of what occurred in the room. The spells of the *Pyramid Texts* inscribed on the walls of late Fifth- and Sixth-dynasty pyramids are thought to have been recited on that spot. The existence of additional contemporary texts written on papyrus or limestone chips called *ostraca* adds even more to our general knowledge. The evidence used to interpret the use of buildings increases considerably for the New Kingdom compared to the earlier periods. For example, a comparison of written descriptions of the king's position in the world dating to the New Kingdom with the decoration of palaces, also built in the New Kingdom, shows how the same ideas had expression in two different mediums.

THE FUNCTIONS OF BUILDINGS. Earlier scholars of Egyptology could be overly influenced by their own preconceptions when they assigned functions to ancient buildings. This tendency was especially true in the nineteenth and early twentieth centuries when archaeologists tried to understand the buildings they had excavated without any corroborating evidence from texts. Early scholars concluded, for example, that buildings with high, paneled surrounding walls that date to the Predynastic Period (4400–3100 B.C.E.) were forts, even though they had no comparative material or extensive textual evidence to support such a theory. New interpretations, based on expanded comparative material, suggest that they were actually part of the kings' burials. The term "mortuary temples," used to describe the section of pyramid complexes built in the Old and Middle Kingdoms (2675–1630 B.C.E.), stems from the false supposition that their sole function concerned the burial rites of the king, which reflected a modern Western focus on the funeral ceremony and burial. Scholars now understand these buildings as being important to the kings' continued life in the next world as the center of an eternal cult to honor the deceased king. These buildings are now called pyramid temples, describing their proximity to the pyramid rather than a definite function.

THE DEVELOPMENT OF EGYPTIAN TECHNOLOGY. In the 2,000-year history of Western interest in ancient Egypt, often the occult, the supernatural, and even the extraterrestrial have been proposed as explanations for certain phenomena. Nowhere is this more evident than in the interpretation of architecture. Many of these non-scientific explanations of ancient Egyptian accomplishments center on the construction of the pyramids. Many of these interpreters look only at the three pyramids at Giza built by kings Khufu, Khafre, and Menkaure between 2585 and 2510 B.C.E. The enormous size and astounding precision with which these buildings were constructed not only arouse a sense of wonder, but have also suggested to many that the simple technology available to the Egyptians would not have sufficed to produce these buildings. A careful consideration of pyramid building from its origins in the time of King Djoser (2675–2654 B.C.E.) to the end of royal pyramid building at the close of the Middle Kingdom about 1630 B.C.E., shows a natural progression and even a learning curve. The earliest buildings contained mistakes. Subsequent buildings were sturdier because of innovations made in response to previous mistakes. Some innovations failed and were not repeated in later buildings. At the same time, the Egyptians learned to move increasingly heavier loads as their technology improved from the Old Kingdom to the New Kingdom. It is even possible to chart the progress in this one field of endeavor that is often ascribed in popular literature to knowledge obtained from space aliens. A study of the technological aspects of Egyptian building reveals much about their approach to problem solving.

TOPICS
in Architecture and Design

EARLIEST TEMPLES AND TOMBS

FIRST STRUCTURES. The earliest temples and tombs built in Egypt are in Abydos in Middle Egypt. Egyptologists have been aware of these structures since the late 1890s. In the roughly 100 years that Egyptol-

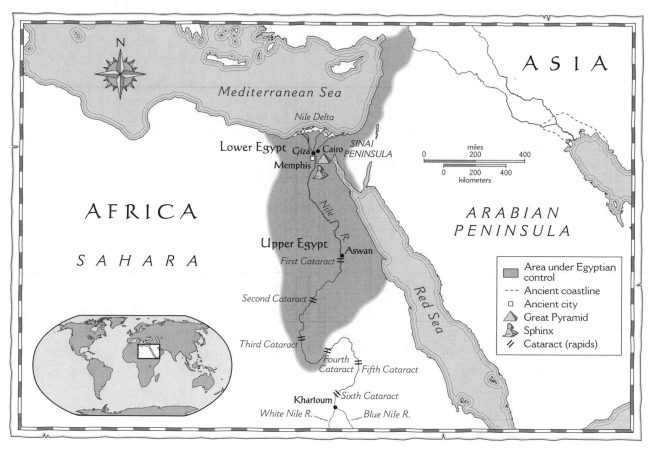

Map of ancient Egypt. XNR PRODUCTIONS, INC. THE GALE GROUP. REPRODUCED BY PERMISSION.

ogists have discussed these sites, there were differing opinions on whether they were temples, tombs, or forts. Other discussions of them suggested that some of these buildings were *cenotaphs,* structures built only to honor certain kings but not to house their burials. Most recently scholars have realized that these buildings represent the earliest royal tombs—located in the section of Abydos called in Arabic *Umm el Gaab* ("Mother of Pots")—and the earliest cult temples dedicated to deceased kings, located in the section of Abydos called in Arabic *Kom es-Sultan* ("Mound of the Ruler") about two kilometers from the tombs. Moreover, the two sets of buildings can be divided into pairs that resemble later funeral complexes consisting of a burial and a temple where the deceased king was eternally worshipped.

EARLY EXCAVATION. One of the first archaeologists to work in Egypt, the Englishman W. M. F. Petrie (1843–1942), excavated some of the earliest temples and tombs. Petrie worked all over Egypt, but during 1899–1900 and 1902–1903, he concentrated his efforts on a site in Middle Egypt called Abydos. Several villages

are now resident at the site formerly known as Abydos, including the village of Kom es Sultan and the village of Umm el Gaab. Petrie worked first in the village of Umm el Gaab, then two years later at the village of Kom es Sultan. At Umm el Gaab Petrie found and identified the cemetery of kings of the First and Second Dynasties (3100–2675 B.C.E.). The underground portion of these tombs was lined with wood protected by a surrounding wall of mud brick. Some of the twelve known burials had more than one room, and some were lined with green *faience* tiles—an early glazed material. In later eras such tiles resembled bundles of reeds that formed the earliest sorts of temporary buildings built by the Egyptians. Many Egyptologists assume that the Egyptians used these tiles in a similar way at the Umm el Gaab burials. Builders probably intended the entire underground burial to reproduce the king's house on earth so that he would have a home in the next world. Thus this pattern of designing the burial after houses on earth began with the very earliest royal tombs. Above ground was a platform, built of brick. The platform was marked by a *stele* (an upright slab of stone), that was inscribed with the king's name. Similar but smaller tombs designed for

Arts and Humanities Through the Eras: Ancient Egypt (2675 B.C.E.–332 B.C.E.)

7

BURIAL
Tombs and Temples at Abydos

In 1899–1900 W. M. F. Petrie excavated the royal tombs of the first and second dynasties at Umm el Gaab, a section of the ancient Egyptian town called Abydos. In 1902–1903 he worked at Kom es Sultan about two kilometers from Umm el Gaab. There he found the temple enclosures that were a part of the royal funeral complexes. When he first discovered the thickly walled buildings at Kom es Sultan, however, Petrie identified them as forts and did not recognize the connections between the Umm el Gaab and Kom es Sultan buildings. Subsequent research identified the buildings that Petrie identified as forts as the first temples, gathering places for the gods. The following map shows the locations of various Abydos burial tombs with corresponding names of the kings that are buried there, along with the location of the Kom es Sultan temples.

SOURCE: Dieter Arnold, "Royal Cult Complexes of the Old and Middle Kingdoms," in *Temples of Ancient Egypt.* Ed. Byron E. Shafer (Ithica, N.Y.: Cornell University Press, 1997): 40.

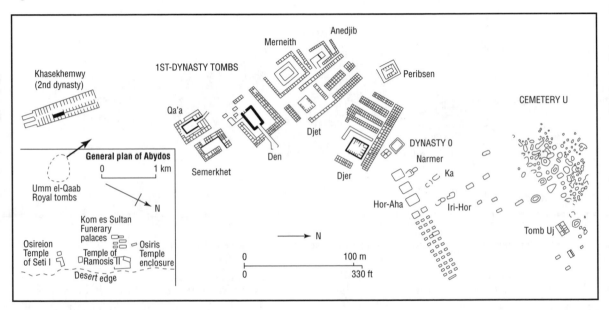

Plan of royal tombs at Abydos. CREATED BY GGS INFORMATION SERVICES. GALE.

the king's courtiers were located around the king's tomb. This practice marks the beginning of a tradition of including the king's courtiers' tombs on the same site that continued through the next thousand years.

TOMBS IN SAQQARA. From 1936 to 1956, the English archaeologist Walter B. Emery excavated large First-dynasty mastaba tombs at Saqqara in northern Egypt (Lower Egypt). These tombs contained many grave goods including jars labeled as the king's property. These labels led Emery to identify these Saqqara mastabas as the real tombs of the First-dynasty kings since he believed that the tombs discovered by Petrie at Umm el Gaab were *cenotaphs*, memorials to the kings that never contained burials. After considerable debate, most Egyptologists believe that the Saqqara tombs belonged to high officials of the First Dynasty while the actual kings' tombs were located in Abydos at Umm el Gaab. Even so, some books and articles written during the mid-twentieth century continue to refer to Saqqara as the burial place of First-dynasty kings.

FUNERARY ENCLOSURES ("FORTS") AT KOM ES SULTAN. Petrie worked his second season at Abydos in 1902–1903 at the area known as Kom es Sultan. There he found the mud brick foundations of five buildings with huge mud brick walls. The walls were up to eleven meters (36 feet) tall and were roughly 65 by 122 meters (213 by 400 feet) long. Petrie believed that these massive walls and large enclosed spaces could only be intended as forts. These structures were built completely above ground and had no underground chambers such as were found at the tombs of Umm el Gaab. The patterned, mud brick walls were laid in what Egyp-

tologists later came to call the "palace façade" pattern. This pattern was repeated throughout ancient Egyptian history, both in buildings and in representation in relief and on statues, and led Egyptologists to arrive at a better understanding of the function of these enclosures. The Egyptians used the walled enclosure with panels, called the palace façade motif, in hieroglyphic writing contemporary with the earliest temples discussed here. A drawing of this motif surrounded the names of buildings the Egyptians called the "fortress of the gods" in hieroglyphic writing. Egyptologists believe that this writing connects the names to the buildings found at Kom es Sultan in Abydos. The buildings were given names such as "Thrones of the Gods" and "Procession of the Gods" which suggests that the Egyptians thought of these buildings as places where the gods gathered. The Egyptians called these gods the "Followers of Horus." Because the king himself was the incarnation of the god Horus the "Followers of Horus" were local gods from the provinces who gathered at the Fortress of the Gods to deliver taxes. The design of the surviving buildings indicates that this process would continue for the king even after he had died and gone to the next world.

FORTRESS OF THE GODS. It is possible to generalize about the architecture of the Fortress of the Gods from the archaeological remains at Kom es Sultan in Abydos and the hieroglyphic writings of the names of these buildings. Located on the west bank of the Nile River, the building's entrance faced the river, suggesting that the gods arrived in boats sailing on a canal that led to the enclosure. Support for this theory comes from the discovery of boats buried along the east side of the enclosure of King Khasekhemwy (fifth king of Dynasty 2, before 2675 B.C.E.) near Abydos. The other architectural feature inside the enclosure was a mound of sand. This mound may be the remains of the platform where the king, as the god Horus, reviewed the assembled gods. These enclosures are prominent remains from the First and Second Dynasties. They diminish in importance during later periods, but still were built as late as the New Kingdom (1539–1075 B.C.E.). Scholars constructed this new interpretation of the buildings at Umm el Gaab and Kom es Sultan based on knowledge of later buildings. The pyramid complexes built by kings in the Third through Sixth Dynasties contained both a burial and either one or two temples intended for preserving the cult of the deceased king. Increased knowledge of these later structures during the early twentieth century allowed archaeologists to reexamine the buildings at Abydos.

Based on knowledge of the basic functions of buildings in the later pyramid complexes, archaeologists have discovered parallel uses for the pairs of buildings that First- and Second-dynasty kings constructed in Abydos.

SOURCES

Dieter Arnold, "Royal Cult Complexes of the Old and Middle Kingdoms," *Temples of Ancient Egypt*, edited by Byron E. Shafer (Ithica, N.Y.: Cornell University Press, 1997): 31–85.

Barry J. Kemp, "Abydos and the Royal Tombs of the First Dynasty," *Journal of Egyptian Archaeology* 52 (1966): 13–22.

David O'Connor, "New Funerary Enclosures (*Talbezirke*) of the Early Dynastic Period in Abydos," *Journal of the American Research Center in Egypt* 26 (1989): 51–86.

SEE ALSO *Religion: Temple Architecture and Symbolism*

PYRAMID COMPLEXES

PART OF A WHOLE. The pyramid is the most widely known Egyptian architectural structure. Yet the pyramid itself is only part of a much larger complex. Egyptian kings built pyramid complexes during a distinct time period. During the Old and Middle Kingdoms (2675–1630 B.C.E.) most, but not all, kings built pyramids as tombs. There are approximately 47 pyramid complexes that Egyptologists have identified from this period. This does not include the pyramids built in the Sudan by Nubian kings at a later time, because they were part of a separate tradition over 1,000 years after the Egyptians stopped building pyramids.

PYRAMID COMPLEX TYPES. Egyptologists recognize two major types of pyramid complexes. In the older type, the main axis of the complex was oriented north and south. This orientation associates the complex with the Egyptian belief that the northern stars represented the gods in the next world. The stars were the physical expression of the belief that the deceased king became Osiris, king of the dead, and that his son on earth was the god Horus who ruled after him. Often the pyramid in the north/south complex was a step pyramid. In such cases many Egyptologists believe the step pyramid represented a staircase to the stars. The second type of pyramid complex has a main axis that runs east and west and reflects a different belief system regarding the afterlife. This orientation associates the complex with the

BUILDINGS
of Dynasty Three

King Djoser's Saqqara complex is the earliest well-preserved stone architecture from ancient Egypt. Other than the remnants of foundations and even some walls which have survived, almost nothing is known about these buildings or the people who built them. Listed be- low are the names of surviving pyramid complexes, the kings that most likely built them, the type of pyramid they likely represented, and where the remains were located or where the pyramid was most likely built based on ancient record. They are listed in chronological order by reigning king. Absolute dates for these kings and their buildings still remain unknown. Scholars had named the pyramid complexes after the kings that most likely built them since the ancient names for these buildings are not preserved.

King/Pyramid Name	Pyramid Type	Location
Nebka (Horus Sannakht)	Unknown	Unknown
Djoser (Horus Netjerykeht)	Step Pyramid	Saqqara
Djoserteti (Horus Sekhemkeht)	Buried Pyramid	Saqqara
Hours Khaba	Layer Pyramid	Zawiyet el-Aryan
Huni (Horus Qahedjet)	Unknown	Unknown

CREATED BY GGS INFORMATION SERVICES. GALE.

course of the sun and the sun-god, Re. In this Egyptian belief system, Re rode in a boat that traveled across the daytime sky from east to west and then traveled in the land of the dead at night, emerging in the east again in the morning. The deceased king joined Re in his journey in the boat, called a *solar barque.* There was no real opposition between people who believed in one or the other of these two myths. In fact, many Egyptians believed that both myths were true. Ancient Egyptians often had divergent explanations or beliefs they held as equally valid. This multiplicity of solutions presents problems today when the inclination is to seek for a simple and exclusive answer to a question. Though these ideas explain individual pyramid complexes, Egyptologists still do not understand why a king would choose to build a north/south rather than an east/west pyramid complex or vice versa. Often Egyptologists try to explain the choice between the two kinds of complexes as a choice in emphasizing one myth of the afterlife over the other.

PARTS OF A PYRAMID COMPLEX. Both north/south pyramid complexes and east/west pyramid complexes have similar elements. They included the pyramid itself, sites for performing daily rituals, and subsidiary burials. Almost every pyramid complex had unique features in addition to these common features. The meaning of these features is almost never clear. The pyramid itself is the most important common element in a pyramid complex. Egyptians first built step pyramids (pyramids constructed in layers that decreased in size at higher elevations) in the Third Dynasty and built mostly true pyramids (pyramids with smooth sides) beginning in the Fourth Dynasty and later. Besides the difference in outward appearance, there are major differences between the interiors of step pyramids and true pyramids. The step pyramids included ritual areas and storage in addition to a burial chamber inside them. True pyramids sometimes included ritual sites and limited storage areas, but emphasized the burial chamber. The Egyptians observed rituals in pyramid complexes with true pyramids at temples built near the pyramid and at the entrance to the complex in the valley. The Egyptians added temples to the newer, true pyramids that they built beginning in the Fourth Dynasty. Often they built a temple adjacent to the pyramid, known today as a pyramid temple. They also built a temple in the valley below the pyramid that served as an entrance to the complex. Egyptologists call these temples "valley temples." Scholars continue to debate the purpose of these buildings. Older interpretations suggest that the pyramid temple was the site of the funeral and was not used after the king's burial. Most recent scholarship suggests that the pyramid temple, like the valley temple, was the site of continuing rituals that the Egyptians planned for eternity. Pyramid complexes also included burials for other royal family members. No real proof exists as to who was buried in these subsidiary burials, though Egyptologists often call them "queen's burials." They often take the form of small pyramids and vary greatly in number from one complex to another. Recently scholars have suggested that subsidiary burial sites were meant to accommodate different parts of the

king's soul. These parts would include the *ka*, the *ba*, the *akh*, and the mummy itself. The *ka* was the part of a king's soul that was passed from one king to another and that designated an individual as the true Horus. The *ba* was the part of the soul that traveled between this world and the next, conveying offerings to the deceased in the next world. The *akh* represented the transformation of the earthly individual into a divine individual that could dwell in the next world. The mummy served as a home for the ba when it was on earth. The pyramid, pyramid temple, and subsidiary burials occupied a space on the plateau that rises above the Nile river valley on the west side. The Egyptians built the valley temple in the valley at the edge of the desert where the agricultural land ended. A covered, stone causeway connected the valley temple with the rest of the pyramid complex.

SOURCES

Alexander Badawy, *A History of Egyptian Architecture: The First Intermediate Period, the Middle Kingdom, and the Second Intermediate Period* (Berkeley: University of California Press, 1966).

THE NORTH-SOUTH PYRAMID COMPLEX: KING DJOSER'S COMPLEX AT SAQQARA

EVIDENCE. King Djoser's complex at Saqqara is the first example of a north/south oriented pyramid complex, built in the Third Dynasty (2675–2625 B.C.E.). This predominant orientation alternated throughout the Old and Middle Kingdoms (2675–1630 B.C.E.) with a pyramid complex that was oriented east/west. A good example of this second type of orientation is the Great Pyramid of Giza, built about 100 years after Djoser's Saqqara complex. While the north/south orientation is primarily associated with the eternal gods the Egyptians recognized in the circumpolar stars that never disappeared, the east/west orientation is primarily associated with the sun-god Re. The alternation between north/south and east/west orientations for pyramid complexes has thus been interpreted to have a religious dimension. Further, Djoser's pyramid complex reveals that the split between Upper (southern) and Lower (northern) Egypt can be traced back to the Third Dynasty, a split that is more fully established in later times by texts. Though the Egyptians had already been reading and writing for hundreds of years before the construction of Djoser's complex, there are few surviving extended texts from this period. Thus a seemingly obvious political fact

such as the early establishment of the importance of Upper and Lower Egypt can only be established in the Third Dynasty by architecture. Finally, evidence for the celebration of the religious-political Jubilee (*sed*) Festival can be established from the architecture of Djoser's complex. Buildings that Egyptologists know to be used mainly for such a festival were located on the east side of the complex.

FIRST WELL-PRESERVED STONE BUILDING. King Djoser's complex at Saqqara is the earliest preserved example of stone architecture in Egypt. The Egyptian archaeologist Nabil Swelim has convincingly argued that it represents an early culmination of stone architecture. While archeologists are aware of the existence of foundations from earlier buildings, Djoser's complex is the first stone building in Egypt whose architect is known: Imhotep. A large-scale stone wall—277 by 544 meters (908 by 1,784 feet)—surrounds the complex. The wall was built in the palace façade motif with panels and with the addition of towers at intervals around the entire wall. Unlike the earlier enclosures of the First and Second Dynasties, Djoser's wall surrounded extensive architecture as well as large courtyards. The buildings inside Djoser's complex included a monumental entranceway, step pyramid, a series of buildings designed as a backdrop for the king's Jubilee Festival (*sed*-festival), two model palaces, and a model of an Upper Egyptian-style tomb.

SYMBOLIC, NON-FUNCTIONAL BUILDINGS. Imhotep designed four areas of symbolic, non-functional buildings in Djoser's complex in Saqqara: the Pavilion of the North, the Pavilion of the South, the South Tomb, and the Jubilee Festival Courtyard. These buildings are full-size models rather than functional buildings. Builders constructed only the exterior façade of the building, like a stage set. It was not possible to enter any of these buildings, though some of them had doors carved in stone. French archaeologist Jean-Phillipe Lauer, the excavator of the complex, believes that the non-functional buildings were for the use of the king's *ka*, or spirit, in the afterlife. Some evidence suggests that workers purposely buried the non-functional buildings soon after construction, though it is not clear why.

FUNCTIONAL BUILDINGS. While it is readily apparent which elements of the tomb were not functional, it is not as easy to determine which elements of the complex were in use. The northern end of the enclosure is still unexcavated, leaving scholars in doubt as to how it was used, and the ruined state of the complex likewise hinders an accurate perspective. Lauer argued that the

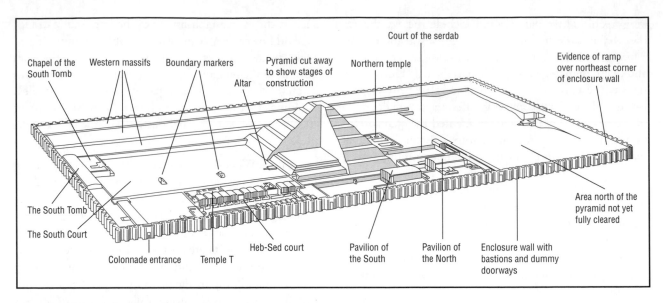

Diagram of Djoser's Step Pyramid complex. **CREATED BY GGS INFORMATION SERVICES. GALE.**

Labels on diagram:
- Chapel of the South Tomb
- Western massifs
- Boundary markers
- Altar
- Pyramid cut away to show stages of construction
- Court of the serdab
- Northern temple
- Evidence of ramp over northeast corner of enclosure wall
- The South Tomb
- The South Court
- Colonnade entrance
- Temple T
- Heb-Sed court
- Pavilion of the South
- Pavilion of the North
- Enclosure wall with bastions and dummy doorways
- Area north of the pyramid not yet fully cleared

functional elements in the complex were the entrance at the southeast corner of the enclosure, the pyramid which served as a tomb for Djoser, and the Northern temple used for the funeral service. The American archeologist Mark Lehner suggested that it is more likely that Djoser's funeral procession entered the building over the still-existing ramp at the northeast corner than through the functional entranceway at the southeast. None of the passageways that lead from the southeast entrance to the northern temple are wider than one meter (39 inches), so a funeral procession through the complex would be very difficult. The functional entrance way to Djoser's complex is located at the southeast corner of the enclosure wall. This location parallels similar functional entrances in the southeast corners of the enclosures that kings of the First and Second Dynasties built at Abydos. Djoser's entranceway, however, was built of stone carved to imitate a building built of reeds and wood. A monumental doorway leads to a hallway surrounded on both sides with engaged columns attached to the sidewalls painted green and carved to resemble columns made from bundles of reeds. The limestone roof is painted brown and carved to resemble logs. Clearly this entranceway imitates the type of ritual buildings that Egyptians built of these light materials previous to the Third Dynasty.

THE STEP PYRAMID. The pyramid itself stands slightly off-center in the complex toward the south. It reaches sixty meters (167 feet) in height in six layers and is the only Egyptian pyramid that has a rectangular base rather than a square base. Lauer interpreted the construction history as a series of additions. The first stage of the building was a square mastaba built in stone. Roughly every three years of Djoser's nineteen-year reign, workers added an additional layer. Lauer and German archaeologist Dieter Arnold have interpreted the expansions as gradual, reflecting emerging ideas about the king's future in the afterlife. The German Egyptologist Rainer Stadelmann, on the other hand, believes that Imhotep planned the step pyramid shape from the beginning. In any case, the shape represented a staircase to the northern stars. These stars represented the god Osiris because they never disappear as do stars in other parts of the heavens. Thus they are eternal, like Osiris. Beneath the Step Pyramid at Djoser's complex are over 400 rooms connected by tunnels. The total length of the rooms and tunnels combined is 5.7 kilometers (3.5 miles). The rooms include the king's burial chamber and a palace to serve as the home for the king's spirit. The king's burial chamber was accessed through a vertical shaft in the pyramid that was seven meters (22.9 feet) on each side and reached a depth of 28 meters (91.8 feet), lined entirely in granite. At the bottom of the shaft was a burial chamber lined with four courses of granite blocks. After the burial, workers lowered a 3.5-ton granite block to block the shaft and prevent future access by robbers. The palace for the king's spirit, located under the east wall of the pyramid, was lined with limestone and decorated with relief sculptures. Other areas were lined with faience tiles arranged to imitate mats made of reeds. The storage rooms were on the east side of the pyramid and housed over forty thousand jars, some inscribed with Djoser's name, but many more made in earlier times for other kings. Some scholars be-

lieve that many of these stored materials came from earlier tombs that had been removed from the Saqqara plateau to make room for Djoser's complex. Nevertheless, the great wealth stored in the pyramid demonstrates both the opulence of the king's life on earth and in the next world.

JUBILEE FESTIVAL (SED) COURT. The Jubilee Festival (*sed*) Court at Djoser's complex was conceived as a space where the king's ka—royal spirit—could celebrate the Jubilee Festival for eternity. Egyptian kings celebrated the Jubilee Festival (*sed*) after roughly thirty years of rule and then every two years thereafter as long as the king lived. During the festival, the gods of the *nomes* (Egyptian provinces) visited the king in the form of statues to pledge loyalty to him. The details of the ritual remain unknown. The kings of the First Dynasty celebrated this festival, both in life and in the afterlife at the so-called forts of Kom es Sultan at Abydos. There is evidence that kings continued to celebrate this festival in every period of Egyptian history, but Djoser's courtyard is the only three-dimensional representation of the physical setting of the festival. The Jubilee Festival Court contains non-functional buildings in two rows that face each other across an open space. These buildings housed the spirits of the visiting gods, probably in the form of statues, during the festival. The dummy non-functional buildings, built of stone, are only façades. The stone is carved to resemble buildings built of woven mats, bundles of reeds, and logs. In some cases doorways carved in stone appear to be open, but it is impossible to enter any of the buildings. At the south end of the open space is a platform reached by steps. This platform supported the royal thrones, one for Lower Egypt and one for Upper Egypt. There the king celebrated the end of the ceremony wherein the gods officially reconfirmed him as king. Since only the spirits of the deceased king and the gods used this space, the American archaeologist Mark Lehner suggested that workers buried it in sand soon after its construction, though the reason for this is unknown. While living, the king probably celebrated this festival at the royal palace.

PAVILION OF THE NORTH AND THE SOUTH. Two of the non-functional buildings at Djoser's complex represent the palaces of Upper and Lower Egypt. They are called the Pavilion of the North and the Pavilion of the South. They are located near the northeast corner of the pyramid, not far from the mortuary temple. The two buildings face each other across an open courtyard. Lauer suggested that the two buildings symbolically represent the palaces Djoser maintained in life as

Seated statue of Imhotep. BROOKLYN MUSEUM OF ART, 08.480.24, CHARLES EDWIN WILBOUR FUND. REPRODUCED BY PERMISSION.

the king of Upper Egypt and the king of Lower Egypt. Both buildings are only façades and may have been buried along with all the dummy buildings in the complex after completion. These buildings attest to the earliest political division in Egyptian thinking, the division between Upper and Lower Egypt. The Egyptians often called their country "The Two Lands" (*tawy*) in reference to this division. The king was actually regarded as a king of two different places that were combined in his person.

THE SOUTH TOMB. The South Tomb at Djoser's complex is located against the center of the south

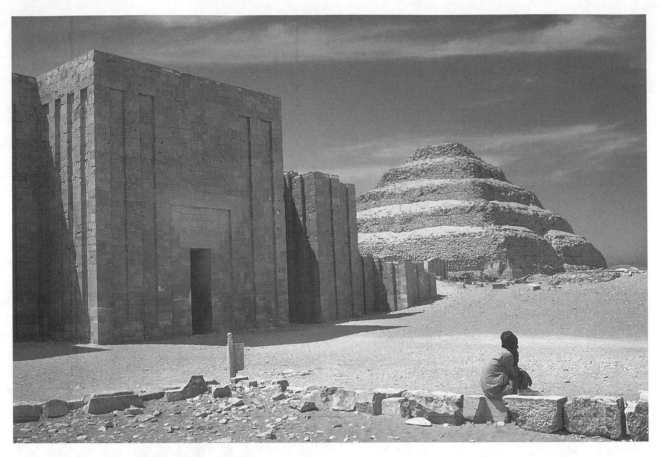

Funeral complex of Djoser's pyramid in Saqqara. The building on the left is a reconstructed entrance to the complex. © RICHARD T. NOWITZ/CORBIS. REPRODUCED BY CORBIS CORPORATION.

enclosure wall. Below the building are structures similar to the burial structures under the pyramid, including the vertical shaft leading to the burial chamber and an underground palace decorated with limestone relief sculptures and faience tiles. The vertical shaft in the south tomb replicates the dimensions of the vertical shaft in the pyramid, but the burial vault is so small that it is unclear what could have been buried there. It was only 1.6 by 1.6 meters (5.2 by 5.2 feet) square with a height of 1.3 meters (4.2 feet). Egyptologists have suggested that it could represent the burial of the king's ka in the form of a statue, the burial of the royal placenta, the burial of the royal crowns, or that it symbolically represented the burial of the king of Upper Egypt. Before this time, the Egyptians buried the king in Abydos in Upper Egypt (southern Egypt). Some Egyptolgoists believe that the south tomb was a reference to this Egyptian tradition, now abandoned. The many possible explanations stem from the fact that so little evidence remains to be interpreted. Egyptologists may never know definitively why such great effort was expended to build the South Tomb.

SOURCES

Dieter Arnold, "Royal Cult Complexes of the Old and Middle Kingdoms," *Temples of Ancient Egypt*, edited by Byron E. Shafer (Ithica, N.Y.: Cornell University Press, 1997): 31–85.

Mark Lehner, *The Complete Pyramids* (London: Thames and Hudson, 1997).

Rainer Stadelmann, *Die Ägyptischen Pyramiden: vom Ziegelbau zum Weltwunder* (Mainz am Rhein: P. von Zabern, 1985).

Miroslav Verner, *Die Pyramiden* (Reinbek bei Hamburg, Germany: Rowohlt Verlag, 1998).

THE FIRST TRUE PYRAMIDS

MAJOR CHANGES. The royal funeral complexes of the Fourth Dynasty (2625–2500 B.C.E.) exhibit three major changes from Djoser's previously built complex at Saqqara. First, the step pyramid of Dynasty Three evolved to become the true pyramids of Dynasties Four through Twelve (2625–1759 B.C.E.). The second ma-

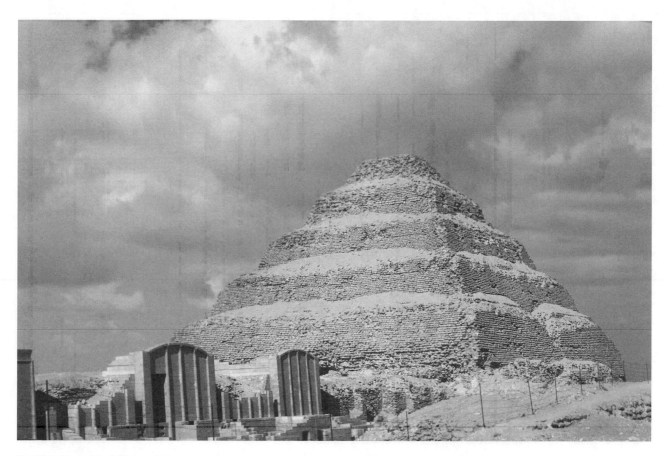

The Step Pyramid of Djoser at Saqqara. © CORBIS. REPRODUCED BY PERMISSION.

jor change was the rotation from a north/south orientation at Djoser's complex in Saqqara to an east/west orientation beginning with King Sneferu's pyramid complex at Meidum. Finally, the third major change was the development of a place in the complex specifically for an ongoing ritual on Earth that would continue long after the king's death. These developments reflected important changes in Egyptian thinking about the king's afterlife and in Egyptian religion. During the Fourth Dynasty, the cult of the sun-god Re rose to prominence, displacing earlier associations of the king with the god Horus, son of the king of the afterlife, Osiris. By the time of King Khufu, builder of the Great Pyramid at Giza, the king's title was the Son of Re. This new emphasis explains all three major changes in the king's pyramid complex. The step pyramid shape was a reference to the ladder the king climbed to reach the stars at night in the afterlife. The true pyramid, however, was a symbol of the sun-god Re. The north/south orientation found at Djoser's complex emphasized the importance of the northern night sky and its fixed stars. The east/west orientation of the Fourth-dynasty pyramids emphasized the course of the sun from east to west.

Finally, the ritual installation implies that the purpose of funeral complexes had changed between the Third and Fourth Dynasties. Whereas the Third-dynasty non-functional buildings and subterranean palaces were stage sets built for the king's ka to continue its life, the Fourth-dynasty complexes tied together this world with the next, creating an institution that required constant input from this world in order to sustain order in both this world and the next. This input was made and received at the pyramid complexes in the form of a ritual performed there to energize the pyramid as a place where the king's ba-spirit merged into the daily cycle of birth, death, and rebirth of the sun.

STANDARD BUILDINGS. In addition to the pyramid itself, Fourth-dynasty pyramid complexes also included a temple attached to the east side of the pyramid called both the pyramid temple and the mortuary temple in Egyptological literature. There are also often subsidiary pyramids near the main pyramid known as the queen's pyramids. The pyramid temple is connected to another temple located further to the east by a covered causeway. The eastern temple is usually called a valley temple because in most cases it is located in the Nile Valley while

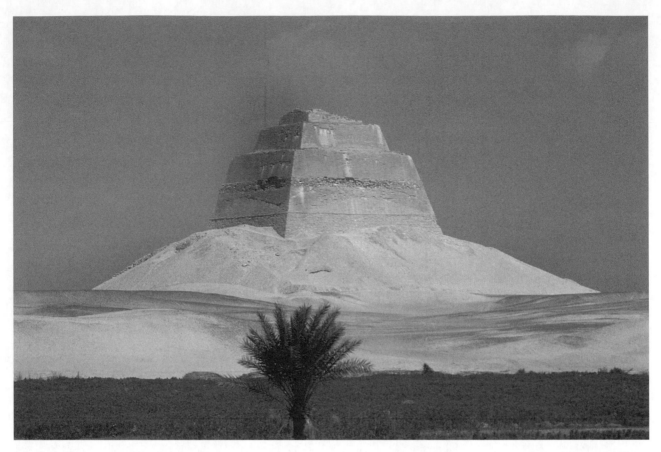

The Meidum Pyramid. CHRISTINE OSBORNE/CORBIS.

the pyramid, subsidiary pyramids, and pyramid temple are located on the higher desert plateau. Even though there were no standardized plans for complexes until the Fifth Dynasty (2500–2350 B.C.E.), these elements are present in all of the pyramid complexes constructed during the Fourth Dynasty.

KING SNEFERU'S THREE PYRAMIDS. King Sneferu, first king of the Fourth Dynasty, came to the throne approximately 2625 B.C.E. During the first fifteen years of his reign until about 2610 B.C.E. Sneferu's workmen constructed the Meidum Pyramid, located at Meidum, south of modern Cairo on the west bank of the Nile River. Though earlier scholars identified the Meidum Pyramid as the work of Sneferu's father, King Huni (before 2625 B.C.E.), new evidence has emerged to indicate that the name of the Meidum Pyramid in ancient times was *Djed Sneferu*—"Sneferu Endures." Thus it is most likely that Sneferu built this pyramid. In the second fifteen years of his reign, Sneferu built two more pyramids at Dahshur. These pyramids are called the Bent Pyramid and the North Pyramid (also known as the Red Pyramid). Sneferu also built a smaller pyramid in Seila,

further south. This smaller pyramid followed in the tradition of King Huni, his father. He built perhaps five smaller pyramids located throughout Egypt rather than just one large pyramid.

SNEFERU'S MEIDUM COMPLEX. The German archaeologist Rainer Stadelmann believed that Sneferu built his Meidum complex in two stages. The first stage began when he first rose to power. The second stage occurred during Sneferu's last years when he was living farther north in Dahshur. Stadelmann believed that originally the central core of the pyramid was a step pyramid, because the construction of this inner core resembled earlier construction completed during the Third Dynasty in which the builders used a series of inward-leaning layers of masonry rather than regular courses. Rather than place each new course of stone on top of the previous course and attempt to level the new course, the builders purposely tried to direct the pressure from each new course of stone toward the center of the pyramid on a diagonal rather than straight down. The builders hoped this would make the pyramid more stable. Yet the appearance of this step pyramid is not

completely understood. Sneferu converted the pyramid into a true pyramid shape near the end of his reign, about Year 28 or 29 (2597–2596 B.C.E.). The structure, in turn, changed dramatically when the site functioned as a rock quarry during the Middle Ages, resulting in the destruction of several layers. Sheikh Abu Mohammed Abdallah described the Meidum pyramid as having five layers when he saw it between 1117 and 1119 C.E. In 1737, the Swedish traveler Frederick Louis Norden saw only three layers, as is visible today. During this 620-year period, a large amount of stone must have been removed from the site. Recent attempts at reconstructing the original appearance of the pyramid suggest it had up to eight layers. Moreover, at some time in antiquity the outer casing that Sneferu had added to turn the earlier step pyramid into a true pyramid collapsed. Recent excavations revealed that this collapse probably occurred after construction had been completed at Meidum. Earlier commentators speculated that the collapse had occurred during construction and in fact had led to the abandonment of the monument. The absence of evidence such as workmen's corpses or of Fourth-dynasty tools found in the rubble surrounding the pyramid's core makes this theory unlikely. The timing of the collapse is important. If it occurred in the middle of construction, subsequent construction technique changes should be seen as a response to the collapse. If, on the other hand, the collapse occurred much later, as is now believed, then the collapse has no direct bearing on decisions that engineers made at Sneferu's two later pyramids.

INTERIOR OF THE MEIDUM PYRAMID. The interior of the Meidum pyramid set the new precedent for configuring the burial. Rather than a vertical shaft as was found in Djoser's dynasty-three pyramid, at Meidum the entrance to the burial came from the north face of the pyramid. A descending passage, 58 meters long and 0.84 meters by 1.65 meters (190 by 2.7 by 5.4 feet), led down to two small rooms. At the end of the second room, a vertical shaft led up to a burial chamber 5.9 by 2.65 by 5.05 meters (19.3 by 8.6 by 16.5 feet). Corbelled blocks—blocks placed on top of each other but projecting slightly over the edge of the lower course from two sides to eventually meet at the ceiling—formed the roof of the chamber. This is the first known example of this early form of arch in Egypt, though it remains incomplete. The remains of cedar logs found in the shaft leading to the burial chamber may have been pieces of a wooden coffin, although no sarcophagus was found. W. M. F. Petrie, the English archaeologist who first excavated at Meidum, did find pieces of a wooden coffin in

a plain style. The change in the entrance to the burial chamber from a vertical shaft to a descending passage is difficult to interpret. It could have been a technical improvement making it easier to bring the sarcophagus into the burial. On the other hand, such drastic changes are often a change in symbolism that reflects a real change in belief. It is not possible to determine conclusively which kind of change is at work in this instance.

OTHER ELEMENTS AT MEIDUM. The other elements found at the Meidum Pyramid demonstrate its value as a bridge between past and future pyramid styles. The subsidiary pyramid south of the main pyramid perhaps had the same function as the South Tomb at Djoser's complex in Saqqara, though that function is not fully understood. Looking to the future, a small altar on the east side of the main pyramid, with two blank, unfinished steles, is a precursor of the pyramid temples built later in Dynasty Four at Dahshur and more elaborately at Giza by Sneferu's son and grandsons. A covered causeway, another common feature of later pyramid complexes, connected Sneferu's Meidum pyramid to the valley, but not to any known temple. Only mud brick walls were found at the valley end of the causeway showing that the valley temple was never completed in stone as Egyptologists would expect if Sneferu himself had completed the structure.

SNEFERU'S BENT PYRAMID AT DAHSHUR. In the fifteenth year of King Sneferu's reign (2610 B.C.E.), he abandoned his building project at the Meidum Pyramid and moved his court 25 miles north to Dahshur. At this point in his reign, the Meidum Pyramid was still a step pyramid, more similar in shape to Djoser's pyramid at Saqqara than to the true pyramids built later. The move to Dahshur indicates a break with the step-pyramid style in an effort to create a true pyramid. The builders' first attempt was the pyramid that Egyptologists call the Bent Pyramid. Step pyramids slope at approximately 78 degrees on each face. A true pyramid like the Great Pyramid at Giza has faces that slope at 53 degrees. The faces of the lower section of the Bent Pyramid were first constructed with a slope at sixty degrees, but this slope was too steep to form a true pyramid that could be supported adequately. At some point in the construction, the builders added more stone to the lower levels and reduced the slope to 54 degrees, 27 minutes, in order to support the inner core. As work proceeded, further structural problems emerged that forced the builders to reduce the angle of slope even further to 43 degrees on the upper half of the pyramid. This reduction accounts for the distinct bend in the shape of this pyramid. The base measures 188 meters (617 feet) and is 105 meters (345

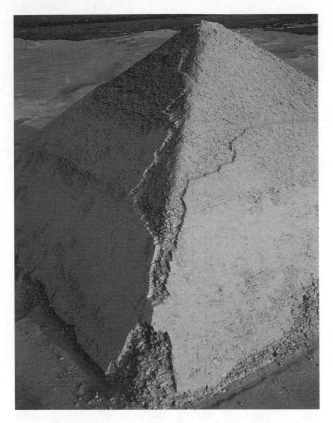

Bent Pyramid at Dahshur. YANN ARTHUS-BERTAND/CORBIS.

the Bent Pyramid's internal plan could refer symbolically both to the idea of the king uniting with the circumpolar stars and to the idea that the king unites with Osiris in death. The small chapel on the eastern side of the pyramid would be a link to the king's role as Son of Re, the sun god. The chapel at the Bent Pyramid parallels the chapel at the Meidum Pyramid by its position on the east side. These two chapels are also similar because they consist of only an altar and two steles. Later in the Fourth Dynasty, a much more elaborate pyramid temple would be included on the east side of the pyramid. Rainer Stadelmann, however, disputed a real connection between the purpose of these chapels and the later temples. He posited the theory that the construction of these chapels occurred when it became clear that Sneferu would not be buried either at Meidum nor at the Bent Pyramid. The subsidiary pyramid located south of the Bent Pyramid demonstrates that the builders had learned from their experience with the Bent Pyramid. The angle of slope resembles the 53 degree angle at Khufu's Great Pyramid at Giza. The construction method also avoided some of the errors associated with the Bent Pyramid. Horizontal layers of masonry now replaced the inward-sloping blocks that made the Bent Pyramid so unstable. It paralleled the subsidiary pyramid at Meidum and perhaps somehow reflected the same purpose as the South Tomb at Djoser's complex in Saqqara. Thus it could have been used to bury a statue or somehow refer to the second tombs for each king known from the First Dynasty at Abydos.

THE PYRAMID COMPLEX AT THE BENT PYRAMID. The pyramid complex at the Bent Pyramid includes a chapel on the east side and a covered limestone causeway that leads to a second small temple to the east. These features parallel some of the previous construction at Meidum and also suggest parallels with later construction at Giza. The chapel at the Bent Pyramid is quite similar to the chapel at the Meidum Pyramid. They both consist of ten-meter (32.8-foot) tall steles and an offering table. At the Bent Pyramid, the steles are decorated with images of King Sneferu seated above the palace façade motif. The pyramid complex is linked to the eastern temple by a 210-meter (688.9-foot) limestone-covered causeway. Though the eastern temple is not actually located in the valley, it seems also to be a precursor to the eastern valley temples built later in the Fourth Dynasty. The temple was a stone building, 27 by 48 meters (88.5 by 157.4 feet). It had an open court with a pillared portico and six statue shrines at the rear. For this reason the German archaeologist Dieter Arnold called it a "statue temple" of the king.

feet) high. It is thus substantially larger than Djoser's Step Pyramid or the Meidum Pyramid. The interior of the Bent Pyramid is unique because it has two passageways: one beginning on the north side and one beginning on the west side. The northern entrance, like the northern entrance at Meidum, slopes downward. It continues for 74 meters (242.7 feet) until it reaches the center of the pyramid. A vertical shaft then leads to a burial chamber that measures 6.3 by 4.96 meters (20.6 by 16.2 feet). The corbelled ceiling is seventeen meters (55.7 feet) above the floor of the chamber. The second, western entrance slopes downward for 65 meters (213.2 feet). It leads to a second corbelled chamber 7.97 by 5.26 meters (26.1 by 17.2 feet) with a ceiling height of 16.5 meters (54.1 feet). This chamber is in reality directly above the chamber reached from the northern entrance. Some time later, workers created a rough tunnel through the masonry to connect the two chambers. No clear explanation exists to explain the presence of two entrances. Speculation, though, has focused on the western entrance as a reflection of a second burial known from earliest times at Abydos. The western orientation of the second passage could also somehow connect with the cult of Osiris, king of the dead, with whom the king's essence traditionally unites at death. Thus in this view,

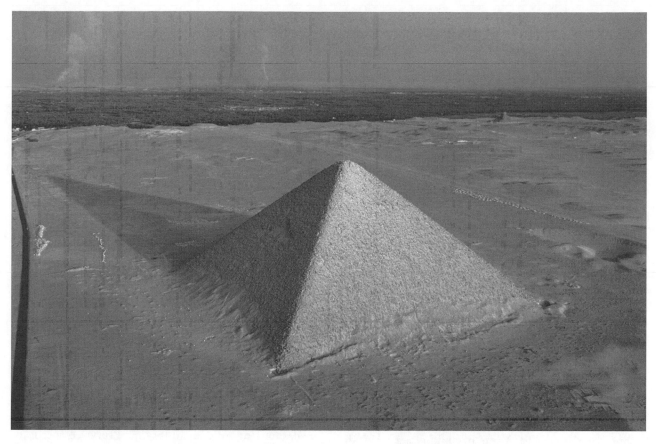

Aerial view of the North (Red) Pyramid of Sneferu at Dahshur. YANN ARTHUS-BERTAND/CORBIS.

Sneferu's statue temple included depictions of the king in the crowns of Upper Egypt, Lower Egypt, and the Double Crown which combines the two, thus representing all of the king's political roles. In addition, there are relief sculptures on the walls of the temple that depict the king accompanied by the gods and performing ceremonies. In the entrance the *nomes* (provinces) are depicted delivering goods to the king brought from the entire country. Part of the temple's great importance is that it contained the first known royal relief sculptures meant to be seen above ground. The Bent Pyramid Complex thus represents a transitional stage between Djoser's earlier complex in Saqqara and the later complexes at Giza.

SNEFERU'S NORTH PYRAMID COMPLEX AT DAHSHUR. Egyptologists' knowledge of King Sneferu's North Pyramid Complex at Dahshur benefits greatly from the fact that excavations there began in the 1980s when excavation techniques allowed for the recovery of much greater detail. Its excavator, Rainer Stadelmann, for example, found inscriptions in the rubble of the North Pyramid Complex that allowed him to demonstrate that the construction began in Sneferu's thirtieth

year, the same year that the subsidiary pyramid at the Bent Pyramid complex was completed. Evidence from inscriptions also established that workers completed thirty courses of stone during four years of labor on the North Pyramid. The North Pyramid (also called the Red Pyramid) was the third large-scale pyramid started by King Sneferu's workers. The base sides measure 220 meters (722 feet) and the height reaches 105 meters (345 feet). The angle of slope is quite low at 43 degrees, 22 minutes. This pyramid is thus 32 meters (104.9 feet) longer on each base side than the Bent Pyramid, but reaches approximately the same height. The interior of the North Pyramid is simpler than the Bent Pyramid. One entrance only descends from the northern face for 62.63 meters (205.4 feet). It reaches two rooms of 3.65 by 8.36 meters (11.9 by 27.4 feet) with corbelled ceilings. A short passage leads to the burial chamber that was 4.18 by 8.55 meters (13.7 by 28 feet) with a ceiling height of 14.67 meters (48.1 feet). Though human remains were found in the burial chamber, it cannot be determined that they were part of Sneferu's mummy. The North Pyramid Complex includes the first real pyramid temple on the east face of the

pyramid, though it was completed in mud brick rather than stone. Stadelmann traced the plan of this building, which included both the pillared court and the statue sanctuary that were part of King Khufu's pyramid temple attached to the Great Pyramid at Giza in the next reign. There was perhaps also a causeway built of mud brick, though excavation has failed to reveal this feature. At the end of the causeway was a town, rather than the expected temple, where archaeologists discovered a stele of Dynasty Six (reign of Pepi I, 2338–2298 B.C.E.). The construction of both the pyramid temple and the causeway in mud brick suggests that workers finished these features quickly after Sneferu's death. Perhaps that is also the reason that this complex lacks a subsidiary pyramid and a valley temple. Or perhaps the Bent Pyramid, with its eastern statue temple, served the same function for Sneferu as the later Valley Temple built by his son, King Khufu, would later serve at the Great Pyramid of Giza.

RELIGION DRIVING TECHNOLOGY. Sneferu's three pyramids are a testament to the way that religious innovation drove the development of Egyptian technology. The decision to abandon step pyramid building, which was already well understood, for the uncertain technology required for a true pyramid was a major diversion of resources. Egyptian engineers had to experiment and innovate because of a religious idea. This idea, as nearly as can be understood today, was to emphasize in the pyramid complex the ascendance of the god Re in religious thinking. This ascendance required that the king be buried in a true pyramid rather than a step pyramid. This innovation required three attempts at large-scale pyramid building. The details are lost to us, but the implications for the power of a religious idea in Egyptian society are significant.

SOURCES

Dieter Arnold, "Royal Cult Complexes of the Old and Middle Kingdoms," *Temples of Ancient Egypt*, edited by Byron E. Shafer (Ithica, N.Y.: Cornell University Press, 1997): 31–85.

Mark Lehner, *The Complete Pyramids* (London: Thames and Hudson, 1997).

Rainer Stadelmann, *Die Ägyptischen Pyramiden: vom Ziegelbau zum Weltwunder* (Mainz am Rhein, Germany: P. von Zabern, 1985).

Miroslav Verner, *Die Pyramiden* (Reinbek bei Hamburg, Germany: Rowohlt Verlag, 1998).

SEE ALSO *Visual Arts: Early Dynastic Period Art*

FOURTH-DYNASTY ARCHITECTURE AND HISTORY

THE PYRAMIDS OF GIZA. The Pyramids of Giza are among the world's most famous architectural monuments. In ancient times the Greeks included the Great Pyramid among the Seven Wonders of the World. The Egyptians themselves took an interest in the pyramids, restoring the adjacent buildings as late as 1,000 years after they were originally built. Yet in spite of the tremendous awe and curiosity that the pyramids inspire, they are limited sources for the writing of history. The pyramids attest that the Fourth Dynasty (2625–2500 B.C.E.) must have been a period of strong central government, religious vitality, and technological innovation. Yet the details of these historical trends must be derived from the physical remains of buildings rather than from written texts. In the Fourth Dynasty the Egyptians had not yet started inscribing extended biographical texts in their tombs, a practice of the Sixth Dynasty 300-400 years later, that provides historical details in the later period. None of the extensive records that scholars believe once existed about the administration of the pyramids in the Fourth Dynasty have survived into modern times. None of the records that the Egyptians maintained for their own knowledge of their history have survived except for records of a much later period. Thus nearly everything that can be inferred in modern times about the Fourth Dynasty stems from modern knowledge of the pyramids at Giza, except for very limited information from short inscriptions in nobles' tombs. A careful look at the plans and details of each building is necessary in order to reconstruct the history of this period. The only supplementary material comes from the Greek historian Herodotus who visited the pyramids in the middle of the fifth century B.C.E.

THE GIZA PLATEAU. Three kings built the most famous pyramid complexes in Egyptian history on the Giza plateau during the years 2585 to 2510 B.C.E. Khufu (in Greek, Cheops), his son Khafre (in Greek, Chephren), and his grandson Menkaure (in Greek, Mycerinus) established funeral monuments that rank among the great architectural accomplishments of ancient times. As the American archaeologist Mark Lehner observed, the coordination of the designs of the three separate monuments is one of the most impressive aspects of ancient planning and engineering. Each of the pyramids is nearly perfectly oriented to the cardinal points—north, south, east, and west—of the compass. The southwest corners of all three pyramids align perfectly, forming a straight line that runs northwest to southeast. The alignment between the west face of Khufu's pyramid and Khafre's

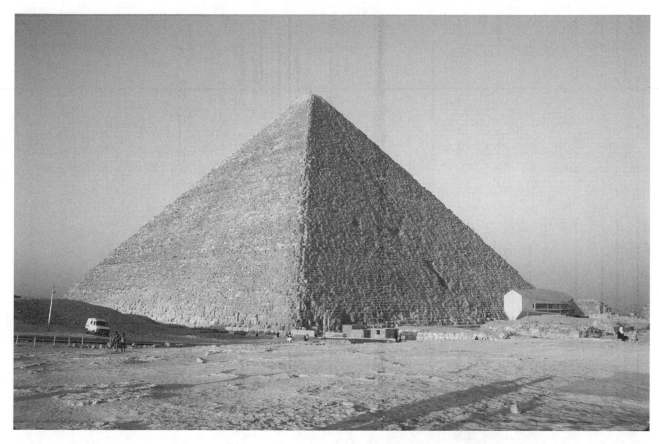

The Great Pyramid at Giza. PHOTOGRAPH BY SUSAN D. ROCK. REPRODUCED BY PERMISSION.

pyramid temple's east façade is repeated with the west face of Khafre's pyramid and the east façade of Menkaure's pyramid temple. Moreover, the south side of the Great Sphinx aligns perfectly with the south face of Khafre's pyramid. This evidence of mathematical sophistication in addition to the enormous size of the monuments has continued to impress visitors to Egypt since the Greek historian Herodotus visited them in the fifth century B.C.E.

THE GREAT PYRAMID OF KHUFU. The Great Pyramid measures 230.33 meters (756 feet) on each side and reached a height of 146.59 meters (481 feet). It was taller than any building constructed by humans anywhere in the world before the twentieth century C.E. The Great Pyramid of Khufu's enormous size has led the German archaeologist Rainer Stadelmann to question if ancient records claiming that Khufu ruled 23 years could be accurate. Even if Khufu ruled thirty years, one average-size stone block would need to be placed every two or three minutes of a ten-hour workday every day of the reign. This "average block" is often said to be about 2.5 tons. Yet the largest blocks at the bottom of the Great Pyramid weighed up to fifteen tons while some of the re-

lieving stones inside the pyramid weigh from fifty to eighty tons each. During that ten-hour day, 230 cubic meters (8,122 cubic feet) of stone would be set in place at his pyramid, causeway, two temples, subsidiary pyramid, queen's pyramids, or officials' mastaba tombs. Over the course of his reign, workers built 2,700,000 cubic meters (95,350,000 cubic feet) of stone architecture. These statistics continue to inspire awe at the ancient Egyptians' accomplishments with such simple tools. The construction techniques reveal that the Egyptian builders had learned well the lessons derived from construction at Meidum and Dahshur during the reign of Khufu's father, Sneferu. The level platform for a base and the laying of stone blocks in horizontal rows rather than inverted layers proved to be a much more stable building technique than those used at the Meidum Pyramid or the Bent Pyramid of Dahshur. There was a clear evolution from the Meidum Pyramid to the Great Pyramid in technique. This evolution demonstrates the Egyptian ability to learn from previous errors. They were not so conservative in their thinking that they could not benefit from experience. The interior of Khufu's Great Pyramid contains three chambers reached by a series of three

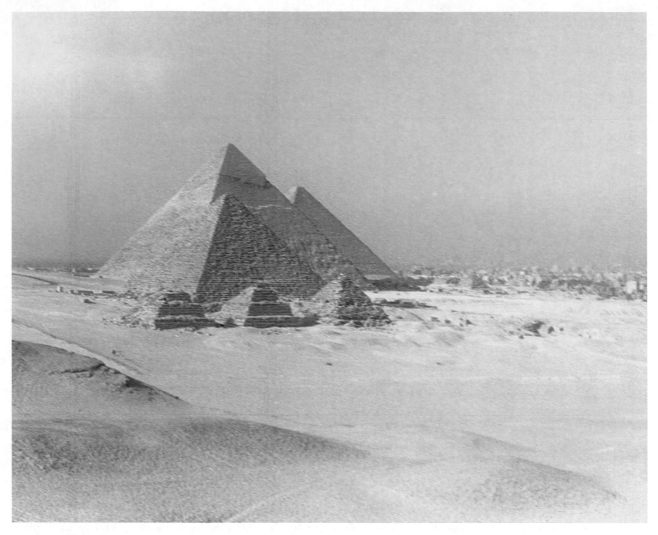

The Giza pyramid complex. PHOTOGRAPH BY ARLENE KEVONIAN. REPRODUCED BY PERMISSION.

passages. The Swiss Egyptologist Ludwig Borchardt explained the existence of three chambers in 1911 as changes in the plan made to fool tomb robbers. In the late twentieth century Egyptologists have found other possible explanations for the existence of the three chambers, though they have retained the early, sometimes erroneous, names for them. The lowest chamber, called the Subterranean Chamber, is carved directly into the bedrock—the solid surface beneath the desert sand—and reached by the 58.5-meter (191.9-foot) Descending Passage that originates in the north face of the pyramid. The planed dimensions of the Subterranean Chamber were 14 by 7.2 meters (45.9 by 23.6 feet) and 5.3 meters (17.3 feet) high—a huge, high-ceilinged chamber—though it was never finished. Borchardt thought that the workers constructed the Subterranean Chamber first, but then abandoned it as the original tomb chamber and left it unfinished. Stadelmann, on the other hand, surmised

that the unfinished nature of the chamber suggested that it had been last, its construction permanently interrupted by Khufu's death. Stadelmann believed the Subterranean Chamber represented the underworld. The so-called Queen's Chamber gained its name from early Arab explorers to the pyramid, and could be reached by the Ascending Passage that diverges from the Descending Passage. The Queen's Chamber is located in the center of the pyramid directly on the east/west axis. This chamber is 5.8 by 5.3 meters (19 by 17.3 feet) with a ceiling six meters (19.6 feet) above its floor—another high-ceilinged room. The Queen's Chamber contains a corbelled niche 4.7 meters high (15.4 feet). Here, Lehner suggested, was the site of a ka-statue representing the king's soul. The actual burial was in the King's Chamber. This chamber—the largest, with the highest ceiling—was 10.6 by 5.2 meters (34.7 by 17 feet) with a ceiling 5.8 meters (28.5 feet) above its floor. It is reached

through the Ascending Passage from which it is possible to proceed through the Grand Gallery, which is 46.7 by 2.1 meters (153.2 by 6.8 feet) with a height of 8.7 meters (28.5 feet). The King's Chamber is lined in red granite and also contains the king's red-granite sarcophagus. W. M. F. Petrie, the late nineteenth- and early twentieth-century English archaeologist, observed that the sacophagus is too wide to have fit through the present door, which suggests that it was placed in the King's Chamber before the masonry for the higher levels of the pyramid were put in place. This fact led Lehner to conclude that this chamber must have always been planned as the burial chamber or at least that was already the plan at this stage of construction. The other unusual elements of the interior of this pyramid are the so-called airshafts that extend from the Queen's Chamber to the south and from the King's Chamber to the south and north. Scholars interpret these shafts as symbolically allowing Khufu to merge with both the northern, circumpolar stars and the stars of the constellation Orion in the south. This interpretation of the "airshafts" shows how religious ideas can be inferred from architectural details. Here it seems the overall east/west orientation associated with the sun-god Re combines with the north/south orientation associated with the gods of the nighttime sky. It is important to remember that the associations of east/west with Re and north/south with the circumpolar stars are also inferred from later documents dating to the Sixth Dynasty. Thus the architecture provides possible confirmation that ideas documented in later dynasties were actually present in the Fourth Dynasty. The Egyptian archaeologist Zahi Hawass located the foundations of the subsidiary pyramid at the southeast corner of the Great Pyramid in the 1990s. It probably represented a parallel to such subsidiary pyramids at Meidum, the Bent Pyramid, and the North Pyramid of Dahshur, though each of these subsidiary pyramids occupies a slightly different location in relation to the main pyramid. The southeast corner is important to the plans of many pyramid complexes. For Djoser's Saqqara complex, it is the location of the only true door into the complex. The southeast corner is also often used in pyramid complexes to house the ka-statue of the king or to symbolize the ancient custom of a southern tomb in Abydos in a northern necropolis. The three Queen's Pyramids on the east side of the Great Pyramid of Khufu were each approximately one-fifth the size of the Great Pyramid. They each contained burial chambers reached from passages that began on the north side of the pyramid and then turned to the west. Each of the Queen's Pyramids had a chapel where offerings could be made to the occupant. The most northern of the three pyramids is thought to belong to Hetepheres, Khufu's

mother. The middle queen's pyramid might have belonged to Queen Meritetes who lived during the reigns of Sneferu, Khufu, and his son Khafre. She is also thought to be the mother of Kawab, a son of Khufu buried in the mastaba tomb directly east of this queen's pyramid, but not the mother of the two sons of Khufu who ascended to the throne—Djedefre and Khafre. The third Queen's Pyramid belonged to Queen Henutsen, another of Khufu's queens, according to an inscription carved nearly two thousand years later at the chapel attached to it. The prominence of these queens' burials suggested the existence of a matriarchal system in Egyptian history to nineteenth-century anthropologists, although modern Egyptologists have since abandoned the theory as being difficult to support with concrete evidence. Part of the theory's fragility rests on interpreting these buildings which cannot even be definitively proven to have belonged to queens. Only foundations and part of the basalt paving stones of Khufu's Pyramid Temple remain. Yet archaeologists have calculated that it measured 52.5 meters by 40 meters (171.9 by 131.2 feet). The building contained a large courtyard surrounded by pillars. Three rows of pillars separated this courtyard from a smaller broad room containing cult statues. A door separated the broad room and the courtyard also. This general layout featuring a courtyard, a group of pillars without real structural purpose, and a room for statues remained the basic outline for all Egyptian tomb chapels for the 2,000 years following the construction of Khufu's Pyramid Temple. Builders decorated parts of this temple with relief sculpture, including a procession of estates and Jubilee Festival (*sed*) rituals. This decoration associates the pyramid temple with Sneferu's statue temple at the Bent Pyramid and the Jubilee Festival (*sed*) Court built by Djoser at the Step Pyramid Complex in Saqqara. Only the most tantalizing ruins of the causeway and Valley Temple of Khufu's Great Pyramid remain. Like Sneferu's causeway, Khufu's causeway must have been covered with relief sculpture. These sculptures might have been the ones described by Herodotus when he visited Giza in the mid-fifth century B.C.E. Hawass discovered the foundations of the Valley Temple forty meters (131 feet) below the Giza Plateau, but the ruins have yielded few clues about the original structure.

DJEDEFRE'S INAUGURATION OF A PYRAMID COMPLEX AT ABU ROASH. King Djedefre (2560–2555 B.C.E.) was Khufu's first son to follow him to the throne. If Djedefre's brother King Khafre and nephew King Menkaure—the next two kings—had not chosen to build at Giza and align their monuments with those built by Khufu, Djedefre's decision to build at Abu Roash

a PRIMARY SOURCE document

HERODOTUS ON THE CRUELTY OF KHUFU

INTRODUCTION: Herodotus (484–430 B.C.E.), the ancient Greek historian, visited the Pyramids at Giza about 450 B.C.E. Thus they were already 2,000 years old when he arrived as a tourist. Herodotus' account of the building of the Giza pyramid complex emphasizes the cruelty of King Khufu (called "Cheops," the Greek name for "Khufu") in forcing the whole population to work only for him and to ignore all other gods.

Cheops became king over them, and he drove them into the extremity of misery. For first he shut up all the temples, to debar them from sacrificing in them, and thereafter he ordered all Egyptians to work for himself. To some was assigned the dragging of great stones from the stone quarries in the Arabian mountains as far as the Nile; to others he gave orders, when these stones had been taken across the river in boats, to drag them, again, as far as the Libyan hills. The people worked in gangs of one hundred thousand for each period of three months. The people were afflicted for ten years of time in building the road along which they dragged the stones—in my opinion a work as great as the pyramid itself. For the length of the road is more than half a mile, and its breadth is sixty feet, and its height, at its highest, is forty-eight feet. It is made of polished stone, and there are figures carved on it. Ten years went to this road and to the underground chambers on the hill on which the pyramid stands. These chambers King Cheops made as burial chambers for himself in a kind of island, bringing in a channel from the Nile. The pyramid itself took twenty years in the building. It is a square, each side of it eight hundred feet long, and the same in height, made of polished and most excellently fitted stones. No stone is less than thirty feet long.

SOURCE: Herodotus, *The History*. Trans. David Grene (Chicago: University of Chicago Press, 1987): 185–186.

brother and nephew returned to Giza when they became kings. Proponents of the theory that Khufu's sons quarreled have still not made a convincing case. In fact there is evidence that Djedefre completed his father Khufu's burial and that any destruction found at Djedefre's monuments at Abu Roash occurred 2,000 years after his successor Khafre came to the throne. Djedefre's nephew Menkaure left a statue at Abu Roash that suggests that he honored his uncle's memory, though no later king completed the pyramid. The pyramid of Djedefre at Abu Roash would have resembled the Meidum Pyramid built by his grandfather Sneferu if it had been completed. The angle of slope would have been 52 degrees. The base length was 106.2 meters (348 feet), thus less than half of Khufu's 230.33 meters (756 feet) of base length at the Great Pyramid. Though only twenty courses were completed, the projected height was about 67 meters (220 feet). Compared to Khufu's 146.59 meters (481 feet), Djedefre's monument was also much shorter. The pyramid itself had an entrance on the north side that led 49 meters (160.76 feet) to an interior pit measuring 21 by 9 meters (68.8 by 29.5 feet) and twenty meters (65.6 feet) deep. A pyramid temple's location—on the east side, but closer to the northeast corner than to the southeast corner—did not follow Khufu's model of centering the pyramid temple on the east face of the pyramid. The building's completion in mud brick indicates that workers finished it quickly, probably after the sudden death of Djedefre. The subsidiary pyramid's location—opposite the southwest corner of the pyramid rather than on the southeast as at the Great Pyramid—is similar in placement to Djoser's South Tomb at Saqqara. The architect's plan for a very long causeway from the north side of the pyramid to the valley was not completed. It would have been 1,700 meters (5,577 feet) long had it been completed.

KHAFRE'S PYRAMID AT GIZA. King Khafre, son of King Khufu and brother of the previous king Djedefre, decided to build a funeral complex at Giza that paralleled and aligned with his father's complex at Giza. The pyramid itself is smaller than the Great Pyramid, but appears equally as tall because of its placement on a section of the Giza plateau ten meters (33 feet) higher than the base of the Great Pyramid. Khafre's pyramid is 215 meters (705 feet) on each side of the base, about fifteen meters (56 feet) shorter per side than the Great Pyramid. Its height is 143.5 meters (471 feet), 3.09 meters (10 feet) shorter than the Great Pyramid. Khafre's pyramid preserves the outer casing of Tura limestone on the upper levels that once covered the entire pyramid. The interior of the pyramid contains two descending passages

would not have seemed unusual. After all, his grandfather, King Sneferu, built his funeral monuments in two new sites, Meidum and Dahshur, and his father Khufu inaugurated the new site at Giza. Yet our knowledge of what followed Djedefre's reign has led some scholars to suggest that Khufu's sons were in conflict. The only evidence for this conflict is the fact that Djedefre inaugurated a new site for his funeral complex and that his

PYRAMID
Complexes of the Later Fourth Dynasty

The table below lists different pyramid complexes from the later Fourth Dynasty built by various kings, the type of pyramid they likely represented, and where the remains were located or where the pyramid was most likely

built based on ancient record. They are listed in chronological order by reigning king. Absolute dates for these kings and their buildings still remain unknown. Scholars named these pyramid complexes after the kings that most likely built them with the location name as a signifier since the ancient names for these buildings are not preserved.

SOURCE: Dieter Arnold, "Royal Cult Complexes of the Old and Middle Kingdoms," in *Temples of Ancient Egypt.* Ed. Byron E. Shafer (Ithica, N.Y.: Cornell University Press, 1997): 58–59.

King	Pyramid	Location
Sneferu	Meidum pyramid	Meidum
Sneferu	Bent pyramid	Dahshur
Sneferu	Red or North pyramid	Dahshur
Khufu	Great pyramid	Giza
Djedefre (aka Radjedf)	Abu Roash pyramid	Abu Roash
Khafre	Second pyramid	Giza
Menkaure	Third pyramid	Giza
Nebka	Unknown	Zawiyet el-Aryan
Shepseskaf	Mastabat el Fara'un pyramid	Saqqara

CREATED BY GGS INFORMATION SERVICES. GALE.

that begin on the north face of the pyramid. The lower passage begins at ground level. It leads to a subsidiary chamber 10.41 by 3.12 meters (34.1 by 10.2 feet) with a ceiling 2.61 meters (8.5 feet) above the floor. The chamber's location below ground level has led to its comparison to Khufu's Subterranean Chamber or Queen's Chamber. American archaeologist Mark Lehner associated it with a statue chamber. The passage continues beyond the chamber and ascends to meet the other, higher descending passage. The passages merge and continue to the burial chamber, a 14.14 by 5-meter (46.3 by 16.4-foot) room with a ceiling 6.83 meters (22.4 feet) above the floor. This chamber contains a black granite sarcophagus. When the Italian explorer Giovanni Belzoni entered the chamber in 1818, he found the lid on the floor and the sarcophagus empty except for some bones belonging to a bull. The German archaeologist Rainer Stadelmann suggested that tomb robbers in antiquity had left the bones in the sarcophagus, though to what purpose is unknown. Khafre's subsidiary pyramid was located in the center of the south side of his pyramid. Only the foundations remain along with the underground portion of the building. One of two descending passages began outside the actual outline of the pyramid and descended into the bedrock. This passage led to a dead end that contained a niche located on the central axis of the pyramid. Archaeologists discovered pieces of wood inside the niche that, when reassembled, formed

a divine booth, a distinctive structure the Egyptians used to house statues. In relief sculptures found in the tomb of Khufu's granddaughter, Queen Meresankh, a divine booth is depicted holding a statue of this queen. The existence of an actual divine booth in the subsidiary pyramid of Khafre adds weight to the theory that these smaller pyramids housed the burial of a statue. Scholars used this evidence to associate all of the subsidiary pyramids found at Fourth-dynasty pyramid complexes with the South Tomb in Djoser's Step Pyramid complex in Saqqara. Khafre's pyramid temple and valley temple are the best-preserved of the Giza temples. They also have been fully excavated, thus making modern knowledge of them much more complete. The pyramid temple contains the five parts that became the standard in the later pyramid complexes: the entrance hall, the broad columned court, a group of five niches for statues of the king associated with the king's five official names, a group of five storage chambers associated with the five phyles (rotating groups of workers who ran the temple), and an inner sanctuary with a pair of steles and a false door. The material for this 56 by 111-meter (183.7 by 364.1-foot) building consisted of limestone megaliths cased with either granite or Egyptian alabaster (calcite). It is likely that the complex included many statues, probably removed during the New Kingdom by Ramesses II (1279–1213 B.C.E.) for other royal projects.

STATUE NICHES FOR THE NAMES OF THE KING. The equation of five statue niches in the pyramid temple with the five names of the king presents a good example of the way that architecture confirms the presence of later historical phenomena in the Fourth Dynasty. It is certain that by the Twelfth Dynasty (1938–1759 B.C.E.) each Egyptian king had five official names and titles. Parts of each of them are known as early as the First Dynasty, yet they are not attested all together as one official name until the Twelfth Dynasty. The names were associated with different deities, including Horus, the two goddesses Nekhbet and Wadjet, the Horus of Gold (another form of Horus), the king's birth name (called the *praenomen*) associated with the king as he incorporates in his person both Upper and Lower Egypt, and finally the name that proclaimed the king to be the son of Re. The five niches strongly suggest that the official names were grouped together into the official titles of the king in the Fourth Dynasty, roughly 600 years before textual evidence exists. Yet this "fact" remains an inference from architecture. No actual examples of the five official titles of the king from the Fourth Dynasty are known.

FIVE STORAGE CHAMBERS. Most Egyptians living during the Old Kingdom were members of one of the five *za*, called a *phyle* in English. A phyle was a group of workers assigned for one-fifth of the year to work for the state. The work included construction and any other kind of service that a temple needed. The evidence for the existence of the phyles comes in its fullest form from the *Abu Sir Papyri*, a daily journal of workers' activities at the pyramid of King Neferirkare written in the Fifth Dynasty (2472–2462 B.C.E.). Supplementary written evidence for the existence of the phyles is found at the Great Pyramid. The names of the different phyles were written on individual blocks. Scholars believe that the supervising scribe wrote the name of the phyle responsible for moving the block on it. Because there were five phyles, scholars infer that each of the five storerooms in the pyramid temple belonged to one of the phyles.

THE VALLEY TEMPLE OF KHAFRE'S GIZA COMPLEX. Khafre's valley temple, like his pyramid temple, is the best-preserved valley temple in Giza. It measures 44.6 by 44.5 meters (146.3 by 145.9 feet) and fronted on the dock of a canal excavated by the Egyptian archaeologist Zahi Hawass in 1995. Like the pyramid temple, its construction material consisted of monolithic limestone blocks cased in either granite or Egyptian alabaster (calcite). The valley temple contained 23 statues of King Khafre, including the famous statue of him with the Horus falcon hovering on his shoulders, now in the Cairo Museum. Herbert Ricke and Siegfried Schott, early twentieth-century German Egyptologists, believed that the statues were critical to a ritual repeated daily that lasted 24 hours of every day. Dieter Arnold, the German archaeologist, suggested that the valley temple relates to the now 500-year-old tradition of a site in the funerary complex where the deceased king could receive the statues of visiting gods as a continuation of the Jubilee Festival (*sed*) in the next world. Egyptologists have largely abandoned Ricke's older theory that the pyramid temple and pyramid functioned only for the funeral service.

THE GREAT SPHINX. Though the Great Sphinx is actually a work of sculpture rather than architecture, it is integral to the architectural plan of Khafre's pyramid complex at Giza. It was the first truly colossal work of sculpture created by the Egyptians. The body is 22 times larger than a real lion, which it represents. The carved human face of the Great Sphinx is thirty times larger than an average man's face. The face hovers twenty meters (66 feet) above the ground. The lion's body combined with the king's head was an important symbol of the king's ability to protect the country from its enemies. In front of the Great Sphinx stood a temple that might not have been completed in Khafre's time. Part of the difficulty in interpreting its original meaning is that both King Amenhotep II (1426–1400 B.C.E.) and King Thutmose IV (1400–1390 B.C.E.) restored it during the New Kingdom. All of the inscriptions date to this later period, leaving no textual evidence contemporary with the original building of the structure. Ricke, however, interpreted Amenhotep II's building with 24 columns as a place for sun worship with each column representing an hour of the day. The New Kingdom association of the Great Sphinx with the sun-god Reharakhty ("Re-Horus on the Horizons") adds to the possibility that Ricke had the correct interpretation of the building. Mark Lehner added to the argument the observation that on the day of the summer solstice, the shadows of the sphinx and pyramids merge to form the hieroglyphs used to write Reharakhty's name. This fact suggests that the name was original to the Old Kingdom and not a New Kingdom addition.

MENKAURE'S PYRAMID COMPLEX AT GIZA. King Menkaure, son of King Khafre and grandson of King Khufu, built the third pyramid at Giza. It is the smallest of the three kings' pyramids, but the most completely preserved. Its base dimensions are 102.2 by 104.6 meters (335 by 343 feet). It is thus roughly 103 meters (around 414 feet) shorter on each side than Khufu's Great Pyramid. Menkaure's pyramid is 65 meters (213.3 feet) high, 81 meters (around 268 feet) shorter than the

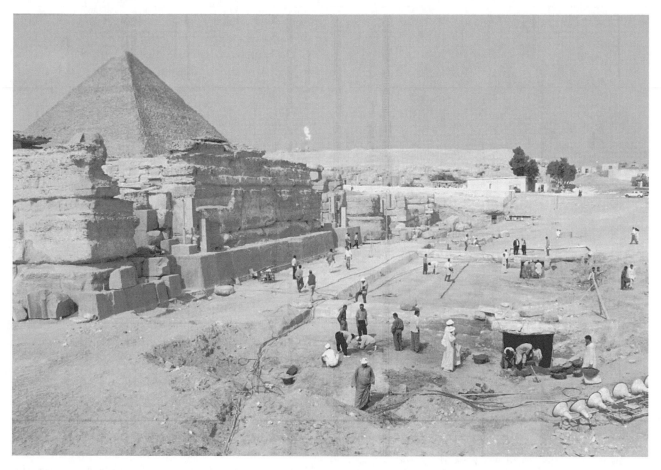

Archeologists uncover what they believe is the world's oldest paved canal beside the Giza sphinx and the Chepren pyramid in Giza, Egypt. © AP/WIDE WORLD PHOTOS, INC. REPRODUCED BY PERMISSION.

Great Pyramid. Menkaure's pyramid thus represents less than one-quarter of the area of the Great Pyramid and only one-tenth of the mass. Lehner speculated that the reduction in size stemmed from the reduced amount of space then available in Giza after the construction of the first two pyramids rather than an indication of diminished importance. The more elaborate decoration of Menkaure's pyramid and valley temples, along with an apparent increased attention to their complexity and size, supports this theory, as does the greater use of granite in Menkaure's temple—a more expensive building material than the limestone used in the other two Giza pyramid complexes. A single tunnel that begins on the north face of the pyramid allows access to the interior of the tomb. The tunnel—1.05 meters wide and 1.2 meters (3.4 by 3.9 feet) high—descends 31.7 meters (102 feet) to a paneled chamber. The chamber—3.63 by 3.16 meters (11.9 by 10.3 feet)—has walls carved with the false door motif. The false door represents the first return of internal decoration of a pyramid since the time of Djoser, over 100 years earlier. A horizontal chamber leads from

the paneled chamber to an antechamber (an outer room that serves as an entrance to the main room) measuring 14.2 by 3.84 meters (46.5 by 12.5 feet) with a ceiling 4.87 meters (15.9 feet) above the floor. A short ascending tunnel was abandoned in antiquity, but a descending tunnel from the antechamber leads to the burial chamber. A small room on the right of the passage before reaching the burial chamber may have been for storage. The burial chamber is 6.59 by 2.62 meters (21.6 by 8.5 feet) with a ceiling 3.43 meters (11.2 feet) above the floor. In the granite-lined burial chamber the English explorer Richard H. W. Vyse found the sarcophagus in 1837. He shipped it to England in 1838, but it was lost at sea in a storm between Malta and Spain and was never recovered. In addition to the sarcophagus, Vyse found a wooden coffin dating to Dynasty 26 but inscribed with Menkaure's name. This wood coffin was roughly 2,000 years younger than the pyramid. In addition, human bones dating to the Christian period in Egypt were in the upper chamber. This evidence of activity of such varied periods indicates that access to the pyramid after the

Arts and Humanities Through the Eras: Ancient Egypt (2675 B.C.E.–332 B.C.E.)

27

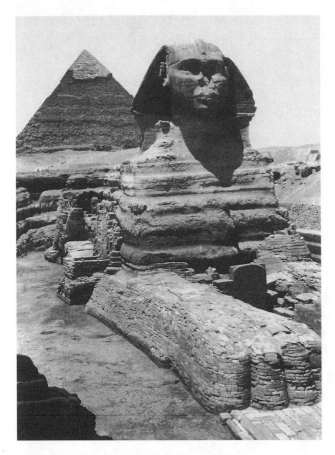

The Great Sphinx, the first colossal work of sculpture created by the Egyptians and integral to the architectural plan of the Giza pyramids. THE LIBRARY OF CONGRESS.

Old Kingdom was more frequent than Egyptologists once suspected. South of the main pyramid, Menkaure's workers built three small pyramids. Two were either never finished or were intended to be step pyramids. The third small pyramid might originally have been planned as a subsidiary pyramid for the king's ka (soul). The presence of a granite sarcophagus in it suggests, however, that it was also used as a queen's pyramid because such coffins were used to bury mummies rather than a ka-statue. All three pyramids had mud brick chapels attached. Menkaure's son, King Shepseskaf, completed his pyramid temple and causeway in mud brick after his death, although apparently the intention was to finish it in limestone covered with granite. The decoration intended for the pyramid temple was the paneled palace façade motif, customary for at least 400 years in royal funeral complexes. This decoration links Menkaure's Pyramid Temple to the earlier royal enclosures in Abydos. On the wall facing the east face of the pyramid, the builders erected a false door and placed a statue of Menkaure striding forward in front of it. This arrange-

ment recalls similar false doors with statues in contemporary mastaba tombs built for the king's extended family. The causeway was incomplete. The mortuary temple was built at the mouth of the wadi (a dry river bed) formerly used to bring construction materials from the Giza quarry. The American archaeologist Mark Lehner observed that the plan to block this wadi suggests that the builders did not intend to use the quarry again, which indicates that Menkaure's valley temple was the last major construction at Giza. Though the builders completed the limestone foundations of the temple, King Shepseskaf completed the building in mud brick. George Reisner, the German excavator of the temple, established that squatters moved into it soon after its completion. The squatters stored the sculpture completed for the temple in storage facilities, leaving them to be discovered in the early twentieth century. Reisner's careful excavation allows Egyptologists to determine that the squatters lived in the temple for many generations, at least through the Sixth Dynasty, roughly 210 years after Menkaure's death.

FUNERAL COMPLEX OF SHEPSESKAF. King Shepseskaf chose a tomb type entirely different from his royal ancestors. He erected a tomb at Saqqara, returning to the royal cemetery that had been used roughly 150 years earlier by King Djoser. The tomb, called in Arabic the *Mastabat el-Fara'un* (Mastaba of the Pharaoh), was a gigantic structure shaped like a contemporary nobleman's mastaba—a building that is rectangular in profile—rather than like a royal pyramid. Though Egyptologists agree that this sudden change represented an important shift in policy, the actual meaning of that shift cannot be established with the information currently available. The Mastabat el Fara'un is 99.6 by 74.44 meters (327 by 244 feet). The two sidewalls slope at seventy degrees and are joined by a vaulted ceiling. The bottom course is granite but the remainder of the building used limestone. A descending corridor inside leads 20.95 meters (69 feet) to a chamber and a further passage to an antechamber. Another short passage with a side room with statue niches slopes downward to the burial chamber with false vaulting carved into the ceiling. Inside the burial chamber was a stone sarcophagus similar to the one made for Shepseskaf's father, Menkaure. This sarcophagus type, the room with statue niches, and the false vaulting in the burial chamber are the major similarities between Shepseskaf's tomb and that of his father. These features will perhaps be significant if scholars draw any conclusion as to why Shepseskaf chose to change royal burial customs so dramatically. The German archaeologist Dieter Arnold emphasized the similarities the structure shares with the

palace of the living king. The paneling of the lowest course of the mastaba suggests the palace façade of the living king. This emphasis on the living king also suggests that there might have been reliefs showing the food offerings made to the king after his death in the temple built on the east side of the mastaba and in the unexcavated valley temple. This theme was already important for noblemen's tombs in this period. If this interpretation is true, it would suggest that Shepseskaf conceived himself as more human than previous kings had claimed to be.

HISTORICAL QUESTIONS. The pyramid complexes built at Giza in the Fourth Dynasty illustrate the advantages and disadvantages historians face when using architecture as the major source for information about a historical time period. Historians concentrate on the change and continuity in plans and techniques found among the Fourth-dynasty complexes and both their precursors and successors. Sometimes it is easier to identify a major change than it is to understand what the change meant. Both Djedefre and Shepseskaf chose to build funerary monuments outside of Giza, a surprising development in light of Khafre and Menkaure's decisions to build at Giza. Though Djedefre's choice to build outside Giza would initially seem to parallel his grandfather's and father's own decisions to build funeral monuments in new sites, it has struck some historians as aberrant. They have even seen it as evidence of a feud among the Fourth-dynasty princes. Djedefre's brother and successor, Khafre, chose to build near his father's pyramid and even to make connections between the plans of the two complexes. Khafre's son and successor, Menkaure, followed in his father's footsteps, but Menkaure's son, Shepseskaf, behaved in a most unusual way by both abandoning Giza for Saqqara and, what's more, building a giant mastaba rather than a pyramid. The real significance of these events cannot be determined in any definitive way. Yet other historical inferences, supported by textual evidence, seem to help us understand where the Fourth Dynasty was located in a long tradition. For example, it is possible to understand the use of five statue niches in Khafre's pyramid temple as placing the tradition of five official royal titles squarely into the Fourth Dynasty. Direct textual evidence for the use of the five official names for the king does not otherwise exist in this period, but only much later. The existence of five separate storage rooms can also be explained as evidence for the independence of the five phyles that worked to maintain the temple.

SOURCES

Dieter Arnold, "Royal Cult Complexes of the Old and Middle Kingdoms," *Temples of Ancient Egypt,* edited by By-ron E. Shafer (Ithica, N.Y.: Cornell University Press, 1997): 31–85.

Mark Lehner, *The Complete Pyramids* (London: Thames and Hudson, 1997).

Rainer Stadelmann, *Die Ägyptischen Pyramiden: vom Ziegelbau zum Weltwunder* (Mainz am Rhein, Germany: P. von Zabern, 1985).

Miroslav Verner, *Die Pyramiden* (Reinbek bei Hamburg, Germany: Rowohlt Verlag, 1998).

SEE ALSO *Visual Arts: The Old Kingdom*

ARCHITECTURE OF THE FIFTH AND SIXTH DYNASTIES

STANDARDIZATION AND NEW LOCATIONS. During the Fifth and Sixth Dynasties, architects followed a standard plan for the royal pyramid complex. The experimentation of the examining Fourth-dynasty pyramid complexes came to an end. Kings also chose a new site called Abu Sir for their complexes after Userkaf initially built his complex at Saqqara, the site of Djoser's Third-dynasty complex. Finally, kings of this era drastically reduced resources directed to pyramid building from the Fourth Dynasty. Instead, they diverted some resources to sun temples dedicated to the god, Re. The meaning of these trends must be inferred without much help from other kinds of evidence. In general, Egyptologists believe that kings now directed more resources toward temples for the god Re and away from their own pyramid complexes because the kings themselves had lost status in their society in comparison with Fourth-dynasty kings.

THE PYRAMID COMPLEX OF USERKAF AT SAQQARA. Userkaf (2500–2485 B.C.E.), the first king of the Fifth Dynasty, built his pyramid complex at Saqqara, aligning it with the northeast corner of Djoser's complex built in the Third Dynasty (2675–2625 B.C.E.). The 49-meter (161-foot) tall pyramid with base sides of 73.3 meters (240 feet) was smaller than Djoser's step pyramid, being eleven meters (35.5 feet) shorter in height and 48 meters (157 feet) shorter on a side. In addition to being smaller, Userkaf's pyramid was not as well constructed. Workers laid the core haphazardly before casing it in limestone, and the core subsequently collapsed when workers removed the casing for other purposes in later times. Inside, the pyramid has a north entrance leading to a descending passage 18.5 meters (61 feet) long. This passage led to an antechamber 4.14 meters long by 3.12 meters (13.5 by 10.2 feet) wide. Another horizontal passage exiting from the right side led to the burial

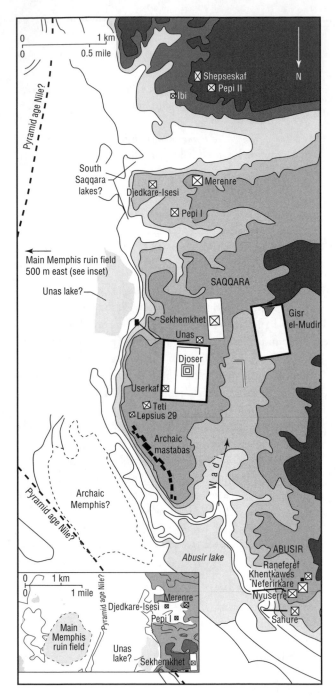

Plan of Saqqara and Abu Sir. CREATED BY GGS INFORMATION SERVICES. GALE.

the side reserved for the pyramid temple in the Fourth Dynasty at Giza. The pyramid temple contains niches for the statue cult, but they are oriented to the south wall of the temple, away from the pyramid rather than toward it as had been the case in Giza. The subsidiary pyramid is located at the southwest corner of the main pyramid rather than on the east or southeast as at Giza. At least two interpretations have been offered for this change in plan. The Egyptian archaeologist Nabil Swelim observed that Userkaf's pyramid would not fit at the northeast corner of Djoser's complex unless the pyramid temple was moved to the south side. He regards this layout as the result of practical problems. The alternative explanation connects the role that the sun-god Re played in the beliefs of the kings of the Fifth Dynasty with this change in plan. According to this explanation, Re became much more important to the Fifth-dynasty kings. This importance can be deduced from their efforts to build the first temples for this god and from some much later literary evidence linking Userkaf and his successors with Re. Thus the pyramid temple's placement at the south side of the pyramid ensured that it had an unobstructed view of the sun. The German archaeologist Dieter Arnold has further observed, however, that beginning with the time of Djoser and then Sneferu, Old Kingdom kings alternated between building a temple complex oriented north/south (the Djoser type) and complexes oriented east/west (the Meidum type). Without further evidence it will never be clear which of these explanations is closer to the truth. Another important point to consider is the relationship between the kings of the Fourth and Fifth Dynasties. The kings of the Fifth Dynasty seem to represent a new family in that they were not direct descendents of Shepseskaf, the last king of the Fourth Dynasty. In *Papyrus Westcar*, a story written nearly 900 years after these events, the writer claims that Userkaf's father was the sun-god, Re, not a human. If this papyrus reflects an older tradition original to the Fifth Dynasty, perhaps Userkaf built his pyramid in Saqqara to associate himself with the earlier king, Djoser, whose pyramid complex was nearby. This tradition also helps explain Userkaf's sun temple at Abu Sir.

USERKAF'S SUN TEMPLE AT ABU SIR. Old Kingdom documents mention six sun temples dating to each of the six kings of the Fifth Dynasty. The oldest of the temples is Userkaf's sun temple at Abu Sir. The only other one to be discovered and excavated is the sun temple built by Nyuserre, the fifth king of the dynasty (ruled 2455–2425 B.C.E.). Userkaf's sun temple represents the first known effort of an Egyptian king to build a temple other than his own funerary monument. Userkaf built

chamber, 7.87 meters long and 3.13 meters wide (25.8 by 10.2 feet). A passage to the left led to a storage area. The arrangement of the buildings associated with Userkaf's pyramid resembles Djoser's Third-dynasty pyramid complex much more than the complex at Giza built only two generations previously. The pyramid temple is located on the south side of the pyramid. A small offering chapel remains on the east side of the pyramid,

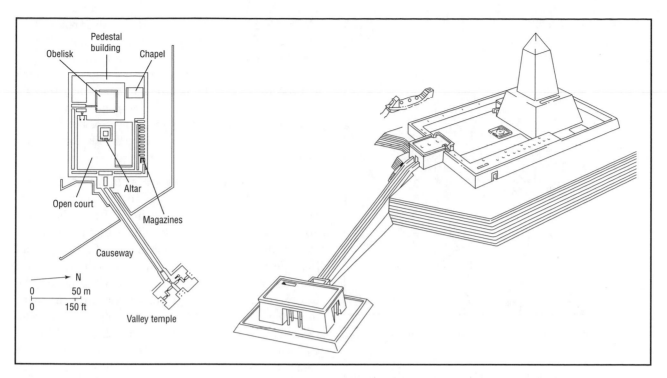

Nyuserre's sun temple. A simulacrum of a barque is docked off the southeast corner. **CREATED BY GGS INFORMATION SERVICES. GALE.**

his sun temple in Abu Sir, a site that would later be utilized for pyramid complexes and sun temples by other Fifth-dynasty kings. Userkaf's sun temple also represents the first clear example of a temple built and then rebuilt by subsequent kings, a common theme in the later architectural history of Egypt. Both Neferirkare, the third king of the dynasty, and Nyuserre added to the temple. The name of this temple, *Nekhen Re* (The Stronghold of Re), associates it with early temple enclosures at the town called Nekhen (Stronghold) in Middle Egypt. The excavator, Herbert Ricke, believed that the first building stage of the temple contained the same key elements as the earlier Stronghold: a rectangular enclosure and a central mound of sand. Neferirkare added an obelisk with altars in front of it in the second building phase. Thus this sun temple contained the first-known example of this typically Egyptian form. Phases three and four, built by Nyuserre, included five benches. Ricke thought the benches were platforms where priests placed offerings to the god. He discovered a stele inside one of the benches inscribed with the name of the "Great Phyle," one of the five groups of priests and workers responsible for work at the temple on a rotating basis. It is possible that the five benches represented each of these five groups, though archaeologists found no other steles. A causeway linked the sun temple with a valley temple. Nyuserre may have constructed the valley temple during the fourth phase of

building, or he may have rebuilt an original building of Userkaf's complex.

PYRAMIDS AT ABU SIR. The Fifth-dynasty kings— Sahure (2485–2472 B.C.E.), Neferirkare Kakai (2472–2462 B.C.E.), Shepseskare (2462–2455 B.C.E.), Renefere (2462–2455 B.C.E.), and Nyuserre (2455–2425 B.C.E.)—built their pyramids at Abu Sir, just north of Saqqara. Though the first king of the Fifth Dynasty, Userkaf, built his pyramid complex in Saqqara, he initiated construction at Abu Sir by building his sun temple on this new site. Sahure, second king of Dynasty 5 who ruled 2485–2472 B.C.E., built a pyramid with base sides 78.75 meters (258 feet) long and 47 meters (154 feet) high. It was thus 151.25 meters (498 feet) shorter on a side and 99 meters (327 feet) lower than Khufu's Great Pyramid at Giza. Instead of a gigantic pyramid, Sahure concentrated his efforts on decorating the complex with relief sculpture. The interior of the pyramid was also much simpler than the complicated system of passages that builders provided for the pyramids of the Fourth Dynasty. An entrance on the north side led to a 1.27 by 1.87-meter (4.1 by 6.1-foot) passage that ran on a level plane for approximately 162.4 meters (533 feet). The amount of rubble still in the passage makes precise measurements impossible. The passage led to a burial chamber measuring 12.6 meters (41.3 feet) by 3.15 meters (10.3 feet). This simple T-shaped interior resembles

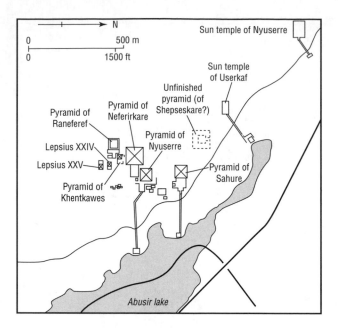

Map of Abu Sir. **CREATED BY GGS INFORMATION SERVICES. GALE.**

the interior of a nobleman's tomb, suggesting that Sahure regarded himself more like other high officials than did the kings of the Fourth Dynasty who claimed to be gods. The architect's plan for Sahure's pyramid complex became the standard for nine of the known complexes of the following Fifth and Sixth Dynasties. Arnold suggested that this phenomenon resulted from the work of a series of architects who had inherited the office of King's Architect for many generations, though it is just as likely that this model served the needs of a long line of kings while they experimented with the sun temples, a new area of focus.

THE STANDARD PYRAMID TEMPLE. Architects positioned the standard pyramid temple on the east side of the pyramid, and included a vaulted entrance hall decorated with relief sculpture. This covered hall led to an open courtyard allowing the architect to exploit the contrast between the darkness of the hall and the bright sunlight of the court. This contrast, alternating light and darkness, was a basic tool of all Egyptian architecture. Relief sculpture also decorated the walls of the courtyard depicting the king protecting Egypt from enemies. Another hall led to a room decorated with scenes from the Jubilee Festival (sed). The relief there showed the gods of Upper and Lower Egypt greeting the king and confirming his right to rule the country. This room offers evidence that the Jubilee Festival depicted in it continued at the king's burial complex as it had been known beginning with the Jubilee Festival (sed) courtyard in the funerary complex of Djoser in the Third Dynasty

(2675–2625 B.C.E.). The rear of the pyramid temple held five niches for the five statues of the king and an offering place. The five statues of the king probably represented each of the five standard names that a king took at his coronation. The pyramid temple's plan thus reflects an Egyptian's idea of the proper evidence that a king had ruled legitimately in the eyes of the gods and also a listing of his functions through the use of sculptural relief.

THE STANDARD CAUSEWAY AND VALLEY TEMPLE. The standard causeway connected the upper pyramid temple and the lower valley temple. In the Fifth and Sixth Dynasties, remains of relief sculpture lined the walls of the causeway. Artists represented two basic subjects. First they showed the king protecting the whole complex from Egypt's human enemies and taming nature. Second, they showed humans on earth supplying the complex with food from all over Egypt. The architect used three different stones in the valley temple, probably with color symbolism in mind. The floor was black basalt, referring to the black mud of Egypt's fertile valley. The *dado* (the lower part of the wall) was red granite, a reference either to the surrounding desert or a punning allusion to holiness, since the Egyptian words for "red" and "holy" sounded alike. Finally, the upper walls were white Tura limestone, decorated with a carved and painted relief depicting the king defeating his enemies. The building served as an entrance to the whole complex and stood as a statement of the basic order of the Egyptian world.

USES OF THE PYRAMID COMPLEX. The pyramid complexes were primarily tombs for the kings. Yet Egyptologists have long abandoned the German Egyptologist Herbert Ricke's theory that the buildings of the complex were solely for the funeral. The discovery of the *Abu Sir Papyri*, the records of Neferirkare's pyramid complex subsequent to the king's death, provides evidence of the numerous activities that continued in the complex after the burial. The *Pyramid Texts* found inside the pyramids beginning with the reign of Unas (2371–2350 B.C.E.) also inform us about the rituals which continued in the pyramid complex, in the Egyptian ideal, for eternity. There were at least two offering services for the king every day—one in the morning and one in the evening. Other rituals centered on the five statues of the king found in the five niches of the pyramid temple. At least three of these statues depicted the king as the god Osiris, king of the dead. The ritual included feeding, cleaning, and clothing the deceased king. Priests then received the food used in the ritual as part of their salary. When they were not attending to their deceased king, priests and

A RITUAL SPEECH TO UNITE WITH THE SUN GOD

INTRODUCTION: The *Pyramid Texts* were carved inside the sarcophagus chambers of the pyramids beginning in the reign of King Unas (2371–2350 B.C.E.). These ritual speeches, according to Egyptian religious belief, helped the deceased king unify with the sun god, his father. In this example the king unites with Re-Atum, a form of the sun-god, Re, merged with the creator god, Atum.

Re-Atum, this Unas comes to you,
A spirit indestructible
Who lays claim to the place of the four pillars!
Your son comes to you, this Unas comes to you,
May you cross the sky united in the dark,
May you rise in lightland, the place in which you
　　shine!
Seth, Nephthys, go proclaim to Upper Egypt's gods
And their spirits:
"This Unas comes, a spirit indestructible,
If he wishes you to die, you will die,
If he wishes you to live, you will live!"

SOURCE: "The king joins the sun god," in *The Old and Middle Kingdoms.* Vol. 1 of *Ancient Egyptian Literature.* Trans. Miriam Lichtheim (Berkeley: University of California Press, 1973): 30–31.

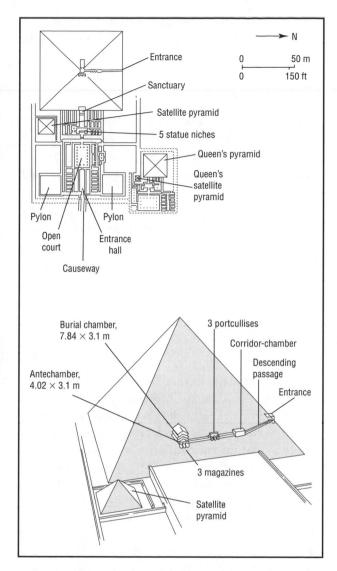

The Djedkare-Isesi temple from above as well as a side profile showing the pyramid, the satellite pyramid, as well as the sanctuary and entrance hall. **CREATED BY GGS INFORMATION SERVICES. GALE.**

administrators engaged in other tasks, including astronomical observations to determine the proper day for celebrating festivals and the administrative tasks associated with delivering, storing, and disbursing large amounts of commodities that arrived at the complex on a regular basis. These goods included food and clothing used during the rituals. The pyramid complexes of the Old Kingdom were probably very busy places rather than just tombs. Some of the complexes operated for much longer periods than others. The cult of Khufu at the Great Pyramid, for example, continued with its own priests as late as the Twenty-sixth Dynasty (664–525 B.C.E.) over 2,000 years after the building of the complex.

EVENTS AND TRENDS. Architecture allows Egyptologists to follow general trends in the history of the Fifth and Sixth Dynasties. The rise of the sun-god Re's importance seems to co-exist with a lowered status of the king himself, compared to Fourth-dynasty kings. This observation depends on the fact that royal pyramids of

the Fifth and Sixth Dynasties were so much smaller than the Fourth-dynasty pyramids. Khufu's Great Pyramid required ten times more stone to build than Nefirkare's pyramid, built in the Fifth Dynasty. Considering that Fifth-dynasty building methods were also more economical because they used some fill rather than being solid stone as the Fourth-dynasty pyramids were, it is even more striking that Fifth- and Sixth-dynasty kings spent fewer resources on themselves than Fourth-dynasty kings had done. Because Egyptologists lack other records to supplement this picture, the actual events that led to this change cannot be examined. It is not clear, for example, whether there were fewer resources to spend on the king because of wars or famines, or whether the

change was solely due to an altered ideology. These questions await further evidence before real answers can be offered.

SOURCES

Dieter Arnold, "Royal Cult Complexes of the Old and Middle Kingdoms," *Temples of Ancient Egypt*, edited by Byron E. Shafer (Ithica, N.Y.: Cornell University Press, 1997): 31–85.

Mark Lehner, *The Complete Pyramids* (London: Thames and Hudson, 1997).

Rainer Stadelmann, *Die Ägyptischen Pyramiden: vom Ziegelbau zum Weltwunder* (Mainz am Rhein, Germany: P. von Zabern, 1985).

Miroslav Verner, *Die Pyramiden* (Reinbek bei Hamburg, Germany: Rowohlt Verlag, 1998).

MASTABA TOMBS OF THE OLD KINGDOM

HOUSE FOR ETERNITY. The mastaba tomb's name comes from the Arabic word meaning "bench," for its resemblance to a mud brick bench sitting on the desert sand. Such benches are often located in front of houses. One name that the ancient Egyptians gave to tombs was *per djet*, "house of eternity." The Egyptians thought of the tomb as one of the places in which their souls would live after they died. The soul divisions included the *ba* that could travel between the mummy and the next world, the *ka* that could inhabit a statue of a deceased person, and the *akh* that was transformed in the tomb into a spirit that could live in the next world. Not only did the ba and the ka spend time with the mummy and the statue of the deceased in the tomb, but also supplies that a person would need in the next life were stored in the tomb, just as there were storage facilities in a house. A deceased person could even receive mail at the tomb just as mail could be delivered to a person in this life. In fact all the functions that a person performed in life—sleeping, eating, dressing, receiving friends—were performed in the tomb by the deceased.

EARLIEST EGYPTIAN TOMBS. In the very earliest periods, Egyptians buried their dead in oval-shaped pits in the desert. From the Nagada I Period (3800–3500 B.C.E.), grave goods such as pots, tools, and weapons were included in the grave along with the body. These graves were unmarked, but the grave goods show that from the earliest period the Egyptians believed that people needed supplies to take with them to the next world. In the Nagada II Period (3500–3300 B.C.E.), the Egyptians dug

more rectangular pits for graves and sometimes lined them with basket-work, reed matting, or wood. These simple linings were the precursors of coffins. It was only during the first two dynasties (3100–2675 B.C.E.) that the Egyptians began to build superstructures over pit graves called mastabas. At first they built them of mud brick, but later switched to stone. The type remained the basic burial architecture for the region around Memphis used by the wealthy into 3100 B.C.E. and later.

MASTABAS OF DYNASTIES ONE, TWO, AND THREE. The mastabas built during the First and Second Dynasties were decorated with the palace façade motif derived from the enclosure wall of the contemporary royal palace as well as the funerary enclosures of kings in this period. First-dynasty mastabas had plastered and painted exteriors, though this feature apparently did not continue into the Second Dynasty. Though the first mastabas had storage chambers, storage moved to the substructure during the course of the First Dynasty. A staircase led to these storage chambers and the burial chamber. The mastaba became a solid brick block with retaining walls and a rubble core. On the east side of the mastaba, architects placed two offering niches where the living could make offerings. Later, architects built exterior chapels on the east side of the tomb, in addition to interior chapels shaped like a corridor, and cruciform chapels on the interior. The living used all of these places to make offerings to the dead. Yet, no definite progression of these types can currently be deduced. They continued into the Third Dynasty as the typical burial for the wealthy, even as kings began to build step pyramids.

FOURTH-DYNASTY MASTABAS. At the beginning of the Fourth Dynasty (2625–2500 B.C.E.), mud brick continued to be the main construction material of mastabas with some elements such as lintels—the top element of a doorway that rests on the sides of the doorway called jambs—made of stone. By the time Khufu built the Great Pyramid, however, all of the surrounding mastaba tombs were limestone. Probably this change is due to the fact that these mastabas belonged to the very richest non-royal people. Most of them were at least relatives of the royal family and held high office in the bureaucracy. The mastaba itself was mostly solid with a corridor that led to two chapels on the east side, built over shafts excavated into the bedrock. The shaft extended to the roof of the mastaba that gave the only access to it and to the burial chamber. At the bottom of the shaft a tunnel extending to the west led to the burial chamber. A stone sarcophagus, decorated with the palace façade motif similar to the older superstructures, rested in a niche in the west wall. A canopic chest—the name given to the con-

tainer holding the mummified lungs, liver, stomach, and intestines—lay buried in a niche either on the south or southeast wall. Egyptians employed elaborate measures to thwart tomb robbers, such as filling the tunnel with rubble after the burial or inserting large blocking stones. These precautions were largely unsuccessful. Nearly all of the Old Kingdom mastabas were robbed in antiquity.

FIFTH- AND SIXTH-DYNASTY MASTABAS. The superstructure of Fifth- and Sixth-dynasty mastabas (2500–2170 B.C.E.) was more complex than the earlier, solid-core mastabas. Designers now included interior chapels in the superstructure. These chapels were often L-shaped, though cruciform (cross-shaped) chapels also existed. The overall size of these chapels was only a tiny part of the solid core of the structure. Very wealthy people began to include interior chapels with multiple rooms sometimes connected by columned halls near the end of the Fifth Dynasty and beginning of the Sixth Dynasty. More and more, the mastaba began to resemble a nobleman's house. Stairs to the roof from the interior of the mastaba allowed access to the burial shaft that continued to be accessed there. The burial shaft extended through the mastaba core then continued into the bedrock. A tunnel led west to the burial chamber. In the burial chambers of the Fifth and Sixth Dynasties designers buried the deceased in a pit excavated into the bedrock, and placed a stone lid over the pit after the mummy's burial.

THE FALSE DOOR. The structure in mastaba tombs known as the false door is a stylized model of a door. It combines an offering place, door jambs, a lintel, and a stela, each carved from stone, though some Third-dynasty examples are wood. The name of the deceased was inscribed on each element, along with his or her titles. If there were two false doors in the western interior wall of the mastaba, the southern one was inscribed for the deceased tomb owner while the northern one was inscribed for his wife. The stela above the false door was often decorated with an image of the deceased at the symbolic funerary meal as well as images of the deceased's family performing rituals that ensured continued life in the next world. The false door, according to Egyptian belief, allowed the ka (soul) of the deceased to travel between the world of the living and the world of the dead and deliver food offerings to the deceased, one of the ka's main functions after death.

OPPOSING TRENDS. It is striking that Fifth- and Sixth-dynasty mastabas are so much bigger and more elaborate than Fourth-dynasty mastabas. This trend is exactly the opposite of the changes from Fourth to Fifth- and Sixth-dynasty royal pyramids, which became smaller

a PRIMARY SOURCE *document*

LETTERS TO THE DEAD

INTRODUCTION: The tomb was a deceased person's house for eternity. Not only did the deceased eat, drink, dress, and sleep in the tomb, but also he or she could receive mail there. The following two letters were deposited at the tomb of Inherhenmet at Kaw, a site in Middle Egypt. In it, the living son, Shepsi, asks his deceased father, Inherhenmet, and mother, Iy, to intervene in a dispute with his brother, Sebkhotep, who is also dead. According to the texts, this brother had caused the living son to lose his land on earth. Shepsi suggested that his parents bring a lawsuit against his brother to restore the land to him, especially considering all the things he had done for his father, his mother, and even his deceased brother. It is unknown how the results of the suit would be communicated to Shepsi.

It is Shepsi who speaks to his father, Inherhenmet. This is a reminder of your journey to the prison, to the place where Son's son Hotpui was, when you brought the foreleg of an ox, and when I came with Newayof, and when you said, "Welcome, you two! Sit and eat meat!" Am I being injured in your presence by my brother, without having done or said anything? (And yet) I buried him, I brought him from …, I placed him among the fellow-owners of his tomb, although he owed me thirty gallons of barley [and other commodities]. He has done this against me wrongfully, since you said to me, "All my property is vested in you, Shepsi." Look, all my fields have been taken away! … Litigate with him since your scribes are with you in one city …

It is Shepsi who speaks to his mother Iy. This is a reminder of the fact that you did say to me, "Bring me quails that I may eat them," and I brought to you seven quails, and you ate them. Am I being injured before you, the children being very discontent with me? Who will then pour water for you [make sacrifices for you]? Oh may you judge between me and Sebkhotep! I brought him from another town … and gave him his burial clothing. Why does he work against me without my having said or done anything?

SOURCE: "Letter From Shepsi to his father Inherhenmet," adapted from Alan H. Gardiner and Kurt Sethe, *Egyptian Letters to the Dead* (London: Egypt Exploration Society, 1928): 4–5.

Arts and Humanities Through the Eras: Ancient Egypt (2675 B.C.E.–332 B.C.E.)

35

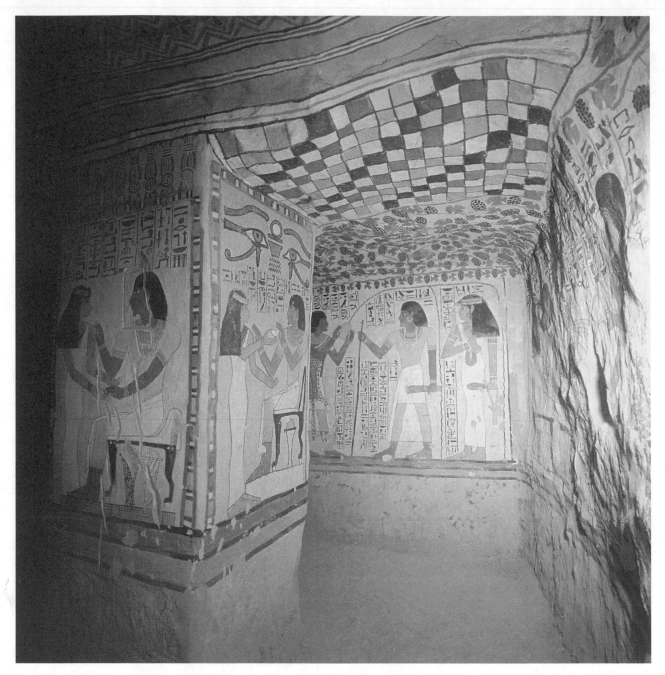

Painted burial chamber of a nobleman in Thebes. © ROGER WOOD/CORBIS. REPRODUCED BY PERMISSION.

over the same time period. These trends suggest again that resources were increasingly directed away from the royal pyramid and instead to other goals during the course of the Old Kingdom.

SOURCES

Naguib Kanawati, *The Tomb and its Significance in Ancient Egypt* (Cairo: Al Ahram Commercial Press, 1987).

Philip Watson, *Egyptian Pyramids and Mastaba Tombs* (Aylesbury, England: Shire Publications, Ltd., 1987).

DOMESTIC ARCHITECTURE IN THE OLD KINGDOM

PLANNED TOWNS. Archaeologists have discovered only a few Old Kingdom towns, all of which are located adjacent to or in Old Kingdom pyramid complexes. The towns demonstrate both the problems that the central government faced in maintaining pyramid complexes and also the way the original function of many buildings was quickly lost as squatters occupied buildings. The

pyramid town at Abu Sir was located along the south and east walls of the pyramid temple of King Neferirkare (2472–2462 B.C.E.). Against an inner enclosure wall, there were nine mud brick houses in a row running south and southeast with a tenth house at the northeast corner of the temple. These houses were home to the scribes of the *Abu Sir Papyri*, the only ancient evidence of the day-to-day function of the pyramid complexes. Given the number of people mentioned in the *Abu Sir Papyri* lists of rations, there was probably another town, not yet discovered by modern archeologists, somewhere nearby. This pyramid temple/pyramid town demonstrates one of the basic problems which all states or institutions face when constructing large buildings: maintenance. The hastily finished columns of the forecourt were originally wood. Termites apparently destroyed the wooden columns fairly soon after completion, and haphazard repairs replaced the wood with less attractive mud brick supports. This kind of repair was probably typical given the administrators' diminishing resources and increasing responsibilities. By the end of the Old Kingdom, there were twenty pyramid complexes to maintain. It is clear from the treatment they received that the Old Kingdom state had no policy for maintaining historic buildings. It was not until the New Kingdom that kings began to replace mud brick structures in temples in the towns with stone construction. For example, Ramesses II's son Khaemwase tried to restore some of the important Old Kingdom buildings in the Memphis area.

CHANGING THE FUNCTION OF BUILDINGS. The pyramid town at the valley temple of Menkaure shows even more clearly the course of events at Old Kingdom pyramid complexes as old temple endowments could no longer support the original intentions of the builders. Since the valley temple of Menkaure is today too ruined to allow meaningful views of the original intentions of the builder, it is useful to imagine the valley temple of Khafre, his immediate predecessor, as the prototype of the original intentions of the builder. We will then follow the history of Menkaure's valley temple as it changed from a holy site to a village. Today's visitor to the valley temple of Khafre at Giza can see the massive walls of white limestone which create an overwhelming sense of peace and majesty, as must have been originally intended. At Menkaure's valley temple the statuary which had been prepared for the building would have added even more to the atmosphere, but the walls were left unfinished after Menkaure's premature death. His successor, Shepseskaf, finished the building in mud brick, which must have reduced the majestic effect considerably. Gradually workmen transformed the temple into a

fortified mud brick village. Some 300 years after the temple's original completion, it would have been unrecognizable to its builders. In the village, by the Sixth Dynasty, an additional entranceway supported by two columns had been constructed which led to a vestibule with four columns supporting the roof. A right turn then led to the main courtyard, now filled with mud brick houses and granaries. In modern times, archaeologists discovered the famous statues of Menkaure now in the Boston and in the Cairo museums in the rooms originally designed for supply storage. At some point during the Old Kingdom, a flood caused some damage to the building. The repairs to that damage led to the remodeling of the building for the temple's new use as a village rather than a temple. The restorations were, in fact, a formal recognition of the new use of the building. Eschewing use of the old sanctuary, workers set up a small shrine in a room with four columns. Four statues of Menkaure were set up there on an altar made from an old worn slab of alabaster set up on two upright stones. In order to reach this makeshift sanctuary, the priest would walk through a mud brick village. All of the associated archaeological material in this village suggest that squatters built it and lived in it during Dynasty Six. A decree of Pepi II found in the inner gateway suggests that this village would have been a normal town in this later period. This situation was certainly very far from Menkaure's and even his successor Shepseskaf's intentions for the building.

SOURCES

Barry Kemp, *Ancient Egypt: A Cultural Anatomy* (London; New York: Routledge, 1989).

TRANSITION TO THE MIDDLE KINGDOM

NEBHEPETRE MENTUHOTEP. Between the end of Dynasty 6 (2170 B.C.E.) and the inauguration of the Middle Kingdom in the Mid-eleventh Dynasty (2008 B.C.E.) royal architecture did not exist because the central government had collapsed. Egypt was ruled by provincial officials. Royal architecture in the Middle Kingdom begins again with King Nebhepetre Mentuhotep, the founder of the Middle Kingdom. Nebhepetre Mentuhotep was among the most famous kings in ancient Egyptian history. He reestablished the central government of Egypt after the First Intermediate Period (the period without central government from 2130–2008 B.C.E.), and ushered in a unified period now called the Middle Kingdom about 2008 B.C.E. Kings for the next 1,000 years claimed

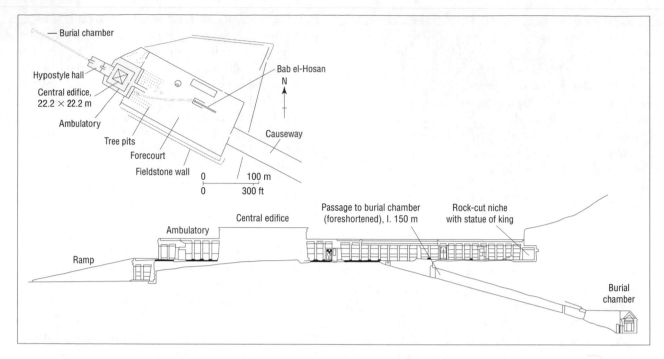

Mentuhotep's tomb complex. **CREATED BY GGS INFORMATION SERVICES. GALE.**

Nebhepetre Mentuhotep as an ancestor because they believed it helped them establish their own legitimacy to rule Egypt.

MENTUHOTEP'S FUNERARY TEMPLE AND TOMB. The funerary temple for Mentuhotep was unlike those built by his predecessors in ruling Egypt, the kings of the Old Kingdom who built pyramid complexes. Instead Nebhepetre Mentuhotep built a temple and tomb based on local traditions in Thebes, the area where he was born. For reasons unknown, only Hatshepsut, the queen who ruled approximately 500 years after him, imitated his temple. The major architecture during his reign was his tomb and temple built in Deir el Bahri on the west bank of the Nile opposite modern Luxor. This region is also known as Thebes. Deir el Bahri is surrounded by cliffs that mark the beginning of the Sahara. The tomb itself was carved out of the mountain. Directly at the base of the mountain, Mentuhotep's builders constructed a T-shaped platform with the longer part of the "T" extending from the mountain and the wider part of the "T" stretching north and south. Priests could access the platform by a long causeway that formed the entrance to the building. Approaching from the causeway, the priest would reach an area called the central edifice, 22.2 meters (72.8 feet) square. A columned ambulatory (a sheltered walkway) surrounded a central core that has been reconstructed in three different ways. The original excavator, Swiss archaeologist Edouard Naville, recon-

structed the now destroyed central core as a pyramid. He knew that the *Abbott Papyrus*, written hundreds of years after this temple's construction, described this building as a *mer*, the ancient Egyptian word for pyramid. The German archaeologist Dieter Arnold, however, restudied the blocks from the temple in the 1970s and demonstrated that the walls of the central edifice were not strong enough to support a pyramid as a central core. Arnold argued that the word *mer* during the time of the writing of the *Abbott Papyrus* meant only "tomb," and no longer meant "pyramid" exclusively, and reconstructed a cube on the central edifice. The German archaeologist Rainer Stadelmann subsequently suggested that a mound was built on the central edifice. This mound would be a reference to the sand mounds found in the most ancient Egyptian funerary structures at Abydos. This reconstruction, though, is purely hypothetical. Behind the ambulatory is a hypostyle hall, literally a room filled with columns. This room contained eighty octagonal columns leading to a rock-cut niche containing a statue of the king. The king appears to stride directly out of the mountain. A tunnel cut in the bedrock leads to the burial chamber.

OTHER ARCHITECTURAL ELEMENTS. The royal tomb itself is cut into the mountain. A tunnel 44.9 meters (147 feet) under the mountain and 150 meters (492 feet) long leads to a granite-lined vault. An alabaster shrine, surrounded by basalt, filled the burial chamber,

38

Arts and Humanities Through the Eras: Ancient Egypt (2675 B.C.E.–332 B.C.E.)

and probably contained the king's mummy in a wooden sarcophagus. A garden surrounded the causeway that led up to the central edifice. The designer planted 53 tamarisk trees and a large sycamore fig in the garden. Twelve statues of Mentuhotep dressed as Osiris, the king of the dead, faced the east. At some point the statues were decapitated though it is not known why. The English Egyptologist Howard Carter, who later discovered the tomb of Tutankhamun, excavated the Secondary Tomb after a horse stumbled over it. The tomb thus gained the name *Bab el-Hosan* ("Gate of the Horse"). There Carter found a forecourt and open trench enclosed with mud brick leading to a tunnel. A statue of Mentuhotep wrapped in linen as if it were a mummy lay in a chamber at the end of the tunnel. The Bab el-Hosan probably represented the same kind of secondary royal burial known as early as the First Dynasty. These secondary or subsidiary burials formed a part of the early complexes in Abydos and in Old Kingdom Pyramid complexes.

UNIQUE STRUCTURE. The funerary temple built by Nebhepetre Mentuhotep is difficult for Egyptologists to understand. The building has nearly no precedents and no successors. This originality, which modern people prize, was unusual in ancient Egypt. Later kings would return to imitating the pyramid complexes of the Old Kingdom. The lack of similar buildings makes it impossible to restore the damaged parts with any certainty.

SOURCES

Dieter Arnold, *Der Tempel des Konigs Mentuhotep von Deir el Bahari* (Mainz, Germany: Mitteilungen d. Deutchen Archaologisches Institut, 1974–1981).

Howard Carter, "Report on the Tomb of Mentuhotep I," *Annales du Service d'Antiquités Egyptien* 2 (1901): 201–205.

Mark Lehner, *The Complete Pyramids: Solving the Ancient Mysteries* (New York: Thames and Hudson, Inc., 1997).

SEE ALSO *Visual Arts: The Middle Kingdom*

THE PYRAMIDS OF THE MIDDLE KINGDOM

REVIVAL OF OLD KINGDOM TRADITIONS. Amenemhet I (c. 1938–1909 B.C.E.) and Senwosret I (c. 1919–1875 B.C.E.), the first two kings of the Twelfth Dynasty, built pyramid complexes in the area near Memphis which revived the traditions of pyramid building

practiced in Dynasties Four to Six (2625–2170 B.C.E.) and signaled a return to the Old Kingdom capital in the north. Yet it is clear that kings devoted fewer resources to pyramid building at the beginning of the Twelfth Dynasty (1938–1759 B.C.E.) than had been allocated for the projects built in the Old Kingdom. Little remains of these relatively poorly built complexes. Innovative building techniques used for these structures appear to be attempts to substitute sand fill or mud brick for solid masonry construction. As a result of these new, cheaper techniques, little remains of the Twelfth-dynasty royal pyramid complexes. The pyramids built by the later kings of the Twelfth Dynasty—Amenemhet II (1876–1842 B.C.E.), Senwosret II (1844–1837 B.C.E.), Senwosret III (c. 1836–1818 B.C.E.), and Amenemhet III (1818–1772 B.C.E.)—reflect attempts to introduce new elements to the pyramid complex imported from Theban traditions. They also revived traditions of pyramid building from the time of Djoser (2675–2625 B.C.E.). These changes suggest that both Senwosret III and Amenemhet III had reconceived their roles as kings in a way that recalled traditions preceding the dominance of the sun cults of the Fourth through Sixth Dynasties. The details of these changes are unfortunately lost because these buildings are also very poorly preserved.

AMENEMHET I'S PYRAMID AT LISHT. When Amenemhet I (1938–1909 B.C.E.) moved the Egyptian capital back to the Memphis area from Thebes, he established a new town called *Itj-tawy* ("Seizer of the Two Lands"). No one has yet discovered the location of Itj-tawy, though it likely was close to Lisht, the site of Amenemhet I's pyramid. Though Amenemhet I used the form of Old Kingdom pyramids, his building techniques differed greatly. The core of his pyramid included limestone blocks, mud brick, sand, debris, and relief sculpture that had been removed from Khufu's temples at Giza. Some Egyptologists believe that Khufu's relief was included to provide a spiritual connection to the earlier king. The pyramid complex of Amenemhet I resembled the standard Old Kingdom pyramid complex. Though poorly preserved today, it included a pyramid temple, causeway, and valley temple. Though the lack of preservation hinders extensive architectural commentary, some Theban features are noteworthy. The causeway was open to the sky, more similar to Nebhepetre Mentuhotep's causeway at Deir el Bahri than to Khufu's roofed causeway in Giza. In addition, the architect placed the pyramid temple on a terrace slightly below the pyramid, not unlike the terraced plan of contemporary Theban tombs such as Nebhepetre Mentuhotep's funeral

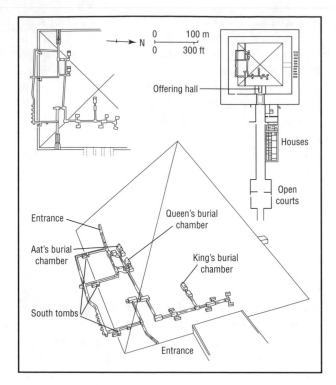

Amenemhet III's Dahshur pyramid. **CREATED BY GGS INFORMATION SERVICES. GALE.**

temple. It is possible that Amenemhet I thought of these features as customary since he also originated in the Theban area.

THE PYRAMID OF SENWOSRET I AT LISHT. Today the pyramid of Senwosret I (1919–1875 B.C.E.) is a 23-meter (75-foot) high mound of mud brick. Originally the pyramid was 105 meters (344 feet) square at the base and 61.26 meters (201 feet) high. The Great Pyramid was more than twice as high and twice as wide at the base than Senwosret's pyramid, but the smaller size is similar to the pyramids built in the Fifth and Sixth Dynasties. The construction of Senwosret's pyramid was innovative, but represents a wrong turn in construction techniques. Senwosret's builders constructed an internal skeleton made from limestone walls to form a pyramid. They filled the skeleton with roughly shaped stones. They then faced the pyramid with fine limestone blocks that were joined with wooden cramps, similar to clamps that held two stones together. These cramps probably weakened the overall structure rather than strengthened it since the wood buckled under the weight of the stone. The interior burial chamber of the pyramid is under the water table and has not been explored in modern times. The entrance was from the north, similar to traditional pyramid complexes built in the Old Kingdom. The major elements of an Old King-

dom pyramid complex were present in this Middle Kingdom complex, including a subsidiary pyramid located at the southeast corner of the main pyramid, a pyramid temple on the east side of the pyramid (though little of it remains today except for piles of mud brick), and a closed causeway leading to a valley temple which has not yet been discovered. The causeway contained at least eight complete statues of Senwosret I dressed as Osiris, the divine king of the dead. The statues on the south side of the causeway wore the White Crown of Upper Egypt (southern Egypt) while the statues on the north side wore the Red Crown of Lower Egypt (northern Egypt). The complex also included nine queen's pyramids. Queen Neferu, Senwosret's wife, occupied the first. A second was the burial place of Princess Itayket, the king's daughter.

THE PYRAMID COMPLEX OF SENWOSRET III. Senwosret III (1836–1818 B.C.E.) built his pyramid complex at Dahshur, the site first occupied by King Sneferu at the beginning of the Fourth Dynasty (2626–2585 B.C.E.). Yet Senwosret III did not imitate Sneferu's plan that led to the Fourth-dynasty type pyramid complex. Instead Senwosret III began the revival of Djoser's Third-dynasty type funeral monument with a dominating north/south axis. He built a "true" pyramid 105 meters (345 feet) square and 78 meters (256 feet) high that contrasts with Djoser's step pyramid. Yet, the arrangement of the parts of the complex follow Djoser's pattern while incorporating some of the Twelfth-dynasty features of pyramid complexes. The entrance passage on the west side is a marked change from previous pyramid entrances, which were located on the north side. A chapel located on the north side of the pyramid perhaps reflects the older tradition, as does a small temple located on the east side of the pyramid. Seven queen's pyramids remind the viewer of the nine queen's pyramids built by Senwosret I at his pyramid complex at Lisht. These more traditional structures were built early in the reign. Sometime later in the reign, Senwosret III added the south temple and a paneled enclosure wall with an entrance at the southeast corner. Though the large south temple was destroyed, perhaps sometime in the New Kingdom, enough decoration remains to suggest that it was the location of the Jubilee Festival (*sed*). Again, these elements recall Djoser's complex at Saqqara.

SENWOSRET III'S ABYDOS TOMB. Not only did Senwosret III revive architectural elements of Djoser's Third-dynasty pyramid complex, he also revived First- and Second-dynasty practice by building a tomb in Abydos, the traditional cult center for the god Osiris. The

a PRIMARY SOURCE *document*

HERODOTUS ON THE LABYRINTH

INTRODUCTION: Herodotus (484–430 B.C.E.), the fifth-century B.C.E. Greek historian, visited Egypt about 450 B.C.E. and wrote the earliest description of the country by a foreigner. His description of the Labyrinth is the earliest of six ancient Greek and Roman impressions recorded.

I saw it myself, and it is indeed a wonder past words; for if one were to collect together all the buildings of the Greeks and their most striking works of architecture, they would all clearly be shown to have cost less labor and money than this labyrinth. ... The pyramids, too, were greater than words could tell, and each of them is the equivalent of many of the great works of the Greeks; but the labyrinth surpasses the pyramids also. It has twelve roofed courts, with doors facing one another, six to the north and six to the south and in a continuous line. One wall on the outside encompasses them all. There are double sets of chambers in it, some underground and some above, and their number is three thou-

sand; there are fifteen hundred of each. We ourselves saw the aboveground chambers, for we went through them and so can talk of them, but the underground chambers we can speak of only from hearsay. For the officials of the Egyptians entirely refused to show us these, saying that there were, in them, the coffins of the kings who had built the labyrinth at the beginning and also those of the holy crocodiles. ... The passages through the rooms and the winding goings-in and out through the courts, in their extreme complication, caused us countless marvelings as we went through, from the court into the rooms, and from the rooms into the pillared corridors, and then from these corridors into other rooms again, and from the rooms into other courts afterwards. The roof of the whole is stone, as the walls are, and the walls are full of engraved figures, and each court is set round with pillars of white stone, very exactly fitted. At the corner where the labyrinth ends there is, nearby, a pyramid two hundred and forty feet high and engraved with great animals. The road to this is made underground.

SOURCE: Herodotus, *The History*. Trans. by David Grene (Chicago: University of Chicago Press, 1987): 196–197.

German archaeologist Dorthea Arnold suggested that his actual burial took place in the now-destroyed temple the king built in the south. If true, it would demonstrate that kings of the Twelfth Dynasty were ultimately more comfortable with older, Upper Egyptian customs than they were with the customs of the Old Kingdom kings who ruled in the Fourth through Sixth Dynasties. Senwosret III and his son Amenemhet III, in fact, bridge very ancient traditions with the future customs which return royal burials to Upper (southern) Egypt during the New Kingdom.

AMENEMHET III'S TWO PYRAMID COMPLEXES. Amenemhet III (1818–1772 B.C.E.) built a traditional, Old Kingdom pyramid complex at Dahshur in the first part of his 46-year reign. In the second part of his reign he built a second pyramid complex at Hawara, near the entrance to the Faiyum basin. This second pyramid complex followed the predominately north/south orientation first used by Djoser in the Third Dynasty. As the American archaeologist Mark Lehner observed, Amenemhet III was the last great pyramid builder, but he followed the design of Djoser, the first great pyramid builder, bringing the history of pyramid complexes in Egypt full circle. The pyramid that Amenemhet III built at Dahshur resembles only a tower of mud brick today. Originally, each side measured 105 meters (344 feet) with a height of 75 me-

ters (246 feet). Thus it resembled the pyramid of Senwosret I but slightly shorter. The pyramid had a mud brick core faced with Tura limestone. Two entrances—one from the east, one from the west—led into a complicated series of chambers and tunnels. The interior of this pyramid recalls Djoser's step pyramid more than any of the simple Old Kingdom interior structures. This pyramid has a ka-chapel, six other small chapels, and burial chambers for two queens. By the fifteenth year of the king's reign (1803 B.C.E.) some of the interior rooms began to collapse. According to Lehner, the foundation of the pyramid was too close to the groundwater, making the earth too soft to support the weight of the building. Also there were too many rooms inside the pyramid with unsupported roofs. It is likely that when the builders realized their mistake they quickly finished the rooms in mud brick. A new pyramid complex at Hawara eventually held Amenemhet III's burial. Amenemhet III's pyramid at Hawara was nearly the same size as his pyramid at Dahshur. Again the pyramid was 105 meters (344 feet) on each side. This pyramid was 58 meters (190 feet) tall, a full seventeen meters (56 feet) shorter than the Dahshur pyramid. Clearly the builders at Hawara reduced the angle of the pyramid—resulting in a lower height—in order to avoid the problems they had faced with the Dahshur pyramid. They also greatly reduced the number of interior chambers and tunnels. The burial chamber had only

a single entrance from the south, with the southern entrance recalling the general north/south orientation of the building, as was the design of Djoser's pyramid complex at Saqqara. In general Amenemhet III followed the pattern of Djoser's pyramid complex when he built at Hawara. The Hawara complex was 385 by 158 meters (1,263 by 518 feet) with the length oriented north/south. The pyramid temple was south of the pyramid, completely unlike the eastern pyramid temples found during the Old Kingdom. The entrance to the walled complex was at the southeast corner, again mirroring Djoser's choice at Saqqara. The pyramid temple was so vast that ancient Greek and Roman tourists called it the Labyrinth, comparing it to the legendary Labyrinth of Minos in Crete. Today Amenemhet III's building has almost entirely disappeared, the result of quarrying in later times. Only the descriptions left by the Greek and Roman authors Herodotus (484–430 B.C.E.), Manetho (third century B.C.E.), Diodorus Siculus (first century B.C.E.), Strabo (64 B.C.E.–19 C.E.), Pliny (23–79 C.E.), and Pomponius Mela (first century C.E.) allow modern scholars to analyze its meaning. Herodotus thought the Labyrinth surpassed the pyramids in the wonder it inspired. Herodotus, Diodorus Siculus, and Pliny all disagree on the number of rooms and courts in the building, but they all imply that each of the administrative districts of Egypt (nomes) and/or each of the regional gods had a courtyard and room within the Labyrinth. German archaeologist Dieter Arnold recognized that these authors were describing a very large version of Djoser's Jubilee Festival (sed) courtyard. Here too, each of the nome gods of Egypt was represented with its own small temple or chapel. Clearly Amenemhet III's pyramid temple represented this very ancient tradition of providing a Jubilee Festival courtyard where the king could celebrate in the next world.

DRAWING ON TRADITION. The kings of the Twelfth Dynasty drew on all of the previous traditions of pyramid building for their new structures. They were clearly aware of Djoser's pyramid complex in Saqqara, the standard Old Kingdom pyramid complex; Nebhepetre Mentuhotep's funerary temple; and even the most ancient royal burials at Abydos. Yet they seem to be unaware of the construction techniques practiced by their predecessors. Twelfth-dynasty builders continued to experiment, but never successfully built buildings as sturdy as those built in the Old Kingdom. Moreover, it is never entirely clear what they hoped to accomplish by imitating one ancient tradition after another. Without supporting textual evidence, it might never be possible to do more than recognize the references that each Twelfth-dynasty king made to the past.

SOURCES

Howard Carter, "Report on the Tomb of Mentuhotep I," *Annales du Service d'Antiquités Egyptien* 2 (1901): 201–205.

Mark Lehner, *The Complete Pyramids* (London: Thames and Hudson, 1997).

Rainer Stadelmann, *Die Ägyptischen Pyramiden: vom Ziegelbau zum Weltwunder* (Mainz am Rhein: P. von Zabern, 1985).

Miroslav Verner, *Die Pyramiden* (Reinbek bei Hamburg, Germany: Rowohlt Verlag, 1998).

SEE ALSO *Visual Arts: The Middle Kingdom*

ROCK-CUT TOMBS OF THE MIDDLE KINGDOM

LOCATION, PLANS, AND POLITICAL POWER. One indication of the central government's control over its officials in ancient Egypt was the location and plan of official's tombs. At times when the central government exercised strong control over the provinces, officials wanted to be buried near the king. This was clearly the case in the Old Kingdom when cities of the dead surrounded the pyramids. These Old Kingdom mastabas were gifts from the king to his top officials. In general their plans were similar since they were all built in the same place by the same people. In contrast, during the early Middle Kingdom, provincial officials preferred to locate their tombs in their home provinces. *Nomarchs,* the officials who ruled the 42 Egyptian provinces that Egyptologists call *nomes,* established their own cities of the dead that included many local officials. This tradition of local burial began in the First Intermediate Period (2130–2008 B.C.E.), a time when the absence of a central government caused the individual nomes to behave as independent entities. Even with the reestablishment of strong central government in the Twelfth Dynasty, nomarchs who lived during the first four reigns of the period (1938–1837 B.C.E.) preferred burial in their hometowns rather than in Itj-tawy, the national capital. Furthermore, in the Middle Kingdom, local variations in tomb plans were common. Local traditions, especially of rock-cut tombs, grew in Beni Hasan, Bersheh, and Asyut, among other places. Then in the reign of Senwosret III (1836–1818 B.C.E.), the burial of provincial officials returned to the area around the king's pyramid in relatively similar mastaba tombs. Egyptologists regard this change as evidence that the king had reasserted his authority over the provinces. A comparison of three

provincial tombs demonstrates how Egyptologists have analyzed this situation: the tomb of Amenemhet at Beni Hasan, the tomb of Djeheutyhotep at Bersheh, and the tomb of Hepdjefa I at Asyut—all built in the early Twelfth Dynasty.

THE TOMB OF AMENEMHET AT BENI HASAN. Beni Hasan in Middle Egypt is 23 miles south of the modern city of Minya on the east bank of the Nile. Eight of the 39 tombs excavated in the mountains belonged to a succession of men who held the title "Great Overlord of the Oryx Nome," the ancient name of Beni Hasan. Amenemhet was Great Overlord, or nomarch, during the reign of Senwosret I (1919–1875 B.C.E.). The pathway to his tomb led up the mountain from the cultivated plain in the river valley to a court cut directly into the bedrock of the mountain. The face of the mountain itself was smoothed to form a façade. The façade is supported by two columns, also cut from the mountain itself. The columns are octagonal and support an architrave, the series of beams that columns support. The architrave carries a cornice, a projecting moulding that imitates the ends of rafters made of wood, though carved in stone. The columns taper to the top and carry an abacus, a plain slab of stone balanced between the top of the columns and the bottom of the architrave, while standing on a wide base. The abacus helps to distribute the weight of the architrave over the column. The base also supports the column and spreads its weight on the floor. Though built more than 1,500 years earlier, the columns and architrave resemble classical Greek architecture. The visitor would then pass between the columns into a square room cut into the mountain. The roof of this room is supported by four columns, each with sixteen sides. The columns support two architraves that run from the front to the back of the room. The architraves appear to support three vaults. The vaults spring from the two sidewalls to the architraves on the two columns and another vault between the columns. The columns, architraves, and vaults all were carved from the stone of the mountain. Centered in the rear is a niche containing a statue of Amenemhet, also carved from the mountain itself. Paintings illustrating daily life in the Oryx nome and military training decorate the sidewalls.

THE TOMB OF DJEHEUTYHOTEP AT BERSHEH. Bersheh is on the east bank of the Nile opposite Mallawi, a modern town in central Egypt. In ancient times it was in the Hare Nome. Djeheutyhotep was the Great Overlord of the Hare Nome during the reigns of Amenemhet II through the time of Senwosret III (1844–1818 B.C.E.). His tomb reflects a local tradition of rock-cut tombs that

KHNUMHOTEP BUILDS HIMSELF A TOMB

INTRODUCTION: The Twelfth-dynasty monarch of the Oryx nome, modern Beni Hasan, Khnumhotep, left a long biographical inscription on the walls of his tomb. In the inscription he described the rebuilding of his father's tomb as his first act. He also described his pride in building a tomb for himself.

[On his father's tomb] I restored it and its riches in everything. I perpetuated the name of my father and I restored his ka-temple [i.e., his tomb]. I followed my statues to the temple. I presented to them their offerings of bread, beer, cool water, and wine, and meat offerings which were assigned to the ka-priest and I endowed him with fields and workers. I commanded invocation offerings of beef and fowl at every festival of the necropolis. ... Now as for any ka-priest or anyone who will disturb it, he can no longer exist! His son does not exist in his place! ... My chief dignity was the embellishing for myself of a tomb, that a man might imitate what his father did. My father had made for himself a ka-temple in Mernofret, made from stone of Anu, in order to perpetuate his name forever and that he might be distinguished forever, his name living in the mouth of the people and enduring in the mouth of the living, upon his tomb of the necropolis and in his splendid house of eternity and his place of eternity.

Translation by Edward Bleiberg.

began in the First Intermediate Period. The court of the tomb stood before a façade cut from the mountain. Two round columns carved at the top to imitate palm leaves supported the entrance to the tomb that is behind the columns and leads upward to a rectangular room. Against the middle of the rear wall are three steps leading up to a shrine that once held a statue. The painted walls depict scenes of daily life, including a famous painting of workmen dragging a colossal statue of Djeheutyhotep. The shape and numbers of columns, shapes of the rooms, and arrangement of the shrine differ from the contemporary tomb of Amenemhet at Beni Hasan, indicating that the two traditions of rock-cut tombs developed separately.

THE TOMB OF HEPDJEFA I AT ASYUT. Asyut is located on the west bank of the Nile at a bend in the river that flows east to west. In ancient times it was the capital of the Lycopolite Nome. The Great Overlords of

the Lycopolite Nome built their tombs in their hometowns from the end of the Sixth Dynasty until the middle of the Twelfth Dynasty. Hepdjefa I lived in the time of King Senwosret I and was also a contemporary of Amenemhet of Beni Hasan. Hepdjefa, who lived the farthest away from the seat of central power in Itj-tawy, built for himself the largest tomb known from the Middle Kingdom. It contains seven rooms cut into the mountain along a central axis. A wide passageway leads from a forecourt to a wide rectangular chamber. The rectangular chamber has three doors on the back wall. Two of the doors, located on the sides, lead to small rectangular rooms. The third door, located in the center of the back wall at the top of two steps, leads to another long hall that splits into a U-shaped room. Finally a smaller hallway located in the center of the "U" leads to a small square room. The front rooms contain inscriptions, notably the contract Hepdjefa made with his priests to continue his cult for eternity. The only scenes are in the back shrine. Here low reliefs depict scenes of sacrifice.

LOCAL TRADITIONS AND CENTRAL POWER. In the generations following these three nomarchs, high officials were once again buried around the king's pyramid. The tombs at a central location were once again uniform in plan. This contrast with the earlier period is very suggestive for historians. The plans and decorations at the tombs of Amenemhet, Djeheutyhotep and Hepdjefa I clearly developed independently. Amenemhet and Djeheutyhotep developed tombs with a small number of rooms. Amenemhet's tomb utilized a colonnade in the front and four columns in the interior room. Djeheutyhotep used only two columns in the front, but they were carved to resemble palms while Amenemhet's columns were carved with geometric facets. Hepdjefa's tomb was even more elaborate with seven rooms, but no columns at all. Decoration also differed. Amenemhet gave much space to depicting military training. Djeheutyhotep emphasized his colossal statue. Hepdjefa recorded an inscription. This variety, especially when it disappears in the reign of Senwosret III, suggests that the nomarchs were also much more independent politically. Thus architecture can be extremely informative about the political history of Egypt.

SOURCES

Alexander Badawy, *A History of Egyptian Architecture: The First Intermediate Period, the Middle Kingdom, and the Second Intermediate Period* (Berkeley: University of California Press, 1966).

A PLANNED TOWN OF THE MIDDLE KINGDOM: KAHUN

PYRAMID TOWN FOR SENWOSRET II'S CULT. In 1889 the English archaeologist W. M. F. Petrie, the founder of scientific archaeology in Egypt, excavated the pyramid town he called Kahun. The town was located just over one kilometer from the valley temple of Senwosret II's pyramid complex at Lahun. The Egyptians built the town to house the priests, administrative personnel, and workers who maintained the cult of Senwosret II at the pyramid after his death. The texts found here reveal that the town's name was originally *Hotep-Senwosret*, "Senwosret is Satisfied." The town's urban planning reveals the extent of social stratification in this period and the failure of planning to meet everyone's needs.

THE TOWN'S FUNCTION. Beyond proximity to the pyramid complex of Senwosret II, the texts found in the town reveal its function. One group of texts deals almost exclusively with the administration of the pyramid complex. A second group, which has never fully been published, deals with a wider circle of people. Some of the documents deal with places outside Kahun, even including construction at a project in the reign of Amenemhet III, 50-75 years after the town's founding.

DESCRIPTION OF THE TOWN. The town was square, roughly 384 meters by 335 meters. The streets run north/south and east/west in a grid pattern, aligned both with the cardinal points of the compass and the pyramid complex of Senwosret II. Such a grid pattern could only be the result of advance planning. One main street on the north side of the town runs east/west with ten large houses on it that Petrie called mansions. One of the mansions is located on the highest point in town, an area Petrie called the acropolis. On the west side of the town, closest to the pyramid complex, there were 220 small houses. The small houses were located on streets that ran east/west. Each of these streets ran into a wider north/south street that led to the gate nearest the valley temple. The town's plan clearly reveals two social classes living in separate quarters.

ELITE HOUSES. The large houses built for the elite were 2,520 square meters (27,125 square feet)—huge houses in any time or place. A staircase carved into the bedrock led from street level to the house on the acropolis. The house itself appears similar to the other large houses on the street, but Petrie believed this house belonged to the mayor because of its position. All the elite houses were rectangular in shape with internal divisions

that were also a series of rectangles. The archaeologist Barry Kemp has compared the house plans at Kahun with contemporary models of houses found in tombs. He found that the focus of the house was a central courtyard that often contained a pool and garden. The walls surrounding the court were plastered and painted in black, blue, yellow, and white. A portico at one end of the courtyard had wooden columns, also brightly painted. Even the flat roof of the portico was painted blue with gold stars on the underside. From the courtyard, it was easy to reach a reception room, the equivalent of an American living room. This room usually had four columns supporting the roof. Arranged around the reception room were bedrooms with built-in platforms for beds in alcoves. Arranged around the bedrooms were additional, smaller courtyards that allowed light and air into them. The house also had workrooms and granaries to store grain. The models show that these workrooms included a bakery, brewery, cattle shed, and butchering area. These houses provided a lot of space and privacy to the members of the elite class at Kahun.

SMALL HOUSES. The small houses contained about 120 square meters (1,291 square feet). According to the surviving texts, the people who lived there were manual laborers, soldiers, low-level scribes, doorkeepers for the temple, and singers and dancers of both sexes for the temple. The houses themselves have no regular plan, though they are all basically rectangular in outline and also in the internal divisions. The English archaeologist Barry Kemp suggests that the residents remodeled an original standard plan to suit each family's needs. A series of census documents for the town provides a glimpse of who lived in these houses and the function of these dwellings. The soldier Hori, his wife Shepset, and their son Sneferu originally occupied one house. At some point Shepset's mother and five sisters joined the household, raising the number of residents from three to nine. By the time Sneferu was an adult, his mother, grandmother, and three aunts lived in the house with him. This fluctuation shows the likelihood that the residents made internal adjustments to the plan to accommodate larger and smaller numbers of people living in them at different times.

SOURCES

Alexander Badawy, *A History of Egyptian Architecture: The First Intermediate Period, the Middle Kingdom, and the Second Intermediate Period* (Berkeley: University of California Press, 1966).

Barry Kemp, *Ancient Egypt: Anatomy of a Civilization* (London and New York: Routledge, 1989).

NEW KINGDOM TEMPLES

NEW KINGDOM. The New Kingdom (1539–1075 B.C.E.) was the period of Egypt's greatest geographical extent. At the end of the Middle Kingdom (about 1630 B.C.E.), a Semitic-speaking ethnic group ruled the eastern delta, closest to the Sinai Desert and the northern portion of Egypt. Whether a conquest or gradual infiltration of peoples, this group called the Hyksos (from the Egyptian term *heka-hasut*, meaning "rulers of foreign countries") ruled the northern portion of the country. The New Kingdom commenced when a series of princes who ruled in Thebes in Upper (southern) Egypt drove the Hyksos out of Egyptian territory. They eventually ruled a united Egypt and expanded their rule to Syria in the northwest and well into the modern Sudan in the south. Taxes coming from these regions made Egypt the richest country in the Mediterranean world at the time and led to increased investments in architecture.

CLASSIFICATION. Since the nineteenth century, Egyptologists have classified New Kingdom temples as either a cult temple for a god or a mortuary temple for the deceased king. The false perception of the god's temple as a place where the Egyptians celebrated a permanently established cult and the mortuary temples as a place to hold a funeral fostered this division. Egyptologists such as Gerhard Haeney, Dieter Arnold, and Alexander Badawy recognized that, from an Egyptian perspective, the so-called mortuary temple is a specific kind of permanent cult temple. In the mortuary temple, the deceased king is one of the minor gods worshipped in a cult primarily devoted to Amun, the chief god of the Egyptian pantheon during the New Kingdom. The cult continued in a mortuary temple long beyond the day of the king's funeral. The architectural plans for gods' temples and mortuary temples are very similar. The major difference between the two stems from the numerous additions kings made to gods' temples over long periods of time. While kings often added to gods' temples—obscuring their original plans—temples that included a deceased king's cult usually had no major additions. Thus in the following analysis of New Kingdom temples the royal mortuary temple will be treated as a specific kind of god's temple rather than a completely different sort of temple altogether.

TYPICAL GOD'S TEMPLE. A god's temple was his house, i.e. his dwelling place. The most common ancient Egyptian words for "temple" were *per* (house), or *hout* (mansion, estate). Beginning in the Eighteenth Dynasty (1539–1292 B.C.E.), temple architects developed a standard plan that resembled the three-part plans of ordinary

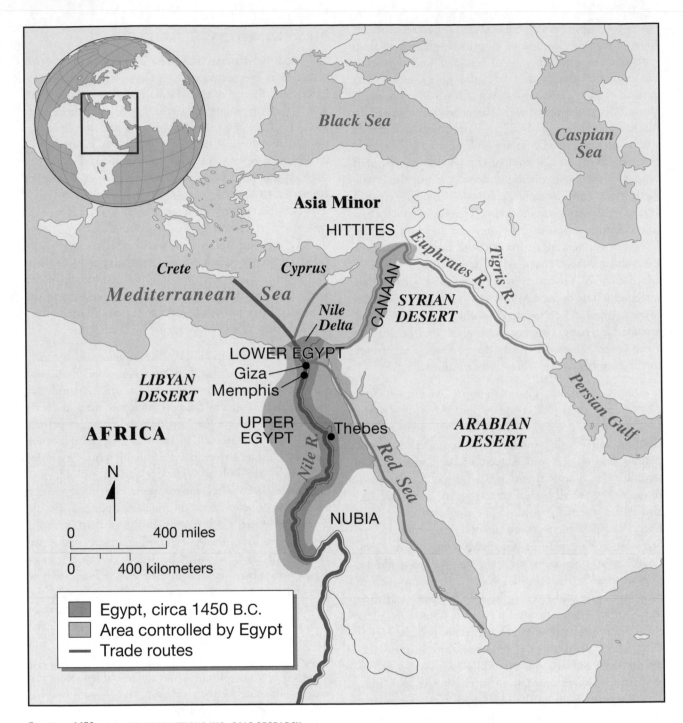

Egypt, c. 1450 B.C.E. XNR PRODUCTIONS INC. GALE RESEARCH.

houses and of royal palaces: the forecourt, the public room, and the private rooms. Multiple additions made to important temples like Amun's temple at Karnak often obscure the original plan. Thus the "standard plan" does not really refer to any one temple but to the necessary component parts, and is a useful tool for analyzing individual temples. The three parts of the standard temple plan are an open forecourt leading to a shrine called the *pronaos*, the public room known as the *hypostyle hall*, and the private rooms which in a temple are called the *naos* or shrine. The forecourt in a temple parallels the courtyard immediately beyond the gateway in an Egyptian house. The pronaos in a temple parallels the typical vestibule in a house, while the hypostyle hall is usually shaped as a broad hall, wider than it is long. These are parallel to similarly shaped public rooms in a house. The

Model of a temple. BROOKLYN MUSEUM OF ART, 49.183, CHARLES EDWIN WILBOUR FUND. REPRODUCED BY PERMISSION.

naos, or shrine, housed the statue of the god and parallels the private bedrooms belonging to the family in a typical Egyptian house. In a temple, the architect also emphasized the dramatic contrasts of light and dark between the public rooms and private rooms. In addition, the floor gently rose as a visitor proceeded from the entrance to the naos, creating a sense that the visitor ascended from the secular sphere outside the temple to the heavenly sphere of the god in the naos. A mud brick wall surrounding the entire temple, called the *temenos wall*, contributed to the sense of separation from the secular world inside the temple.

THE ENTRANCE TO A STANDARD TEMPLE. Egyptologists call the entrance to a standard temple the *pylon*. The pylon often stands at the end of a processional way lined with sphinxes. Often colossal statues of the king, both seated and standing, were positioned in front of the pylon. The pylon itself was divided into two towers and a lower, central doorway. The towers are rectangular with sloping sides. The ascending edges of the towers are decorated with torus—a semi-circular or three-quarter circular molding. The top edges of the towers are decorated with a cavetto cornice—a concave or hollow molding. Both types of molding suggest the origins of the pylon tower in the wood, mat, and reed structures built during the Predynastic Period. The tower was often several stories high and contained a staircase inside. The doorway itself was lower than the towers and decorated with a winged sun disk. The door was usually wood with occasional metal covering. The pylon was most often built of stone, though archaeological remains of mud brick pylons are known. Artists decorated pylons with scenes of the king protecting Egypt from its

Arts and Humanities Through the Eras: Ancient Egypt (2675 B.C.E.–332 B.C.E.)

47

enemies. Cedar flagpoles were positioned in front of the pylon, often in niches cut into the tower structure. These flagpoles were taller than the pylon tower and supported banners that identified the temple. In Egyptian the pylon was called the *bekhen*. Egyptian texts describe the pylon as the "luminous mountain horizon of heaven." The shape of the pylon resembles the hieroglyph that depicts two mountain peaks with the sun rising between them. The sun in the case of the temple pylon is the god striding out of the temple doorway. This symbolism was particularly appropriate for deities associated with the sun such as Amun, Re, and Atum, though the entrances to all temples took the form of pylons.

THE FORECOURT IN THE STANDARD TEMPLE PLAN.

The forecourt—known in Egyptian as *weba*—stands immediately behind the pylon in the standard temple plan. It was normally rectangular, the same width as the hypostyle hall behind it. In some temples the forecourt contains an altar for offerings. Rows of columns support a roof for a portico running on four sides of the forecourt. A ramp in the center of the back wall leads the visitor into the hypostyle hall. The forecourt was part of the public area where the common people observed the procession of the god, a major part of temple ritual. There also the people could see relief scenes carved on the sidewalls that depict the king in both historical and religious activities. Historical activities might include leading the army to victory, while religious scenes showed the king worshipping the gods. The sunny central court served to set up the contrast between dark and light as the visitor proceeded through the dark gateway into the light of the courtyard.

THE HYPOSTYLE HALL IN THE STANDARD TEMPLE.

Egyptologists gave the Egyptian *wadjit* the name "hypostyle hall." This name is a Greek word meaning "full of columns" since it contains many more columns than is needed to support the roof. The hypostyle hall is wider than it is long. The central axis of the building passes through its middle aisle. At least in the Ramesside Period (1292–1075 B.C.E.), the columns along the central aisle are taller than the columns on the sides of the building. This allows for a roof that is higher in the center than on the sides. The gap between the roof resting on the taller columns and the roof resting on the shorter columns, covered by a stone grill, allowed diffused light to enter the building. This arrangement is called a *clerestory*. The internal decoration of the hypostyle hall depicts the king making offerings to various gods. In some hypostyle halls there were divisions among the "hall of appearance," "hall of offering," and "intermediate hall." These names suggest but do not entirely explain the use of the hypostyle hall. The "appearance" of the god was a ritual where certain people could see the god's statue. The offerings were the opportunity to feed the god.

THE SANCTUARY IN THE STANDARD TEMPLE PLAN.

Just as the back rooms of an Egyptian house were the private family rooms, the back of an Egyptian temple is the sanctuary (*naos*)—the private rooms where the god sleeps, dresses, and washes. The god, in this case, was a statue, often made from precious metal. Only the high priests entered this room to assist the god in his daily routine. In some cases the private rooms also included a storage area for the god's *barque,* a boat that priests used to transport the god in procession. Often there were multiple sanctuaries in a temple to accommodate the worship of multiple gods in one temple.

PURIFICATION FACILITIES.

Temples often included a "pure court" used to slaughter animals for sacrifice and an artificial lake where the priests washed. In some rituals the lake was also used for the god's ritual voyages. The lakes were sometimes shaped like a "U" that enclosed part of the temple or were rectangular.

TEMPLE ORIENTATION IN THE NEW KINGDOM.

The determination of temple orientation is much more complex in the New Kingdom than in the Old and Middle Kingdoms. Old and Middle Kingdom temples' orientation falls into two groups. The so-called Djoser type favored a north/south axis. The Meidum type favored an east/west axis. Research conducted by Alexander Badawy, the Egyptian Egyptologist, shows that New Kingdom temples' orientation stemmed from their relationship to the Nile River or the local canal that led from the Nile to the temple entrance. The temple axis seems always to have been perpendicular to the Nile or the canal. Thus temples' orientation seems to shift from place to place with the meanders of the river. This is the reason that archaeologists refer to "local north," when describing a particular building, a concept that corresponds with the direction that the river flows downstream.

SOURCES

Alexander Badawy, *A History of Egyptian Architecture: The Empire (the New Kingdom)* (Berkeley: University of California Press, 1968).

Richard H. Wilkinson, *The Complete Temples of Egypt* (London: Thames and Hudson Ltd., 2000).

SEE ALSO *Religion: Temple Architecture and Symbolism*

THEBES AND THE ESTATE OF AMUN

NAME AND LOCATION OF THEBES. Thebes, located on the east and west banks of the Nile River around modern Luxor, was known as *Waset* in Egyptian, capital of the fourth Upper Egyptian nome (province). The Greeks called it Thebes, identifying it with one of their own cities after they conquered Egypt in the fourth century B.C.E. Some scholars believe that the name Thebes was a Greek pronunciation of Egyptian *ta-ipet*, meaning "The Harem," that Egyptians used to describe the Luxor temple. In addition to the Luxor temple, the Karnak temple, the temple of Medinet Habu, and the temple of Hatshepsut at Deir el Bahri form the major monuments that scholars have identified as the Estate of Amun during the New Kingdom. Each of them played an important role in the major festivals of the god Amun, chief of the Egyptian pantheon.

KARNAK TEMPLE: AMUN'S HOME. The Karnak temple was the god Amun's home. It is the largest Egyptian temple ever built. It stands inside an enclosure wall that surrounds 16,000 square meters (172,222 square feet). Scholars have worked to excavate and record Karnak since the late nineteenth century and still have not nearly completed this task. The kings of the Twelfth Dynasty built the first structure on the site, but the present plan originates in the Eighteenth-dynasty remodeling of the site. At this time the government evacuated and leveled the whole town surrounding Karnak to provide a platform for the new temple. Essentially the plan established a temple perpendicular to the river with an axis that ran east/west. The kings of the Eighteenth, Nineteenth and Twentieth Dynasties continued to expand the temple, adding a north/south axis. In total there are ten pylons at Karnak, reflecting the numerous additions to the building continuing into the second century C.E. Within the temple complex are precincts dedicated to the god's wife, Mut, and their son, Khonsu. There are also smaller chapels dedicated to Egypt's other important gods, including Montu, the war god; Osiris, king of the dead; and Ptah, the chief god of Egypt's northern capital, Memphis. The mass of the people went to the eastern gate of the temple where the shrine of "Amun of the Hearing Ear" allowed ordinary people to approach the god with requests. Royal statues in the temple and at least two festival temples dedicated to the royal ancestors emphasized the connection between Amun and the king. Egyptian religion was clearly part of Egyptian politics. North of the main temple was an additional temple dedicated to the war-god, Montu. South of the main structures was the Tem-

a PRIMARY SOURCE *document*

PRAISE OF THEBES

INTRODUCTION: The following anonymously written text, composed during the Nineteenth Dynasty (1292–1190 B.C.E.), illustrates Egyptian thinking about towns. It is preserved on a papyrus now in the Royal Museum of Antiquities in Leiden, The Netherlands.

Thebes is the pattern for every city. Both water and earth were within her from the beginning of time. There came the sands to furnish land, to create her ground as a mound when the earth came into being. And so mankind also came into being within her, with the propose of founding every city in her proper name. For all are called "City" after the example of Thebes.

SOURCE: Charles F. Nims, *Thebes of the Pharaohs: Pattern for Every City* (London: Elek Books, 1965): 69. Text revised by Edward Bleiberg.

ple of Mut, the mother goddess. Though the temple as a whole was dedicated to the chief god of the Egyptian pantheon, Amun (also called Amun-Re), one of the most important buildings in it was the "Festival Hall of Thutmose III." At the entrance to the building stand four colossal statues of Thutmose III dressed and posed as the god Osiris. These statues established for the ancient viewer the connection between the temple and the office of king. Osiris was the first king of Egypt, according to Egyptian myth. When he died, his son Horus became rightful king while Osiris became king of the dead. All living kings of Egypt identified themselves as Horus while the deceased king was Osiris. Inside this limestone building, the columns resembled the poles of a military tent, recalling Thutmose III's numerous military expeditions. Recalling these expeditions also emphasized the king's role as Egypt's protector. The decoration of the interior also established the king's role as ruler of the universe. Relief sculpture includes a series of scenes depicting the underworld god Sokar, the solar god Re, the procreative form of the god Amun, the Jubilee Festival called *sed*, and the king's ancestors. Re and Sokar associated the king with all that is above and below the earth. The procreative Amun helped the king assure the fertility of the earth. The Jubilee Festival—perhaps the most ancient of all Egyptian festivals as was demonstrated in the architectural layout of the Step Pyramid complex at Saqqara—renewed the king's power in a

Arts and Humanities Through the Eras: Ancient Egypt (2675 B.C.E.–332 B.C.E.)

49

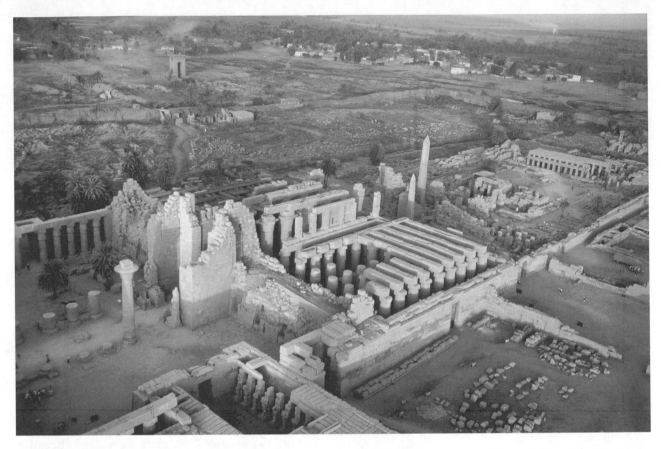

Aerial view of Great Temple of Amun in Karnak. © YANN ARTHUS-BERTRAND/CORBIS.

perpetual cycle. Finally, the king's ancestors helped to establish him as the "correct" Horus in a succession of Osiris and Horus who ruled the underworld and Egypt throughout eternity. This building, along with another festival hall built by Amenhotep II but now destroyed, shows the close connection between worship of Amun at this temple and the legitimacy of the king.

PROCESSIONS AND PROCESSIONAL WAYS. The four major temples of the Estate of Amun—Karnak, Luxor, Medinet Habu, and Deir el Bahri—were linked in ancient times by processional ways and axis alignments designed for the celebration of processional festivals. A processional way is a road, permanently decorated for use in a formal parade. Axis alignment refers to the practice of building two distant structures on the same axis so that one imaginary straight line would pass through the center of both buildings. One processional way ran from Karnak to Luxor, about three kilometers (1.86 miles) both on the east bank of the river. Karnak's east/west axis was aligned with Deir el Bahri's east/west axis across the river. Luxor and Medinet Habu were also aligned with each other across the river. The main festivals celebrated at these temples featured the god's pro-

cession from Karnak to Luxor (Feast of Opet), from Luxor to Medinet Habu (Feast of Amunemopet), and from Karnak to Deir el Bahri (Feast of the Valley). The stone-paved processional routes passed through a series of pylons in Karnak. Lines of sphinxes stood on both sides of the street. Along the way were small, formal shrines that provided a place for the priests carrying the god's barque, a ceremonial boat, to rest on a stone pedestal. The route from Karnak led south to Khonsu's temple, Mut's temple, and to the Luxor temple. The most important of these processional festivals was the Feast of Opet.

FEAST OF OPET. The Feast of Opet took place annually in late August during the New Kingdom. On the Egyptian calendar this was the second month of the season of inundation when the Nile flooded. In the reign of Hatshepsut the festival lasted eleven days, but by the time of Ramesses III it lasted 27 days. In Hatshepsut's time the festival procession proceeded along the north/south axis of the temple, exited the south gate, and followed the processional way to the Luxor temple. The priests paused six times at stations where they could support the barque on a stand in a sacred booth. Amun's

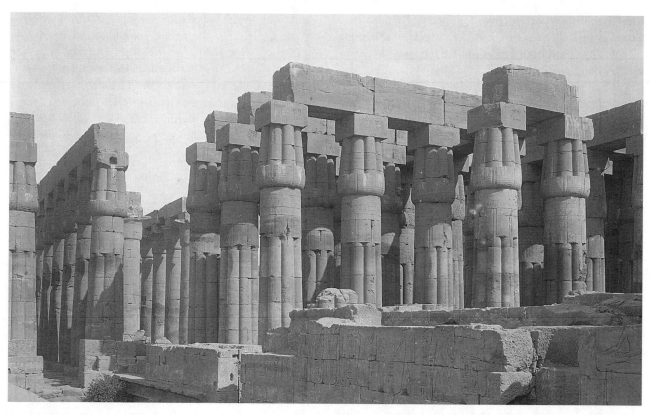

The columned court of the temple of Luxor. © BETTMANN/CORBIS.

barque was accompanied by soldiers, dancers, and singers who provided part of the spectacle of the procession. In Ramesses III's time the temples distributed to the people 11,341 loaves of bread, 85 cakes, and 385 jars of beer during each day of the festival. During Hatshepsut's reign the procession returned to Karnak from Luxor by water, sailing on the Nile.

LUXOR TEMPLE: WOMEN'S QUARTERS OF AMUN'S ESTATE. The present Luxor temple, built by Amenhotep III and expanded by Rameses II, represented the women's quarters in Amun's estate. The Egyptians called it *ta-ipet,* "the harem." During the Opet Festival, the Egyptians celebrated the divine birth of the king at this location. This divine birth provided a religious explanation for how the king could be both a human and the genetic son of the god Amun. The Egyptians visualized the genetic relationship literally, as attested in reliefs from both Deir el Bahri and the Luxor temple. They believed that the spirit of Amun inhabited the king's human father at the moment of conception, an act ritually re-created in the Luxor temple by the king with a living woman, probably the queen, annually during the Opet Festival. Moreover, the act of conception, in Egyptian thought, conveyed a spirit called the royal ka into the

fetus of the unborn king. Amun created the royal ka as part of his essence that gave the child possessing the royal ka a legitimate right to rule Egypt. The festival also re-infused the royal ka in the living king. This festival was the main purpose of the inner rooms of the Luxor temple. The king was part of the god's procession from Karnak to Luxor. The king then entered the inner rooms at the temple and mystically re-enacted both his own conception and his rejuvenation by absorbing the royal ka. Perhaps the best illustration of the way this helped the king is found in King Horemheb's coronation at Luxor. Horemheb was the second general to become king at the end of the Eighteenth Dynasty after the last royal heir, Tutankhamun, died. Horemheb merged his coronation with the Festival of Opet, infusing his originally non-royal self with the royal ka, and thus becoming the legitimate king.

LINKING EAST AND WEST THEBES. In general, Amun's living quarters were on the east bank of the Nile at Thebes. On the west bank of the river, associated with the land of the dead, lived other forms of Amun inhabited by the spirits of deceased kings. All of the Eighteenth-dynasty kings built temples on the west bank that Egyptologists have called mortuary temples. In reality

these temples were residences for forms of Amun that would eventually merge with each of the deceased kings. The two most important locations for these temples were Deir el Bahri and Medinet Habu. Deir el Bahri was the site of the Eleventh-dynasty temple of Nebhepetre Mentuhotep and of Hatshepsut. Medinet Habu was the site of Ramesses III's mortuary temple built in the Twentieth Dynasty, but was also recognized as the location of a mound where the gods had created the earth. The Festival of the Valley connected Karnak and Deir el Bahri. The Festival of Amunemopet connected Luxor and Medinet Habu with a procession between them.

DEIR EL BAHRI AND THE FEAST OF THE VALLEY.
Nebhepetre Mentuhotep built the first mortuary temple in Deir el Bahri in the Eleventh Dynasty, but in the Eighteenth Dynasty the more important temple was the mortuary temple constructed by Hatshepsut. This unique building, based on Nebhepetre Mentuhotep's neighboring structure, consisted of three terraces connected by two ramps. On the two lower levels are colonnades opposite walls illustrating important events from Hatshepsut's reign. These relief sculptures include the hauling of obelisks from Aswan for the Karnak temple, Hatshepsut's divine birth, and the expedition to Punt (probably in Ethiopia) to bring back incense for Amun. This terrace also holds shrines for Hathor, the goddess of the necropolis, and for Anubis, the god of mummification. The third and highest terrace supported a temple for Amun and for Hatshepsut. This temple was the focus of Amun's annual trip from Karnak to Deir el Bahri to celebrate the Festival of the Valley. During the Festival of the Valley, Amun, his wife Mut, and their son Khonsu visited the deceased kings of Egypt and his incarnation living in Deir el Bahri called Amun Holy of Holies. The images of the gods were ferried across the river in a special barque and then carried from the west bank of the river to the temple. After the reign of Hatshepsut, the statues spent the night in the temple of the reigning king. The procession returned to Karnak the next day. On this occasion many Egyptian families also visited their family tomb, often having a meal there.

MEDINET HABU AND THE FESTIVAL OF AMUNEMOPET. Ramesses III built the large temple at Medinet Habu that stands on the site today for himself as Amun-United-with-Eternity. Earlier in the time of Thutmose III, there was a temple of the "True Mound of the West" on this site. The mound refers to the place where the god first created the world. By linking the mound to the west, the intention is to affirm that this first creation would continue in the west, the land of the dead. The god Amunemopet, meaning "Amun who is in the Opet" (i.e. the Luxor temple), traveled weekly from the Luxor temple to Medinet Habu to visit the mound temple. This is the final link between the temples of the east and west bank. The statue of the god traveled by barque across the river, then either by a canal or on a road to the Medinet Habu temple. This feast also called for distributions of food and drink to the population.

THE PROCESSIONAL PERIMETER OF THE ESTATE OF AMUN. The processional routes from Karnak to Luxor, from Karnak to Deir el Bahri with detours to the temples associated with various kings' cults, and from Luxor to Medinet Habu form a rectangle on the map that delineates the Estate of Amun. The festivals and their processions tie together the major monuments of Thebes and allow for a unitary overview of the sacred places. The individual buildings, however, also functioned as independent units. They each owned and administered land that ultimately provided the upkeep for each building. There seems to be no administrative or economic connection between the different religious units of the Estate of Amun. This fact points to a certain decentralization in the New Kingdom in administration which is not apparent in other periods of Egyptian history.

SOURCES

B. J. J. Haring, *Divine Households: Administrative and Economic Aspects of the New Kingdom Royal Memorial Temples in Western Thebes* (Leiden, Netherlands: Nederlands Instituut voor het Nabije Oosten, 1997).

Barry Kemp, *Ancient Egypt: Anatomy of a Civilization* (London; New York: Routledge, 1989).

EGYPTIAN CONSTRUCTION TECHNOLOGY

QUARRYING AND TRANSPORTING STONE. The ancient Egyptians are widely recognized as great engineers, but are also thought to be extremely conservative. There is a real contradiction in these two views. Part of the Egyptians' greatness included the ability to improvise solutions to technical problems. Innovations allowed the Egyptians to develop new quarrying tools and to increase the weight of stones they hauled over time. Large numbers of people had to be involved in quarrying and transporting stone, which was a dangerous endeavor. The description of a quarrying expedition in the inscription of Amenemhet from the reign of Men-

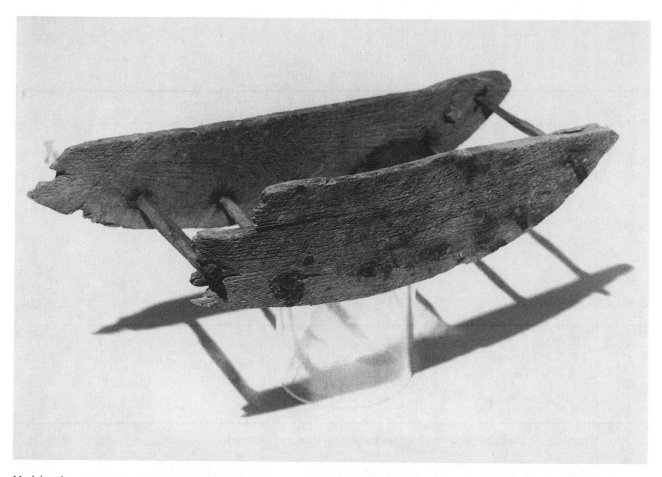

Model rocker. BROOKLYN MUSEUM OF ART, 02.226, GIFT OF THE EGYPT EXPLORATION FUND. REPRODUCED BY PERMISSION.

tuhotep III emphasizes this reality in that the leader counts among his major accomplishments the fact that the entire crew returned safely to Egypt. This success is associated with miracles, but clearly the Egyptians' careful study of the technical side of quarrying should receive much of the credit. For example, the Egyptians developed methods for quarrying both hard and soft stones.

CHISELS AND AXES. There was a development in tools during the roughly 2,300 years from the Old Kingdom (2675–2170 B.C.E.) to the Ptolemaic Period (332–30 B.C.E.) as is evident in the different marks the chisels or axes left in different time periods. In the earlier period—the Old and Middle Kingdom—the marks are irregular lines that all curve in one direction. Rosemarie Klemm, a German geologist who extensively studied ancient Egyptian quarries, suggested that these lines are compatible with the soft copper chisels discovered by archaeologists in Egypt, but Dieter Arnold, the German archaeologist, posited that these lines were more likely the marks of stone axes or picks. Early in the New King-

dom the lines left by tools in quarries are longer than those lines made during the Old and Middle Kingdoms. These New Kingdom lines also alternate in direction in a type of herringbone pattern, unlike the earlier lines which all curve in the same direction. R. Klemm suggested these patterns match the harder bronze chisels which had already been in use in Egypt for other purposes since the Middle Kingdom (2008–1630 B.C.E.). Arnold again refuted Klemm's chisel theory and attributed the marks to stone picks or axes. In Ramesside times and later (1292–1075 B.C.E.), the lines left by the tools changed yet again, this time as closely set together lines, longer than the marks made in previous times but again all curving in the same direction. These lines suggested to Arnold the use of a pick-like instrument made of stone since the only bronze chisel in use during this time period was shaped like a bar. Marks that match the bar chisel are commonly found in rock-cut tombs; apparently the builders used the tool to cut a tunnel that they formed into a tomb, rather than to cut blocks for building. Arnold's suggestion would mean that only the tunneling tool is currently known from archaeological

Arts and Humanities Through the Eras: Ancient Egypt (2675 B.C.E.–332 B.C.E.)

53

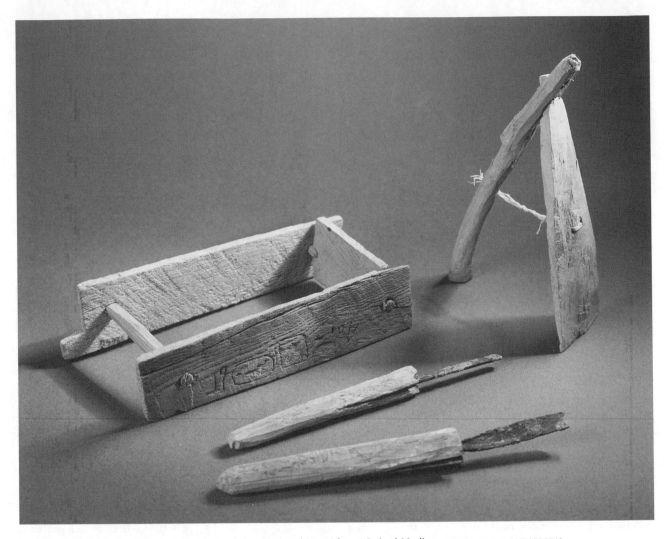

Wooden tools from the 18th-dynasty tomb of the royal architect Kha at Deir el-Medina. GIANNI DAGLI ORTI/CORBIS.

examples. The stone axe or pick that Arnold suggested as a quarrying tool has not yet been recognized in the archaeological record.

TRANSPORTING BUILDING MATERIALS. The Egyptians transported stone through both human and animal power. A basic understanding of physics and balance allowed Egyptian workmen to lift and lower heavy loads using, in different periods, pulleys, wedges, ramps, and construction roads. The use of the shaduf in the Ramesside Period to raise water demonstrates that the Egyptians understood the basic physics of lifting heavy weights. Measuring from the beginning of Egyptian history through the New Kingdom, engineers moved increasingly larger stone loads through innovation. Many Egyptian relief sculptures depict men carrying sand, gravel, mud, bricks, timber, and even small stones over long distances from their source near the river to construction sites. Men carried bricks or single small blocks

of stone on their shoulders or in slings attached to poles. In the tomb of Rekhmire (reign of Thutmose III, 1479–1425 B.C.E.) drawings depict workmen hauling three bricks on each side in carrying slings. Groups of men also carried bricks and stones in handbarrows with handles on four sides. The oldest known handbarrow dates to Dynasty 3 (2675–2625 B.C.E.). Donkeys still haul building materials in Egypt in the early twenty-first century, carrying up to 100 kilograms (220 pounds) for short distances.

HEAVY LOADS. The Egyptians moved extremely heavy weights beginning as early as the reign of Khufu (2585–2560 B.C.E.) in the Old Kingdom. Some of the heaviest blocks moved by the Egyptians include stones from the Great Pyramid weighing up to sixty tons and spanning as much as eight meters (26 feet) in width. By the reign of Ramesses II (1279–1213 B.C.E.) the Egyptians regularly moved colossal statues weighing up to

a PRIMARY SOURCE *document*

A QUARRY INSCRIPTION FROM THE MIDDLE KINGDOM

INTRODUCTION: Opening a quarry was an official event often commemorated with steles at the quarry. Leaders of quarrying expeditions were high officials who proudly left records of their accomplishments in long inscriptions. Amenemhet, one such official, led an expedition to the Wadi Hammamat during the reign of Mentuhotep III in 1957 B.C.E. and left the following record. Because he shares a name with the next king, Amenemhet I, many scholars have identified him with the first king of Dynasty 12. The section head within was not resident in the original document.

Year two, month two of the Inundation season, Day fifteen of the Horus Nebtawy, the Two Ladies, Nebtawy, the Horus of Gold, the King of Upper and Lower Egypt, Nebtawyre, the Son of Re, Mentuhotep, living forever. His Majesty commanded the erection of this stela for his father, (the god) Min, the Lord of the Hill Country in this noble, primeval mountain. (Min is) one who is foremost of place in the land of the Horizon Dwellers and the palace of the god. (He is) one who offers life in the sacred nest of Horus with which this god is content. (This mountain) is his pure place of enjoyment which is over the hill countries and god's country in order that his (Min's) soul might be satisfied. (Min is) one who is honored by gods, that being what the king who is on the Great Throne does. (The king) is one who is foremost of thrones and one who is enduring of monuments, a beneficent god, the lord of joy, one who is greatly feared and one who is great in love, one who is heir of Horus in his Two Lands, one whom Isis—the divine mother of Min and one great of magic—had reared for the kingship of Horus of the Two Banks, the king of Upper and Lower Egypt, living like Re forever. (He) says: I caused that Amenemhet—a nobleman, mayor, vizier, and one whom the king trusts—go forth together with an expedition of ten thousand men from the southern nomes of Upper Egypt and the frontier of Oxyrhynchus in order to bring to me a noble, costly, and pure stone which is in this mountain—whose excellence Min made—to be a sarcophagus, an eternal remembrance that will be a monument in the temples of Upper Egypt. (I sent him) just as a king sends the chief of the Two Lands in order to bring to him his desire from the hill country of Father Min. He made it as a monument for his father Min of Coptus, the lord of the hill country and chief of the tribesmen that he might make many great offerings, living like Re forever.

Day 27. The cover of this sarcophagus descended, a block of four cubits by eight cubits by two cubits (2.10 x 4.20 x 1.05 meters; 6.8 x 16.5 x 3.4 feet), that being what came form from the work. Three calves were slaughtered and goats were slaughtered and incense was burned. Now an expedition of three thousand sailors from the nomes of Lower Egypt followed it in peace to Egypt.

The Same Expedition: The Commander's Record

Nebtawyre, living forever, Regnal Year Two, Month Two of Inundation, Day Fifteen: A royal mission which the noble, count, mayor, vizier, judge, King's-confidant, Overseer of Works, Great One in his Office, Great One in his Nobility, Foremost one of Place in the House of His lord, Inspector of Magistrates, Chief of the Six Great Ones, Judge of Nobles and Commoners, Judge of Sun Folk, One to Whom the Great Ones Come Bowing and the Whole Land is Prone, One Whose Lord Promoted his Rank, One Who Enters His (the king's) Heart, Overseer of the Door of Upper Egypt, One Who Controlled for Him Millions of Commoners in order to do for him his heart's desire concerning his monuments which endure on earth, Great One of the King of Upper Egypt, Great One of the King of Lower Egypt, Controller of the Mansions of the Crown of Lower Egypt, Priest of Herakleopolis being the One who Stretches the Cord, One who Judges Without Partiality, Overseer of all Upper Egypt, One to Whom Everything is Reported, One Who Controls the Affairs of the Lord of the Two Lands, One Who Sets his Heart on a Royal Commission, Inspector of Inspectors, Controller of Overseers, Vizier of Horus in His Appearance, Amenemhet says: My Lord—may he live, prosper, be healthy—the King of Upper and Lower Egypt Nebtawyre sent me as a god sends his (own) limb in order to establish his monuments in this land. He chose me in front of his town while I was honored before his entourage. Now then, His Majesty commanded a procession to this noble foreign country, an expedition together with the best men of the whole land—stone masons, craftsmen, stone cutters, carvers, outline scribes, metal workers, goldsmiths, treasurers of the Palace of every department of the treasury, every rank of the palace being gathered under my control. I made the hill country as a river, the high valley as a water way. I brought a sarcophagus—an eternal remembrance, enduring forever—to him. Never did anything like it descend from the hill country since the time of the gods. The expedition returned without a loss, no man perished. The troops did not turn back. A donkey did not die. There was no deficiency of the craftsmen. I brought it about for the Majesty of the Lord as a Spirit, while Min acted for him, in as much as he loved him. And that his soul might endure on the Great Throne in the Kingship of Horus. What he did was a greater thing. I am his servant of his heart, one who did all which he praises every day.

Translated by Edward Bleiberg.

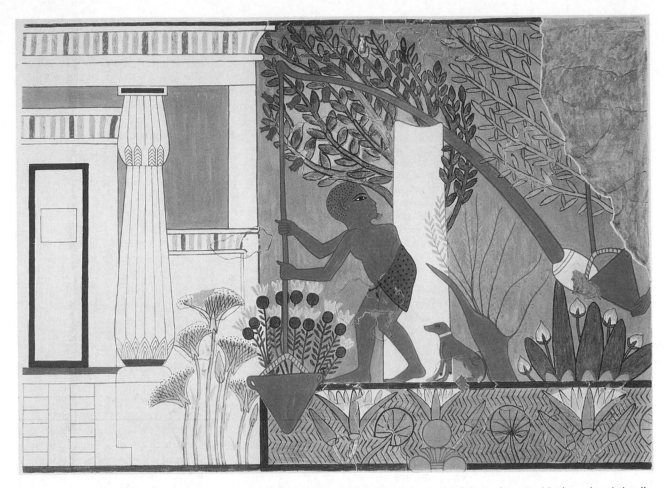

This painting of The Watering of Plants in a Garden with Help of a Shaduf from the tomb of the sculptor Ipui is the only existing illustration showing the use of this lever. BILDARCHIV PRESUSSICHER KULTURBESITZ/ART RESOURCE NY.

1,000 tons. In almost every period of Egyptian history, there is ample evidence that engineers devised methods of moving massive stones long distances. The gradual increase in the weight of construction-use stones from Khufu's time to Ramesses II's time suggests that Egyptian engineers continued to improve their methods for moving stone. Thus in the Middle Kingdom the engineers of Senwosret I (1919–1875 B.C.E.) and Amenemhet III (1818–1772 B.C.E.) devised methods of moving blocks twice as large as Khufu's Great Pyramid blocks. The kings of the early Eighteenth Dynasty (1539–1400 B.C.E.) moved blocks three times heavier than the blocks moved in the Middle Kingdom. Amenhotep III's (1390–1352 B.C.E.) engineers doubled the weight of construction-use blocks yet again over the earlier Eighteenth Dynasty, only to be topped by Ramesses II's engineers, who moved blocks thirty percent larger than those moved at the end of Dynasty Eighteen. Ramesses II's reign seems to mark the end of these gains. Yet kings of the Late Period such as Psamtik II (595–589

B.C.E.) and Amasis (570–526 B.C.E.) moved large-scale monuments weighing as much as 580 tons. The Roman historian Pliny (23–79 C.E.) provided the best description of the transporting of an ancient Egyptian obelisk. According to Pliny, workmen dug a canal from the river to the resting spot of the obelisk, actually tunneling under the obelisk, allowing the ends of it to rest on either bank of the canal. Two vessels traveled up the canal loaded with blocks of stone double the weight of the obelisk, causing the boats to submerge slightly. They then stopped under the obelisk and removed the stones from the boats. Free from the weight of the stones, the boats rose in the water until the obelisk balanced between them. Though long-distance hauling of heavy loads was primarily by boat, transportation from the quarry to the boat and from the boat to the building site forced the Egyptians to develop methods for overland hauling of heavy loads. A relief sculpture in the tomb of Djeheutyhotep dating to Dynasty Twelve (1938–1759 B.C.E.) at Bersheh in Middle Egypt depicts the Egyp-

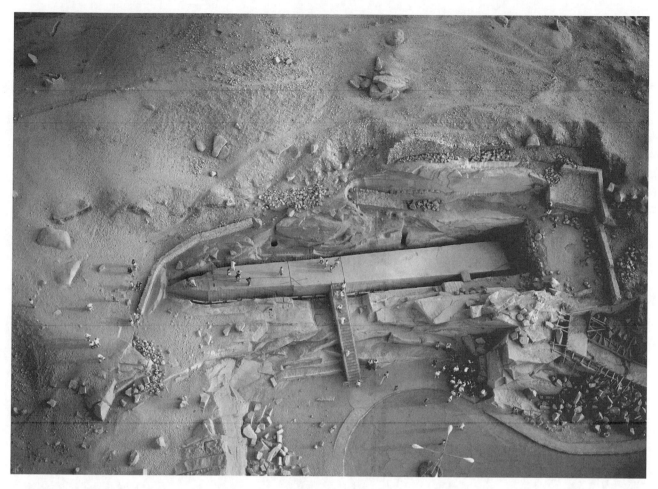

A 42-meter long unfinished obelisk still in the granite quarry at Aswan. © YANN ARTHUS-BERTRAND/CORBIS.

tians using rollers on skid poles and sledges as tools to enable very large numbers of men to pull the block or statue by ropes fastened around the stone. Liquid poured on the sand or on a construction road made the surface more slippery and allowed the sledge to move more easily.

ROLLERS ON SKID POLES. Egyptian rollers were made from sycamore, a locally grown tree. The archaeological examples that have been excavated are short, with rounded ends and approximately ten centimeters (3.9 inches) wide. The rollers work best on skid poles—a track made of parallel beams. The skid poles keep the rollers moving in the right direction. Such skid poles have been found at the entrances to pyramid corridors where builders used them to roll the closing block into position. For very heavy loads such as obelisks, whole tree trunks were used as rollers.

SLEDGES. Sledges are known both from archaeological examples and from relief sculptures that show

sledges transporting heavy stone columns and more frequently, funerary goods such as shrines and coffins. Of the examples of sledges found in archaeological contexts, the largest was found near the pyramid of Senwosret III at Dahshur. It is 4.2 meters long and 0.9 meters wide (13.7 by 2.95 feet). The runners are twelve by twenty centimeters (4.7 by 7.8 inches). Four cross beams connect the runners using tongue and groove construction to join them. In tongue and groove construction, all the beams have slotted holes where ropes were attached. A smaller sledge from the time of Senwosret I (1919–1875 B.C.E.), found at Lisht, measures 1.73 by 0.78 meters (5.6 by 2.5 feet). It only has two cross beams but also additional round poles mounted in front of one cross beam and behind the other cross beam. These poles were probably used to attach ropes. The relief representations of sledges show them transporting stone statues, coffins, canopic boxes, and shrines used in tombs. The scene from the causeway of Unas shows sledges transporting granite columns and architraves. These columns are known to be six meters (19.6 feet) long. Thus it seems

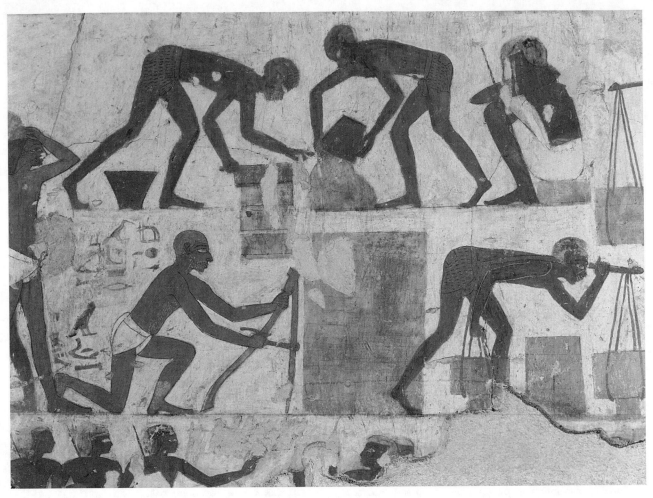

Builders making mud brick and constructing a wall. Painting from the tomb of Rekhmire, vizier under Thutmose III and Amenhotep II, Valley of the Nobles at Qurna, 18th Dynasty. THE ART ARCHIVE/DAGLI ORTI.

likely that they were transported on sledges at least seven meters (22.9 feet) long. The most famous transport scene depicts a colossal alabaster statue of Djeheutyhotep on a sledge hauled by 172 men. The men are depicted in four different registers (divisions of the scene by a series of parallel lines), suggesting that they were divided into four columns of workers. Arnold estimated that the statue was seven meters (22.9 feet) high and weighed 58 tons. Another scene from the reign of Ahmose shows three bulls hauling a block that weighed about five tons on a sledge. Finally a scene depicting the transport of Hatshepsut's 320-ton obelisk found at her temple in Deir el Bahri shows a sledge that must have been 31 meters (101.7 feet) long, probably constructed from whole tree trunks. A sledge could not carry a heavy load over a soft surface such as sand, so the Egyptians prepared paths with limestone chip surfaces, possibly covered with mud. Many representations of sledges show a man pouring water on the road surface in front of the sledge. Henri Chevrier, the French archaeologist, conducted experiments on using an Egyptian sledge in modern times and showed that six men easily moved a 4.8-ton stone over a wet mud surface.

ROPES. Ropes were essential for almost all construction operations, particularly for hauling stone blocks. Egyptian ropes were made of dom palmfibers, reed, flax grass, sparto grass, halfa grass, or papyrus. The largest archaeological examples of ropes were 20.3 centimeters in circumference and 6.35 centimeters in diameter (7.9 by 2.5 inches). Literary evidence suggests that ropes of 525 to 735 meters (1,722 to 2,411 feet) were manufactured in special cases to move especially heavy loads.

SOURCES

Dieter Arnold, *Building in Egypt: Pharaonic Stone Masonry* (New York: Oxford University Press, 1991).

Mark Lehner, *The Complete Pyramids* (New York: Thames and Hudson, 1997).

the first stage of the Luxor temple, and the king's mortuary temple in western Thebes, the largest ever built. After his death, Amenhotep son of Hapu was deified and considered a healing god.

SOURCES

William J. Murnane, "Power Behind the Throne: Amenhotep son of Hapu," *KMT: A Modern Journal of Ancient Egypt* 22 (Summer, 1991): 8–13.

Dietrich Wildung, *Egyptian Saints: Deification in Pharaonic Egypt* (New York: New York University Press, 1977).

HEMIUNU, SON OF NEFERMAAT

fl. Fourth Dynasty (2625–2500 B.C.E.)

Priest
Architect

ROYAL CONNECTIONS. Hemiunu was the son of Nefermaat, a son of King Sneferu. He was thus grandson of one king and nephew of King Khufu, patron of the Great Pyramid at Giza. As a member of the royal family he reached many high offices. The list of his achievements is recorded on his statue, currently located in Hildesheim, Germany. They include,

> Member of the elite, high official, vizier, king's seal bearer, attendant of Nekhen, and spokesman of every resident of Pe, priest of Bastet, priest of Shesmetet, priest of the Ram of Mendes, Keeper of the Apis Bull, Keeper of the White Bull, whom his lord loves, elder of the palace, high priest of Thoth, whom his lord loves, courtier, Overseer of Royal Scribes, priest of the Panther Goddess, Director of Music of the South and North, Overseer of All Construction Projects of the King, king's [grand-]son of his own body …

The last title listed, and perhaps the most important title he held, allows Egyptologists to determine that he was the architect and construction supervisor for the Great Pyramid and of all the mastaba tombs located at Giza. His own large mastaba tomb and magnificent statues suggest the extent of the rewards King Khufu gave Hemiunu in return for this work. As is true with so many other important individuals who lived in ancient Egypt, little detail of his life can be added.

SOURCES

Marsha Hill, "Hemiunu Seated," in *Egyptian Art in the Age of the Pyramids* (New York: Harry N. Abrams, Inc., 1999): 229–231.

PLINY'S DESCRIPTION OF LOADING AN OBELISK ON A SHIP

INTRODUCTION: The Egyptians left no descriptions of the way they moved heavy pieces of stone. The best evidence of Egyptian methods comes from the Roman author Pliny the Elder who visited Egypt in the first century C.E. and observed the following.

… a canal brought the waters of the Nile right up to the place where the obelisk lay. Two very broad ships were loaded with cubes of the same granite as that of the obelisk, each cube measuring one foot, until calculations showed that the total weight of the blocks was double that of the obelisk, since their total cubic capacity was twice as great. In this way, the ships were able to come beneath the obelisk, which was suspended by its ends from both banks of the canal. Then the blocks were unloaded and the ships, riding high, took the weight of the obelisk.

SOURCE: Pliny, *Natural History.* Vol. X. Trans. D. E. Eichholz (Cambridge, Mass.: Harvard University Press, 1962): 56.

SIGNIFICANT PEOPLE
in Architecture and Design

AMENHOTEP, SON OF HAPU

Late in the reign of Thutmose III (1479–1425 B.C.E.–Early in the reign of Tutankhamun (1332–1322 B.C.E.)

Scribe
Chief of the King's Works

COMMONER TO COURTIER. Amenhotep son of Hapu was born in the Nile delta late in the reign of Thutmose III. His father, Hapu, was a commoner. Amenhotep's first known official position was royal scribe. He was thus an embodiment of the Egyptian belief that education was the key to moving up in society. Eventually, he became Chief of All the King's Works in the reign of Amenhotep III (1390–1352 B.C.E.). In this position he supervised enormous building projects. These projects included additions at the Karnak temple,

Arts and Humanities Through the Eras: Ancient Egypt (2675 B.C.E.–332 B.C.E.)

59

Hermann Junker, "Giza I: Die Mastabas der IV. Dynastie auf dem Westfriedhof" *Denkschrift der Kaiserlichen Akademie der Wissenschaften* 69 (1929): 153–157.

IMHOTEP

fl. Dynasty 3 (2675–2625 B.C.E.)

High Priest of Heliopolis
Architect

ARCHITECT AND PRIEST. Little is recorded of Imhotep's personal life. Even the date of his birth and death remain unknown, though he lived during the Third-dynasty reign of King Djoser (2675–2654 B.C.E.). He certainly reached the highest stratum of society, acting as both High Priest of Re at Heliopolis and the architect for King Djoser's Step Pyramid Complex at Saqqara. Even these facts come from much later sources. According to Manetho, the third-century B.C.E. historian, Imhotep built the first stone building—the Step Pyramid complex. The inscription that mentions his name on a statue of Djoser confirms his high position. The next information about Imhotep after the statue inscription comes 1,000 years later from a papyrus now in the Turin Museum, which calls Imhotep a patron of scribes. In addition, he was already described as son of the god Ptah, the god of the capital city, Memphis. After 664 B.C.E., Egyptians made numerous bronze statuettes of Imhotep. They described him as a teacher, physician, and god. The Greek rulers of Egypt after 332 B.C.E. associated Imhotep with Asclepius, the Greek god of medicine.

SOURCES

Erik Hornung, *Conceptions of God in Ancient Egypt* (Ithica, N.Y.: Cornell University Press, 1982).

Dietrich Wildung, *Egyptian Saints: Deification in Pharaonic Egypt* (New York: New York University Press, 1977).

INENI

Late Dynasty 17 (1630–1539 B.C.E.)–Early Dynasty 18 (1539–1425 B.C.E.)

High Government Official
Superintendent of Royal Buildings

VARIED RESPONSIBILITIES. Ineni held important offices in the administration of Egypt beginning with the reign of King Amenhotep I (1514–1493 B.C.E.) and ending in the reign of Thutmose III (1479–1425 B.C.E.). He held the titles Superintendent of the Granaries, Superintendent of Workmen in the Karnak Treasuries, Superintendent of the Royal Buildings, and Mayor of Thebes. His career probably stretched from late in Amenhotep I's reign to early in Thutmose III's reign, a period encompassing over twenty years. He was active in overseeing the excavation of the first tomb in the Valley of the Kings, belonging to Thutmose I (1493–1481 B.C.E.). He must also have been involved in building Hatshepsut's temple in Deir el Bahri, though the architect for that tomb was Senenmut, a younger colleague. Ineni's own tomb was badly destroyed in antiquity. His autobiography carved on the wall and his statues were all defaced, perhaps by enemies. The most unusual feature of his tomb is the prevalence of trees both in paintings and lists. Over 394 sycamore, acacia, and palm trees of different varieties were painted and listed in hieroglyphs in the tomb, a feature unknown in other tombs.

SOURCES

Nathalie Baum, *Arbres et arbustes de l'Egypte ancienne: la liste de la tombe thébaine d'Ineni (no. 81)* (Leuven, Belgium: Departement Orientalistiek, 1988).

Eberhard Dziobeck, *Das Grab des Ineni: Theben Nr. 181* (Mainz am Rhein, Germany: P. von Zabern, 1992).

SENENMUT, SON OF RAMOSE

fl. early Dynasty 18 (reign of Hatshepsut, 1478–1458 B.C.E.)

Government Official
Architect

FROM COMMONER TO THE ROYAL HOUSEHOLD. Senenmut was probably born in Armant, a town north of modern Luxor. His parents, Ramose and Hatnofer, were commoners, so it is unclear how Senenmut joined the upper administration. He may first have achieved recognition as a scribe since he became tutor to the royal princess Neferura during the reign of Thutmose II (1481–1479 B.C.E.). By the end of this reign he served as steward of estates both for the princess and her mother, Queen Hatshepsut. His connection with Hatshepsut clearly led to his prominence. When Hatshepsut began to perform the functions normally performed by a male king on the death of her husband (1478–1458 B.C.E.), Senenmut first served as leader of a quarrying expedition to bring obelisks back to the temple at Karnak. He also achieved increasingly higher offices at the chief god Amun's temple. One of his 25 statues names him as architect at Hatshepsut's mortuary temple at Deir el Bahri.

SOURCES

Peter Dorman, *The Monuments of Senenmut: Problems in Historical Methodology* (London: Kegan Paul International, 1988).

——, *The Tombs of Senenmut: The Architecture and Decoration of Tombs 71 and 353* (New York: Metropolitan Museum of Art Egyptian Expedition, 1991).

SETY I

Late Dynasty 18 (1316? B.C.E.–1279 B.C.E.)

King
Patron of Architecture

PERSONAL LIFE. Sety I was the second king of Dynasty 19. He ruled from 1290 B.C.E. to 1279 B.C.E. His father was Ramesses I, the founder of the dynasty. His son was Ramesses II, who was even more famous than his father as a builder. Sety's reign is important to the history of Egyptian architecture, however, because the model of the Heliopolis temple gateway that he commissioned is the only surviving architectural model from ancient Egypt.

DESCRIPTION OF THE MODEL. The model is a large rectangular block of reddish-brown quartzite. The dimensions of the base are 28 by 87.5 by 112 centimeters (11 by 34 by 44 inches). The top of the base is cut back to create a platform for the temple. Ten steps lead up to the platform. The top of the model was carved with ten recesses that originally contained the elements that represented the building and statuary in front of the building. Three sides of the model are carved with scenes of Sety I and inscriptions that describe the king making offerings to the Egyptian sun gods named Atum and Horakhty. The king is represented twice on the front and three times each on the sides of the model. The inscriptions also reveal that the recesses originally held models of the pylons, doors, flagstaffs and obelisks of the holy of holies of Atum's temple, probably at Heliopolis, but possibly another temple of Atum at Tell el Yeudiah, the spot where the model was discovered about 1880. The inscriptions also describe the materials used to make the elements of the model. The pylon was white crystalline limestone. The doors were described as bronze, but were probably wood overlaid with bronze. The flagstaffs were *mesdet*-stone, but usually real flagstaffs were made from cedar trees. The model obelisks were carved from greywacke, a highly prized Egyptian stone that was quarried in the Wadi Hammamat. Actual obelisks were carved from red granite, as is Sety's actual obelisk from Heliopolis now located in Rome. The shapes of the recesses make clear where each of the elements would have been set. There are also additional recesses in the model that are not described in the inscriptions but can easily be reconstructed from knowledge of actual Egyptian temples. The long recesses behind the pylon towers held the walls of the building. The square recesses in front of the tower held standing statues of Sety I. The four remaining recesses shaped like rectangles with one short side replaced by an arc accommodate the shape of a sphinx. There are recesses to hold four sphinxes that here represent the processional way of the temple, commonly decorated in actual temples with long rows of sphinxes. The temple is approached by a stairway. This arrangement is known in temples from Amarna which predate the model by fifty to seventy years. The stairs suggest that the temple was built on a hill, just as the temple at Heliopolis was. This hill was called the "High Sand" and represented the first hill to emerge from the water at the beginning of time. On this hill the god Atum created the world, according to Egyptian belief.

PURPOSE OF THE MODEL. The precious materials used to create this model suggest that its purpose was not as an architect's model, but may have been part of a religious ritual called "To Present the House to Its Lord." This ritual is the last in a series of five rituals that the Egyptian king performed to dedicate a new building. The rituals included "Stretching the Cord" (surveying the site), Spraying Natron (purification of the site), Cutting a Trench (digging the foundation), Striking a Brick (taking the first mud brick from its mould), and finally when the building was complete, Presenting the House to Its Lord. Such models are represented in reliefs of this ritual at Esna, Edfu, and at Kawa.

SOURCES

Alexander Badawy, *A Monumental Gateway of King Sety I* (New York: Brooklyn Museum, 1972).

Peter Brand, *Monuments of Seti I* (Leiden, Netherlands: Brill, 1999).

DOCUMENTARY
SOURCES
in Architecture and Design

Amenemhet (King Amenemhet I?), *Quarry Inscriptions* (c. 1957 B.C.E.)—This series of inscriptions found in the Wadi Hammamat in the Eastern Desert of Egypt recounts a successful expedition to quarry a sarcophagus for King Mentuhotep III. The Amenemhet who wrote it probably was the next king of Egypt.

Anonymous, *Praise of Thebes* (c. 1292–1190 B.C.E.)—This poem, preserved on a papyrus in the Royal Museum of Antiquities, Leiden, The Netherlands, describes the splendors of the New Kingdom capital.

Anonymous, *Pyramid Texts* (reign of Unas, c. 2371–2350 B.C.E.)—These ritual speeches, carved inside pyramids beginning in the reign of Unas, helped the deceased king unify with the sun god, his father, according to Egyptian religious belief.

Hemiunu, *Great Pyramid of Khufu*—Largest and best known pyramid, built in the Fourth Dynasty.

Herodotus, *The Histories* (c. 440 B.C.E.)—The first book of history by the Greek "Father of History" describes major monuments he saw in Egypt. Though often fanciful, it remains a valuable source for information on Egyptian monuments now in ruins.

Imhotep, *Step Pyramid of Djoser*—First preserved stone monument in ancient Egypt.

Khnumhotep, *Autobiography of Khnumhotep* (c. 1857 B.C.E.)—This autobiography describes Khnumhotep's activities restoring his father's tomb and building a tomb for himself.

Pliny the Elder, *Natural History* (c. 77 C.E.)—This Roman writer described the geography of Egypt, including wonders of architecture and building techniques he observed while visiting in the first century.

Senenmut, *Temple of Hatshepsut*—Part of the Estate of Amun, on the west bank of Thebes, opposite modern Luxor. The terraced temple was a major achievement of Egyptian architecture.

Shepsi, son of Inherhenmet, *Letters to the Dead* (Old Kingdom, c. 2675–2170 B.C.E.)—These letters deposited in tombs illustrate the Egyptian belief that the dead participated actively in the life of the living and the tomb was the place the living and dead could meet.

Temple of Amun at Karnak—Largest and most important temple for the chief deity of the New Kingdom, located in the Estate of Amun on the east bank at Thebes (modern Luxor). The temple includes over 200 acres of buildings built from the Middle Kingdom to the Ptolemaic Period.

chapter two

DANCE

Edward Bleiberg

IMPORTANT EVENTS
in Dance

All dates in this chronology are approximations (c.) and occur before the common era (B.C.E.).

3500–3300 Statuettes and paintings on pots buried in graves represent dancers performing a funeral dance, the earliest known representations of such dances. Ostriches are depicted dancing in the desert.

2500–2170 More Old Kingdom tombs include scenes of dance. Tombs of the high officials Ti and Kagemni include scenes of dancing monkeys.

2415–2371 Traders bring an African pygmy to dance in Egypt in the reign of Djedkare Isesy.

2371–2350 First example of Pyramid Text 310 which priests recite or sing during the *muu*-dance at the beginning of a funeral.

2350–2170 The funeral priest Khnumhotep describes dancing the *heby*-dance in an inscription on his statue.

2350–2338 Princess Watetkhethor commissions artists to decorate one entire wall of her tomb with the funeral dance, including details of its execution.

2338–2298 The Pyramid Texts carved in Pepy I's pyramid include the liturgy for the king to perform the "Dance of the God" while imitating a pygmy.

2286 The boy king, Pepi II, sends a royal decree to his expedition leader, Harkhuf, thanking him for the gift of a dancing pygmy.

1844–1837 A list written on papyrus enumerates twelve dancers' names and the many festivals where they perform.

1539–1075 Artists regularly depict dancers in scenes of funerary banquets.

1539–1514 A hymn dedicated to King Ahmose refers to ostriches dancing in the desert.

1352–1336 Dancing ostriches are depicted in King Akhenaten's tomb.

945–712 Horihotep serves as chief dancer of the goddess Bastet, a little-known title that suggests increased interest in dancing as part of divine worship.

381–343 Pawenhatef dances the *heby*-dance for the cult of the Apis bull.

OVERVIEW
of Dance

DEFINITION. Dance, at its most basic, is rhythmic body movement, often performed to music. In modern society dance can be an art form, recreation, or religious expression. Professional dancers entertain through ballet, modern dance, tap, and a variety of other art forms, while non-professionals dance at celebrations such as weddings or for fun at discos and clubs. In ancient Egypt, however, dance mostly served a ritual purpose at funerals or in ceremonies for the gods and was limited to professional dancers. One papyrus from the reign of King Senwosret II (1844–1837 B.C.E.) listed monthly dance performances incorporated into the New Moon, Half Moon and Full Moon festivals. Dancers performed annually at the Night of Welcoming the Flood Festival when the Nile rose; the Festival of the Five Days Between the Years during the New Year Festival; the Festival of Sokar, the sun god; the Festival of Hathor, the goddess of music, dance, and love; and many other festivals. The common scenes of dancers performing at banquets in New Kingdom tombs were probably also religious rituals, though the banquets initially appear to be social occasions with the dancers apparently entertaining the guests. Egyptians viewed social dancing, however, with suspicion. In one Late Period text, for example, "dancing in the desert" is synonymous with laziness. Non-professional dancing was virtually unknown in ancient Egyptian society.

SOURCES. Scholars depend on scenes carved on tomb and temple walls to learn about Egyptian dance. A few ancient texts refer directly to dance, but the most useful texts for this study are the captions in tomb illustrations of dances and the liturgy recited during funerals. Both of these sources present difficulties in interpretation, however. Egyptian artists followed conventions for representing motion which differ greatly from the perspective drawings used in Western society since the Renaissance. Moreover, artists often chose a few characteristic poses to illustrate a dance, omitting important links between steps, because they only intended to represent enough of the dance to make it magically effective for the tomb owner. They never intended these illustrations to be used as a manual for learning the dances. All dance in Egypt seems to be programmatic, always representing or symbolizing something beyond the gestures of the dance itself, although scholars cannot always decipher the dance's meaning. Yet the purpose and meaning of the dance and the accompanying captions must have been clear to most Egyptians.

DANCERS. Most dancers were professionals who were members of the *khener*—an organization that could be a bureau in an institution or could function independently as a troupe. Institutional kheners were attached to temples, tombs, towns, and royal or other wealthy households. In some cases, the sons and daughters of the deceased performed the ritual dances at funerals. Dwarfs, or more likely pygmies, performed certain dances called the Dance of the God. They also performed with the khener during funerals. The Egyptians also represented animals such as monkeys and ostriches dancing.

SEGREGATED DANCING. Depictions of dance show that men and women danced separately. Either a male or female couple performed the couples funeral dance called *tjeref.* Since the dancers impersonated the deceased in this dance, male tomb owners depicted male tjeref-dancers in their tombs while female tomb owners showed female tjeref-dancers in their tombs. Men performed another funeral dance called the *muu*-dance for both men and women because the muu-dancers represented ferrymen who guided the funeral processions of both men and women. Women generally performed the dance called *iba*, also part of the funeral ritual. Men acted as muu-dancers for deceased men and women acted as muu-dancers for deceased women. The dances thus were closely linked to the dancer's gender.

MUSIC. Dancers performed funeral dances and cult dances for the gods accompanied by percussion. The most common percussion "instrument" was hand clapping, and musicians used specially carved wooden clappers to increase the volume of this sound. Musicians also played the *sistrum* and the *menat*—two different kinds of ritual rattles—during the cult dances performed before the gods. Dancers at banquets sometimes accompanied themselves on the lute or danced to the harp. Women performed with woodwinds on very rare occasions at funeral banquets depicted in New Kingdom tombs.

COSTUMES. Dancers often wore specialized costumes, jewelry, and headgear tailored to a specific dance.

The muu-dancers, for example, wore a hat that never appeared in other contexts. Female dancers sometimes wore a ponytail weighted at the end with a ceramic disk or ball. Young male and female dancers often performed nude or wearing only a belt around the hips. Adult dancers wore fewer clothes than most Egyptians, though in some cases dancers wore "street clothes." In any case, Egyptians in general felt comfortable with minimal clothing.

IMPORTANCE. The Egyptians integrated dance into many aspects of their religious observance. At times, dance, as ambiguous as its meaning might be to modern observers, is the only evidence for certain religious beliefs in the earlier periods of Egyptian history. Scholars have historically underrated dance's importance in Egyptian culture.

TOPICS
in Dance

PRECONCEPTIONS ABOUT DANCE

EARLIER MISUNDERSTANDINGS. Nineteenth-century Egyptologists hindered accurate interpretations of ancient Egyptian dance by imposing their own value systems on the evidence. The lack of clothing in Egyptian dance caused scholars to think of Egyptian dance as lewd, and thus they turned to more seemly subjects for study. These scholars also mistranslated the word "khener"—an Egyptian word meaning "musical bureau"—as "harem." They assumed that there was a connection between the word for musical bureau and the word for women's quarters (harem) because of the similarity of the hieroglyphic writing of the two different words. This misconception added to scholars' difficulties in dealing with Egyptian dance. Moreover, Western scholars did not make an immediate connection between dance and religious ritual because Western culture does not generally maintain the tradition of sacred dance that was common to biblical religion. The absence of dance in the church, synagogue, or mosque traditions found in the West made scholars tentative in accepting dance as integral to ancient Egyptian culture.

RECENT SCHOLARSHIP. Recently scholars have recognized the important role dance played in Egyptian funerals and cult ritual. They note, for example, that the ancient text called "The Wisdom of Any" ranks dance along with food, clothing, and incense as essential to divine worship. Some scholars have now studied different words for dance in ancient Egyptian and recorded dance

a PRIMARY SOURCE *document*

THE WISEMAN ANY ON DANCE

INTRODUCTION: Egyptologists have given the name "wisdom texts" to a genre of Egyptian texts that dispense advice and explain the nature of the world. The "Wisdom of Any" was written in the late New Kingdom and touches on many aspects of life. In this passage Any discusses man's relationship to the gods, which includes a mention of the importance of song and dance to the gods.

Observe the feast of your god,
And repeat its season,
God is angry if it is neglected. ...

It will extol the might of the god.
Song, dance, incense are his foods,
Receiving prostrations is his wealth;
The god does it to magnify his name.

SOURCE: "Ani," in *The New Kingdom*. Vol. 2 of *Ancient Egyptian Literature*. Trans. Miriam Lichtheim (Berkeley and Los Angeles: University of California Press, 1976): 136.

scenes in tombs and temples. Additional data, along with less prudish attitudes toward dance, will eventually result in a better understanding of this phenomenon.

SOURCES

Janice M. Cummings, "Temple Dance in Ancient Egypt." Unpublished master's thesis (New York: New York University, 2000).

Jonathan van Lepp, "The Dance Scene of Watetkhethor. " Unpublished master's thesis (Los Angeles: University of California at Los Angeles, 1987).

Magda Saleh, in *International Encyclopedia of Dance* (New York: Oxford University Press, 1998): 482–483.

DANCE IN VISUAL ART

DRAWN FIGURES. The great majority of the evidence for dance in ancient Egypt comes from visual art. As early as the Nagada II Period (3500–3300 B.C.E.), sculptures and paintings on pots represented dancers. In the Fifth and Sixth Dynasties (2500–2170 B.C.E.), relief sculpture in mastaba tombs included scenes of dance. The artists who decorated many New Kingdom Theban tombs (1539–1075 B.C.E.) included dancers in banquet scenes. When artists represented dancers, the rules, or canon, of Egyptian art used to depict the tomb owner and his or

Dancers and musicians. Painted limestone relief from the Tomb of Nenkhefetka in Saqqara, 5th Dynasty. © SCALA/ART RESOURCE, NY.

her family did not apply for the following reason. The canon for artistic representation was in place because the deceased and his or her family needed to be depicted in a very specific way in order to activate the magic that transported them to the next world. Dancers depicted in the tomb, however, were not being transported to the next world, and so could be represented more freely in drawings than the deceased. Thus, there is a great difference between representations of dancers in the act of performing and the canonical representation of the human form. The canonical Egyptian representation of a human in two dimensions requires the head in profile with the eye represented frontally, as if the viewer saw the whole head from the side but the eye from the front. The artists depicted the shoulders from the front, but the figure seems to twist at the waist so that the legs and feet are again in profile. Additionally, artists used hieratic scale, meaning that size indicated importance rather than the visual reality of the relative size of human beings. In the canon, finally, there was little use of overlap and no simulation of visual depth

as practiced in most of Western art. These rules, if observed, would have made representations of dance impossible since the rules exclude motion and emphasize timelessness. Thus artists experimented with a number of techniques to represent dancers in the act of performing.

REPRESENTING DANCERS. Dancers could be represented differently from the tomb owner and his or her family because the dancers were not the figures whose eternal life was guaranteed through this tomb. Thus artists represented dancers in a manner closer to true profile than the figures allowable under the official canon. They also developed methods for showing dancers beside, in front of, and behind each other using overlap. Often, artists elongated arms to allow them to reach to the other side of a group of partners.

CHOOSING POSES. Artists also chose characteristic poses in order to represent a dance. Wall space limited the number of steps and figures that artists could include from one dance. For example, in the relatively small tomb

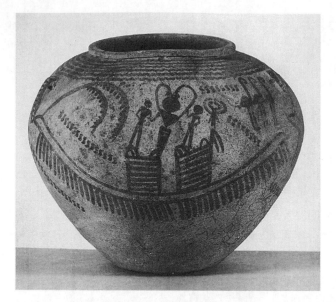

Jar with river scene. BROOKLYN MUSEUM OF ART, 09.889.400, CHARLES EDWIN WILBOUR FUND. REPRODUCED BY PERMISSION.

Pear-shaped pot with flamingo decoration, showing the flamingo dance. BROOKLYN MUSEUM OF ART, 07.447.402, CHARLES EDWIN WILBOUR FUND. REPRODUCED BY PERMISSION.

of Iy-mery, six dancing figures represent parts of the same dance that artists portrayed with 31 figures in the very large tomb of Watetkhethor. Iy-mery's artists had much less wall space, so they found ways to condense and abbreviate the action. Watetkhethor's very large tomb accommodated a more detailed portrayal of the dance. During the Fifth and Sixth Dynasties, artists first represented these characteristic movements from each dance in the order they were executed. This technique was the beginning of narrative in Egyptian visual art.

TEXTUAL SOURCES. The Egyptians left inscriptions in relief scenes and the texts of funeral liturgies that further explain the meaning and significance of dance. The captions that sculptors carved in relief scenes are extremely abbreviated. Often only two- or three-word sentence fragments stood for a whole sentence that was part of a well-known song. Unfortunately, modern scholars cannot always make sense of these highly abbreviated inscriptions. Sometimes, though, scholars have connected the words in the captions to fuller texts in the liturgy of the Pyramid Texts, carved in the royal pyramids of King Unas and the kings of the Sixth Dynasty, and Coffin Texts, the rituals written on the inside of many Middle Kingdom coffins. These two sets of spells recited during a funeral often can illuminate both the captions and thus the meaning and significance of dance steps or even entire dances.

SOURCES

Emma Brunner-Traut, *Der Tanz in alten Ägyptischen nach bildlichen und inschriflichen Zeugnissen* (Glückstadt, Germany: J. J. Augustin, 1938).

Jonathan Van Lepp, "The Dance Scene of Watetkhethor." Unpublished master's thesis (Los Angeles: University of California at Los Angeles, 1987).

COSTUMES AND FASHION IN DANCE

CLOTHING. During the Old Kingdom, women normally wore long dresses with straps over the shoulders. The hems of such dresses hung just above the ankles. Dancers wore this costume while performing the mirror dance in the tomb of the prime minister, Mereruka. Singers and clappers accompanying dances also often wore this costume in scenes of all periods. However, the Old Kingdom dress fit snugly and obstructed free movement. This garment could only accommodate dances performed with short steps that avoided raising the legs. During more vigorous dances, female performers wore a short kilt cut at an angle in the front. A belt often hung down from the waist. This belt was long enough so that its movement would accentuate the dancer's movements. The Old Kingdom dress continued in popularity for everyday wear and for singers during the Middle Kingdom, but dancers mostly wore the short kilt, probably because Middle Kingdom dances were more lively and athletic than Old Kingdom dances. During the New Kingdom, the typical woman's dress added a cloak with either broad or narrow sleeves. The dress under the cloak often included a belt. Both the cloak and the dress were often pleated. Dancers wore both the narrow- and broad-

sleeved cloak sometimes wearing a belt over the cloak. Many New Kingdom female dancers wore only a belt, performing in the nude. The Egyptians exhibited few inhibitions about displaying the female body. Since a funeral reenacted the steps leading to re-birth, the Egyptians regarded funerals, in part, as containing erotic elements that would lead to conception and birth into the afterlife. Children were also depicted as dancing nude. Most representations of pre-pubescent boys and girls in all situations reveal a lack of clothing. Girls often danced wearing a belt to emphasize the movement of the hips, just as modern Middle-Eastern dancers tie scarves around their hips. Egyptians felt no embarrassment at young children dancing, playing, or living with minimal clothing. Most Egyptian men wore kilts as their normal "street clothes" as well as for dancing. Sometimes men added a belt with a suspended panel to the front of the kilt. The belt sometimes also had fringes attached. These elements would have emphasized their movements by enlarging them. Men's costumes for dance exhibit little change over long stretches of time.

HAIRSTYLES. In the Old Kingdom, women wore their hair short. Representations of women with long hair usually include visual clues that they were wearing wigs. Egyptologists call the long wig the tripartite hairstyle. The hairdresser arranged the hair of the wig in three sections with one section over each shoulder and the central mass of hair down the back. Dancers sometimes wore this style, and it was common for singers. Other dancers wore their natural hair very close-cropped in a style resembling men's hairstyles. Some scholars believe that women represented with short hair were wearing a close-fitting cap. The third typical hairstyle for women dancers was a ponytail weighted at the end with a disk or ball. In many representations this disk is painted reddish-orange, the same color as the sun. This element thus might relate to the cult of the sun-god, Re. Middle Kingdom female dancers also wore this ponytail with a disk-shaped weight. Others wore three pigtails, though this style was less common. New Kingdom women were subject to more quickly changing styles. Though both the close-cropped style and the tripartite hairstyle continued in popularity, women also wore wigs that entirely enveloped their backs, shoulders, and chests, and dancers sometimes imitated this fashion. Some female dancers wore complicated hairstyles that scholars believe came from Nubia, in the modern Sudan, just south of Egypt. Perhaps some of these changes from the earlier periods resulted from artists' increased interest in representing this kind of detail. When men danced, they normally wore their hair in a close-cropped short style. They might also wear a tight-fitting cap. The only specialized headgear that men wore for the dance was the tall, crown-like muu-hat. This distinctive headgear identified the muu-dancer with ferrymen who conducted boats through Egypt's canals, and revealed their function in the dance as conductors of the funeral procession from place to place. The muu-hat was made from woven reeds and was rather tall and cone-shaped. Though rare, representations of men wearing ponytails with the disk-shaped weight more commonly worn by female dancers do exist. This style possibly associated the dance with the cult of the sun-god, Re.

ACCESSORIES. Women's accessories emphasized parts of their bodies important to the dance. Bracelets and armlets drew attention to their arms and large gold earrings brought focus to the head. The same was true of the headbands and fragrant cones that women wore on their heads as a perfume. Finally, many women wore straps crossed over the chest and back as part of the dance costume. The only accessories that male dancers wore were bracelets and collars. While the precious metals worn on the wrists and around the neck served to draw the viewer's attention, this jewelry was similar to what men wore in other situations and so was not particularly significant to the dance costume.

SCHOLARS' REACTIONS. Western scholars in the past have often expressed discomfort with the relatively revealing costumes that Egyptian dancers wore. They were reacting, in part, to the issue of public nudity, but also to the real presence of erotic intent that was integral to Egyptian funerals. Egyptian funerals led the deceased to rebirth into the afterlife. The Egyptians believed that this rebirth required a sexual conception resembling conception and birth into this world. Revealing clothing paired with movement played an obvious role in this process.

SOURCES

Rafael Perez Arroyo, *Egipto: La música en la era de las pirámides* (Madrid: Ediciones Centro de Estudios Egipcios, 2000).

Fr. W. von Bissing,"Ein altägyptische Mädchentracht," *Zeitschrit für Ägyptische Sprache* 37 (1899): 75–78.

SEE ALSO *Fashion: Clothing*

THE DANCERS

PROFESSIONAL BUREAU. Most dancers were women who belonged to the bureau called the *khener.* A smaller number of men were also khener members.

Female dancer. BROOKLYN MUSEUM OF ART, 07.447.505, CHARLES
EDWIN WILBOUR FUND. REPRODUCED BY PERMISSION.

The khener was a bureau within other institutions, including the royal palace, a temple, a town, or the household or the tomb of a wealthy individual. Many earlier scholars confused the khener with a "harem," the Turkish word for women's quarters that housed wives and concubines in a polygamous society. Because so many of the members of the khener were women who entertained men, these scholars assumed that khener members also had sexual relations with the head of the household or tomb owner. Current scholarship considers the members of the khener to be professional musicians and dancers who had no other intimate personal relationship with the head of the household. According to ancient inscriptions, these musicians and dancers "refresh[ed] the heart" of their master. Many inscriptions make clear that this refreshment came only in the form of music and dance. There were many female overseers of the khener

recorded in inscriptions, and they were often singers. One Amarna period relief sculpture in a tomb depicts the women's quarters where both musicians and dancers rehearse together, though admittedly this is a unique representation. Oddly enough, only a few male professional dancers recorded inscriptions. They include Khnumhotep, who was also a priest of the king's funerary cult, and Horihotep who served in the cult of Bastet. In at least one case, the male dancers portrayed in a tomb were sons of the deceased. The major evidence for the khener comes from captions to tomb scenes. Egyptologists thus make use of a passage in *Papyrus Westcar* to establish an understanding of the way the khener worked. The papyrus contains the story of Ruddedet, a woman who bore triplets destined to become kings. In the story, the midwives are goddesses disguised as traveling musicians and dancers. The text specifically calls them a khener, which suggests that a khener of traveling musicians and dancers was unremarkable, a good disguise. In the story they traveled freely and received wages in grain for their services. There is no other evidence that musicians and dancers also normally worked as midwives. However, the god Bes was associated both with music and dance in the cult of Hathor and with protecting a mother in childbirth. It is hard to know if this story represents a broader reality, but the limited evidence available has encouraged Egyptologists to use this story to the greatest extent possible.

FOREIGN DANCERS. Many scholars have identified dancers in Egypt as foreigners, particularly in the New Kingdom, when Egypt had extended contact with neighboring regions. Scholars recognize these foreign dancers by their clothing and hairstyles and in some texts by their names. One Middle Kingdom papyrus from the reign of Senwosret II (1844–1837 B.C.E.) contains a list of twelve singers and dancers who performed at the king's funerary temple. Five of the dancers had Semitic names, while two had Nubian names. One dancer definitely had an Egyptian name, but four other names are too damaged to read. Even if all of the damaged names were Egyptian in this case, only 41 percent of these musicians and dancers would be Egyptian. It is impossible to know how representative these figures are for Egyptian dancers and musicians in general, but it does seem significant that foreign dancers and musicians could be incorporated into the khener of this important religious institution. This situation suggests that foreigners were certainly welcome to participate in this aspect of Egyptian society. On the other hand, some relief scenes in temples represent only Egyptian women of elite status performing in the god's cult.

a PRIMARY SOURCE *document*

A PRINCE SENDS THE KHENER TO A FUNERAL

INTRODUCTION: The cycle of stories that Egyptologists refer to as the *Pedubastis Stories* contains a local prince's response to the call for participants in a funeral for a deceased king. This prince instructs his son to send the khener of the town, the musicians and dancers, to help with the funeral.

My son, Pemu, go and see to … the troops of the eastern country, have them prepared with their girdles and myrrh, with the temple officials, masters of ceremony and dancers, who frequent the embalming rooms. Let them sail by boat to Per Osiris, let them convey the deceased body of Osiris, the King Jenharrou to the anointing room, have him embalmed and buried and arrange a beautiful, grand funeral for him such as is being prepared for Hapi and Merwer, the king of the gods.

SOURCE: Irena Lexová, *Ancient Egyptian Dances* (Mineola, N.Y.: Dover Publications, 2000): 67–68.

a PRIMARY SOURCE *document*

STORY OF A KHENER

INTRODUCTION: The majority of music and dance bureaus, known as "kheners," were attached to temples, tombs, towns, or the homes of wealthy individuals. The Papyrus Westcar contains a story in which a group of goddesses—Isis, Nephthys, Meskhenet, and Heket—and the god Khnum disguised themselves as a traveling khener and acted as midwives and servant to the birth of triplets who would later become kings. The fact that deities saw nothing shameful in disguising themselves as dancers suggests that dancers in ancient Egypt enjoyed high status.

On one of those days Ruddedet felt the pangs and her labor was difficult. Then said the majesty of Re, lord of Sakhbu, to Isis, Nephthys, Meskhenet, Heket, and Khnum: "Please go, deliver Ruddedet of the three children who are in her womb, who will assume this beneficent office in this whole land. They will build your temples. They will supply your altars. They will furnish your libations. They will make your offerings abundant!"

These gods set out, having changed their appearance to dancing girls [i.e., a khener], with Khnum as their porter. When they reached the house of Rawoser, they found him standing with his loincloth upside down. They held out to him their necklaces and sistra [ceremonial rattles]. He said to them: "My ladies, look, it is the woman who is in pain; her labor is difficult." They said; "Let us see her. We understand childbirth." He said to them: "Come in!" They went in to Ruddedet. They locked the room behind themselves and her.

SOURCE: "The Birth of the Royal Children," in *The Old and Middle Kingdoms.* Vol. 1 of *Ancient Egyptian Literature.* Trans. Miriam Lichtheim (Berkeley and Los Angeles: University of California Press, 1973): 220.

DANCING DWARFS. Egyptian artists often represented a dwarf dancing alongside the female troupe of dancers in funerals and in cult scenes in temples. The Egyptians distinguished among different physiological conditions that led to dwarfism. These conditions include achondroplasia, a pathological condition, and pygmies, who exhibit a natural adaptation to their environment. Egyptians had different words to distinguish between different kinds of dwarfs. Yet, both kinds of dwarfs became associated with the sun god, Re, and with the god Bes, associated with music and childbirth. Thus dwarfs were important in dance.

PYGMIES. Traders brought an African pygmy to dance in Egypt in the reign of Djedkare Isesy (2415–2371 B.C.E.). Pygmies were apparently highly prized dancers in the royal courts, as evidenced by an inscription carved on the tomb of the nobleman Harkhuf near Aswan, who had delivered a pygmy to King Pepi II (2288–2194 B.C.E.). The carving is a royal decree expressing both gratitude and excitement that Harkhuf had delivered a dancing pygmy who could perform the "dances of the god." The inscription described the pygmy's origin as the "Land of the Horizon-Dwellers," suggesting that he had come from the farthest reaches of the earth. The god whose dance the pygmy could per-

form was probably the sun god, Re. The *Pyramid Texts,* carved in the pyramid of King Pepi I (2338–2298 B.C.E.) mentions these divine dances where the king himself imitated a pygmy for the benefit of the god.

DWARFS IN THE HEBY-DANCE. Two dwarfs who lived in widely separated periods danced the heby-dance. Khnumhotep, who lived in the Sixth Dynasty (2350–2170 B.C.E.), and Pawenhatef, who lived in the Thirtieth Dynasty (381–343 B.C.E.), are both spoken of in

a PRIMARY SOURCE *document*

THANKS FOR A GIFT OF A DANCING PYGMY

INTRODUCTION: In approximately 2286 B.C.E., the eight-year-old King Pepi II received a gift of a dancing pygmy from his expedition leader Harkhuf. Harkhuf recorded in his tomb the thank-you note that the king sent him. The note reveals the role of African pygmies in ancient Egyptian dance. The young king tells Harkhuf that the pygmy will dance for the soul of the king's predecessor, Neferkare. It seems that the king also eagerly awaits the pygmy's arrival for his own enjoyment.

The King's own seal: Year 2, third month of the first season, day 15.
The King's decree to the Sole companion, Lector-priest, Chief of scouts, Harkhuf.

Notice has been taken of this dispatch of yours which you made for the King at the Palace, to let one know that you have come down in safety from Yam with the army that was with you. You have said in this dispatch of yours that you have brought all kinds of great and beautiful gifts, which Hathor, mistress of Imaau, has given to the ka of King Neferkare, who lives forever. You have said in this dispatch of yours that you have brought a pygmy of the god's dances from the land of the horizon-dwellers, like the pygmy whom the god's seal-bearer Bawerded brought from Punt in the time of King Isesi. You have said to my majesty that his like has never been brought by anyone who did Yam previously.

Truly you know how to do what your lord loves and praises. Truly you spend day and night planning to do what your lord loves, praises, and commands. His majesty will provide you many worthy honors for the benefit of your son's son for all time, so that all people will say, when they hear what my majesty did for you, "Does anything equal what was done for the sole companion Harkhuf when he came down from Yam, on account of the vigilance he showed in doing what his lord loved, praised, and commanded?"

Come north to the residence at once! Hurry and bring with you this pygmy whom you brought from the land of the horizon-dwellers live, hale, and healthy, for the dances of the god, to gladden the heart, to delight the heart of King Neferkare who lives forever! When he goes down with you into the ship, get worthy men to be around him on deck, lest he fall into the water! When he lies down at night, get worthy men to lie around him in his tent. Inspect ten times at night! My majesty desires to see this pygmy more than the gifts of the mine-land and of Punt!

When you arrive at the residence and this pygmy is with you live, hale, and healthy, my majesty will do great things for you, more than was done for the god's seal-bearer Bawerded in the time of King Isesi, in accordance with my majesty's wish to see this pygmy. Orders have been brought to the chief of the new towns and the companion, overseer of priests to command that supplies be furnished from what is under the charge of each from every storage depot and every temple that has not been exempted.

SOURCE: King Pepi II, in *The Old and Middle Kingdoms*. Vol. 1 of *Ancient Egyptian Literature*. Trans. Miriam Lichtheim (Berkeley and Los Angeles: University of California Press, 1973): 26–27.

inscriptions as dancing the heby-dance for the cult of the Apis bull. This cult worshipped the bull in his lifetime and performed a special funeral for him. Dancing the heby-dance in his funeral was a particular honor.

DANCING ANIMALS. The Egyptians depicted both monkeys and ostriches dancing. Dancing monkeys comprised part of the Egyptian tradition that depicted animals in human pursuits. Artists included these depictions in the Old Kingdom tombs of the high officials Ti and Kagemeni. Monkeys may have been linked with pygmies, perhaps because both monkeys and pygmies had their origins in the far south of Africa, the area Egyptians called "God's Land," which gave them special access to the divine. A New Kingdom sketch depicted a monkey dancing with a Nubian dressed in a non-Egyptian costume of a red, leather kilt with a feather in his hair. Monkeys also danced with Egyptian dancing girls in the New Kingdom. One sketch shows a monkey dancing on a ship. Scholars consider many of these scenes to be satirical. They depict an upside-down world where animals wait on each other as servants. These scenes reverse normal preconceptions, for example, by showing a cat serving a mouse. Yet, dance scenes with monkeys might represent actual performances that included animals. The Egyptians believed that ostriches danced in the wild. They called the violent movements with outstretched wings that ostriches do at sunrise an *iba*, the same word they used for human dancing. Modern ornithologists also have observed this behavior and independently called it a dance. The Egyptians spoke directly of the ostrich dance in a hymn to King Ahmose

(1539–1514 B.C.E.). They also represented the ostrich dance in the tomb of King Akhenaten (1352–1336 B.C.E.) and at the funeral temple of Ramesses III (1187–1156 B.C.E.) at Medinet Habu. The painting of ostriches on Nagada II period (3500–3300 B.C.E.) pots near a dancing woman might also represent the ostrich dance. The Egyptians understood the ostrich dance to be part of general jubilation on earth at the rising of the sun-god Re. All creation, in Egyptian belief, rejoiced daily at sunrise. The ostrich was one animal that directly expressed its joy through dance.

SOURCES

Emma Brunner-Traut, *Der Tanz im Alten Ägypten* (Glückstadt, Germany: J. J. Augustin, 1938).

Betsy Bryan, "The Etymology of HNR: Group of Musical Performers," *Bulletin of the Egyptological Seminar* 4 (1983): 35–54.

Charles Kuentz, "La danse des autruches," *Bulletin d'Institut français d'archéologie oriental* 24 (1924): 85–88.

Auguste Mariette, *Les mastabas de l'ancien empire* (Paris: F. Vieweg, 1889): 435b.

SEE ALSO *Music: A Musical Bureau in the Old Kingdom*

FUNERAL DANCES

LONG TRADITION. The tradition of a funeral dance in Egypt probably began in the Nagada II Period, as early as 3500 B.C.E. Evidence of funeral dances continued into the Thirtieth Dynasty more than 3,000 years later. Yet these dances are not well understood today. Many problems in understanding the dances stem from the way that the evidence is preserved. The evidence comes mostly from paintings and relief sculptures that have severely abbreviated the dance steps in order to fit a representative number of steps on the limited wall space in a tomb. The liturgy of the funeral service can supplement modern understanding of the dances, but the best way to understand the dances is to see how they fit with the parts of the funeral service, a ritual which lasted for many days.

FUNERAL RITUAL. The funeral dance portrayed the five major parts of an Egyptian funeral. The separate sections included:

1. The deceased's journey from East to West across the sky with the sun god Re,

2. The deceased's arrival in the West under the protection of the *matjerut*-priestess,

3. The deceased's rebirth and washing the newborn in the House of Purification,

4. Animating the newborn through a ritual called "opening the mouth," led by a panther-skin clad priest, and judging the deceased's previous life in the House of Embalmment,

5. Depositing the mummy in the tomb, called "reception in the West."

Dancers portrayed each segment of the funeral, but not every tomb included every part of the dance on its walls. During the Old Kingdom, for example, there are 76 tombs that illustrate some part of the funeral dance, either with the depiction of the funeral procession or as part of the funeral meal. The fullest depiction of the dance comes from the tomb of Princess Watetkhethor, daughter of King Teti (2350–2338 B.C.E.) and wife of his prime minister, Mereruka. In this very large tomb comprising six separate rooms, the princess commissioned one wall depicting the funeral dance. This large amount of space contrasts greatly with the usual amount of space allotted to dance scenes in other tombs. In the princess's tomb, 31 figures comprise the fullest known illustration of the funeral dance. Yet other tomb reliefs concentrated on and expanded particular parts of the dance found in this tomb. Thus scholars can only achieve a full understanding of the dance by combining information from various tombs.

COUPLES DANCE. Two couples perform the funeral dance. In eight different Old Kingdom tombs belonging to men, two groups of men impersonate the deceased while female dancers simultaneously perform the *iba*-dance. In Princess Watetkhethor's tomb, however, the two couples are women, indicating that the gender of the dancers in the couples dance is determined by the gender of the deceased. In the tombs belonging to men, the tomb owner sits at an offering table while the performers execute the steps. In the princess's tomb, she sits in a carrying chair and observes it.

BEGINNING. Artists depicted the dance scene in the Tomb of Watetkhethor using registers, a device for organizing the space in a picture by creating a series of parallel groundlines within the picture. The dancers in the first register of Watetkhethor's tjeref dance perform the opening movements of the dance. These movements were called the *muu*-dance. Artists in other tombs expanded this section with more detail, allowing scholars to determine that the muu-dance represented the beginning of the funeral where the deceased symbolically crossed the heavens in the sun-god's boat. The dancers

a PRIMARY SOURCE *document*

DANCE CAPTIONS FROM THE TOMB OF WATETKHETHOR

INTRODUCTION: These captions add an abbreviated explanation to the drawing of 31 figures executing the tjeref dance in the Tomb of Watetkhethor in Saqqara. Watetkhethor was a royal princess, daughter of King Teti (2350–2338 B.C.E.) and wife of the prime minister, Mereruka. Watetkhethor was also a priestess of Hathor—a goddess associated with dance—which might explain why she devoted one whole wall of her tomb to a dance scene. The *khener*, a professional music and dance troupe, performed the tjeref dance at the end of the funeral. The dance recapitulated the major components of the funeral. The captions give some clues as to the relationship between the dance and a funeral, but are very abbreviated due to the limitations of space on the wall. They are divided by horizontal lines into five spaces called registers.

Register One

"I am clapping; I am clapping; Hey! A quick crossing; Hey! The movement is hidden; Hey! The movement is golden."

Register Two

Hey! The *matjerut*-priestess is in charge of it; She comes, she comes; Tenet is the *matjerut*-priestess. Hey! The beautiful one is taken … by?; Hey! I unite (with you); Hey! All pavilions (of/and) the audience hall;"

Register Three

"Hey! You praise the Festival of Birth; Quick, quick; It is the same thing; O, Quartet, come and pull; Hey, the secrets of the harem; Hey, recitation of the private rooms; Hey, a gesture of supplication."

Register Five

"May she give the arm … may she give the secret … tomb; Go people of …"

SOURCE: Jonathan Van Lepp, "The Dance Scene of Watetkhethor: An Art Historical Approach to the Role of Dance in Old Kingdom Funerary Ritual" (master's thesis, University of California at Los Angeles, 1987): 44. Text modified by Edward Bleiberg.

associated with Osiris, the god of the Afterlife. The Egyptians believed that a pilgrimage to Buto was the first stage of the journey to the land of the dead. Finally, the muu-dancers pulled the sledge—a sled that travels on sand—containing the mummy, the canopic jars used to store the mummified organs, and the tekenu—the placenta of the deceased. The text of the first register refers to the Egyptians' wish for a quick passage across the sky, the hidden movements of the funeral, and the pulling of the sledge. The text also alludes to gold at this point, which probably refers to the sun and its journey across the sky, which the deceased joined. The Egyptologist Jonathan Van Lepp suggests convincingly that the movement accompanying this caption is a gesture that allows the dancers to form the hieroglyphic sign for gold. This attempt to imitate writing through movement is also used in modern Egyptian folk dance where the dancers imitate Arabic calligraphy in their poses. The dancers use this technique in other parts of the dance.

ARRIVAL. Register two symbolizes the deceased arriving on the west bank of the Nile river, the land traditionally viewed as the necropolis or "city of the dead." Here the text asks the funeral priestess called the *matjerut* to protect the ka statue that will act as a home for the soul. The dancers form a circle that represents the circuit the sun follows through the sky of the living and under the earth in the land of the dead.

REBIRTH. Register three depicts the festival of rebirth that priests celebrated at the House of Purification. They probably recited "The Lamentations of Isis and Nepthys" at this point in the funeral, a secret text mourning the death and anticipating the rebirth of Osiris, god of the dead. The inscription suggests that this portion of the funeral was kept secret from the majority of the participants. Only the priests were admitted to the House of Purification. The ceremony consisted of symbolically washing the newly born spirit with water. Pyramid Texts 2063a to 2067b, a liturgy of washing, seems to describe this process. In this part of the ceremony, the Egyptians expressed their belief that birth and death are nearly equivalent. The inscription calls this the "secrets of the harem" or the women's quarters. These secrets include the mystery of birth and thus also the mystery of rebirth into the next world. The Egyptians viewed this part of the ceremony as the rebirth into the afterlife and thus an intimate part of the world of women. The dancers form the hieroglyph for *akhet*, the "horizon," which symbolizes the daily rebirth and death of the sun. The greeting to the "quartet," which follows in the inscription, refers to the four sons

who performed the muu-dance impersonated the guardians at the entrance to the land of the dead and the ferrymen who conducted the boat carrying the sarcophagus to the land of the dead. The muu-dance further represented the symbolic journey to Buto, a city

a PRIMARY SOURCE *document*

THE LAMENTATIONS OF ISIS AND NEPHTHYS

INTRODUCTION: Scholars have associated "The Lamentations of Isis and Nephthys" with the secret rituals mentioned in the captions of Princess Watetkhethor's funerary dance. This text consists of a series of prayers for the rebirth of the Osiris, the god of the dead. Since each deceased person was equated with Osiris, praying for his revival was the same as directly praying for an individual. The following extract describes how the text should be recited. These directions also inform us about the dancers' movements.

Now when this is recited the place is to be completely secluded, not seen and not heard by anyone except the chief lector-priest and the *setem*-priest. One shall bring two women with beautiful bodies. They shall be made to sit on the ground at the main portal of the Hall of Appearings. On their arms shall be written the names of Isis and Nephthys. Jars of faience filled with water shall be placed in their right hands, offering loaves made in Memphis in their left hands, and their faces shall be bowed. To be done in the third hour of the day, also in the eighth hour of the day. You shall not be slack in reciting this book in the hour of festival.

SOURCE: Miriam Lichtheim, *The Late Period*. Vol. 3 of *Ancient Egyptian Literature* (Berkeley and Los Angeles: University of California Press, 1976): 120.

a PRIMARY SOURCE *document*

LITURGY OF WASHING

INTRODUCTION: The Egyptians believed that the funeral service led to rebirth in the next world. Thus they thought both birth and death required the same washing ritual. The following liturgy comes from the *Pyramid Texts*, the royal funeral liturgy. It describes washing the "newly reborn" deceased. In this translation, the term "NN" refers to the places where the priest would insert the name of the deceased. These words would be ritually enacted through the dance.

The Water of Life which is in heaven comes,
The Water of Life which is on earth comes.
Heaven burns for you,
Earth trembles for you before the god's birth.
It seizes the body of NN.
Oh NN, pure water kisses your feet.
It is from Atum,
Which the phallus of Shu made,
Brought forth from the vulva of Tefenet.
They have arrived and brought to you pure water
 from their father.
It purifies you, you are incensed …
The libation is poured to the outside of this NN.

SOURCE: Jonathan Van Lepp, "The Dance Scene of Watetkhethor: An Art Historical Approach to the Role of Dance in Old Kingdom Funerary Ritual" (master's thesis, University of California at Los Angeles, 1987): 61.

of Horus, the demi-gods that convey the reborn from the House of Purification to the House of Embalmment. The inscription asks them to come and pull, explicit directions to take the funeral procession and the mummy to the next stop in the funeral: the House of Embalmment.

HOUSE OF EMBALMMENT. Register four depicts in movement the time that the funeral procession spent in the House of Embalmment. Now that the deceased was reborn, the priests performed the ritual that protected the mummy so that it had the potential to live forever. The *setem*-priest performing this ritual wore a panther skin so the inscription refers to seeing a panther, a direct reference to the priest performing the ritual. Then the judges of the afterlife gave their verdict, judging that the deceased had lived a just life and would be admitted to the afterlife. The dancers in the relief make quiet, respectful gestures to the judges of the dead and speak of *maat*, the standard of justice the judges use to reach a verdict about the dead. The inscription speaks of granting millions of years to the deceased, a standard phrase for awarding eternal life. The mystery of birth was now complete. The dancers then enacted a pulling gesture according to the instructions of the inscription. These words and actions represent the conducting of the deceased into the tomb.

AT THE TOMB. Register five depicts the final transformation of the deceased into a *ba*-soul. According to Egyptian belief, the ba traveled between the land of the dead and the tomb in this world. The ba delivered the food offered at the tomb to the deceased in the next world. One dancer represented the transformation into the ba by gestures while the second dancer performed the adoration gesture, celebrating that the deceased now existed as an ethereal being in the next world. The next

dancers form the *hewet* hieroglyph, used to write the name of the tomb and indicating the resting place for the mummy. Finally, dancers offered their arms, impersonating the Goddess of the West who "extends her arms toward the deceased in peace" according to the funerary wishes found in many tombs. The dancers have now reenacted the entire funeral in movement.

COSTUME. Both men and women wore very similar costumes while performing this dance: a short kilt cut at an angle with a long belt hanging down in front. Both men and women wore a band of cloth wrapped across the chest without any other shirt or blouse. Men wore their hair close-cropped, but women wore a long ponytail with a red disk attached at the end. The color of the disk, sometimes called a ball, associated it with the disk of the sun. The dance thus has some association with cult of Re.

IMPORTANCE. The tjeref-dance thus recapitulated the entire funeral. Scholars believe that the dancers performed it at the entrance to the tomb at the conclusion of the funeral. Such a performance would reflect the Egyptians' use of magical redundancy. The Egyptians performed the ritual, performed it again through the dance, and performed it a third time by representing it on the walls of the tomb. Thus they could guarantee that the proper rituals were celebrated and the deceased would continue to live in the next life.

SOURCES

Else Baumgartel, *The Cultures of Prehistoric Egypt* (London: Oxford University Press, 1955): 65–66.

Jonathan Van Lepp, "The Dance Scene of Watetkhethor: An Art Historical Approach to the Role of Dance in the Old Kingdom Funerary Ritual." Unpublished master's thesis (Los Angeles: University of California, Los Angeles, 1987).

SEE ALSO *Religion: Funerary Beliefs and Practices*

MUU-DANCERS

FUNERAL PROCESSION. The muu-dancers performed in people's private funerals in the Old, Middle, and New Kingdoms, a period lasting about 1,500 years. The muu-dancers performed throughout the funeral. Representing the muu-dancers in tomb drawings was a popular choice for tomb owners, more popular than representing the whole funeral ritual as Princess Watetkhethor chose to do. Scholars do not know why this scene was represented so often. Artists represented in

tombs the muu-dancers' performance at four different stages of the funeral procession. The muu-dancers greeted the funeral procession at the "Hall of the Muu" where the dancers lived at the edge of the necropolis. They danced while priests loaded the sarcophagus onto the funerary barge at the ritual site called "Sais," associated with the town of Sais in the delta. They danced a greeting to the sledge carrying the sarcophagus at the ritual site in the necropolis called the "Gates of Buto," and associated with the town of Buto, also in the delta. Finally, at an unknown place in the necropolis, the dancers were the reception committee for the sledge bearing the canopic jars and *tekenu*—the containers for the viscera of the deceased and the still unidentified portion of the corpse, or perhaps the placenta, of the deceased that the Egyptians also placed in the tomb. The sites where the muu-dancers performed illustrate the itinerary that the funeral procession followed, allowing Egyptologists to reconstruct parts of the typical funeral.

DISTINCTIVE COSTUME. Muu-dancers usually wore a distinctive costume that made them easily identifiable. They wore a headdress made from a plant, probably papyrus stems. The headdress resembled a wreath wrapped around their heads. Rising from this wreath was a woven, cone-shaped structure that came to a point, then flared at the end. The headdress resembled but was not exactly the same as the king's White Crown. During the New Kingdom, scribes sometimes identified the images of muu-dancers only with captions rather than showing them wearing the distinctive headgear. In these cases the muu-dancers appear only as male dancers.

IDENTITY CRISIS. The most vexing question about the muu-dancers remains an explanation of their identity and thus their symbolic meaning. Earlier Egyptologists have explained the symbolism of the muu-dancers by equating them with other, known semi-divine beings. These beings include the gods of the necropolis who transported the deceased; the Souls of Buto who received the deceased; the Sons of Horus who rode in the barque (sun-boat) with deceased kings and the sun-god, Re; and the most recently proposed and most convincing suggestion, ferrymen who guided the deceased from the beginning of the funeral procession to the entrance of the tomb. In the earlier twentieth century, the Egyptologist E. Brunner-Traut thought the muu-dancers represented gods of the necropolis who transported the newly dead into their world. This interpretation built on earlier ideas advanced by the Egyptologist H. Junker. Junker tried to identify the muu-dancers with the "Souls of Buto," who were described in the *Pyramid Texts* as the beings that received the dead into the next world. He also believed

that the "Souls of Buto" were deceased kings. Though it is true that the "Souls of Buto" had some role in welcoming the deceased into the next world, no texts actually equate the "Souls of Buto" with the muu-dancers. Rather the muu-dancers danced at the ritual point, called the Gates of Buto. Advances in understanding the *Pyramid Texts* demonstrate that the muu-dancers performed a different ritual function from the "Souls of Buto" during the funeral procession.

EVIDENCE FROM TEXTS AND IMAGES. The Egyptologist H. Altenmüller identified six places where the muu-dancers were active in the funerary procession, combining the evidence of texts and representations. This itinerary of the muu-dancers corresponds with the funeral procession's itinerary. The muu-dancers began their role in the funeral from the "Hall of the Muu." They were present as the deceased journeyed westward toward the land of the dead and then journeyed to Sais, a pilgrimage that was ritually re-enacted during the funeral. They attended the procession of the sarcophagus on a sledge, the separate procession of the canopic jars and tekenu on a sledge, and at the tekenu ritual. Artists represented the parts of this procession in paintings and relief sculpture in Old, Middle, and New Kingdom tombs, establishing that this ritual was part of the funeral for over 1,500 years. Though it must have evolved and changed over time, the muu-dance was a very long-lived ritual.

HALL OF THE MUU-DANCERS. Artists also represented the setting of the Hall of the Muu-Dancers in tomb paintings and relief sculptures. The Hall sat in a vegetable garden at the edge of the necropolis. When the funerary procession reached the Hall of the Muu-Dancers, the priests called for the dancers to join the procession. In the paintings and reliefs, the caption for this event is, "The Coming of the Muu-dancers." The dancers, standing in pairs, executed a step, crossing one foot over the other with their arms raised to hip-level. In some representations they say, "She has nodded her head" while they dance, perhaps singing. The Egyptologist E. Brunner-Traut explained this phrase to mean that the Goddess of the West—the goddess of the necropolis—had approved the deceased's entry into the necropolis. The muu-dancers' first important role then was to welcome the deceased to the necropolis with their dance.

PYRAMID TEXT 310. Egyptologists have gained further understanding of the muu-dancers from the *Pyramid Texts*. These texts were the ritual that priests recited at royal funerals beginning no later than the reign of King Unas (2371–2350 B.C.E.). Something similar be-

a PRIMARY SOURCE *document*

FERRYMEN IN A FUNERAL PROCESSION TEXT

INTRODUCTION: The following funeral procession text associated the deceased with the god Atum and thus magically protected him or her from enemies. It then addressed two ferrymen called "Whose-Face-is-on-his-Front" and "Whose-Face-is-on-his-Back." These two ferrymen most likely are represented by the paired muu-dancers.

If [Name of the Deceased] is enchanted, so will Atum be enchanted!
If [Name of the Deceased] is attacked, so will Atum be attacked!
If [Name of the Deceased] is struck, so will Atum be struck!
If [Name of the Deceased] is repelled, so will Atum be repelled!
[Name of the Deceased] is Horus.
[Name of the Deceased] has come after his father.
[Name of the Deceased] has come after Osiris.
Oh, you, Whose-Face-is-on-his-Front!
Oh, you, Whose-Face-is-on-his-Back!
Bring these things to [Name of the Deceased].

(Speech of the Ferryman)
"Which Ferry should I bring to you, oh, [Name of the Deceased]?
(Answer)
"Bring to [Name of the Deceased] (the ferry named)
"It flies up and lets itself down!"

Translated by Edward Bleiberg.

came part of the beginning of all elite funerals somewhat later. H. Altenmüller correlated *Pyramid Texts* 306 through 310 with New Kingdom scenes of the *tekenu* and canopic jar procession. Artists divided the scenes into five parts, including the bringing of the tekenu, a censing, the bringing of the canopic jars, the bearing of the papyrus stocks, and the dance of the muu-dancers. These five scenes correlate with the five *Pyramid Texts*. In *Pyramid Text* 310, the spell identifies the deceased with the god Atum. According to the text, if enemies enchanted, opposed, struck, or repelled the deceased, it would be no more effective than to do the same to the god Atum. The text then associated the deceased with the god Horus. As Horus he asks the two ferrymen—Whose-Face-is-on-his-Front and Whose-Face-is-on-his-Back—to bring the ferry boat called "It flies up and lets itself down" to him. Thus in this text the pair of

MUU-DANCERS AS FOUR ROYAL CROWNS

INTRODUCTION: In this *Pyramid Text* the deceased appeared before the personifications of four royal crowns. A priest greeted these beings on behalf of the deceased. The deceased was called Horus, a god who was also the king and whose damaged and healed eye became the symbol for healing and rebirth. By making this connection between the deceased and Horus, the priest enlisted the personifications of the royal crowns in the rebirth into the next world. It is likely that the muu-dancers became personifications of the crowns at this point in their dance. Various connections within the pyramid texts associated groups of four with the muu-dancers who appeared as two pairs.

The gates of the horizon are open, the door-bolts
 are shoved back.
He [the deceased] has come to you, Oh *net*–crown!
He [the deceased] has come to you, Oh
 neseret–crown!
He [the deceased] has come to you, Oh
 weret–crown!
He [the deceased] has come to you, Oh *weret-
 hekaw*–crown,
While he is pure for you and while he fears you.
May you be satisfied with him!
May you be satisfied with his purity!
May you be satisfied with his word, that he might
 say to you,
"How beautiful is your face, when you are satisfied,
 when you are new and young. A god has created
 you, the father of the gods!"
He [the deceased] has come to you, oh *weret-
 hekaw*–crown!
He is Horus, who has strived to protect his eye, oh
 weret-hekaw–crown.

Translated by Edward Bleiberg.

muu-dancers are ferrymen whose job was to transport the tekenu and the canopic jars.

PERSONIFIED AS CROWNS. H. Altenmüller connected *Pyramid Text* 220 with scenes in tombs of the muu-dancers before the Gates of Buto. The four personifications of crowns named in *Pyramid Text* 220 were probably the same four beings addressed in *Pyramid Text* 310 where they were called ferrymen. In the spell, the crowns were not symbols of royal power. Rather they were personified as beings that wore crowns, each with a beautiful face. The fact that these beings had a face at all, and could also feel

satisfaction and appear both new and young, indicates that the spell was addressing beings rather than crowns themselves. The three statements about them in the text referred to their outer form, physical circumstances, and descent from gods. H. Altenmüller associated these four beings with the two pairs of muu-dancers in tomb scenes. As gatekeepers at the gates of the horizon, they played a similar role to the ferrymen of *Pyramid Text* 310; they facilitated transport of the deceased to the afterlife. Furthermore, Altenmüller showed through connections with other spells that this horizon gate is located in the east, making it the beginning of the sun-god Re's journey from east to west. Thus the evidence from the *Pyramid Texts* connects the muu-dancers with the transport of the deceased from the east—the land of the living—to the west—the land of the dead—through their dance. This transportation involves the god's boat, a place easily associated with the ferrymen muu-dancers. *Pyramid Text* spells 220 and 310 thus establish that the muu-dancers represented ferrymen. This connection is clear because of comparisons between the scenes in tombs of the Old Kingdom and the role the texts played in the burial ritual. In *Pyramid Text* 220, the dancers represented ferrymen who double as border guards on the east side of heaven and who were personifications of the Lower Egyptian crowns. These crowns were also associated with ferrymen in *Pyramid Text* 1214a.

PLANTS. Egyptian thought conceived of a heavenly world filled with canals and ferrymen from experience of life on earth. These ferrymen, in both realms, wore plants and wreaths as clothing. Numerous depictions of boats in tombs show that the crewmembers decorated themselves with braided plants, placed in their hair. The papyrus-stem headdress worn by the muu-dancers thus connects them further with boats and ferries.

STATUE PROCESSIONS. Another connection between ferrymen and muu-dancers can be found in statue processions. In Old Kingdom tombs, there are scenes that depict processions of statues guarded by muu-dancers. Inscriptions in these scenes compare the processions to a trip by boat. The dancers in the processions thus perform the same guardian function during funerals as the dancers perform in the statue processions.

SONS OF HORUS. The muu-dancers probably were fused with the Sons of Horus, the spirits who were directly connected to the canopic jars that held the viscera of the deceased. The Sons of Horus helped convey the funerary procession in the land of the dead. The Sons of Horus were also ferrymen and border guards, further connecting them to the muu-dancers.

Canopic jars of Neskhons, 21st Dynasty. The wooden lids of these jars represent the four Sons of Horus, four minor gods who protected the organs that they contained: the falcon-headed Qebhsenuef (intestines), the jackal-headed Duamutef (the stomach), the baboon-headed Hapy (the lungs), and the human-headed Imsety (the liver). © THE BRITISH MUSEUM/TOPHAM-HIP/THE IMAGE WORKS.

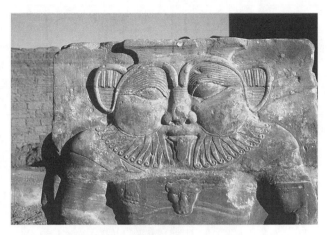

The Egyptian god Bes, god of dance, music, and pleasure. Stele in the temenos at Dendera. © 2003 CHARLES WALKER/TOPFOTO/THE IMAGE WORKS.

ANCESTORS. The muu-dancers might also have represented the deceased's ancestors. The muu-dancers were clearly part of a large group called the "Followers of Re." This group rode in the sun-god Re's boat that carried the sun from east to west in this world during the day and conveyed the sun through the land of the dead at night. Membership in the "Followers of Re" was available to all high officials after their death. The muu-dancers represented all the dead ancestors of the deceased that rode in the sun-god's boat. This connection between the deceased's ancestors and the muu-dancers also explains a line from *The Story of Sinuhe.* In the letter that the king wrote to Sinuhe inviting him to return to Egypt from the Levant, the king said, "The Dance of the Weary-ones will be performed at the entrance to your tomb." The "weary-ones" was another name for all the deceased's ancestors. The dancers at the tomb entrance certainly included the muu-dancers. Thus the muu-dancers and the ancestors can easily be equated.

CHANGE. Muu-dancers were a feature of Egyptian funerals for at least 1,500 years from the Old Kingdom through the New Kingdom. It is possible, though, that the muu-dancers were replaced by dancing dwarfs by the Twentieth Dynasty. The Egyptian national epic, *The Story of Sinuhe,* was recopied from its composition in the Middle Kingdom through the end of Egyptian history. A copy made near the time of composition is quoted as saying, "The Dance of the Weary-ones will be performed at the entrance to your tomb." The word for weary-ones

in Egyptian is *neniu.* In a Twentieth-dynasty copy of the same text it reads, "The dance of the dwarfs will be performed for you at the entrance to your tomb." The word "dwarfs" in Egyptian is *nemiu.* Perhaps by the Twentieth Dynasty, the dwarf-god Bes joined the funeral procession. Bes was both a god of birth and re-birth as well as a dwarf. Thus Egyptian traditions could easily assimilate him into the funeral procession.

SOURCES

Hartwig Altenmüller, "Zur Frage der *MWW,*" *Studien zur Altägyptischen Kultur* 2 (1975): 1–37.

Emma Brunner-Traut, *Der Tanz im Alten Ägypten* (Glückstadt, Germany: J.J. Augustin, 1938).

SEE ALSO *Religion: Funerary Beliefs and Practices*

THE IBA-DANCE AND HEBY-DANCE

LIFE AND DEATH. The *iba*-dance and the *heby*-dance are two different names for the same dance. Old and Middle Kingdom artists used the word *iba* in captions to scenes depicting it, while New Kingdom scribes used *heby* in the same context. Artists portrayed the *iba*-dance and the *heby*-dance in tombs, suggesting they had some meaning for the deceased in the next life. Yet they portrayed the dancers performing while people ate meals, a quintessential part of daily life on earth. During the Old Kingdom, the tomb scenes show the deceased eating, often with a spouse. New Kingdom scenes portray a banquet with many guests in addition to the deceased and close family members both eating and watching the dance. Thus it seems likely that the Egyptians watched

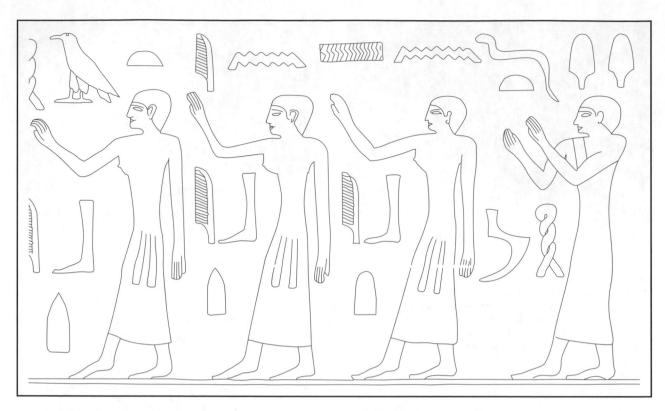

Drawing of Iba dance from the tomb of Qar, Giza. **CREATED BY GGS INFORMATION SERVICES. GALE.**

iba- and heby-dances while eating on earth and also expected to see them again after death. Nevertheless, the cultic connections between the dance and ritual are so close it is unlikely that these dances are truly secular.

DESCRIPTION. Women danced the iba and heby, usually for men or a couple in the Old and Middle Kingdoms and for a larger group of men and women in the New Kingdom. The characteristic steps included arms raised above the head and joined to form a diamond shape. In a second step, the dancers raised the right hand in greeting as the left hand and arm pointed straight down. At the same time, both heels were raised from the ground, so that the dancers were resting only on their toes. The next step included raising the left hand and arm until it was parallel with the ground and simultaneously raising the left foot above the ground with the sole of the foot parallel to the ground. In tombs outside the capital regions of Memphis and Thebes, the dances included more lively and athletic steps that appear quite acrobatic. The dancers formed a bridge by leaning backward until the hands and head reached the ground. In the New Kingdom, the dancers sometimes played the lute as they danced in a more lively manner.

COSTUME. The women performing this dance during the Old and Middle Kingdoms wore a short skirt that ended just above the knees. They sometimes wore a band of cloth that encircled the neck and crossed between the breasts and over the back. Sometimes the women wore a headdress of lotus flowers. This costume was certainly less modest than the typical Old Kingdom dress for women. Women of all classes normally wore tight-fitting long dresses with straps over the shoulders and a V-neck; the singers and clappers are distinguished from the dancers by their wearing of this more traditional clothing. The short skirt clearly allowed the dancers to move more freely than they would while wearing the typical street clothes. Some scholars have suggested that this costume indicates the dancers were foreigners. Though foreigners could be members of the dance troupe, there is no evidence to support the belief that foreigners or foreign dress dominated Egyptian dance.

IN PROCESSION. In at least one case during the Old Kingdom, a tomb displays dancers doing the iba dance in a funeral procession rather than during a meal. The women dancing in the tomb of Akhethotep raise their arms to form a diamond shape with the hands apart. Perhaps this scene is a clue that the iba actually was a part of the tjeref funeral dance. The nature of the evidence makes it difficult to know exactly how these dances fit together.

SOURCES

Emma Brunner-Traut, *Der Tanz in alten Ägyptischen nach bildlichen und inschriflichen Zeugnissen* (Glückstadt, Germany: J. J. Augustin, 1938).

CULT DANCES

WORSHIP. Cult dances were essential to worshipping the gods in Egypt. Just as the gods required food, clothing, and incense, they expected dances to be performed periodically at festivals. These dances are less studied than the dances associated with the funeral, perhaps because the scenes of these dances are less available for study in publications, requiring further research. The Egyptians worshiped Hathor, Amun, and Osiris with dance, along with other gods.

LEAPING HATHOR DANCE. The goddess Hathor had many connections to dance and music. Scribes included inscriptions naming Hathor in depictions of a leaping dance and an acrobatic dance. In the leaping dance, a girl in a short skirt danced while swinging a mirror and a staff that she raised in her hand. Mirrors often depicted Hathor on the handle as an expression of her connection to female beauty. Two musicians surrounded her. They wore long dresses and manipulated the same two objects. A third girl dancing in a circle around the others also lifted a mirror and staff with another gesture. All the dancers wore the ponytail with disk hairstyle that associated the dancers with the sun-god Re. A very abbreviated text mentions Hathor, but it is too brief to allow translation.

ACROBATIC HATHOR DANCE. In the tomb of Ankhmahor from Dynasty Six, artists depicted five women performing a distinctive acrobatic step. They raised one leg at a steep angle, while they leaned far back, dangling their ponytail with the disk weight on to the ground. They balanced on one foot, flat on the ground. They wore a short skirt with a band of cloth descending from the belt to below the hem and anklets. The accompanying inscription mentions Hathor, but is too abbreviated to translate. The artists included singers who clapped and kept time for the dancers. In New Kingdom representations of this dance, the singers held the *menat,* a percussion instrument also associated with Hathor.

OTHER CULT DANCES. Blocks from a chapel built by Hatshepsut (1478–1458 B.C.E.) at the Karnak Temple depict dancers in a procession during the Feast of the Valley and the Feast of Opet. These two festivals were the god Amun's main annual festivals. The Feast of the Valley included a procession between the god's home in Kar-

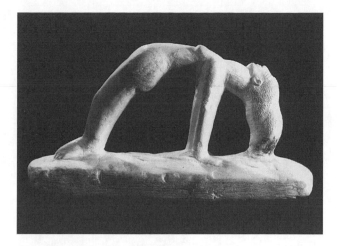

Statuette of a female acrobatic dancer. BROOKLYN MUSEUM OF ART, 13.1024, GIFT OF THE EGYPT EXPLORATION FUND. REPRODUCED BY PERMISSION.

nak and the temples of deceased kings across the Nile river. The Opet Festival included a procession from Karnak to Luxor, the temple that represented the god's harem. The dancers in both festival processions performed an acrobatic dance. Its major movement was the bridge where the dancers leaned back until their arms supported them. Characteristically for this dance, their hair surrounded their upper bodies. The women wore only long skirts and their hair was loose. The musicians played the sistrum and menat, two different kinds of ritual rattles. Both the sistrum and menat link the dance to Hathor, whose image was often included on these instruments.

SOURCES

Emma Brunner-Traut, *Der Tanz in alten Ägyptischen nach bildlichen und inschriflichen Zeugnissen* (Glückstadt, Germany: J. J. Augustin, 1938).

SEE ALSO *Music: Musical Deities*

SIGNIFICANT PEOPLE
in Dance

HORIHOTEP

fl. Twenty-second Dynasty (c. 945–712 B.C.E.)

Chief Dancer of Bastet

PRIEST AND DANCER. Horihotep lived some time during the Twenty-second Dynasty. Only a small, pyramid-shaped stone, roughly 22 inches tall, that once

Arts and Humanities Through the Eras: Ancient Egypt (2675 B.C.E.–332 B.C.E.)

81

capped the façade of his tomb, attests to his life. His title, Chief Dancer of Bastet, suggests that this goddess required dance to be part of her regular worship. The title also suggests that male dancers might have had a greater role in temple worship than was obvious from other evidence available for study. The mystery of who Horihotep was and what exactly he did can only be solved with further discoveries of chief dancers of gods.

SOURCES

Jan Quaegebeur and Agnes Rammant-Peeters, "Pyramidion d'un danseur de Bastet," *Studio Paulo Naster Oblata* (Leuven, Belgium: Uitgeverij Peeters, 1982): 179–205.

KHNUMHOTEP

fl. Sixth Dynasty (c. 2350–2170 B.C.E.)

Overseer of Ka-priests

PRIEST AND DANCER. Khnumhotep left only a statue with inscriptions to mark his life on earth. The statue depicts a man who was a dwarf. He reached a mid-level managerial position as an overseer of ka-priests, the priests who perform the daily ritual for the deceased. Dwarfs were never the object of prejudice in Egyptian society. In fact, Egyptians associated dwarfs with the sun god, Re, and the god of dance and childbirth, Bes. In the inscription carved on Khnumhotep's statue, he speaks of dancing in the funerals of two sacred bulls. Sacred bulls, associated with the funeral god Osiris, were buried in special tombs in Saqqara. These dance performances must have been high points of Khnumhotep's career because he specifically mentions them. Khnumhotep is one of a very few male dancers known by name from ancient Egypt.

SOURCES

Ola el-Aguizy, "Dwarfs and Pygmies in Ancient Egypt," *Annales du Service des Antiquités del l'Égypte* 71 (1987): 53–60.

Auguste Mariette, *Les mastabas de l'ancien empire* (Paris: F. Vieweg, 1889): 435b.

WATETKHETHOR

Before the reign of King Teti (c. 2350–2338 B.C.E.)–The reign of King Pepi I (c. 2338–2298 B.C.E.)

Princess
Priestess of Hathor

KING'S DAUGHTER. Watetkhethor Sheshat was born sometime before the reign of her father, King Teti.

She descended from the family that ruled Egypt during the Fifth and Sixth Dynasties. She married the prime minister, Mereruka, who served her father. They had a son and a daughter. She served as a priestess of the goddess Hathor, which perhaps explains her interest in dance, since Hathor was the goddess most associated with sacred dance in Egypt. Watetkhethor's tomb, which was attached to her husband's tomb, contained six rooms. This large mastaba-tomb had considerably more wall space than ordinary tombs. Watetkhethor commissioned an artist to decorate one wall with a depiction of the tjeref dance. The artist divided the wall into six registers that contain 31 different female figures performing the dance, step by step. Members of the *kheneret,* the organization of professional dancers, performed the tjeref dance at the conclusion of a funeral. The dance contained allusions to each of the major components of a funeral. Watetkhethor's scene of the tjeref dance is the most complete account of this important Egyptian dance.

SOURCES

P. Duell, *The Mastaba of Mereruka.* 2 vols. (Chicago: The University of Chicago Press, 1938).

Jonathan Van Lepp, "The Dance Scene of Watetkhethor: An Art Historical Approach to the Role of Dance in the Old Kingdom Funerary Ritual." Unpublished master's thesis (Los Angeles: University of California, Los Angeles, 1987).

DOCUMENTARY SOURCES
in Dance

Any, *The Wisdom of Any* (c. 1539–1075 B.C.E.)—A book of instructions on living properly, composed in the New Kingdom, that claims the gods require dance as an offering along with food, drink, and incense.

Anonymous, *The Lamentations of Isis and Nepthys* (after 332 B.C.E.)—This addition to a copy of the *Book of the Dead* contains instructions for how dancers should perform parts of the funeral dance.

Anonymous, *Papyrus Westcar* (before 1630 B.C.E.)—The only description of a dance and music bureau in context, it describes gods and goddesses disguised as singers and dancers who act as midwives.

Anonymous, *Pyramid Texts* (at least the reign of Teti, c. 2350–2338 B.C.E.)—Several of the spells refer to the dances performed during the funeral procession.

Pepi II, *Thank-you Note to Harkhuf* (c. 2286 B.C.E.)—
Recorded on the recipient's tomb wall, King Pepi II
thanks Harkhuf for bringing to him a dancing pygmy
from central Africa to perform dances for the gods.

Watetkhethor, *Tomb Relief of Funeral Dance* (c. 2350–2338
B.C.E.)—Princess Watetkhethor ordered this most com-
plete depiction of the parts of the funeral dance for her
tomb.

Arts and Humanities Through the Eras: Ancient Egypt (2675 B.C.E.–332 B.C.E.)

83

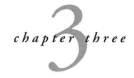

chapter three

FASHION

Edward Bleiberg

IMPORTANT EVENTS
in Fashion

All dates in this chronology are approximations (c.) and occur before the common era (B.C.E.).

5000 Archaeological evidence that flax grew in Egypt suggests that linen fabric was available at this early date. Flax was originally an import to Egypt, perhaps from Syria.

4400–4000 The first Egyptian depiction of a horizontal loom for making linen comes from this period.

3100–2675 An ivory statuette depicts a king wearing a patterned cloak.

3100–2800 Kings wear both the White and Red Crowns, symbols of rule over Upper and Lower Egypt.

King Narmer wears the earliest known archaic wraparound kilt. The style persists into the New Kingdom for both men and women.

Kings begin to wear the striped Nemes kerchief and the Uraeus snake over the forehead.

A brown shirt from this time period, excavated from Tarkan, shows the first evidence of dyed clothing.

2675–2170 Men wear both close-cropped natural hairstyles and shoulder-length wigs covering the ears.

Women wear short natural hairstyles and the tripartite wig.

Kings wear at least nine different crowns in the coronation ceremony. These crowns persist until the Ptolemaic period.

Kings first wear the Cap Crown, a tradition that persists until the New Kingdom.

Queens first wear the Vulture Cap, the oldest queen's crown.

Royal jewelry has a standard red/green/blue pattern.

2675–2625 Third-dynasty evidence shows women wearing sleeveless v-necked dresses, a style that persists into the New Kingdom.

King Djoser first wears the Nemes kerchief.

2625–2585 A shirt excavated from the reign of King Sneferu shows evidence of the use of red dye.

The first evidence of the bead-net dress for women dates from this time period.

2500–2350 Fifth-dynasty artistic evidence shows workmen wearing aprons without other clothing. This practice continues in the Middle Kingdom.

2485–2472 King Sahure is the first king to wear the Atef crown, most likely a crown referring to the king's strength.

2350–2170 Royal women first wear the Uraeus snake above their foreheads.

2008–1938 An Eleventh-dynasty letter written by a scribe named Nakht mentions long-distance shipping of cloth.

Women first wear the v-necked dress with sleeves, a style that persists into the New Kingdom.

The first evidence of the full-length and the short bag tunic, a style that persists into the New Kingdom, dates from this period.

Officials begin wearing shawls and cloaks.

Men wear shoulder-length wigs with hair tucked behind the ears.

Royal women begin to wear the Hathoric wig.

1938–1759 Twelfth-dynasty evidence shows hunters wearing protective codpieces.

1844–1837 During the reign of King Senwosret II, small-scale home spinning and weaving workshops begin to appear.

1759–1630 A Thirteenth-dynasty papyrus, now in the Brooklyn Museum, lists twenty female weavers who specialized in different kinds of cloth.

1630–1539 Kings first wear the Blue Crown, the everyday crown of kings in the New Kingdom.

1539–1075 Women first wear the complex wraparound dress, supplanting the simple wraparound dress.

New Kingdom evidence that soldiers, sailors, and craftsmen wore leather loincloths to protect linen loincloths dates from this period.

Women first wear the enveloping wig.

Men begin to wear more elaborate hairstyles.

1539–1514 Royal women first wear a double Uraeus in the reign of King Ahmose.

1514–1493 Curved ram's horns, a symbol of the god Amun, become a regular element of the king's crowns during the reign of Amenhotep I.

1479–1425 Textual evidence from the tomb of the vizier Rekhmire names a large number of different grades of linen.

1478–1458 The tomb of princess Hatneferet and vizier Ramose contains large numbers of examples of upper-class, non-royal clothing.

1400–1390 King Thutmose IV is the first king to combine the Red and White crowns with the Nemes kerchief.

1390–1352 The queen's crowns in the reign of Amenhotep III adopt a circlet of Uraeus-snakes as a base.

1352–1332 Unisex hairstyles called the Nubian wig and the rounded wig are worn during the reign of Akhenaten and Nefertiti.

Nefertiti is the first queen to wear the Cap Crown, worn by kings since the Old Kingdom.

1332–1322 King Tutankhamun's tomb contains hundreds of examples of clothing.

1292–1075 Very long wigs—waist length for women and shoulder length for men—become fashionable.

Priests begin shaving their heads.

760–656 Egyptian rulers from the Sudan adopt a double Uraeus formerly only worn by women.

332–30 Ptolemaic queens begin wearing a triple Uraeus.

Arts and Humanities Through the Eras: Ancient Egypt (2675 B.C.E.–332 B.C.E.)

87

OVERVIEW
of Fashion

IMPORTANCE OF CLOTHING. In ancient Egypt cloth was one of the major commodities, along with bread and beer, used in place of money in barter transactions. Cloth making was a labor-intensive activity before the invention of mechanical spinning machines and looms, so it was not uncommon for the average person to have only one or two sets of clothing to last them through the years. Thus the amount of clothing a person owned was a key indicator of status and wealth among the Egyptians. For example, the tomb of King Tutankhamun (r. 1332–1322 B.C.E.) contained hundreds of garments. But even upper-class, non-royal tombs included cloth. The tomb of princess Hatneferet and vizier (high-ranking government official) Ramose, who died during the reign of Hatshepsut (1478–1458 B.C.E.), contained 76 sheets, one old shirt, eighteen shawls, fourteen sheets of linen, and shrouds, in addition to vast quantities of other clothing. The clothing scholar Gillian Eastwood-Vogelsang speculated that the clothing in tombs could have been equivalent in worth to gold to this ancient society, and was often a motivating factor for tomb robbers.

EVIDENCE FROM ART. The evidence that can be gleaned from art about ancient Egyptian clothing is distorted by artistic conventions, though it is useful for discovering the way clothing was worn and how it changed over time. Artists were often conservative in their depictions of the deceased, showing people in older fashions that they might rarely have worn in life in order to preserve art's magical function in tomb decoration. Artists also neglected to depict the changes from work clothes to home clothes for workers. There is no indication in art that different clothes were worn in different seasons and at different times of day. Tomb owners, in general, were always depicted in their best clothing in tomb scenes. Furthermore, scholars sometimes disagree on how to interpret the clothing worn in a work of art. For example, a statue of a First-dynasty king depicts the king wearing a cloak that can be described as embroidered, quilted, or knitted. Each of these terms implies a different technique and suggests different degrees of sophistication in the production of clothing. Comparing archaeological examples of clothing to art, it seems to be true that Egyptian fashion changed slowly. The New Kingdom (1539–1075 B.C.E.) was one brief period during ancient Egyptian history when paintings depict changes in fashion. However, from the Predynastic (beginning in 4400 B.C.E.) to the Ptolemaic Period (ending in 30 B.C.E.) basic everyday wear did not appear to change significantly. In the archaeological record, Egypt displays a surprising lack of class-consciousness in clothing styles. Evidence shows that King Tutankhamun dressed similarly to his subjects. The bag tunic, for example, was a common garment for both kings and commoners, though there were considerable differences in the quality of fabrics. In art, however, priests and kings wear occupational clothing while performing their duties.

TYPES AND ADORNMENTS. Egyptian clothing is divided into two main categories. One category—wraparound clothing—used a length of cloth that the wearer draped on the body. The second category—cut-to-shape garments—were either triangular or rectangular pieces of cloth with sewn edges. These categories are difficult to recognize in the archaeological record. Wraparound clothing found in tombs often resembles bedsheets. Only careful examination of fold marks reveals the way large pieces of textiles were actually used. Garments cut-to-shape that archaeologists have discovered in tombs are easy to recognize yet are not often represented in the artistic record. Headgear such as crowns and kerchiefs and jewelry were as equally important as clothing in ancient Egyptian fashion. These adornments often conveyed a message through symbolism and magically protected the wearer. Crowns and kerchiefs identified kings and the particular purpose of a statue or relief. Often, for example, a pair of royal statues depicted the king with the red crown of Lower Egypt and the white crown of Upper Egypt. This pair of statues would then convey the message that the king ruled the whole country. Jewelry could be a means of displaying wealth but also protected the wearer. Amulets worn suspended from chains around the neck were a major source of divine protection in daily life for an Egyptian.

TOPICS
in Fashion

CLOTH PRODUCTION

LINEN. Linen was the most popular cloth for ancient Egyptian clothing. There are rare examples of both

a PRIMARY SOURCE document

LETTER FROM IRER TO HER MASTER

INTRODUCTION: Weaving shops were frequently part of a household in ancient Egypt. The following letter concerns difficulties that the woman responsible for supervising the weavers faces without adequate food supplies for payment. In this letter, Irer blames her master directly for her problems. Moreover, she has additional responsibilities to serve as a priestess at a temple. The letter illustrates the difficulties in administering a household weaving shop. The letter writer observes certain conventions of Egyptian epistles. Because Irer writes to her social superior, she calls herself "your humble servant" and calls the recipient, "the lord l.p.h." The initials indicate the ancient Egyptian formula, "may he live, may he prosper, may he be healthy" that follows any mention of such a social superior in writing. Words in square brackets are restored in this somewhat tattered papyrus. When followed by a question mark, it is a best-guess as to what the text originally said.

What the lady of the house Irer sends:

This is a communication to the lord, l.p.h., to the effect that all business affairs of the lord, l.p.h., are prosperous and flourishing wherever they are. In the favor of the King of Upper and Lower Egypt Khakheperre (Senwosret II), the deceased, and of all the gods as [I, your humble servant, desire]!

[It is] a communication to the lord, l.p.h., about this neglectfulness on the part of the lord, l.p.h. Are you all safe [and sound? The women weavers(?)] are left abandoned, thinking they won't get food provisions inasmuch as not any news of you has been heard. It is good if [the lord, l.p.h.] takes note.

This is a communication to the lord, l.p.h., about those slave-women who are here unable to weave clothes. Your presence [is demanded(?)] by those who work at(?) the warp-threads so as to be guided(?). I, your humble servant, couldn't come myself owing to the fact that I, your humble servant, entered the temple on the twentieth day of the month to serve as *wab*-priestess for the month(?). [So] may the lord, l.p.h., bring them (food supplies?) with him. It is a case of paying attention to that other(?) woman Heremhab when coming [for the(?)] Asiatic. the lord, l.p.h., should spend sometime here since [not] any clothes [have been made] while my attention is being directed to the temple, and the warp-threads are set up on the loom without its being possible to weave them.

This is a communication for the lord, l.p.h. It is good if the lord, l.p.h. takes note.

Address: the lord, l.p.h., Good luck(?)! [from the lady of the house Irer].

SOURCE: "Letter from the lady of the house Irer to her Master," in *Letters from Ancient Egypt.* Ed. Edward F. Wente (Atlanta: Scholars Press, 1990): 82–83.

sheep's and goat's wool garments and of palm fiber clothing found in the archaeological record. But Egyptians of all ranks and classes wore various grades of linen clothing in all periods. The flax plant (*Linum usitatissimum*) was the source of Egyptian linen. There is good evidence that flax grew in Egypt as early as 5000 B.C.E., but flax was not native to Egypt and might have originally been imported from Syria. The flax plant matures in three months from seed to flower. After its blue flowers died, the Egyptians pulled the plant from the ground rather than using a sickle to harvest it. The dead flowers are the source of the seeds and they remained part of the plant until the whole stock dried. Then the cultivator removed the seeds either by hand or using a tool called a rippling comb. The seeds were planted for the next crop. Workers then retted the plant by alternately wetting it and drying it in the sunlight. The retting process loosened the fibers inside the plant stem. Preparation for spinning the fibers included washing, drying, beating, and combing. The plant fiber then would be turned into thread by spinning it. The Egyptians used hand spindles consisting of a stick used for a shaft and a whorl that acted as a weight to stretch the fiber and kept the spindle moving at a constant pace. Spinning twisted the fibers of the flax stem together to form a longer piece of thread. Spinning also included a process called attenuation that fully extended the fiber. Twisting then added to its strength. Finally the spinner wound the thread onto a shaft. The resulting linen thread was both strong and elastic.

WEAVING. Weavers used spun thread to make cloth. They removed spun thread from the spindle once it was finished and strung it on a loom, forming the warp. The warp was the system of parallel threads kept under tension on a loom. The weft is the system of threads passed over and under the warp to form cloth. Egyptians used both horizontal and vertical looms to weave. Horizontal looms rested on the ground with the warp stretched between two beams. Pegs in the ground held the beams in place. A predynastic tomb (before 4000 B.C.E.) in Badari, a village in Upper Egypt, contained a representation on a bowl of a horizontal ground loom. Vertical looms

Arts and Humanities Through the Eras: Ancient Egypt (2675 B.C.E.–332 B.C.E.)

89

A CARPENTER'S CORRESPONDENCE

INTRODUCTION: Clothing was an essential element in a person's pay if he or she was too poor to have servants who could weave cloth. This letter written by a carpenter in the reign of Ramesses V (1150–1145 B.C.E.) illustrates the way ordinary Egyptians thought of clothing as payment.

The carpenter Maanakhtef greets the carpenter Kenkikhopeshef: In life, prosperity and health and in the favor of Amon-Re, King of the Gods! To wit:

I have reached Hu (Hu-Sekhem). Both Amenmose and Pahemnetjer as well have taken very good care of me in the way of bread, beer, ointment, and clothing. As soon as my letter reaches you, you shall send me a wooden door as well as a cubit stick. Then shall Amon give to you. Farewell!

SOURCE: Maanakhtef, "Letter to Kenkikhopeshef," in *Letters from Ancient Egypt.* Ed. Edward F. Wente (Atlanta: Scholars Press, 1990), 167.

symbols on them in ink that Egyptologists believe refer to the quality of the material. Differences in quality refer to fineness of the cloth. Some examples from the tomb of Tutankhamun are nearly transparent. Thus artistic representations of "see-through" costumes are likely to be accurate. Another quality that set certain linens apart was color. By the First Dynasty (3100–2800 B.C.E.) the Egyptians used brown thread to weave cloth. Excavators found red cloth fragments at Meidum, the site of Sneferu's pyramid (2625–2585 B.C.E.). In the New Kingdom (1539–1075 B.C.E.) colored cloth is even more common. The Egyptians used both ocher and plant material to make dye. Ocher is an iron oxide (the technical name of rust) mixed with clay. Naturally occurring ocher is yellow, but heating it transforms the color to red. Thus ocher could be used to produce either yellow or red cloth. A number of Egyptian plants could also produce red dye. These include madder root (*Rubia tinctorum*), safflower (*Carthamus tinctorum*), henna (*Lawsonia alba* or *L. inermis*), and alkanet (*Anchusa tinctoria*). Blue dyes also came from plants. The Egyptians probably made it from woad (*Isatis tinctorum*), which is found in Egypt. Yellow dye came from safflower and pomegranate (*Punica granatum*). Imported dyes found in Egyptian textiles include indigotin that creates blue, and alizarin that creates red. These dyes, much like the flax plant, most likely originated in Syria, and the Egyptians imported them. Thus textiles other than natural linen color must have been relatively expensive and available only to the wealthy.

TEXTILE WORKSHOPS. The vast majority of textile workers in ancient Egypt were women. Representation of weavers, laundresses, and even the flax harvest depict women doing this work. Yet the supervisors were all men. The exception to this division of labor was the male weavers who operated the vertical looms. Women dominated horizontal weaving while men were responsible for the heavier vertical looms. Regardless of who worked the looms, almost every sort of Egyptian home had spinning and weaving workshops. Small houses in the village at Kahun in Middle Egypt, dating to the time of Senwosret II (r. 1844–1837 B.C.E.) and later, were production sites for small-scale spinning and weaving. The larger the household, the more women would be assigned to textile workshops. Nobles' estates, royal palaces, harems, and temples (gods' houses) also contained workshops staffed by large groups of women. Among the papyri that refer to cloth are two examples from the Middle Kingdom (2008–1630 B.C.E.). In *Cairo Papyrus* 91061, a man named Nakht wrote to a man named Aau that the weavers had finished a bolt of cloth and that he had

leaned against walls. An upper beam could rest on limestone blocks set up against house walls. Such looms could be up to five meters (sixteen feet) high, allowing for long pieces of cloth. Each loom supported the four main patters of weaving in ancient Egypt. The simplest form was balanced tabby, where there are an equal number of warp and weft threads per square centimeter or inch. The Egyptians also wove faced tabby weaves. These weaves include either more warp (warp-faced) or more weft (weft-faced) threads per square centimeter or inch of fabric. They also made tapestry weaves, a process where the warp and weft were different colors. Often in tapestry, a weft thread did not reach from one end of the warp to the other, but was interwoven in the place where the color was needed to form a pattern. Known tapestry from tombs seems restricted to the royal sources. Though not a separate weave, the Egyptians also added loops of threads to the warp in a process called weft-looping. The resulting cloth resembles modern towels. The Egyptians used weft-looping to create delicate patterns.

LINEN QUALITIES. The Egyptians had names for several different qualities of linen. An inscription in the tomb of Rekhmire, a vizier in the time of Thutmose III (r. 1479–1425 B.C.E.), refers to royal linen, bleached linen, fine linen, and close-woven linen, among other types. Some archaeological examples of linen also have

sent it already. This papyrus thus suggests that cloth was shipped long distances within Egypt. A list of 38 servants in *Papyrus Brooklyn* 35.1446 includes twenty weavers. This list suggests through the titles that weavers could specialize in particular kinds of cloth. From these papyri, many scholars have also concluded that cloth played an important economic role in Egyptian life. Egyptians needed cloth for their own clothing but also used it as an offering to the gods. From archeological evidence, it can be seen that cloth could also be used to pay wages in-kind. Cloth was produced both in private domestic settings and in large institutions such as palaces and temples and was a vital cog in ancient Egyptian economy.

SOURCES

J. Allgrove-McDowell, "Kahun: The Textile Evidence," in *The Pyramid Builders of Ancient Egypt*. Ed. Rosalie David (London: Routledge, Kegan Paul, 1986): 226–252.

Rosalind Hall, *Egyptian Textiles* (Aylesbury, England: Shire, 1986).

Elizabeth Riefstahl, *Patterned Textiles in Pharaonic Egypt* (Brooklyn: Brooklyn Museum, 1944).

CLOTHING

EVIDENCE. Two kinds of evidence survive for modern scholars to study ancient Egypt clothing. The Egyptians included complete wardrobes for the deceased in their tombs to wear in the next world. Thus it is possible to study garments that were folded for storage in the tomb. Many Egyptian garments, however, were not constructed like modern Western clothing, but rather were simply squares, rectangles, and triangles of cloth or leather that were arranged on the body in different styles and foldings. Thus some garments such as elaborately folded dresses or kilts can only be understood through the second kind of evidence available: a careful study of artistic representations. Yet this evidence is often problematic in itself. Artists who worked in two dimensions presented combined perspectives on a garment, including, for example, both a side view and a front view in the same representation, as was the convention for representing the human face in two dimensions, and these often left the viewer without a clear view of the shape of a garment. Three-dimensional works of art are thus more helpful in understanding the shape of a garment, though not all the details of the folds would be obvious even from the best statues. Furthermore, certain artistic conventions forced artists to represent clothing as tight-fitting when it is clear from the archaeological evidence that dresses, for example, were usually worn looser—otherwise walking would have been impossible. Furthermore, in art, especially from tombs and temples, people wear only their best clothing even in situations that seem incongruous for such finery. Senedjem and his wife, two Nineteenth-dynasty (1307–1196 B.C.E.) tomb owners, are represented in their tomb plowing in their most elaborate clothing. Everyday wear thus can only be observed from the wardrobes left in tombs for the deceased to wear in the afterlife. For these reasons scholars have tried to combine the archaeological evidence of tomb wardrobes with artistic evidence to achieve a fuller understanding of ancient Egyptian clothing.

LOINCLOTHS. The loincloth was most likely a universal item of clothing in ancient Egypt. Tutankhamun's tomb contained fifty loincloths, and workmen also wore them, as is seen in tomb paintings. Loincloths were made from both cloth and leather, though leather loincloths had a specialized use. The cloth loincloths, worn by both women and men, consisted of two triangular pieces of linen sewn together to form a larger triangle with three equal sides. The top and sides were hemmed and strings were attached at either corner of the top. The strings allowed the wearer to tie the loincloth around the waist with the cloth covering the wearer's buttocks. Some representations of workmen suggest that some men did not bother to make additional ties in the garment, leaving the front open. Others tucked the tip of the garment in the front of the waist after pulling it between the legs. Some people added a sash that tied at the waist. The major differences between the loincloths of royals and the loincloths of workmen were in the quality of the cloth and the stitching. Tutankhamun's loincloths were soft and silky linen while workmen's loincloths were more sturdy and coarser. The stitching in Tutankhamun's loincloths was more delicate with smaller stitches than those found in ordinary people's loincloths. Men began wearing leather loincloths starting in the New Kingdom (1539–1075 B.C.E.). Soldiers, sailors, craftsmen, and servants wore them to protect their linen loincloths while they worked. Yet they were also found in tombs belonging to kings, officials, and Nubian mercenaries. The burials that Egyptologists call pan graves, long associated with Nubians, often include mummies wearing leather loincloths. Leather loincloths consisted of one piece of hide, usually thought to be gazelle skin. The hide resembled a mesh because the leather worker cut either slits or diamond-shaped holes in it. Some

Nykara (center) wears a short kilt with a pleated apron. His wife wears a tight v-neck dress that almost surely was an artistic convention rather than a real fashion. Their son is naked, the common way of representing children. BROOKLYN MUSEUM OF ART, 49.215, CHARLES EDWIN WILBOUR FUND. REPRODUCED BY PERMISSION.

examples are either patched or uncut over the area that would cover the buttocks. The garment also had ties that were part of the hide rather than added as in linen loincloths. Many of the archaeological examples of leather loincloths have connections to Nubia. There are examples of leather loincloths from Nubia in the collections of the Royal Ontario Museum in Toronto and in the Museum of Fine Arts in Boston. For this reason most scholars believe that this fashion originated in modern-day Sudan.

APRONS. Aprons are cloth strips hanging from a belt or sash that wrapped around the wearer's waist. Upper-class Egyptians wore aprons over or under other garments such as kilts while aprons could be a workman's only garment while he performed certain labors. In the Fifth Dynasty (2500–2350 B.C.E.) there are tomb representations of men capturing a bull and slaughtering a bull wearing only such aprons. Men wore an apron with a short kilt. This apron was shaped like a four-sided piece of cloth with a half-circle of cloth added to the bottom. Tomb reliefs include representations of these aprons in the Sixth Dynasty (2350–2170 B.C.E.) and again during the Middle Kingdom (2008–1630 B.C.E.). By the New Kingdom (1539–1075 B.C.E.), men had a wider choice of clothing types to wear with a pointed apron. Some men represented in Old and Middle Kingdom reliefs and paintings wear a triangular apron over their kilts. Artists represent the apron as a triangle that rose above the kilt in the front. One point was tucked into the waistband while one side of the triangle hung parallel to the hem of the kilt. The artistic emphasis on this item of clothing and the fact that the pleats of the triangle normally run in a different direction from the pleats of the kilt have led many scholars to believe that it is a separate item of clothing. Others have suggested that the triangle of cloth is actually the end of the kilt tied in some elaborate manner. Since no archaeological examples of the triangular apron have been recognized, it is not possible to determine whether it is a separate item of clothing or not.

KILTS. Kilts were wraparound garments that men wore to cover all or part of the lower half of the body and legs, and were worn throughout ancient Egyptian history. Only a very small number of archaeological examples of kilts are available for study. There are, however, nearly countless examples of men wearing kilts in Egyptian art. The length of the kilts varies greatly. It is likely that the length varied with economic and social status. Cloth was expensive and so poorer people tended to wear clothing with less material. The standard wraparound kilt probably consisted of a rectangular piece of linen wrapped around the waist. The ends were often inserted into a sash worn around the waist. The ends of the sash sometimes visibly hung from the waist and over the front of the kilt. Men often wore two kilts over one another. In this case one kilt was pleated while the other was flat. Some kilts also included decorations such as fringes, tassels, and pleats. During the New Kingdom, two additional kilt styles came into fashion. The sash kilts were one piece of cloth that were gathered and then tied in the front without a separate sash. The ends of the cloth hung in the front and were arranged in elaborate decorative patterns of folds. Typically they appear to cover part of the small of the back in addition to the buttocks. Sash kilts could be worn alone or in combination with bag tunics. The sash kilt could also bear fringe decoration on the edge. The scalloped-edge kilts

MEN'S Wardrobes: Continuity and Change

The following chart demonstrates continuity and change in men's wardrobes in the Old, Middle, and New Kingdoms. Many innovations occurred in the Middle Kingdom and continued into the New Kingdom. New Kingdom dress was the most various and elaborate.

SOURCE: Gillian Vogelsang-Eastwood, *Pharaonic Egyptian Clothing* (Leiden, Netherlands: E. J. Brill, 1993).

Garment	Old Kingdom	Middle Kingdom	New Kingdom
Cloth loincloth	X	X	X
Leather loincloth		X	X
Short wraparound kilt	X	X	X
Long wraparound kilt		X	X
Sash kilt			X
Bag tunic			X
Long, narrow apron	X	X	X
Triangular apron		X	X
Sashes and straps	X	X	X
Long cloak	X	X	X
Short cloak			X
Shawl	X	X	X

SOURCE: Gillian Vogelsang-Eastwood, *Pharaonic Egyptian Clothing* (Leiden: E. J. Brill, 1993).

CREATED BY GGS INFORMATION SERVICES. GALE.

were worn in combination with bag tunics and triangular aprons. Scalloped-edge kilts, as their name implies, were characterized by a cloth with vertically gathered large folds that resemble a scallop when worn. Women did not wear kilts, but could be depicted in art wearing skirts. The length of skirts seems to depend on social status and access to cloth. Poorer women wore shorter skirts out of economic necessity. In general, however, women wore dresses more commonly than skirts in ancient Egypt.

ARCHAIC WRAPAROUND. Both men and women could wear the archaic wraparound. The wearer could tie together two corners of a rectangular piece of cloth, placing the knot on the chest just below one shoulder and the opposite arm passed through the circle now formed by the top edge of the cloth. Kings, laborers, and fishermen could wear this garment with a sash. King Narmer (thirty-first century B.C.E.) wears it on the Narmer Palette with additional aprons and a bull's tail. But workmen depicted in Old Kingdom tombs also wore a simpler but similar garment. Men continued to wear the archaic wraparound through the Old Kingdom until about the twenty-first century B.C.E. In the Middle Kingdom (2003–1630 B.C.E.) and New Kingdom (1539–1075 B.C.E.) only gods wore the archaic wraparound. Gods' fashions were inherently more conserva-

tive than the clothing of the living. Women wore a long version of the archaic wraparound. Surprisingly, only female servants wore it, and it continued into the Middle Kingdom.

DRESSES. Dresses were women's clothing consisting of a section fit close to the upper body and a skirt that was either flowing or tight. Women of all social classes wore dresses as their most common garment. The clothing scholar Gillian Vogelsang-Eastwood recognized three basic ancient Egyptian dresses: the wraparound dress, the v-necked dress, and the bead-net dress. A wraparound dress consisted of one large piece of fabric that was wrapped around a woman's body in various ways. The fabric was not cut to shape. The wraparound dress could include or omit shoulder straps. In the archaeological record, it is easy to confuse a wraparound dress with bed linen. They are both rectangular in shape. But careful examination of both folds and wear marks on certain cloth rectangles reveals that they were indeed dresses rather than bed sheets. In the archaeological examples of these dresses, the rectangle of cloth measures about two meters by one meter (six feet by three feet). The cloth is finished on four sides with hems. The cloth was wrapped two to three times around the body depending on both the length of the cloth and the wearer's body. The top line of this dress could be worn

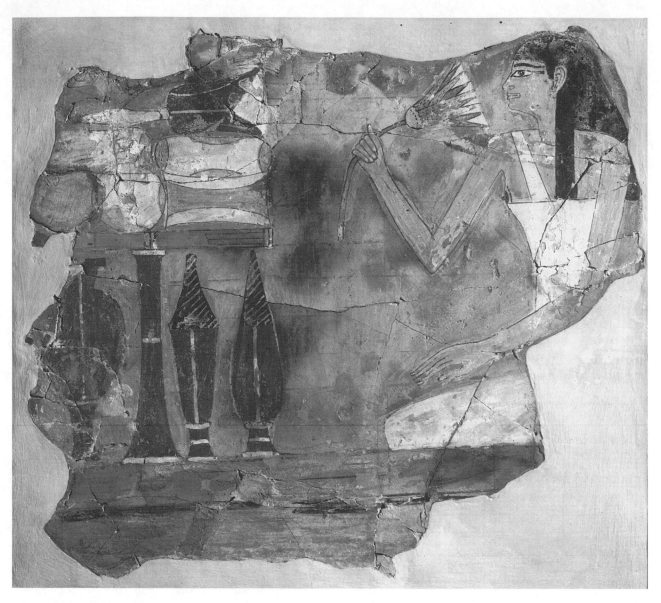

Fragment of a tomb painting with seated woman with lotus in one-strap dress. BROOKLYN MUSEUM OF ART, 05.390, CHARLES EDWIN WILBOUR FUND. REPRODUCED BY PERMISSION.

either over or under the breasts, depending on the amount of material available and the task the wearer performed. Often women wore either single or double straps with the wraparound dress. The straps covered part of the torso. There was a wide variation in the way the straps were worn. Women wore either one or two straps, arranged either across the body or hanging straight from the shoulder. The straps also varied in width from broad to narrow. These straps were probably decorative but might have served some practical purpose. Vogelsang-Eastwood suggested they were neither pinned nor sewn to the wraparound dress. The majority of wraparound dresses both in art and from archaeology are white.

SHEATHES AND COMPLEX DRESSES. Many art historians have claimed that the most common dress that ancient Egyptian women wore was a sheath with either one or two straps. Vogelsang-Eastwood argued convincingly that this sheath is actually a wraparound with straps. She doubted the reality of the sheath dress because there are no archaeological examples of it among the twenty known dresses from ancient Egypt and because no woman's grave has contained the pins that would have attached the straps to a sheath. Moreover, many scholars have commented that the sheath dress would have been difficult to wear while performing the tasks portrayed in tomb and temple paintings and reliefs. Kneeling, bending, and walking would have been

impossible if women wore a sheath that was as tight as artists portray. Thus the art historian Gay Robins suggested that the tight sheath was only an artistic convention and not a real dress. A more accepted dress form by art historians was the complex wraparound dress. Artists first depicted women wearing the complex wraparound dress during the New Kingdom (1539–1075 B.C.E.). Women created these dresses from large cloth rectangles wrapped in various decorative manners. Sometimes a second, smaller length of cloth secured the garment in place as a sash. The wearer could drape the cloth over one or both shoulders, wrap it around the lower part of the body, and tuck it into itself at the waist. Other versions of the dress included knotting the cloth under the breast. The dresses could be pleated or plain. Women at all social levels wore the complex wraparound dress.

V-NECKED AND BEADED DRESSES. V-necked dresses were tailored and cut to shape. Some examples have sleeves, while others are sleeveless. The sleeveless v-necked dress first appears in the Third Dynasty (2675–2625 B.C.E.) and continues into the New Kingdom. Both royal women and upper-class women wore this dress. There are some examples with pleats, though pleating is less common than plain examples. V-necked dresses with sleeves survive in the archaeological record in greater numbers than sleeveless v-necked dresses. The seamstress made the bodice and sleeves from two pieces of cloth that she attached to a large rectangle of cloth that formed the skirt. Archaeologists have discovered examples of these dresses dating from the First to Eleventh Dynasties (3100–1938 B.C.E.), proving their popularity for at least 1,200 years. Yet artists never seem to represent such dresses in the artistic record. This evidence provides a caution concerning the reliability of tomb and temple representations to provide a complete picture for modern scholars. Bead-net dresses were often worn over V-neck dresses as well as wraparound dresses and were constructed in geometric patterns. Two archaeological examples date to the Old Kingdom. The beads are cylinders of blue or green faience threaded into a diamond pattern. In the artistic evidence the bead-net dresses are worn over a wraparound dress. In art the bead-net dresses are fairly common in the Old and Middle Kingdoms, but decline in number during the New Kingdom.

BAG TUNICS. Both men and women wore bag tunics. They could wear them either full-length or half-length. Though the full-length bag tunic superficially resembled the modern Egyptian galabiyah due to its shirt-like nature, the bag tunic differs from the modern costume because male and female galabiyahs are

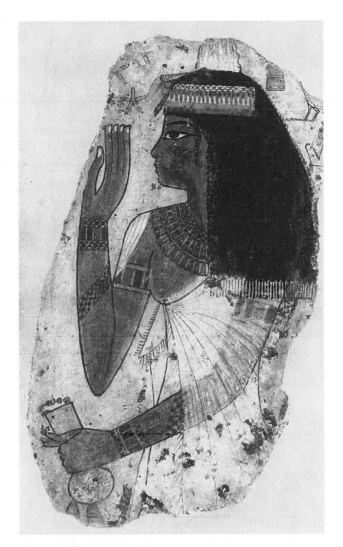

The Lady Tjepu wears a complex wraparound dress that became fashionable in the New Kingdom. More complex and luxurious fashions reflect the wealth of the period. **BROOKLYN MUSEUM OF ART, 65.197, CHARLES EDWIN WILBOUR FUND. REPRODUCED BY PERMISSION.**

constructed in entirely different ways. Bag tunics for men and women, however, were both made from a single piece of cloth, folded, and then sewn together on two sides, leaving holes for the arms. The bottom was left open. A key-hole shaped opening was cut in the shorter side to allow the wearer to pull it over the head. The ends and the openings were hemmed. Some bag tunics were made from heavy material while others were from fine material, and people of all stations owned both kinds. Vogelsang-Eastwood and others suggested that the differences in weight represent summer and winter wear. Some bag tunics were also decorated. They could have fringe, bead work, gold or faience sequins, applied patterns, or embroidery. The full-length bag tunic first appeared in the Middle Kingdom and

WOMEN'S Wardrobes: Continuity and Change

Women's wardrobes were very conservative in ancient Egypt. Old and Middle Kingdom wardrobes were nearly identical. New, more elaborate fashions became popular in the New Kingdom.

SOURCE: Gillian Vogelsang-Eastwood, *Pharaonic Egyptian Clothing* (Leiden, Netherlands: E. J. Brill, 1993).

Garment	Old Kingdom	Middle Kingdom	New Kingdom
Cloth loincloth	X	X	X
Skirts, various lengths	X	X	X
Simple wraparound dress	X	X	X
Complex wraparound dress			X
V-necked dress		X	
Bag tunic			X
Bead-net dress	X		
Sashes and straps	X	X	X
Long cloak	X	X	X
Shawl	X	X	X

SOURCE: Gillian Vogelsang-Eastwood, *Pharaonic Egyptian Clothing* (Leiden: E. J. Brill, 1993).

CREATED BY GGS INFORMATION SERVICES. GALE.

became widespread in the New Kingdom. While both men and women wore the full-length bag tunic, only men wore the short bag tunic. This garment was identical to the long bag tunic, differing only in its length. The existing archaeological examples of short bag tunics date to the Eleventh Dynasty (2081–1938 B.C.E.) and to the New Kingdom (1539–1075 B.C.E.). They vary in length from seventy to ninety-three centimeters (27.5 to 36.6 inches). Mainly workmen wore these garments that seem to replace the archaic wraparound worn during the Predynastic Period and the Old Kingdom. These changes suggest that the Egyptians increasingly wore sewn garments during the transition to the New Kingdom.

SHAWLS AND CLOAKS. Shawls and cloaks are similar because people wore them over other garments. In Egypt, shawls and cloaks were both fashioned from oblong, square, or rectangular pieces of cloth. Scholars have paid little attention to archaeological examples of shawls. Of nineteen shawls that Howard Carter, the archaeologist, mentioned in his notes on the tomb of Tutankhamun, scholars have had access to only one fine linen example. Carter, however, discovered it wrapped around the neck of a statue of the jackal god Anubis. Thus it is not clear that this is an example of human clothing. In tomb and temple reliefs, some officials in the Middle Kingdom wore pleated shawls. But the majority of representations of shawls are worn by foreign musicians during the reign of Akhenaten (1352–1336 B.C.E.). Cloaks were similar to blankets, a large oblong, square, or rectangular piece of cloth worn for warmth. People could either wrap them around the body or knot them at the shoulder. No archaeological examples have been recognized, but artists often depicted people wearing cloaks. Normally wraparound cloaks were worn over both shoulders and held together with the hands, especially in Old Kingdom examples. In some Middle Kingdom and New Kingdom examples in art, the cloak passes over only one shoulder and is wrapped tightly around the body. More active people, such as hunters and chariot drivers, wore knotted cloaks. The difference in whether an Egyptian wore a wraparound or knotted cloak seems to depend on whether his/her hands needed to be free. Thus the wraparound cloak was worn when a person could hold the cloak closed, while active people whose hands were otherwise occupied knotted their cloaks.

ACCESSORIES. There were three types of accessories that could be added to most types of clothing: sashes, straps, and codpieces. Sashes differed from belts because they were made from cloth rather than leather. Sashes were an important element in ancient Egyptian clothing and were commonly illustrated in depictions of men and women. Surviving examples of sashes from archaeological contexts are made from rope or tasseled cloth. In general the cloth sashes had hemmed edges

96

Arts and Humanities Through the Eras: Ancient Egypt (2675 B.C.E.–332 B.C.E.)

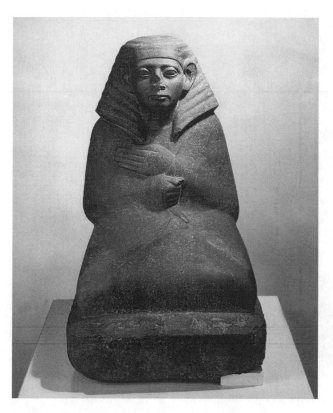

Cloaked official. BROOKLYN MUSEUM OF ART, 62.77.1, CHARLES ED-
WIN WILBOUR FUND. REPRODUCED BY PERMISSION.

and tassels at the ends. Sashes could be very wide, vary-
ing between five and sixteen centimeters (two to six
inches). Sashes also varied by economic status. The
cheapest sashes must have been ropes that workmen
wore. Some soldiers in relief scenes wear broad cloth
sashes that hang down from the waist in the front. They
could be placed so that they covered the top of the kilt
or beneath the top edge of the kilt. Scholars have not
studied sash placement but it is possible that certain
fashions predominated in different times. The most va-
riety, as is often the case, is visible in representations
from the New Kingdom. Women rarely wore sashes in
artistic representations. Like sashes, it was men who
commonly wore either single or double straps that ex-
tended from the shoulder to the opposite hip. The
straps could be either one or two pieces of cloth. Both
high officials and workmen could wear such straps,
though they appear most commonly worn by officials.
Women wore separate straps while dancing or doing
strenuous work in the fields, but straps were not com-
mon for women except in these special circumstances.
The codpiece was an accessory only worn by men and
usually was used for protection. Several battle scenes
dating to the Middle Kingdom show men wearing a
separate garment over the genital area. The American

Egyptologist H. G. Fischer suggested that it is a cod-
piece or penis sheath that originated in Nubia. The
Egyptian officials Ukhhotep and Senbi wore similar
garments on a hunting expedition in a relief of Dynasty
Twelve (1938–1759 B.C.E.).

SOURCES

Gay Robins, "Problems in Interpreting Egyptian Art," in
Discussions in Egyptology 17 (1990): 45–58.

Gillian Vogelsang-Eastwood, *Pharaonic Egyptian Clothing*
(Leiden: E. J. Brill, 1993).

SEE ALSO *Dance: Costumes and Fashion in Dance;
Music: Banquet Music during the New Kingdom;
Visual Arts: Interpreting Egyptian Art*

HAIRSTYLES

USE OF WIGS. Most scholars believe that some an-
cient Egyptian men and women often wore wigs re-
gardless of the style of their natural hair. The more
elaborate styles that artists represented for upper-class
men and women were almost certainly wigs. Represen-
tations of rich women often include a fringe of natural
hair at the forehead, under a wig, leading scholars to be-
lieve that it was a sign of wealth and status to wear a wig
and that vanity had little to do with it. Most scholars as-
sume that all people above a certain station were depicted
with wigs on, yet it is not always clear whether the style
in a statue, relief, or painting is a wig or is natural hair.

MEN'S HAIRSTYLES. During the Old Kingdom
(2675–2170 B.C.E.), men wore both a close-cropped
style and a shoulder-length style. The shorter style
probably represents natural hair cut close to the skull.
The wearer swept the hair back in wings, covering the
ears, when wearing the shoulder-length style. Men also
wore moustaches and sometimes a goatee in this pe-
riod. Working men wore their natural hair cropped
closely. Only workmen were ever depicted with gray
hair or with male-pattern baldness. This difference be-
tween richer and poorer men in statues, reliefs, and
paintings reflects a wider convention of portraying
upper-class tomb owners in an idealized manner, at the
most attractive point in their lives. The major distinc-
tion between men's hairstyles of the Old and Middle
Kingdoms (2008–1630 B.C.E.) was in the shoulder-
length style. Often in the Middle Kingdom men tucked
their hair behind the ears when wearing shoulder-
length hair in contrast to the covered ears of the Old
Kingdom. This feature of the hairstyle probably relates
to the fashion for large, protruding ears during this

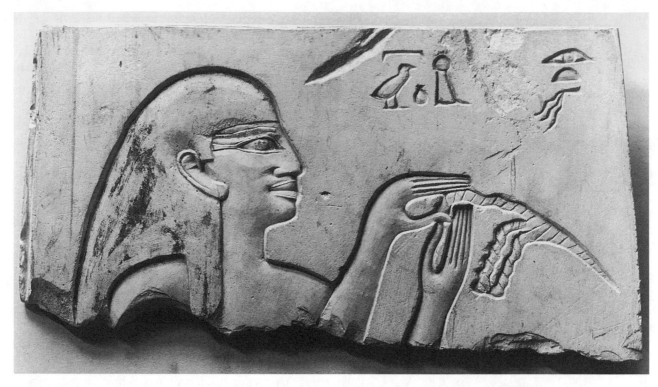

Relief of hairdresser Inu. BROOKLYN MUSEUM OF ART, 51.231, CHARLES EDWIN WILBOUR FUND. REPRODUCED BY PERMISSION.

period. Men also wore wigs pushed farther forward than they had during the Old Kingdom, indicating that a low forehead was considered attractive in this period. While early in the New Kingdom, men continued to wear the same styles that had been popular in the Middle Kingdom, men's styles became more elaborate around the reign of Amenhotep II (1426–1400 B.C.E.). Artists portrayed a hairstyle with two different styles of curls: one in triangular-shaped wings, or lappets, at the side of the head and one down the back. Scholars sometimes call it the lappet wig because of these overhanging folds of hair. These details made hairstyles appear more complex and suggest that men paid more attention to their hair in this period of relative peace and prosperity.

WOMEN'S HAIRSTYLES. Women also could wear either a short or a long hairstyle in the Old Kingdom. The ideal was heavy ringlets that could just frame the face, or a longer wig that included hanks of hair over each shoulder and down the back. Scholars call this style "tripartite" because the wearer divided her hair into three sections. Tripartite hairstyles could be shoulder-length or longer. Often a fringe of natural hair was displayed over the forehead when wearing a tripartite wig. Almost all women wore the same styles regardless of class. During the Middle Kingdom, women

added short, curled wigs to the possibilities for coiffure. Royal women also began wearing the so-called Hathoric wig, named for the goddess Hathor. This style resembled the way Hathor wore her hair when depicted on the capital of an architectural column. The thick, wavy hair came forward over the shoulder and curled, sometimes around a ball. Natural hair remained visible down the woman's back. At the beginning of the Eighteenth Dynasty (1539–1292 B.C.E.), royal women continued to wear the Hathoric wig and the now ancient tripartite wigs. When human women wore this style in depictions, the artists decorated it with additional rows of horizontal ringlets. Goddesses, however, wore their hair in the most conservative fashion, recalling the Old Kingdom style. Upper-class women also added a full-length style called enveloping. Rather than dividing the hair into three parts as in the tripartite wig, an enveloping style presented the hair as a continuous mass enclosing both shoulders and the back. In the Eighteenth Dynasty, enveloping styles generally reached the shoulder blades. Women's hair was a component of their sexual allure. Images of young women on cosmetic articles such as mirrors or the objects called cosmetic spoons, have especially elaborate hairstyles. In *The Story of Two Brothers,* written in the Ramesside Period (1292–1075 B.C.E.), the scent of a woman's hair prompts a man to kill her husband because he desires

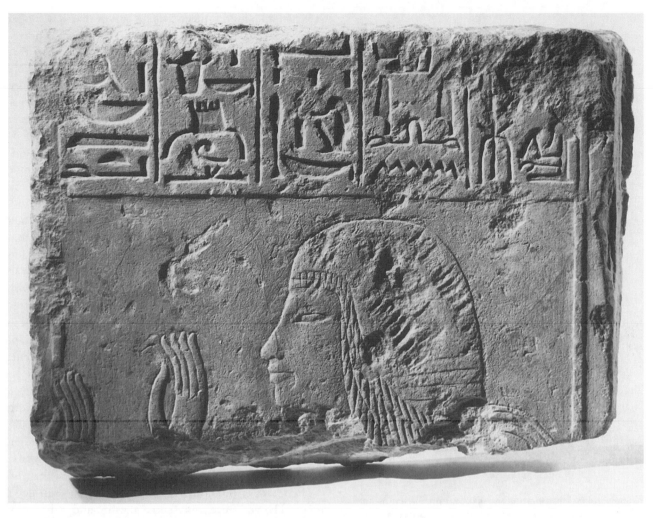

Relief of Amunmose in New Kingdom hairstyle. BROOKLYN MUSEUM OF ART, 65.196, CHARLES EDWIN WILBOUR FUND. REPRODUCED BY PERMISSION.

her so greatly. The scent of a god's hair also helps identify him.

UNISEX STYLES. During the reign of Akhenaten (1352–1336 B.C.E.) men and women could wear nearly identical styles. The most popular unisex style was the Nubian wig. This hairstyle consisted of tapering rows of tight ringlets in layers. Such hairstyles can be found in sub-Saharan Africa in modern times and most likely derived from hairstyles in Sudan (ancient Nubia) during the New Kingdom. Another Nubian style worn in New Kingdom Egypt was the rounded wig. This wig hung in ringlets to the nape of the neck. Both men and women wore the Nubian wig and the rounded wig. Moreover, both royalty and commoners wore these styles. The royal wearers had more complex wigs, but basically the styles were the same for all. These styles, however, were abandoned at the end of the Eighteenth Dynasty. During the Ramesside Period (Nineteenth and

Twentieth Dynasties, 1292–1075 B.C.E.), long hair was the defining stylistic characteristic. Men continued to wear the lappet wig, and women still wore enveloping and even tripartite wigs. But now men's hair could reach below the shoulders. Women's hair could reach their waists.

SHAVED HAIRSTYLES. Both male and female children could wear the so-called "side lock of youth." In this style, most of the head was shaved, except for a long tuft of hair gathered at one side and usually plaited. This style also associated the child with certain gods who played the role of a child within a divine family. In many periods of Egyptian history priests shaved their heads, and perhaps other parts of their bodies, to achieve ritual purity. Especially in the Ramesside period, artists depicted processions of bald priests carrying the god's boat or performing other ritual actions.

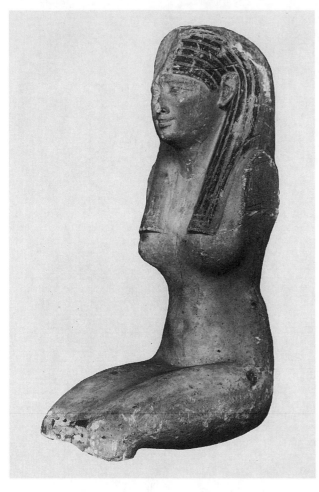

Seated goddess in tripartite wig. BROOKLYN MUSEUM OF ART, 37.594E, CHARLES EDWIN WILBOUR FUND. REPRODUCED BY PERMISSION.

SOURCES

Jacques Vandier, "Coiffure, Costume et parure (ancien empire)," in *Manuel d'archéologie égyptienne* (Paris: A. et J. Picard, 1952–1978): 106–115.

——, "Costume et coiffure (moyenne empire)," in *Manuel d'archéologie égyptienne* (Paris: A. et J. Picard, 1952–1978): 248–253.

——, "Costume et coiffure (nouvel empire)," in *Manuel d'archéologie égyptienne* (Paris: A. et J. Picard, 1952–1978): 347–352.

CROWNS

CONNECTION BETWEEN DEITIES AND ROYALTY.
Royalty in ancient Egypt wore crowns that connected them to the gods. In almost every artistic depiction of the gods, the gods can be seen wearing a crown that identifies them with some sort of aspect of nature or power.

When a king or a queen wore a crown that was similar to the depicted crown of the deity, they were connecting themselves with power and the protection of that god or goddess. Kings, queens, and princesses also wore crowns that identified their rank and function, while also enhancing the wearer's appearance and status by association with precious materials and by making the wearer to appear physically taller. A very limited selection of archaeological examples of crowns has survived into modern times. These examples include only circlets and some kerchiefs. The circlets were crafted from gold, silver, and gemstones. Thus precious materials worn by the deities and the royal family enhanced and demonstrated their high status. Moreover, precious materials associated royalty with the divine. Gods, in Egyptian belief, had skin made from gold. Thus the addition of a gold element to a human's headgear suggested a close connection with the divine. Additionally, reliefs and sculpture portray royal and divine crowns that were very tall. These tall crowns often included feathers that made the wearer appear taller and allowed him or her to dominate a scene. This height also connected the wearer to the divine by being closer to the heavens; one text described Queen Hatshepsut's crown "piercing the heavens." Along with height, some accessories on crowns also linked the wearer with the divine. The solar disk, for example, was often a central element of a crown and associated the wearer with the sun god, Re. The Uraeus-snake (cobra) was also often part of the crown and symbolized the sun god's eye. The god's eye represented the fire and radiance of the sun that consumed potential enemies. The Uraeus thus represented divine protection for the wearer.

URAEUS. The number of Uraeus snakes on a crown can often help an Egyptologist determine its date. In the earliest periods, kings wore the Uraeus attached to a stripped kerchief called the Nemes. Egyptian kings wore the Nemes with Uraeus and the Uraeus on a circlet from the First Dynasty through the Sixth Dynasty (3100–2170 B.C.E.), but in this period did not wear it with the tall crowns. During the Sixth Dynasty (2350–2170 B.C.E.) royal women also began to wear the Uraeus. At the beginning of the Eighteenth Dynasty in the reign of Ahmose (1539–1514 B.C.E.), royal women started wearing a double Uraeus as part of their crowns. These snakes wore miniature versions of the king's primary crowns—the Red Crown and the White Crown—on their heads. Sometimes the double Uraeus flanks a vulture's head on the female crowns. This combination represented the goddesses Wadjit and Nekhbet who were symbols of Upper and Lower Egypt. When a deceased king wore the double Uraeus, however, it represented the goddesses Isis

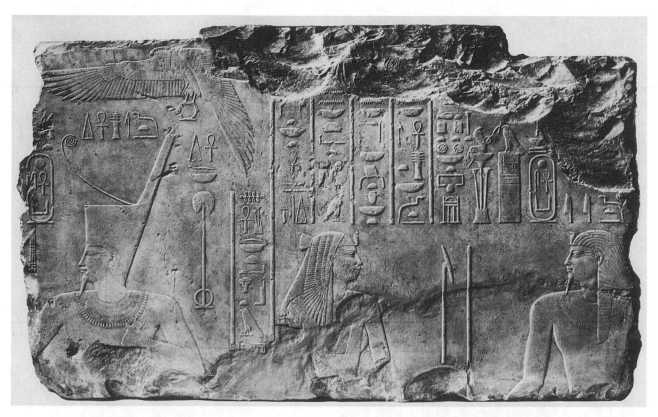

Relief of Mentuhotep III, showing queen in vulture headdress, king in Red Crown and Neme. **BROOKLYN MUSEUM OF ART, 37.16E, CHARLES EDWIN WILBOUR FUND. REPRODUCED BY PERMISSION.**

and Nephthys, the chief mourners for the king. During the Twenty-fifth Dynasty (760–656 B.C.E.), rulers from Sudan (ancient Kush) adopted the double Uraeus as part of their cap-like crown. Women's crowns also included the Uraeus with the head of a gazelle or ibis. By the Ptolemaic Period (332–30 B.C.E.) queens adopted triple Uraeus adornments to their crowns. Finally, some tall crowns adopted in the reign of Amenhotep III (1390–1352 B.C.E.) incorporated a base made from multiple Uraeus snakes. Amenhotep III's son, Akhenaten, adopted this base as a circlet and wore Uraeus snakes around some of his crowns. The expansion of the importance of the Uraeus correlated with the importance of the sun god, especially during the reign of Akhenaten. The Uraeus was thus a basic element of royal crowns in all periods, but was used in a variety of ways.

ANIMAL AND PLANT ELEMENTS. Some crowns incorporated elements in shapes derived from other animal's bodies. These features also associate the wearer with the god who had an association with that animal. Thus falcon feathers on the crown associated the king with the falcon god Horus. The curved ram's horn, a symbol of the god Amun, became part of the royal crown as early as the reign of Amenhotep I (1514–1493 B.C.E.) and as-

sociated the king with the chief of the Egyptian pantheon during the New Kingdom. Some crowns were woven from reeds or were made from other materials in the shape of plant elements. Some crowns worn by queens and princesses incorporate plant elements that suggest youthful beauty. Some kings' crowns and even the crowns worn by the muu-dancers during funeral dances were made from reeds.

RED AND WHITE CROWNS. At least as early as the Old Kingdom (2675–2170 B.C.E.), kings wore nine different crowns. These crowns probably represented different aspects of the king's office. Similar crowns appeared in the coronation of Hatshepsut (1478–1458 B.C.E.) and of Ptolemy V (209–180 B.C.E.). Thus kings separated by thousands of years wore essentially the same crowns. The most commonly represented crowns were the White Crown, Red Crown, and Double Crown. The Red Crown and White Crown were the oldest crowns that Egyptian kings wore. Kings wore them from at least Dynasty 0 in the Predynastic Period (3200–3100 B.C.E.) and continued to wear them until the end of ancient Egyptian history. The Red Crown took its name from the oldest Egyptian name for the crown, *desheret* ("red thing"). By the Middle Kingdom (2008–1630 B.C.E.), Egyptians

Arts and Humanities Through the Eras: Ancient Egypt (2675 B.C.E.–332 B.C.E.)

101

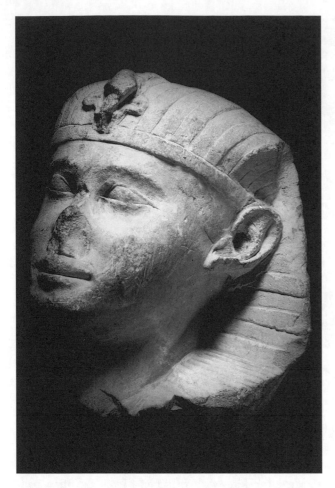

This king wears a nemes kerchief with a uraeus snake over his forehead. This style was restricted to kings and was popular from earliest to latest times in Egyptian history. **BROOKLYN MUSEUM OF ART, 16.169, GIFT OF EVANGELINE WILBOUR BLASHFIELD, THEODORA WILBOUR, AND VICTOR WILBOUR HONORING THE WISHES OF THEIR MOTHER, CHARLOTTE BEEBE WILBOUR AS A MEMORIAL TO THEIR FATHER, CHARLES EDWIN WILBOUR. REPRODUCED BY PERMISSION.**

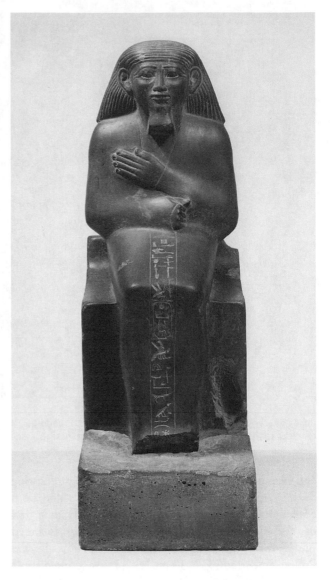

Ahmose, also known as Ruru. **BROOKLYN MUSEUM OF ART, 61.196, CHARLES EDWIN WILBOUR FUND. REPRODUCED BY PERMISSION.**

called the Red Crown the *net*—the Egyptian name of the goddess Neith. The Red Crown identified the king as ruler of Lower (northern) Egypt. The White Crown takes its name from the Egyptian *hedjet* ("white thing"). The White Crown designated the king as ruler of Upper Egypt. These crowns might have been made from leather or fabric. The *Pyramid Texts* include references to the Red Crown and White Crown where their colors associated them with planets and stars. From the earliest periods until the reign of Thutmose IV (1400–1390 B.C.E.) the Red Crown and White Crown were worn alone or combined in the Double Crown. By Thutmose IV's reign, the Red Crown or White Crown could be worn over a Nemes kerchief. This trend continued through the subsequent Ramesside Period (1292–1075 B.C.E.) when the Red Crown or White Crown always was worn with additional elements.

DOUBLE CROWNS. The name "Double Crown" is a modern construction. The Egyptians called the Double Crown *pas sekhemty* ("the two powerful ones"). The king wore the Double Crown to symbolize his rule over both Upper and Lower Egypt. Gods associated with kingship also wore the Double Crown. The god Horus wore it because each king was a living manifestation of this god. The god Atum wore the double crown to emphasize his cosmic rule. The goddess Mut wore the Double Crown over a vulture cap. Because Mut was the divine mother and a consort of the chief god Amun, her headgear stressed her connection to the king. The Double Feather Crown, called *shuty* ("two feathers"), was nearly always worn in combination with

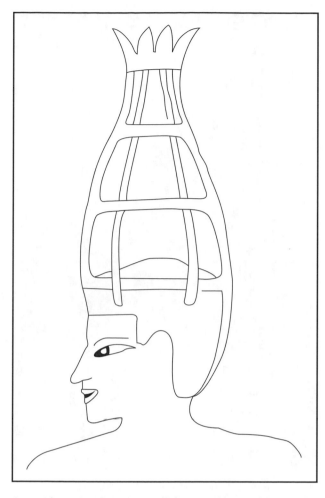

A muu-dancer's crown was made from reeds. Muu-dancers performed in the funeral procession, acting out the deceased's journey from this world to the afterlife. **CREATED BY GGS INFORMATION SERVICES. GALE.**

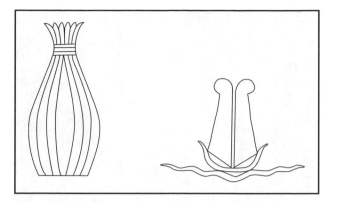

On the left, a crown made of reeds might be the ancestor of the king's White Crown, symbol of the king of Upper (southern) Egypt. On the right, the Atef crown consists of two tall feathers, cow horns, and ram horns. The king wore this crown when performing temple rituals. **CREATED BY GGS INFORMATION SERVICES. GALE.**

another crown. The major elements of the Double Feather Crown are two tall feathers, from either an ostrich or falcon, and the horns of a ram and a cow. The first king known to wear this crown was Sneferu (r. 2625–2585 B.C.E.), and kings continued to wear it until the end of ancient Egyptian history. The crown originated in Lower Egypt in the town called Busiris and was worn by its local god named Andjety. Busiris later was the Lower Egyptian home for the god Osiris who also sometimes wore feathers. The chief god of the pantheon Amun, the fertility god Min, and the war god Montu all also wore the Double Feather Crown. Their characteristics might have been conveyed to the king when he wore the crown. The Double Feather Crown sometimes included Uraeus snakes and sun disks. The king wore this crown during one segment of the coronation. The Double Feather Crown could also be worn with the Atef Crown.

ATEF CROWN. The Atef Crown combined a cone-shaped central element that resembles the White Crown with the Double Feather Crown. Sahure (r. 2485–2472 B.C.E.) was the first king known to wear the Atef Crown, and it continued in use until the end of ancient Egyptian history. The god of the afterlife, Osiris, as well as the ram god Herishef, the royal god Horus, and the sun god Re all were depicted wearing an Atef Crown. In the New Kingdom (1539–1075 B.C.E.), the Atef Crown also bore a sun disk and Uraeus snakes. Thutmose III (1479–1425 B.C.E.) also added the fruit of the *ished*-tree (probably the persea tree) to the crown, associating it with the eastern horizon where this tree grows. The meaning of the word "atef" in Egyptian remains in dispute. It might mean "his might" or "his majesty."

KERCHIEFS. The blue and gold striped cloth arranged as a kerchief on the king's head and called the Nemes is also very ancient. The earliest known representation was part of a statue of King Djoser (r. 2675–2654 B.C.E.). The Nemes is included in the emblem of the royal ka (spirit) called the Standard of the Ka. The Nemes' association with the royal ka suggests that the Nemes somehow represents kingship itself. By the Eighteenth Dynasty (1539–1292 B.C.E.), the Nemes covered the king's head while he wore other crowns on top of it. The king also wore the Nemes when he appeared as a sphinx, such as at the Great Sphinx of Giza, or when he appeared as the falcon god Horus. The Khat Kerchief and the related Afnet Kerchief may be the funerary equivalent of the Nemes. The pairs of statues that guard New Kingdom royal tombs wear the Khat and Afnet Kerchiefs. Tutankhamun's mummy is also depicted wearing the Khat. The goddesses of mourning,

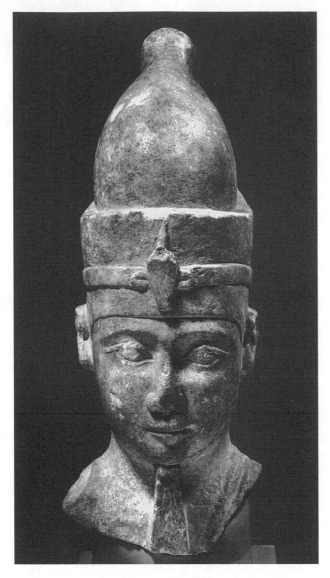

Head of a king in a double crown. BROOKLYN MUSEUM OF ART, 37.1489E, CHARLES EDWIN WILBOUR FUND. REPRODUCED BY PERMISSION.

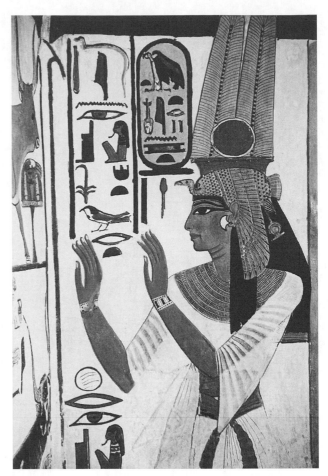

Queen Nefertari wearing the vulture headdress, modius, a sun disk, and two tall feathers. © CHRISTEL GERSTENBERG/CORBIS. REPRODUCED BY PERMISSION.

Isis and Nephthys, also wore the Khat. This strong representation among funerary goods suggests that the Khat and Afnet aided in rejuvenation after death.

CAP CROWN. The Cap Crown first appeared in the Old Kingdom (2675–2170 B.C.E.). Circles or horizontal lines decorate the cap crown in most representations. It is blue or gold in representations that include color. The preserved Cap Crown that Tutankhamun's mummy (1332–1322 B.C.E.) wore, in contrast, was white and decorated with blue faïence and gold beads. The king often wore the Cap Crown when performing religious rituals. Queen Nefertiti, wife of Akhenaten (1352–1336 B.C.E.), also wore the Cap Crown. Kushite kings of the Twenty-fifth Dynasty (760–656 B.C.E.) wore a Cap Crown with a double Uraeus snake. The color of the Cap Crown and the circle decoration relates it to the Blue Crown. The Blue Crown, called the *kheperesh* in Egyptian, first appeared in the Second Intermediate Period (1630–1539 B.C.E.). It shares both the color and circle pattern with the older Cap Crown, and thus some Egyptologists believe they are related. The Blue Crown is most likely the crown that the king wore most often while performing his duties in life during the New Kingdom. Because the king also wears this crown while riding in a war chariot, the crown is sometimes called a war crown, though this is probably an error. The crown represents action, both in peace and in war. When combined with the Nemes, however, it represents a deceased king.

WOMEN'S CROWNS. Fewer crowns were available to royal women than to men, and they are slightly better understood. Female crowns relate clearly to god-

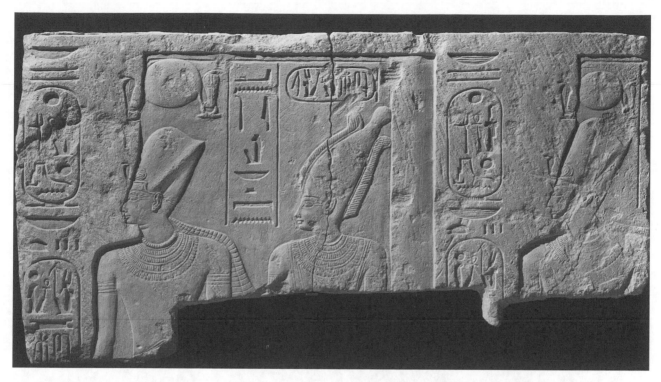

Temple relief of Ramesses II, wearing the Blue and Atef Crowns, and the goddess Anat. **BROOKLYN MUSEUM OF ART, 54.67, CHARLES EDWIN WILBOUR FUND. REPRODUCED BY PERMISSION.**

desses and wearing them associated the queen or princess with the characteristics of the related goddess. The oldest known female crown is the Vulture Cap. The vulture was the sacred animal of the goddess Nekhbet of Upper Egypt. The hieroglyph of a vulture was the writing of the word "mother," and thus the mother goddess Mut wore the Vulture Cap, too. The Vulture Cap thus associated the queen with Nekhbet and stressed her role as mother of the next king. Fertility and motherhood were also symbolized by cow horns added to the queen's wig, a symbol of the goddess Hathor. Royal women after the Sixth Dynasty could wear the Uraeus snake, a solar symbol associated with the eye of the god Re. Since the Egyptians recognized the eye as the Lower Egyptian goddess Wadjit, wearing the Vulture Cap (Nekhbet) with the Uraeus (Wadjit) could symbolize the union of Upper and Lower Egypt. When queens wore tall feathers, they were meant to represent the eastern and western horizons. The feathers thus also connected the crown to the cult of Re who rose and set on the horizon as the sun. The base for the feathers was interpreted as the marsh of Khemmis, the place where the goddess Isis raised her child Horus, the infant king. Thus the crown could combine symbolism from both solar religion and funerary religion.

SOURCES

Abd el-Monem Abubaker, *Untersuchungen uber die altägyptischen Krone* (Gluckstadt, Germany: J. J. Augustyn Verlag, 1937).

Edna R. Russmann, "Vulture and Cobra at the King's Brow," in *Chief of Seers: Egyptian Studies in Memory of Cyrial Aldred.* Ed. E. Goring (London: Kegan Paul International, 1997): 266–284.

SEE ALSO *Religion: Kingship Rituals*

JEWELRY AND AMULETS

PROTECTION. Archaeology has provided many examples of Egyptian jewelry for study. Upper-class Egyptian men and women wore jewelry and considered it essential for being fully dressed. Jewelry served to protect people, according to Egyptian thought. The areas most in need of protection were the head, neck, arms, wrists, fingers, waist, and ankles. Thus hairpins, necklaces, armlets, bracelets, finger-rings, decorative girdles, and ankle bracelets all became popular as a means of protecting vulnerable areas. Unlike modern jewelers, who normally use casting to shape their products, Egyptian jewelers more often hammered sheet metal, then cut, shaped, crimped, and soldered it to

Arts and Humanities Through the Eras: Ancient Egypt (2675 B.C.E.–332 B.C.E.)

105

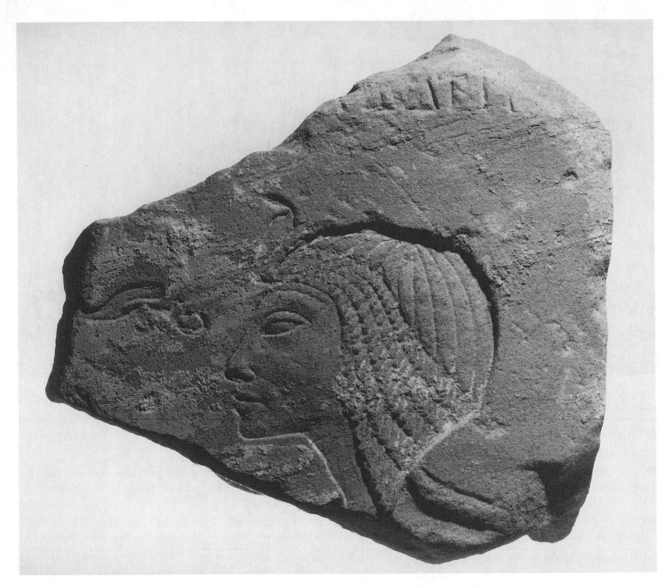

Late image of Nefertiti. BROOKLYN MUSEUM OF ART, 35.1999, GIFT OF THE EGYPT EXPLORATION SOCIETY. REPRODUCED BY PERMISSION.

make settings for stones. Jewelers also hand-wrought wires for chains. Often tomb jewelry was inexpensively gilded wood or steatite (soapstone) rather than solid gold. Only the wealthiest Egyptians could afford to bury solid-gold objects. People who could not afford jewelry made from precious metals and semi-precious stones but who still desired the protection it could give used flowers, seeds, and shells for personal adornment. The most popular inexpensive substitute material was faience. Faience is made from fired sand with a glaze made of soda-lime-silicate. Jewelers could make faience jewelry in molds. Thus faience could imitate nearly any shape. It also could be colored in a wide variety of shades from white to green to blue. Many scholars believe that, though inexpensive, faience was also popular because of its dramatic transformation from sand as a raw material to a glittering colored surface.

SYMBOLISM. Many items of Egyptian jewelry were symbolic as well as expressions of wealth and status. The Egyptians thought that the gods' flesh was gold and their bones were silver. Thus these two precious metals associated the wearer with the divine. Colorful semi-precious stones could also represent various ideas through symbolism. Red stones represented powers such as the sun. Green represented regeneration and growth, important for the symbolism of rebirth into the next world. Deep blue represented the heavens and the waters of the Nile. Royal jewelry beginning in the Old Kingdom had a standard red/green/blue pattern that tied together the most important concepts through symbolism.

SEMI-PRECIOUS
Stones—Imported and Local

The Egyptians used a wide variety of imported and local semi-precious stones in their jewelry. The following lists show the range of colorful stones available for the ancient jeweler to set. Jewelry also helps to establish wide-ranging trade networks available to the Egyptians.

Local Stones

Amazonite

Amethyst

Banded Agate

Calcite

Carnelian

Emerald

Fluospar

Green feldspar

Hematite

Jasper

Malachite

Olivine

Peridot

Porphyry

Rock crystal

Serpentine

Imported Semi-Precious Stones

Lapis lazuli, Afghanistan

Turquoise, Sinai

Obsidian, Iran

BOATMAN'S CIRCLET. The Egyptians called the first known head ornaments worn both by men and women the boatman's circlet. Originally it was a headband made of woven reeds that kept a boatman's hair in place while he worked. Wealthy women such as Seneb-tisi who lived in the Twelfth Dynasty (1938–1759 B.C.E.) had a gold head circlet imitating the boatman's headband. Princess Khnumet, also of the Twelfth Dynasty, was buried in a headband of gold imitating the reeds of a boatman's circlet but with additional blue, red, and green stones to represent flowers.

DIADEMS. A headband or circlet becomes a diadem when a royal person wears it. Gold headbands with added Uraeus-snake or vulture were worn by queens in the Twelfth Dynasty. Princess Sit-Hathor-Yunet wore a diadem with fifteen inlaid roundels, papyrus flowers, and a Uraeus-snake. A royal woman of the Eighteenth Dynasty wore such a diadem with a gazelle rather than a Uraeus, a sign she was a secondary queen.

WIG DECORATIONS. Burials of the Twelfth and Eighteenth Dynasties also have revealed wig decorations. Seneb-tisi, a woman who lived in the Twelfth Dynasty included gold rosettes spaced at regular intervals on her wig. Princess Sit-Hathor-Yunet wore short gold tubes threaded on the hair of her wig. One of the royal women from the Eighteenth Dynasty wore a head covering of gold rosettes strung between beads over her wig.

RINGS AND EARRINGS. Finger rings of gold, silver, bronze, copper, or faience often incorporated hieroglyphic signs, especially signs for words that signified characteristics Egyptians prized. Thus jewelers made rings from the ankh (life) hieroglyphs along with signs for eternal existence, healing, protection, and stability. One popular ring form was a bezel or base for a scarab beetle with an inscription on the bottom. Often the inscription was the name of a king, a deity, or a wish for health. Unlike rings, which were standard jewelry long before 2000 B.C.E., ear ornaments joined Egyptian jewelry in the Second Intermediate Period (1630–1539 B.C.E.) and did not become popular until the New Kingdom (1539–1075 B.C.E.). Popular styles included hoops, pendants, studs, and plugs. Both men and women wore earrings, though kings did not wear them in representations, even though several royal mummies have pierced ears. Earrings were included among Tutankhamun's treasures, but the mummy did not wear earrings even though he had pierced ears and wore many other kinds of jewelry. This is a puzzling contradiction.

BEADED COLLARS. In Egypt's long history there were several trends or fads in jewelry. But the longest-lived item was the beaded collar. There were two types of beaded collars worn by men, women, and deities. They included the *wesekh* ("broad") collar and the *shenu* ("encircling") collar. The wesekh collar consisted of several rows of upright tube-shaped beads, strung close together. The bottom row used pendants shaped like a beetle, a

Arts and Humanities Through the Eras: Ancient Egypt (2675 B.C.E.–332 B.C.E.)

107

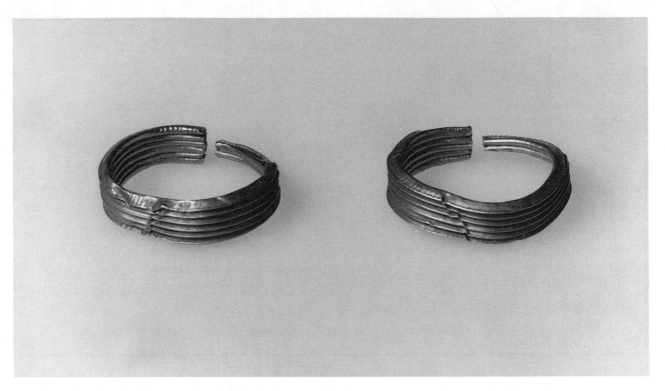

Pair of corrugated hoops. **BROOKLYN MUSEUM OF ART, 72.123A-B, CHARLES EDWIN WILBOUR FUND. REPRODUCED BY PERMISSION.**

symbol of eternal life, or a simple drop-shaped bead. The shenu collar used similar tube-shaped beads in alternating segments strung vertically and horizontally. Both collars were symmetrical, a general characteristic of Egyptian jewelry. They both also used the larger beads in the center and gradually reduce the size of the beads toward the edges, as well as terminals to gather the stringing of the beads. Finally they both used counterweights worn toward the back that relieved the weight of the necklace on the neck. The menat or counterweight also made it possible for the beaded collar to lie properly at the neck. The menat thus became a symbol of stability.

PECTORALS. Simple beads on a string around the neck developed into both collars and chest ornaments called pectorals. A pectoral is a piece of jewelry that hangs over the chest. The first pectorals were pendants with the name of the king inscribed on them. They were made from precious metals often inlaid with semi-precious stones. Some examples were shaped like a shrine with the king's name in a cartouche in the center. In the New Kingdom, pectorals often substituted a scarab for the king's name. The scarab beetle was a symbol of the sun-god. These scarab-beetle pectorals were worn only by mummies, not living people.

ARM/LEG ORNAMENTS. The Egyptians wore armlets on their upper arms and bracelets on their fore-

arms and anklets around their ankles. Both men and women wore armlets, bracelets, and anklets. All three could be either flexible or rigid. The flexible armlets, bracelets, and anklets were made from beads, while the rigid type is called a bangle, made from elephant ivory or precious metal. Bracelets were popular in both the Old and Middle Kingdoms. Armlets came into fashion only in the New Kingdom. Among the most famous sets of bracelets were the thirteen worn by Tutankhamun's mummy. They were made from gold with inlays of precious stones. They included protective symbolism such as the vulture, the Eye of Horus that could represent healing, and the scarab beetle representing the sun god. Anklets are indistinguishable from bracelets. They can be either made from beads or can be rigid bangles made with a hinge. It would not be possible to pass a rigid bangle over the entire foot to reach the ankle. Thus they were made with hinges that allowed them to open. There are many representations of men and women wearing anklets, but they can only be recognized when a mummy is wearing one. Tutankhamun's anklet, for example, looks exactly like a bracelet. Yet because it was discovered around his ankle, its true purpose is known.

JEWELERS. Jewelers were represented in tomb paintings, relief, and on stelae. Tomb representations

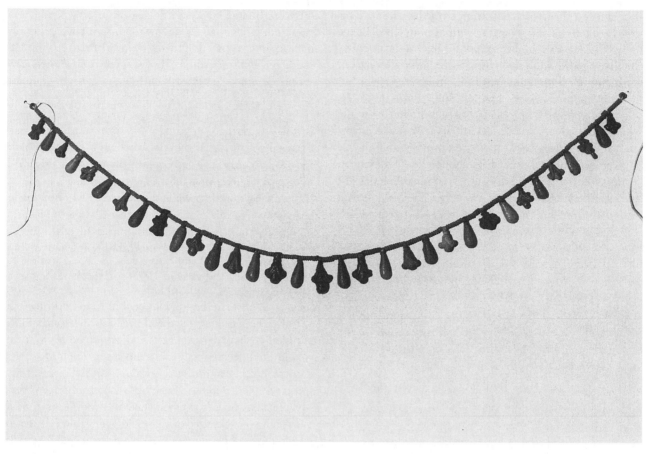

Single strand necklace with flower pendants. BROOKLYN MUSEUM OF ART, 48.66.44, GIFT OF MRS. LAWRENCE COOLIDGE AND MRS. ROBERT WOODS BLISS, AND THE CHARLES EDWIN WILBOUR FUND. REPRODUCED BY PERMISSION.

of jewelers show them at work at work benches and using their tools. In the tomb of the Sixth-dynasty (2350–2170 B.C.E.) prime minister Mereruka, people who weigh precious metals then melt them are represented with gold workers and bead stringers. Several dwarves work as jewelers in this scene, a common phenomenon. Dwarves had an association with Ptah, the patron god of craftsmen. But also it is possible that the small hands of dwarves were an asset in working with jewelry. In the New Kingdom, the best representation of jewelers is in the tomb of another prime minister named Rekhmire (reign of Thutmose III, 1479–1425 B.C.E.). Here men are represented drilling stone beads and stringing them as if they were in an assembly line. Stelae include the names of jewelry workers and imply that they were at least middle-class workers.

SOURCES

Cyril Aldred, *Jewels of the Pharaohs* (New York: Praeger, 1971).

Carol Andrews, *Ancient Egyptian Jewelry* (London: British Museum, 1990).

SIGNIFICANT PEOPLE
in Fashion

IRER

fl. Dynasty Twelve (1938–1759 B.C.E.)

Priestess
Overseer

HOUSEHOLD MANAGER. Irer lived in a town attached to the pyramid of Senwosret II (r. 1844–1837 B.C.E.) called Hotep-Senwosret. Irer was responsible for managing a household during the owner's absence on business. She also had responsibilities as a priestess in the temple dedicated to the deceased Senwosret II. In a letter

Arts and Humanities Through the Eras: Ancient Egypt (2675 B.C.E.–332 B.C.E.)

109

she wrote to the owner, she complains that she was unable to supervise the weaver's workshop attached to the household because of her responsibilities as a priestess. Irer's tone in the letter fluctuates between the subservience of an employee and annoyance that the owner is not fulfilling his responsibilities. She uses the standard formula, calling herself "your humble servant" and referring to the owner as "the lord, l.p.h." The initials refer to the Egyptian expression, "may he live, may he prosper, and may he be healthy," that follows each mention of a superior in writing. Yet Irer is straightforward in complaining that she cannot supervise the weavers properly if food supplies do not arrive from her master. Irer's letter demonstrates the way that household weaving shops were managed.

SOURCES

Edward F. Wente, *Letters from Ancient Egypt* (Atlanta: Scholars Press, 1990): 82–83.

DOCUMENTARY SOURCES
in Fashion

Anonymous, *Papyrus Brooklyn 35.1446* (c. Dynasty Thirteen, 1759–1630 B.C.E.)—This papyrus is a list of servants that includes twenty weavers who each specialized in a particular kind of cloth.

Irer, *Letter to her Master* (c. 1844–1837 B.C.E.)—This letter describes a woman's trouble supervising a home weaving workshop while the master is absent on business.

Nakht, *Cairo Papyrus 91061* (c. 2008–1938 B.C.E.)—This scribe's letter confirms the existence of home workshops for spinning and weaving cloth, and that cloth was sent long distances.

chapter four

LITERATURE

Edward Bleiberg

IMPORTANT EVENTS
in Literature

All dates in this chronology are approximations (c.) and occur before the common era (B.C.E.).

3300–3000 The earliest hieroglyphic writing emerges in the town of Abydos in Middle Egypt. This pre-dates the earliest Sumerian writing in Mesopotamia by about 300 years.

2625–2170 Old Egyptian, the oldest known stage of the ancient Egyptian language, is written in hieroglyphs and hieratic, a cursive writing system based on hieroglyphs.

 The first Egyptian literature includes the *Pyramid Texts*, the funeral service for the king carved on the interior walls of the pyramids of kings and autobiographies of noblemen carved on the walls of their tombs.

2625–2532 The earliest autobiographical inscriptions suggest that a man achieves self-worth by fulfilling responsibilities to his father.

2532–2425 Autobiographies of the late Fourth and the Fifth Dynasties portray a man's self-worth as being based on his relationship with the king.

2500–2350 Autobiographies of the Fifth Dynasty reveal that the Egyptians believed goodness was innate.

2065–1957 Egyptian noblemen revive the ideal of royal service as the theme of autobiography, an idea that had disappeared at the end of the Old Kingdom.

 2008 The literary theme of the overcoming of political chaos by a strong king appears in the new literature of pessimism, a litera-

ture that contrasts earthly reality with Egyptian ideals.

2008–1630 Middle Egyptian, the classical stage of the ancient Egyptian language used to compose poetry and prose for nearly 1,500 years, is also the spoken language.

1938–1759 New literary genres appear including narrative, teachings, and discourses.

1919–1875 *The Story of Sinuhe*, Egypt's great national epic poem is probably composed during this time.

1543–1539 The *Kamose Stela*, the oldest known historical account, is composed; the genre will grow in importance during the New Kingdom.

1539–1075 Late Egyptian, the language of a number of sophisticated prose stories, is also the spoken language.

 Autobiography grows less important as a form than it was in the earlier period and is published on statues rather than on tomb walls.

 Hymns emerge as an important literary form.

1479–1425 The *Annals of Thutmose III*, carved on the wall of the Temple of Amun at Karnak, directs readers to a leather roll in the library for the full version of the text, indicating that fuller versions of some texts existed in other media.

 A poem praising the city of Thebes is the only known Eighteenth-dynasty verse, contrasting with numerous poems of earlier and later periods.

1478–1458 Queen Hatshepsut publishes an historical account of her expedition to the land of Punt in Ethiopia, a very early description of a foreign country.

1390–1352 King Amenhotep III uses large faience scarabs to publish and distribute decrees and information, one way of producing multiple copies of a text with molds.

1352–1332 The king Akhenaten publishes the *Hymn to the Aten*, the first known literary work in Late Egyptian. Late Egyptian will become increasingly important for literature.

1292–1190 There is an apparent sudden flowering of a new narrative literature in Late Egyptian vernacular.

664 The Demotic language and script begin to be used in speech and literature by most Egyptians.

332 Alexander the Great, a Macedonian Greek, conquers Egypt and brings the Greek language to Egypt as the language of the ruling class.

196 The decree of Ptolemy VI exempting priests in Memphis from certain taxes is carved on a stela in Egyptian and Greek that will later be known as the Rosetta Stone, the key to recovering the ancient Egyptian language in modern times.

OVERVIEW
of Literature

LONG TRADITION. Ancient Egyptian authors produced literature for a 2,500-year period, making it one of the longest continuous literary traditions in world history. Ancient Egyptian literature began as hieroglyphic autobiographical accounts on the tomb walls of kings and nobles, and developed on papyrus, wooden tablets, and limestone chips over the centuries into several recognizable genres, including poetry, historical accounts, teachings, and stories. Despite its rich tradition, however, ancient Egyptian literature has not received the scholarly attention given to other ancient writings, such as those in Latin, Greek, and Hebrew. While scholars have been able to develop accurate translations and methods for uncovering the underlying meaning of Latin, Greek, and Hebrew texts since the fifteenth century, the study of Egyptian texts is a relatively new field, begun in the nineteenth century. And while the literature of ancient Greece and Rome as well as Hebrew texts like the Old Testament of the Bible are considered landmarks of world literature, ancient Egyptian literature is still an obscure branch of world literary tradition with virtually no readership beyond the Egyptologist community.

LOSS AND RECOVERY. The reason scholarship of ancient Egyptian literature has lagged so far behind that of other ancient writings stems from the difficulties of translating the language. From the late fifth century C.E. until 1822, the ancient Egyptian language was lost, largely due to changes in the language brought about by the conquering of Egypt by foreign nations: first the Greeks in 332 B.C.E., and then the Arabs in 642 C.E. Though Coptic, the last developmental stage of ancient Egyptian, continued to be spoken as the language of prayer for Egyptian Christians, the official government language in Egypt was Greek after Alexander the Great conquered the country in the fourth century B.C.E. Three centuries later, Egypt underwent another dramatic language shift when the conquering Arabs introduced the Arabic language and the Islamic religion to the nation. Now twice removed from their ancient tongue, Egyptians were no longer able to de-

cipher ancient texts; these writings remained unknown for centuries until the first modern Egyptologist, J.-F. Champollion cracked the code of hieroglyphics on the Rosetta Stone in 1822. This translation did not remove all the barriers to the study of literature, however, as ancient Egyptian literature comprises texts written in five dialects and six different scripts. More translations would have to follow, slowly building on the Rosetta-Stone translation.

NOT MUCH EVIDENCE. The problem of translation was not the only barrier to the study of ancient Egyptian literature, however. The surviving texts of what may be truly classified as literature include only about fifty examples, most in fragmented condition. The absence of inscribed dates and authors' names makes it difficult for scholars to pin down dates of composition, particularly when the surviving work is actually a copy of a text written in a much earlier period. The difficulty is compounded when, as is often the case, the setting of a text is historical. Many Twelfth-dynasty (1938–1759 B.C.E.) authors, for example, set their texts in the Fourth Dynasty (2625–2500 B.C.E.), which confused many late nineteenth-century scholars into believing that certain Middle Kingdom texts represented works from the Old Kingdom. Though these texts can now be sorted into approximate time periods, the absolute order in which they were written has not yet been established.

LIMITED INTERPRETATIONS. The lack of a complete body of works poses additional problems to scholarly interpretation of ancient Egyptian literature. Few texts are complete; some lack beginnings, others the middle, still others the end of the text. These fragments only provide clues to major themes, and the absence of a "big picture" can skew modern perspective. The problem of interpretation looms larger when scholars look beyond individual texts and attempt to draw conclusions on the basis of the larger body of surviving works. For example, there are dozens of copies of *The Story of Sinuhe* preserved while there is only one copy of *The Shipwrecked Sailor*, perhaps because *Sinuhe* was a model copied by students. If scholars could be certain that this ratio accurately reflected the body of Egyptian literature as a whole as opposed to that which survived, they could draw the conclusion that *Sinuhe* was much more important than *Shipwrecked Sailor* in Egyptian culture. It is not clear, however, whether the survival of a greater number of *Sinuhe* texts is an accident of preservation or whether there were more copies around to survive. A similar problem exists with apparent gaps in literary production. In the New Kingdom (1539–1075 B.C.E.), for example, there are many important narratives dating to the Nineteenth Dynasty (1292–1190 B.C.E.) and no narratives dating to the equally important Eighteenth

Dynasty (1539–1292 B.C.E.). Should scholars conclude that narratives were unimportant in the Eighteenth Dynasty or that by the accidents of discovery, the texts written then have not survived or not yet been discovered? Such problems have no immediate solution.

TYPES OF LITERATURE. Subject matter is one key to understanding the types of ancient Egyptian literature. Autobiography is the oldest subject, beginning in the Old Kingdom. Autobiographies are recorded in tombs and include prayers for offerings along with events from the deceased tomb-owner's life. In general, they include many stereotyped statements that demonstrate that the author had lived his life according to Egyptian principles of justice. Advice was the next most popular subject for Egyptian authors. Modern scholars have called these texts "wisdom," though they mostly deal with practical tips on careers and interacting with superiors. Wisdom could also include information about the nature of the moral life. Another subject was the gap between moral values and reality. This literature, called pessimistic, emerged at the end of the First Intermediate Period (2130–2008 B.C.E.), after a time of political chaos. The pessimistic literature represents the values of the ruling class and laments their loss of power during the period of political decentralization. Morality, indeed, is associated with the restoration of an Egyptian central government. Narratives emerged in both poetry and prose in the Middle Kingdom and were even more popular in the Nineteenth Dynasty and in the Late Period. Middle Kingdom narratives include the epic poem that deals with the adventures of a man named Sinuhe and the experience of a shipwrecked sailor, narrated in prose. New Kingdom and Late Period narratives seem more concerned with the gods' activities, though authors composed them in the contemporary speech of the people rather than the classical language. Modern knowledge of ancient love poetry is confined to the Nineteenth Dynasty, though this too seems an accident of discovery. The love poems are especially appealing because their interests and concerns seem so contemporary: a young girl yearns for a glimpse of her boyfriend while he spends time with his friends, or a boy plots to surprise his girlfriend while she lingers at the river.

TOPICS
in Literature

EGYPTIAN WRITING AND LANGUAGE

BIRTH AND LOSS. The earliest evidence for writing the Egyptian language in hieroglyphs dates to about 3300 B.C.E. During the 1990s, the archaeologist Gunter Dreyer discovered the earliest known inscriptions, a group of seals bearing the names of early Egyptian kings who reigned from 3300 B.C.E. to about 3100 B.C.E., in the town of Abydos, located in central Egypt. Dreyer's discoveries newly suggest that Egyptian was the first written language in the eastern Mediterranean, pre-dating Sumerian, the next oldest written language, whose writing system was invented in what is now modern Iraq about 3000 B.C.E. Hieroglyphs and more cursive forms of Egyptian writing called hieratic and demotic continued in use in Egypt for nearly 3,500 years. The *Pyramid Texts*, the funeral liturgy found in royal pyramids in the late Fifth and early Sixth Dynasties, and the autobiographies found in tombs of the same period (2500–2170 B.C.E.) constitute the first known Egyptian literature. In contrast to the vague date and unknown scribes of the first inscriptions, the last known Egyptian inscription written in hieroglyphs includes a date equivalent to 24 August 394 C.E. and the name of the scribe, Nesmeterakhem, son of Nesmeter, who composed it and carved it on a wall at the Temple of Isis in Philae on Egypt's southern border. By this time, Macedonian Greeks ruled Egypt following Alexander the Great's conquest of the country in 332 B.C.E. Greek had become the official language of the Egyptian government with Alexander's conquest, though ordinary Egyptians continued to speak and write their own language. Yet the ruling class, even among Egyptians, began to speak and write Greek because this language was now the key to power and success. Approximately 100 years after the last hieroglyphic inscription at Philae, an Egyptian named Horapollo who lived in Alexandria wrote a book in Greek called *The Hieroglyphics of the Egyptian*, completely mischaracterizing the hieroglyphic writing system. Horapollo probably based his description of hieroglyphs on lists he found in the Library of Alexandria. He had access to some accurate facts about the meaning of particular hieroglyphic signs, but he did not know that most of the hieroglyphic signs had phonetic values and that the hieroglyphs were a means of writing ordinary language. He wrote instead that hieroglyphs were pictures that could convey philosophical ideas to readers who were initiated in their mysteries. Horapollo's ideas derived from neo-Platonism, a Greek philosophical school current during his lifetime that stressed the role of contemplation in achieving knowledge. Horapollo believed that hieroglyphs were an object of contemplation and thus a source and expression of knowledge. Horapollo's book led early European scholars astray for the 403 years between his book's modern publication in Italy in 1419 and French scholar J.-F. Champollion's decipherment of hieroglyphs in 1822.

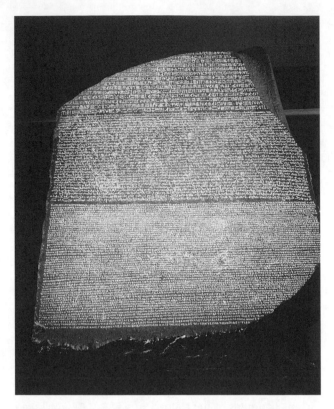

The Rosetta Stone, on which the same text was written in two forms of ancient Egyptian, hieroglyphic and demotic, as well as Greek. Discovery of the stone led to the decipherment of the demotic and hieroglyphic script in 1822. THE ART ARCHIVE/BRITISH MUSEUM/DAGLI ORTI.

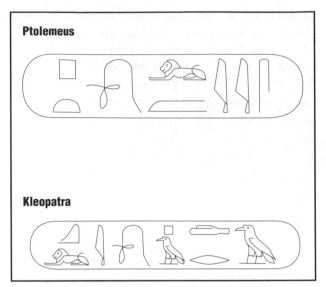

Hieroglyphic and Greek writings of the names of Ptolemy and Cleopatra. CREATED BY GGS INFORMATION SERVICES. GALE.

DECIPHERING HIEROGLYPHS. In 1822 Champollion became the first modern person to read Egyptian hieroglyphs. He based his study of hieroglyphs on the Rosetta Stone, a tri-lingual inscription bearing a date equivalent to 27 March 196 B.C.E. It is a decree issued by King Ptolemy VI, exempting the priests of Memphis from certain taxes, and recorded in Greek, Egyptian hieroglyphic, and in Egyptian Demotic, a cursive writing system derived from hieroglyphic. Champollion began his work with the assumption that the hieroglyphs represented the same text as the Greek. Since European scholars had never lost the ability to read ancient Greek, Champollion understood the contents of that section of the inscription with little difficulty. Champollion may have been aware of an English scholar named Thomas Young, whose private work on hieroglyphs, written in 1819 but never published, suggested that the ovals with hieroglyphic signs inside them carved on the Rosetta Stone were a phonetic writing of King Ptolemy VI's name. Champollion assigned sounds to the signs that represented Ptolemy's name by relying on the Greek text. He then compared the text in Greek and Egyptian hieroglyphs on the Bankes' Obelisk, a monument brought to England from southern Egypt in the early nineteenth century. This monument exhibited a Greek inscription with the name Cleopatra and a hieroglyphic inscription that included an oval with signs inside it. Taking the sounds "p," "t," "o," "l," and "e" that are common to both Ptolemy and Cleopatra's names, Champollion made a comparison between the two groups of hieroglyphic signs. He found that the expected hieroglyphic sign was in a predictable place. The same sign was present to write "p," the first sound in Ptolemy and the fifth sound in Cleopatra, in the first and fifth position of the writing of their names. The same expectations were met for the sounds "t," "o," "l," and "e." This comparison demonstrated that hieroglyphs were phonetic, not mystical, philosophical symbols. Using these known signs as equivalents for known sounds, Champollion was quickly able to identify the hieroglyphic writings of the names of many of the Roman emperors who ruled Egypt after Octavian (later the Roman emperor Augustus) conquered the country in 31 B.C.E. He used his knowledge of Coptic, the last stage of the Egyptian language written with Greek letters, to further identify the meanings of Egyptian words written in hieroglyphics. Subsequent scholarly work since Champollion's discovery has resulted in a nearly complete understanding of the Egyptian language, its grammar, and its place among the languages of the world.

DIALECTS OF EGYPTIAN. Egyptologists have discovered five different dialects of the Egyptian language, all of which had literature. A dialect is a variety of language distinguished by features of vocabulary, gram-

mar, and pronunciation from other varieties, but constituting together with them a single language. Some dialects are associated with different regions of a country. Other dialects, as is true with Egyptian, are separated by time. A more familiar example of this phenomenon is the language of the medieval English poems *Beowolf* and Chaucer's *Canterbury Tales*. They were composed in dialects of English, but are nearly incomprehensible to modern English speakers. Yet the languages of these poems are still the natural ancestors of our modern language. In the same way, the dialects of Egyptian—called Old Egyptian, Middle Egyptian, Late Egyptian, Demotic, and Coptic—each grew out of the previous dialectical stage of the language and represent different time periods. There must also have been regional dialects that scholars cannot recognize from the written evidence. Of the dialects preserved on papyrus, stone, and other writing materials, the oldest is Old Egyptian, used to compose the *Pyramid Texts* and the autobiographies found in Old Kingdom (2675–2170 B.C.E.) tombs. Middle Egyptian, spoken during the Middle Kingdom (2008–1630 B.C.E.) was Egypt's most important dialect. It was the classical language used to compose poetry and prose for 1,500 years after Egyptians stopped speaking it as their day-to-day language. Late Egyptian was the day-to-day speech of the New Kingdom (1539–1075 B.C.E.) and was favored by authors of popular tales. Demotic, used in speech by Egyptians during the Late Period through the Roman Period (664 B.C.E.–395 C.E.) was a vehicle for popular literature and business deals. At the same time that Demotic predominated among the Egyptian-speaking populace, the ruling class spoke Greek. Finally Coptic, written with the Greek alphabet and some additional characters used to convey sounds not found in Greek, is the last stage of the Egyptian language, emerging in the first century C.E. Egyptian Christians still use it as the language of prayer. Egyptians began speaking Arabic after the Moslem conquest of their country in 641 C.E.

LANGUAGE FAMILY. The ancient Egyptian dialects form one language and one language family called Hamito-Semitic or Afro-Asiatic. A language family normally groups together languages with similar vocabulary and grammar. English, for example, is a branch of the Indo-European language family with close connections to both German and French. The Egyptian language's close connections are with languages now spoken in other parts of Africa and in the Near East. Among the many African languages related to Egyptian are Berber, spoken in North Africa; Wolof, spoken in West Africa;

Scribe's exercise board with Hieratic text. BROOKLYN MUSEUM OF ART, 16.119, GIFT OF EVANGELINE WILBOUR BLASHFIELD, THEODORA WILBOUR, AND VICTOR WILBOUR HONORING THE WISHES OF THEIR MOTHER, CHARLOTTE BEEBE WILBOUR AS A MEMORIAL TO THEIR FATHER, CHARLES EDWIN WILBOUR. REPRODUCED BY PERMISSION.

and Bedja, spoken in Eritrea in East Africa. Egyptian also shares similarities with the vocabulary and grammar of the Semitic languages including Arabic, Aramaic, and Hebrew. These connections illustrate that Egypt was always a bridge between the African continent and western Asia.

EGYPTIAN SCRIPTS. Hieroglyphs are the most easily recognized ancient Egyptian script, but were not the most commonly used. Hieratic, a cursive writing system based on hieroglyphs, was the most commonly used Egyptian script from the Old Kingdom (2675–2170 B.C.E.) to the beginning of the Late Period about 664 B.C.E. Scribes used cursive hieroglyphs, a writing of hieroglyphs that included fewer interior details in each sign, for writing the *Book of the Dead*. During the Late Period, scribes developed the Demotic writing system, a

cursive writing system that does not correspond sign-for-sign with either hieratic or hieroglyphic writings of words. It is by far the most difficult writing system for modern scholars to master. Finally, the Coptic alphabet emerged with Christianity in Egypt during the first century C.E. The Coptic alphabet uses the 24-letter Greek alphabet plus seven signs from Demotic to represent sounds that do not exist in Greek but are needed to write Egyptian.

LANGUAGE AND LITERATURE. Compared to other ancient languages such as Greek, Latin, or Hebrew which were never lost, Egyptian is a newcomer to the scholarly scene. Though scholars have made great strides in understanding Egyptian since Champollion's initial accomplishment, translations of Egyptian literature have not yet established the Egyptian achievement in modern consciousness alongside their ancient neighbors in Greece, Rome, and Judea. Yet Egyptian literature included great works whose continuing study will eventually establish it among the world's great literary accomplishments.

SOURCES

Alan Gardiner, *Egyptian Grammar* (Oxford: Oxford University Press, 1957).

Richard Parkinson, *Cracking Codes: The Rosetta Stone and Decipherment* (Berkeley: University of California Press, 1999).

SEE ALSO *Philosophy: Secret Knowledge*

EGYPTIAN WRITING MATERIALS AND PUBLISHING

MEDIUM AND MESSAGE. The Egyptians normally used a particular kind of writing surface for particular purposes. Papyrus, the most famous of Egyptian inventions, was not the most commonly used writing surface. Papyrus was relatively expensive but very durable so scribes used it for important texts that had to last a long time. Works of poetry, letters, and *Books of the Dead* preserved for eternity in tombs were normally written on papyrus using cursive hieroglyphs or hieratic and later Demotic or Coptic. Scribes made *ostraca* (singular: *ostracon*) from large pieces of broken pots or from limestone chips. Ostraca were much cheaper and more plentiful than papyrus. Scribes used them to practice writing, nearly always in hieratic, but also for letters, contracts, and receipts. Students practiced writing literary texts on ostraca. Archaeologists have recovered thousands of ostraca on limestone from the artists' village at

"Marriage Scarab" of Amunhotep III and Queen Tiye. BROOKLYN MUSEUM OF ART, 37.475E, CHARLES EDWIN WILBOUR FUND. REPRODUCED BY PERMISSION.

Deir el-Medina, one of the few places where large numbers of literate, but relatively poorer people lived. Scribes also prepared wooden boards with a plaster surface to practice writing in hieratic. Some scholars believe these boards served as a display text, a kind of writing sample that could be used when a scribe wanted to find work. They preserve literary texts. Scribes also used leather as a writing surface, but very few examples have survived into modern times. Yet inscriptions on stone that are normally abbreviated sometimes include the information that the full text was written on leather and stored in the library. Tomb walls provided a writing surface for prayers, captions to sculptural reliefs, and, by the Sixth Dynasty, for extended biographies written either by or for the deceased. Many scholars view these biographies as the first literature in Egypt written with aesthetic values in mind. Temple walls provided a surface for kings to publish long inscriptions that proclaimed royal success in military matters or to describe rituals. *Stelae* (singular: *stela*)—upright, inscribed slabs of stone—provided a surface for writing prayers, historical accounts, and royal decrees. The Egyptians placed them in tombs, memorial chapels, and in tem-

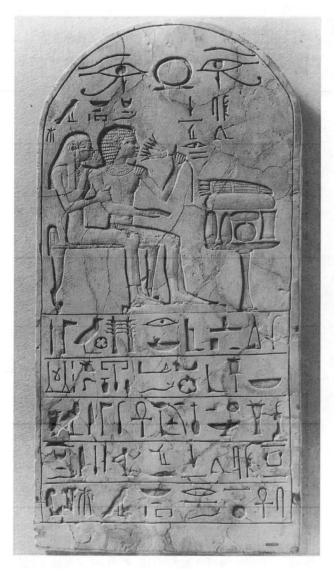

Stela of Senres and Hormose. BROOKLYN MUSEUM OF ART, 07.420, MUSEUM COLLECTION FUND. REPRODUCED BY PERMISSION.

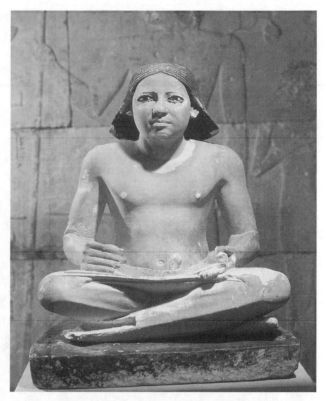

Limestone statue of a scribe, seated with a papyrus scroll. THE ART ARCHIVE/DAGLI ORTI. REPRODUCED BY PERMISSION.

ples of the gods. Tomb and temple walls and stelae preserve the most extensive inscriptions written with hieroglyphs. Scarabs—small images of beetles carved from stone or molded in faience with a smooth underside that could serve as a writing surface—also preserve kings' names and, rarely, preserve extended historical texts. The faience scarabs were created in molds and constitute one means of publishing multiple copies other than writing copies by hand.

MULTIPLE COPIES. Some Egyptian works of literature still exist in multiple copies. Other works exist in only one sometimes heavily damaged copy. Scholars who hope to establish the popularity or importance of a particular work in ancient times are frustrated by the accidents of discovery and preservation that result in

knowing dozens of partial copies of the *The Story of Sinuhe* but only one copy of *The Shipwrecked Sailor*, two works of Middle Egyptian literature. Multiple copies both complicate and facilitate the establishment of the true text of a particular work. There are almost always small variations in spelling and even word choice in different copies of the same work. With *Sinuhe*, many of these variations stem from the time period when the text was written. *Sinuhe* was a classic, composed and copied by scribes in the Middle Kingdom but still studied in the New Kingdom and Late Period. Sometimes multiple copies help modern scholars learn the meaning of the text. But other times, poorly written and spelled student copies frustrate and mislead modern scholars. Multiple copies can also complicate the determination of a text's date of composition.

DATE OF COMPOSITION. Scholars must attempt to distinguish between the date of composition and the date of a copy of a work of literature. The date of composition refers to the time when the author created the work. The date of the copy refers to the dates of copies made for the publication and dissemination of a work of literature, sometimes many years after the date of composition. It is not always easy to determine the date of

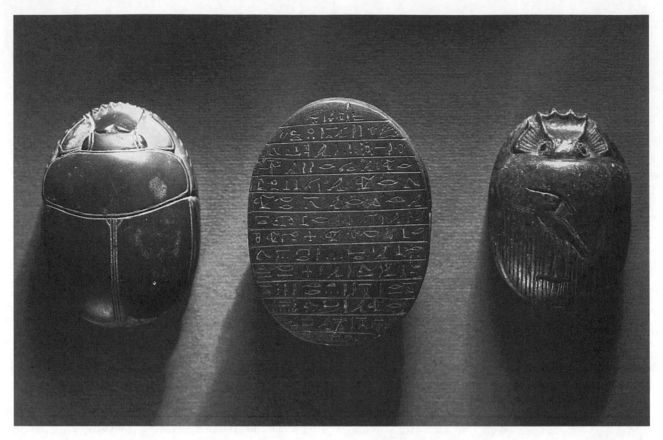

Ancient Egyptian scarabs. THE ART ARCHIVE/EGYPTIAN MUSEUM TURIN/DAGLI ORTI.

composition. For example, an anonymous author composed the text known as *The Teachings of Ptahhotep* in the Middle Kingdom (2008 to after 1630 B.C.E.) using as the narrator a vizier who lived in the reign of King Djedkare Isesy (2415–2371 B.C.E.) during the Old Kingdom, approximately 400 years before the text was composed. Only one known copy of the text dates to the Middle Kingdom, the time of composition. The three other copies known to scholars all date to the New Kingdom (1539–1075 B.C.E.) about 500 years after the composition and one thousand years after the setting found in the text. When scholars first examined the text, they assumed that Ptahhotep himself composed it in the Old Kingdom. In the late twentieth century, as scholars learned more about the differences between the dialects of the Old Kingdom (Old Egyptian) and the Middle Kingdom (Middle Egyptian) they realized that the language in the text mostly reflects the way scribes talked and composed in Middle Egyptian rather than Old Egyptian. This study resulted in reassigning the text to a composition date in the Middle Kingdom. Copies reveal their dates through the handwriting on them. The study of handwriting, called paleography, reveals that scribes used particular letter forms in particular periods.

Paleographers compare the forms of particular signs found in dated copies to undated copies to establish the date of a copy. In general, scholars agree more often on the date of a copy than they do on the date of composition for particular texts. Dating texts, naturally, is central to any understanding of the history of Egyptian literature.

TITLES OF WORKS. The Egyptians probably referred to literary works by the first line, using it as a title. Today scholars assign a name to Egyptian texts, but there is no authority that can impose one standard title on each text. Thus in different books it is possible to see *The Tale of Sinuhe*, *The Story of Sinuhe*, or even just *Sinuhe* used as the title of the Egyptians' great national epic poem. In this book, the titles for the texts are listed in the section on the Egyptian literary canon near the end of the chapter. There are also some examples found in ancient literature that refer to the "Book of Sinuhe" using the word for "papyrus roll."

SOURCES

Miriam Lichtheim, *Ancient Egyptian Literature*. Vol. I (Berkeley: University of California Press, 1973).

Richard Parkenson and Stephen Quirke, *Papyrus* (Austin, Tex.: University of Texas Press, 1995).

THE AUTHOR

DETERMINING THE AUTHOR. Nearly all Egyptian works of literature are anonymous. Even in works of wisdom or teaching attributed to famous sages of the past, it is never clear to modern readers whether or not the "I" of a first person text is the actual author or whether the attribution to a famous sage is a literary device that adds value to the advice given in the text. Though authors are difficult to name, it is still possible to detect the voice of a real author behind many kinds of stories and texts. The best method for finding the voice of an author, suggested by the French Egyptologist Phillipe Derchain, is to compare two or more texts that relate similar information. Yet even when there is only one version of a text, it is possible to appreciate the author's voice.

NARRATOR AND AUTHOR. Literary critics distinguish between the "I" of a first-person narrative, called the narrator, and the author of the text. In Egyptian literature, modern scholars have often supposed that the author was either the person named as the "I" in the text or that the author was the scribe who wrote down an oral tradition. For example, Egyptologists once identified the author of the text called *The Teachings of Ptahhotep* with a vizier who lived during the reign of King Djedkare Isesy (2415–2371 B.C.E.) during the Old Kingdom, approximately 400 years before the text was composed in the Twelfth Dynasty. This attribution, in Egyptian thought, made the text more important. Modern culture attaches such importance to knowing the author that it seems unimaginable that the person who composed the text would attribute it to the long-dead vizier. Sometimes Egyptologists have thought that the author of the text was the scribe who wrote it down or who owned it. Such is the case with the poem composed about the Nineteenth-dynasty Battle of Qadesh. Older Egyptologists thought that Pentawer, the scribe who wrote it down and possibly owned the papyrus, was the author. Derchain suggested that even the Egyptians became confused about this practice in the New Kingdom. In the Ramesside text known as *Papyrus Chester Beatty*, eight famous authors of the past are praised. Among them is Ptahhotep, who almost certainly did not write the text that Ramesside readers had available. In the end, the anonymity of the majority of Egyptian authors is similar to the anonymity of almost all Egyptian artists.

AUTHOR'S ROLE. One way to assess the author's role, suggested by Derchain, is to compare the way that different writers described similar experiences. Derchain analyzed three Middle Kingdom stelae (upright slabs of stone with inscriptions), that each commemorate a different writer's pilgrimage to Abydos, the city sacred to the god Osiris. The three authors are Sehetepibre, Iyhernefert, and Mentuhotep. All three came from families wealthy enough to ensure that they were literate. They also had access to libraries and archives and were familiar with Egyptian literature. As authors, they each chose different aspects of the pilgrimage to emphasize in their accounts. Sehetepibre emphasized his loyalty to the king and the way that the pilgrimage demonstrated that loyalty. Iyhernefert wrote about the ritual of Osiris that he observed and attended when he went to Abydos. Mentuhotep's account supplements Iyhernefert's account of the ritual, but he also included information on his own earlier career and more epithets about himself. His account is the most literary of the three. Its style is the most sophisticated, and he makes more references to other Egyptian literature in his account. This higher style confirms his contention that he worked in the library of a temple and might be considered more of an intellectual than the other two authors. Sehetepibre and Iyhernefert write more like the bureaucrats they were. But beyond style, each author chose to include different details of the pilgrimage. When combined with stylistic decisions, these choices are what distinguish them as authors.

FICTION AUTHOR. Another example of a story whose author had a distinctive voice was the anonymous writer of *The Contendings of Horus and Seth*. Alan Gardiner, the English Egyptologist, suggested in the early twentieth century that this story was a tale, written down from an oral storyteller's recitation. Derchain and others have realized that the story is too sophisticated, especially in its literary allusions, to be merely a popular story. In fact, it probably contains veiled references to the struggle for power which followed the death of Ramesses III (1156 B.C.E.) and continued in the reign of Ramesses IV (c. 1156–1150 B.C.E.). Some scholars have suggested that the story celebrates the accession of Ramesses IV in the same way European kings used to commission operas for their coronations. The story has a definite point of view and that in itself suggests that there was a real author, though his name is not known.

WARS OF THUTMOSE III. Another case study for an examination of authors' voices concerns two works of literature on the wars of Thutmose III (1479–1425

a PRIMARY SOURCE *document*

IMMORTALITY OF WRITERS: ANONYMITY AND FAME

INTRODUCTION: The majority of Egyptian authors were anonymous. Yet certain authors of teachings and of the pessimistic literature who wrote in the Twelfth Dynasty (1938–1759 B.C.E.) were acclaimed by an anonymous author of the Ramesside period (1292–1070 B.C.E.), six or seven hundred years later. This Ramesside author asserted that literary fame was more important, and even more reliable, than the immortality granted through building a tomb. Indeed, this later author seems unaware that at least one of his heroes, Ptahhotep, did not even write the work attributed to him. Instead, a Twelfth-dynasty author attributed a work to Ptahhotep, who lived in the Fifth Dynasty, in order to make the work more important. A scribe copied this text onto columns two and three of a papyrus now known as *Papyrus Chester Beatty IV*.

If you but do this, you are versed in writings.
As to those learned scribes,
Of the time that came after the gods,
They who foretold the future,
Their names have become everlasting,
While they departed, having finished their lives,
And all their kin are forgotten.

They did not make for themselves tombs of copper,
With stelae of metal from heaven.
They knew not how to leave heirs,
Children [of theirs] to pronounce their names;
They made heirs for themselves of books,
Of Instructions they had composed.

They gave themselves [the scroll as lector]-priest,
The writing-board as loving-son.
Instructions are their tombs,
The reed pen is their child,
The stone-surface their wife.
People great and small
Are given them as children,
For the scribe, he is their leader.

Their portals and mansions have crumbled,
Their *ka*-servants are [gone];
Their tombstones are covered with soil,

Their graves are forgotten.
Their name is pronounced over their books,
Which they made while they had being;
Good is the memory of their makers,
It is for ever and all time!

Be a scribe, take it to heart,
That your name become as theirs.
Better is a book than a graven stela,
Than a solid [tomb-enclosure].
They act as chapels and tombs
In the heart of him who speaks their name;
Surely useful in the graveyard
Is a name in people's mouth!

Man decays, his corpse is dust,
All his kin have perished;
But a book makes him remembered
Through the mouth of its reciter.
Better is a book than a well-built house,
Than tomb-chapels in the west;
Better than a solid mansion,
Than a stela in the temple!

Is there one here like Hardedef?
Is there another like Imhotep?
None of our kin is like Neferti,
Or Khety, the foremost among them.
I give you the name of Ptah-emdjehuty,
Of Khakheperre-sonb.
Is there another like Ptahhotep,
Or the equal of Kaires?
Those sages who foretold the future,
What came from their mouth occurred;
It is found as [their] pronouncement,
It is written in their books.
The children of others are given to them
To be heirs as their own children.
They hid their magic from the masses,
It is read in their Instructions.
Death made their names forgotten
But books made them remembered!

SOURCE: "The Immortality of Writers," in *The New Kingdom*. Vol. 2 of *Ancient Egyptian Literature: A Book of Readings*. Trans. Miriam Lichtheim (Berkeley and Los Angeles: University of California Press, 1976): 176–177.

B.C.E.). The differences between the two accounts of his wars—*The Annals* and *The Gebel Barkal Stele* (named after the place where it was found)—illustrate how two different authors approached similar subject matter. Scribes carved *The Annals* on the walls of the Karnak Temple, just north of modern Luxor, in an in-

ner court. The author remarks in the text that he based it on extracts from the journal that military scribes kept while the campaigns were in progress. In addition to lists of places that the army subdued, the most remarkable segment is the description of the council of war preceding the Battle of Megiddo (1458 B.C.E.). The

scene is common to a genre that Egyptologists call the *Königsnovelle*, or the "King's Story," in which the king's bravery, cunning, and wisdom are emphasized. In this instance, the officers advise the king against proceeding to the battle along a narrow path, fearing an ambush. In imploring the king to take the army along a longer, safer route, they speak to the king in a way that would be impossible for mere officers in actuality, suggesting that the author took some liberties in describing the event in order to underline the king's valor. Derchain recognizes this liberty as a mark of a particular author. This material, however, is completely omitted from *The Gebel Barkal Stele*, a text that another scribe wrote based on the same sources. The stele also recounts the highlights of the reign. Though the author includes the Battle of Megiddo, he fails to mention the council of war. The author narrates the stele in the first person, using the king as narrator. The language is hyperbolic and triumphant. The profits of the war are its first concern. Unlike the more factual presentation of *The Annals*, the king is presented as an orator and a man of destiny who stands above the crowd, indicating the purely political intentions of the text. Perhaps the author of *The Gebel Barkal Stele* wrote for a different audience from the one envisioned by the author of *The Annals*. Based on the differing depictions of the same historical event, scholars can conclude that the author of *The Annals* was an historian, while the author of the *Gebel Barkal Stele* was a rhetorician and poet. These two texts reveal how authors shaped the material, even though they were anonymous. All Egyptian authors left some mark on the texts that they composed. Even when a work is a compilation of stereotyped claims, the author's importance is clear in the way he chooses, combines, and emphasizes the information he conveys.

SOURCES

Phillipe Derchain, "Auteur et société," in *Ancient Egyptian Literature: History and Forms.* Ed. Antonio Loprieno (Leiden, Netherlands: E. J. Brill, 1996): 83–96.

Georges Posener, *L'enseignement loyaliste: sagesse égyptienne du Moyen Empire* (Geneva: Droz, 1976).

THE IDEA OF GENRE IN MIDDLE EGYPTIAN LITERATURE

IMPORTANCE. Understanding Middle Egyptian genres is central to any understanding of ancient Egyptian literature. The literature created during the Middle Kingdom (2008–1630 B.C.E.) in the Middle

Egyptian dialect, the spoken language of this period, was the classical literature of ancient Egypt. Egyptians continued to read, study, and enjoy it through the New Kingdom into the Late Period—essentially the full extent of subsequent ancient Egyptian history. In modern times, a genre refers to a type of literature. Each genre has a formal pattern known to readers and authors and is related to the culture surrounding it. Egyptian authors and readers had no idea of modern literary genres like the novel, epic, tragedy, or comedy. These European literary genres derive from theories developed by the Greek philosopher Aristotle (384–322 B.C.E.) who lived 1,500 years after authors composed in Middle Egyptian. The Egyptians did have their own categories of literature, however. It is important to remember that such systems of classification belong to a particular culture. There are no universal classification systems in literature, but the idea of genre does exist across cultures. Knowledge of genre is important because it influences judgments of quality. When modern readers try to appreciate ancient Egyptian literature, a particular work seems deficient because the rules and expectations held by the original readers and authors are not clear. For example, *The Shipwrecked Sailor* has been compared to a modern short story. Yet it lacks the clear motivations and characterizations that a modern reader might expect in this modern genre. Modern readers, thus, judge by rules unknown to the original readers and authors. It is thus important to define ancient Egyptian genres that the original readers from the culture would have recognized intuitively. If modern readers are to understand an ancient literature they must understand the expectations the original readers had when they read. Indeed, the author shaped narratives while writing to conform to the original reader's expectations.

DISCOVERING ANCIENT GENRES. Egyptologists have recognized certain patterns in Egyptian literary works and then grouped works by type to establish ancient genres. These patterns sometimes can be recognized in the contents. For example, Egyptologists group together narratives that tell a story, teachings that give advice, or poetry that describes emotions. They also group works by linguistic forms. These forms include formulae—exact wordings repeated from work to work—or patterns—such as the thought couplet where the same thought is expressed twice in different words. Another criterion for distinguishing genres is the social setting. Some works describe only royalty or commoners or priests. Scholars consider all of these factors when identifying genres.

COMBINING LITERARY GENRES

INTRODUCTION: *The Teachings of Amenemhet* begins as a typical Middle Kingdom teaching, even using the genre name in its first line. Yet it includes among its subjects the traditional advice found in teachings, autobiographical information, and elements of the pessimistic literature. The text is also unusual because Amenemhet addresses his son from beyond the grave while most teachings are set in this world only. Yet this text provides a good sample of many types of ancient Egyptian literature.

Beginning of the teaching

Made by the Person of the Dual King: Sehotepibre;
Son of Re: Amenemhet, true of voice,
When he spoke in a revelation
To his son, the Lord to the Limit.
He said "Rise as a god!"
Listen to what I tell you,
That you may rule the land, and govern the Banks,
Increasing the good.

Gather yourself against subjects who do not (really) exist,
Whose respect cannot be trusted;
Do not approach them when you are alone!
Trust no brother; know no friend!
Make for yourself no intimates—there is no profit in this!

May you sleep, having yourself guarded your heart,
For there will be no serfs for a man
On the day of pain.

I gave to the poor, raised the orphan,
And caused him who had not to end up like him who had.

It was one who ate my provisions that made insurrection;
One to whom I had given my arms was creating plots with them;
One clad in my linen was looking at me as if needy;
One anointed with my myrrh was passing water.

O my living images, my partners among men,
Make for me mourning, such as has not been heard!
An abundance of fighting, such as has not been seen!
When one fights in the arena, forgetful of the past,
There is no profit in the goodness of him who ignores what he should know.

It was after supper, when night had fallen,
And I had spent an hour of happiness.
I was asleep upon my bed, having become weary,
And my heart had begun to follow sleep.
When weapons of my counsel were wielded,
I had become like a snake of the necropolis.

As I came to, I awoke to fighting,
And I found that it was an attack of the bodyguard.
If quickly I had taken weapons in my hand,
I would have made the buggers retreat with a charge.
But there is none mighty in the night,
None who can fight alone;
No success will come without a helper.

Look, my injury happened while I was without you,
When the entourage had not yet heard that I would hand over to you,

THE SAMPLE. It is very difficult to judge the representative nature of a sample of surviving ancient Egyptian literature. Often scholars cannot know if a work that has survived had a wide audience or whether ancient readers thought it represented the highest quality. When a work survives in many copies from different historical periods, it seems safe to assume that the Egyptians considered it important. But with works surviving in one copy near its time of composition, it is harder to judge.

TITLES AND GENRE. The Egyptians used the first line of the text as its title. Some titles provide the name of the genre. For example, the genre name *seboyet* ("teaching") often occurs in the phrase "Beginning of the teaching which [narrator's name] made" that is the title of the text. The German Egyptologist Siegfried Schott made a catalog of ancient Egyptian book titles that provide some genre names. Unfortunately, many preserved texts do not preserve the beginning. Of 33 works from the Middle Kingdom, only fifteen are complete. The three most common genres are narratives, teachings, and discourses.

NARRATIVES. No Egyptian word bears the same meaning as the English word "narrative," but certain texts definitely tell a story. These narratives include the prose text *The Shipwrecked Sailor* and the verse epic *The Story of Sinuhe*. Each of these stories appears to the modern reader to have a moral. *The Shipwrecked Sailor* counsels against despair, while *Sinuhe* urges the reader to depend on the king's mercy. All of the known Egyptian narratives lack titles. Some narratives begin with words best translated "There was once," a formula similar to the modern English "Once upon a time." But there is no reason to think that this could be the name of the genre or the name of the work.

When I had not yet sat with you, that I might make
 counsels for you
For I did not plan it, I did not foresee it,
And my heart had not taken thought of the negligence of
 servants.

Had any woman previously raised troops?
Is tumult raised in the Residence?
Is water which destroys the earth let forth?
Are commoners deceived by what they have done?
Evil had not come around me, since my birth;
The like of my deed as a valiant hero had not
 occurred.

I went to Elephantine,
And I traveled to the Delta;
I stood on the limits of the land, having seen its midst.
The limits of strengths I reached,
With my strong arm, and my forms.

I was a maker of corn, beloved of Nepri.
On every plain the Inundation paid respect to me.
No one hungered in my years; no one thirsted then.
Men relaxed through what I had done, and told of
 me.
All that I decreed was as it should be.

I subjugated the lions; I captured crocodiles.
I subdued the Nubians; I captured Medjai;
I made the Asiatics do the dog-walk.

I made for myself a mansion decorated with electrum,
And its portal were of lapis-lazuli,
With walls of silver,
A floor of sycamore,

Doors of copper,
Bolts of bronze,
Made for all time,
Prepared for eternity.
I know, for I was the lord thereof, to the limit!

Yet, the offspring of many are in the street,
The wise saying "yes,"
The fool "no,"
For he knows not himself, he who lacks your sight.
O Senwosret, my son!
My feet are departing, even as my very heart draws
 near,
And my eyes are looking for you—
The offspring of a joyous hour,
Beside the sunfolk, who were praising you!

Look, I have made the beginning, that I might tie up the
 end for you.
It is I who has brought to land for you what was in my
 heart:
My likeness, wearing the White Crown, divine progeny!
This is as it should be, as I decreed for you.
In the bark of Re I have descended;
Arise to the kingship created aforetime,
It being what I made, in the midst of (all) this!
Set up monuments, endow your funerary buildings!
May you fight for the wisdom the heart knows,
For you want it beside your Person!
It is come, well and in peace.

SOURCE: R. B. Parkinson, *Voices from Ancient Egypt: An Anthology of Middle Kingdom Writings* (Norman: University of Oklahoma Press, 1991): 49–52.

TEACHING. The genre called *seboyet* in Egyptian is best translated with the word "teaching." Many Egyptologists formerly called these documents "Wisdom Texts," creating an artificial parallel with the books of the Hebrew Bible that are classified in this way including Job, Proverbs, Song of Songs, and Ecclesiastes. Egyptian teachings deal with the nature of the ideal life. Of the three broad genres that Egyptologists have identified, the teaching is the most coherent. It has an Egyptian name, assuring modern scholars that the Egyptians also recognized this form as a genre. The texts labeled as teachings also have a common form, theme, and style. Egyptologists divide the teachings into two subgroups: royal and private. For example, the advice given in *The Teachings of Amenemhet* or *The Teachings for Merykare* describe a king's ideal life whereas the advice found in *The Teachings of a Man for his Son* centers on the life of a private person. Both types consist of descriptions of the proper response for very specific situations. For example, in many private teachings, the author includes the proper way to behave when a nobleman speaks or the right way to behave at the dinner table. Kings receive advice on specific matters of state or in handling underlings.

DISCOURSE. A second kind of wisdom is the discourse. A discourse includes meditations known in Egyptian as *medjet* ("pronouncement") or *tjesu* ("utterance"). These discourses are often laments such as the *Complaints of Khakheperre-sonb* or the *Prophecy of Neferty*. In both texts the speaker contrasts an ideal past with the degraded present. In *Neferty*—the one complete example with an ending—there is also a future restoration of the ideal past attributed to King Amenemhet I. Another group of texts that considers similar content is

the dialogue. In the *Dialogue of a Man with His Ba*, for example, two speakers debate the effectiveness of preparations for the afterlife.

OTHER TEXTS. Some known texts fall outside of this scheme of genres. They include a description of the king performing athletic feats and an account of fishermen performing their tasks. Both are discourses, but are otherwise not well understood. Neither one seems pessimistic like the other laments in dialogue form. These positive dialogues might have been an important genre themselves. In addition, they are difficult to understand because they are very fragmentary and preserved in only one copy each. Thus it is difficult to predict the events described in them, and to classify them.

MIXTURES. Some texts preserve a combination of genres. *Sinuhe*, for example, includes narrative, hymns, and a letter. *The Eloquent Peasant* includes discourse within a narrative frame. These mixtures suggest that the modern understanding of ancient genres is incomplete.

SOURCES

Miriam Lichtheim, *Ancient Egyptian Literature.* Vol. I (Berkeley and Los Angeles: University of California Press, 1973).

Richard B. Parkinson, "Types of Literature in the Middle Kingdom," in *Ancient Egyptian Literature: History and Forms.* Ed. Antonio Loprieno (Leiden, Netherlands: E. J. Brill, 1996): 297–312.

THE LITERATURE OF MORAL VALUES

FIRST LITERATURE. Egyptian noblemen recorded the earliest Egyptian literature in tomb inscriptions called autobiographies. They composed them in the first person and included some details of the author's own life. The real purpose of these texts is to demonstrate that the author lived a moral life. Thus the texts illustrate Egyptian ideas of morality. These texts are also the first attempts at extended narrative. Previous to these autobiographies, Egyptians wrote only short inscriptions, usually captions to tomb scenes carved in relief describing the action or identifying the participants. The autobiographies include three topics: protection of the tomb, major events in the tomb owner's life, and a moral self-portrait. These three areas correspond to ideas of self-esteem, interconnectedness with others, and recognition that the world is governed by an ideal of justice called *maat*. Maat is the ideal that each author demonstrates was the basis for his life. It is the most important concept in Egyptian thought embodying correct conduct in

the world and in man's relations with the king and with the gods.

THE IDEA OF THE PERSON. Miriam Lichtheim, the American Egyptologist, traced the development of claims of self-worth among Egyptian noblemen as recorded in their tombs. She found a progression from self-esteem based on fulfilling filial responsibilities, to a reliance on the king's regard as the source for self-worth, and finally to the development of an objective standard called "maat" to measure self-worth. The short statements carved in Fourth-dynasty mastaba-tombs mostly state that a son fulfilled his duty to his father and that the tomb owner never did anything wrong. For example, Ihy, a nobleman of the early Fourth Dynasty, informs visitors to his tomb in an inscription, "I made this for my father, when he had gone to the West [the land of the dead], upon the good way on which the honored ones go." Another writer, the King's Companion Sefetj-wa wrote in his tomb inscription, "I never did an evil thing against anyone." Lichtheim argued that such statements are the first literary works that make the claim for an individual's moral identity. They record a sense of self based on filial duty and relationships with other people. By the end of the Fourth Dynasty in the reign of King Menkaure (2532–2510 B.C.E.) the prime minister Ptahshepses carved in his tomb short inscriptions that described his life and its importance in terms of his relationship with the reigning king. In captions to separate reliefs, Ptahshepses lists the reasons why he was important. He specifically mentions that he attended school with King Menkaure's children. Ptahshepses describes in the next caption that he reached adulthood in the reign of the next king, Shepseskaf (2508–2500 B.C.E.). Ptahshepses' marriage to a daughter of an unnamed king follows in the caption to the next adjacent relief scene. A fourth scene and inscription describe Ptahshepses' claim that he worked as an administrator for King Userkaf (2500–2485 B.C.E.). In the scene corresponding to the period when he worked for Neferirkare Kakai (2472–2462 B.C.E.), Ptahshepses mentions that the king accorded him a special honor: Ptahshepses could kiss the king's foot rather than the ground directly in front of the king's foot when he greeted the king. These statements demonstrate that Ptahshepses' self-worth was based on the king's high regard for him. Ptahshepses worked for a total of seven kings, including Sahure (2485–2472 B.C.E.), Shepseskare (2462–2455 B.C.E.) and Reneferef (c. 2462–2455 B.C.E.), before dying in the reign of Nyuserre (c. 2455–2425 B.C.E.). He thus lived about sixty years. Another nobleman named Rawer who lived in the time of Neferirkare Kakai, and thus was a

contemporary of Ptahshepses, also described an example of this king's high regard for him. One day, according to the tomb inscription, Rawer stood next to the king on a boat sailing on the Nile. The king unintentionally struck Rawer with the royal scepter, probably due to the movement of the boat. The king apologized and ordered that his apology be described in Rawer's tomb. Both the king and the nobleman regarded this apology as a special mark of favor. The king accorded a certain dignity to his official by apologizing. By the late Fifth Dynasty (about 2350 B.C.E.) noblemen began to claim in their tomb inscriptions that the tomb owner followed *maat*, a quality that the king both liked and required. This is a subtle shift from the idea that all self-esteem comes from the king's favor. Now man's right behavior is the direct source of self-esteem. This view prevailed throughout subsequent Egyptian literature.

GOODNESS IS INNATE. Fifth-dynasty nobles also began to express in their autobiographies the idea that goodness was innate. They used the expression "since birth" to make this claim. Thus Werhu, a priest of the cult of King Menkaure, could write in his tomb, "I never let anyone spend the night angry with me about a thing since my birth." Likewise the Sixth-dynasty nobleman Metjetji could claim, "Never did I make anyone unhappy since my birth." Such statements continued through the First Intermediate Period (Dynasty Seven through the first part of Dynasty Eleven, 2130–2008 B.C.E.). By the Twelfth Dynasty (1938–1759 B.C.E.), when noblemen serving kings were again writing autobiographies to place on stelae (upright pieces of stone), they described knowledge and skills as innate since birth. But during the later Old Kingdom (Dynasties Five and Six), noblemen described only good qualities as innately part of a person's character. Lichtheim observed that the same progression from qualities to skills and knowledge being innate was also true of the king, but such statements were first made in regard to nobles. Egyptians also believed that one could be evil at birth. The Twelfth-dynasty text attributed to the Old Kingdom prime minister Ptahhotep speaks of "one whose guilt was fated in the womb." But the Egyptians also understood that instruction could bring out the best in people. Thus they recognized that both nature and nurture played a role in the way a person behaved. By the Nineteenth Dynasty (1292–1190 B.C.E.), the wise man Any wrote that a person could choose between good and bad impulses that are both innate.

SIDING WITH GOOD. As early as the Fourth Dynasty nobles declared in their autobiographies that they always sided with the good. The Sixth-dynasty architect

a PRIMARY SOURCE *document*

MORAL DECLARATIONS FROM THE AUTOBIOGRAPHY OF NEFER-SESHEM-RE

INTRODUCTION: From the Fourth Dynasty (2625–2500 B.C.E.) to the Sixth Dynasty (2350–2170 B.C.E.), the basis of autobiographies' claims to the moral life depend on changing grounds. The earliest autobiographies speak only of fulfilling obligations to the immediate family, especially the father. Subsequently, obedience to the king becomes the highest moral value. Finally, in the Sixth Dynasty, men like Nefer-seshem-re claim a much broader understanding of social obligations that constitute the basis for moral action.

I have gone from my town,
I have descended from my nome,
Having done Maat for its lord,
Having contented him with what he loves.

I spoke truly [using the word *ma'a*], I did right [using the related word *ma'at*],
I spoke the good [using the word *nefer*], I repeated the good [*nefer*],
I grasped what was best [using the phrase that literally means "I seized" and the form *tep-nefer*, the abstract idea of goodness],
for I wanted the good for people [using the phrase that literally means "I desired the good (nefer) for all people in general].

I judged two trial partners so as to content them,
I saved the weak from one stronger than he as best I could;
I gave bread to the hungry, clothes to the naked,
I landed one who was boatless.

I buried him who had no son [to do it for him],
I made a ferry for him who had none;
I respected my father,
I pleased my mother,
I brought up their children.

SOURCE: "Autobiography of Nefer-seshem-re," in *Moral Values in Ancient Egypt*. Trans. Miriam Lichtheim (Fribourg, Switzerland: University Press, 1997): 12.

Nekhebu makes this claim in its most developed form when he wrote, "I am one who speaks the good, and repeats the good. I never said an evil thing against anyone." Nekhebu speaks here of avoiding speaking ill of others. But the Egyptians also assumed other definitions of the good by the Eleventh Dynasty (2008–1938

B.C.E.). The good includes good character and kindness according to *The Teachings for Merykare, The Teachings of Ptahhotep*, and *The Teachings of a Man for his Son*. All of these texts remark that good character will be remembered in the future, while evil men are forgotten. Good character is even more important than good deeds. The stela of a man named Mentuhotep makes this point: "A man's good character is better than doing a thousand deeds. People's testimony is the saying on the lips of commoners. His goodness is a man's monument. The evil-natured [one] is forgotten."

BASIS FOR THE FUTURE. The earliest autobiographies inscribed on tomb walls in the Old Kingdom and on stelae during the Middle Kingdom served scribes as the basis for composing both narratives and teachings during the Middle Kingdom. They represent Egyptian authors' first experiments with defining justice and the good. In later narratives, authors both illustrated these moral traits and established with the instructional literature the best teachings to nurture both the good and the just within a young man's character.

TJETJI AND TRANSITIONAL AUTOBIOGRAPHY. Tjetji's autobiography reflects traditions of the late Old Kingdom and anticipates the best of Dynasty 11. It serves as an excellent example of the way autobiographies changed from the previous time period while still carrying the tradition forward. It is carved on a stela that is divided into three unequal fields. At the top is a fourteen-line, horizontal, autobiographical inscription reading right to left. The lower left portion depicts Tjetji facing right, in high raised relief, with two members of his staff; a small figure presents offerings before him. The lower right field is an elaborate, five-line, vertical offering prayer listing wishes for the afterlife. Tjetji's autobiography revives an Old Kingdom literary tradition nearly 200 years after its disappearance. In Tjetji's era, autobiographies typically praise provincial leaders' efforts on behalf of their provinces. But Tjetji, a court official, returns to an Old Kingdom theme: the ideal of service to the king. He makes constant reference to his success at carrying out the king's wishes. This ideal continued to dominate subsequent autobiographies written during the Middle Kingdom. Tjetji recounts his service as Overseer of the Seal Bearers of the King to Wahankh Intef II (2065–2016 B.C.E.) and Nakht-neb-tep-nefer Intef III (2016–2008 B.C.E.), establishing for historians the order of these kings. Tjetji also describes the borders of the Theban kingdom just before the reunification of Egypt under Nebhepetre Mentuhotep II (2008–1957 B.C.E.). These borders stretch from Elephantine in the south to Abydos in the north. The text is limited in length by the size of the stela, unlike later, extended autobiographies carved on tomb walls. Yet Tjetji's use of the Egyptian language is striking and eloquent. Ronald J. Leprohon, the Canadian Egyptologist, suggested that this elaborate language, structured in tight grammatical patterns, derives from the deceased's own efforts to attain the ancient Egyptian ideal of "perfect speech." Tjetji's stela clearly demonstrates the high standards of language that had been established in Thebes before political unification with Lower Egypt. These standards and their connection to the previous period of political unity perhaps point toward the early Eleventh Dynasty's conscious political plans for reunifying the country.

SOURCES

Jan Assmann, "Der literarische Aspekt des ägyptischen Grabes und sein Funktion im Rahmen des 'monumentalen Diskurses,'" in *Ancient Egyptian Literature: History and Forms*. Ed. Antonio Loprieno (Leiden, Netherlands: E. J. Brill, 1996): 97–104.

Miriam Lichtheim, *Ancient Egyptian Autobiographies Chiefly of the Middle Kingdom: A Study and an Anthology* (Freiburg & Göttingen: Universitätsverlag, 1988): 39–45.

———, *Moral Values in Ancient Egypt* (Fribourg, Switzerland: University of Fribourg Press, 1997).

SEE ALSO *Philosophy: Maat; Religion: The King*

PESSIMISTIC LITERATURE

REFLECTING ON CHAOS. The exact cause of the collapse of the central government at the end of the Old Kingdom between 2170 and 2130 B.C.E. remains the subject of debate. Nevertheless, it is clear that the central government located in Memphis gradually surrendered its control to local rulers of the provinces during this forty-year period. From 2130 to about 2003 B.C.E., Egypt experienced decentralized, local government with each province ruled separately by local noble families. This is the period Egyptologists call the First Intermediate Period. When Mentuhotep II restored the central government about 2008 B.C.E., the newly re-established central bureaucracy, composed of the literate class, generated a literature sometimes called the literature of pessimism. The theme of these works, mostly composed in the early Twelfth Dynasty, is a reproach or accusation against the gods for allowing chaotic conditions between the end of the Old Kingdom and the establishment of the Middle Kingdom. The texts include laments about the insecure state of society and nature, and assert the hopelessness of discussing these problems. In general, the

authors wrestle with the problem that reality does not match the Egyptian ideal of justice. The list of texts included with the pessimistic literature comprises *The Admonitions of Ipuwer*, *The Complaints of Khakheperre-sonb*, *The Dialogue of a Man with his Ba*, *The Eloquent Peasant*, *The Teachings for Merykare*, *The Prophecy of Neferty*, and *The Teachings of Amenemhet*. These seven texts, all written during the Twelfth Dynasty (1938–1759 B.C.E.), form a group unified by theme, if not a distinct literary genre. They thus reflect an intellectual position which was probably widely held among the literate class during this time period. They shared a fear of two things: disrespect for traditional wisdom and the loneliness of the individual without an ordered society. At least some of the authors of these texts recommended trust in the king and his government as the only antidote to these severe social problems. No authors are known and the exact order and date of composition remains difficult to ascertain. Yet they all share important themes: accusations against the gods, the insecure state of the world, and, by contrast, the nature of a secure world.

INSECURE WORLD. An insecure world serves as the setting for the seven works of pessimistic literature. Each author describes the world slightly differently, but they all touch on similar ills that they find in it. First, they acknowledge a threat to or loss of important political, economic, and religious institutions that leads to chaos. The threatened institutions include an effective king who controls an operating government and administers swift justice, a functioning economy, proper religion, and a permanent funerary cult. The *Teachings of Amenemhet*, for example, begins by narrating the assassination of a king by his trusted advisors. In the *Teachings for Merykare*, a king either colludes in grave robbing or is powerless to stop it. False friends threaten both Amenemhet and Merykare. The result of ineffectively functioning kings is a chaotic world defined by abandoned fields, empty granaries, and hungry people and animals. Trade breaks down because robbers stalk the highways while corrupt officials act arbitrarily; local rulers fight each other, fomenting civil war. According to the German Egyptologist Elke Blumenthal, the authors of *Ipuwer*, *Neferty*, and *Khakheperre-sonb* regard all of these circumstances as equally important, with none assigned more weight than another. None of the authors specifically diagnose the cause to be a weak or ineffective king because no author is willing to state unequivocally that the king is responsible for chaos in the world. Yet the implication can easily be read between the lines of the text. Thus the author seems to say that a weak king is just another circumstance on the same level as the prevalence of hunger, robbers, and corrupt officials. No author willingly condemns the king's weakness.

GODS BETRAYED. The king was responsible in Egyptian ideology for guaranteeing the integrity of divine rituals, both for the gods and for the dead. Yet in spite of lengthy descriptions of inadequately supplied temples, desecrated altars, the destruction of the sun-god Re's temple at Heliopolis, the expulsion of priests, the profanation of holy texts—all apparently everyday occurrences in this group of texts—none of the authors of the pessimistic literature even mention the king's role as protector of order. The king also guaranteed that the mortuary cult would be effective, according to Egyptian belief. Even though the king supplied financial help with burial only to high-level officials, funeral prayers all assume that the king will provide offerings for everyone throughout all time. Yet the pessimistic literature portrays kings' cults as defiled. The rabble disturbs the king's mummy in its tomb or during the embalming and throws it in the river. Yet even the current king is not directly blamed in the literature. No author is willing to charge the king directly with responsibility for chaos and disorder, even though this clearly is the implication of the author's words.

ACCUSATIONS AGAINST THE GODS. The roots of the world's troubles include ungrateful royal advisors, the king's weakness, and men's greed. Yet no author can specifically accuse the king of weakness. *The Admonitions of Ipuwer* suggests that there is a being responsible for this state of affairs: the creator god Atum. Atum never recognized people's capacity for evil and never inhibited people's attempts to be evil, according to the narrator. From this idea grew the accusations against the gods found mixed with complaints about chaos among men in the pessimistic literature. The god is both guilty and withdrawn from the world. Not only has the god allowed injustice, but also has become unjust himself by betraying the very justice he created. Neferty goes even farther than Ipuwer, claiming, "Creation is as if it were never created. Re should begin creation anew." Yet this view was not universal among Egyptians. In *Coffin Text* 1130, a text commonly inscribed on Middle Kingdom coffins, the sun-god Re describes four acts of creation that he performed in the world. He made the wind so people could breathe. He made the Nile flood to benefit both the humble and the great. He also claims that he created all people to be the same. He never told anyone to act in an evil way. Thus acting in an evil way contradicts the gods' wishes. Finally, Re claims that people were created to carry out the mortuary cult. This text thus shows that there was a debate about mankind's nature and

whether men were inherently evil because of the gods or were themselves responsible for their actions. The origin of evil and the degree to which humans' actions are fated occupy much of the pessimistic literature.

THE SECURE WORLD. The debate over the origin of evil and human fate can also continue within a single work. Thus descriptions of the secure world can also be found within works that accuse the gods of creating evil. *The Prophecy of Neferty* is structured as a series of antithetical statements contrasting the evil world of the First Intermediate Period with the better world to come during the Twelfth Dynasty. Rebellion will end, foreign enemies will be subdued, people will celebrate, and the king will restore justice. The contemporary literary texts called "teachings" also provide a method for subduing evil through practicing justice. *The Teachings for Merykare* discusses how a king can act to create a better world for all. Merykare receives advice on how to handle each class of people including officials, soldiers, rebels, and criminals. His father in the text urges reliance on tradition, the daily divine cult, and the mortuary cult in order to foster justice. Even the very pessimistic *The Teachings of Amenemhet* seems to anticipate better from the reign of his son Senwosret I in his teachings. The author of *The Eloquent Peasant* is also able to describe a world with justice, appropriate punishments, and the merciful treatment of the weak that is all part of the Egyptian idea of justice. In *The Dialogue of a Man with his Ba*, the next world contains many of the elements of justice that are missing in the world of the living, including properly provisioned temples and punishment of evildoers.

IMPORTANT THEMES. The pessimistic literature shows that the Egyptians contemplated many of basic problems facing mankind. They were particularly concerned with the origin of evil, the proper way to combat evil, and the proper way to promote justice in an insecure world.

SOURCES

Elke Blumenthal, "Die literarische Verarbeitung der Ubergangszeit zwischen Altem und Mittererm Reich," in *Ancient Egyptian Literature: History and Forms*. Ed. Antonio Loprieno (Leiden, Netherlands: E. J. Brill, 1996): 105–136.

Miriam Lichtheim, *Ancient Egyptian Literature*. Vol. I (Berkeley: University of California Press, 1973).

STORY OF SINUHE

IMPORTANCE. *The Story of Sinuhe* survives in many manuscripts, suggesting that the Egyptians considered it among their most important literary works. The oldest manuscripts date to the Twelfth Dynasty (1938–1759 B.C.E.), also the time of the story's setting. There are also more than twenty New Kingdom (1539–1075 B.C.E.) copies and even a Late Period copy (664–332 B.C.E.). This large number of copies surviving in all major periods is due to the fact that scribe schools required scribes to copy this text as part of scribal training. Yet, the fact that so many scribes worked on copying *Sinuhe* suggests that it was also studied in all time periods. It is thus a work of literature that connected the Egyptian literate class for 2,000 years. The text also includes variations on many literary genres. Overall, it is structured to resemble an autobiography and is narrated in the first person. Unlike a tomb autobiography, however, Sinuhe's life goes astray rather than meeting the ideal as in the standard biography. It also includes songs, monologues, and even a letter.

CONTEXT. Though *Sinuhe* was an important point of reference for all literate Egyptians, it also provides an important window into the Twelfth Dynasty, the time when it was written. The story deals briefly with the assassination of King Amenemhet I (1938–1909 B.C.E.) and the accession of his son King Senwosret I who had co-ruled with him since 1919 B.C.E. The story emphasizes Senwosret's mercy to Sinuhe. This has led scholars to believe that the story provided propagandistic support for this king. The story also reveals Egyptian attitudes toward foreigners in the period directly preceding an actual foreign domination of Egypt by the Hyksos. Thus it has great importance for helping scholars understand Egyptian attitudes toward foreigners before the Hyksos. More recent study has emphasized the high literary quality found in the text. All of these elements combine to make *Sinuhe* important both in its own time and to scholars today.

THE STORY. *The Story of Sinuhe* narrates the adventures of a nobleman who served Queen Neferu, daughter of Amenemhet I (1938–1909 B.C.E.) and wife of Senwosret I (1919–1875 B.C.E.). When the story opens, Sinuhe is on a military campaign in Libya with Senwosret I, son of the reigning king Amenemhet I. The news of Amenemhet I's assassination reaches the army and Sinuhe panics, fearing that Egypt will fall into turmoil. He is particularly worried that his close connections to the royal family will jeopardize his own life should Senwosret I be denied his legitimate claim to the throne. He decides to flee Egypt, traveling across Egypt's eastern border into the lands beyond. In his haste to leave, however, he does not pack sufficient provisions and nearly dies of thirst in the desert. A bedouin chief

rescues him, and Sinuhe is able to reach the town of Byblos in modern Lebanon, eventually settling in Upper Retenu in modern Syria. There he meets a local ruler named Amunenshi, who gives him his daughter in marriage and land in a place called Yaa. Sinuhe prospers in Yaa, has children, and successfully leads Amunenshi's army against other tribes. Near the end of his life, however, he decides he wants to return to Egypt for burial. He sends a letter to the king, and the benevolent Senwosret I welcomes him back to Egypt with full honors despite his cowardly flight years before. Senwosret I arranges for Sinuhe's burial in Egypt, and the final verses describe Sinuhe's tomb and his final contented days in Egypt waiting for death.

TRANSFORMATION. John L. Foster, the American Egyptologist, analyzed Sinuhe's personal development from his loss of status when he fled from Egypt to his eventual restoration to his rightful place in Egyptian society. Foster demonstrated that the real interest of the story for modern readers is in Sinuhe's personal development. It is one suggestion that perhaps helps modern readers understand the story's appeal to ancient readers. At the start of the story Sinuhe is a coward who deserts his king out of fear of losing his own life. His action nearly costs him his life, but he is rescued by a bedouin chief, a man whom Sinuhe would never have recognized as an equal earlier in his life. When Sinuhe meets Amunenshi, he feigns ignorance of his reasons for leaving Egypt, claiming that it was the act of a god. The real turning point in Sinuhe's life comes when an unnamed "hero" challenges him to single combat. Though Sinuhe is smaller, he successfully overcomes the hero through physical courage. This scene witnesses Sinuhe's transformation from the coward who abandoned Senwosret to an effective agent himself. Sinuhe recognizes the change himself in the poem he recites after his victory over the hero. In the poem, Sinuhe remembers the story of his life and contrasts his cowardly escape from Egypt with his current situation as a conqueror. With his transformation from cowardly nobleman to victorious hero now complete, Sinuhe is ready to return to his homeland.

THE GOODNESS OF THE KING. Senwosret's response to Sinuhe's request to return to Egypt indicates that this story served a political purpose. The king readily forgives Sinuhe for his disloyalty and welcomes him with open arms, restoring him completely to his former status. Most commentators have seen the king's forgiveness of Sinuhe as the central purpose of the story. As propaganda, the story established Senwosret's goodness and loyalty to those who remained loyal to him. But Foster's analysis, which stresses Sinuhe's development,

a PRIMARY SOURCE *document*

SINUHE: A MAN WHO CHANGED

INTRODUCTION: *The Story of Sinuhe* begins with an act of cowardice when the protagonist flees the scene upon learning of the death of King Amenemhet. Sinuhe's situation changes when he summons the courage to fight a local hero in his new home in the East. The following extract is the poem he recites after his victory in which he recognizes the changes that he has experienced.

A fugitive flees from his neighborhood,
But my fame will be in the Residence [i.e.,
 Senwosret's palace].
One who should guard creeps off in hunger,
 But I, I give bread to my neighbor;
A man leaves his own land in nakedness,
 I am one bright in fine linen;
A man runs (himself) for lack of his messenger,
 I am one rich in servants.
Good is my home, and wide my domain,
 [But] what I remember is in the palace.

SOURCE: John L. Foster, *Thought Couplets in "The Tale of Sinuhe"* (Frankfurt am Main, Germany: Peter Lang, 1993): 50–51.

demonstrates that this epic was also a close look at individual psychology. The story depicts Sinuhe's development, starting with his removal from his own society to full restoration as a nobleman. Sinuhe moves from disgrace, to renewal, to forgiveness. In the course of this development he also passes from ignorance of his own motives to self-awareness and acknowledgement of his own responsibilities. Not only does he learn to take responsibility for his actions but he also ponders man's proper relationship to the temporal powers of the world.

SOURCES

John L. Foster, *Thought Couplets in the Tale of Sinuhe* (Frankfurt am Main & New York: Peter Lang, 1993).

Alan Gardiner, *Notes on the Story of Sinuhe* (Paris: Librairie Honoré Champion, 1916).

EMERGENCE OF NEW KINGDOM LITERATURE

PUZZLE. Egyptian literature of the New Kingdom (1539–1075 B.C.E.) presents a puzzle for scholars.

Looking at the evidence that survives, no original narrative fiction or teachings date to the first historical division of the New Kingdom, called the Eighteenth Dynasty (1539–1292 B.C.E.). Most of the texts copied at this time seem to have been composed in the Twelfth Dynasty hundreds of years earlier. Historical narratives on temple walls might be an innovation of this time. There is also meager evidence of poetry. The second part of the New Kingdom (Dynasties Nineteen and Twenty, 1292–1075 B.C.E.), in contrast, seems to abound with new literary genres including narratives in a new colloquial dialect, love poetry, and new manuals of advice in the old tradition. Egyptologists question whether the surviving evidence that creates the picture outlined here is truly indicative of how events occurred. They note in connection with this situation the enormous creativity found in the visual arts during the Eighteenth Dynasty. They question whether scribes of the Eighteenth Dynasty ceased to create new fiction and composed only historical texts and hymns. Perhaps the accidents of discovery have created a false picture of the Eighteenth Dynasty.

HISTORICAL BACKGROUND. The golden age of Egyptian literature coincided with the end of the Twelfth Dynasty in 1759 B.C.E. when the reign of Queen Sobeknefru came to a close. The Thirteenth Dynasty ushered in a time of conflict that had split the country in two by 1630 B.C.E. The divided nation was ruled by Semitic-speaking foreigners called the Hyksos in the north and Theban princes in the south until 1539 B.C.E. when Theban princes drove the Hyksos out of Egypt. The Theban prince Ahmose (1539–1514 B.C.E.) founded the Eighteenth Dynasty of the New Kingdom, the period of greatest geographical power of the ancient Egyptian state. The New Kingdom included three dynasties—the Eighteenth (1539–1292 B.C.E.), led by descendants of Ahmose; the Nineteenth (1292–1190 B.C.E.), ruled by descendants of a certain General Ramesses which included Ramesses the Great; and the Twentieth (1190–1075 B.C.E.), led by a new family which continued to use the Ramesses name even though they were probably unrelated. Although Egypt was again unified, this period of Egyptian history was not without its share of upheaval; in the Eighteenth Dynasty, King Akhenaten (1352–1336 B.C.E.) introduced religious reforms in a period known to modern scholarship as the "Amarna Period," in which he proclaimed a new religion that excluded the traditional gods. His successor, King Tutankhamun, restored the traditional gods about four years after Akhenaten died, and subsequent Nineteenth- and Twentieth-dynasty kings continued in this

old tradition. These historical events perhaps were a major influence on the composition of literature during the New Kingdom. In the early years of this period, scribes reached back to the historical precedents of the Middle Kingdom for an authentically Egyptian mode of expression after years of foreign domination. However, as the New Kingdom kings provided a more stable state over the course of time, authors expressed a new Egyptian self-confidence through creating new forms of literature.

COPIED FROM THE MIDDLE KINGDOM. The Middle Kingdom's literary achievements in prose and verse narrative fiction were not duplicated in the Eighteenth Dynasty, and scholars question whether scribes from this dynasty composed new works of literature of the type and intent of those written in the Middle Kingdom. Many surviving texts from this dynasty are generally copies of works from the Middle Kingdom, acknowledged even then to be Egypt's classical age of literature. At least one Eighteenth-dynasty copy of *The Story of Sinuhe*, the great epic poem composed in the Twelfth Dynasty, is known. The earliest preserved manuscripts of the Twelfth Dynasty works *The Teachings for Merykare*, *The Prophecy of Neferty*, *The Teachings of Amenemhet*, and *The Instruction of Khety* also date to the Eighteenth Dynasty.

ORIGINAL COMPOSITIONS. Scholars have proposed three possible genres where Eighteenth-dynasty scribes could have broken new ground: historical texts, love poetry, and advice. The earliest preserved historical narratives date to this period. These works include *The Kamose Stele*, *The Annals of Thutmose III*, and *The Gebel Barkal Stele*. It is unclear whether there were Twelfth-dynasty texts of this type. Love poetry is well known from the Nineteenth and Twentieth Dynasties. One text from the Eighteenth Dynasty might anticipate the later work, though it is a description of the city of Thebes. Finally, two manuals of advice might date to the Eighteenth Dynasty, though the only manuscripts date to the Nineteenth and Twentieth Dynasties. These texts are known as *The Teachings of Any* and *The Teachings of Amenemope*.

HISTORICAL WRITING. Eighteenth-dynasty scribes produced historical narratives that might represent an original literary genre. *The Kamose Stele* is considered to be a work of literature because it narrates a story, but this text has a stronger affinity with historical literature than with classical, fictional narrative. This text, though, certainly dates to the early Eighteenth Dynasty because it is preserved on a dated stela (an upright, inscribed slab of stone). It tells the story of Kamose's war to expel the

Hyksos from Egypt. This was the first stage of driving these foreign rulers out of the country. Scribes working for Hatshepsut (1478–1458 B.C.E.) produced narrative inscriptions that described her birth and also the expedition to the land of Punt (modern Ethiopia) that she commissioned. They are found along with sculptural relief at her temple in Deir el Bahri. *The Annals of Thutmose III*, carved on the walls of the Karnak Temple, present a narrative of battles, tactics, and booty that seems to be a new kind of writing. Some scholars suggest that there was a Middle Kingdom tradition for such texts, though the evidence is meager. There is a fragmentary Twelfth-dynasty inscription from Memphis published in the reign of Amenemhet II (1876–1842 B.C.E.) that might represent the precedent for Thutmose III's inscription. There is also an Eighteenth-dynasty manuscript called *The Berlin Leather Roll* (because it is written on leather and preserved in the Egyptian Museum in Berlin) that might be a New Kingdom copy of an historical inscription written in the Twelfth Dynasty during the reign of Senwosret I (1919–1875 B.C.E.). Some scholars, however, have argued that this text was an Eighteenth-dynasty forgery, designed to serve as a precedent for similar New Kingdom texts. This argument assumes that scribes were not free to invent new forms in the Eighteenth Dynasty and had to create a precedent from the age of the classics in order to write new kinds of works.

AUTOBIOGRAPHIES. Eighteenth-dynasty autobiographies have not been closely studied, but they seem to be less central to the literature of the Eighteenth Dynasty than they were in the Old and Middle Kingdoms. Nobles published these autobiographies in their tombs, as was done in the Old Kingdom, and on statues, which was an innovation. There are no autobiographies on stelae, a practice typical in the Middle Kingdom. The personal subject matter in these autobiographies often concentrates on military exploits or on religious subjects. Later in the Eighteenth and Nineteenth Dynasties the autobiographies are entirely religious rather than narratives of personal experience. For some unknown reason, officials no longer considered these personal experiences to be important.

HYMNS. Hymns were also a new creation in the New Kingdom. They were published mostly in tombs of nobles and bureaucrats, two of the social classes that could afford elaborate Egyptian burials. Most of the hymns are unique copies, suggesting that perhaps the tomb owner composed them for his own use. Hymns seem to be the literary form used to develop religious debates in writing. *The Great Hymn to Osiris*, for example, recorded on

the *Stela of Amenmose*, gives the most complete account in Egyptian of the myth of Osiris. It helps establish the cities where the god had temples, describes Osiris' relationship with other gods, and associates the deceased king with the god. *The Hymns to the Sun God*, recorded on the stela of Suti and Hor, argues through its multiple stanzas the primacy of the sun as a god. It lists the sun's multiple names such as Amun, Harakhti, Re, Khepri, and Aten. It makes the argument that all of these gods are the equivalent of Amun. It was only during the Amarna Period of the Eighteenth Dynasty (1352–1332 B.C.E.), a period of tremendous religious upheaval, that hymns utilized the language of common everyday speech, a dialect called Late Egyptian. Late Egyptian represented the spoken language as it had evolved during the hundreds of years since the end of the Middle Kingdom. The classical texts of the Twelfth Dynasty were written in Middle Egyptian, the spoken language of that period. Now once again scribes were using everyday speech to create new works of literature. Some scholars suggest that Akhenaten understood the use of the colloquial language as a way to conform with maat or right conduct. The Egyptians themselves provide no explanation for this change.

TWO LANGUAGES. Whether or not Eighteenth-dynasty scribes created new literature, they were familiar with both the classical language of Middle Egyptian and the spoken language called Late Egyptian. In the historical work *The Annals of Thutmose III*, the author wrote in Middle Egyptian, though there are clues in certain word choices and grammatical forms that he was a Late Egyptian speaker. By the Nineteenth Dynasty, at least one scribe living in Deir el-Medina in Upper Egypt owned a library that contained texts in both Middle and Late Egyptian. Numerous examples of Nineteenth-dynasty student copies of classics such as *Sinuhe* demonstrate that students used copying as one way to learn the older language. From the Nineteenth to the Twentieth Dynasty, highly literate scribes must have known how to read the classical and the modern language.

INNOVATION. The preserved record of New Kingdom literature certainly creates the impression that the early Nineteenth Dynasty witnessed a sudden literary revolution. New forms including love poetry, narrative fiction, and occasional pieces appear, written in Late Egyptian. Scribes also wrote works following older forms such as teachings, but composed in everyday speech rather than the classical Middle Egyptian dialect. Still, it remains difficult to know whether there really was a revolution or if such texts existed in the Eighteenth Dynasty but did not survive into modern times.

HYMN TO THE SUN GOD

INTRODUCTION: Hymns comprise the best known new literary form during the first half of the New Kingdom (Eighteenth Dynasty, 1539–1292 B.C.E.). Egyptians used hymns as the literary form that explored religious debates in writing. *The Great Hymn to Osiris*, for example, recorded on the *Stela of Amenmose*, gives the most complete account in Egyptian of the myth of Osiris. It helps establish the cities where the god had temples, describes Osiris's relationship with other gods, and associates the deceased king with the god.

I

Turn your face gentle upon us, Osiris!
 Lord of the life eternal, king of the gods,
Unnumbered the names of his protean nature,
 Holy his manifold visible forms,
 hidden his rites in the temples.
First in Busiris is he, that noble spirit,
 Splendid his wealth in Letopolis,
Hailed in the ancestral home of Andjeti,
 Finely provided in Heliopolis;
God who remembers still
 Down in the halls where men must speak true,
Heart of the inexpressible mystery,
 Lord of regions under the earth,
Worshipped in the white-walled Memphis, power that
 raises the sun,
 Whose earthly form rests in Heracleopolis;
Long echo his chants in the Pomegranate nome
 Where the sacred tree sprang, a perch for his soul;
Who dwells in the high Hermopolitan temple,
 Most awful god in Hypselis,
Lord of forever, first in Abydos,
 Yet far off his throne in the red land of death.
His tale endures in the mouths of men;
 God of the elder time,
Belonging to all mankind—
 He gave earth food,
Finest of the Great Nine,
 Most fruitful among the divinities.

II

It was for him chaos poured forth its waters
 And the north wind drove upstream;
Sky would make breeze for his nostrils
 That thereby his heart might find peace;
For his sake green things grew, and the
 Good earth would bring forth its riches.

Sky and its stars obeyed him,
 For him the great gates of heaven stood
 open;
Praise of him thundered down southern skies,
 He was adored under northern heavens;
The circling, unfaltering stars
 Wheeled near his watchful eye,
And the weary ones, who sink below seeing—
 With them was his very dwelling.

III

And he went forth in peace
 Bearing the mace of Earth, his father,
 And the Nine Great Gods gave worship;
Those in the underdark kissed ground,
 Grateful dead in the desert bowed,
Gone generations joyed when they saw him,
 Those seated Beyond stood in awe,
And the Two Lands united worshipped him,
 Welcomed the advent of majesty.
Lordly leader, first of the eminent,
 Whose kingdom endures to eternity—
His rule made kingship distinguished;
 Power for good of the godhead,
Gracious and kind,
 Whom to see is to love.
He made the nations revere him, that mankind
 might
 Lift up his name before all they offered him;
Rememberer of whatever was, whether in heaven or
 earth,
 His mind entire in the land of forgetting;
Unending the shouts and the dancing at festival—
 rites for him of rejoicing
 done by Two Lands with one will.

IV

First-ranked of his brothers, the gods,
 Noblest of the Great Nine,
He made order the length of the Riverbank,
 Set a son at last on his throne,
Pride of his father, Geb,
 Beloved of Nut, his mother.
With strength of the leopard he threw down the
 rebel,
 With powerful arm slew his opponent,
 Put fear on his fallen enemy,
Reached the far borders of evil, uprooted,
 Unflinching, set foot on his foe.
He inherited earth from his father,
 Earned the Two Lands as their king.

V

For when Geb saw how perfect he was, he gave over his
 throne,
 Gave him to guide the world to good fortune;
And this earth he delivered into his care—
 Its waters, its air, its pastures and forage,
All of its walking creatures,
 What leaps into flight or flutters down,
Its creepers and crawlers,
 And the wild desert things—
All given as his to the son of Sky;
 And the Two Lands approved the succession.

VI

And he rose splendid, ascended the seat of his father in
 glory,
 Like Rê when he shines from horizon;
He put dawn on the blank face of darkness,
 Igniting the sun with his double plume;
And he flooded the Two Lands with well-being
 Like the Sun-disk rising at day.
His gleaming crown pierced heaven,
 Became a brother to stars.
And he lived and ruled, a pattern for deity—
 Good king governing well—
Praised and admired by greatest gods
 While lesser divinities loved.

VII

His sister served as shield and defender,
 Beat off the enemies,
Ended unspeakable mischief by power of her spell,
 Golden-tongued goddess
 (her voice shall not fail),
Skilled to command,
 Beneficent Isis,
 Who rescued her brother.
Who searched for him
 And would not surrender to weariness,
Wandered this earth bent with anguish,
 Restless until she had found him.
And she made him shade with her feathers,
 Brought air by fanning her wings,
Performed the rites of his resurrection,
 Moored, married, made breathe her brother,
Put life in the slackened limbs
 Of the good god whose heart had grown weary.
And she took to herself his seed, grew big with the
 heritor,
 Suckled and taught the child apart
 (his refuge not to be known),

Presented him, with his arm grown hardy,
 At Court in the broad hall of Geb.

VIII

And the Nine Great Gods were glad:
 "Welcome, Horus, son of Osiris!
Whose heart shall endure, whose cry shall find
 justice,
 Son of Isis and heir of Osiris!"
Assembled for him the Tribunal of Truth—
 Nine Gods and the Lord of the Universe—
Oh, the Lords of Truth, they gathered within there,
 the Untempted by Evil took seats in Geb's
 hall
To offer the legacy to its just owner
 And the kingship to whom it belonged.
And they found it was Horus, his voice spoke true:
 And they gave him the realm of his father.

IX

And he went forth bearing the mace of Geb;
 And he took the scepter of the Two Banks;
 And the crown stood firm on his head.
Allotted to him was earth, to be his possession,
 Heaven and earth alike put under his care;
Entrusted to him mankind—
 Nobles, and commons, and Sunfolk;
And the dear land of Egypt,
 The islands set in the northern sea,
Whatever the sun's disk circles—
 All these were given his governing—
And the good north wind, and the River, the flood,
 The plants men eat, and all that grows green.
And Nepri, Lord of the Risen Grain, he helped him
 To nurture fruits of the vital earth
So that Horus might bring on abundance,
 Give it as gift to the nations.
And all mankind grew happy, hearts warmed,
 Thoughts danced, and each face saw joy.

X

And they all gave thanks for his kindness:
 "How sweet is the love of him, way we;
His charm, it has ravished the heart.
 Great is the love for him in every person!"
And they offered this song for the son of Isis:
His antagonist is down for his wrongdoing,
 Since evil injures the mischief maker;
He who was hot to cause trouble,

(continued)

HYMN TO THE SUN GOD (continued)

His deed recoils upon him
As Horus, son of Isis,
 Who for him rescued his father:
 Hallowed be, and exalted, his name!
Majesty, it has taken its throne,
 Egypt's splendor is sure under law;
The highroad is safe, bypaths lie beckoning—
 How ordered the banks of the River!
Wrongdoing, it weakens,
 Injustice shall all pass away!
Earth lives in peace under its Lord,
 Ma'at, Lady Truth, stands firm for her
 master,
 Man turns his back upon evil.

XI

Hale be your heart, Osiris,
 You who were truly good,
 For the son of Isis has taken the
 crown!
Adjudged to him is his father's kingdom
 Down in the broad hall of Geb.
Rê it was uttered this; Thoth wrote it down:
 And the Grand Tribunal concurred.
Osiris, your father decreed in your favor!
 All he said has been faithfully done.

SOURCE: "Hymn to Osiris," in *Ancient Egyptian Literature*. Trans. John L. Foster (Austin: University of Texas Press, 2001): 103–109.

POLITICAL FICTION. At least two stories written in the Nineteenth Dynasty are set in the reign of the Eighteenth-dynasty king Thutmose III (1479–1425 B.C.E.), at least 200 years before the time of composition. *The Taking of Joppa* and *The Story of a Military Expedition of Thutmosis III into Syria* both assume this period was a golden age of Egyptian military prowess. In *The Taking of Joppa*, Egyptian soldiers sneak over the town walls using baskets, a theme anticipating the Greek story of the Trojan Horse and tales of Ali Baba and the forty thieves. Such stories suggest the Nineteenth-dynasty policy that restored values associated with Egypt's rulers before the time of Akhenaten and the Amarna period. Military values which had received less attention during the Amarna period once again rank high in authors' estimation.

OTHER NARRATIVES. Other narratives in Late Egyptian occur outside of time, when the gods still walked the earth. *The Contendings of Horus and Seth* recounts a series of struggles between these gods as they compete to follow Osiris as rightful king of the living. Horus, Osiris' son, faces many difficulties in his fight against his uncle Seth, brother of Osiris. Horus eventually triumphs with the aid of his mother Isis, the goddess of magic. *The Doomed Prince* also contains elements associated with the myth of Osiris and does not occur in a recognizable historical period. It also considers questions of the nature of fate. Because the papyrus lacks an ending, it is not clear whether or not the prince is able to escape the doom mentioned in the story's modern title. *The Story of Two Brothers* contains an episode strongly reminiscent of the biblical story of Potiphar's wife found in Genesis of the Bible. In both stories, a

handsome young man suffers for refusing to betray his master with the master's wife. The wife turns on the young man, accusing him of rape. This episode serves as the mechanism for subsequent adventures in the story. All of these stories exist in unique manuscripts on papyrus. This circumstance raises questions of how widely known such literature was among Egyptians. Some scholars have suggested that this literature also circulated orally and that it is the manuscripts that are exceptional.

LOVE POETRY. About fifty love poems composed during the Nineteenth and Twentieth Dynasties represent a unique aspect of New Kingdom literature. Though an Eighteenth-dynasty poem about the author's love of the city of Thebes might represent a precedent for these poems, they otherwise seem the sole examples of personal lyric. They are unusual in the ancient world because they are completely secular. While Twelfth- and Eighteenth-dynasty authors had composed verse hymns and prayers or praise of the king, these love songs concern the affairs of ordinary men and women. The songs are usually twenty to thirty lines long. The translator John L. Foster has described the broad range of emotion they summon, including tenderness, romance, and joy. They hint at both elevated, pure love and at physical passion. They also capture familiar situations: the young woman surprised at meeting her lover unexpectedly, or a young couple sitting together in the garden. They include a young lover cataloging his girlfriend's charms and a young woman trying to sleep but distracted by thoughts of her boyfriend. Both male and female voices speak in the poems, but it is not clear that there were

Egyptian hieroglyphs which read "given life, stability, power, and health," Temple of Amun, Ancient Thebes, modern-day Karnak, near Luxor. FORTEAN PICTURE LIBRARY. REPRODUCED BY PERMISSION.

both male and female authors. The love poems represent a rare window into the emotions of ancient people.

CLASSICAL ALLUSIONS. One Twentieth-dynasty teaching, a form known from the Twelfth Dynasty, contains quotations from much older texts. *The Instruction of Menna for his Son* quotes the Twelfth-dynasty texts *The Shipwrecked Sailor* and *Eloquent Peasant.* Though the text is written in Late Egyptian, the author must have believed his audience could appreciate such an elevated literary technique.

FICTIONAL NON-FICTION. The last two known Late Egyptian stories take a non-fictional genre—the government report and the letter—and use it as a basis for telling a fictional story. *The Report of Wenamun* and the *Tale of Woe* both were composed late in the Twentieth Dynasty, based on the language used and the setting the author describes. Yet they are known in unique

manuscripts of the Twenty-second Dynasty (945–712 B.C.E.). The language in both documents is the most colloquial Late Egyptian found in any narrative. It most closely reproduces everyday speech and avoids any literary flourishes. Both stories recount unhappy experiences and reflect the government's failures as the New Kingdom collapsed and central government once again retreated. Both stories, however, reflect a cultural vibrancy that demonstrates that political strength and flourishing artistic movements do not always overlap.

REMAINING QUESTIONS. This picture of New Kingdom literature remains unconvincing for many Egyptologists. Most scholars would expect that Eighteenth-dynasty writers would both copy Twelfth-dynasty predecessors and create new literature in that tradition. Yet there is no evidence that Eighteenth-dynasty authors wrote in the traditional genres of their predecessors. There is no Eighteenth-dynasty equivalent of Old Kingdom tomb

biographies, Middle Kingdom stela, fictional narratives such as *The Shipwrecked Sailor* and *Sinuhe*, pessimistic studies of chaos, or even advice manuals. In a tradition-bound culture like ancient Egypt, it seems impossible that these genres were not carried forward. Yet the evidence that does survive hints that Eighteenth-dynasty authors developed a new historical literature and created new hymns as a literary genre. This picture is even less convincing because of the hypothetical rebirth of narrative fiction in the Nineteenth and Twentieth Dynasties. These later writers created many variations on fictional writing that discussed politics, the gods, and used bureaucratic genres to create fictional non-fiction. Only the discovery of new manuscripts can solve the mystery of this gap in Egyptian literary history.

SOURCES

Giuseppe Botti, "A Fragment of the Story of a Military Expedition of Thutmosis III," in *Journal of Egyptian Archaeology* 41 (1955): 64–71.

John B. Baines, "Classicism and Modernism in the New Kingdom," in *Ancient Egyptian Literature: History and Forms.* Ed. Antonio Loprieno (Leiden, Netherlands: E. J. Brill, 1996): 157–174.

Miriam Lichtheim, *Ancient Egyptian Literature II: The New Kingdom* (Berkeley: University of California Press, 1976).

Edward F. Wente Jr., "The Capture of Joppa," in *The Literature of Ancient Egypt.* Ed. William Kelly Simpson (New Haven, Conn.: Yale University Press, 1973): 81–84.

DEMOTIC LITERATURE

DEFINITION. The word "Demotic" refers to both the natural developmental stage of the Egyptian language in the Late Period (664–332 B.C.E.), Ptolemaic Period (332–30 B.C.E.), and Roman Period (30 B.C.E.–395 C.E.), as well as a new script. The script developed from a highly cursive form of hieratic, the cursive form of hieroglyphs. This even more cursive hieratic appeared in Memphis toward the end of the New Kingdom (1075 B.C.E.). In the seventh century B.C.E., there is some evidence that scribes deliberately modified the script for writing legal contracts and documents. These changes were related to the Twenty-sixth Dynasty's reorganization of the government. Demotic, however, was not actually used to record literature until the fourth century B.C.E. Scribes used Demotic under the native Egyptian government and subsequent Greek and Roman governments.

DIFFICULTY. Most Egyptologists find Demotic more difficult to learn than the earlier forms of the Egyptian language. This difficulty has influenced the study of Demotic literature and has to some extent kept the study of Demotic literature separate from the earlier literature written in Old, Middle, and Late Egyptian. Additionally, many early twentieth-century Egyptologists considered the period when Demotic was used as a period of decline. The fact that this period coincided with the classical age of Greece in the fifth and fourth centuries B.C.E. reinforced this perception of Egypt as a backwater. Most later twentieth and early twenty-first century scholars, however, view Egypt of this period as a mature civilization that both reflected its ancient past and created new and vital means of expression.

GENRES. A genre refers to a type of literature. Each genre has a formal pattern known to readers and authors and is related to the culture surrounding it. Egyptian authors in the time when Demotic was written might have had more familiarity with the ancestors of modern genres. Modern, Western literary genres derive from theories developed by the Greek philosopher Aristotle (384–322 B.C.E.). Demotic literature comes from the time when Greeks ruled Egypt. Yet Demotic literature, still written in the Egyptian language, seems not to have imitated Greek genre. The genres of Demotic literature are not clearly understood. *The Petition of Petiese* is the story of the wrongs committed against one family. It seems to date to the reign of the Persian king Darius I (521–486 B.C.E.) who ruled Egypt at this time. The text does not follow exactly the form of petitions known from actual court archives. It is both too long and it includes hymns along with the legalistic material. There is also a mixture of genres in the text called *The Demotic Chronicle.* The text contains a series of oracles that the distinguished English scholar of Demotic W. John Tait called "baffling." The action takes place in the reign of Teos (365–362 B.C.E.), though the date of composition is probably in the later fourth or early third century B.C.E., nearly 100 years later. The text appears to be a critique of Egyptian kings. Some scholars view it as an attack on the Greek (Ptolemaic) kings of Egypt, though not all agree. The text depends on word play, an important literary device common in the long Egyptian tradition but not so common in Demotic literature in general.

AUDIENCE. The intended audience for Demotic is an important issue because for most of the time Demotic literature was composed the language of government was Greek. Literate Egyptians still knew hieratic and hieroglyphic which they used for religious texts like the *Book*

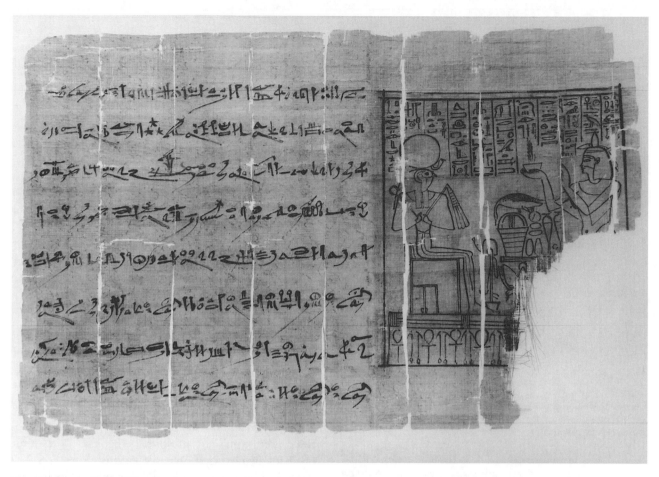

Vignette from a Book of the Dead. BROOKLYN MUSEUM OF ART, 37.1826E, CHARLES EDWIN WILBOUR FUND. REPRODUCED BY PERMISSION.

of the Dead. A few rare Demotic copies of the *Book of the Dead* exist, but traditional texts were still written in the old language. The new contemporary script and language seems to be used mostly for business, government, and narratives after Alexander the Great conquered the country in 332 B.C.E. Scholars assume that the royal court had little interest in Demotic literature and the audience was lower-level Egyptian scribes and priests. This group constituted the native Egyptian literate elite. After the arrival of the Romans, there is at least one archive that included both Demotic and Greek manuscripts, indicating that native Egyptians had an interest in both languages. Additionally there is the literature called Graeco-Egyptian. These texts might represent Greek translations of Demotic and Greek literature set in Egypt for the Greek-speaking Egyptians. This evidence suggests that the majority of Greeks in Egypt did not read Demotic even if they could speak it.

RANGE OF MATERIALS. Most of the Demotic literary papyri now known to scholars were excavated between 1964 and 1973 in North Saqqara. The texts date from Saite (Dynasty Twenty-six, 664–525 B.C.E.) to Roman times (30 B.C.E.–395 C.E.). Included in this group of papyri are stories, teachings, satire, prophecy, astrology, magic, and medical texts. Very few of these texts have been studied beyond identifying their basic context. In fact, the sudden rise in the number of known Demotic texts in the late twentieth century will inevitably revolutionize scholarly ideas about the period. The majority of these texts are narratives.

EARLIEST NARRATIVES. The fragmentary preservation of the earliest narratives found in Saqqara makes it difficult to reconstruct any stories. One papyrus seems to contain several stories within stories. They include the sufferings of a priest and of a young couple. Another Saqqara papyrus deals with a villain who kidnaps Pharaoh. The goddess Hathor then guides a hero who finds the king through the use of a horse. Another story tells of a magician making wax figures. A group of Ptolemaic stories (332–30 B.C.E.) set in the reign of King Amasis (570–526 B.C.E.) begins with the king drinking so much wine that he becomes drunk. The next day,

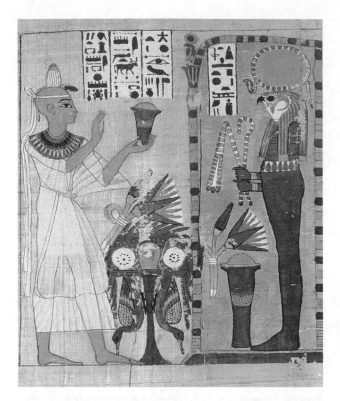

Deceased Making an Offering Before Horus, illustration from the Egyptian *Book of the Dead.* © GIANNI DAGLI ORTI/CORBIS. RE-PRODUCED BY PERMISSION.

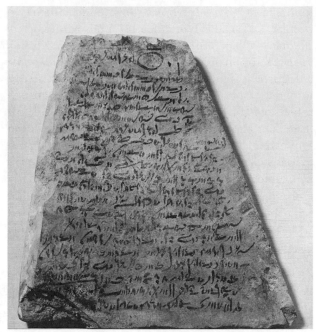

Ostracon with Demotic inscription. BROOKLYN MUSEUM OF ART, 37.1821E, CHARLES EDWIN WILBOUR FUND. REPRODUCED BY PERMIS-SION.

plagued by a hangover, the king asks for stories to divert him while he recovers. Here again it is difficult to understand these stories as other than criticism of the current regime, set in the earlier period.

ORAL TRADITION. Earlier twentieth-century scholars attempted to connect Demotic literature with oral tradition, assuming that the nature of the stories was popular rather than a part of high culture. Yet it is hard to make the connection between oral tradition and Demotic literature. In favor of the theory is the large number of catch phrases repeated throughout a text, reminiscent of a device used by storytellers in many cultures. Additionally, some stories include extended repetition of paragraphs in different places, another common oral storytelling technique. Yet, these stories are prose, and most oral traditions are verse in the ancient world.

CYCLES. Many stories are found in groups in the same papyrus and center on one character who lived in the distant past. For example, there is a cycle concerning a character called Setna Khaemwas, who was historically the fourth son of Ramesses II (1279–1213 B.C.E.). Setna stories all involve the use of magic. Many of the stories involve Setna and the ghost of a magician from former times. Another cycle centers on the character

called Inaros and the members of his family. Inaros stories center on military exploits, perhaps set in the time of a King Petubastis of Dynasty Twenty-three (838–712 B.C.E.). In any case, the stories resemble the earlier tradition of historical rather than contemporary settings.

TEACHINGS. Scholars have known two long texts belonging to the genre the Egyptians called *seboyet*, or "teachings," since the nineteenth century. One text is known as *Papyrus Insinger*, the other as *The Teachings of Ankhsheshonqi*. *Papyrus Insinger* is named after J. H. Insinger, a Dutch museum patron who purchased the text for the Royal Museum of Antiquities in Leiden in the Netherlands. The beginning is lost. A scribe copied this manuscript in the first century C.E., but the author composed it up to 300 years earlier. A second copy of the text in the Ny Carlsberg Museum in Copenhagen demonstrates that there were multiple copies. Both *Ankhsheshonqi* and *Insinger* consist of one-line sentences. *Insinger*'s author, however, grouped the sentences into themes and chapters which he numbered, while the arrangement of *Ankhsheshonqi* is less clear. The theme in both texts is that there is a good and a bad way to live. Yet living by the good is no guarantee of success in life. These texts admit, unlike earlier teachings in Egypt, that sometimes the wicked prosper. Yet the texts counsel that the wise man does not judge his life so much by results as he does by his morality and piety. The wicked, how-

ever, are always punished ultimately. The author of *Insinger* believed that there was an all-embracing moral order in the world which governed nature and human existence. The *Ankhsheshonqi* manuscript dates to about the first century B.C.E., but the date of composition remains a matter of debate. Certainly, though, the structure of *Ankhsheshonqi* relates it to earlier teachings. It begins with the story of a man who inadvertently learns that his friend is involved in a plot against the Pharaoh's life. This man is jailed when the plot is discovered, but avoids execution. He writes this instruction for the good of his son. The format of the advice is single sentences on how to act. As was true in the earlier *Teachings*, the advice is pragmatic and humorous. It remains utilitarian rather than lofty and moralistic.

CONTINUATION. Demotic literature remains a fertile but as yet nearly untilled field for literary research. An unknown number of individual papyri remain to be studied in the future. Most have not been published even in the form of photographs. It is likely that these texts hold the answer to many of the questions that remain about Egyptian literature. They are especially important, on the one hand, because they are the last stage of a 3,000-year old literary tradition. But they also, on the other hand, represent the only stage of Egyptian literature written while the Egyptians were in close contact with a foreign culture, the Greeks and Romans. Since Greek and Roman writers are the ancestors of Western authors, it will be fascinating to learn how Egyptian and classical literature interacted with and perhaps influenced each other.

SOURCES

Miriam Lichtheim, *Late Egyptian Wisdom Literature in the International Context* (Freiburg, Switzerland: Universitätsverlag, 1983).

W. John Tait, "Demotic Literature: Forms and Genres," in *Ancient Egyptian Literature: History and Forms.* Ed. Antonio Loprieno (Leiden, Netherlands: E. J. Brill, 1996): 175–190.

THE EGYPTIAN LITERARY CANON

DEFINITION. A literary canon is a group or body of related literary works, often sanctioned by an authority. Though modern canons of literature have traditionally been set by universities or other official bodies, there is no authoritative body that scholars know today from ancient Egypt that would have designated an Egyptian literary canon. In fact, for ancient Egypt the canon consists of the works that have survived into modern times. New works can still emerge as they are discovered in museum storerooms and through archaeology. Many papyri collected in the nineteenth century remain unread in Egyptian, European, and American museums. A slow and painstaking process of study and publication gradually has added works to the Egyptian canon. At this time, scholars cannot know whether or not modern knowledge of Egyptian literature contains important gaps or if it is nearly complete.

ADMONITIONS OF IPUWER. Egyptologists have disagreed on when the author first created *The Admonitions of Ipuwer.* The composition date probably falls in the Twelfth Dynasty (1938–1759 B.C.E.) based on the language used, though the setting is the First Intermediate Period (2130–2003 B.C.E.), a time of social chaos. The only manuscript is a long papyrus now in Leiden, The Netherlands. It dates to the Nineteenth Dynasty (1292–1190 B.C.E.), demonstrating the long-standing popularity of descriptions of national chaos followed by resolution by a strong king. The author describes terrible social disorders including rebellion and death. He longs for the social order that only the king can provide.

ASTARTE AND THE SEA. This story, composed in the Eighteenth Dynasty (1539–1292 B.C.E.), may be a direct translation of a Canaanite story. One papyrus in New York preserves it. The story describes how the goddess Astarte defeated a sea-monster called Yam with the help of the god Seth. The story demonstrates that the Egyptians were familiar with foreign literature during this period.

COMPLAINTS OF KHAKHEPERRE-SONB. The narrator of the *Complaints* bears a name that honors Senwosret II (1844–1837 B.C.E.), using his throne name plus the phrase "may he live!". The author must have written it during this reign. The only copy dates to the Eighteenth Dynasty (1539–1292 B.C.E.), preserved on a writing board in London, showing the continued popularity of pessimistic descriptions of national chaos in Egyptian literature hundreds of years later. Since this author lived in a peaceful time, it is difficult to know whether he had a political purpose in writing this text or whether it is a strictly literary enterprise.

CONTENDINGS OF HORUS AND SETH. This Ramesside (1292–1075 B.C.E.) story, preserved in one papyrus in Dublin, describes the long court battle between the falcon-god Horus and his uncle, the god Seth, over who should inherit the throne from Osiris, Egypt's mythical first king. Eighteen courtroom sessions are interrupted by four trials of ritual combat. In the end, the court of

UNCERTAIN DOOM

INTRODUCTION: *The Doomed Prince* contains elements associated with the myth of Osiris and does not occur in a recognizable historical period. Additionally, sections of dialogue repeat verbatim in the text. These elements are typical of the new style of narrative composed in the Nineteenth Dynasty (1292–1190 B.C.E.). The author also considers the nature of fate. Because the papyrus lacks an ending, it is not clear whether or not the prince is able to escape the doom mentioned in the story's modern title. The story occupies four columns on the back (*verso*) of Papyrus Harris 500. The numbers in parentheses give the column and line numbers.

(4,1) It is said, there once was a king to whom no son had been born. [After a time his majesty] begged a son for himself from the gods of his domain, and they decreed that one should be born to him. That night he slept with his wife and she [became] pregnant. When she had completed the months of childbearing, a son was born.

Then came the Hathors to determine a fate for him. They said: "He will die through the crocodile, or the snake, or the dog." When the people who were with the child heard (it), they reported it to his majesty. Then his majesty's heart became very very sad. His majesty had [a house] of stone built [for him] upon the desert, supplied with people and with every good thing of the palace, and the child was not to go outdoors.

Now when the boy had grown, he went up to his roof, and he saw a greyhound following a man who was walking on the road. He said to his servant, who was beside him, "What is it that is walking behind the man who is coming along the road?" He told him: "It is a greyhound." The boy said to him: "Have one like it brought to me." Then the servant went and reported (4,10) it to his majesty. His majesty said: "Bring him a little puppy, [so that] his heart [will not] grieve." So they brought him a greyhound.

Now when many days had passed and the boy was fully grown in all his body, he sent to his father saying: "To what purpose is my sitting here? I am committed to Fate. Let me go, that I may act according to my heart, until the god does what is in his heart." Then a chariot was harnessed for him, equipped [with] (5,1) all sorts of weapons, and [a servant was given him] as an attendant. He was ferried over to the eastern shore and was told "Go wherever you wish," and his greyhound was with him. He went northward across the desert, following his heart and living on the best of all the desert game.

He reached the Prince of Nahrin. Now the Prince of Nahrin had no children except one daughter. For her a house had been built whose window was seventy cubits away from the ground. Ha had sent for all the sons of all the princes of Khor and told them: "He who reaches the window of my daughter, his wife she shall be." Now when many days had passed and they were at their daily pursuit, the youth passed by them. Then they took the youth to their house. They washed him; they gave fodder to his team. They did everything for the youth. They anointed him; they bandaged his feet; they (5,10) gave food to his attendant. And they said to him by way of conversation: "Whence have you come, you good youth?" He said to them: "I am the son of an officer of the land of Egypt. My mother died; my father took another wife, a stepmother. She came to hate me, and I went away, fleeing from her." Then they embraced him and kissed him on [all his body].

[Now when many days had passed], he said to the sons: "What is this you are doing [here?" They said]: "For three [months] now we are here passing (6,1) the time [in leaping. For he] who reaches [the] window of the daughter of the Prince of Nahrin [will] get her as [wife]." [He] said to them: "If only my feet did [not] hurt, I would go leaping with you." They went leaping in their daily manner, while the youth stood at a distance watching, and the gaze of the daughter of the Prince of Nahrin was upon him.

Now when many days had passed, the youth came to leap with the sons of the princes. He leaped, he

gods awards Horus the throne as the rightful heir of Osiris. The story seems somewhat satirical and possibly reflects political events in the Nineteenth or Twentieth Dynasty.

THE DESTRUCTION OF MANKIND. This story is part of a larger work called *The Book of the Heavenly Cow.* The oldest copy known today was inscribed in the tomb of King Tutankhamun (1332–1322 B.C.E.), and scribes also inscribed it in five other royal tombs of the

New Kingdom. The last known copy was in the tomb of Ramesses VI (1145–1137 B.C.E.). Thus all the copies date to the New Kingdom, but the language is Middle Egyptian, the vernacular of the Middle Kingdom (2008–1630 B.C.E.). Scholars disagree about whether an author composed it in the Middle Kingdom or if it is an original work of the New Kingdom. The story describes the sun-god Re becoming tired of humanity's wickedness. Re sends his daughter Sakhmet, a lioness

reached the window of the daughter of the Prince of Nahrin. She kissed him, she embraced him on all his body. One went to inform her father and told him: "One man has reached the window of your daughter." Then the Prince questioned him saying: "Which prince's son?" They said to him: "The son of an officer who came fleeing from Egypt, away from his stepmother." Thereupon (6,10) the Prince of Nahrin became exceedingly angry. He said: "Am I to give my daughter to this fugitive from Egypt? Make him go away!"

They went and told him: "Go back where you came from!" But the daughter held him, and she swore by the god saying; "As Pre-Harakhti lives, if he is taken from me, I shall not eat, I shall not drink, I shall die right away!" The messenger went and reported to her father every (word) that she had said. And her (father) sent men to slay him on the spot. But the daughter said to (them): "As Pre lives, if they slay him, when the sun sets I shall be dead. I will not live an hour longer than he!"

They [went] to tell her father. Then her (7,1) [father had] the [youth brought] before him [together with] his daughter. And when [the youth stood before him] his dignity impressed the Prince. He embraced him, he kissed him on all his body; he said to him: "Tell me about yourself, for now you are my son." He said to him: "I am the son of an officer of the land of Egypt. My mother died; my father took another wife. She came to hate me; I left fleeing from her." Then he gave him his daughter as a wife. He gave him a house and fields as well as cattle and all sorts of good things.

Now when many days had passed, the youth said to his wife: "I am given over to three fates: the crocodile, the snake, the dog." Then she said to him: "Have the dog that follows you killed." He said to her: "What foolishness! I will not let my dog be killed, whom I raised when it was a puppy." So she began to watch her husband very much and did not let him go out alone.

Now on the day on which the youth had left Egypt in his wandering, the crocodile, (7,10) his fate [had followed him] ———. It came to be opposite him in the village in which the youth was, [and it dwelled in] the lake. But there was a demon in it. The demon did not let the crocodile come out; nor did the crocodile let the demon come out to stroll about. As soon as the sun rose [they] stood and fought each other every day for three months now.

And when more days had passed, the youth sat down to a feastday in his house. Then when night had come, the youth lay down on his bed, and sleep overwhelmed his body. Then (8,1) his wife filled a [bowl] with [wine] and another bowl with beer. Thereupon a [snake] came out [of its] hole to bite the youth. But his wife was sitting beside him, not sleeping. [She placed the bowls before] the snake. It drank, it became drunk, it lay down on its back. Then [the woman had] it hacked to pieces with her axe. They woke her husband ———. She said to him: "Look, your god has given one of your fates into your hand. He will protect [you from the others also]." [Then he] made an offering to Pre, praising him and extolling his might every day.

Now when many days had passed, the youth went out for a pleasure stroll on his estate. [His wife] did not go out [with him], but his dog was following him. Then his dog began to speak [saying: "I am your fate."] Thereupon he ran before it. He reached the lake. He descended into [the water in flight from the] dog. Then the crocodile [seized] him and carried him off to where the demon was. [But he was gone. The] crocodile said to the youth: "I am your fate that has come after you. But [for three months] now I have been fighting with the demon. Now look, I shall release you. If my [enemy returns] to fight [you shall] help me to kill the demon. For if you see the ——— the crocodile." Now when it dawned and the next day had come, [the demon] returned ———.

SOURCE: "The Doomed Prince," in *The New Kingdom*. Vol. 2 of *Ancient Egyptian Literature: A Book of Readings*. Trans. Miriam Lichtheim (Berkeley: University of California Press, 1976): 200–203.

goddess, to destroy mankind. After some time, Re changes his mind. In order to stop Sakhmet, he floods the world with beer dyed red to resemble blood. Sakhmet drinks the beer, becomes drunk, and ceases her destruction. The story echoes the Hebrew Bible's account of Noah and the flood, especially in the deity's decision to destroy mankind because of its wickedness and in the use of a flood and drunkenness as key elements in the story.

DIALOGUE OF A MAN WITH HIS BA. This Middle Egyptian dialect text is preserved on one papyrus now in the Egyptian Museum in Berlin. The grammar and word choice found in the document suggest a date of composition in the early Twelfth Dynasty, shortly after 1938 B.C.E. The substance of the text is a discussion between a man and a part of his soul, called the *ba* in Egyptian. The man argues that traditional funeral arrangements meant to ensure a happy afterlife are useless. His ba tries to reassure

a PRIMARY SOURCE *document*

TEACHINGS OF PTAHHOTEP—PRACTICAL AND WISE

INTRODUCTION: The *Teachings of Ptahhotep* incorporates many of the elements found in the Egyptian literary genre called teachings. The author set the frame story in the past and attributed his own words to a great man from history. He combined in one document both practical and lofty wisdom. For example, proper household arrangements receive as much attention as the importance of following divine law. Finally, he follows the standard of "perfect speech," the Egyptian belief in the power of well-crafted prose.

Beginning of the phrases of perfect speech
Spoken by the Patrician and Count,
The eldest King's Bodily Son,
The Lord Vizier Ptahhotep,
In teaching the ignorant to be wise, to be the standard of perfect speech,
excellent to him who shall listen, baneful to him who will transgress it,
And he said before his son:

(Maxim 1)
Be not proud for being wise,
Consult with the ignorant as with the wise.
The limits of art have not been attained;
There is no artist (fully) equipped with his excellence.
Perfect speech is concealed, more than emerald
(yet) it is found with the maids at millstones.

(Maxim 5)
If you are a leader,
Ordaining the affairs of the multitude,
Seek out for yourself every good deed,
So that your affairs shall be faultless.
Great is Truth, enduring is (its) effectiveness,
It has not been disturbed since the time of Osiris.
He who transgresses the laws is punished
—it is a transgression (even) in the view of the selfish.

It is baseness which seizes a lifetime of wealth,
But wrong has not yet ever brought its deed to land.
A man says, "I myself will snare,"
But he cannot say, "I will snare because of my occupation."
When the end comes, Truth endures.
Let no man say, "It is my family property."

(Maxim 11)
Follow your heart as long as you live.
Do not do more than is required.
Do not waste the time of following the heart;
It is an abomination to the spirit to destroy it.
Do not reject an occasion in the course of a day,
Beyond (the requirements of) establishing your household.
Goods will exist—follow your heart!
There's no gain in goods, when it is disaffected.

(Maxim 12)
If you are a man of excellence,
You shall beget a son for the pleasing of god.
If he is straight, he will take after your character,
And care for your goods in the proper way.
Do goodness for him: he is your son;
He is of your spirit's seed: may you not withdraw your heart from him!
Progeny (can) make trouble:
If he stays and transgresses your advice, having defied all that was said,
His speech coming out with evil words,
You shall belabour him for his speech accordingly.
Oppose yourself to one hateful to them
—he is one for whom opposition was ordained in the womb;
he whom they guide cannot go astray, whom they leave boatless cannot find a crossing.

(Maxim 13)
If you are in the court,
Stand and sit according to your position,
Which was ordained for you on the first day.
Do not overstep, or you will come to be opposed.

him that this is untrue. It is not clear who wins this debate. The text surprises modern readers since it suggests that not all Egyptians believed the traditional reassurances that the afterlife was a continuation of life on earth.

THE ELOQUENT PEASANT. The author composed *The Eloquent Peasant* late in the Twelfth Dynasty (1938–1759 B.C.E.) but set the story earlier in the reign of a King Nebkaure, perhaps the king of this name who reigned in the Ninth or Tenth Dynasty (2130–1980 B.C.E.). In the introductory story, an of-

ficial robs a peasant on his way to market. The peasant protests to the official's superior. Though the superior intends to rule in favor of the peasant, he insists that the peasant return to orate on justice many days in a row because the peasant is so eloquent. The text plays both on the meaning of justice and the Egyptian love of oratory. The four papyrus copies of this text, now in Berlin and in London, all date to the Middle Kingdom. There is no proof that readers of the later periods knew this text.

Clever is he who enters when announced,
And wide the access for him who is summoned.
The court is according to standard;
Every affair is by measure.
It is god who advances position;
The jostler is not appointed.

(Maxim 17)
If you are a leader,
Be calm when you hear a petitioner's speech,
Do not rebuff him from purging his body
Of that which he planned to tell you.
One in distress loves to pour his heart out
More than accomplishing that for which he came.
As for him who rebuffs petitions, it is said: "Why does he
 reject it?"
Everything for which he petitioned may not come
 about,
(but) a good hearing is what soothes the heart.

(Maxim 18)
If you want to make friendship last
In a house you enter,
Whether as lord, or brother, or friend,
In any place you enter,
Beware of approaching the women!
The place where this is done cannot be good;
There can be no cleverness in revealing this.
A thousand men are turned away from their good;
A little moment, the likeness of a dream,
And death is reached by knowing them.
It is a vile thing, conceived by an enemy;
One emerges from doing it
With a heart (already) rejecting it.
As for him who ails through lusting after them, no plan
 of his can (ever) succeed.

(Maxim 19)
If you wish your condition to be good,
Protect yourself from every evil.
Beware of a selfish man's deed.
It is a painful disease of an incurable.

He who catches it cannot exist: it makes trouble with
 fathers and mothers,
And also with brothers by the same mother;
It drives apart husband and wife.
It is the sum of all evil;
It is a compound of all that is hateful.
A man shall endure when he uses Truth aright.
He who goes according to his position
Makes a legacy by this: there is no tomb for the selfish.

(Maxim 21)
If you are excellent, you shall establish your household,
 and love your wife according to her standard:
Fill her belly, clothe her back;
Perfume is a prescription for her limbs.
Make her happy as long as you live!
She is a field, good for her lord.
You shall not pass judgment on her.
Remove her from power, suppress her;
Her eye when she sees (anything) is her stormwind.
This is how to make her endure in your house:
You shall restrain her. A female
Who is in her own hands is like the rainwater:
She is sought, and she has flown away.

(Maxim 22)
Gratify your close friends with what comes to you,
Which has happened to one favoured by god,
As for him who fails to gratify his close friends,
It is said: "Isn't he a nice spirit!"
What will happen cannot be known, when thinking of
 tomorrow.
A spirit by whom people are gratified is a true spirit.
If occasions of favour come,
It is close friends who say: "Welcome,"
(and if) supplies are not brought to town,
then close friends are brought, when there are difficulties.

SOURCE: "Teachings of Ptahhotep," in *Voices from Ancient Egypt: An Anthology of Middle Kingdom Writings*. Ed. R. B. Parkinson (Norman: University of Oklahoma Press, 1991): 65–70.

THE DOOMED PRINCE. The author composed this story early in the Nineteenth Dynasty. One papyrus, now in London, preserves it. In the story, a fictional prince is fated at birth to die either through an attack by a snake, a dog, or a crocodile. The prince grows to adulthood in a protected palace. He then travels to western Asia and marries a princess. One day his dog tries to attack him, but he escapes. Then a crocodile carries the prince away to witness a fight with a demon. The papyrus breaks off with the crocodile requesting help from the prince in his fight with the demon. The ending is unknown.

THE TEACHINGS OF AMENEMHET. The author of this text composed it during the reign of Senwosret I (1919–1875 B.C.E.) but after 1909 B.C.E. The narrator is the deceased King Amenemhet I (1938–1909 B.C.E.), speaking from beyond the grave. Some scholars believe the author was a certain Akhtoy. All the manuscripts date to the New Kingdom (1539–1075 B.C.E.). The primary manuscripts are long papyri in the Egyptian Museum in

Berlin and in the British Museum in London. There are also many fragments, a copy on a leather roll, three wooden tablets and over 100 ostraca (copies on potsherds and limestone chips). This text must have been one of the most widely read of ancient Egyptian compositions since so many copies exist. In the text, King Amenemhet I advises King Senwosret I not to trust anyone. Amenemhet suggests that he was assassinated in spite of his good deeds throughout his life. The discourse is surprisingly pessimistic.

THE TEACHINGS OF PTAHHOTEP. The author of *The Teachings of Ptahhotep* composed it during the Middle Kingdom, probably during the Twelfth Dynasty (1938–1759 B.C.E.). The author set the text during the reign of King Djedkare Isesy (2415–2371 B.C.E.) during the Old Kingdom, approximately 400 years before his own time. Scribes continued to copy the text into the Nineteenth Dynasty (1292–1190 B.C.E.). Four copies on papyrus have survived to modern times along with five ostraca and a wooden writing board. This evidence suggests that this text was widely read for over 600 years in ancient Egyptian schools. The author composed 37 maxims, including both rules of conduct and proverbs. The theme throughout the text is the proper conduct that will lead to success in life. The narrator, Ptahhotep, argues that following these maxims will result both in success and in justice. Yet many of the maxims strike a modern reader as banal; one rule, for example, suggests that at the dinner table it is best to wait to serve yourself until after your boss is served.

TEACHINGS FOR MERYKARE. This text might have been composed during the First Intermediate Period (2130–2008 B.C.E.), perhaps by a king, the father of King Merykare (exact dates unknown). Yet the only copies of the text date to the Eighteenth and Nineteenth Dynasties (1539–1075 B.C.E.). The copies include three papyri now in St. Petersburg and Moscow in Russia, and in Copenhagen in Denmark. An ostracon (a copy on a limestone chip) now in the Cairo Museum originated in the artists' village of Deir el-Medina. Though the text seems to include advice from a king to his son, more middle-class Egyptians took an interest in that advice as much as 800 years later. The narrator discusses the best ways for a king to win the hearts of his followers, stressing the importance of justice in his dealings with all.

KHUFU AND THE MAGICIANS. The late Middle Kingdom (2008–1630 B.C.E.) author of *Khufu and the Magicians* set the story in the time of the builder of the Great Pyramid, King Khufu (2585–2560 B.C.E.). Only one manuscript, written during the Hyksos Period (1630–1539 B.C.E.), preserves the story. It is now in Berlin. The story describes a contest conducted among Khufu's sons. Each tries to tell a story that will relieve the king's boredom. The stories all involve miracles performed by magicians. The last story, however, describes the miraculous birth of triplets who were the kings of the Fifth Dynasty (2500–2350 B.C.E.). Such a story would seem to have a political meaning. Yet it is difficult to understand how the events described here relate to the period when the story was actually written.

NEFERKARE AND THE GENERAL SISENE. The Middle Kingdom author set this story in the reign of Pepy I (2338–2298 B.C.E.), though it was written approximately 400 years later. There are two manuscripts: one on papyrus, now in Paris, and an ostracon in Chicago. Using Pepy's throne name, Neferkare, the story describes the king visiting one of his generals late at night, sneaking into the general's house through a window. Because both manuscripts are very fragmentary, it is not clear what the author meant to portray. Some scholars have understood the text to describe furtive homosexual activity.

PROPHECY OF NEFERTY. The author set *The Prophecy of Neferty* during the reign of King Khufu (2585–2560 B.C.E.) during the Fourth Dynasty. Yet the author probably lived in the reign of King Amenemhet I (1938–1909 B.C.E.) nearly 650 years later. In the text, Neferty explains the future that Egypt will experience. First, the country will fall into chaos, the period that Egyptologists call the First Intermediate Period (2130–2008 B.C.E.). Then, King Amenemhet I will save Egypt and reunite it. Clearly the author lived during Amenemhet's reign and was adding to the literature that glorified the beginning of the Twelfth Dynasty (1938–1759 B.C.E.). Yet all the copies known today—a papyrus in St. Petersburg in Russia, writing tablets in Cairo and in London, and twenty ostraca—originate during the New Kingdom (1539–1075 B.C.E.). This New Kingdom interest in the Twelfth Dynasty reflects the way the kings of this period used the past to legitimate their own rule.

THE QUARREL OF APOPHIS AND SEQENENRE. The author of this early Nineteenth-dynasty narrative (1292–1190 B.C.E.) set the story during the reigns of the Hyksos king Apophis and the Theban prince Seqenenre about 1543 B.C.E. At this time the foreign kings called the Hyksos controlled the north and Theban princes controlled southern Egypt. The story describes the quarrel between these two rulers that led to the war between them. Eventually the historic Theban princes expelled the Hyksos from Egypt. In this story, preserved on one manuscript now in London, Apophis

complains to Seqenenre in a letter that a Theban hippopotamus is bellowing so loudly that it disturbs his sleep in the town of Avaris. Since Thebes and Avaris were 500 miles apart, it seems that Apophis' claim was meant as an insult or a taunt. The meaning of this story for readers living 250 years later, when the story was composed, is unclear.

THE REPORT OF WENAMUN. The author of *The Report of Wenamun* set the text in the time of King Smendes (1075–1049 B.C.E.) in the Twenty-first Dynasty, just after the close of the New Kingdom. The one papyrus manuscript, now in Moscow, is roughly contemporary with the setting of the story. The story, written in the style of a bureaucratic report, describes Wenamun's journey to Byblos, in modern Syria, to purchase wood for a new boat for the god Amun. One disaster follows another as pirates steal Wenamun's money and the prince of Byblos mistreats him. At the end of the papyrus, Wenamun flees to Cyprus where he is apparently sheltered by the local queen. The end of the story is not preserved. Scholars disagree about whether the story is fictional or reflects the historical situation in Smendes' time. Arguments for the former focus on the fact that the misfortune Wenamun reports never was included in other bureaucratic reports. *Wenamun* would be a rare fictional narrative if it was actually set in the same period as the time of its composition, since most ancient Egyptian fiction is set in time periods centuries before their date of composition. The difficulty in categorizing the text adds to its interest.

SATIRE ON THE TRADES. The grammar and word choice found in *The Satire on the Trades* indicate that an author composed it in the Twelfth Dynasty (1938–1759 B.C.E.), but all the manuscripts known in modern times date to the New Kingdom (1539–1075 B.C.E.). The manuscripts include four papyri preserved in both London and New York, two wooden boards in Paris, and nearly 100 ostraca on potsherds and limestone chips in Cairo. The large number of copies demonstrates that the text was well-known and popular hundreds of years after it was written. In the introductory story, a man from the northern-most provinces is bringing his son to school in the capital city, Memphis. As they travel by boat, the father explains to the son that only a scribe can have a happy life. He describes all other occupations in both derogatory and satirical terms. Because the father who narrates the text bears the name Dua-khety, some scholars call him the author.

THE SHIPWRECKED SAILOR. The author composed this story in the Twelfth Dynasty (1938–1759 B.C.E.) and set it on a mythical island. Only one Twelfth-dynasty papyrus manuscript, now in Moscow, survives. In the story, a sailor attempts to comfort his ship's captain with a story. He describes how he was shipwrecked on an island and saved according to the prophecy of a gigantic snake who lived there. The snake also tells a story-within-the-story to the sailor. In the end, the captain tells the sailor that this story is no comfort at all. The meaning of the story and its multiple layers of narrative continues to be problematic. Some scholars have regarded it as an adventure tale, comparing it to *Sinbad the Sailor*. Others have recognized religious teachings, especially in the story that the snake tells.

THE STORY OF SINUHE. The author composed *The Story of Sinuhe* during the Twelfth Dynasty, probably during the reign of Senwosret I (1919–1875 B.C.E.). Six papyrus manuscripts written shortly after Senwosret's reign preserve the text. The two earliest copies are now in Berlin. There are also numerous ostraca both on potsherds and on limestone chips. Many of these ostraca date to the New Kingdom (1539–1075 B.C.E.) but at least one is as late as the seventh century B.C.E. The text's wide distribution throughout Egyptian history demonstrates the importance of *Sinuhe* in Egyptian culture. The story recounts a nobleman's flight into western Asia when he believes he has been accused of a crime. He has many adventures and marries a bedouin woman, but eventually returns to Egypt at the end of his life. This return and offer of forgiveness from King Senwosret I was the real theme of the story because it emphasized the king's mercy. Yet the story was immensely popular and important throughout ancient Egyptian history.

THE TAKING OF JOPPA. The story's Nineteenth-dynasty author (1292–1190 B.C.E.) set it during the reign of King Thutmose III (1479–1425 B.C.E.), 200-300 years earlier. Only one manuscript, now in London, preserves the story of General Djeheuty capturing the town of Joppa, in modern Israel. The Egyptian army hides in baskets attached to donkeys in a caravan to enter the walled city. The story reflects a more general interest in Thutmose III's reign popular during the early Nineteenth Dynasty.

THE STORY OF TWO BROTHERS. In this Nineteenth-dynasty story, preserved on one papyrus in London, a woman makes sexual advances to her brother-in-law, Bata. When he rejects her advances, she tells her husband that Bata raped her. Bata's brother confronts him with his wife's charges and Bata responds by castrating himself. Bata then undergoes several changes in form, most importantly when

he transforms into a bull. The story is probably an account of the origins of the bull-god, Bata.

TRUTH AND FALSEHOOD. The Nineteenth-dynasty story *Truth and Falsehood*, preserved on one papyrus in London, describes a dispute between two brothers with these obviously allegorical names. Truth accuses Falsehood of stealing his dagger. Falsehood convinces a court consisting of the nine major gods that this charge is untrue. The court blinds Truth as punishment for the charge. Truth's son, however, eventually avenges him by arguing before the same court that Falsehood has stolen the son's ox. When the son wins this case, Falsehood is punished and Truth is compensated for his previous unjust conviction.

SOURCES

Miriam Lichtheim, *Ancient Egyptian Literature.* 3 vols. (Berkeley: University of California Press, 1973–1980).

William K. Simpson, ed., *The Literature of Ancient Egypt* (New Haven, Conn.: Yale University Press, 1972).

SEE ALSO *Philosophy: Teaching Philosophy; Religion: Magic in Egyptian Religion*

SIGNIFICANT PEOPLE
in Literature

KHAEMWASE

Early Nineteenth Dynasty (about 1290–1279 B.C.E.)–Nineteenth Dynasty (before 1213 B.C.E.

Prince
Priest

FOURTH SON. Khaemwase was the fourth son of Ramesses II and the second son of Queen Istnofret, a secondary wife. He thus held high rank among Ramesses' 115 children. Khaemwase was probably born while his grandfather, Sety I, was still king (1290–1279 B.C.E.). As a boy of about five, he accompanied his father on military campaigns in Lower Nubia to the south of Egypt. He also followed his father to war as a teenager. But Khaemwase had interests other than war.

PRIEST. Khaemwase became a priest of the god Ptah in Memphis when he was in his twenties, in Year 16 of his father's reign, about 1263 B.C.E. Among his first duties as priest was to supervise the burial of the Apis bull. The Apis bull was an animal born with particular mark-

ings and considered especially sacred to the god Ptah. There was only one Apis bull at a time. Khaemwase supervised the bull's burial in 1263 B.C.E. and again in Year 30 of his father's reign, about 1249 B.C.E. For later bulls, he built a special burial-place called the Serapeum. This new burial place developed over time into an extensive building full of hallways and chambers leading in multiple directions like a maze. The building was in use for nearly one thousand years until King Nectanebo built a new burial place for the Apis bull. But knowledge of the Serapeum and Khaemwase's role in it continued to fascinate readers during the time when Demotic literature flourished. The fact that Khaemwase was also buried in the Serapeum must have added to popular interest in him later.

FICTIONAL KHAEMWASE. A thousand years after his death, Khaemwase was the main character in two important Demotic stories. In *Khaemwase and Naneferkaptah*, Khaemwase steals a magic book from Naneferkaptah, the man charged by the god Ptah to guard it. After an attempt to win the book in a game, Khaemwase ran away with it. Ghosts then pursued him, he lost his good name, and finally his father Ramesses II convinced him to return the book. In *Khaemwase and his son Si-Osiri*, Khaemwase and his wife's much desired, long-awaited son turns out to be a magical spirit. As a boy he is a skilled magician. Later in life during a contest with another magician, Si-Osiri disappears. Finally, Khaemwase's real son is born. These lively tales preserve detailed legends, perhaps inspired or at least sustained by knowledge of the Serapeum.

SOURCES

K. A. Kitchen, *Pharaoh Triumphant: The Life and Times of Ramesses II* (Warminster, England: Aris and Phillips Ltd., 1982).

PTAHHOTEP

fl. Fifth Dynasty (2500–2350 B.C.E.)

Statesman
Prime minister

PRIME MINISTER. At least five men during the Fifth Dynasty bearing the name Ptahhotep served as prime minister. They were probably related, but the relationships among these men are unclear. Somehow, the name of these viziers was associated with an important teaching, *The Teachings of Ptahhotep*, composed in the Twelfth Dynasty (1938–1759 B.C.E.), approximately 600 years later. Though most Egyptian literature is anonymous, when an author is named, the relationship is often fic-

tional. Because the name Ptahhotep bore great prestige among later generations, the author hoped that Ptahhotep's prestige would attach to his work of literature. Composed of 37 maxims, the rules of conduct and proverbs aim to present the reader with the proper conduct that will lead to success in life. The narrator, Ptahhotep, argues that following these maxims will result both in success and in justice. The success and importance of the work is evident in the fact that it was still being copied in the Nineteenth Dynasty, and was probably used in ancient Egyptian schools.

SOURCES

Elke Blumenthal, "Ptahhotep und der 'Stab des Alters,'" in *Form und Mass: Beiträge zur Literatur, Sprache und Kunst des alten Ägypten: Festschrift für Gerhard Fecht zum 65. Geburtstag am 6. February 1987.* Ed. J. Osing (Wiesbaden, Germany: Otto Harrasowitz, 1987): 84–97.

Henry G. Fischer, *Varia* (New York: Metropolitan Museum of Art, 1976): 82.

WENAMUN

Twentieth Dynasty (1190–1075 B.C.E.)–Twenty-first Dynasty (1075–945 B.C.E.)

Elder of the Portal of (the god) Amun
Envoy

MERCHANT. Wenamun's personal history is unknown. In fact, it is difficult to ascertain whether he was an historical or fictional figure. The document called *The Report of Wenamun,* a papyrus now in Moscow, is written to resemble a bureaucratic report on a mission to a foreign country. Yet the level of detail and the negative information included in it is never otherwise found in ancient Egyptian non-fiction. Wenamun travels to Byblos, a town in modern Lebanon, to buy wood for the ceremonial ship of the god Amun. En route, robbers steal Wenamun's money. He continues to Byblos, but the king of Byblos has no interest in trading with a man without money, even if he represents the god. Finally, after many tribulations, Wenamun is forced to flee and he reaches Cyprus. Here the papyrus ends, before the story is concluded. Egyptologists disagree on how to judge this mixture of a non-fiction form with what is usually fictional content. In any case Wenamun's report undoubtedly reflects the state of affairs at the close of the New Kingdom when Egypt had lost control of its possessions in the Near East.

SOURCES

Erik Hornung, *Sinuhe und Wenamun: Zwei ägyptische Wanderer* (Munich: Wilhelm Fink, 1995).

DOCUMENTARY SOURCES
in Literature

Complaints of Khakheperre-sonb (c. reign of Senwosret II, 1844–1837 B.C.E.)—This example of the pessimistic literature contrasts reality with the Egyptian ideal of justice.

The Doomed Prince (c. 1292–1075 B.C.E.—This narrative concerns a young prince who attempts to escape fate. Because the papyrus breaks off, it is not clear if he succeeds.

Horus and Seth (c. 1292–1075 B.C.E.)—In this story, two gods sue each other in a court of the gods to determine who is the rightful heir to the throne. It may be a satire of the process of succession and the political machinations of the many sons of either Ramesses II or Ramesses III.

The Immortality of Writers (c. 1292–1075 B.C.E.)—This verse description claims that writing is more important a monument to the author than his tomb.

Prophecy of Neferty (c. Twelfth Dynasty, 1938–1909 B.C.E.)—This pessimistic work of prophecy is set in the Old Kingdom but was written in the Middle Kingdom. Neferty tells King Khufu of the troubles to come and Egypt's salvation by King Amenemhet I.

The Report of Wenamun (c. 1075–1049 B.C.E.)—This narrative, styled as a bureaucratic report, describes an ill-fated expedition to buy wood for a new ship for the god Amun.

The Shipwrecked Sailor (c. Twelfth Dynasty, 1938–1759 B.C.E.)—This narrative about a sailor who attempts to comfort his captain about the failure of their expedition contains stories within the story.

The Story of Sinuhe (c. reign of Senwosret I, 1908–1875 B.C.E.)—Egypt's great national epic shows the mercy of the king and the ability of one man to transform himself.

The Story of Two Brothers (c. 1292–1075 B.C.E.)—This narrative describes the origin of the god Bata but also reflects parallels with the Hebrew Bible story of Joseph.

The Teachings of Amenemhet I (c. 1909–1875 B.C.E.)—This work provides advice on how to rule, reportedly given by the king Amenemhet I to his son.

Teachings of Ptahhotep (c. Twelfth Dynasty, 1938–1759 B.C.E.)—This work of moral and practical advice was attributed to the prime minister Ptahhotep, although it was actually written several centuries after his lifetime.

MUSIC

Edward Bleiberg

IMPORTANT EVENTS
in Music

All dates in this chronology are approximations (c.) and occur before the common era (B.C.E.).

2675–2170 Tomb carvings record the earliest representations of singing and clapping, the first percussion instrument. Carvings also depict female musicians shaking the *menat*, a rattle/necklace used in worship.

Egyptian ensembles first use the flute-like *mat* and the clarinet-like *memet*. Both solo and ensemble musicians begin to use the arched harp.

Carvings show singers making hand gestures. Scholars conjecture that such gestures might serve to signal particular notes to the musicians or represent spontaneous feeling.

Evidence from tomb carvings suggests that Egyptians may have used music to flush animals from the marsh during hunting.

A tomb carving of the song "Bata Mutilates Himself" provides the first record of an Egyptian song, also known from *The Story of Two Brothers* recorded on papyrus.

The sistrum—a rattle-like instrument—is used to accompany dance and to worship the goddess Hathor.

Gender distinctions in instruments relegate men to the playing of flutes and oboes, while women play percussion. This segregation is not universal in music, however, as both men and women play harps and sing.

Evidence suggests the existence of women called *heset*, or "singer," who chant the ritual for the gods.

Tomb-wall carvings reveal that female harpists in the Old Kingdom were almost universally the relatives of the deceased tomb owner and not professional musicians. Other carvings demonstrate that male musicians can be members of the elite class.

2625–2500 Carvings in the tomb of Debhen show male and female musicians playing in one ensemble.

2500–2350 Earliest representation of professional singer and harpist is recorded in a tomb.

2350–2338 A tomb drawing of the prime minister, Mereruka, shows him sitting on his bed while his wife, Watetkhethor, plays the harp for him; the interplay of a bedroom scene with music suggests the erotic associations of music in ancient Egyptian society.

2008–1630 Egyptians develop barrel-shaped drums made from tree trunks and ceramic drums with animal skin covers. In addition, they import the thin lyre from Syria as well as the thick lyre.

Owners of stelae (inscribed slabs of stone) at Abydos claim to be musicians in their tomb carvings, suggesting that the office of musician enjoyed elite status in Ancient Egypt.

Tomb and stelae owners include harpists' songs in their tomb carvings which express their views of the afterlife.

1539–1075 The oboe-like *wedjeny* replaces the clarinet used during the Old and Middle Kingdoms.

Egyptians import the angular harp from Mesopotamia and use it alongside the native arched-shape harp.

Another Mesopotamian import, the lute, becomes popular.

The thin lyre gains popularity.

The title *shemayet*, or "musician," is used for women who chant the ritual for the gods, though the meaning of the change in title from *heset* in the Old Kingdom is not clear.

Tomb inscriptions indicate that musicians are more likely to be professionals than they were in the earlier periods.

1539–1292 The standard ensemble for banquet music develops. It includes a harp, a lute, a double oboe, and a lyre.

1479–1425 Examples of work songs are carved in the tomb of the nobleman Paheri.

The clothing style for female musicians switches from the traditional sheath dress to a wide variety of gowns, beaded girdles, and hair decorations.

1352–1332 Temple depictions of male musicians show them playing the lute and lyre, instruments played only by women in other periods. These scenes reflect a general trend toward the breaking down of barriers between the sexes in general during the reign of Akhenaten.

The giant lyre, imported from Mesopotamia, becomes popular.

Royal princesses play the sistrum—a sacred rattle—for the god Aten, demonstrating the increased status of the king's daughters in this reign.

1332–1322 Trumpets are first used as military instruments for communication on the battlefield.

Ivory clappers inscribed with the names of Queen Tiye and Princess Merytaten are included in the king's tomb, demonstrating the role of royal women in musical life.

1292–1075 Drawings depict solo harpists as fat and bald, indicating that they were wealthy and pure.

The *Turin Erotic Papyrus* shows musical instruments in scenes of sexual intercourse, suggesting the importance of the art form to Egyptian notions of eroticism.

332 The only evidence of musical notation in Ancient Egyptian culture comes from a statue created after this date of a harpist and a scribe recording the harpist's song.

OVERVIEW
of Music

IRRETRIEVABLE LOSS. Music is sound organized in time. All humans naturally make music, and most societies throughout history organized sound in a way that we would call music. To judge by the popularity of scenes of music making in Egyptian tombs, temples, and a few houses, the Egyptians loved music. Yet of all Egyptian arts, music is the most difficult to reconstruct. Neither the sounds of melodies nor rhythms are recoverable, and scholars have yet to uncover evidence that would allow them to reconstruct the sounds made by the musical instruments represented by ancient artists or discovered by modern archaeologists. The Egyptians never described their music in the texts that they wrote, though there are some references to music and musicians in Egyptian literature. The Greeks, who admired Egyptian music along with other aspects of this culture, described only the last stages of Egyptian history; even these descriptions can be inaccurate or based on misconceptions stemming from the Greeks' projections of their own ideas of music on a foreign culture. The absence of musical notation from ancient Egyptian culture—a surprising reality given the fact that Egyptians were among the first to write words—means the sound of Egyptian music is irretrievably lost to modern ears.

VALUE OF STUDYING EGYPTIAN MUSIC. Nevertheless, a study of the surviving evidence of a vibrant Egyptian musical culture is still valuable. Archaeological examples of musical instruments; numerous representations in relief, painting, or sculpture of musicians and music making; and occasional references to music in Egyptian literature serve as the basis for a study of Egyptian musical life. In addition, the lyrics to songs, many of which the Egyptians recorded in tombs and papyrus, make it possible to imagine musical forms, even if the sounds cannot be reconstructed. Egyptian music spanned both the secular and religious arenas, including temple life, work situations, leisure time activities such as banquets, and even Egyptian sexuality. As such, a care-ful study of music yields clues into the workings and values of this ancient society, illuminating such disparate topics as gender and class issues, institutional organization, professionalization of some activities, and foreign relations, in addition to such religious issues as the role of deities in musical life and the insights about the afterlife provided through the study of lyrics.

SECULAR ISSUES AND MUSIC. The nature of archeological evidence largely prevents scholars from examining ancient Egyptian society outside of a religious context. Most of what is known about this culture comes from the remains of temples and tombs, both of which are religious structures. Therefore, the representations of Egyptian secular life depicted in tomb drawings and carvings serve a greater religious purpose that can make it difficult to draw accurate conclusions. Egyptians selected as topics for their tomb drawings the best from life on earth in order to perpetuate a better version of earthly life in the next world. A tomb depiction of field laborers singing happily about the success and joy inherent in their work, for example, is by no means an accurate depiction of the drudgery of Egyptian agricultural life but an idealized one for the next life from the standpoint of the well-to-do. Aside from the evidence of archaeological examples of musical instruments, all that can be known about Egyptian music comes from representations in either temples or tombs. Yet there is no reason to doubt that the types of songs recorded in these tomb scenes greatly differed from earthly reality. Tomb carvings of Egyptian banquets show musical ensembles performing for elegantly dressed men and women as they dined. While such a carving conveys a wish for food and entertainment in the next world, it is reasonable to assume that the general structure of a banquet with music reflects the banquets Egyptians knew on earth. A study of music also enables scholars to study Egyptian eroticism. The Egyptians, like other peoples, considered music an aphrodisiac. Numerous scenes in a papyrus preserved at the Egyptian Museum in Turin, Italy, depict impassioned couples with musical instruments nearby. A close examination of the musicians themselves in tomb and temple scenes can illuminate gender and class issues. The association of women and men with particular instruments in segregated ensembles hints at Egyptian gender relations, and a study of Egyptian bureaucratic titles associated with music allows scholars to learn about the institutional organizations associated with music. For example, it is clear that a musical bureau called the *khener* was responsible for organizing and performing music at both secular and religious events. Finally, it is possible to ob-

serve the extent of Egyptian contact with foreign cultures by examining the import of both foreign musical instruments and musicians into Egypt. Foreign musicians, for example, played at the court of Akhenaten, king of the Eighteenth Dynasty. The study of Egyptian music thus relates to numerous secular issues in Egyptian history.

RELIGIOUS ISSUES AND MUSIC HISTORY. The study of Egyptian music also illuminates strictly religious issues. The role of deities in musical life illustrates that some Egyptian deities could be associated with music without actually being a "god of" music. For example, in most periods a representation of the goddess Hathor's head tops the sistrum, a sacred rattle played in the worship of all gods, and her temple at Dendera had columns designed to resemble the instrument. Despite the close association with music, however, Hathor did not function as a muse of music in the pantheon. Music was, however, essential to worship. The Egyptian sage Any claimed that playing music for a god was as important for his/her worship as food and incense. The lyrics from Egyptian songs are also very telling in the deciphering of Egyptian religious beliefs. A study of the lyrics of the harpists' songs carved in tombs and on stelae (standing stone slabs with inscriptions) indicates that the Egyptians used music to consider the nature of life after death in a non-ritual setting, giving voice to both their fears and their hopes for the next world. In this way, the study of Egyptian music adds immeasurably to an understanding of Egyptian culture, even though the actual sound of music from ancient Egypt is lost.

TOPICS
in Music

MUSICAL INSTRUMENTS

SACRED AND SECULAR EVIDENCE. The evidence for ancient Egyptian music comes exclusively from surviving religious structures such as temples and tombs, which limits scholarly understanding of this art form to its role within religious life. Relief sculptures and paintings created by artists for the walls of tombs and temples, as well as a few actual instruments found in tombs, are all that is left of Egypt's musical tradition. The scenes carved in temples provide unambiguous evidence for music in religious life, but the scenes on the walls of tombs present considerable difficulties for in-

EGYPTIAN Musical Instruments

The following list describes various musical instruments from ancient Egypt, including the Egyptian name (when known), the modern equivalent, and a brief description.

Egyptian Name	Modern Equivalent	Description
?	Clappers	Ivory or wood
Menat	Rattle	Part of a necklace
Sekhem or Sesshet	Sistrum (rattle)	Ritual use
?	Finger Cymbal	Ritual use
?	Barrel Drum	Military use for marching or signaling
Ser	Frame drum	Tambourine without shakers
?	Harp	Native Egyptina, arched
?	Harp	Imported from Mesopotamia, angled
Gengenty	Lute	Syrian import
Djadjaret or kinnarum	Thin Lyre	Syrian import, c. 1900 B.C.E.
?	Thick Lyre	Foreign import
?	Giant Lyre	Canaanite import
Mat	Flute	Used for entertainment
Memet	Clarinet	Single reed, Old and New Kingdom only
Wedjeny	Oboe	Double reed; invented in the New Kingdom
Sheneb	Trumpet	Military use only; made of metal

terpretation because the tomb drawings served a very specific purpose in the Egyptian belief system regarding the rebirth of the dead. Scenes in tombs were meant to ensure through magical means that the deceased would be reborn into the afterlife and that the good things in this life could be made available magically in the next life. Egyptians particularly relied on scenes with erotic content to aid in the process of rebirth because they believed that sexual energy had the religious

Arts and Humanities Through the Eras: Ancient Egypt (2675 B.C.E.–332 B.C.E.)

155

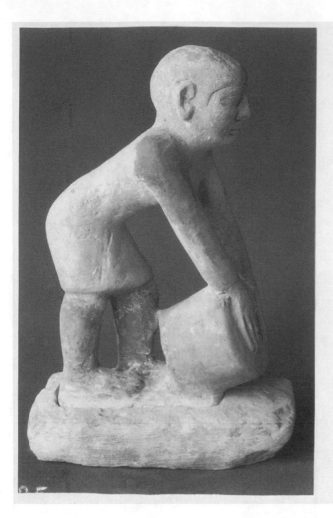
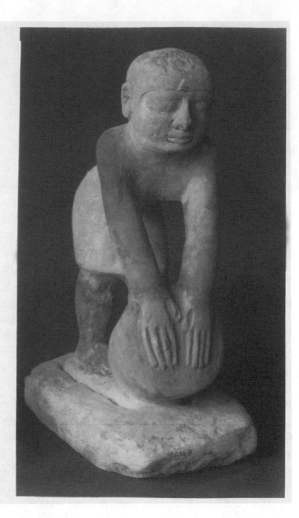

Two views of a limestone statuette of a drummer from the Fifth or Sixth Dynasty (2494–2181 B.C.E.). THE ORIENTAL INSTITUTE OF THE UNIVERSITY OF CHICAGO.

purpose of duplicating the sexual act that began the first birth so that one could be "reconceived" into the next life. Thus, the tomb scenes of parties involving men and women drinking wine while music entertains them aided the rebirth of the dead by their erotically charged content. While it is reasonable to conclude from these drawings that music served an important and pleasurable purpose in ancient Egyptian society, the magical purpose of these drawings presents only indirect evidence for how music truly functioned outside of a religious context.

TYPES OF INSTRUMENTS. The Egyptians used percussion, wind, and stringed instruments as well as the human voice to make music. Musicians played clappers as well as sistra and menats—two kinds of sacred rattles—in cult ceremonies. Harps also functioned in a religious context by accompanying songs about life and death. Other stringed instruments, such as lutes, joined with woodwinds for entertainment at parties, demonstrating the more secular nature of these instruments. Evidence for these instruments comes from both archaeological finds of actual instruments and the relief sculptures and paintings found on tomb and temple walls. Some instruments are indigenous, but Egypt also participated in a wider musical culture, importing many instruments from the Near East over time. Egyptian music gained from foreign imports in greater measure during the New Kingdom, when Egyptian political fortunes expanded the area of rule to include other cultures and their musical traditions. The Egyptians, for example, imported the Mesopotamian harp, though they never abandoned their native instruments. During the reign of Akhenaten, foreign musicians dressed in distinctive flounced gowns played the giant harp at court. Two musicians played this instrument simultaneously, suggesting that they played notes together in harmony.

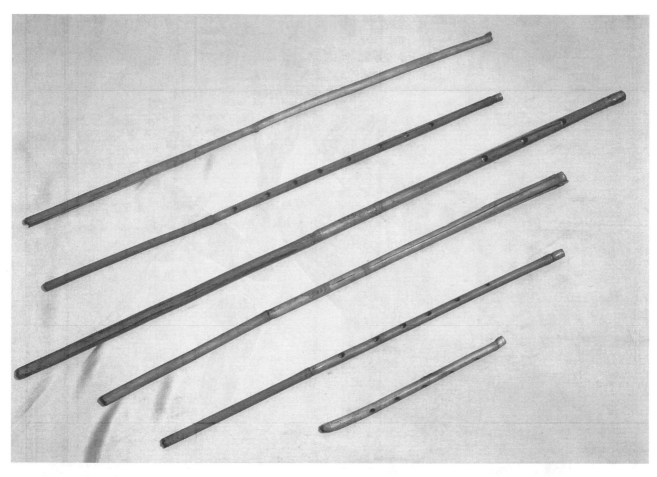

Ancient Egyptian flutes. © SEF/ART RESOURCE, NY.

PERCUSSION. The first percussion instrument in Egypt was probably the human hands in the act of clapping. The Egyptians depicted singers clapping in Old Kingdom tombs and called clapping *mech*. Beyond the clapping of singers, Egyptians developed an instrument to mimic human clapping; archeologists have recovered many examples of ivory clappers shaped like arms and sometimes ending in representations of human hands. Smaller clappers, called finger cymbals, were also part of the Egyptian percussion repertoire. Even jewelry could function as a percussion instrument; female singers wore or held the *menat,* a counter-weight for a necklace, and shook it so that its beads made a musical noise. Ancient Egyptians also had barrel-shaped drums made from tree trunks covered with hide in the Middle Kingdom, although these were primarily used for military purposes, both for marching and signaling. A ceramic drum covered with animal skin also came into use in the Middle Kingdom. A tambourine-like instrument called the *ser* was a hoop with a skin stretched across it, though the absence of the metal shakers found around the edge of a modern tambourine makes the term "frame drum" more suitable than "tambourine." The sistrum, a rattle used almost exclusively by women in worship, did resemble a tambourine in its use of pierced metal disks suspended from rods to make noise.

WIND INSTRUMENTS. The Egyptians played four wind instruments, each translated into English by the name of a modern instrument. The *mat* is a flute with a wedge on the mouthpiece. It was held across the musician's body. The *memet* consisted of two tubes lashed together. This instrument resembles a modern Egyptian folk clarinet with a single reed. Almost exclusively used during the Old and Middle Kingdom, it disappeared with the invention of the *wedjeny* in the New Kingdom. The wedjeny consisted of two diverging tubes and resembled the ancient Greek *aulos*, a double reeded instrument. Egyptologists thus call it an oboe in English. Unlike these wind instruments, which were made from stalks of reeds, the trumpet was made of metal. The trumpets discovered in Tutankhamun's tomb, for example, were made from silver and bronze with mouthpieces of gold and silver. Like the barrel-

Arts and Humanities Through the Eras: Ancient Egypt (2675 B.C.E.–332 B.C.E.)

157

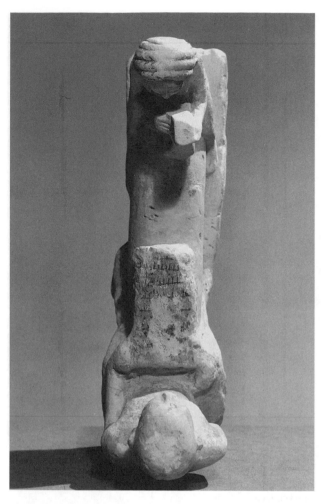

This statue shows the only known musical notation from ancient Egypt. BROOKLYN MUSEUM OF ART, 58.34, CHARLES EDWIN WILBOUR FUND. REPRODUCED BY PERMISSION.

notes at least by 1500 B.C.E., as did the Greeks by the first millennium B.C.E. Yet scholars have not identified any musical notation in a written form in Egypt until after the Greeks had conquered the land about 322 B.C.E. Even then, there is only one possible example of musical notation, discovered on a statue depicting a woman playing a harp while a man sits before her with a writing board. On the board is a series of horizontal lines with longer and shorter vertical lines attached to it. The lack of comparative material hampered musicologists' efforts to interpret the notation. The only other possible evidence of ancient notation comes from ninth-century C.E. Coptic manuscripts that may reflect an earlier native Egyptian system of musical notation. The Coptic Church (the Egyptian Christian Church) does preserve some memories of ancient Egyptian customs, but it is impossible to prove that the Coptic system of notation that post-dates the Old Kingdom by

thousands of years preserves an older form of musical notation.

HAND GESTURES. Scholars conjecture that the hand gestures made by singers indicated pitches to the harpists or wind players that accompanied them. If true, the representations of singers—called "chironomists," or "one who makes signs using the hands" in Greek—especially on Old Kingdom tomb walls, preserve evidence that instrumentalists could be led in particular songs. Scholars have tried to find a correlation between the hand gestures that singers made and the note or pitch that a harpist or clarinet player played in numerous representations in Old Kingdom tombs without much success. Other scholars have argued that these hand gestures were spontaneous expressions accompanying singing. There is some evidence that gestures were a critical component of a musical performance; the word for singing in Egyptian, *hesi*, uses the final hieroglyphic sign for an arm, which might indicate that singing is done as much with hands as it is with the voice. As with many issues relating to the role of music in Egypt, there is not enough evidence to draw a firm conclusion.

SOURCES

Hans Hickman, "Ein neuentdecktes Dokument zum Problem der altägyptischen Notation," *Acta Musicologica* 33 (1961): 15–19.

———, "La chironomie dans l'Egypte pharaonique," *Zeitschrift fur ägyptische Sprache und Altertumskunde* 83 (1958): 96–127.

Bo Lawgren, "Music," in *The Oxford Encyclopedia of Ancient Egypt.* Vol. 2. Donald B. Redford et al. (New York: Oxford University Press, 2001): 450–454.

Lisa Manniche, *Music and Musicians in Ancient Egypt* (London: British Museum Press, 1991).

WORK SONGS

EVIDENCE. Tomb and building drawings present us with evidence that Egyptian laborers integrated music with their labor, although such evidence is fraught with barriers to interpretation. For instance, the pictorial combination of music and labor is an uncommon theme in Egyptian art so it is difficult to draw conclusions based on comparison. The songs themselves throw up barriers to a greater application to Egyptian life since the meaning of the words that accompany the image does not clearly relate to the work being depicted. Neither is it possible to determine whether the songs preserved on tomb walls represent songs that workmen actually sang in the fields or whether the songs represent only the

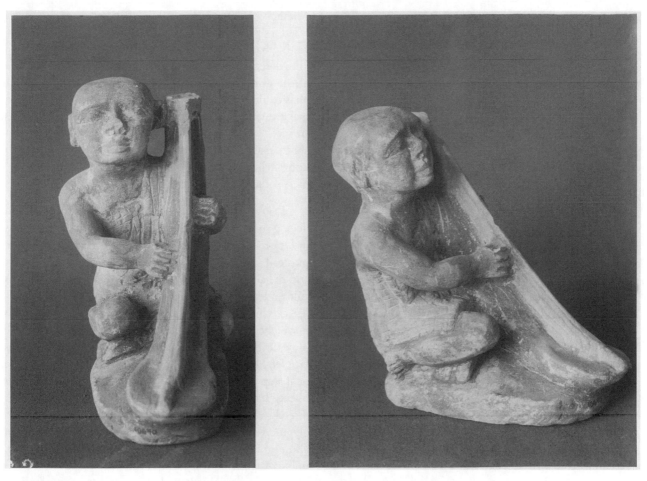

Two views of a limestone statuette of a harpist from the Fifth or Sixth Dynasty (2494–2181 B.C.E.). THE ORIENTAL INSTITUTE OF THE UNIVERSITY OF CHICAGO.

hopes of the elite who paid for the tombs. Tomb walls, after all, depicted an idealized version of life on earth to ensure the continuation of such a life in the next world, particularly as it related to the growing and harvesting of crops which would provide the necessary food for the dead tomb owner in the next life. Yet there is enough evidence to show that workmen eased their labor through song. There is also evidence to suggest that musical instruments aided in hunting as a method to flush game out of bushes.

AGRICULTURAL CALL AND RESPONSE SONGS. Agriculture was the basis of the Egyptian economy, and agricultural workers made up the majority of the population. Evidence for this agricultural activity and the songs sung during the workday is preserved on the walls of tombs. One Old Kingdom song preserves a call and response routine such as those that are still sung by Egyptian workers on archaeological excavations during the course of the work. This song, sung during planting season, begins with a leader singing "O West! Where is

Bata, Bata of the West?" A chorus or perhaps another individual responds, "Bata is in the water with the fish. He speaks with the *phragos*-fish and converses with the oxyrhynchus-fish." The song refers directly to *The Story of Two Brothers* that is preserved from a Nineteenth-dynasty papyrus (1292–1190 B.C.E.), nearly 1,200 years later. Though the manuscript dates later, the presence of the song in an earlier tomb suggests the story is older than the only known manuscript. Bata was a god who died but returned three times, first in the form of a pine tree, then a bull, and then a persea tree. The *phragos*-fish in *The Story of Two Brothers* helped with Bata's rebirth by swallowing and thus preserving his phallus after he mutilated himself to prove he was telling the truth in a dispute with his brother Anubis. The Greek writer Plutarch assigned the same function to the oxyrhynchus-fish in the myth of Osiris, another god who died only to be reborn. The song thus suggests that Bata and Osiris are related. This story also emphasized for the Egyptians that the crops that die at the end of the season would

Arts and Humanities Through the Eras: Ancient Egypt (2675 B.C.E.–332 B.C.E.)

161

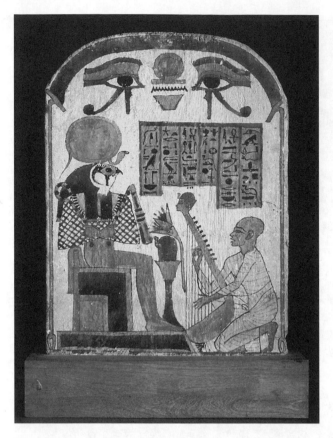

Stele depicting the harpist of Amon, Djedkhonsouioufankh, before the god Horus, Third Intermediate Period. © REUNION DES MUSEES NATIONAUX/ART RESOURCE, NY.

be reborn through the planting of seed. Both fish thus reinforced the meaning of the song both as appropriate for the planting season and for the hopes of the tomb owner to be reborn in the next world. This song is preserved in six different tombs in Saqqara, demonstrating its common usage.

HARVEST SONGS IN PAHERI'S TOMB. Yet another call and response song from an Old Kingdom tomb represents workers encouraging each other through compliments while working in the barley field. Two groups of workers are singing similar songs while a flute player accompanies them. In the first group the leader sings "Where is the one skilled at his job?" The worker next to him responds "It is I!" A second leader sings, "Where is the hard-working man? Come to me!" The second worker sings, "It is I. I am dancing." Through these compliments, boasts, and jokes the workers encourage themselves and each other to continue working. To judge by modern usage on archaeological excavations, such call and response songs were repeated with varying rhythms throughout the workday. Sometimes they are improvised, commenting on particular events of the workday.

The harvest song in the tomb of Paheri is explicitly labeled a "part song." The carving shows eight men harvesting barley with sickles while they sing. The first two lines describe the day, emphasizing that it is cool because of the northern breeze. The third and fourth lines emphasize that the workers and nature both cooperate to make the harvest go smoothly. Again this song depicts an ideal world where both workers and nature cooperate to ensure food for the deceased. It is not possible to know whether the song was actually sung or only expresses the deceased tomb owner's wishes.

PLOWING AND HOEING SONGS. The plowing and hoeing songs are known from two New Kingdom tombs in Upper Egypt. The words of the songs seem to divide into call and response sequences. The layout of the text and the accompanying illustrations make it a little difficult to determine the correct order of the verses. The relief carving shows four men dragging the plow—a job normally performed by oxen—an old man steadying the plow, and a young man sowing seed. All of the figures face left. Further to the left are four figures hoeing, the next step in the process of planting the seed. These four hoeing figures face right. The words of the song appear directly above each group of figures. Egyptian hieroglyphic writing can also face either left or right and can also begin on the right side going to the left or vice versa, unlike English writing, which can only begin on the left and run to the right. It is thus easy to associate the lines of text with the proper group of figures because of this characteristic of Egyptian writing. The order of the lines, however, is unclear. It might be that the songs were an endless sequence of call and response so the slight confusion in the layout of the words might be a reflection of the fact that these songs have no real beginning or end. These songs emphasize the positive and show the stake that the workers have in the success of the crop, even though they work for a nobleman. The second plowing song in the tomb of Paheri is written above a group of workers sowing seed and plowing with oxen. A leader stands behind one of the plows with his own columns of text arranged near him. The arrangement of text and image here is clearer to modern eyes. The leader sings, "Hurry, the front guides the cattle. Look! The mayor stands watching." The three men and the boy near the cattle reply, "A beautiful day is a cool one when the cattle drag (the plow). The sky does our desire while we work for the nobleman." Such a song reveals the main purpose for depicting these scenes in a tomb in the first place; by depicting the sequence of growing crops and eager workers, the deceased ensures that he will have adequate food supplies in the next world.

a PRIMARY SOURCE *document*

THE STORY BEHIND THE SONG

INTRODUCTION: The lyrics to a song about the god Bata recorded in the Tomb of Paheri are from a story called *The Story of Two Brothers*. In this tale, a child named Bata came to live with his older brother Anubis and Anubis' wife. As Bata matured into a young man, Anubis' wife made sexual advances toward him, which he repulsed. In revenge, Anubis' wife told her husband that Bata had tried to seduce her. Anubis determined to kill Bata, but the young man escaped. In the following passage, Bata confronts his brother Anubis across a river filled with crocodiles.

Then the youth rebuked his elder brother saying: "What is your coming after me to kill me wrongfully, without having listened to my words? For I am yet your young brother, and you are like a father to me, and your wife is like a mother to me. Is it not so that when I was sent to fetch seed for us your wife said to me: 'Come, let us spend an hour lying together'? But look, it has been turned about for you into another thing." Then he let him know all that had happened between him and his wife. And he swore by Pre-Harakhti, saying: "As to your coming to kill me wrongfully, you carried your spear on the testimony of a filthy whore!" Then he took a reed knife, cut off his phallus, and threw it into the water; and the catfish swallowed it. And he grew weak and became feeble. And his elder brother became very sick at heart and stood weeping for him loudly. He could not cross over to where his brother was on account of the crocodiles.

SOURCE: "The Story of the Two Brothers," in *The New Kingdom.* Vol. 2 of *Ancient Egyptian Literature.* Trans. Miriam Lichtheim (Berkeley and Los Angeles: University of California Press, 1976): 206.

a PRIMARY SOURCE *document*

SONGS FROM PAHERI'S TOMB

INTRODUCTION: These songs were preserved in the tomb of Paheri of El Kab. Another partial copy of these songs is painted on the walls of the Tomb of Wensu in Thebes. Both of these sites are in Upper Egypt. It is difficult to determine whether these songs spread to other parts of Egypt, but it is significant that at least some songs were repeated in different places and at different times. This phenomenon suggests some continuity in knowledge of Egyptian music.

The Plowing Song

We do (it).
Look! Do not fear for the fields! They are very good!
How good is what you say, my boy!
A good year is free from trouble.
All the fields are healthy. The calves are the best!

The Hoeing Song

I shall do more than my work for the nobleman!
My friend, hurry up with the work, and let us finish
in good time.

The Harvest Song

A part song:
This fine day goes forth on the Land.
The northern breeze has risen.
The sky does our desire.
Our work binds our desires.

Translated by Edward Bleiberg.

HUNTING. In addition to agricultural work, music appears to have played a role in the hunting of game. Three scenes, each carved in different time periods, seem to depict servants flushing game with music. Yet it is not clear if the servants are just making noise to scare away birds, perhaps from crops, or if they are indeed flushing game. Furthermore, the scenes do not clearly demonstrate whether the servants are making music or are just making noise. The three examples come from an Old Kingdom tomb, from a block from a building in Tell el Amarna, and from a Roman period relief. The Old Kingdom tomb scene shows a small boat steered through the marsh by an oarsman and helmsman. Two other men stand in the boat. A boy holds two bird decoys with one hand while the other hand holds a tube on which the boy is blowing. Since not all of the tube is preserved, it is not possible to say for certain that it is a trumpet whose noise or song would flush out the game in the marsh, but the presence of decoys certainly suggests hunting given evidence of their use in the New Kingdom. In the Amarna relief only one stone block is preserved. On the left side, a woman holds a tambourine. There is also the figure of a second woman and a boy with up-raised arms. On the right side is a tree with one bird either alighting or flying off, startled by the tambourine. Again it is unclear whether there is a connection with hunting, though the bird's pose is similar to other New Kingdom

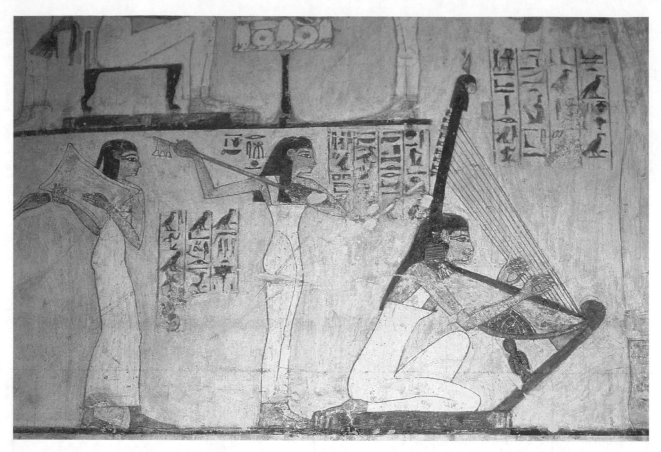

Women playing the harp, lute, and tambourine. Wallpainting. Nineteenth Dynasty. **WERNER FORMAN/ART RESOURCE NY**.

hunting scenes. A third Roman period relief shows women beating tambourines to scare birds out of the undergrowth. Such scenes suggest possibilities for the use of music in hunting that cannot be fully confirmed with the present state of the evidence.

SOURCES

Hartwig Altenmüller, "Bemerkungen zum Hirtenlied des Alten Reiches," *Chronique D'Egypte* 48 (1973): 211–231.

T. G. H. James, *Pharaoh's People: Scenes from Life in Imperial Egypt* (Oxford: Oxford University Press, 1985).

Lisa Manniche, *Music and Musicians in Ancient Egypt* (London: British Museum Press, 1991).

MALE AND FEMALE MUSICIANS IN THE OLD KINGDOM

GENDER DISTINCTIONS. Men and women both worked as musicians during the Old Kingdom. While some instruments—such as the harp and certain forms of percussion—could be played by either men or women, other instruments were gender-designated. Only men played single and double flutes and oboes, while women played the shoulder harp, frame drums, clap sticks, and the sistrum. Singing, another musical expression open to either sex, was so fundamental to almost every performance that the instrumentalists functioned either as accompanists to other singers or to themselves if they were singing. The singers and the instrumentalists were largely professionals, though there is evidence that women entertained members of their family as amateur musicians. In the Sixth Dynasty, for example, a tomb drawing shows the high official Mereruka and his wife Watetkhethor lounging on a bed while she played the harp. In other tombs there are examples of wives, daughters, or granddaughters of the deceased playing the harp for the deceased. The first known professional singer, named Iti, performed with the harpist Heknut during the Fifth Dynasty according to a depiction of the pair on the tomb of Nikawre in Saqqara. Since they do not appear to be relatives of Nikawre, Egyptologists assume that they were professionals.

ENSEMBLES. Though all-male ensembles predominated in the Old Kingdom, all-female and mixed-gender ensembles are represented in tomb scenes of music mak-

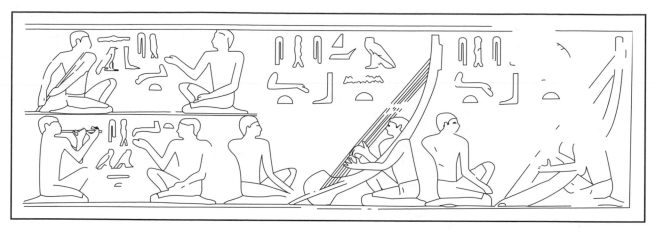

Depictions of Egyptian musicians in the tomb of Iymery. **CREATED BY GGS INFORMATION SERVICES. GALE.**

ing. This conclusion is based on an interpretation of two different Egyptian artistic conventions. Relief sculptures and paintings in tombs are divided into registers. Each register can represent a different place, or in some cases the upper register can be read as located behind the lower register. In most Old Kingdom examples the male and female members of the ensemble are located in different registers. Yet, in the tomb of Queen Mersyankh III, the tomb owner herself is located in both registers, identifiable by her representation as a figure two times larger than the other figures in the relief. This placement of the queen suggests that the male ensemble members in the top register and the female singers in the lower register are understood as playing and singing together. The same is true of the dancers, also located in the lower register. The dancers and singers are probably closer to the tomb owner, while the all-male ensemble of two harps, a flute, and an oboe are behind the dancers and singers. A similar scene in the tomb of Debhen at Giza also uses the artistic device of the tomb owner spanning all the registers to signal that here five registers should be read as one behind the other, the topmost at the back. This scene includes two harps, two oboes, a flute and two male singers in the top register. The second register includes four female dancers and three female singers. These examples both come from the Fourth Dynasty (2625–2500 B.C.E.). By the end of the Fifth Dynasty (2500–2350 B.C.E.), in the tomb of Iymery, a scene shows female dancers and singers together with a male harpist, a male singer, and a male oboe player in the same register. Another musical scene in the tomb, however, separates four female singers and nine female dancers from a male ensemble made up of a flute, an oboe, two harps, and four male singers in different registers. Thus it is likely that the separation of male and female musicians in tomb scenes was more of an artis-

tic convention than evidence that male and female musicians played separately. The grouping of men and women into separate groups may have been a division borne more of their association with particular instruments than a division based on gender. Perhaps the true separation is between the strings (harps), winds, and lower-voiced male singers in the back, and the higher-voiced female singers and percussion section in the front of the ensemble.

SOURCES

Lisa Manniche, *Music and Musicians in Ancient Egypt* (London: British Museum Press, 1991).

Emily Teeter, "Female Musicians in Pharaonic Egypt," in *Rediscovering the Muses in Women's Musical Traditions.* Ed. Kimberly Marshall (Boston: Northeastern University Press, 1993): 68–91.

A MUSICAL BUREAU IN THE OLD KINGDOM

KHENER. The Egyptians used the word *khener* to refer to a troupe of professional singers and dancers organized through a bureau. Earlier Egyptologists misunderstood the khener to be specifically attached to the harem because tomb drawings always depicted female singers and dancers entertaining a man in his private quarters. This erroneous identification stemmed from historians' misunderstanding of Islamic customs in the Middle East and Victorian preconceptions about male/female relationships in ancient times. Victorian scholars were often embarrassed by ancient behavior that they considered lewd in their own time. European scholars also condemned their contemporaries in Islamic countries that practiced polygamy. In reality, many institutions

Arts and Humanities Through the Eras: Ancient Egypt (2675 B.C.E.–332 B.C.E.)

165

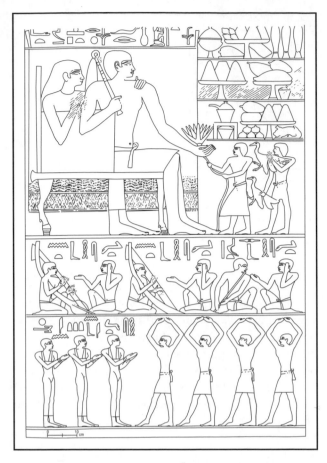

Drawing of a musical scene with musicians and dancers, from the tomb of Nefer. CREATED BY GGS INFORMATION SERVICES. GALE.

had a khener, including the royal palace, the funerary estates that supported a king's cult after he died, and the temples of the goddesses Bat and Hathor, and the gods Wepwawet and Horus-Iunmutef. Many titles found in tombs show that women were usually the supervisors of the khener, which is one indication of the degree of freedom enjoyed by women in ancient Egypt. Because the titles change in Egyptian according to whether the office holder was male or female, it is clear that the Overseer of the Khener and the Inspector of the Khener were women in most cases. There is also an example of a male Overseer of the King's Khener. The evidence for the khener comes almost entirely from scenes on the walls of tombs and temples. Thus it is not clear if all the possible performance venues for the khener are represented in the evidence. The khener is often depicted entertaining the deceased in a tomb while he eats from the offering table. This could imply that the khener entertained at meals during life on earth. Other evidence that the khener entertained at secular functions includes some titles held by khener members. A member of the

khener could also be the "overseer of all the entertainments of the secrets of the palace," or the "overseer of all the fine entertainments of the king," or the "overseer of the singing of the palace." Some singers of the khener are even described as those whose singing "rejoice the heart of the king with beautiful songs and fulfill every wish of the king by their beautiful singing." The khener also played for religious ceremonies. It is depicted in funeral processions and performing in front of the tomb during funerals. Specific kheners were also attached to temples of Hathor, Bat, Wepwawet, and Horus Iunmutef. Nevertheless, this does not mean that the khener was exclusively religious.

SOURCES

Lisa Manniche, *Music and Musicians in Ancient Egypt* (London: British Museum Press, 1991).

Emily Teeter, "Female Musicians in Pharaonic Egypt," in *Rediscovering the Muses in Women's Musical Traditions.* Ed. Kimberly Marshall (Boston: Northeastern University Press, 1993): 68–91.

SEE ALSO *Dance: The Dancers*

BANQUET MUSIC DURING THE NEW KINGDOM

STANDARD ENSEMBLE. In the New Kingdom (1539–1075 B.C.E.) a standard ensemble developed for playing at banquets. These banquets are depicted on tomb walls and are a frequent component of tomb decoration, especially during the Eighteenth Dynasty (1539–1292 B.C.E.). Though the depictions in the tombs are connected with the tomb's function of providing the necessities for the deceased to be reborn into the next world, still the banquet scenes also represent real banquets held in this world. Music was always included at these banquets. The standard ensemble included a harp, a lute, a double oboe, and sometimes a lyre. These instruments were played by both men and women either in mixed groups or in all-women bands. These bands seem to replace the Old Kingdom entertainers who played a single harp.

NEW LIVELINESS. The depictions of musicians at banquets during the New Kingdom are considerably livelier than depictions carved during the Old Kingdom. It is possible to attribute part of this change to developments in art style that allowed New Kingdom artists more freedom in depicting people. Yet even the poses of the musicians have changed. In the Old Kingdom,

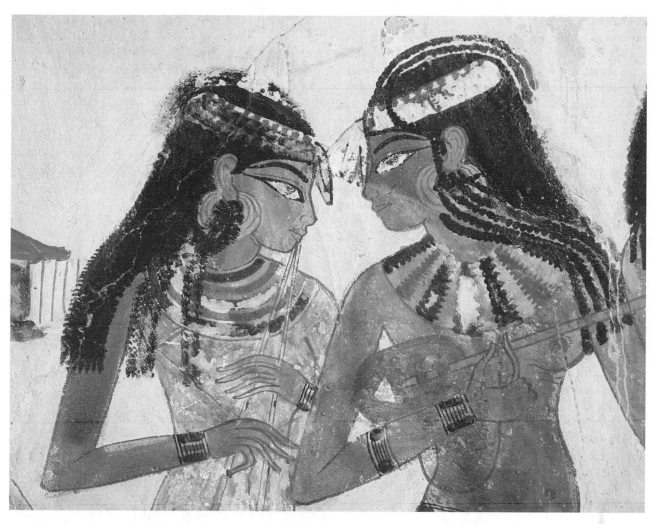

Depiction of musicians at a banquet. Mural from the tomb of Rekhmire, vizier under Thutmosis III and Amenophis II, Eighteenth Dynasty. The woman on the left is playing a double-reeded wind instrument while the woman on the right plucks a stringed instrument. © ERICH LESSING/ART RESOURCE, NY.

musicians at banquets were seated and separated from the dancers. New Kingdom scenes depict standing musicians who tap their feet in time to the music. They often stand near the dancers rather than being separated into a different register. Their fingers seem to move over the strings and some even sway in time to the music. All of these changes suggest that New Kingdom music at banquets was much livelier than the music played in earlier times.

MUSICIANS' CLOTHING AT NEW KINGDOM BANQUETS. Female musicians dressed in a much greater variety of clothing during the New Kingdom than they did during the Old Kingdom. In the Old Kingdom, female musicians wore a tight sheath dress with straps. This outfit, in fact, was commonly worn by almost all women during the Old Kingdom, including nobles and goddesses. The greater variety of dress types available in the

New Kingdom was exploited by musicians, too. In the earlier representations from the time of Thutmose III (1479–1425 B.C.E.), some female musicians are depicted in the old style of sheath dress. The harpist and lute player in the tomb of Rekhmire, for example, both wear this older attire as do the harpist and double oboe player in the tomb of Amenemhet. Yet in the contemporary tomb of Wah, a lute player and an oboe player each wear loose-fitting, transparent gowns with only a girdle of beads around the waist. It is difficult to determine if this instance of nudity indicates lower social status. They also wear headbands and a single lotus flower over the forehead. In the tomb of Djeserkaresoneb, decorated during the reign of Thutmose IV (1400–1390 B.C.E.), four female musicians are depicted playing the harp, lute, double oboe, and lyre. The harpist wears a white linen dress with a striped shawl that is knotted at the waist to hold

it in place. The lute player wears only jewelry, including a broad collar made of beads, bracelets, armlets, and a girdle around her waist. The double oboe player wears an elaborate New Kingdom dress made of transparent fabric. Finally, the lyre player wears the traditional sheath dress. In the nearly contemporary tomb of Nakht the band consists of only a harpist, lute player, and double oboe player. The harpist and double oboe player are dressed similarly in white linen sheaths with overlying cloaks made from a transparent fabric. The lute player is once again nearly naked wearing only a broad collar, bracelets, armlets, and a girdle around her waist. All three women wear garlands of flowers in their hair including a lotus flower positioned over the forehead. They also wear the typical cones of scented fat on top of their wigs. This cone melted during the course of the evening, providing a sweet scent. It seems likely from these examples that there was a great deal of variety in the performers' dress during the Eighteenth Dynasty. Female musicians in the New Kingdom often performed at parties nude, wearing only jewelry, or wearing very sheer clothing that revealed the body. Many scholars have interpreted this custom as evidence that these women belonged to a lower social class. Yet Egyptian women of all classes wore clothing that was appropriate to the warm climate and that emphasized the female form. Elite women wore diaphanous gowns even when portrayed praying to the gods. Ancient Egyptians appeared to be very comfortable with nudity and did not consider it a mark of low status.

MALE MUSICIANS. Male musicians wore street clothes typical of any Egyptian man. In the earliest periods they wore the typical kilt that all men wore. By the New Kingdom, men added a tunic to their dress clothing and sometimes wore a pleated shawl.

SOURCES

Lisa Manniche, *Music and Musicians in Ancient Egypt* (London: British Museum Press, 1991).

Emily Teeter, "Female Musicians in Pharaonic Egypt," in *Rediscovering the Muses in Women's Musical Traditions.* Ed. Kimberly Marshall (Boston: Northeastern University Press, 1993): 68–91.

SEE ALSO *Fashion: Clothing*

THE OFFICE OF CHANTRESS

TWO ANCIENT TITLES. Two ancient Egyptian titles refer to women who chanted the ritual for gods and goddesses. They participated in the daily ritual and in special festival liturgies. In the daily ritual, singers "woke" the deity in the morning and sang the god to sleep in the evening. Their titles are *heset*, literally "singer," and *shemayet*, literally "musician." Since most of the evidence for "singers" and for "musicians" comes from titles on coffins, it is nearly impossible to determine the difference between the two titles. The title "singer" appeared earlier, first known from the Old Kingdom (2675–2170 B.C.E.). The title "musician" is better documented from the New Kingdom (1539–1075 B.C.E.). The titles nearly always associate the woman who holds it with a particular deity, including Isis, Mut, Osiris, Montu, and Amun. These titles are united in translation under the name "chantress."

ORGANIZATION OF THE CHANTRESSES. The women who served as chantresses generally came from the upper class, and even queens belonged to the most important group of chantresses: those who served the god Amun, king of the gods. The chantress accompanied her singing with a sistrum. This sacred rattle was closely associated with the goddess Hathor, whose symbol often appeared as decoration on it. Many representations of the queens and princesses show them holding the sistrum while they chant for the god. Queen Nefertiti was described as "one who pacifies the god with a sweet voice and whose two hands carry the sistra." Organized into four groups known as *phyle*, the chantresses served in rotation at the temple over the course of the year. The role of chantress was an honored one in Egyptian society with the chief of each phyle reporting directly to the High Priest of the temple in which the phyle served. The chantress was less a professional musician than a priestess who recited or chanted the liturgy before the statues of the god.

SOURCES

Emily Teeter, "Female Musicians in Pharaonic Egypt," in *Rediscovering the Muses in Women's Musical Traditions.* Ed. Kimberly Marshall (Boston: Northeastern University Press, 1993): 68–91.

Lana Troy, *Patterns of Queenship in Ancient Egyptian Myth and History* (Uppsala, Sweden: Uppsala Studies in Ancient Mediterranean and Near Eastern Civilizations, 1986).

THE SOCIAL STATUS OF MUSICIANS

MODERN SCHOLARLY BIAS. Scholars from the nineteenth and twentieth centuries differed widely in their hypotheses regarding the status of musicians in ancient Egypt. This difficulty stems, in large part, from

a PRIMARY SOURCE *document*

SINUHE WELCOMED HOME WITH MUSIC

INTRODUCTION: *The Story of Sinuhe* was the most important literary work from ancient Egypt. It is an epic poem that describes Sinuhe's flight from Egypt to the Levant after the assassination of Amenemhet I. Sinuhe left because he mistakenly believed he had been implicated in the plot against the king. During his absence, Sinuhe lived with a bedouin tribe. He dressed like a bedouin even for his fearful return to Egypt at the king's invitation. At the end of the poem, King Senwosret I welcomed Sinuhe back to Egypt. Music and song were integral to Sinuhe's formal welcome as the royal princesses sang, accompanied by sistra.

Thereupon, they brought in the Royal Family;
And then his Majesty said to the Queen,
"Look, it is Sinuhe,
come as a Bedouin created by the Asiatics!"
so that she gave a very great cry,
the royal children [joining in] with a single shriek.
Then they said before his Majesty,
"Truly, it is not he, our sovereign Lord?"
Then his Majesty replied, "Truly, it is he."
So then they brought out their necklaces,
With their scepters and their sistra in their hands.
Then they presented them to his Majesty;

"Your state is more than beautiful, King,
who bears the insignia of the Lady of Heaven.
The Golden Goddess offers life to your nostrils,
The Lady of the Stars protects you;
The White Crown goes north, and the Red Crown goes
 south;
And what has been joined unites in the utterance of your
 Majesty;
Success is given from your brow.
You have delivered the poor man from evil,
Having propitiated Re, Lord of the Two Lands;
Praises to you, as to the Mistress of Us All!
Loosen your bow, lay aside your arrow,
Give breath to him who is in suffocation!
Give to us this fine thing
In favor of the foreign chieftain, Son of the Northwind,
The foreign bowman born in [our] beloved land.
He has made a flight for fear of you,
He has fled the land in terror of you.
[Yet] there should be no blanching of the face which
 looks upon you,
no fear in the eye which gazes at you."
Then his Majesty said, "He shall not fear henceforth …

SOURCE: "The Tale of Sinhue," in *Thought Couplets in "The Tale of Sinuhe."* Trans. John L. Foster (Frankfurt am Main, Germany: Peter Lang, 1993): 60–61.

their projections of the modern status of musicians—particularly female musicians—onto an ancient culture. For example, scholars assigned to female musicians of ancient Egypt the same class associations that they knew in Europe and America. One Victorian scholar suggested that only non-elite women became professional musicians. A mid-twentieth century scholar, on the other hand, suggested that young, elite girls learned to play the harp in ancient Egypt much as upper-class ladies in America learned to play the piano. Others suggested that musicians held a place of honor but were also slaves, a statement that has no basis in the evidence. In fact, there is no evidence that explicitly comments on the social status of musicians, although evidence from tomb drawings suggests that musicians and singers throughout ancient Egyptian history enjoyed elite status in their society.

OLD KINGDOM STATUS. In the Old Kingdom (2675–2170 B.C.E.), tomb drawings indicate that there was no professional class of female musicians, but there was an amateur class of high-status women who played for the men of the household. Women playing the harp in tomb representations were nearly always family mem-

bers of the deceased. They include a daughter in the tomb of Idu and the tomb owner's wife in the tombs of Pepi at Meir and of Mereruka at Saqqara. The latter is significant in that Mereruka's wife was specifically identified with her name, Watetkhethor. The Egyptians attached great importance to the preservation of personal names in a tomb, because the purpose of a tomb was to ensure the survival of the tomb owner's name for eternity. When an additional name appeared in a tomb, even the name of a wife, the Egyptians considered this to be an honor. Further evidence that these family members were relatively high status comes from the tomb of Pepi of Meir. His wife, depicted as a harp player, also bore the title "King's Companion," a recognition of her high status at court. There is some evidence to support the theory that men could be professional musicians; the male singer Khufwy-ankh enjoyed high status at court. He was a singer, Overseer of Singers, and flutist who owned a tomb in Giza near the Great Pyramid. Both the location of the tomb near such an important structure and the fact that a musician could own a tomb at all is an indication of his high social status. Clearly the Old Kingdom evidence supports the idea that elite men and

women learned to play music and that music was a part of elite society.

MIDDLE KINGDOM STATUS. In the Middle Kingdom, the evidence for musicians is sparser than in other periods. Yet there are examples of musicians among the elite, or at least the class that obtained stelae for monuments in Abydos and even among princesses. The high official Seba-shesu boasted in his tomb that he trained ten musicians. Stelae from Abydos belonging to Neferhotep, Renseneb, and Sathathor were decorated with artistic renderings of musicians. If these prominent men and women included musicians on monuments intended to honor their own memories, musicians must not have been considered shameful. In literature there are examples of both princesses and goddesses taking on the role of musician. The daughters of Senwosret I in *The Story of Sinuhe* played the sistrum and sang in honor of Sinuhe's return to Egypt. In the late Middle Kingdom story contained in *Papyrus Westcar*, a group of goddesses and a god disguised themselves as professional musicians, indicating that there was nothing reprehensible about being a musician.

NEW KINGDOM STATUS. There is more evidence to support a growing class of professional musicians in the New Kingdom (1539–1070 B.C.E.), as indicated by the presence of musicians with no relationship to the deceased on tomb walls. There is also more evidence of the elite status enjoyed by musicians in both literature and tomb drawings. A passage in *Papyrus Anastasi* IV, for example, expresses the disappointment of the parents of a man who has become a drunk, a lout, and a customer of prostitutes; they suggest that this is not the behavior they expected from him since he is a highly trained musician. The high status of the chantress in the New Kingdom—which sometimes included queens who chanted the ritual for the god—also suggests that musical training was an elite trait. Singers served the gods and succeeded each other as the office passed from one generation to the next in elite families. For example, the female family members of Rekhmire, a vizier of the king, were nearly all musicians. Thus it seems likely that there was no shame in being a musician in the New Kingdom.

SOURCES

E. Hickmann, "Musiker," in *Lexikon der Ägyptologie*. Vol. IV. Ed. Wolfgang Helck (Wiesbaden, Germany: Otto Harrassowitz Verlag, 1972–1992): 231–234.

Emily Teeter, "Female Musicians in Pharaonic Egypt," in *Rediscovering the Muses in Women's Musical Traditions*. Ed. Kimberly Marshall (Boston: Northeastern University Press, 1993): 68–91.

MUSICAL DEITIES

HATHOR AND IHY. The Egyptians associated the deities Hathor, her son Ihy, Bes, Isis, and Osiris with music. Egyptians honored the goddess Hathor and her son Ihy at her temple in Dendera as the deity of the sistrum and the *menat*, rattles played primarily by women during worship of the gods. Hathor's temple in Dendera has a roof supported by columns shaped like sistra. One of the sanctuaries in the temple is known as the "shrine of the sistrum." In the crypts below the temple there are relief sculptures of sistra that were specially decorated and part of the temple's treasure. Hathor's son, Ihy, also was depicted in the Dendera temple playing the sistrum.

BES. The god Bes has associations with music in the temple and in the home. In the temple of Philae in southern Egypt, relief sculptures of Bes depict him playing the harp, playing the frame drum, and dancing in honor of Hathor. In the home Bes was associated with childbirth. The combination of the two areas—music and childbirth—explains why the goddesses who act as midwives in the story found in *Papyrus Westcar* disguised themselves as musicians. Furthermore some musicians in New Kingdom paintings bear a tattoo of the god Bes.

ISIS AND OSIRIS. Isis and Osiris had no real connection with music according to Egyptian traditions. Yet Greek and Roman traditions about Egypt closely associated them with Egyptian music. By the time that Greek philosophers and historians like Plato (427–347 B.C.E.) took an interest in Egyptian music, Isis and Hathor had merged in the minds of many people. Thus as the religion of Isis and Osiris spread across the Mediterranean Sea, Isis took with her some of Hathor's associations with music, along with the reputation given to her by Plato—that she had established all the forms of Egyptian music. In Apuleius' Latin novel *Metamorphoses*, written in the second century C.E., Isis transforms the hero Lucius from an ass or donkey back into a man with the use of a sistrum. The Greek writer Plutarch (45–125 C.E.) recorded that Osiris ruled the world by the power of his reason and his music. In reality, the Egyptians themselves called Osiris the Lord of Silence and forbade music during his worship except during one joyous ceremony called the Raising of the Djed Pillar. Plutarch also preserved the tradition that the trumpet could not be played at Osiris' temple at Busiris because its sound reminded the god of his evil brother, Seth, sometimes represented as an unidentified animal who could make a similar sound.

a PRIMARY SOURCE *document*

APULEIUS OF MADAURUS: A ROMAN VIEW OF EGYPTIAN MUSIC

INTRODUCTION: The Egyptians themselves did not write about music. Many Greek and Roman writers, however, commented on Egyptian music, including the Roman novelist, Apuleius of Madaurus. In his novel *Metamorphoses*, written in Latin in the second century C.E., the hero Lucius is magically transformed into an ass, then magically returned to his original form through worship of the Egyptian goddess, Isis. The goddess appears to him and promises her aid in transforming him back to human form. Music and musical instruments play a role both in the worship of Isis and in the transformation. In this passage Lucius hears the answer to his prayers to Isis.

When I had thus poured out my prayers, adding pitiable wailings, sleep again spread over my wilting spirit and overpowered me on that same sandy bed. I had scarcely settled down when lo! from the middle of the sea a face divine arose, showing above the waves a countenance which even gods must admire; and then gradually the radiant image of the whole body, when the brine had been shaken off, seemed to stand before me. I will try to communicate to you her wonderful appearance …

First, her abundant, long hair, gently curled over her divine neck or loosely spread, streamed down softly … The things she carried were of quite varied kind. For in her right hand she bore a bronze rattle in which a few rods in the middle, thrust across a thin sheet of metal that was curved like a belt, emitted a tinkling sound when the arm made three quivering jolts. From the left hand there hung a golden vessel … Such was the great goddess who, breathing the blessed fragrance of Arabia, deigned to address me with divine voice.

"Lo, I am with you, Lucius, moved by your prayers, I who am the mother of the universe, the mistress of all the elements, the first off-spring of time, the highest of deities, the queen of the dead, foremost of heavenly beings. …

"I am here taking pity on your ills; I am here to give aide and solace. Cease then from tears and wailings, set aside your sadness; there is now dawning for you, through my providence, the day of salvation. For this reason pay careful heed to these commands of mine. The day which will follow the coming night has been dedicated to me by eternal religious sanction. Then, when the storms of winter have been calmed, and the wild waves of the sea have been stilled, my priests are wont to vow a new barque to the now navigable sea and offer it as first-fruits of a new year's navigation. You should await that sacred rite with a mind neither anxious nor profane.

"For at my suggestion a priest in the very midst of the moving procession will carry a crown of roses attached to the sistrum in his right hand. Without delay, therefore, push through the crowds and eagerly join the procession relying on my favour; then get close to the priest and gently, as if you meant to kiss his hand, pluck off the roses with your mouth and forthwith cast off the hide of that vile beast that has long since been hateful to me. … You shall live indeed a happy man, you shall live full of glory in my protection. …"

Thus did the revered oracle come to an end, and the unvanquished deity withdrew into her own being.

While these amusing delights of the people were appearing all over the place, the procession proper of the Saviour Goddess was on its way … Then came the charming music of many instruments, and the sound of pipe and flute in the sweetest melodies. They were followed by a delightful choir of the most select youths, radiant in snow-white festal tunics; they repeated a captivating song which a skilled poet had written for music with the aid of the Goddesses of Song, and the theme of this from time to time contained musical preludes to the solemn vows to come. There came also flautists dedicated to great Sarapis, who repeated through a reed, held sideways towards the right ear, a tune traditional to the temple and its deity; and there were many shouting out, "Keep the way clear for the holy procession!"

And behold! here come to me the promised blessings of the most helpful goddess and a priest approaches bringing with him my destiny and my very salvation. He was equipped as the divine promise had foretold, carrying in his right hand a sistrum intended for the goddess, and a crown for me—and assuredly the crown was most fitting, since after enduring so many and so great toils and passing through so many dangers, by the providence of the mighty goddess I was now overcoming Fortune that had buffeted me so cruelly. …

First my scruffy bristles fell off, then my rough hide became thin and the fat belly subsided, while the soles of my feet now ended in toes instead of hoofs and the hands were no longer feet, doing their work now in my upright posture. My lofty neck contracted, my mouth and head became round; my huge ears regained their former slenderness and my rock-like molars returned to human scale; and my tail, my chief torment of old, was non-existent!

SOURCE: "Apuleius of Madaurus," in *The Isis Book (Metamorphoses, Book XI).* Trans. J. Gwyn Griffiths (Leiden, Netherlands: E. J. Brill, 1975): 73, 75, 77, 81, and 85.

THE HYMN TO THE ATEN

INTRODUCTION: The Hymn to the Aten is attributed to King Akhenaten. In this hymn Aten receives credit for all creation, and this extract specifically includes music as part of Aten's ritual.

Singers, musicians, shout with joy,
in the court of the sanctuary
and in all temples in Akhetaten,
the place of truth in which you rejoice.
Foods are offered in their midst,
Your holy son performs your praises,
O Aten living in his risings,
And all your creatures leap before you. Your august
 son exults in joy,
O Aten living daily content in the sky.

SOURCE: "Akhenaten," in *Music and Musicians in Ancient Egypt*. Trans. Lisa Manniche (London: British Museum Press, 1991): 93.

SOURCES

Robert D. Anderson, "Music and Dance in Pharaonic Egypt," in *Civilizations of the Ancient Near East*. Ed. Jack M. Sasson (New York: Charles Scribner's Sons, 1995): 2555–2568.

Lisa Manniche, *Music and Musicians in Ancient Egypt* (London: British Museum Press, 1991).

SEE ALSO *Dance: Cult Dances; Religion: Myth of Osiris*

MUSIC DURING THE REIGNS OF AKHENATEN AND NEFERTITI

RICH MUSICAL DOCUMENTATION. The reigns of Akhenaten and Nefertiti spanned only seventeen years from 1352 to 1336 B.C.E. Yet Akhenaten's artists decorated the palace, tombs, and temples with many scenes of music making. This brief period witnessed a dramatic change in Egyptian religion. Akhenaten abandoned the worship of Amun, the King of the Gods, and substituted the god Aten, the physical disk of the sun. He closed Amun's temples and moved the royal court from homes in Thebes and Memphis to a new city at the site of Tell el Amarna. Thus this period is called the Amarna Period and includes the reign of Tutankhamun, who restored the religion of Amun and returned the royal court to Thebes. The richness and diversity of the scenes of music-making demonstrate some key trends in music during this time. Many scenes show Akhenaten's six daughters playing the sistrum and menat—two sacred rattles used in worship—suggesting that the royal daughters had a prominent role in the musical life of Aten's cult. Also, the presence of foreign musicians at court in drawings demonstrates the cosmopolitan nature of Akhenaten's reign. The foreign musicians may have accompanied foreign wives to court, though the evidence that Nefertiti, his primary wife, was a foreigner is not conclusive.

MUSIC AT THE PALACE WOMEN'S QUARTERS. A scene from a tomb in Amarna representing the women's quarters at the palace of Akhenaten and Nefertiti at Amarna includes many musical instruments. The scene shows six different rooms. In one room, musicians manning a harp, lyre, and lute play for a woman who is singing and perhaps dancing. In a second room, a woman dressed in foreign clothing dances to a harp player and another instrumentalist whose image is too damaged to interpret. Four other rooms appear to be for instrument storage. Included in them are lutes, lyres, and the giant harp imported from Mesopotamia in this time period. Akhenaten's many wives and daughters clearly spent some of their time at home playing music. Notably the instruments shown in their domestic quarters are not the same instruments that they played in religious settings. In the temples they played mostly the sistrum, an instrument not depicted in this private, domestic scene.

SISTRUM PLAYING IN THE AMARNA PERIOD. During the Amarna Period the royal daughters and the queen played the sistrum for the Aten rather than Hathor. Though Hathor had been the main deity associated with sistrum playing in traditional Egyptian religion, her worship was not practiced during the Amarna Period. Thus the two sistra found in the tomb of Tutankhamun and the sistrum depicted on a block from an Amarna building omit the normal decoration with Hathor's head. Instead the sistra from this period have simple handles shaped like papyrus plants. The rattle disks themselves are housed on snake-shaped rods. Perhaps the sound of the sistrum was associated with the cobra who protects the royal family.

CLAPPERS. Included among the treasures buried with Tutankhamun were a pair of ivory clappers. Amarna artists depicted men playing clappers during

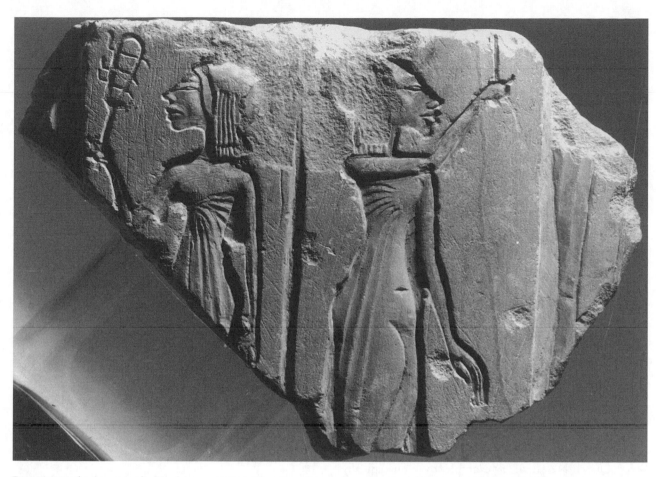

Two unnamed princesses playing sistrum. BROOKLYN MUSEUM OF ART, 35.2000, GIFT OF THE EGYPT EXPLORATION FUND. REPRODUCED BY PERMISSION.

processions. Yet the clappers found in Tutankhamun's tomb were inscribed with the names of women: Queen Tiye, Akhenaten's mother, and Merytaten, his eldest daughter. These instruments were carved to end in human hands recalling through their shape the arms and hands that Amarna artists gave to the sun disk.

AMARNA PROFESSIONAL MUSICIANS. Amarna professional musicians included native Egyptian women and men as well as foreign men. The foreign women playing instruments in the women's quarters of the palace show them playing privately for themselves. Many representations of foreign musicians are damaged, however. Since clothing worn especially by Syrian male and female musicians was so similar, it may be that some scenes that do not preserve the head have been misinterpreted as men rather than women. At present it is not possible to know for certain.

FEMALE MUSICIANS. In the Amarna Period, including Tutankhamun's reign (1352–1322 B.C.E.), female musicians played in the same combination of instruments often found earlier in the Eighteenth Dynasty (from 1539–1352 B.C.E.). The biggest difference is that the strings are sometimes doubled in number during the Amarna Period. Thus while earlier groups consisted of a harp, a lyre, a lute, and an oboe, the Amarna ensembles have two harps, two lutes, and two lyres and sometimes omit the oboe altogether. The detailed reliefs also show a waisted lute (narrowing in the middle of each side) that anticipates the shape of the modern guitar.

MALE MUSICIANS IN THE AMARNA PERIOD. Amarna artists depicted male musicians only during the first four years of Akhenaten's reign in buildings at Karnak. Neither the tombs nor temples of Amarna itself depict male musicians. At Karnak the male musicians wear blindfolds while they play. Their heads are shaved and they wear both short kilts and the longer, calf-length kilt. These characteristics connect them with the priesthood in other time periods, though officially Akhenaten himself was the only priest of the Aten. Male musicians at Akhenaten's Karnak temples

Pair of clappers in the form of human hands. BROOKLYN MUSEUM OF ART, 49.58.1-2, CHARLES EDWIN WILBOUR FUND. REPRODUCED BY PERMISSION.

played the harp, lute, and lyre. Usually these instruments were only played by women in other contexts. In fact the harp, lute, lyre, and oboe ensemble was the typical female band that played at earlier Eighteenth-dynasty banquets. This combination of instruments, lacking only the oboe, reflects a general Amarna Period tendency to break down barriers between the sexes. Queen Nefertiti, for example, took on typically male activities such as ceremonially smiting Egypt's enemies at the temple in Karnak. The other male ensemble during this period is composed of a large group of men—up to seventeen—chanting and clapping to the rhythm of a barrel-shaped drum. This drum was primarily a military instrument in other time periods. These scenes also occur only at Karnak during Akhenaten's reign.

FOREIGN MUSICIANS DURING THE AMARNA PERIOD. Male foreign musicians who played in Akhenaten's temples in Karnak are identified by their unusual clothing and instruments. They wore conical hats and long kilts with three flounces. They also wore blindfolds. They played both the giant lyre and the hand-held lyre. Two musicians played the giant lyre at the same time. This lyre was taller than the musicians. They each stood on one side of it and seem from the relief sculptures to have played at the same time. There were more strings on a giant lyre than on the smaller, hand-held lyre. These additional strings suggest either that the giant lyre had a greater range of notes than a hand-held lyre or that the two musicians played strings tuned to the same note simultaneously. If both played the same note, this would increase the volume of the

sound. These musicians and their instrument were unique to the Karnak temples of the Amarna period. Even the tombs of this period did not depict the giant lyre.

MUSIC IN THE CULT OF THE ATEN. The cult of the Aten, Akhenaten's new religion, included music in the palace that honored the king as the earthly embodiment of the god. In the "Great Hymn to the Aten" the author made a specific connection between offering food to the Aten and music. Food offerings were the god's meal. The god consumed the spirit of the food while priests or even the royal family acting as priests consumed the physical food. While everyone ate, music played. The relief sculptures from the temples at Karnak suggest that lyres and even lutes were included in these offering ceremonies in addition to the more traditional sistra played throughout Egyptian history during ritual chanting.

SOURCES

Lisa Manniche, *Music and Musicians in Ancient Egypt* (London: British Museum Press, 1991).

THE BLIND SOLO HARPIST AND HIS SONG

MUSICAL GENRE AND ARTISTIC CONVENTION. As early as 1768 when James Bruce discovered the tomb of Ramesses III, Westerners have been aware of the idea of the blind harpist in Egyptian art. Bruce discovered two images of a blind harpist who sang about death in the tomb. Bruce had discovered what proved to be a very common theme in Egyptian art. At least 47 tombs in the Theban necropolis depict blind harp players. This motif decorated tombs of nobles and royalty. The blind harpist entertained at banquets but sang of death and life after death. It was only in the mid-twentieth century that M. Lichtheim conducted a full study of the blind harpists' songs. The songs reveal the history of Egyptian attitudes toward death and the afterlife, although the convention of the blind or blindfolded harpist remains an intriguing mystery.

EARLIEST BLIND HARPISTS' SONGS. The blind harpists' songs were carved on tomb walls and on stelae in the Middle Kingdom and the New Kingdom. Their lyrics discuss the nature of death and the afterlife but are not necessarily part of the funeral ritual. Because their purpose was contemplative rather than ritual words to effect the transformation from this world to the next, the authors of these lyrics contem-

174

Arts and Humanities Through the Eras: Ancient Egypt (2675 B.C.E.–332 B.C.E.)

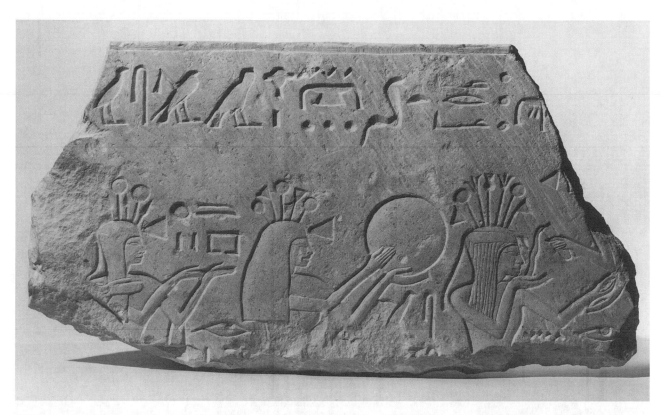

Relief with female musicians. BROOKLYN MUSEUM OF ART, 68.150.1, CHARLES EDWIN WILBOUR FUND. REPRODUCED BY PERMISSION.

plated death on a broader level. The earliest blind harpists' songs reassure the deceased that the tomb is a joyful place and that the dead are happy. Such is the point made by the blind harpist Neferhotep, son of Henu, on the stele of Iki, now in the Leiden Museum. The blind harpist Tjeniaa gave an even more elaborate description of the joys of the tomb on a stela carved for Nebankh, now in the Cairo Museum. Tjeniaa assured Nebankh that his tomb itself was well-built and eternal, that it would always be filled with food for his spirit, and that his ka-soul would always be comfortable there. It is clear that this sort of song fits well with the other inscriptions associated with Egyptian tombs. The positive words uttered or sung about the deceased's future after death were part of the ritual that assured the word's truth.

THE SONG FROM THE TOMB OF KING INTEF. There are two copies of a blind harpist's song that the scribe attributed to a certain King Intef. One copy is part of *Papyrus Harris* 500 in the British Museum. A scribe copied the song on this papyrus during the Ramesside Period (1292–1075 B.C.E.). The second copy was made slightly earlier. It is carved in the tomb of Paatenemheb, an official who died at the beginning of the Amarna Period (1352–1336 B.C.E.). The best-known kings named Intef lived at least 650 years before Paatenemheb was buried. They include Intef I (2075–2065 B.C.E.), Intef II (2065–2016 B.C.E.), and Intef III (2016–2008 B.C.E.) of the Eleventh Dynasty. A less-well known king, Intef V (after 1630 B.C.E.), might also have been the author. Nevertheless, aside from the Amarna text and Ramesside papyrus, there are no copies of the song from the period when a king named Intef ruled. Nevertheless, the language of the copies is classical Middle Egyptian, the dialect spoken during the earlier period. Thus M. Lichtheim believes that the true time of composition must have been in the Middle Kingdom. The song suggests that not all the assurances about the joys of the afterlife can be trusted. The author suggests that no one on earth knows for sure what will happen in the land of the dead, and thus it is important to enjoy life here. He urges everyone to dress well, wear soothing oils, and have fun. Death is inevitable, he says, but that is no reason not to enjoy life. The answer to this critical approach is found in a New Kingdom tomb of a priest named Neferhotep who was buried in Thebes. Nefterhotep claims that in spite of the "old songs" which urge that life on earth must be enjoyed to the hilt, the land of the dead holds even more joys. It is fascinating to know that among Egyptians

Arts and Humanities Through the Eras: Ancient Egypt (2675 B.C.E.–332 B.C.E.)

175

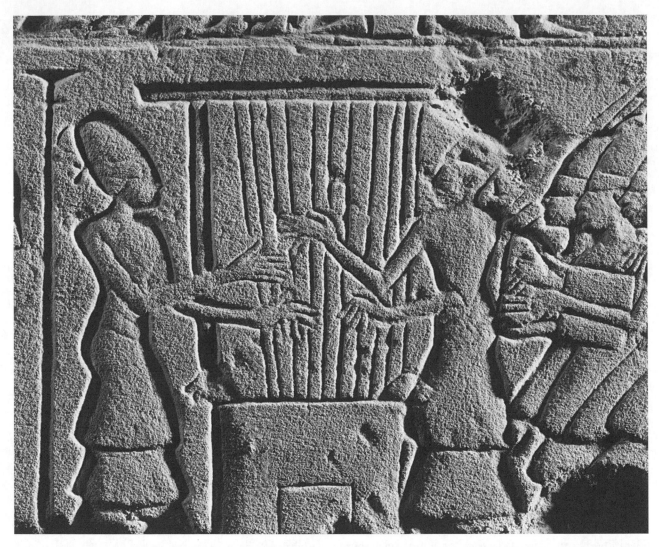

Musicians from Egypt and abroad. Relief from the Akhenaten temple project in Karnak, 1350 B.C.E. New Kingdom. ERICH LESSING/ART RESOURCE NY.

there was room for disagreement and doubt about basic beliefs.

THE BLIND SOLO HARPIST. Representations of the blind solo harpist in the Ramesside Period perhaps developed from Eighteenth-dynasty tomb representations of musical ensembles at banquets. The characteristics of the male blind harpists found in these tombs resemble the blind solo harpists found in Ramesside tombs. Egyptian artists represented the blind solo harpist as wealthy. As a fat man he was interpreted as well fed and thus had access to greater resources than the average person. He was also well dressed in a linen garment with a shawl. The blind solo harpist was also bald, a characteristic that associated him with priests who shaved their heads to achieve ritual purity. He was often, though not always, represented with impaired vi-

sion, a fact that led to his usual designation by Egyptologists as blind. However, L. Manniche estimates that only one-quarter of the known representations of the blind solo harpist were shown with unusual eyes. These unusual eyes are generally interpreted as blindness or visual impairment. Blindness can be represented in one of four ways. First, a normal eye can be represented without an iris. Second, the eye could be shown as a slit with an iris. Third, the slit-shaped eye could have no iris. Fourth, only the upper curve of the eye can be shown, without any further representation of the eye. Manniche, however, observes that in cases where the iris appears to be omitted in the carving, it might have been painted in the original state. Moreover, even the slit eyes might only represent closed eyes. Thus it is not altogether certain that the blind solo harpist was represented as blind.

a PRIMARY SOURCE *document*

HARPIST SONGS

INTRODUCTION: The earlier examples of the harpists' song stress the good to come in the afterlife. These two examples of harpists' songs were carved in the Middle Kingdom.

Song of Neferhotep

This is the song:
O Tomb, you were built for festivity,
You were founded for happiness!
The singer Neferhotep, born of Henu.

Song of Tjeniaa for Nebankh

The singer Tjeniaa says:
How firm you are in your seat of eternity,
Your monument of everlastingness!
It is filled with offerings of food,
It contains every good thing.
Your ka is with you,
It does not leave you,
O Royal Seal-bearer, Great Steward, Nebankh!
Yours is the sweet breath of the northwind!
So says his singer who keeps his name alive,
The honorable singer Tjeniaa, whom he loved,
Who sings to his ka every day.

SOURCE: "Song of Neferhotep" and "Song of Tjeniaa for Nebankh," in *The Old and Middle Kingdoms*. Vol. 1 of *Ancient Egyptian Literature*. Trans. Miriam Lichtheim (Berkeley and Los Angeles: University of California Press, 1973): 194.

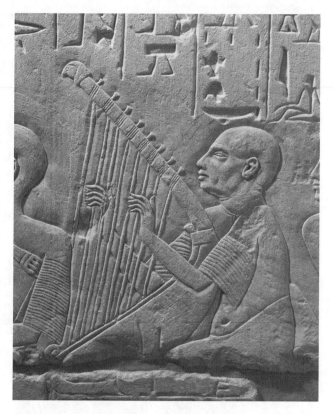

Blind harpist, detail of relief. Nineteenth Dynasty, New Kingdom. © ERICH LESSING/ART RESOURCE, NY.

DOUBTS AND PUZZLES. The tomb of Raia represents a puzzle about the harpist's blindness. The harpist is represented with a slit eye while he plays, but a normal eye in other parts of the tomb. If he was truly blind in life, perhaps Raia's representations with normal eyes represented a wish for total health in the next world. On the other hand, perhaps Raia was not blind at all nor even intended to be represented as blind while playing his harp before the god. Perhaps all of the so-called blind harpists are only closing their eyes with emotion while they sing. A look at the so-called blind harpist reveals both ancient Egyptian doubts about the next life and a puzzle about artistic representation. The songs the harpists sing both affirm that the next life is a happy one and offer doubts that there is any other happiness but life on earth. The eyes of the harpist, represented in a variety of ways, either show the harpist as blind or as an emotion-filled singer, closing his eyes in the grip of his feelings while chanting for the god.

SOURCES

Miriam Lichtheim, *Ancient Egyptian Literature: The Old and Middle Kingdoms* (Berkeley: University of California Press, 1973).

SYMBOLIC BLINDNESS. Because there is some doubt about whether so-called blind solo harpists were truly blind, L. Manniche has suggested that many harpists were represented with symbolic blindness. She observes that large numbers of musicians represented at the palace in Amarna were wearing blindfolds when they played. She describes this condition as temporary lack of sight. One of her strongest arguments concerns the tomb of Raia, a musician who lived in the Ramesside Period. When represented in his tomb playing the harp for the god, Raia's visible eye was depicted as only a slit. In his other representations, his eye appears to be normal. Perhaps, Manniche argues, his blindness was symbolic, only present when he sat playing for the god.

Arts and Humanities Through the Eras: Ancient Egypt (2675 B.C.E.–332 B.C.E.)

177

a PRIMARY SOURCE *document*

THE SONG FROM THE TOMB OF KING INTEF

INTRODUCTION: This song is preserved in two New Kingdom documents. It is known from a tomb from early in the reign of Amenhotep IV, later called Akhenaten (1352–1336 B.C.E.). It is also known from a Ramesside (1292–1075 B.C.E.) papyrus called *Papyrus Harris 500*, now in the British Museum. The text, however, states that it was written in the reign of King Intef who would have lived in the Middle Kingdom, perhaps 800 to 1,000 years earlier. The language of the text is consistent with this claim. This song urges people to enjoy life on earth since it is not certain what will follow.

Song which is in the tomb of King Intef, the justified, in
 front of the singer with the harp.
He is happy, this good prince!
Death is a kindly fate.
A generation passes,
Another stays,
Since the time of the ancestors.
The gods who were before rest in their tombs,
Blessed nobles too are buried in their tombs.
(Yet) those who built tombs,
Their places are gone,
What has become of them?
I have heard the words of Imhotep and Hardedef,
Whose sayings are recited whole.
What of their places?

Their walls have crumbled,
Their places are gone,
As though they had never been!
None comes from there,
To tell of their state,
To tell of their needs,
To calm our hearts,
Until we go where they have gone!
Hence rejoice in your heart!
Forgetfulness profits you,
Follow your heart as long as you live!
Put myrrh on your head,
Dress in fine linen,
Anoint yourself with oils fit for a god.
Heap up your joys,
Let your heart not sink!
Follow your heart and your happiness,
Do your things on earth as your heart commands!
When there comes to you that day of mourning,
The Weary-hearted hears not their mourning,
Wailing saves no man from the pit!
Make holiday,
Do not weary of it!
Lo, none is allowed to take his goods with him,
Lo, none who departs comes back again!

SOURCE: "Songs and Hymns," in *The Old and Middle Kingdoms*. Vol. 1 of *Ancient Egyptian Literature*. Trans. Miriam Lichtheim (Berkeley and Los Angeles: University of California Press, 1973): 196–197.

Lisa Manniche, *Music and Musicians in Ancient Egypt* (London: British Museum Press, 1991).

EROTIC MUSIC

NATURAL AND SPIRITUAL SIGNIFICANCE. In artistic renderings of erotic scenes, the Egyptians placed musical instruments such as the lute, oboe, and lyre near to couples engaged in sexual intercourse. In some cases it appears that the female musician holds her instrument in one hand during intercourse. At the natural level, the connection between music and physical love may represent a more universal belief in the power of music to inspire love-making, but there is also a spiritual significance to the inclusion of instruments in erotic drawings. Egyptians incorporated physical love into the religion of rebirth into the next world, and to that end included numerous erotic symbols in their tomb decorations. Music's role in aiding this sacred act, then, endows it with powerful meaning and importance. The most famous examples are found in the *Turin Erotic Papyrus*, a series of drawings representing couples in various sexual positions. Many scholars who have remarked on these scenes believe they represent a brothel. A famous example of the erotic power of harp music is found in the tomb of Mereruka, the prime minister of King Teti (2350–2338 B.C.E.). His large tomb at Saqqara contains a relief sculpture of him sitting on his bed with his wife Watetkhethor, who plays the harp while Mereruka reclines holding a fly whisk, the mark of a high official. Other, nearby scenes show the couple preparing for bed with special ointments and new hairstyles. The scene's erotic force, the Egyptians believed, ensured fertility and rebirth into the next world, and the harp music functioned as a critical component of the ritual.

SOURCES

Lisa Manniche, *Music and Musicians in Ancient Egypt* (London: British Museum Press, 1991).

SIGNIFICANT PEOPLE
in Music

AMENEMHAB MAHU

fl. during the reign of Amenhotep III (1390–1352 B.C.E.)

Chief of Singers of Amun
Singer of the Noble Harp of Amun

EARLY BELIEVER IN SUN RELIGION. As is true with most ancient Egyptian individuals, little is known of Amenemhab's personal life. He lived during the reign of Amenhotep III, the father of Akhenaten. Akhenaten was the first king to radically alter Egyptian religion by proclaiming that only the sun should be worshipped as the god Aten. Amenemhab anticipated Akhenaten's beliefs with the song he sang about the sun-god Re. Amenemhab must have been an important member of Amenhotep III's court. He traveled with the king to foreign countries, according to his inscription. Perhaps he knew the young Akhenaten and even influenced the prince's beliefs. In a stela, Amenemhab speaks of the sun as the creator god, an idea that was part of Akhenaten's religion. Amenemhab must have been an important individual, but little is known about the details of his life.

SOURCES

Charles Kuentz, "Une Stèle d'un chef de chanteurs," in *Recueil d'études égyptologiques dédiées à la mémoire de Jean-François Champollion* (Paris: E. Champion, 1922): 601–610.

Lisa Manniche, *Music and Musicians in a Ancient Egypt* (London: British Museum Press, 1991).

ITI

fl. during Dynasty 5 (2500–2350 B.C.E.)

Singer

FIRST KNOWN PROFESSIONAL SINGER. Iti is the earliest known professional singer whose name is preserved from ancient Egypt. Her name appears along with her accompanist, Hekenu, a harpist, represented in a relief sculpture on the false door of the tomb of the judge and priest, Nikawre, and his wife, Ihat, at Saqqara. In the relief, Iti sits on the ground facing Hekenu. Her right hand makes a gesture toward the harpist. Her left hand is raised to her ear, a common way for Egyptian artists to represent singers. In fact this hand-to-ear gesture is often used by many Egyptian singers today. Iti wears the typical Old Kingdom sheath dress that was worn by all classes of women in this period. Her hair is cropped short and she is not wearing a wig as would the tomb owner's wife. A hieroglyphic caption gives her name and no other information. Egyptians considered including a person's name in a tomb to be an honor, especially if the person was not a family member. If Iti had been a family member, her relationship would have been included. Thus Egyptologists believe that she was a professional singer who was honored with a portrait in the tomb, rather than a member of Nikawre's family. In spite of her prominence, almost nothing else is known about her.

SOURCES

Lisa Manniche, *Music and Musicians in Ancient Egypt* (London: British Museum Press, 1991).

Emily Teeter, "Female Musicians in Pharaonic Egypt," in *Rediscovering the Muses in Women's Musical Traditions.* Ed. Kimberly Marshall (Boston: Northeastern University Press, 1993).

NEFERHOTEP, SON OF HENU

fl. during the Middle Kingdom (2008–1630 B.C.E.)

Singer
Harpist

HARPIST AND SINGER. Neferhotep, son of Henu, was one of the earliest known singer/harpists from ancient Egypt. His portrait and his song were included on the stela of a man named Iki. On the stela, Iki is seated before an offering table while his wife stands behind him. Neferhotep plays on the other side of the table. He kneels next to his harp as he plays. He is portrayed with the rolls of fat Egyptian artists depicted in portraits of wealthy people. He also wears his hair very closely cropped. His eyes are slits, suggesting either that he is blind or that his eyes are squeezed closed with emotion. Neferhotep's song is recorded in four short columns of hieroglyphs carved in front of him. In the song Neferhotep praises life in the tomb after death.

SOURCES

Miriam Lichtheim, *Ancient Egyptian Literature: A Book of Readings I* (Berkeley: University of California Press, 1973).

Lisa Manniche, *Music and Musicians in Ancient Egypt* (London: British Museum Press, 1991).

DOCUMENTARY SOURCES
in Music

Akhenaten, *Hymn to the Aten* (c. 1352 B.C.E.)—This hymn describes the use of music in religious ritual.

Anonymous, *The Story of Sinuhe* (c. Twelfth Dynasty, 1938–1759 B.C.E.)—Egypt's national epic includes a scene of musical welcome when Sinuhe returns from his journey to the Levant.

Anonymous, *Songs from Paheri's Tomb* (c. early Eighteenth Dynasty, 1539–1425 B.C.E.)—A series of agricultural work songs recorded in this tomb.

Anonymous, *Song from the Tomb of King Intef* (c. early Eleventh Dynasty (?), 2075–2008 B.C.E.)—Song sung to harp accompaniment that stresses enjoying this life since the next life is uncertain.

Anonymous, *Story of Two Brothers* (c. Ramesside Period, 1292–1075 B.C.E.)—This story contains the episode "Bata Mutilates Himself," which explains in detail the events recounted in the lyrics to the "Shepherd's Song."

Apuleius (Lucius [?] Apuleius), *Metamorphoses,* or *The Golden Ass* (c. 155 C.E.)—This novel, the only Roman one that has survived intact, includes the famous story describing an Egyptian religious procession with music.

Neferhotep, *Song of Neferhotep for Iki* (c. Twelfth Dynasty, 1938–1759 B.C.E.)—Song sung to harp accompaniment that stresses the joys of the afterlife.

Tjeniaa, *Song of Tjeniaa for Nebankh* (c. Twelfth Dynasty, 1938–1759 B.C.E.)—Song sung to harp accompaniment that stresses the joys of the afterlife.

chapter six

PHILOSOPHY

Edward Bleiberg

IMPORTANT EVENTS
in Philosophy

All dates in this chronology are approximations (c.) and occur before the common era (B.C.E.).

2625–2585 King Sneferu is the first Egyptian king to call himself "Possessor of Maat," stressing his role in maintaining justice in the world.

2500–2350 The first Egyptian tomb biographies in the Fifth Dynasty state that the deceased gave charity to the unfortunate in the name of *maat* ("right conduct").

The first allusions to Egyptian ideas about the creation of the world are contained in the *Pyramid Texts*, the royal funeral ritual.

1938–1759 In the Twelfth Dynasty a series of teachings describe maat. Most of these teachings are attributed to famous men of the past such as the Fifth-dynasty prime minister, Ptahhotep.

The *Coffin Texts*—spells found on Middle Kingdom coffins—use maat to ensure admission to the afterlife. They also make the connection between the creation of humans and the god's tears.

1919–1875 *The Teachings of Amenemhet I* are composed during the reign of his son Senwosret I. Scholars acknowledge this text as the earliest royal philosophical teaching, and is notable for its cynicism regarding the loyalty of others.

1539–1075 In the New Kingdom, kings regularly perform the ritual of presenting maat to the gods as a way of ensuring justice in the world.

New Kingdom authors Any and Amenemope write of the possibility that even correct conduct by individuals does not guarantee that the gods will provide justice.

In the New Kingdom, the *Book of the Dead* explicitly links correct behavior and admission to the afterlife.

New Kingdom copies of *The Teachings of Ptahhotep*, *The Teachings of Hordjedef*, and *The Teachings for Merykare* show that these Middle Kingdom philosophical texts were still studied in schools.

1478–1458 Hatshepsut takes the throne name Maat-ka-re, which emphasizes that she is the embodiment of the idea "The soul of the sun god Re is Justice."

Hatshepsut celebrates her coronation in the Temple of Maat, the first time the temple is used for this purpose.

1390–1352 King Amenhotep III chooses a throne name, Neb-maat-Re, that stresses that he is "The Possessor of the Justice of Re."

1352–1336 Akhenaten and Nefertiti use the presentation of *maat* ("right conduct") to their god Aten as the primary ritual.

1332–1322 The first known text of the *Book of the Heavenly Cow* describes the ideal world before death entered it. This text comes from the tomb of Tutankhamun.

1319–1292 King Horemheb creates Egypt's first known written law code that sanctions punishment in the name of maat.

The Egyptian god Thoth is first called the "one who knows mysteries," establishing the Egyptian basis for the Greek idea that Thoth presided over secret wisdom.

1290–1279 King Sety I takes the throne name Menmaat-Re, which means "The Justice of Re is firm."

1126–1108 A picture of jackals towing the god's boat is substituted for the normal phonetic

writing of the verb "to tow" in Ramesses' IX tomb. Such intellectual puzzles may have spawned the Greek idea that all hieroglyphs are symbolic rather than phonetic, leading to the idea that hieroglyphs express only philosophical concepts.

1075–945 Amulets made in the Twenty-first Dynasty are the first evidence that the stars could effect activities on earth and are perhaps a reflection of early astrology.

874–830 Armbands from the tomb of Osorkon II depict the stars as protectors of the king, perhaps an early form of astrology.

760–525 The God's Wife of Amun, the chief priestess, takes responsibility for presenting maat to the gods in the Twenty-fifth and Twenty-sixth Dynasties.

716–702 The only copy of the *Memphite Theology* that describes how Ptah created the world from words is carved in stone during the reign of King Shabaka.

525–404 The Greek historian Herodotus begins the tradition of describing the Egyptians in Book Two of his collection, *The Histories*. Greek interpretations of Egyptian society will become the basis for Western understanding until 1822 when Champollion deciphers hieroglyphs.

An Egyptian text first calls the god Thoth "very, very, very great" anticipating the Greek name for him "Trismegistus" meaning "thrice great." The Greeks will consider Hermes Trismegistus to be the source of Egyptian philosophy.

381–362 A shrine from the reign of Nectanebo I contains an inscription suggesting the stars can effect wind and water and cause illness and sudden death. This is early evidence for Egyptian belief in astrology.

305–30 The Egyptians compose and carve on the walls of temples their first connected accounts of the creation of the world.

Egyptian scribes invent intellectual puzzles in hieroglyphs such as writing an entire hymn with only the crocodile sign. Such puzzles will mislead the Greeks into believing that hieroglyphs are completely symbolic rather than phonetic and ultimately convinced the Greeks that hieroglyphs only could express philosophical ideas.

Egyptian astrologers are active at the royal court, suggesting to the Greeks that astrology was an ancient Egyptian belief.

The Babylonian zodiac brought to Egypt at this time becomes a part of astrology.

OVERVIEW
of Philosophy

CATEGORIES. Philosophy was originally a Greek category of knowledge. It sought the answers to questions concerning the nature of knowledge itself (metaphysics), the core of goodness (ethics), and the essence of beauty (aesthetics). Greek philosophers also raised questions about politics and methods of persuasion (rhetoric). Only some of these questions have relevance to Egyptian categories of thought. Though the Greeks credited the Egyptians with the beginnings of philosophy, the Greeks often interpreted Egyptian data to yield thoughts similar to their own, causing modern scholars to wonder about the true nature of Egyptian philosophy.

EGYPTIAN CONCERNS. Egyptian philosophers were intensely concerned with questions of proper conduct and justice. Many Egyptian texts advise the reader on how to act properly. Egyptian philosophers did not discuss the nature of knowledge in itself but they did have opinions on the proper way to teach justice. Egyptian thinkers did not write about the political system, but some pessimistic literature considered the results when there is no legitimate king. A few documents also contain advice for princes who someday would be kings. Methods of persuasion, as in Greek rhetoric, were not an Egyptian concern. It is from these basic ideas that scholars have built a true structure of Egyptian philosophy and have deciphered Egyptian thoughts on certain standard philosophical questions.

ATTRIBUTES. The three main attributes that all Egyptian philosophies share are flexibility, pragmaticism, and attention to emotion. The Egyptologist Erik Hornung stressed that Egyptian answers to philosophical questions were flexible. He asserted that the Egyptians never offered final and definitive answers to philosophical questions. Rather Egyptian philosophies tended to be pluralistic, offering, for example, several possible explanations for the origins of the world that were all equally true. Hornung believed that the Egyptians knew there was no single answer to a question, hence Egyptian thought avoided stressing one cause to the detriment of another. Egyptians did not believe in absolutes. Egyptian philosophy is also pragmatic. Egyptian teachings considered concrete life situations without generalizing to abstract laws. The Egyptian notion of *maat* ("justice") stressed solutions to real-life problems. Abstract thought was not as important as finding a practical solution to a specific problem. The wisdom that older men offered to their children spoke directly to specific situations they expected would occur in the course of any career or life. Finally, Egyptian thought recognized the lure of emotion, but advised against submitting to transitory feelings. It might seem odd to modern Western cultures that the Egyptians believed that the heart was the organ of thought. Yet Egyptian philosophers advised that the silent man who ignored his emotions and who thought before he acted was the ideal. The opposite of the silent man was the heated man, one who immediately submitted to his emotions without giving adequate thought to his actions. Much of Egyptian philosophy counseled against impulsive action without thought.

RELIGION. It is difficult to separate Egyptian philosophical ideas from religion. Maat stood at the center of all Egyptian life, including both philosophy and religion. Maat itself was a goddess and in some periods had a temple. Maat was also part of the god's food, a way of stating that all the gods' survival depended on maat's existence. Establishing maat also was essential to the world's creation by a god. When the god created order from chaos, the god established maat. In the same way, the king maintained maat in the world and thus kept chaos from overcoming the Egyptian way of life. Finally, individuals obeyed the king and thus established maat in the world. A person's success in life completely depended on following and creating maat. Thus religion, politics, and philosophical concerns were bound in an intricate web of concepts.

MISUNDERSTANDINGS. The ancient Greeks were the first people from a Western culture to write about the ancient Egyptians, beginning in the fifth century B.C.E. Greek perceptions of Egypt dominated Western understanding of the culture, especially before J.-F. Champollion deciphered hieroglyphs in 1822 C.E. Because the Egyptian pictoral language was unavailable to Western scholars for hundreds of years, Egyptologists were completely dependent on Greek and later Roman writers to form an opinion of Egyptian culture. Even after modern Egyptology allowed the ancient Egyptians to speak for themselves, Greek notions continued to influence modern perceptions of Egyptian philosophy. Nowhere is this more obvious than in modern approaches to Egyptian thought, science, and spirituality. Many mod-

ern people still credit the Egyptians with secret knowledge, both technical and spiritual. Many believe that the Egyptians perfected astrology and alchemy. These ideas stem directly from ancient Greek notions of Egyptian thought. The popularity and survival of such ideas into the twenty-first century C.E. is a testament to the power of Greek writing and its constant repetition. In fact, some Greek ideas have a basis in certain Egyptian traditions, but the interpretations of those traditions are purely Greek.

TOPICS
in Philosophy

MAAT

ORDER. The Egyptian philosophical view of existence was based on the idea that all existence was either orderly or chaotic. Order was called *maat* while chaos was called *isfet*. Maat encompassed the physical world, political conditions, and ethical conduct. In the physical world maat meant that the sun rose and set in a regular pattern. Maat also meant that the Nile flooded Egypt on a regular schedule and provided fertility to agricultural fields. In politics, maat meant that the true king sat on the throne and ensured order within Egypt. In Egyptian thought, maat depended on correct personal conduct. In fact correct personal conduct ensured loyalty to the king, which, in turn, supported an orderly physical world. For individuals, maat also meant telling the truth, and dealing fairly with others in addition to obedience to authority. Ultimately an individual who supported maat through his actions could enter the afterlife as a reward.

KING'S ROLE. The king's primary duty was to maintain maat in the world. If the king behaved correctly, the physical world behaved in a predictable way. This was important due to the Egyptians' dependence on crops and the food and clothing they provided. The king's conduct could affect the regular rising and setting of the sun, necessary for crop growth. The fertility of the soil was the result of the annual Nile flood that deposited rich new silt on Egypt's fields annually. The Egyptians believed that the height of the flood and the subsequent success of the crops depended on the king performing maat. The individual's primary duty was to obey the king. In fact obeying the king allowed him to perform maat, and thus maintain order in the physical world. This world view led to an extremely stable political structure.

RITUAL. In the New Kingdom (1539–1075 B.C.E.) kings performed the ritual of presenting maat to other gods as a means of stressing that they had maintained maat in their actions. Maat was personified as a seated goddess who wore a feather in her hair. A depiction of a feather was one way of writing the word "maat" in hieroglyphs. Hatshepsut (1478–1458 B.C.E.) was most likely the first ruler to depict herself presenting a statuette of maat to the gods. Large numbers of representations of the presentation of maat to the gods date to the reign of Akhenaten (1352–1336 B.C.E.) when it appeared to be the major ritual act that the king and the queen performed. During the Nineteenth and Twentieth Dynasties (1292–1075 B.C.E.), temples often displayed relief scenes showing the king offering maat to the gods. The priestess called the God's Wife of Amun performed this function in the Twenty-fifth and Twenty-sixth Dynasties (760–525 B.C.E.). The ritual served to legitimize kings in the eyes of the ruled. It was a physical expression of the king's obligation to uphold maat in the world.

ROYAL NAMES. Many kings took throne names that included maat or epithets, self-descriptions included with a name, that claimed they were possessors of maat. The earliest use of the epithet "possessor of maat" was most likely Sneferu of the Fourth Dynasty (r. 2625–2585 B.C.E.). In the New Kingdom Hatshepsut (1478–1458 B.C.E.) took the throne name Maat-ka-re, "the soul of Re is maat." Amenhotep III (1390–1352 B.C.E.) called himself Neb-maat-re, "Possessor of the maat of Re." Sety I (1290–1279 B.C.E.) took the throne name Men-maat-re, "the maat of Re is firm." All of these names are attempts to associate the king with maat. These kings also presented their own names to the gods as way of cementing the association between the king and maat.

THE DEITY. As a deity, Maat was the daughter of the sun god Re. She also constituted Re's eye, making her integral to the god's body. The other gods claimed to "live on Maat," meaning that they ate Maat to sustain themselves. Maat was thus a food offering for all of the gods. The scribal god Thoth was often paired with Maat, showing their close connection. Before the New Kingdom, there was no temple dedicated to the goddess Maat. The first known temple was in Karnak and was in use in Hatshepsut's time. In texts there are references to a temple of Maat in Memphis, Egypt's political capital, and in Deir el-Medina, the workman's village across the river from modern Luxor. Hatshepsut's coronation took place in the temple dedicated to Maat. In the late Twentieth Dynasty there is some evidence that criminal investigations took place at the temple of Maat. There is also some evidence that there were priests of Maat and

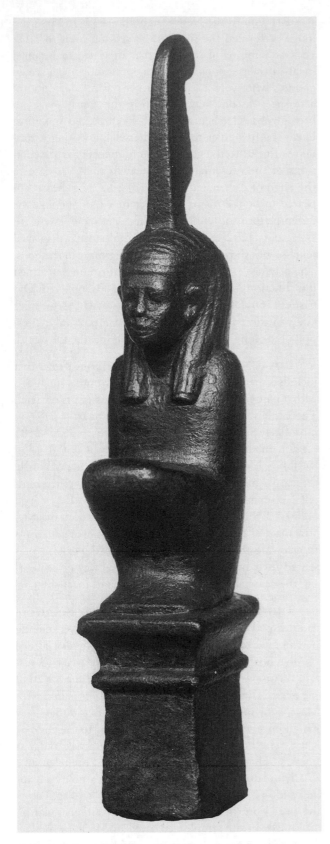

Small statuette of the goddess Maat, seated on a shrine.
**BROOKLYN MUSEUM OF ART, 37.561E, CHARLES EDWIN WILBOUR
FUND. REPRODUCED BY PERMISSION.**

an overseer of the domain of Maat. The existence of these officials suggests that the temple held land and other resources. There are few examples in art of Maat accepting offerings. This would be the usual Egyptian way of indicating that Maat's cult possessed resources on earth as did other gods.

LEGAL JUSTICE. Justice, a tenet of any philosophical system, was also part of the right order that maat guaranteed. The prime minister, whose job included dispensing justice, was a priest of Maat. The law code of King Horemheb (1319–1292 B.C.E.), inscribed on a stele standing in front of the tenth pylon at the Karnak Temple, ordained punishments in the name of Maat. Court decisions also found one party to be "the one who is performing maat," and therefore the innocent party. Maat also meant protecting the weak. Tomb autobiographies that describe the deceased's life as the pursuit of maat usually claim that he performed acts of charity for the impoverished, including distribution of food, drink, and clothing. Any official was expected to do justice by conforming to maat.

TEACHING MAAT. A written definition of maat in Egyptian texts has not survived. Yet surviving texts do describe the ideal life of living through maat in a series of texts scholars call instructions. Instructions exist from the Middle Kingdom (2008–1540 B.C.E.) through the Roman Period (332 B.C.E.–395 C.E.). The earlier texts stress guidelines for correct behavior in specific situations. They could include the proper way to behave on the street, in a public dispute, when appearing before a magistrate, as a houseguest, or as the head of a household. Maat also dictated proper relations with a wife, superiors, friends, and servants. In instructions formulated for princes, political advice also took the form of how to conform to maat. The Egyptians typically concentrated on specific situations rather than formulating broader guidelines.

ACTIVE PURSUIT. Though obeying authority was integral to maat, not all forms of maat were passive. The instructions recognize that individuals must pursue maat actively. Otherwise the forces of chaos could overwhelm the world. Chaos, according to the pessimistic literature written following the First Intermediate Period (2130–2008 B.C.E.), had temporarily triumphed between the Old and Middle Kingdoms when there was no strong central government. Only with active effort can chaos be contained according to these texts.

DOUBT. In the Nineteenth and Twentieth Dynasties (1292–1075 B.C.E.) some writers doubted whether humans had any control over maat. In the *Instruction of*

Any, the author linked maat with the god's capricious will. The *Teachings of Amenemope* calls maat the god's burden. Amenemope suggests that the gods give maat without any clear explanation of why some receive it and others do not. Yet even these two authors stress that humans must try to follow maat.

MAAT AND AFTERLIFE. If an individual lived according to maat, access to the afterlife was assured. In *Coffin Texts* Spell 816, a ritual for ensuring entry to the next life utilizes the power of maat. Maat also is integral to *Book of the Dead* Chapter 125. In this chapter the deceased describes in detail the actions he took and avoided in order to comply with maat. The illustrations for this chapter include weighing the deceased's heart against the symbol of maat. If the two are in balance, the deceased is able to enter the afterlife. Maat also played a role in uniting the deceased with the sun god Re, another goal for all Egyptians. Many hymns recorded in New Kingdom tombs stress the association of maat and Re. The Egyptians ultimately associated maat with the cemetery itself. It came to be called the "Place of Maat."

SOURCES

Erik Hornung, *Idea Into Image* (New York: Timkin, 1992): 131–146.

Emily Teeter, *The Presentation of Maat: Ritual and Legitimacy in Ancient Egypt* (Chicago, Ill.: Oriental Institute of the University of Chicago, 1997).

SEE ALSO *Literature: The Literature of Moral Values; Religion: The King*

COSMOGONY: THE ORIGIN OF THE WORLD

SEP TEPI. Much of philosophy as well as religion focuses on theories of creation. Egyptians described the world's origin with the phrase, *sep tepi* ("the first time"). This phrase suggests that creation was not a single isolated event. Instead they saw it as an event that was endlessly repeated, though it had had one original enactment. The Egyptologist Erik Hornung suggested that this vision of creation allowed the Egyptians to conceive the world as repeatedly new and that this was a source of their personal creativity.

ACCOUNTS. In the early periods of their history, the Egyptians did not write one connected account that described creation. At the end of their history, in the Ptolemaic and Roman periods (332 B.C.E.–395 C.E.),

some accounts were carved on the walls of temples. In the Pharaonic period (3000–332 B.C.E.), the Egyptians left only isolated statements and allusions to a creation myth. Many of these allusions speak of the separation of the earth and sky as the primal event that occurred in sep tepi. But the Egyptians had more than one explanation for how the earth came to be. In one version the god Atum used his own seed to create the world. In a second account, the god Ptah used speech to create everything.

BEFORE CREATION. The Egyptians conceived of a time before creation. According to allusions in the *Pyramid Texts*, the funeral ritual carved inside late Fifth- and in Sixth-dynasty royal pyramids (2371–2194 B.C.E.), before creation all was a watery darkness. The blend of darkness and water was the essence of the unformed, chaotic state before creation. It was also the opposite of creation, distinguishing the previous times through the lack of the things that now exist. The period before creation was defined by its lack of gods, people, heaven, earth, day, and night. There was neither life nor death. When the *Pyramid Texts* state that even strife did not yet exist, it refers to the on-going mythical battle between the legitimate heir to the throne, Horus, and his evil uncle, Seth.

EMERGENCE. Somehow from the watery darkness, a hill of mud emerged. This hill provided a resting place for the creator. The Egyptians based this hill on the reality of the way that the earth emerged from the annual flood. Firm ground separated from the watery mass and created a place where the god could work. Here the god separated into four pairs of divinities including primeval flood, the hidden ones, endlessness, and the undifferentiated ones. The sun then emerged from these beings. The first sunrise signaled the beginning of creation. Many Egyptian symbols refer to this emergence on a hill. The pyramid shape is a model of the hill but also points toward the sun. The lotus blossom that floats on the water comes to symbolize the birth of the sun god. A cow goddess can also emerge from the water with the sun between her horns. The best-known form of this goddess is Hathor. All these symbols were another way for the Egyptians to state that emergence was the beginning of creation.

CREATOR GODS. The creator god took numerous forms. It could assume the form of a bird, a human, or a snake. The god could be a *benu*-bird, a heron sometimes associated with the Greek phoenix. This bird's shriek signaled that the sun would hatch from an egg the bird had laid. The bird was also the first living creator to alight on the mound that emerged after the dark

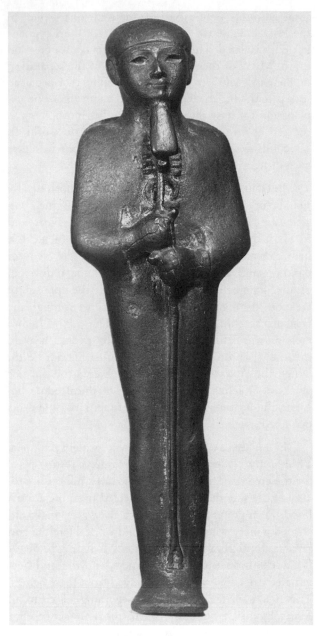

Standing mummiform statuette of Ptah. BROOKLYN MUSEUM OF ART, 08.480.25, CHARLES EDWIN WILBOUR FUND. REPRODUCED BY PERMISSION.

water subsided. In human form the creator was Atum, Ptah, Re, Neith, or Khnum. Atum's name means "undifferentiated." There are several versions of how Atum created the world, but all deal with a body fluid he emitted in order to create. He would either spit, cough, or masturbate to produce seed. From Atum's moisture the first sexually differentiated couple, a divine pair called Shu and Tefnut, came into being. They are unique in not being the offspring of a couple. The *Coffin Texts* affirm that Shu was not formed in an egg, like other be-

ings. The first couple created through sexual procreation were Geb and Nut, the son and daughter of Shu and Tefnut. The following generations included the gods Osiris, Isis, Seth, and Nephthys. This group of nine deities formed the Ennead of the city of Heliopolis. Ptah, also known as Ptah-Tatenen, was the local god of Memphis. Ptah used language to create. First he thought of what the world should be, then said it out loud in order to create it. The text called the Memphite Theology—dating roughly to 716–702 B.C.E., though scholars once thought it had been copied from an Old Kingdom (2625–2170 B.C.E.) text—describes the process. The sun god Re was also a creator. In the *Pyramid Texts*, the sun god creates through planning and speech as did Ptah. However, he adds the concept of magic power to animate his planning and speech. The texts describe Re's relationship with these three powers by saying that they travel in his boat with him. The goddess Neith created the world through seven statements. These statements were later called the seven-fold laugh of the creator god. Neith's connection to creation seems to come from her relationship to a cow goddess called Mehetweret. This cow emerged from the watery darkness with the sun lodged between her horns. The Egyptians also associated this cow with the goddess Hathor. Finally, Neith could be a scarab beetle, another source of creation. Later the Egyptians identified the scarab with Khepri, a form of the morning sun. Neith thus lost her primary connection with creation through the increased importance of Hathor and Khepri in the later periods. Yet it appears that early in Egyptian thought, she was an important figure in creation of the world. Khnum was a ram-headed god worshipped at temples in Esna and in Elephantine, both in Upper (southern) Egypt. As a creator, Khnum worked with his hands to create mankind, the primal egg from which the sun hatched, and the earth itself. He fashioned all of these things on a potter's wheel. In some versions, Ptah performed these same tasks on a potter's wheel after he had planned and spoken creation.

UNIFIED SYSTEM. For many years Egyptologists have tried to organize all of this information about creation into a coherent whole. They have suggested that certain traditions were local and believed only at certain temples. They have tried to organize these stories chronologically, seeing some as more primitive than others and proposing that the sophisticated versions evolved from the primitive stories. The Egyptologist Erik Hornung suggested, on the contrary, that the Egyptians saw each of these stories as mutually re-enforcing, adding detail and complexity rather than contradicting each other. No story was dogma that excluded the possibilities of an-

other story. Yet he has identified certain common themes found in all the stories.

THEMES. The creator gods all share certain characteristics that are themes of the story. All the creators are self-created and pre-date sexual differentiation. All the creators were what the Egyptians called, *kheper djesef,* "what came to exist by itself." A hymn to the god Amun suggests a male creator "formed his egg himself." These creators acted as both father and mother in the process of self-producing. But Hornung stressed that this individual was able to reproduce so that many now exist. The important point is that one became many. The *Coffin Texts* refer to Atum and the time when "he gave birth to Shu and Tefnut in Heliopolis, when he was one and became three." Diversity, in other words, grows out of a unity. In a New Kingdom hymn, Atum is "the one who begat his begetter, who engendered his mother, who created his own hand." Here both of the prime characteristics of the creator are in evidence. The creator is an individual who creates the many alone.

IMAGE. The Egyptian image that summarizes the story of creation also makes clear that the Egyptians saw creation as a movement from the one to the many. In the Egyptian language, a distinction was made among singular (one), dual (two), and plural (three or more). Thus three represents the many. In the images of the separation of earth and sky, three gods are pictured. The sky goddess Nut hovers above the earth god Geb. Between them, separating earth and sky is Shu, the god of air. Thus, once the primal unity separates, it becomes three, the symbol for many.

CREATING HUMANS. In many creation stories, the creator made humans from tears. The initial relationship between divine tears and humans is in the sound of the words that describe them. Tears in Egyptian are *remy.* People in Egyptian are *remetj.* Thus the connection is based on a pun. But Erik Hornung believed the connection is even deeper than the word play. He suggested that humanity sprang from a blurring of the god's vision. The *Coffin Texts* suggest that "humans belong to the blindness behind" the creator god.

EARLIEST WORLD. In the earliest world, according to Egyptian belief, the sun god Re served as king. When Re was king, the sun never set and people had access to the sun at all times. The fact that there was no night meant that there was no death. The Egyptians thought people lost this perfect sun-filled world through the aging process. In the *Book of the Celestial Cow,* the author explains that the youthful freshness of the world eventually faded. The sun god himself grew old. As he aged,

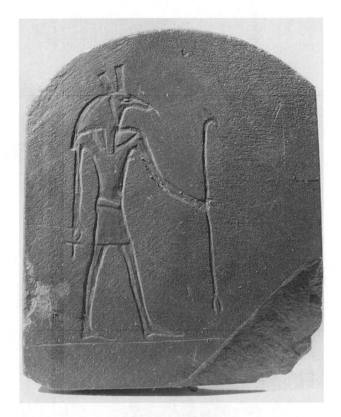

Stela with image of Seth. BROOKLYN MUSEUM OF ART, 16.580.187, GIFT OF EVANGELINE WILBOUR BLASHFIELD, THEODORA WILBOUR, AND VICTOR WILBOUR HONORING THE WISHES OF THEIR MOTHER, CHARLOTTE BEEBE WILBOUR AS A MEMORIAL TO THEIR FATHER, CHARLES EDWIN WILBOUR. REPRODUCED BY PERMISSION.

the sun god's power began to fail and he lost control. As control waned, forces of opposition challenged the sun god. Humans devised attacks against Re and thus they were punished. At first Re sent his eye, a ball of fire, to destroy mankind. In the end Re allowed a remnant of people to live. However, Re also retreated from the world riding on the celestial cow and forced people to live in a much less ideal world. For one thing, it was now dark. When humans tried to survive in the dark, they turned against each other. This strife among humans caused the other gods to retreat from the earth. Osiris took charge of the new land of the dead, which was lit during the nighttime hours by the sun. On earth war and violence become part of humanity's fate. Only in death could people regain the perfect world in the presence of the gods. This early myth of the god Re gave the Egyptians the philosophical idea of renewal. Renewal was only possible through the cycling of the sun. Thus every sunrise represented a new creation and renewal of the earth. Every sunset represented the death of the day. Sunrise was a time for rejoicing. Sunset suggested that though the sun disappeared into the land of the dead, it would

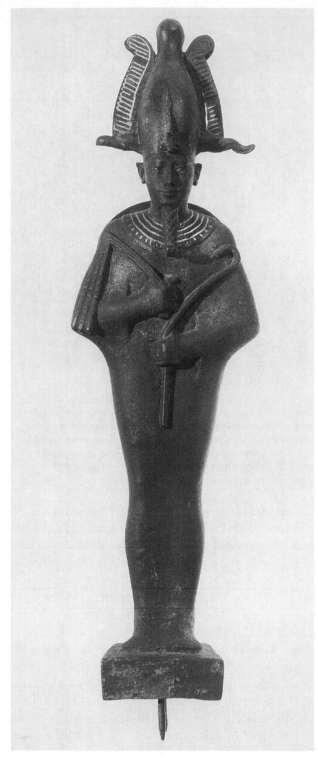

Standing mummiform statuette of Osiris. BROOKLYN MUSEUM OF ART, 08.480.27, CHARLES EDWIN WILBOUR FUND. REPRODUCED BY PERMISSION.

return and recreate the world anew the next day. This is similar in many ways to later philosophical ideas of redemption and reconciliation.

RETURN TO ONE. The Egyptians feared the possibility that the world would return to one watery darkness. The *Book of the Celestial Cow* details the efforts of man and god to keep the sky from collapsing into the earth. If the sky and earth reunited, the original watery darkness would be restored. Chaos would then rule, and human life would be impossible. Yet the Egyptians believed that eventually the world would end and the watery darkness would return. In the Egyptian end of time, a snake will emerge when the sky collapses into the earth and recreates watery darkness. The snake will return to the chaos where he originated. Though Egyptian expressions of belief in the end of time are rare, they give symmetry to Egyptian beliefs about the beginning. Thus Egyptian ideas of creation falls naturally into a series of cycles. Though creation's "first time" was an important, pristine event, the Egyptians believed that creation would repeat infinitely, making it possible to have an endless cycle of rebirth and death.

SOURCES

James P. Allen, *Genesis in Egypt: The Philosophy of Ancient Egyptian Creation Accounts* (New Haven, Conn.: Yale Egyptological Seminar, 1988).

Erik Hornung, *Idea Into Image* (New York: Timken, 1992): 39–56.

J. Martin Plumly, *The Cosmology of Ancient Egypt* (London: Geo. Allen, & Unwin, 1975).

SEE ALSO *Religion: Egyptian Myths*

TEACHING PHILOSOPHY

TYPES OF TEXT. Egyptologists have identified ancient texts that teach the Egyptian idea of philosophy. These texts divide into more than one ancient literary type. Many of them are instructions, identified in Egyptian with the word *seboyet*. But other texts that discuss philosophy include complaints, prophecies, and testaments. Some scholars refer to these texts as a group as "didactic literature," the literature the Egyptians used to teach philosophy. Many of the texts identified as didactic literature combine more than one literary type within them. *The Eloquent Peasant*, for example, begins as the story of a farmer bringing his crops to market. He encounters a corrupt official who attempts to rob the farmer. The majority of the text is a series of orations on the nature of *maat* ("right conduct"). These orations amount to a treatise on the nature of maat. The narrative or frame story enhances the treatise by giving a concrete example of what happens when maat is ignored.

Both the frame and the treatise mutually reinforce each other and thus the reader learns more about the nature of maat. Additionally, the orations themselves amount to an example of Egyptian rhetoric.

AUTHORS. Teachings are the only Egyptian literary category that regularly names the author. The named author might not actually be the person who wrote the text, however. For example, the text attributed to Ptahhotep of the Fifth Dynasty (2500–2350 B.C.E.) was likely written in the Twelfth Dynasty (1938–1759 B.C.E.). Yet copies of teachings, no matter when they were written or re-copied, maintain a connection with an author. By the New Kingdom (1539–1075 B.C.E.), authors associated with teachings were the classic writers. Men whose names were attached to teachings such as Ptahhotep, Hordjedef, Khety, Ipuwer, and Neferty were named in a New Kingdom document as immortals. The New Kingdom text claims that their writings are better guarantees of immortality than their tombs.

RIGHT ORDER. The central subject of all the didactic literature is the nature of maat. The teachings describe specific cases that allow a person to live according to maat. The complaints and prophecies describe the world that lacks maat. The absence of maat is the central cause of disorder, injustice, and social ruin. The farmer in *The Eloquent Peasant* compares his own situation with the presence and absence of maat. Royal teachings, written for princes, also discuss the political implications of adhering to maat.

FRAME STORIES. Most of the teachings have frame stories. These stories introduce the dramatic situation where usually a father speaks to his son or all his children so that he can explain the nature of maat. Often the father is an old and famous person who has reached the end of his career. He clearly states that he wants to share the knowledge he has gained in the course of a long life. In *The Teachings of Ptahhotep* the speaker is the prime minister of King Djedkare Isesy (2415–2371 B.C.E.), though the text was probably actually composed by someone else nearly 500 years later. In the frame story, Ptahhotep asks the king's permission to share his knowledge. The king's agreement indicated to an ancient Egyptian that the knowledge and philosophy contained in the text was important and should be shared with the sons of all officials. Many other teachings specifically describe the speaker talking to his own son or children.

WISE MEN. The frame stories help scholars determine who could be a wise man or philosopher in Egyptian thought. Ptahhotep was a prime minister, the highest political office available to a commoner. A New Kingdom

instruction names Amenemope, who held a title placing him in charge of agriculture for all Egypt. Thus he was also a very high official. Much of his advice centers on agriculture. These men derive their authority from success in their careers. They also speak about the way to gain success in public life. Their concerns include the proper way to debate and how to behave at important social events. They enumerate different ways of pleasing a superior and generally how to get ahead in life. But other texts name only "a man" as the speaker. In this case where the father may not have been as great a success as Ptahhotep or Amenemope, he tells his son that loyalty to the king is the best way to advance in life.

DEVELOPMENT. The earlier texts such as *Ptahhotep* speak mostly of practical tips for advancement and equate these tips with maat. The *Teachings of Amenemope*, which dates to the New Kingdom, additionally includes many examples of moral behavior. Yet it is not clear that this change in subject matter is a true example of development. So few texts have been preserved from antiquity that it is not fair to say that the moral dimension was lacking in the earlier period. Perhaps texts similar to *Amenemope* existed in the earlier period but have not survived. Yet it is clear that *Amenemope* includes virtues not discussed by Ptahhotep. It integrates wider human experience into the text and promotes a way of life rather than just isolated behaviors.

IDEAL MAN. Much of the didactic literature describes an ideal man that the Egyptians called the *ger* ("silent man"). The opposite type was the *shemem* ("heated man"). The silent man is not only silent, however. His silence comes when he thinks before he reacts. He is thoughtful, temperate, and judicious. He reflects before answering a "heated man," a man ruled by his emotions. The contrast between the silent man and the heated man is most fully developed in *Amenemope*. The silent man is truthful, honest, straightforward, open, respectful, circumspect, diligent, generous, caring, and sympathetic. Amenemope compares him to a tree growing in the sunlight that flourishes in the garden. He contrasts this tree with the heated man, a tree planted in dark. Without sunlight, he withers and dies. The gardeners remove him and burn him on the rubbish heap. Here it is clear that the silent man earns eternal life for his virtues, while the heated man cannot achieve the afterlife.

THE TEACHINGS OF PTAHHOTEP. The didactic literature includes a wide variety of texts, though the majority of them are teachings. *The Teachings of Ptahhotep* is the most complete of any ancient Egyptian philosophical

teaching. Thus it is the standard of comparison. The frame story depicts the prime minister, Ptahhotep, requesting and receiving the king's permission to share his wisdom. In the course of the request Ptahhotep speaks of old age and its frailties. But attaining old age also allows Ptahhotep to attain wisdom. He then states 37 maxims that summarize his understanding of maat. He stresses the proper conduct needed for success. He also enumerates the qualities a successful man needs: honesty, judiciousness, respect for superiors, and moderation. Then Ptahhotep speaks of the good son, one who is obedient. His obedience leads him to imitate his father and eventually become a wise man himself.

TEACHINGS OF ANY. Any's teachings date to either the Eighteenth or Nineteenth Dynasty. Any's title is not included in the text and he concentrates more on personal life than official life. He gives his son, Khonshotep, advice on marriage, managing a household, and living a virtuous life. In an unusual twist, Khonshotep answers his father at the end of the text and suggests he might not be able to reach his father's high standards.

THE TEACHINGS OF AMENEMOPE. In his teachings, Amenemope identifies himself as a high official of the department of agriculture. He addresses his words to his youngest son Horem-maakheru. Amenemope grounds his description of living a life according to maat in religious belief, making his reasoning seem familiar to modern readers. He emphasizes that his son should follow the "way of truth" as he pursues his career. He also closely examines the differences between the "silent man" and the "heated man," or the controlled man versus the emotional man.

THE TEACHINGS FOR MERYKARE. Merykare was a king of the Tenth Dynasty (2130–1980 B.C.E.) and his teaching is set in his father's reign in the town of Herakleopolis where the family lived. This family was a major opponent of the Theban family that eventually reunited Egypt during the Eleventh Dynasty (2008 and 1980 B.C.E.). Surprisingly, the text was recopied during the New Kingdom when another Theban family ruled Egypt after reuniting and establishing a central government. Only the New Kingdom copies of the text remain. The text includes advice on good government, historical speculation, and a testament where the king describes his own life to his son. It ends with a hymn to the creator god Atum. It is unclear whether this text is truly useful for constructing a history and philosophy of the Tenth Dynasty. It is also unclear why later Egyptians took an interest in Merykare's father's advice.

THE TEACHINGS OF AMENEMHET. The narrator of *The Teachings of Amenemhet* is Amenemhet I (1938–1909 B.C.E.). Yet he speaks after his own death to his son Senwosret I (1919–1875 B.C.E.). Amenemhet gives Senwosret advice on ruling Egypt, especially in view of his own difficulties. Amenemhet was assassinated, probably by his own courtiers. Amenemhet tells Senwosret not to trust anyone. He also justifies his own policies. In the end Amenemhet reassures Senwosret that his spirit will help his son rule.

THE TEACHINGS OF SEHETEPIBRE. *The Teachings of Sehetepibre* survives in several versions from the Twelfth and Eighteenth Dynasties. As a whole it is also known as the *Loyalist Teachings*, though one early stele names the speaker as Sehetepibre. The narrator tells his children to be loyal to the king and heaps praises upon him. The second part provides advice on managing servants. Together, the two parts of the text discuss giving and receiving loyalty.

THE TEACHINGS OF KHETY. From the Eighteenth Dynasty, *The Teachings of Khety* is a defense of education narrated by Khety for the benefit of his son Pepi. Khety describes the occupations that people without education perform and stresses their discomforts. He contrasts the fate of the uneducated with scribes who have an education. The scribe, Khety points out to Pepi, is everyone's boss. Thus, Pepi should study hard at scribe school, be a success, and follow the wisdom of the ancestors.

THE ADMONITIONS OF IPUWER. *The Admonitions of Ipuwer* laments the chaos the narrator sees around him. The setting is most likely the First Intermediate Period (2130–2008 B.C.E.), though most modern commentators believe the author composed it in the Twelfth Dynasty (1939–1759 B.C.E.). Ipuwer speaks at length of chaotic social conditions, especially that the formerly poor have replaced the rich in power. Since the text lacks both a beginning and an ending, it is difficult to know Ipuwer's predictions or conclusions.

THE ELOQUENT PEASANT. *The Eloquent Peasant* tells a story but also contains a treatise on the nature of maat. The story concerns the unjust arrest of a farmer traveling to market with his goods. The evil official who arrests him for trespassing allows the farmer to appear in court nine times to defend himself. The nine orations that the farmer makes are eloquent discussions of the nature of maat. They are both rhetorically complex and elegant in their language. In the end, the king rewards the farmer for his eloquence with full restitution of his goods.

THE COMPLAINTS OF KHAKHEPERRE-SONB. The narrator of *The Complaints of Khakheperre-sonb* finds social conditions intolerable. Yet he spends nearly half

the text describing his efforts to find adequate language to describe this low point in history. Oddly, the text was composed in the Twelfth Dynasty, a period of social stability. The only copy dates to Dynasty 18, another period of relative stability. Perhaps this text constitutes criticism of the current regime, though it is not specific enough to have meaning for the modern reader. It fits well in the Egyptian tradition of laments for the lack of order.

THE DIALOGUE OF A MAN WITH HIS BA. *The Dialogue of a Man with His Ba* is a discussion between a man and his own soul. The man argues that life is not worth living and that traditional funeral rites are useless. His soul responds that people must live their whole natural lives and that following his death he will reap his reward. The end of the text is not preserved, so it is unclear how the discussion ends.

THE PROPHECY OF NEFERTY. In *The Prophecy of Neferty*, the prophet Neferty describes to the Fourth-dynasty king Sneferu (2625–2585 B.C.E.) the horrors of the First Intermediate Period (2130–2008 B.C.E.). Neferty also knows that these horrors will end with the appearance of Amenemhet I (1938–1909 B.C.E.). Thus most scholars believe the text was composed in Amenemhet's reign. The discussion of disorder argues that the lack of maat is the cause of social chaos. When the proper king arises, maat is automatically restored.

FRAGMENTED TEACHINGS. Several other teachings exist in fragments. One such fragment is *The Teachings of Hordjedef*, referred to by one New Kingdom text as a classic. Not enough of the text survives to translate its maxims, although a surviving frame story places the action in the Fourth Dynasty (2625–2500 B.C.E.). Another work known principally by its frame story rather than by its maxims is *The Teachings of Kagemni*. Only the conclusion survives, but the frame story places it in the reigns of Huni (Third Dynasty, before 2625 B.C.E.) and Sneferu (2625–2585 B.C.E.) though this is the setting and not the time of composition. While less is known regarding the speaker, setting, or time period, *The Teachings of a Man for his Son* is written in the language of the Middle Kingdom and includes maxims typical of the teachings and statements about loyalty to the king.

CONFIDENCE. The large number of texts that discuss maat and promote ways of recognizing it attest to Egyptian confidence that the young can learn maat and the philosophies behind it. Tremendous effort was expended to define, teach, and propagate this core value in Egyptian life.

a PRIMARY SOURCE *document*

THE MEANING OF MAAT

INTRODUCTION: In *The Eloquent Peasant*, a corrupt official frames a farmer passing through his territory and seizes his goods. The farmer appears in court nine times to demand his property. His orations amount to a treatise on the meaning of *maat*, the Egyptian concept of right conduct. In the sixth oration, the farmer equates right conduct with truth, with reducing evil in the world, and with finding the right balance.

Now this farmer came to petition a sixth time saying,
 "Oh Overseer, my lord."
The one who lessens falsehood creates truth.
The one who creates the good, reduces evil.
As surfeit's coming removes hunger,
Clothing removes nakedness.
As the sky is calm after a storm,
Warming all who shiver;
As a fire cooks that which is raw,
As water satisfies thirst.
Now look.
The judge is a robber,
The one who makes peace makes grief.
He who should soothe makes sore.
However, the cheater reduces justice.
Justice rightly filled neither is too little or too much.

SOURCE: Friedrich Vogelsang and Alan Gardiner, *Die Klagen des Bauren* (Leipzig, Germany: J. C. Hinrich, 1908). Translated by Edward Bleiberg.

SOURCES

Jan Assmann, *Ma-at: Gerechtigkeit und Unsterblichkeit im Alten Ägypten* (Munich, Germany: Beck, 1990).

Miriam Lichtheim, *Late Egyptian Wisdom Literature in the International Context* (Göttingen, Germany: Vandenhoeck & Ruprecht, 1983).

SEE ALSO *Literature: The Egyptian Literary Canon*

SECRET KNOWLEDGE

GREEK BELIEFS. Ancient Egypt's neighbors in Greece wrote of their belief that Egyptian priests and magicians possessed secret knowledge. Greek belief in Egyptian secret knowledge is one strand of Greek philosophy that contributed to the modern belief that the Egyptians perfected mysticism, astrology, and magic.

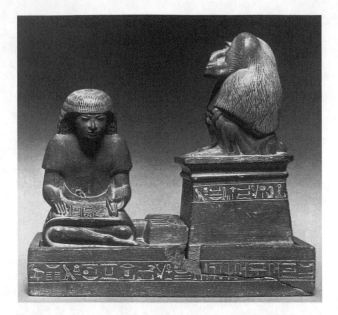

The Egyptian god Thoth in the form of a baboon, protecting a royal scribe. THE GRANGER COLLECTION, NEW YORK.

Because of this Greek belief, a wide variety of modern truth seekers have looked to the Egyptians for inspiration. They include the freemasons, Rosicrucians, theosophists, anthroposophists, and Afrocentrists. These groups share a belief that the Egyptians both created the first civilization and that their knowledge has only recently been rediscovered by modern science. Many of these modern groups also believe that Egyptian spiritual knowledge far exceeded the knowledge that can be gleaned from the surface of hieroglyphic texts. Though most nineteenth and twentieth century C.E. Egyptologists rejected this approach to Egyptian culture, a scientific, rationalist, and text-based study of Egyptian spiritualism has recently added Egyptological knowledge to the mix of data on Egyptian secret knowledge. The Egyptologists Jan Assmann and Erik Hornung made important contributions to this debate, finding the roots of the idea of secret knowledge in Egyptian society itself.

THOTH. In the Old Kingdom (2675–2170 B.C.E.) the Egyptians regarded the god Thoth as a violent deity who helped the king defeat enemies. But in the Middle Kingdom (2008–1630 B.C.E.) the Egyptians identified Thoth as the author of *The Book of the Two Ways*, a text that described the afterlife. All preserved copies of this text come from the town of Hermopolis in central Egypt. There the local deity was Thoth and thus he received credit for this first statement of knowledge of the next life. The *Coffin Texts*—spells inscribed on Middle Kingdom coffins—refer to the "divine books of Thoth" and to this god as the "lord of wisdom." In the New King-

dom (1539–1075 B.C.E.) Thoth continued to develop as a god of culture and invention. The Egyptians regarded Thoth as the author of many sacred writings. In the *Book of the Dead*—spells meant to guide the deceased to the next life—the deceased identified himself with Thoth and claimed that knowledge justified his entrance to the afterlife. Thoth was regularly the other gods' scribe, responsible for divine documents, letters, and decrees. The Egyptians now described Thoth as "lord of divine words," that is, the hieroglyphic writing system. Thoth became responsible for regulating the calendar and measuring time. At the judgment of the dead, Thoth recorded the final verdict for each individual. In general, Thoth was increasingly viewed as the god who controlled knowledge and the recording of knowledge, and hence was also the ruler of philosophy.

THOTH AND AKHENATEN. Though King Akhenaten (1352–1336 B.C.E.) banned the worship of all gods except for Aten, the disc of the sun, his new capital at Amarna was located in Thoth's home province. Perhaps for that reason, a statue now excavated in Amarna shows a scribe sitting at Thoth's feet recording his wisdom. The

EGYPTIAN Magic

The story of Setne Khamwas was written in the Ptolemaic Period (332–30 B.C.E.). It tells the story of the struggle between Setne Khamwas and the magician Naneferkaptah for possession of a book of magic written by the god Thoth. Naneferkaptah had taken the book with him to his grave. Setne Khamwas then stole it from the tomb. This story and perhaps others like it no longer preserved possibly shaped the Greek view of the Egyptians as great magicians. The story stresses that mankind has access to magic, but only the gods know the ultimate secrets of life. When Setne attempts to learn through magic more details about the afterlife than should be available to people on earth, his children die. The gods punish him for trying to know too much. Because Setne was exploring a book said to be written by Thoth, it connects with Greek ideas that Egyptian magic stems from the god they believed was Thoth's equivalent in their own culture, Hermes Trismegistus. Greek writers regularly misinterpreted Egyptian stories to create a philosophy called Hermeticism that they believed was Egyptian, but in fact was a Greek misinterpretation of Egyptian culture.

artist who created the famous bust of Nefertiti also found at Amarna was named Thutmose, "Thoth is born." This name had been common earlier in the Eighteenth Dynasty, but it is striking that the name was tolerated at Amarna. Perhaps this indicates that even in Amarna, Thoth's connection to wisdom and philosophy was recognized.

THOTH AFTER AMARNA. Immediately after the Amarna Period with the restoration of the old gods, Thoth assumed an important place. King Horemheb (1319–1292 B.C.E.) recorded a *Hymn to Thoth* that called the god "one who knows the mysteries" and gave him responsibility for informing the sun god of all that occurred on earth. King Ramesses IV spoke in an inscription of his ability to read the writings of Thoth and that he learned about Osiris from Thoth's books located in the temple library. Thoth thus continued to grow in his role as the source of knowledge and philosophy.

THOTH IN THE LATE PERIOD. In the Late Period (664–332 B.C.E.), Thoth became the god responsible for magic. Thoth helped deceased people enter the next world by writing letters of recommendation for them. According to Late Period belief, Thoth also wrote a new guide to the land of the dead called *The Book of Breathings* with the help of the goddess Isis. Thoth's stature continued to grow with a new epithet, "twice great," first known from the reign of King Apries (589–570 B.C.E.). By the time of Darius I (521–486 B.C.E.), Thoth's epithet increased his greatness to "very, very, very great." The Greeks later identified Thoth with their own god, Hermes, whom they gave the epithet "Trismegistus" or "thrice great." In Greek belief, Hermes Trismegistus was a major source of ancient Egyptian secret knowledge. It seems likely that at least the tradition of Thoth as the keeper of secret knowledge had Egyptian roots in the Late Period.

HIEROGLYPHS. The Egyptians believed that Thoth invented hieroglyphic writing. The nature of Egyptian picture writing also played a role in Greek beliefs about the supposed secret knowledge and philosophy contained in these writings. Hieroglyphic writing was basically phonetic with each picture standing for a sound or group of sounds. Yet the final picture in each word had no sound but rather stood for a category. For example, the picture of walking legs at the end of the phonetic writing for the verb "to go" placed it in the category "verbs of motion." Thus on one level these signs, called determinatives, could bear a symbolic meaning. Some signs such as a billowing sail for "breath" or "air," a flamingo for "red," a taut bow string for "strong," and an egg for "within" thus leant themselves to extended symbolic meanings.

HERMES Trismegistus

The Greek historian Herodotus first identified the Greek god Hermes with the Egyptian god Thoth. Thoth was the god responsible for writing, knowledge, and the calendar. By the Egyptian Late Period (664–332 B.C.E.), Thoth was already called "very, very, very great." In Greek he therefore came to be known as Hermes Trismegistus—Thrice Great Hermes.

A large group of texts were attributed to Hermes Trismegistus. These writings came to be known as Hermeticism. There remains much debate about how many of these texts are actually ancient. Many of them may well be fifteenth-century forgeries. Others may date to the fifth century C.E. They include descriptions of astrology, magic, and various myths of the origins of the world. Hermeticism is a major source for various spiritual interpretations of ancient Egyptian philosophy. Hermeticism is based on the writings of the Greek philosopher Plato. Hermeticism develops arguments about the beginnings of the world based on allegory rather than on direct observation of the world. Explanations are based on spiritual similarities rather than physical characteristics.

SCRIBE'S PUZZLES. Beginning in the New Kingdom, scribes invented scholarly puzzles with hieroglyphs as a form of intellectual entertainment. They used whole pictures with new phonetic values that would amaze other scribes by their creativity. A picture of jackals towing the god's boat in the tomb of Ramesses IX (1126–1108 B.C.E.) substitutes for the old and simple phonetic writing of the verb "to tow." Or the verb "to vanquish" which could easily be written and recognized with a phonetic writing, instead was written with a king smiting the heads of foreign enemies. These intellectual games became increasingly popular in the Ptolemaic Period (332–30 B.C.E.) when Greek-speaking kings ruled Egypt. At the temple in the town of Esna in Upper (southern) Egypt, a scribe wrote a hymn to Khnum, a ram god, writing only ram signs that could each be read with a different phonetic value and thus could represent different words. Another hymn was written entirely with crocodile signs that had seven different phonetic values. At this temple, there were 143 different ways of writing the god Khnum's name. The name of the god Osiris could be written 73 different ways. These games then led

Arts and Humanities Through the Eras: Ancient Egypt (2675 B.C.E.–332 B.C.E.)

195

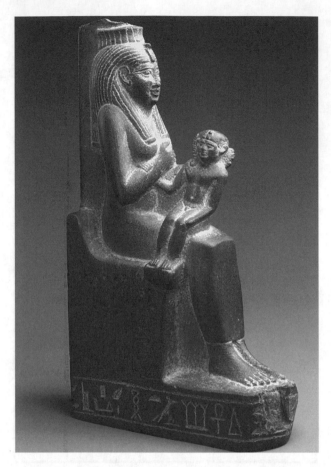

Statue of Isis holding the child Horus. BROOKLYN MUSEUM OF
ART, 37.938E, CHARLES EDWIN WILBOUR FUND. REPRODUCED BY
PERMISSION.

to the Greek belief that hieroglyphs were only to be in-
terpreted symbolically rather than phonetically.

HIEROGLYPHIC SYMBOLS. By the fifth century
C.E. the Egyptians had stopped writing hieroglyphic
inscriptions. But the Greek writer Horapollo, who lived
in Egypt, wrote a book called *The Hieroglyphs* that at-
tempted to explain the symbolic meanings of Egyptian
writing. Even when Horapollo knew the correct pho-
netic reading of a hieroglyph, he gave a symbolic expla-
nation for it. For example, the picture of the Egyptian
hare has the meaning "to open" because the Egyptian
word for "hare" and the Egyptian word for "to open"
share the same consonants. But Horapollo had a dif-
ferent explanation. He claimed that the Egyptians wrote
the verb "to open" with a hare because hares sleep with
their eyes open. He also claimed that the vulture repre-
sents the word "mother" in hieroglyphs because there
are no male vultures. Egyptologists understand that the
word for vulture and the word for mother shared the
same consonants. Thus Horapollo set the stage for

Greek and later Roman authors to apply a completely
symbolic approach to reading hieroglyphs. And this
symbolic approach supported the idea that hieroglyphs
contained mystical knowledge and philosophical secrets
rather than being an ordinary symbol system for repre-
senting language. Horapollo eliminated the boundary
between hieroglyph and symbol. This boundary was not
restored until the nineteenth century C.E. when J.-F.
Champollion read the Rosetta Stone and deciphered
hieroglyphs for the first time in modern history.

CULTS. In ancient Greek cults, initiation was the
norm. Initiation consisted of secret rites, ceremonies,
ordeals, or instructions used to allow a member to enter
a sect or secret society, usually one that held a certain
philosophy about Egyptian life and the gods. The Greeks
assumed that Egyptian cults also had initiation. The
mysteries of Osiris of Abydos are the most frequently
cited example of initiation in the Greek sense. Yet the
festival route in Abydos, as with festival routes in other
Egyptian towns, points to a public ceremony with pro-
cessions to public shrines, singing, dancing, and general
rejoicing as integral to the festival. As late as 200 C.E.
the Christian writer Minucius Felix knew that the Aby-
dos festival was public rather than private. Egyptologists
believe the festival is a re-enactment of the myths asso-
ciated with Osiris, his wife Isis, and their son Horus.
The vast numbers of people involved in the Festival of
Opet in Karnak also shows that it is unlikely that these
festivals were secret initiations. Yet the Greeks developed
their own cult of the Egyptian goddess Isis that incor-
porated typically Greek religious ritual, including initi-
ation. There were three degrees of initiation. The person
who wished to join the cult had to experience a sym-
bolic death, confront the gods, and pass through all the
elements. The most important part of the ceremony
allowed the initiate to view the sun at midnight. This
vision allowed the initiate to escape man's fate and over-
come death eternally.

DISTINCTIONS. The Egyptologist Erik Hornung
suggested an Egyptian basis for the ideas behind initi-
ation into the Greek cult of Isis. The ceremony sug-
gests the Egyptian myth of the sun's journey at night.
The sun, according to Egyptian belief, entered the land
of the dead after it set on this earth. Thus a person who
was symbolically dead and in the land of the dead
would see the sun at midnight and would have over-
come death. Yet there was an important difference be-
tween Egyptian and Greek belief. The Egyptians believed
that the dead eternally viewed the sun at night in an
endless cycle. The Greeks believed that the initiate was
released from fate and was no longer imprisoned in this

world, even before death. A second important distinction between Greek and Egyptian ideas was the way knowledge of the gods could be acquired. In the Greek cult of Isis, knowledge of the goddess and release from fate was achieved through the mystical trial of symbolic death and the revelation of viewing the sun at midnight. The Egyptians, however, stressed study as the means of knowing truth. The Egyptian wisdom texts repeat many times that studying with the philosophers would lead to knowledge of *maat* ("right order"). The Egyptians also stressed the importance of learning to read and studying the words of philosophers as the means of enlightenment. There is no evidence that the Egyptians believed in mystical revelation of knowledge in the Greek sense.

THE FALL. Many secret Greek cults were based on the premise that humanity had fallen from a previous paradise. According to these beliefs, people needed the cults to be saved and thus regain access to paradise. It is possible that later Egyptian ideas communicated to the Greeks originated with *The Book of the Heavenly Cow*. This text first appears in the reign of Tutankhamun (1332–1322 B.C.E.) after the Amarna Period (1352–1332 B.C.E.), when the Egyptians had briefly worshipped only the sun disc, the Aten. In this Egyptian version of mankind's fall, man's original state allowed people to have access to the sun's light at all times. There was no night that separated people on earth from the sun's rays. Yet humans rebelled against the sun god. At first the sun god tried to kill all people by sending his fiery eye against humanity. In the end, a small group was saved, but they were punished by having less access to the sun's rays than they did previously. Now the sun retreated on the back of the Heavenly Cow. Thus the Egyptians also believed that an original paradise had been lost. Strife and death entered the world through people's rebelliousness. These ideas continued into later texts such as are found in the temple of the town of Esna. The Esna texts were written at the same time as Greeks dominated Egypt. Thus these Greek ideas might have found some inspiration in Egyptian ideas.

EGYPTIAN BASIS. Thus there does seem to be an Egyptian basis for many ideas propagated by the ancient Greeks about Egyptian spiritual knowledge. Clearly, however, the Greeks interpreted much of what they saw in ancient Egypt to conform with their own ideas of spirituality, philosophy, and secret knowledge. Though there was an Egyptian basis for many Greek ideas about ancient Egypt, the Greeks' distinctive interpretation led to many modern views of Egypt as the land of mystery, spiritualism, and secret knowledge.

HERODOTUS: Prime Source

Herodotus was a Greek historian who lived in the fifth century B.C.E. His nine-book exploration of the causes of the war between Persia and Greece in the fifth century led him to write about Egypt and its role in the Persian Empire. His study of Egypt is broad, investigating the antiquity of Egyptian civilization, the geography of Egypt, the Nile and its behavior, and Egyptian manners and customs, especially religion. Herodotus took a special interest in anything he found to be astonishing about Egyptian culture. For example, he expressed his wonder at the Egyptians' architectural achievements, describing buildings that modern people also found to be marvels, such as the pyramids. Yet he claims that King Khufu financed the building of the pyramids through his daughter's acts of prostitution, a rather astonishing assertion. He also stressed Egypt's invention of some aspect of culture, especially when he thought that the Egyptians had invented some aspect of Greek culture. He assumed that anything the Egyptians invented that resembled Greek culture began first in Egypt, and then traveled to Greece. His work was repeated by Greek and then Roman writers for centuries, leading to many false ideas about Egypt and its relationship to the classical Greek and Roman world. Perhaps the most important of these ideas was his equation of Egyptian and Greek deities. Herodotus was the first to equate the Egyptian god of writing, Thoth, with the Greek god Hermes. This equation eventually led to the Greek creation Hermes Trismegistus or Thrice Great Hermes, a mythical figure that the Greeks credited with the invention of astrology and alchemy, and the Egyptians credited with the invention of writing. Out of these ideas grew the false impression that hieroglyphs were symbols of philosophical ideas rather than representations of ordinary language like other writing systems. This idea resulted in centuries of misunderstanding until J.-F. Champollion deciphered hieroglyphs in 1822. The Greek vision of the Egyptians allowed many commentators who followed to invent theories about the Egyptians with no basis in empirical reality.

SOURCES

Jan Assmann, *Egyptian Solar Religion in the New Kingdom* (New York: Kegan Paul International, 1995).

Erik Hornung, *The Secret Lore of Egypt: Its Impact on the West* (Ithica, N.Y.: Cornell University Press, 2001).

SEE ALSO *Literature: Egyptian Writing and Language*

ASTROLOGY

INFLUENCE OF STARS. The ancient Greeks and Romans believed that the Egyptians invented astrology. Astrology is the divination of the supposed influences of the stars and planets on human activity and events on earth by their positions and aspects. Though the Egyptians indeed studied the stars, the belief that the stars influenced events on earth was probably a later development and not a major part of Egyptian philosophy. Yet it is clear that at varying points in Egyptian history, they did believe in power of the stars in terms of protection and future knowledge. It was Greek and Roman interpretations of these beliefs that created the field of modern-day astrology.

KNOWLEDGE OF STARS. In *Pyramid Text* 1583, dating to the Old Kingdom (2675–2170 B.C.E.), the king after his death becomes a star in the sky among the gods. Yet this set of spells for a royal funeral stresses the role of the daytime sky and the sun over the stars in the royal afterlife. As Egyptian thought about the afterlife developed, the sun took the most prominent place and was the only celestial body found in the next world. The sun's journey at night lighted the next world, according to Egyptian belief. Yet the Egyptians surely took some interest in the nighttime sky, especially to calculate the calendar and help measure time. During the First Intermediate Period (2130–2008 B.C.E.) and the Middle Kingdom (2008–1630 B.C.E.) some coffins include star charts that the Egyptians used to calculate the dates for celebrating holidays. In the New Kingdom (1539–1075 B.C.E.), star ceilings were painted in some tombs and temples. Senenmut, a high official in the reign of Hatshepsut (1478–1458 B.C.E.), had the Egyptian constellations painted on the ceiling of his tomb. The Ramesseum, a temple built by Ramesses II (1279–1213 B.C.E.) for his continued worship after his death, portrays the god Thoth at the center of the star ceiling. The stars' role in establishing the calendar led to Thoth's depiction here. Thoth was the god responsible for both time and for fixing the calendar. There are also scattered references in the New Kingdom to worshipping stars. In the *Book of the Dead* Chapter 135, an illustration shows the deceased praying before a blue nighttime sky filled with stars. The same scene is included on the walls at the tomb of Senedjem in Deir el-Medina (reign of Ramesses II, 1292–1213 B.C.E.). A stele in a museum in Hanover, Germany, shows Thoth as the moon god worshipped with two goddesses with stars on their heads. The text speaks of the moon and the stars of the sky. Yet none of these texts mention any influence the stars could have on life on earth. The planets had names formulated with the name of the god Horus. Yet even these names only appear in lists and never seem to play a role in religion.

DECANS. The decans were 36 stars whose rising marked a night hour equivalent to forty minutes on the modern clock. Every ten days a different star marked the beginning of the night. The principal star was Sirius, already an important marker for the beginning of the New Year. All the decans disappear from the sky for seventy days then first return to view just before sunrise. This is called a star's helical rising. Each star's rising pinpointed the start of a new ten-day week on the civil calendar. Three of these weeks formed one month. After the star reappeared, it joined the others that were visible. At any one time there were eighteen visible stars. They were spaced in eighteen one-hour intervals across the sky. This system created a clock consisting of eighteen hours at night equivalent to the modern 12 hours. This system developed during the Middle Kingdom. Because the decans disappeared and reappeared on a regular basis, the Egyptians identified them as symbols of death and regeneration. In the New Kingdom, the king's funeral temples included lists of the decans. Some officials' tombs in the Ramesside Period (1292–1075 B.C.E.) included the decans on the ceiling. In the tomb of Ramesses VI (1145–1137 B.C.E.) the decans are represented worshipping the regenerating sun. Yet in the Twenty-first Dynasty (1075–945 B.C.E.) some officials believed it necessary to wear amulets to protect them from dangers caused by the decans. These amulets seem to represent a sudden change in attitude toward the stars.

PROTECTORS. The Egyptians recognized that a dangerous power could be either a threat or a protector. Though the Twenty-first Dynasty amulets suggest the decans are a threat to people, by the reign of Osorkon II (874–835/30 B.C.E.) there is evidence that the decans' power had been harnessed to protect the king. Two armbands from Osorkon II's tomb depict the decans with the gods Osiris, Horus, Thoth, Isis, and Nephthys. The decans are snakes with lion's heads who now protect the king. This is due to the belief that the goddess Sakhmet had control of the decans in this period. Sakhmet was a lion-headed goddess responsible for sending illness to people but also capable of curing illness. Thus Sakhmet also has a clear connection with fate, as is further supported by the inscriptions on the armbands. The decans also appear on protective amulets and necklaces in this period. By wearing this jewelry, a person could claim their protection.

EXPANDING INFLUENCE. By the reign of Darius I (524–486 B.C.E.), the decans appear on the temple of

Hibis in the Kharga Oasis. They also appear on a shrine of Nectanebo I (381–362 B.C.E.) and a chapel of Ptolemy VIII (ruled 170–163 and 145–116 B.C.E.). Though widely spaced in time, these monuments show that the decans continued to expand their influence. The shrine of Nectanebo I includes inscriptions that claim the decans can affect wind and water, bring fertility to the fields, and cause illness and sudden death. The decans also influenced specific parts of the body, an idea that would later receive much elaboration.

LATER VIEWS. The first millennium B.C.E. Egyptian view that the decans could influence certain phenomena on earth, including specific parts of the human body, was incorporated into heretical early Christian texts found at Nag Hammadi in Upper Egypt. The *Apocryphon of John* includes ancient Egyptian names along with Greek and Semitic names. It also connects the decans and some constellations with influence over different parts of the body. A Coptic text also from Nag Hammadi describes the decans as many-faced demons associated with both death and the devil. These texts combined a Greek idea of fate and a theory of how an individual's pre-assigned fate could be avoided. In Greek magical texts, the god Sarapis can help an individual avoid his fate through reciting the proper spell. This fate was assigned by the stars. Yet only one small part of this theory descends from ancient Egyptian sources, the decans and their ability to influence events on earth.

ASTROLOGERS. Two known Egyptian astrologers were active in the second century B.C.E. during the reigns of Ptolemy VI and Ptolemy VIII. One was Harchebis who claimed to know the mysteries of the stars and the mysteries of snakes. He also claimed in an inscription on his statue that he had observed the heavens, especially the planet Venus. The priest Petosiris claimed to be the author of an astrological handbook. Petosiris traced his own sources to the Twenty-sixth Dynasty (664–525 B.C.E.), though it is not clear how reliable this information is. Thus the real origin of Egyptian astrology probably was in this mixed society, depending on both Egyptian and Greek sources for its information.

ZODIAC. The zodiac certainly played a role in later Egyptian star study, yet it only became known in Egypt in the Ptolemaic Period (332–30 B.C.E.). The first zodiac in Egypt was carved in the temple located in Esna built in the reigns of Ptolemy III and Ptolemy IV (246–205 B.C.E.). The origin of this zodiac was most probably Babylon. It contains Babylonian forms of some signs such as the goat-fish for Capricorn, a two-headed winged horse for Sagittarius, a maiden with ears of wheat, and a crab to represent Cancer. Other signs were Egyptian-

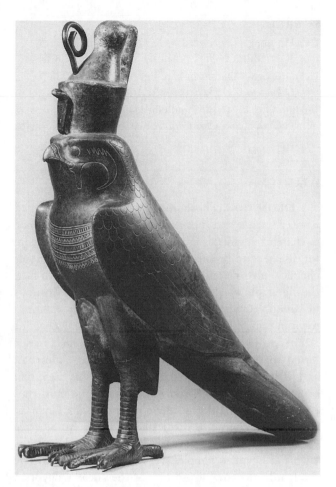

Large hawk free-standing, wearing the crown of Upper and Lower Egypt. BROOKLYN MUSEUM OF ART, 05.394, CHARLES EDWIN WILBOUR FUND. REPRODUCED BY PERMISSION.

ized such as Aquarius as a Nile god. Some scholars have attempted to identify the whole zodiac with Egyptian symbols. But Erik Hornung suggested that the symbols became more Egyptian the longer they were used in Egypt. The origin appears to be Babylonian.

ROMAN EGYPT. After the Roman conquest of Egypt (30 B.C.E.), astrology became even more popular. The emperor Augustus forbade private consultations with astrologers in 11 C.E., a sign that they had become increasingly common. Yet Augustus issued coins with his own zodiacal sign. The emperor Tiberius (r. 14–37 C.E.) took a great interest in astrology and executed those whose horoscope indicated they could be emperors. Egyptian astrologers were popular at the emperor Nero's court (r. 54–68 C.E.). Nero appointed the astrologer Balbillus a prefect of Egypt from 55 to 59 C.E. All of this activity must have played a role in Egypt's reputation for expertise in astrology. Yet it was relatively late in Egyptian history and had little to do with classical Pharaonic civilization.

SOURCES

Erik Hornung, *The Secret Lore of Egypt: Its Impact on the West* (Ithica, N.Y.: Cornell University Press, 2001).

László Kákosy, "Decans in Late-Egyptian Religion" in *Oikumene* 3 (1982): 163–191.

Joachim Quack, "Decane und Gliedervergottung" in *Jahrbuch fur Antike und Christentum* 38 (1995): 97–122.

ALCHEMY

DEFINITION. Those who practiced alchemy claimed it was a science and speculative philosophy which aimed to change base metals into gold, discover a universal cure for disease, and prolong life indefinitely. The earliest alchemical texts claim an origin in ancient Egypt. In fact, the oldest known alchemical text was written by Zosimus of Panopolis, who lived in the fourth century C.E. in a town in central Egypt now known as Akhmim. Zosimus claimed as his sources Persian and Jewish writers in addition to certain Egyptians named Peteese, Phimenas, and Pebechius. The best identified of his Egyptian sources was Bolus of Mendes who live in the third century B.C.E. In addition to these claims for the Egyptian origins of alchemy, a text called *Physika kai Mystika* written by Psudo-Democritus claims that alchemy was taught in Egyptian temples. He even attempted to derive the word "alchemy" from one of the ancient Egyptian names of the country, Kemi.

GREEK SOURCES. The Egyptologist François Daumas believed that Ptolemaic Egypt would have been an intellectual milieu that would be conducive to the development of alchemy. Yet all early texts about alchemy, even when they have origins in Egypt, were written in Greek. The Greek sources, however, claim Egyptian origins and refer to the Egyptian gods Isis, Osiris, and Horus. They even claim that Khufu (2585–2560 B.C.E.), a king of the Fourth Dynasty who built the Great Pyramid, wrote an alchemical work.

STONE. Daumas' claims for an Egyptian origin for alchemy are based on Egyptian views of stone and stone's relationship with alchemy. The proper use of the philosopher's stone was for alchemists the key to reaching their goals. Alchemists believed that this imaginary stone, properly used, could transmute base metals into gold. Daumas notes that the Egyptians understood stone to be dynamic. In *Pyramid Text* 513—a spell from an Old Kingdom (2675–2170 B.C.E.) royal funeral—lapis lazuli grows like a plant. In the Middle Kingdom (2008–1630 B.C.E.) an expedition leader to the Sinai commented on the constantly changing color of turquoise. The Egyp-

tians believed that the weather could change the color of turquoise and that the best color was only available in the cool months. In an inscription at Abu Simbel carved in the reign of Ramesses II (1279–1213 B.C.E.) the god Ptah describes how mountains actively bring forth stone monuments and the deserts create precious stones. This view of stone as dynamic rather than inert is basic to alchemy.

HOUSE OF GOLD. The Egyptologist Phillippe Derchain connected the "House of Gold," a section of the Temple of Hathor at Dendera, with the origins of alchemy. The room was used to prepare cultic instruments. The god in charge of this room was Thoth—whom the Greeks associated with Hermes—who was the god of knowledge and philosophy. The king was represented on the doorway of the room with the epithet "Son of Thoth." Part of the mystery performed while making the cultic material here symbolically transformed grain into gold. Derchain believed that the border between symbolism and later alchemy that sought to transform materials into gold was still maintained here.

HORUS OF EDFU. The temple of Horus in the town of Edfu also dates to the Ptolemaic Period. The walls of the treasury of this temple depicts mountains offering gold, silver, lapis-lazuli, turquoise, jasper, carnelian, hematite, and other semi-precious stones. The ointments prepared at this temple for use in the ritual utilized these materials. They were prepared over long periods, with particular actions required on each day. The description of the preparations closely resembles alchemy with repeated heating and cooling of these stones in order to create something different. These second-century B.C.E. activities might be the origins of Egyptian alchemy.

ARABIC TRADITION. Two texts in Arabic highlight the connection between alchemy and Egyptian cult. They are the *Risalat as-Sirr* (Circular Letter of Mystery) and the *Ar Risala al-falakiya al kubra* (Great Circular Letter of the Spheres). In the Arabic tradition, alchemy was the science of the temples, and Egyptian temples were the places where its secrets were located. Zosimus had previously associated the hieroglyphs on temple walls with the secrets that Hermes and the Egyptian priests knew. The *Risalat as-Sirr* maintains that it too came from a temple in Akhmim. It had been hidden under a slab of marble in the crypt of a woman, perhaps a reference to the Egyptian goddess Isis. This text places its own finding in the ninth century C.E. The *Ar Risala al-falakiya al kubra* claims for itself a find spot under a statue of Isis-Hathor in the temple located in Dendera. It claims that Hermes wrote it at the instruction of Osiris. Both texts seem to have origins in the Ptolemaic Period,

though such stories are similar to ancient Egyptian lore. The *Book of the Dead* in one tradition was discovered under a statue of Thoth. Thus it is possible that the Arabic tradition preserves some knowledge of Egyptian practice.

EGYPT'S HEIRS. Thus ancient Egypt's heirs, both Greek and Arabic speaking, practiced alchemy. They attempted to connect this practice to Pharaonic knowledge with varying degrees of success. It is possible that both traditions preserve some aspects of Egyptian thought though it is not clear that alchemy truly was an Egyptian area of knowledge or philosophy.

SOURCES

F. Daumas, "L'Alchimie a-t-elle une origine égyptienne?" in *Das römisch-byzantinische Ägypten* (Mainz, Germany: Twayne, 1983): 109–118.

P. Derchain, "L'Atelier des Orfèvres á Dendera et les origins de l'Alchemie," in *Chronique d'Egypte* 65 (1990): 219–242.

Erik Hornung, *The Secret Lore of Egypt: Its Impact on the West* (Ithica, N.Y.: Cornell University Press, 2001).

SEE ALSO *Religion: Magic in Egyptian Religion*

SIGNIFICANT PEOPLE
in Philosophy

ANKHSHESHONQI

fl. Ptolemaic Period (332–30 B.C.E.)

Writer of aphorisms

LESSONS TO HIS SON. Ankhsheshonqi was a priest of the sun god Re at the god's temple in Heliopolis who, according to ancient Egyptian history, was implicated in a plot to assassinate the pharaoh. Although not a direct participant, he was thrown into prison for his failure to report the plot, which involved his childhood friend, Harsiese, who was also the pharaoh's chief physician. While in prison he wrote a teaching for his son. Ankhsheshonqi's teaching differs from earlier teachings because it consists of individual aphorisms. Though several of these sayings might deal with the same subject, they do not follow one another in any understandable sequence as was true in the earlier periods. Some scholars have tried to connect this work to the biblical book of Proverbs.

SOURCES

S. R. K. Glanville, *The Instructions of Onchsheshonqy* (London: British Museum Press, 1955).

Miriam Lichtheim, *Late Egyptian Wisdom Literature in the International Context* (Freiburg, Switzerland: Orbis Biblicus et Orientalis, 1983).

ANY

Unknown, before 1539 B.C.E.–Unknown, after 1514 B.C.E.

Scribe of the Palace of Queen Ahmes-Nefertari

WROTE TEACHING TO SON. Nothing is known of Any's early life. He was a commoner who had an opportunity to gain an education and became a scribe. He must have married and had at least one son who grew to adulthood, whose name was Khonshotep. Any's highest title was "Scribe of the Palace of Ahmes-Nefertari." Thus he was an official who reached the lower end of the royal bureaucracy. This office was a significant enough accomplishment to allow him to write a teaching for his son. Any's teaching combines traditional material with two innovations. Previous to Any's time, only teachings of the highest officials survive. As a minor official, Any offers advice to his son that will help him in the lower offices that he can expect to attain. There is no aristocratic pretension in Any's advice. Second, Any's son answers him at the end of the teaching. Khonshotep is skeptical about whether he can follow his father's advice. He suggests it is too difficult for him. This section of the text leads to the possibility that the teaching will fail in spite of Any's best efforts. Such a proposition was never previously discussed in Egyptian philosophical literature.

SOURCES

Miriam Lichtheim, *Ancient Egyptian Literature, Volume II: The New Kingdom* (Berkeley: University of California Press, 1976): 135–146.

Axel Volten, *Studien zum Weisheitsbuch des Anii* (Copenhagen, Denmark: Danske videnskabernes selskab, 1937–1938).

HORDJEDEF

fl. Fourth Dynasty (2625–2500 B.C.E.)

Prince
Author

A PRINCE AND A TEACHER. Hordjedef was a son of King Khufu who reigned 2585–2560 B.C.E. His mastaba tomb was never finished, but was located near his father's tomb, the Great Pyramid. Hordjedef had at

Arts and Humanities Through the Eras: Ancient Egypt (2675 B.C.E.–332 B.C.E.)

201

least one son named Au-ib-re to whom he wrote a teaching. As an author, Hordjedef is credited as being a teacher and a great storyteller. He is the narrator of a story in the collection called *Khufu and the Magicians*. In his teaching, Hordjedef concentrates on the importance of starting a family and preparing a proper burial. Unfortunately, very little of the text of his instruction survives. The copies that do survive, however, date from the New Kingdom, at least one thousand years after he originally composed the text. In the Ramesside Period (1292–1075 B.C.E.) he was remembered as one of the great authors of the past.

SOURCES

Jan Assmann, *Weisheit, Schrift uind Literature im alten Agypten* (Munich: W. Fink Verlag, 1991).

Miriam Lichtheim, *Ancient Egyptian Literature*, Vol. I (Berkeley: University of California Press, 1973).

MERYKARE

fl. during the Tenth Dynasty (2130–1980 B.C.E.)

King

ROYAL TEACHINGS. Merykare was king during the Tenth Dynasty, a period of which little is known. He is named in the tomb of Khety—a provincial governor— where it is clear that Merykare fought the Theban family that eventually united Egypt in the Middle Kingdom (2008–1630 B.C.E.). Merykare must have been quite prominent in his own time. He might have had a pyramid at Saqqara, the site of many important Old Kingdom pyramids. A text known only from New Kingdom copies claims to be a teaching written by Merykare's father, whose name is not preserved, when Merykare was a prince. If the text truly was composed in the Tenth Dynasty, it is the oldest royal teaching from ancient Egypt. Merykare's father gives him advice on being a king in the text. He also enumerates his own mistakes during his reign. Perhaps these mistakes are the reason that the text was still studied in the New Kingdom. The Theban kings of the Middle and the New Kingdom must have considered Merykare and his father hostile to them. Yet his teachings were preserved.

SOURCES

Miriam Lichtheim, *Ancient Egyptian Literature*, Vol. I (Berkeley: University of California Press, 1973).

Jaromir Malek, "King Merykare and His Pyramid," in *Hommages à Jean Leclant*, Volume IV. Ed. C. Berger (Cairo, Egypt: Institut français d'archéologie orientale, 1994): 203–214.

DOCUMENTARY SOURCES
in Philosophy

Anonymous, *The Dialogue of a Man with His Ba* (c. 1938–1759 B.C.E.)—This philosophical text describes a man debating suicide with his own soul. It gives a clear indication of Egyptian belief in a soul and the consequences of suicide. The text breaks off before the end so the result is not clear.

Anonymous, *The Eloquent Peasant* (c. 1938–1759 B.C.E.)— In this philosophical study, a corrupt official falsely imprisons a farmer. The farmer's pleas for justice amount to a treatise on *maat* ("right conduct").

Anonymous, *Teachings for Merykare* (c. 2130–1980 B.C.E.)— An unnamed king writes advice for his son, the future king Merykare of the Tenth Dynasty. Perhaps the oldest of the royal instructions, it is directed to the enemy of the Theban family that reunited Egypt in the Middle Kingdom.

Anonymous, *The Teachings of a Man for his Son* (c. 1938–1759 B.C.E.)—A man of lower station advises his son to be loyal to the king in order to succeed in life. It is one of the Egyptian philosophical texts that deals with issues of loyalty and the importance of the king to his people.

Attributed to Amenemhet I, *The Teachings of Amenemhet* (c. 1919–1875 B.C.E.)—Probably composed in the reign of Senwosret I, the ghost of Amenemhet I advises his son not to trust any courtiers. This is a good example of a royal philosophical teaching.

Attributed to Amenemope, *The Teachings of Amenemope* (c. 1539–1075 B.C.E.)—Amenemope, a high agricultural official, advises his son in this philosophical text on pursuing the way of truth as well as career advice.

Attributed to Any, *The Teachings of Any* (c. 1539–1975 B.C.E.)—Any, a low-level scribe, gives his son advice on marriage, managing a household, and the virtuous life. This is the first example of philosophical teachings that came from a person who was not royalty and not of high office.

Attributed to Hordjedef, *Teachings of Hordjedef* (c. 1938–1759 B.C.E.)—Written in the Twelfth Dynasty but set in the Fourth Dynasty, Hordjedef offers practical advice for career advancement. It is clearly a philosophical teaching text, but not enough of the maxims included in it survive to be clear on the message it holds.

Attributed to Ipuwer, *The Admonitions of Ipuwer* (c. 1938–1759 B.C.E.)—Written in the Twelfth Dynasty but set in the preceding First Intermediate Period, the author

laments the social chaos around him. This is one of the Egyptian pessimistic writings and points to the philosophical idea of the existence being either ordered or chaotic.

Attributed to Kagemni, *The Teachings of Kagemni* (c. 1938–1759 C.E.)—Set in the reign of the Third-dynasty king Huni but probably composed in the Twelfth Dynasty, only the end of this advice survives. Much like *The Teachings of Hordjedef*, this text is clearly philosophical, but its tenets are unknown.

Attributed to Khakheperre-sonb, *The Complaints of Khakheperre-sonb* (c. 1938–1759 B.C.E.)—Written in the Twelfth Dynasty, the author laments social conditions but mostly speaks of the difficulty of finding the right words to describe the situation. This is one of the few surviving examples of Egyptian complaint literature and speaks on the Egyptian philosophy of order as a necessary tenet to a proper society.

Attributed to Khety, *The Teachings of Khety* (c. 1938–1759 C.E.)—This Twelfth-dynasty text stresses the value of education. It is one of the only surviving texts to speak philosophically about education as a matter of pleasure instead of as a necessity.

Attributed to Neferty, *The Prophecy of Neferty* (c. 1938–1909 B.C.E.)—Probably composed in the reign of Amenemhet I, the prophecy is set in the reign of Sneferu nearly 700 years earlier. The text describes a period of anarchy followed by peace restored by Amenemhet I. This text is philosophically concerned not only with the necessity of order, but of the connection between the king and maat.

Attributed to Ptahhotep, *The Teachings of Ptahhotep* (c. 1938–1759 B.C.E.)—Written in the Twelfth Dynasty but set in the Fifth Dynasty, the prime minister shares his wisdom gleaned from a long career. This is the most complete ancient Egyptian teaching to survive and is the best example of a royal teaching.

Attributed to Sehetepibre, *The Teachings of Sehetepibre* (c. 1938–1759 B.C.E.)—This philosophical text stresses loyalty to the king as the primary way of establishing justice in the world.

chapter seven

RELIGION

Stephen E. Thompson

IMPORTANT EVENTS
in Religion

All dates in this chronology are approximations (c.) and occur before the common era (B.C.E.).

3800–2298 The first Egyptians bury their dead in oval pits in the desert and include pots, tools, and weapons, presumably for the use of the dead in the afterlife.

2585 King Sneferu completes construction of the first true pyramid in ancient Egypt, suggesting the rise of the cult of the sun-god Re.

2585–2560 King Khufu completes the Great Pyramid on the Giza plateau, the first stage of the massive complex of three pyramids, multiple temples, and the Great Sphinx, all representing the cult of Re's importance in Egyptian funerary religion.

2560–2555 King Redjedef is the first to call himself "Son of Re" in texts, a title that will continue for kings throughout ancient Egyptian history.

2555–2532 King Khafre builds the second pyramid at Giza and completes the Great Sphinx, probably an image of the sun-god Re in the form Re-Horus-on-the-two-horizons (Rehorakhty).

2532–2510 King Menkaure completes the third pyramid at Giza and brings the building program to a close.

2500–2350 Kings build sun temples to honor the god Re in addition to building pyramids for their own burial. The sun temples absorb a considerable amount of royal resources formerly spent on pyramid building.

2371–2350 In the reign of King Unas the *Pyramid Texts* are first inscribed on the interior of a royal pyramid. These texts probably represent the funeral ritual for a king and are a guide to entering the afterlife.

The first writing of the funerary god Osiris' name appears in the *Pyramid Texts*.

2170 The first example of *Coffin Texts* are written. These texts offer a funeral ritual for non-royal people that is similar to the ritual found in the *Pyramid Texts* for kings for the first time.

2130–1980 The serpent demon Apophis, who threatens the sun god Re in the afterlife, is first mentioned in texts.

1938–1759 Widespread use of the *Coffin Texts* by the common people in their burials indicates the importance of the cult of Osiris in the afterlife expectations of both kings and common people.

The god Amun rises to prominence as kings from the town of Thebes, Amun's home, come to rule Egypt.

1919–1875 King Senwosret I builds the White Chapel, the first evidence of building activity at the Karnak Temple, the main cult center of the god Amun which will continue in importance through the rest of ancient Egyptian history.

1630–1539 The first examples of the *Book of the Dead* are written. This guidebook to the afterlife remains important in the New Kingdom (1539–1075 B.C.) and in the Late Period through the Roman Period (664 B.C.E.–395 C.E.).

1493–1481 Thutmose I is the first king to be buried in the Valley of the Kings and to include in his tomb the funerary text *Amduat* ("What is in the Underworld").

1479–1425 King Thutmose III's tomb contains the first complete copy of the *Amduat*, the text fully describing the underworld.

An oracle indicates Thutmose III is the legitimate king to follow Thutmose II, the first known use of oracles in ancient Egypt.

1478–1458 Hatshepsut, a female king ruling with the child-king Thutmose III, describes her conception through the agency of the god Amun at her temple in Deir el Bahri.

1390–1353 The first known burial of the Apis bull, a temple animal worshipped as an incarnation of the god Ptah, occurs during this time.

King Amenhotep III disassembles the White Chapel at Karnak built by King Senwosret I (1919–1875 B.C.E.) to expand the Temple of Amun in Karnak.

King Amunhotep III takes the title "The Dazzling Disk of the Sun," a step toward identifying the king with the sun itself.

1353–1336 Amenhotep IV (Akhenaten), with his wife Nefertiti, decrees the worship of the sun disk (Aten) and the closing of all other temples in Egypt. He moves the religious capital to modern Amarna (Akhetaten) in Middle Egypt from the traditional capital in Thebes, home of the god Amun.

1332–1322 King Tutankhamun returns the religious capital to Thebes and reopens the temples of other gods throughout Egypt.

Tutankhamun is buried with the *Book of the Heavenly Cow*, part of a number of new royal funeral texts that are popular until the end of the New Kingdom.

1322–1319 King Ay includes the *Book of Gates* in his tomb, a new description of the afterlife.

1292–1075 Non-royal Egyptians are first shown in tombs praying and making offerings at chapels. Some scholars believe this came in response to the religious upheaval of Akhenaten's time (1353–1336 B.C.E.).

1075–945 Priests of the god Amun at Thebes control Upper and Middle Egypt as the central government declines.

1075–954 The priest of the god Amun is buried with the *Amduat* ("What is in the Underworld"), an honor previously restricted to kings.

716–702 During the reign of King Shabaka, a copy of the text known as the *Memphite Theology* is inscribed on stone. This creation story stresses creation through speech, not unlike descriptions of creation that will later appear in the biblical books of Genesis and the Gospel of John.

664–525 A revision of the *Book of the Dead* becomes newly popular.

Animal mummification increases greatly and continues to the end of ancient Egyptian history.

Cult guilds that worship one god become popular among non-royal people.

OVERVIEW
of Religion

DEFINITION. The ancient Egyptians had no word for religion. For them, religion was not a separate category of thought requiring an approach different from that used when discussing philosophy, science, or any other topic. Therefore, the first step in any study of Egyptian religion is to decide what religion is and then examine the Egyptian record for data relating to this definition. Attempts to define religion as a phenomenon are numerous, and no universal definition has been agreed on. The definition used here will follow that of Melford Spiro, who suggested that religion is an "institution consisting of culturally patterned interaction with culturally postulated superhuman beings."

COMPONENTS. This definition consists of three main components. First, religion is an institution. Only social groups practice religion. In other words, a person cannot have a religion of one. An individual can have his or her own beliefs, but for those beliefs to be called a religion a wider group must practice them. Egyptian religion could be practiced in the formal setting of the massive state temples, with their extensive holdings of land, buildings, and personnel, or in the privacy of an Egyptian home. Second, religion assumes the existence of "culturally postulated superhuman beings," beings we may call gods, demons, or spirits. The Egyptians believed these beings were able to influence the lives of human beings, either for good or bad. The ancient Egyptian term for these beings was *netjer*. Third, religion includes the interaction between people and these superhuman beings. These interactions can take two forms: people engage in activities that they think please the superhuman beings, such as behaving morally and ethically, carrying out prescribed rituals, and participating in festivals; and people engage in activities for the purpose of influencing the superhuman beings. They urge the superhuman beings to act on behalf of a particular individual or cease acting against that individual. They can also urge similar requests for a group. These activities include prayers, sacrifices, or votive offerings.

MEANING OF NETJER. The Egyptian word that is translated into English as "god" is *netjer*. This word is written with a hieroglyph resembling a yellow flag on a green flagpole. The etymology of the word "netjer" is uncertain. We know it corresponds roughly to the word "god" because in the Ptolemaic period (332–30 B.C.E.) of Egyptian history, bilingual decrees in Greek and Egyptian translate the Egyptian netjer with the Greek word for god, *theos*. A detailed examination of Egyptian texts reveals that the word netjer has a far wider frame of reference than the English "god." The word could also refer to the Egyptian king, certain living animals, and to dead people or animals. The one thing every entity referred to as "netjer" had in common was that it was the object of a ritual, or received some sort of offerings during a ritual. When viewed in this light, there are five classes of beings that the Egyptians called "netjer." First are those beings modern-day theologians would call gods. They were created as netjer from the beginning, and did not acquire the status at a later date. For them, ritual served to maintain and preserve their status as gods, much as food allows a person to maintain the status of a living being. These beings received daily rituals and offerings in the temples and shrines throughout Egypt. Next are those beings that acquired the status of netjer through undergoing a ritual at some time after their birth. These entities fall into two categories: those who undergo a ritual and therefore become a netjer while living, and those who become a netjer after death. In the first category are the kings of Egypt and certain sacred animals. The king, at his accession, underwent a coronation ritual and as a result acquired the status of netjer. In addition to the king, the Egyptians viewed certain animals as being special manifestations of particular gods, usually based on the presence of special markings or characteristics. These animals also underwent a ritual which inducted them into the category of netjer and made them instruments through which a particular god could make his presence manifest. The last category of beings that were considered to be netjer is those beings that underwent a ritual, and hence became netjer, after death. The funerary ritual had the effect of turning every deceased Egyptian for whom it was practiced into a netjer. The dead person would become an *akh*, the Egyptian word for a glorified spirit, and would be the recipient of offerings of food and drink from his family members. Finally, animals belonging to particular species that were kept at Egyptian temples would be mummified and buried at death, conferring on them the status of netjer.

CHARACTERISTICS. Ancient Egyptian religion has certain characteristics that differ from what most West-

ern observers would call religion in several ways. Unlike Judaism, Christianity, and Islam, the Egyptian religion was not a founded religion. In other words there is no single individual such as Abraham, Moses, Jesus, or Mohammed who received credit for founding Egyptian religion. The exception is Akhenaten (1352–1336 B.C.E.), who founded the cult of the Aten. Furthermore, Egyptian religion is not scriptural. There is no set of writings thought to be revealed by the gods to mankind explicating the tenets of Egyptian religion. This does not mean that the Egyptians did not have religious texts, for they most certainly did. But these writings never achieved the status of a canon against which all else could be judged. There was no doctrine for people to believe, and no creeds to which people had to agree. Egyptian religion was greatly influenced by the natural world. The Egyptians did not worship nature, but it was through nature that they gained their knowledge of the gods. The landscape, plants, and animals could all have religious significance. The Nile River and the scorching Egyptian sun played prominent roles in Egyptian theology.

MULTIPLICITY OF APPROACHES. One of the most striking characteristics of Egyptian religion to the modern student is what has been termed the "multiplicity of approaches." The Egyptians did not seek a single explanation for phenomena or events. Rather, the same phenomenon could have several different, and to us mutually exclusive, explanations. There were several different explanations for the creation of the world that ascribed creation to different gods. The same phenomenon could be described through several different symbols. For example, the Egyptians imagined the sky as a cow with stars adorning her belly, as a body of water on which the sun-god sailed in his boat, as a woman's body stretched out over the earth, and as a roof or canopy, all at the same time.

SPOKEN WORDS AND NAMES. Another feature of Egyptian religion was the importance of the spoken word and names. Words were not simply vibrations of sounds or collections of letters; they possessed power. The Egyptians did not believe that similarities in sound between words were coincidental, but rather revealed essential information about the relationship between the entities. Just as individuals like the king or vizier (high government official) could accomplish things by speaking orders, the speaking of words could bring about concrete events. Reading the offering formula on behalf of a deceased relative provided him with the commodities needed in the afterlife. Names referred to the essence of a person or deity, and manipulation of an entity's name granted control over the entity. In order to bring about

the destruction of an enemy, his name could be written on a clay bowl or anthropomorphic figurine. The writer could then smash the bowl or the figurine. This action ensured the enemy's destruction. Knowing the true name of a god granted one power over the god. The names of gods became the building blocks for expanding knowledge of the deities, and the more names a god had the more aspects his being possessed.

EVIDENCE. When studying Egyptian religion, scholars must always keep in mind that most interpretations are based on evidence spread out over more than 3,000 years of history. The main source of information about Egyptian religion is the abundant written material that has been preserved. The first written evidence for Egyptian religion comes from the period of Dynasty 0 (3200–3100 B.C.E.) and the Early Dynastic Period (3100–2675 B.C.E.). This evidence is in the form of names of individuals that include a god's name as an element. Names such as "he whom Khnum has saved," or "he whom Anubis has created" or "she whom Neith loves" give scholars the first indication of which gods the Egyptians worshipped, and the types of actions and relationships people expected from their gods. Labels and clay seals used to close jars also preserve brief texts that give evidence for temples in ancient Egypt. The texts occasionally indicate that the commodities in the containers were destined for, or came from, a particular temple.

TEXTS. The texts that the Egyptians buried with their dead to aid them in making a successful transition to the afterlife are an extremely important source of information on the Egyptian gods and their doings. The earliest of these texts, and in fact the oldest religious texts known anywhere in the world, are found on the walls of the pyramids of the last king of the Fifth Dynasty, Unas (2371–2350 B.C.E.), and in the pyramids of the Sixth-dynasty kings (2350–2170 B.C.E.) and even some of their queens. Because of their location Egyptologists call them *Pyramid Texts*. These texts were initially the exclusive prerogative of royalty. Towards the end of the Old Kingdom a new type of funerary text appeared among the high officials of the bureaucracy. These texts became more frequent during the Middle Kingdom, and are found mainly on the walls of wooden coffins, and therefore are called *Coffin Texts*. At the end of the Middle Kingdom, funerary spells written on papyri and buried with the deceased or painted on tomb walls replaced the *Coffin Texts*. The Egyptian title of these spells was "The Book of Going Forth by Day." Once introduced, these texts continued in use until the end of the Roman period of Egyptian history. In 1842 the German Egyptologist Karl Richard Lepsius published a Ptolemaic

period papyrus of these texts, and coined the name *Totenbuch*, which in English is *Book of the Dead*, and that is how these texts have been known ever since.

NEW KINGDOM. In addition to the *Book of the Dead*, the New Kingdom pharaohs included in their tombs a new type of funerary text, which scholars call underworld books. These books described the nightly journey of the sun through the underworld, and it was a goal of the dead pharaoh to join the sun god on this voyage. Scholars include several different compositions among the underworld books. The most important are the *Amduat*, the *Book of Gates*, the *Book of Caverns*, and the *Book of the Earth*. A similar category of text is found in tombs after the Amarna period, which scholars call books of the sky. These texts represent the sun's voyage as a passage along the body of the sky-goddess Nut. During the day, the sun passes along her body, and at night it is swallowed by Nut, passes through her internally until dawn, when the sun is reborn between her thighs. The compositions known as the *Book of Nut*, *Book of Day*, and *Book of Night* belong to this genre of text.

LITERATURE. Funerary texts are not the only source of knowledge on Egyptian religion. Egyptian literature is replete with references to the gods and to people's interactions with them. Hymns and prayers are commonly found carved on tomb walls and on stelae (carved stone slabs) set up as monuments to the king, memorials to the deceased, or as votive offerings to the gods. Private letters, contracts, royal decrees, and medical texts, while not "religious" in purpose, all contain references to the gods and preserve important information on Egyptian religion. Instructional texts, used to train scribes, contain advice on how to live a life pleasing to the gods. Magical spells are an important source for some of the myths of the gods. Fortunately for modern scholarship, the ancient Egyptians covered the walls of their temples with texts and scenes relating to the activities which went on inside these massive buildings. The best-preserved temples are also the latest (Ptolemaic and Roman periods), and caution must be exercised when using these late sources to throw light on earlier religious practices.

ARTIFACTS. The practice of burying goods with the deceased has preserved important artifacts relating to Egyptian religion. Earliest evidence for Egyptian religion comes from the burials of people and animals during the Predynastic period (4500–3100 B.C.E.). The fact that people at this early stage were buried with grave goods and foodstuffs indicates a belief in some sort of life after death. Human figurines of clay and ivory included in some of the burials may represent deities, but this is uncertain. The number of animal burials discovered from this period may indicate that the Egyptians already worshipped divine powers in animal form. Excavations at the New Kingdom town sites of Amarna and Deir el-Medina have revealed important information about the personal religious practices of their inhabitants, and about the types of shrines at which these practices were carried out.

TOPICS
in Religion

THE GODS

CHARACTERISTICS. For the Egyptians, the gods represented the powers of nature conceived as personalized beings. They helped to explain the world, how it came into existence, why it continued to exist, and why events occurred as they did. The Egyptian gods had many characteristics that distinguish them from the Western conception of "god." Egyptian gods had a beginning; they did not always exist. Egyptian texts speak of a time when the gods did not yet exist. The creator god (of whom there are several) is unique in that he (or she, in one instance) creates himself; the other gods were born to mothers and fathers. This brings up another characteristic of Egyptian gods: they have gender, male and female. Some are said to go through a childhood and grow to maturity. Not only did the Egyptian gods grow up, they grew old, and even died. An Egyptian deity could be killed, as when Seth killed his brother Osiris, or they could simply grow old and die. Every day, the Egyptians visualized the setting sun as an old man near death. The Ibis-headed god Thoth determined the life spans of both men and the gods. Egyptian texts even make references to the tombs of the gods, and one late text even mentions an entire graveyard of gods.

LIMITATIONS. Egyptian gods had other limitations as well. The Egyptians did not consider them to be omnipotent. Most gods and goddesses had power only within certain closely defined areas, such as a particular town, nome (province), or region of the world. Egyptians had a term that meant "local gods," meaning the gods of any particular locality. When an Egyptian traveler was in another part of Egypt, or in another country such as Nubia, he would pray to the local gods to protect him. Egyptian gods were not considered omniscient; they did not know everything. The story of Isis and Re, in which Isis concocts a plan to learn Re's secret name

and therefore gain power over him, demonstrates that Isis was ignorant of Re's name, and that Re was ignorant of Isis's plan, because he falls into her trap.

NAMES. The Egyptian gods did not have well-defined personalities. A few stories provide insight into the characters of Osiris, Isis, Seth, Horus, Re, Hathor, and a few other deities, but most of what is known of the gods comes from their names and iconography. An Egyptian god could have more than one name, and the more powerful the god, the more names he could have. A name was not merely a label but was part of the god's personality, and it revealed something about him. Almost all of the gods' names can be translated, and generally denote a characteristic feature or function of the god. Examples include Amun (the Hidden One), the invisible god of the air; Khonsu (The Traveler), the moon god; and Wepwawet (Opener of the Ways), the jackal guide of the deceased. Some names tell of the god's origin, such as the snake goddess Nekhbet, whose name means "she of Nekheb," modern el-Kab, a town in southern Upper Egypt.

GROUPINGS. The Egyptians grouped their deities together using several different numerical schemas. The simplest grouping was in pairs, usually of a god and goddess, although pairs of the same sex did exist (Isis and Nephthys; Horus and Seth). The most common method of organizing deities was based on the triad, usually consisting of a god, a goddess, and their offspring. There are many examples of such triads in Egyptian religion: Osiris (god), Isis (goddess), and Horus (offspring); Amun (god), Mut (goddess), and Khonsu (offspring); and Ptah (god), Sakhmet (goddess), and Nefertem (offspring). Triads could also consist of a god and two goddesses—for example, Osiris (god), Isis (goddess), and Nephthys (goddess); or Khnum (god), Satis (goddess), and Anukis (goddess). There were also all-male triads—such as Ptah, Sokar, and Osiris (who were worshipped at Memphis)—and all-female triads—Qadesh, Astarte, and Anat (all foreign deities introduced into Egypt). In one grouping, the goddess Qadesh was matched with two gods, Reshep, and Min. These numerical groupings could grow larger, as with the Ogdoad (grouping of eight pairs of gods) and the Ennead (grouping of nine gods). An Ennead could simply refer to the genealogical classification of gods, and was not limited to only nine members; some Enneads had as few as seven members, while others could have as many as fifteen.

SYNCRETISM. There was an additional method of associating deities that is difficult for modern students of Egyptian religion to comprehend. The Egyptians could combine two or more gods into a single god. This phenomenon has been called syncretism by scholars, and gave rise to the compound names such as Amun-Re. What occurred with the god Amun-Re was the merging of Amun and Re to form a new god, Amun-Re. The gods Amun and Re continued to have separate existences, however; where there were once two gods, Amun and Re, there were now three, Amun, Re, and Amun-Re. Generally, the second name in the pairing was the older god. Syncretism was a way for one deity to extend his sphere of action and influence. In a compound deity consisting of two components, the first name is the individual, while the second indicates the role that the deity is fulfilling. For example, Khnum-Re fulfills the role as life-giver—powers associated with Khnum—and is also seen as a sustainer—powers associated with Re. The number of such combinations a deity could enter into was not limited; in addition to Amun-Re scholars have found Sobek-Re, and from the *Pyramid Texts*, Re-Atum. Syncretism was not limited to two deities; examples of combinations of three (Ptah-Sokar-Osiris) and even four (Harmakis-Kheper-Re-Amun) occurred. In each instance a new deity possessing all the powers and attributes of the individual constituents was formed, while each individual deity retained its own unique existence and influence. A striking example of this was found at the Great Temple of Ramesses II at Abu Simbel, where the sanctuaries dedicated to the gods Amun-Re, Re-Horakhty, and Ptah were found. Re occurred simultaneously in two different syncretistic combinations in this sanctuary.

ICONOGRAPHY. Just as a god could have many different names, each revealing something about the nature of the deity, so could a god be depicted in many different ways. Egyptian gods could be shown as fully human, fully animal, or—perhaps most familiar to even the most casual student of ancient Egypt—in a hybrid form combining both human and animal elements. When creating images of their gods, the Egyptians were not attempting to depict the god as he really was, but rather their goal was to communicate something essential about the god's nature.

ANIMAL FORM. The earliest evidence for the depiction of Egyptian gods seems to indicate that in the prehistoric period (before 3100 B.C.E.) the Egyptians worshipped divine powers in animal form. Around the beginning of the Dynastic period (after 3100 B.C.E.), powers that had been worshipped as deities came to be represented in human form. Towards the end of the Second Dynasty (2675 B.C.E.) the method of depicting Egyptian deities that was to become so commonplace is first in evidence. On cylinder seal impressions from King

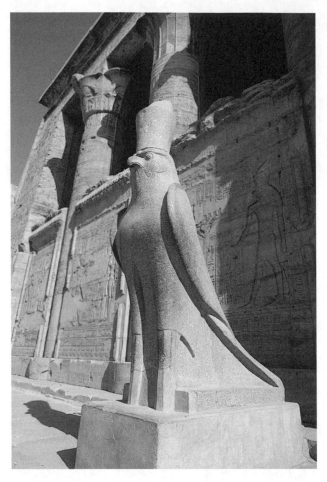

Large sculpture of the god Horus as a falcon with the crowns of Upper and Lower Egypt, outside his temple, at Edfu on Nile, between Aswan and Luxor. PHOTO RESEARCHERS, INC. REPRODUCED BY PERMISSION.

tempt to discern what meanings were intended by the different methods of representation of the Egyptian deities. An animal head on a human body revealed certain characteristics or attributes of the deity. Unfortunately, the symbolism intended by the use of particular animals is not clearly understood. A human head combined with an animal's body seems to indicate the acquisition or possession of divine aspects by humans. For example, the human headed ba-bird represented the ability of a deceased individual to freely move about and transform himself into different forms. That classic Egyptian symbol, the sphinx, which placed a human head on a lion's body, represented the royal power of the individual. A sphinx was not solely human-headed; it could take the head of several different animals, each representing a particular deity. A ram-headed sphinx represented the royal power of the god Amun-Re. A falcon-headed sphinx indicated the royal power of the god Horus, while a sphinx with the head of a hawk represented the same for Seth. Each mixed figure, whether it be human head with animal body or animal head with human body, represented a theological statement in iconographic form about the Egyptian god.

ACCOUTREMENTS OF THE GODS. The items the gods and goddesses were shown wearing or carrying also contributed information regarding their characteristics. The double crown of kingship was worn by several deities, including Atum, Horus, and even Seth. The Hathor-crown, consisting of cow horns with a sun-disk in the middle, was worn by goddesses known for their motherly nature, such as Hathor, Isis, and Renenutet. A deity shown wearing a crown with a sun-disk incorporated into it was thought to have some sort of relationship to the sun-god. Deities could also be shown wearing an identifying hieroglyph as a headdress. The goddess Isis, for example, often wore the throne-sign that was the hieroglyph for her name on her head. Deities could be shown carrying the ankh-symbol, representing their power to bestow life. Gods could be shown carrying a *was*-scepter, indicating their dominion and control, while goddesses often carried the *wadj*-staff, representing fertility and renewal in nature. The goddess Taweret, the protector of women in childbirth, was shown carrying a large *sa*-amulet, representing protection. Even the color associated with the gods was significant. Amun, the king of the gods during the New Kingdom, was shown with blue skin, possibly representing the color of the sky. Osiris, Anubis, Isis, and various demons could be shown with black skin, indicating their association with the underworld and the afterlife. Osiris could also be depicted with a green face, an allusion to his powers

Peribsen (fourth king of the Second Dynasty) gods in human form are depicted with animal heads, in this case the god Seth with the head of a hawk. Once these different methods of representing the deities made their appearance, they continued to coexist with the other forms; one form did not replace another. The same god could be represented using all three methods of purely human, purely animal, or animal-human hybrid. The goddess Hathor could be shown as a woman, as a cow's head on a woman's body, or simply as a cow.

SIGNIFICANCE OF DEPICTIONS. If the same deity could be represented in several different forms, it is obvious that not all of these depictions could represent the actual appearance of the deity. In fact, none of these depictions represented the "true" form of the deity; this form was forever hidden to man, just as the true name of the deity was a closely guarded secret. The task for the modern student of ancient Egyptian religion is to at-

of revival associated with fertility. The aggressive and hostile Seth was shown with red skin, the color of the rising and setting sun.

PERSONIFICATIONS. Some Egyptian deities fall into the category of personifications, that is, deities who embody some characteristic or trait. The names of these deities are also found as nouns having a non-personal meaning. Examples of personifications include Amun (*imn*, also the word for "hidden") and Gereh (*gereh*, also the word for "darkness"). Many types of things could be personified, including geographical locations (such as names of nomes or temples); time, including the seasons (such as *Renpet* for "Spring"); directions (including *Imenet* for "West" and *Iabt* for "East"); emotions (such as *Hetepet* for "peace"); products (such as *Nepri* for "corn" or *Nub* for "gold"); and various activities (such as *Tayt* for "weaving"). Personifying such entities allowed them to be depicted or described as interacting with other entities, including the other gods, and living or dead individuals. Major personifications include the goddess Maat for Truth and Order, the god Heka for magic, and Hapy, for the personified inundation of the Nile. A particularly important category of personification includes gods of birth and destiny and deities who protected women during childbirth such as Bes and Taweret.

DEMONS. For the ancient Egyptians, "demons" were not considered evil. In fact, the Egyptians did not have the dichotomy between good and evil found in Western thought. They distinguished between those things that upheld order (maat), and those that did not (isfet). The real dichotomy for the Egyptians was between being and non-being, that is, those things which belonged to the created world, Maat, and that which belonged to the uncreated world of chaos, called Nun. Demons belonged to chaos. They were thought to inhabit those areas that the Egyptians associated with chaos, such as deserts, foreign places, water, night, and darkness. Demons were not able to receive the light of the sun, either because they were blind or had an "evil eye." They did not speak in comprehensible language, but in incomprehensible howling. They had a foul smell and ate excrement. Demons were never the focus of a cult, which distinguishes them from gods who were thought to be responsible for various calamities. Demons could take many forms, including a crocodile, snake, ass, jackal/dog, bull, or cat. They were frequently shown brandishing knives. They had fearsome names such as "Slaughterer," "Fighter," "Rebel," or "Black-faced One." Demons inhabited liminal areas, or were particularly dangerous at liminal times. They were particularly feared

during times of transition, such as the five days added at the end of the 360-day year of the Egyptian calendar, called the epagomenal days. They inhabited bodies of water, and were responsible for causing disease. The underworld teemed with demons that punished those who did not make the successful transition to the next life. They guarded the various gates of the underworld that the deceased had to pass, and if the dead did not know their names, they put their fearsome knives to use. Major demons included Apophis, the snake demon who threatens creation by attempting to stop the sun in its path, and Ammemet, "She who devours the dead." This goddess had a composite form, consisting of a crocodile's head, the forepart of a lion or leopard, and the hindquarters of a hippopotamus. She sat near the scales of justice, and gobbled up the heart of the unfortunate deceased individual who did not meet the requirements of justice, represented by the goddess Maat.

FOREIGN GODS. Throughout their history, the Egyptians added several foreign deities to their pantheon. During the Old and Middle Kingdoms, only one foreign god—the Nubian god Dedun—entered the Egyptian pantheon. Beginning with the Second Intermediate Period, there were several Syro-Palestinian deities worshipped in Egypt. There are several possible explanations for their appearance. The Hyksos brought their Asiatic deities with them when they entered Egypt, and identified them with Egyptian deities, such as Baal with Seth, and Anat with Hathor. Also, Egyptian traders and soldiers who went abroad brought back the gods they encountered on their travels. It was common for people to pray to the gods of the lands in which they were, and gods were thought to be portable. If an individual felt that a particular god had been beneficial to him, then he may have brought that god back with him to Egypt. During the Eighteenth and Nineteenth Dynasties, the Egyptians brought back many prisoners of war from their campaigns in Syria-Palestine, and these people would have brought their gods back with them.

MEMPHIS AND MAJOR FOREIGN GODS. Memphis, the political capital of Egypt, was a major center of the worship of foreign gods in Egypt. Among the significant foreign gods found in Egypt are Reshep, a Semitic god of plague and lightning who was thought to live in a valley south of Memphis. He was frequently associated with the Theban god Montu. At Deir el-Medina he was considered a healer god, the patron of good health and honesty. The Semitic god Baal appeared in two guises. The first was Baal of Sapan, a mountain in north Syria, who was honored as a protective deity of sailors and had his cult place at Peru-nefer, the harbor of Memphis. The

second was Baal the storm god associated with the Egyptian god, Seth. Three important foreign goddesses appeared in Egypt. They included Astarte also called Ishtar, a goddess associated with healing, love, and war often depicted on horseback. Egyptians also worshipped the foreign war goddess Anat and the Syrian goddess Qadesh, associated with sexuality and fertility.

SOURCES

Erik Hornung, "Ancient Egyptian Religious Iconography," in *Civilizations of the Ancient Near East Volume III*. Ed. Jack M. Sasson (New York: Charles Scribner's Sons, 1995): 1711–1730.

———, *Conceptions of God in Ancient Egypt: The One and the Many* (Ithica, N.Y.: Cornell University Press, 1982).

David Silverman, "Divinity and Deities in Ancient Egypt," in *Religion in Ancient Egypt: Gods, Myths, and Personal Practice*. Ed. Byron Shafer (Ithaca, N.Y.: Cornell University Press, 1991): 7–87.

EGYPTIAN MYTHS

STORIES. Myths are stories that have a beginning, middle, and end, and which describe the activities of superhuman beings. Prior to the New Kingdom, myths are scarce in Egyptian texts, but allusions to myths are numerous. The reasons for this are uncertain, but it is probably related to the types of text that have survived to modern times. Allusions to the activities of the gods are found in texts whose purpose is to provide for the successful transition of the dead into the afterlife or texts which accompany ritual activities. For these purposes, allusions to the doings of the gods are sufficient. Prior to the New Kingdom, Egyptian myths may only have been transmitted orally.

CREATION MYTHS. While mythic narratives do not appear in the Egyptian records until the New Kingdom, the frequent allusions to the activities of the gods found in the *Pyramid Texts* and *Coffin Texts* allow scholars to reconstruct a fairly comprehensive and consistent view of the earliest Egyptian stories about the gods. One of the most important categories of myth for the Egyptians was creation stories. The Egyptians believed that for existence to continue, it had to be continually recreated at each dawn, at each full moon, or each New Year. One part of the process of this recreation was to recall the first time of creation. Characteristically the Egyptians did not have only one creation account, but the creation of the universe was ascribed to several gods, and even a goddess. These creation accounts are named after the location where the creator god had a major temple.

ATUM. The earliest of all creation accounts is associated with the god Atum at Iunu (*Heliopolis* in Greek, the biblical *On*), which scholars call the Heliopolitan Cosmogony. A cosmogony is a story of how the world came to exist. In this version of creation, the universe is originally an infinite, dark, watery expanse called *Nun* or *Nuu*. Within this watery expanse, the god Atum essentially creates himself, and looks about for a place to stand. One tradition states that Atum stood on Mehetweret, a goddess in the form of a cow representing a solid emerging from the waters. According to another tradition Atum stood on the primeval hill located at Iunu, an image deriving from the emergence of land after the annual Nile flood recedes. After finding a place to stand, Atum masturbates with his hand (personified as the goddess *Iusaas*, "she who comes and grows"), and from his semen produces the first pair of gods, Shu (male) and Tefnut (female). The name Shu means void or emptiness. The meaning of Tefnut is uncertain; one tradition may associate her with moisture.

BIRTH OF MANKIND. After Atum created them, Shu and Tefnut become separated from him in the dark expanse of Nun. Atum, finding himself alone again, sends out his eye to find his missing children. While his eye is away, Atum creates another eye to take its place. When the eye returns with Shu and Tefnut, it becomes angry at its replacement. Atum then puts the eye on his forehead, where it becomes the protective, fire-spitting Uraeus snake found on the headdress of Egyptian kings and gods. A late tradition connects this event with the creation of mankind. When the eye returned with Shu and Tefnut, Atum became so happy he wept, and from his *remet* ("tears"), *remetj* ("mankind") came into being.

FATHER EARTH. Shu and Tefnut mate and give birth to the god Geb and the goddess Nut. Geb represents dry land, while his sister-wife Nut is the sky. Originally, Geb and Nut are locked in an embrace, and Geb impregnates Nut. A significant event in the creative process occurs when Shu separates Geb from Nut, thereby creating a space in which life can take place, a bubble in the expanse of Nun. This act is represented as Shu standing on a prone Geb while lifting the arching body of Nut high overhead. Shu represents the air and light separating the earth from the sky. A late text explains why Shu separated Geb and Nut; apparently they were quarreling because Nut kept swallowing her own children, that is, every morning the stars disappeared. Shu stepped in to stop the quarreling. One important aspect of this myth is the gender of the earth and sky. In most societies the earth was thought of as female (mother earth) and the sky as male. In Egypt, this im-

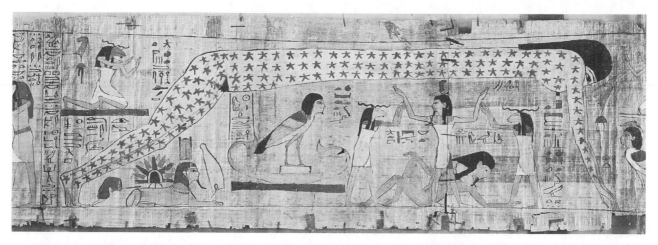

Papyrus drawing of the separation of the Sky and Earth. Shu, the god of air, stands on the prone Geb, the god of the earth, while lifting Nut, the goddess of the sky, overhead. GIRAUDON/ART RESOURCE, NY.

agery is reversed. This reversal was probably due to the source of moisture in Egypt. In most places the land depends on rainfall, seen as the semen of the sky god, for fertility. In Egypt, the fertility of the land did not depend on rainfall, which was scarce in Egypt, but rather on the rising floodwaters of the Nile. Since the earth was considered to be the source of these waters, it would follow that the earth was male.

THREAT OF EXISTENCE. Another important aspect to this myth is the precariousness of the continued existence of the world. All life as the Egyptians knew it took place within the bubble created by the bodies of Geb and Nut separated by Shu. This bubble existed within the vast realm of chaos, Nun. At any point, the sky could come crashing down on the earth, obliterating all life and returning everything to Nun. Magical spells threatened to cause this to come about if the practitioner did not gain what he desired. Rituals were carried out in Egyptian temples in order to prevent this watery chaos—represented by the serpent Apophis—from overcoming Re—the sun god. In one passage in the *Book of the Dead*, Atum, in dialogue with Osiris, says that one day "this land will return to Nun, to the flood, like it was before."

HELIOPOLITAN ENNEAD. Geb and Nut eventually give birth to two gods, Osiris and Seth, and two goddesses, Isis and Nephthys. Osiris and Isis give birth to the god Horus. The myths surrounding these deities belong to the funerary mythology. The birth of these gods completes the Heliopolitan Ennead, or group of nine gods: Atum, Shu, Tefnut, Geb, Nut, Osiris, Isis, Seth, and Nephthys. Horus, the tenth member of the Ennead, is a later addition.

HERMOPOLIS CREATION STORY. Another version of the creation story is associated with the town of Hermopolis, modern Ashmounein in Middle Egypt. This account centered on the Hermopolitan Ogdoad, or group of eight gods. These deities were grouped in pairs of male-female gods with three constant pairs: Nun and Naunet (primeval water, formlessness), Heh and Hehet (spaciousness), and Kek and Keket (darkness). The identity of the fourth pair varies in different texts. At times it is Tenem and Tenemet (confusion and gloom). It can also be Gereh and Gerehet (completion) or Niu and Niut (void). Eventually, the god Amun and his female counterpart Amaunet, representing concealment, become the customary fourth pair in the Ogdoad. The gods of the Ogdoad all represented characteristics of the chaos that existed before creation. A late tradition associates the origin of these gods with Amun's main city, Thebes. The serpent god Kematef, "he who accomplishes his time" had a son, another snake god, Irta "he who makes the land." Irta traveled from Thebes to Hermopolis, where he created the Ogdoad. Another late tradition describes Thoth as the creator of the Ogdoad. The gods of the Ogdoad were depicted as frog-headed (male) and snake-headed (female) humans.

CREATION OF THE SUN. When the primeval hill, called the *iu neserer* ("island of flame"), arises out of chaos, the Ogdoad comes together and creates the sun on this hill. Building inscriptions tell us that there was once a shrine called the "island of flame" at Hermopolis, but its location has yet to be determined. The Ogdoad was said to create the sun in two ways. One tradition says that the Ogdoad came together and created an egg on the primeval hill. The goose that laid this egg, called the Great Cackler, came to be associated with

Amun. Amun can occasionally be found depicted on stelae from Deir el-Medina as a goose, at times accompanied by eggs. An inscription from the tomb of Petosiris, dated to the fourth century B.C.E., claims that the shell of this egg was buried at Hermopolis.

LAKE OF ORIGIN. Another version of the creation of the sun arose during the Ptolemaic Period. In this account, the sun emerges from the opening blossom of a lotus. The male members of the Ogdoad were said to have placed their semen in the waters of Nun. This semen traveled to a vegetable ovary called benen, which was also the name of the temple to Khonsu at Thebes. In the hieroglyphic script, benen is represented as an egg. This egg is the contribution of the female members of the Ogdoad. The place where the egg was fertilized was called the "lake of origin." From the benen, a lotus sprouts, and takes root on the island of flame. When the lotus blossom opens, the sun rises, depicted as a child sitting inside the flower. The association of the lotus blossom and the sun arises from the fact that the Egyptian blue lotus sinks underwater at night, and rises and opens at daylight.

DEATH OF THE GODS. The remainder of the cosmology is not detailed. The sun-god created the gods from his mouth, mankind from his tears, and cattle from his limbs. After the Ogdoad completed their work of creation, either by creating the egg or lotus blossom, they traveled to Thebes, where they died. They were buried at Medinet Habu, Edfu, and Esna. At these locations they were the recipients of a funerary cult.

MEMPHITE THEOLOGY. Another cosmogony, called the Memphite Theology, is preserved in only one text, known as the *Shabaka Stone*, after the Twenty-fifth Dynasty king who had it carved. Because of the archaic nature of the writing and language, scholars thought that this text originated in the early Old Kingdom. Subsequent studies have shown that the text cannot be earlier than the New Kingdom, perhaps dating to the reign of Ramesses II. One scholar even suggested that the text should be dated to the time of the copy, that is, to the Twenty-fifth Dynasty. Such a discrepancy in assigning a date to the text arises from the fact that Egyptian scribes would copy and re-copy religious texts for hundreds, and in some cases, thousands of years. The existence of only one copy of a text makes it difficult to be certain when the text originated. For example, some Ptolemaic funerary papyri contain examples of *Pyramid Texts*, and if it were not for copies from the Old Kingdom pyramids it would be impossible to determine how old these texts really were. Another problem in dating texts is that the Egyptians would deliberately write in an archaic style and attribute a text to an ancient author to lend the text an aura of antiquity, and therefore enhance its authority.

PTAH. The main actor in the Memphite Theology was the god Ptah. Ptah was originally a patron god of craftsmen and artisans. By the New Kingdom he had increased in importance to become a universal creator god. Hymns call him the father of the fathers of all the gods, possibly a reference to the Hermopolitan Ogdoad, who were called the fathers of the gods. Hymns further describe him as the one who carries Nut and lifts up Geb, equating him with Shu. Ptah is said to have brought about creation by first planning it in his mind—literally the heart—and then by speaking the name of everything and calling it into existence. The Memphite Theology has received considerable attention because it is similar to the Judeo-Christian tradition of creation through speaking seen in the biblical description of creation in Genesis and the opening of the Gospel of John, in which the creative word is emphasized rather than the physical methods of creation employed by the other Egyptian creator gods.

ESNA COSMOGONY. The final cosmogony to be discussed merits mention because, unlike the other creation accounts examined so far, the creator in the Esna Cosmogony is not a god, but the goddess Neith. This cosmogony is found on the walls of the Temple of Khnum at Esna and dates to the period of the Roman emperor Trajan (98–117 C.E.). This creation story borrows significantly from earlier accounts. Neith is the first being to emerge from Nun. She changes herself into a cow, and then a *lates*-fish, also known as Lake Victoria perch. These images derive from the cult of Neith. She was worshipped in the form of a cow and lates-fish at Esna. Neith creates a place for herself to stand, and then turns herself back into a cow. She pronounces thirty names, which become thirty gods to help her in the process of creation. These gods are said to be *hemen* ("ignorant"), and they then transform themselves into the *hemen* ("Hermopolitan") Ogdoad. The story thus rests on a word play between two words that sounded similar but had different meanings. Neith then creates the sun-god through producing an excrescence from her body and placing it in an egg, which hatches as Re, the sun, who promptly takes the name of Amun. Amun then continues the act of creation through emanations from his body, creating the *netjeru* ("gods") from his saliva, and *remetj* ("mankind") from his *remt* ("tears"). This explanation demonstrates the Egyptian belief that puns reveal some basic, underlying truth.

SOURCES

James P. Allen, *Genesis in Egypt: The Philosophy of Ancient Egyptian Creation Accounts* (New Haven, Conn.: Yale Egyptological Seminar, 1988).

Rudolf Anthes, "Mythology in ancient Egypt," in *Mythologies of the Ancient World*. Ed. Samuel Noah Kramer (Garden City, N.Y.: Anchor Books, 1961): 15–92.

Leonard Lesko, "Ancient Egyptian Cosmogonies and Cosmology," in *Religion in Ancient Egypt: Gods, Myths, and Personal Practice*. Ed. Byron Shafer (Ithaca, N.Y.: Cornell University Press, 1991): 88–122.

John Wilson, "Egypt," in *The Intellectual Adventure of Ancient Man*. Ed. Henri Frankfort (Chicago: University of Chicago Press, 1946): 31–61.

SEE ALSO *Philosophy: Cosmogony: The Origin of the World*

MYTH OF OSIRIS

ORIGIN. An important series of myths involved the god Osiris. Osiris played an important role in Egyptian mythology as the god of the underworld and judge of the dead. As a *chthonic* ("earth") deity, he also became associated with the fertility of the earth. Osiris first appears in Egyptian texts at the end of the Fifth Dynasty (2500–2350 B.C.E.), when he is mentioned in both inscriptions in private mastabas (tombs) and in the *Pyramid Texts* found in Unas' pyramid. His name was written with the hieroglyph of an eye surmounting a throne, and this combination has given rise to much speculation as to the origin and meaning of the name Osiris. At this point, there is no agreement about the significance of the name or its spelling. The simplest etymology would connect his name to the Egyptian word *weser*, meaning "mighty," making Osiris the "mighty one."

FERTILITY AND THE UNDERWORLD. Osiris was not originally viewed in a positive light. He may have been the god of the unsuccessful dead, that is, those who did not ascend to the sky to become a star or gain a spot in Re's barque (sailing vessel). Osiris seems to have originally been thought of in the form of a dog, based on a *Pyramid Text* passage which states that the king has the face of a jackal, like Osiris. Osiris quickly lost this form, however, and his earliest depictions show him as a mummiform human with his hands protruding from the mummy bandages and gripping the symbols of kingship, the crook and flail. He is frequently shown wearing the white crown of Upper Egypt, or the Atef-crown. His face and hands are often painted green, representing his association with fertility, or black, a color associated with the underworld.

ASSOCIATION WITH DEAD KINGS. Whatever Osiris' origin, the *Pyramid Texts* show that by the end of the Fifth Dynasty (2350 B.C.E.) the dead king was identified with Osiris. These texts frequently refer to the dead king as the Osiris N (representing the name of the dead king). As such, the king had gone from being the king of Egypt to being the king of the underworld. In these texts, the first allusions to the myth of Osiris are found, which are not recorded in narrative form until the first century C.E., when the Greek writer Plutarch recorded the myth. In this version, Osiris was a king of Egypt who was murdered by his jealous brother Seth. How this takes place is uncertain. Some texts refer to Osiris as being "thrown down" in the town of Nedyet in the land of Gehesty, while others refer to Osiris being drowned in the water of Djat. There may also be references to the dismemberment of Osiris. In the Greek version, Seth throws a banquet, and offers an exquisitely carved chest to whoever can fit inside it. When Osiris climbs into the chest, Seth slams it shut, seals it with molten lead, and throws it into the Nile. From there, it makes its way along the currents to the shores of Lebanon, where it becomes enfolded in the trunk of a tree, which is used as a column of a temple by the king of Lebanon.

FIRST MUMMY. All versions of the myth include the search and discovery of Osiris' body. There are some indications in the *Pyramid Texts* that his father Geb found Osiris' body. Most commonly, however, his sister-wife Isis and sister Nephthys discover the body of Osiris. They are able to restore the body to life just long enough to allow Osiris to impregnate Isis with his son and heir, Horus. In later versions of the myth, the god Anubis transforms the corpse of Osiris into the first mummy, and he serves as the prototype of the treatment all deceased Egyptians wished to receive. According to the Greek version of the story, Isis leaves the chest containing the body of Osiris in Buto while she attends to her newborn child. Seth discovers the chest, becomes enraged, and dismembers the body of Osiris, scattering the pieces throughout Egypt. Isis finds each part and buries it. This provides an explanation for the numerous tombs of Osiris found up and down the Nile. Osiris then assumes his permanent position as ruler of the underworld.

CULT. The major cult center of Osiris was Abydos. Originally, this city was the cult-center of the jackal-god of the dead Khentiamentiu, "foremost of the Westerners" (i.e., the dead). During the Fifth and Sixth Dynasties, however, Khentiamentiu became assimilated with Osiris. Beginning in the Twelfth Dynasty (1938–1759

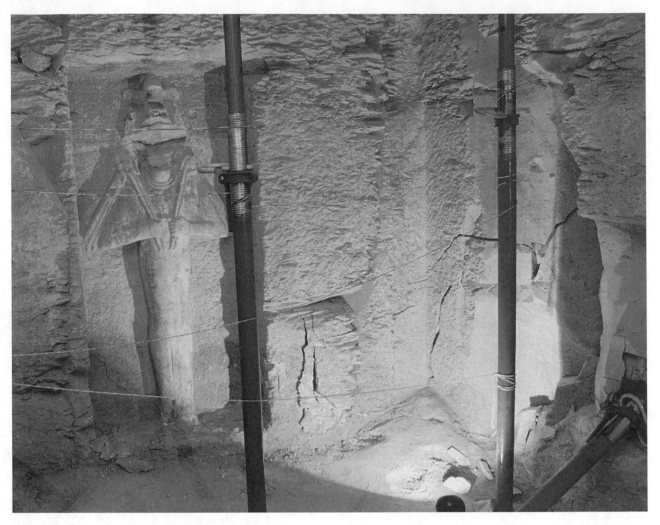

Depiction of Osiris, the ancient Egyptian god of the underworld, inside a tomb located in the Valley of the Kings near Luxor, Egypt. © AP/WIDE WORLD PHOTOS, INC. REPRODUCED BY PERMISSION.

B.C.E.), his temple at Kom el-Sultan was taken over by Osiris. Also in the Twelfth Dynasty, the First-dynasty (3100–2800 B.C.E.) mastaba of King Djet in Abydos was mistakenly interpreted as the tomb of Osiris. Every year, Abydos was the site of a huge festival during which a dramatic presentation of the myth of Osiris took place. In order to participate vicariously in this festival, kings would build *cenotaphs* ("false tomb memorials") for themselves at Abydos. Along the festival route, private individuals erected small chapels for themselves. These chapels, called *mahat*, could contain a small stele or statue of the owner. This object would become the conduit through which the individual could magically share in the bounty of the festival.

SOURCES

J. Gwyn Griffiths, *The Origin of Osiris and his Cult* (Leiden, Netherlands: E. J. Brill, 1980).

Eberhard Otto, *Egyptian Art and the Cults of Osiris and Amon* (London: Thames and Hudson, 1968).

SEE ALSO *Music: Musical Deities; Theater: The Osirian Khoiak Festival Drama*

MYTHS OF HORUS, SETH, AND AMUN

HORUS THE SKY GOD. Horus, in the form of a falcon, or falcon-headed human, is one of the oldest gods of the Egyptian pantheon. He was the god of the sky, whose right eye was associated with the sun, and whose left eye was the moon. A First-dynasty (3100–2800 B.C.E.) comb found in a tomb shows the sky as the two wings of a bird, probably Horus. Horus was also associated with the king, and from the First Dynasty onwards one of the king's names was preceded by the Horus fal-

con, making the king the earthly embodiment of the cosmic Horus.

BATTLE WITH SETH. In the earliest version of the myths surrounding Horus, he was involved in a struggle with his brother, Seth, for the throne of Egypt. This is apparently a reflection of the political situation in which the city of Hierakonpolis (a major cult center for Horus) gradually expanded and engulfed the town of Nagada (ancient Ombos), a center of Seth-worship. This version of the myth must be reconstructed from allusions in the *Pyramid Texts*. For unstated reasons, Seth attacks Horus, and a violent struggle ensues. Horus loses an eye, and Seth loses his testicles. Eventually, the missing pieces are restored to their rightful owners, and the two gods go before a tribunal of the gods of the Heliopolitan Ennead, with either Geb or Atum presiding. The verdict of this tribunal is that Horus is the rightful ruler of Egypt, because he is the older of the two.

SON OF OSIRIS. With the entrance of the god Osiris into the Egyptian pantheon, the protagonists in the myth shift roles. When Osiris becomes equated with the dead king, the living king, Horus, comes to be thought of as the son of Osiris, since the dead king was usually the father of the living ruler. The conflict between Horus and Seth then shifts to become a conflict between Osiris and Seth, and serves to explain why Osiris is dead. He was killed by his brother Seth. Horus then assumes the role of a son avenging the wrong done to his father and fighting for his rightful inheritance, which in this instance is the throne of Egypt. Horus also takes on two aspects: Horus the elder, ruler of Egypt, and Horus the Child (Greek, Harpokrates), the son of Osiris and Isis. Hence, the purpose of the trial before the gods serves two purposes: the need to punish Seth for the murder of Osiris as well as the need to determine who should inherit the kingdom of Egypt from Osiris.

BATTLE FOR INHERITANCE. The New Kingdom story "The Contendings of Horus and Seth" is a narrative detailing the events which take place during the trial of Horus and Seth before Atum and the gods of the Ennead. Unlike earlier myths, this one leaves out the issue of Seth killing Osiris and deals strictly with the issue of inheritance. Each god has his supporters, and the tribunal's judgement sways first one way, and then the other. The gods appear to be petty, petulant bickerers who cannot make up their minds. Finally, Seth suggests a contest between the two. They are to transform themselves into hippopotamuses to see who can stay submerged underwater the longest. Due to Isis's interference, first on one side and then the other, the contest is indecisive. Seth then commits a sexual assault against Horus, intending to call forth his semen from Horus' body in the presence of the judges, thereby demonstrating his superiority over Horus. Again, Seth's efforts are thwarted by Isis, who rids Horus of Seth's semen, and tricks Seth into unwittingly ingesting Horus' semen. Finally, in desperation, Seth suggests the two gods build and race boats of stone, with the winner being declared the rightful heir. Seth proceeds to build a boat of stone, while Horus builds his boat of pine wood plastered over with gypsum to give it the appearance of stone. When the race begins, Seth's boat sinks while Horus' continues on the course. Seth transforms himself into a hippopotamus and scuttles Horus' boat. Again, there is no clear winner. Finally, the judges decide to write a letter to Osiris, and ask who he would have as his heir. Osiris chooses Horus, who becomes the ruler of all Egypt. Since in this myth Seth is not guilty of killing his father, he is given the consolation prize of being sent to live in the sky with Re, where he becomes the god of storms and thunder.

POISONED CHILD. Another series of stories relate the events of Horus' childhood. After Isis finds herself pregnant by Osiris, Re-Atum suggests she hide this fact from Seth, lest he try to destroy the infant Horus. When Horus is born, Isis hides him in the marsh at Khemmis. Isis leaves the infant alone while she goes in search of food. When she returns, she finds the baby weak and unable to suckle. A local wise woman diagnoses the child as suffering from a poisonous sting, either of a scorpion or snake. Isis cries out for help, and the sound of her anguish brings even Re in his solar barque to a stop. The god Thoth arrives to aid Isis, and recites spells which remove the poison from the child. Texts describing such events in the life of the infant Horus were carved on stone stelae known as *cippi*. These stelae depicted the infant Horus standing on the backs of crocodiles, grasping snakes, scorpions, and other dangerous animals by the tails. Water poured over the stele was thought to absorb the power of the spells, and was drunk by those seeking a cure for snake bite or scorpion sting.

AMUN, HIDDEN ONE. Amun, whose name means "the hidden one," was originally associated with the area of Thebes. When Theban families rose to prominence and became the rulers of all Egypt, first in the Twelfth Dynasty (1938–1759 B.C.E.) and again in the Eighteenth Dynasty (1539–1292 B.C.E.), Amun's power and influence also increased. As the Eighteenth-dynasty kings expanded Egypt's empire into Asia, they attributed their successes to Amun's blessings, and rewarded

Arts and Humanities Through the Eras: Ancient Egypt (2675 B.C.E.–332 B.C.E.)

219

his priesthood accordingly. Eventually, Amun, joined with Re to form the god Amun-Re, rose to become the state god of Egypt, known as Amun-Re, king of the gods, lord of the thrones of the two lands. During the Third Intermediate Period (1075–656 B.C.E.), the priesthood of Amun at Thebes became the virtual rulers of southern Egypt, and one of the most important priestly offices was that of God's Wife of Amun.

SELF-BIRTHING GOD OF AIR. Egyptian artists usually depicted Amun as a human wearing a cap adorned with two tall, multi-colored feathers. His skin is blue, perhaps related to Amun's association with the wind and air. His principle cult center was at Karnak, where he was worshipped in conjunction with his consort Mut, a goddess representing motherhood, and their son Khonsu, whose name means "the wanderer" and represents the moon. Amun was associated with the ram and goose. In the Hermopolitan cosmogony, Amun is one of the sixteen gods representing the state of the world before creation. Egyptologists gave it this name because it is thought to have originated in Hermopolis, before being transferred to Thebes. The gods of this cosmogony form an Ogdoad, or group of eight pairs of deities. This group includes Nu(n) and Naunet (representing the primeval water and formlessness), Huh and Huhet (spaciousness), Kek and Keket (darkness), and Amun and Amaunet (concealment). Another tradition describes how Amun, in his form of Kematef (a serpent deity), fathers the Ogdoad. This idea of Amun being his own progenitor, and therefore having no creator, is also encountered in the form of Amun Kamutef, "Amun, bull of his mother." This epithet states that Amun was his own father. Amun was closely associated with kingship. Reliefs from New Kingdom temples describe a myth in which Amun falls in love with the queen of Egypt. He visits her in the guise of her current husband, the reigning king, and fathers the next king of Egypt. When the child is born, Amun acknowledges his paternity, and presents the child to the gods as the future king of Egypt.

SOURCES

Jan Assmann, *Egyptian Solar Religion in the New Kingdom. Re, Amun and the Crisis of Polytheism* (London: Kegan Paul International, 1995).

J. F. Borghouts, *Ancient Egyptian Magical Texts* (Leiden, Netherlands: E. J. Brill, 1978).

J. Gwyn Griffiths, *The Conflict of Horus and Seth* (Liverpool, England: University Press, 1960).

E. Otto, *Egyptian Art and the Cults of Osiris and Amon* (London: Thames and Hudson, 1968).

Geraldine Pinch, *Magic in Ancient Egypt* (Austin: University of Texas Press, 1994).

THEOLOGY

DEEDS OF THE CREATOR GOD. According to Egyptian mythology, the gods were responsible for the creation and sustaining of the world and everything in it. One question that needed to be worked out, however, was the nature of the gods' continuing relationships with their creations, particularly man. In the Middle Kingdom (2008–1630 B.C.E.) text known as the *Teachings for Merykare*, the king's father explains the creator god's actions on behalf of man. After establishing order by vanquishing chaos (described as the "water monster"), the god provides breath and light for his children. For food, he provides them with plants, cattle, fowl, and fish. The creator god continues to take an interest in his creation, and every day he watches them as he sails through the sky. When they are sad, he takes notice. In order to aid his children, the god provided them with rulers to protect the weak, and perhaps most importantly, with *heka* ("magic") "to ward off the blow of events."

EVIL. But if the gods created the world, and outfitted it for the benefit of man, how is it that it contains elements which are inimical to man? Here scholars encounter the Egyptian view of theodicy, how to account for the presence of evil in a world created by the gods. In the Egyptian view, *isfet* ("evil") was not the creation of the gods. Evil resulted from the actions of mankind. Egyptian texts contain several references to a rebellion by mankind. In the text from the time of Merykare it is said that the creator god "slew his foes, reduced his children when they thought of making rebellion." In a passage from the Middle Kingdom *Coffin Texts* Spell 1130, the creator god states that "I made every man like his fellow, but I did not command that they do evil. It is their hearts that disobey what I have said."

BOOK OF THE HEAVENLY COW. More references to a rebellion of mankind find mythological expression in the New Kingdom composition known as the *Book of the Heavenly Cow*. This text appeared first in the tomb of Tutankhamun (1332–1322 B.C.E.), and thereafter in several royal tombs of the New Kingdom. The text states that at one time Re ruled as king over gods and men. When Re grew old, mankind began to plot against him. Re summoned the other gods to a meeting to discuss his response to mankind's actions. In the story, Nun advises Re to send his fiery eye (Hathor) to destroy those who plotted against him. Hathor undertakes her task with rel-

ish, and kills those conspirators who had fled into the desert. Before Hathor can complete the job of destroying mankind, Re has a change of heart. He concocts a plan to get Hathor drunk on what she thinks is human blood, and in her altered state she fails to continue in her destructive work. Re preserves mankind, but as a result of their rebellion he withdraws to the sky on the back of his daughter, Nut, the sky, who takes the form of a cow.

FATE. The ancient Egyptians believed that at birth, a person's name, profession, length of life, and time and manner of death were assigned by a god or goddess. Some texts describe the manner of death of an individual as decreed by deities referred to as the Seven Hathors. In *The Doomed Prince*, the Seven Hathors attend the birth of a prince, and decree that he shall die by means of a crocodile, a snake, or dog. In *The Story of Two Brothers*, the Seven Hathors attend the creation of a wife for one of the brothers, Bata, and decree that she shall die through execution by means of a knife. In the Middle Kingdom *Khufu and the Magicians*, Re sends the goddess Meskhenet to attend the birth of his three children, and to decree that each will in turn assume the kingship of all Egypt. Other deities involved with determining a person's fate include the goddess Shay, the personification of fate who was thought of as allotting a person's length of life and manner of death, and Renenet, the goddess of harvest and fertility. Renenet could assume the form of a woman suckling a child or of a serpent, and was thought of as assigning those physical aspects of a person that seem to be beyond an individual's control, such as height, weight, complexion, and even material goods and prosperity. Gods were also thought to control fate, and Amun, Khnum, and Horus were each said to assign an individual's fate. In a text known as *A Calendar of Lucky and Unlucky Days*, a particular date is listed as being lucky or unlucky based on mythological events which were thought to have occurred on that date. Some dates contain a notation that assigns a particular fate to anyone born on that date. Anyone born on day three of the first month of Akhet would die by a crocodile, while anyone born on day six of the second month would die on account of drunkenness. Day five preserves a particularly interesting fate; one born on that date was fated to die "of copulation." The extent to which one's decreed fate was unalterable is uncertain. In *The Doomed Prince* mentioned above, the flow of the narrative seems to suggest that the prince will eventually escape his three ordained fates, but since the end of the papyrus is missing, this conclusion cannot be certain.

a PRIMARY SOURCE *document*

EVIL IN INSTRUCTION FOR MERYKARE

INTRODUCTION: *The Teachings for Merykare* primarily discusses the king's obligations to his people. In one digression, however, the author describes both creation and the way that evil entered the world through mankind's rebellion against the gods.

Well tended is mankind—god's cattle,
He made sky and earth for their sake,
He subdued the water monster,
He made breath for their noses to live.
They are his images, who came from his body,
He shines in the sky for their sake;
He made for them plants and cattle,
Fowl and fish to feed them.
He slew his foes, reduced his children,
When they thought of making rebellion.
He makes daylight for their sake,
He sails by to see them.
He has built his shrine around them,
When they weep he hears.
He made for them rulers in the egg,
Leaders to raise the back of the weak.
He made for them magic as weapons
To ward off the blow of events.

SOURCE: "Instruction for Merykare," in *The Old and Middle Kingdoms*. Vol. 1 of *Ancient Egyptian Literature*. Trans. Miriam Lichtheim (Berkeley and Los Angeles: University of California Press, 1973): 106.

SOURCES

Jan Assmann, *The Mind of Egypt* (New York: Metropolitan Books, 2002).

Bob Brier, *Ancient Egyptian Magic* (New York: Quill, 1981).

Susan Tower Hollis, *The Ancient Egyptian "Tale of Two Brothers"* (Norman, Okla.: University of Oklahoma Press, 1990).

Frank T. Miosi, "God, Fate and Free Will in Egyptian Wisdom Literature," in *Studies in Philology in Honour of Ronald James Williams*. Eds. Gerald Kadish and Geoffrey Freeman (Toronto: SSEA Publications, 1982): 69–111.

ANIMALS IN EGYPTIAN RELIGION

SIGNIFICANCE. Animals played an important role in Egyptian religion. Most of the Egyptian gods could at times be depicted either as an animal or as an animal-headed

CLEMENT OF ALEXANDRIA ON EGYPTIAN RELIGION

INTRODUCTION: Clement of Alexandria (died 215 C.E.) was an early Christian theologian. He wrote about Egyptian religion to discredit it for the Christian faithful living in Egypt in his own time when Egyptian paganism still thrived. Yet it is possible to derive some facts about the Egyptian cult from his writings in spite of his prejudices.

The temples [of the Egyptians] sparkle with gold, silver and mat gold and flash with colored stones from India and Ethiopia. The sanctuaries are overshadowed by cloths studded with gold. If, however, you enter the interior of the enclosure, hastening towards the sight of the almighty, and look for the statue residing in the temple, and if a [priest] or another celebrant, after having solemnly looked round the sanctuary, singing a song in the language of the Egyptians, draws back the curtain a little to show the god, he will make us laugh aloud about the object of worship. For we shall not find the god for whom we have been looking inside, the god towards whom we have hastened, but a cat or a crocodile, or a native snake or a similar animal, which should not be in a temple, but in a cleft or a den or on a dung heap. The god of the Egyptians appears on a purple couch as a wallowing animal.

SOURCE: "The Cult of the Ibis in the Graeco-Roman Period," in *Studies in Hellenistic Religions*. Ed. M. J. Vermaseren. Trans. K. A. D. Smelik (Leiden, Netherlands: E. J. Brill, 1979): 225–226.

human. Since the Egyptians apprehended their gods through the natural world, it is not surprising to find that animals were viewed as manifestations of the divine. Several theories have been suggested as to why this was the case. The American scholar Henri Frankfort suggested that it was the apparently unchanging nature of the animals that impressed the Egyptians. From generation to generation, humans exhibit changes in appearance, while animals appear the same. An important element in Egyptian theology was that the perfect pattern of existence had been established by the gods at the time of creation, called the *sep tepi*, "the first time," and it was important that this pattern be maintained. Animals would seem to have been more successful than man at maintaining their form established at the first time. The German Egyptologist Hellmut Brunner suggested

alternatively that it was the animals' possession of superhuman powers, such as flight, speed, stealth, heightened senses, and strength that made the Egyptians perceive them as beings through whom the gods were manifest. One thing is certain: the Egyptians did not see a wide gulf separating gods and humans from the animals. The creative powers of the mind and tongue were thought to be operative in the gods, mankind, and animals equally. A hymn to Amun states that he cares even for worms, fleas, mice in their holes, and insects. The First Intermediate Period (2130–2008 B.C.E.) nomarch Henqu states that not only did he give bread to the hungry and clothing to the naked in his nome, but he also provided the jackals of the mountains and the birds of the sky with food, putting good deeds towards humans and animals on the same level. Given the close association between animals and the gods, it is not surprising that animals could be worshipped, not as gods but as the means through which the gods manifested themselves, much as a statue was worshipped as a vehicle through which the god was manifest. This distinction was lost on the Greeks, who, when they encountered Egyptian religion, thought the Egyptians were worshipping the animals as their gods, as the ancient Greek author Clement of Alexandria (died 215 C.E.) described.

SACREDNESS. Evidence for the veneration of animals dates back to the fourth millennium B.C.E. Predynastic burials of gazelles, dogs, cattle, monkeys and rams have been found at the villages of Badari and Nagada in southern Egypt, and Maadi and Heliopolis in northern Egypt. The care taken in the burial of these animals, and the fact that they were buried with grave goods, is considered to be evidence for a cult of sacred animals in Egypt at this early date. The earliest mention of a particular sacred animal, the Apis bull, dates to the reign of Aha, the first king of the First Dynasty (3100–2800 B.C.E.). During the Twenty-sixth Dynasty (664–525 B.C.E.) the cult of sacred animals received renewed emphasis, perhaps an expression of a resurgence of Egyptian nationalism after Kushite rule in the Twenty-fifth Dynasty (760–665 B.C.E.). Animal cults reached their acme during the rest of the Late Period (664–332 B.C.E.) and Ptolemaic Period (332–30 B.C.E.). Most of the large animal necropolises date to the latter period.

CLASSIFICATION OF SACRED ANIMALS. There were three types of sacred animal in ancient Egypt. One type is the temple animal. These animals performed the same function as cult statues, and were considered vessels through which the gods could make their wills manifest. These animals lived in or near a temple and were distinguished by special markings. For example, the Apis

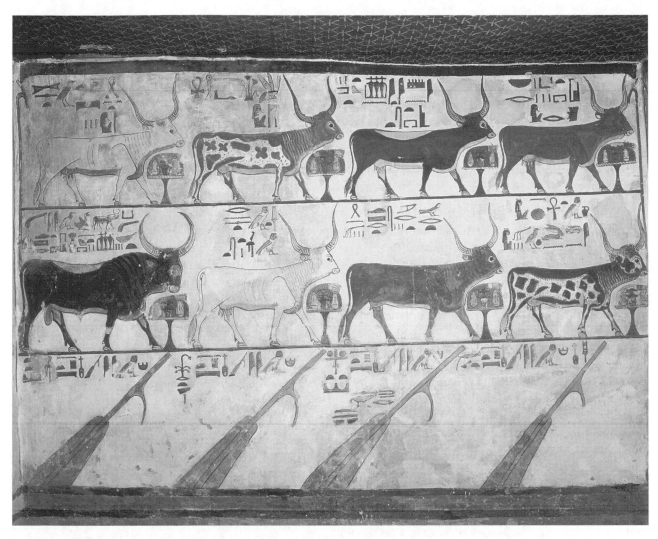

The seven celestial cows and one sacred bull, painted limestone relief in the tomb of Nefertari, chief royal wife of Ramesses II from her tomb in the Valley of the Queens at Thebes, 19th Dynasty. **THE ART ARCHIVE/DAGLI ORTI.**

bull, who lived at Memphis, was a bull with a white triangle on its forehead, a crescent moon on its chest and another on its flanks, and double hairs, black and white, in its tail. The Apis bull was thought to be the ba, or manifestation, of the god Ptah. At certain times of day the bull was released into a courtyard where worshippers would gather to see him and receive oracles. People could put a yes-or-no question to the bull, and the answer was received when the bull entered one of two stables. When the bull died, there was a time of widespread mourning, and an elaborate embalming and burial ceremony was performed. The Apis bull was buried in a stone sarcophagus in a mausoleum known as the Serapeum at Saqqara. The search for the new Apis bull then began. Other examples of such temple animals include the Mnevis bull at the Temple of Atum-Re at Heliopolis, the Buchis bull of the Temple of Montu at Hermonthis,

the ram at the Temple of Osiris-Re at Mendes, and the ram of the Temple of Khnum at Elephantine.

SAME SPECIES. The second type of sacred animals were animals that belong to the same species as the temple animal. These animals were not thought to be special manifestations of particular gods, but because the god or goddess could appear in the guise of one of these animals, others of the same species were considered dear to the god. Large numbers of these animals could be kept near a temple. At Saqqara there was an extensive complex of buildings dedicated to the care of flocks of ibises associated with Thoth, falcons associated with Horus, and cats associated with Bast. Such large collections of animals served as the source of the enormous number of animal mummies that have been preserved. Sacred animal necropolises throughout Egypt contain literally millions of mummified animal burials. In addition to the

ibis necropolis at Saqqara, there are necropolises for cats at Bubastis; rams at Elephantine; crocodiles, snakes, falcons, and ibises at Kom Ombo; and ibises and falcons at Abydos. Other animals that were buried include sheep, dogs, baboons, jackals, fish of several species, shrews, scorpions, and scarab beetles. The main difference between temple animals and animals of the same species is there was only one temple animal at a time; the temple animal received a cult, while these animals did not, and the mortuary services for the temple animals were much more elaborate.

MUMMIES AS VOTIVE OFFERINGS. The reason for the mummification and burial of such enormous numbers of animals in ancient Egypt is related to their association with the gods. People who visited the various temples during festival periods were anxious to make an offering to the god in an attempt to earn his blessing. One acceptable votive offering was the mummified remains of an animal associated with the god. A prayer inscribed on a jar containing an Ibis mummy asked Thoth to be benevolent towards the woman who had embalmed his sacred animal. Of course, most such offerings took place during festivals. In order to ensure a plentiful supply of animals for pilgrims, the priests were not adverse to hastening the death of an animal. At this point, the extent of this practice is uncertain. The one population of animal mummy that has been systematically studied is cats. An examination of their mummies at the British Museum reveals that the majority of them died either at two or four months old, or between nine and twelve months. The average lifespan of a cat should have been around twelve years. In addition, a common cause of death among the cats was a dislocation of the cervical vertebrae, which could be the result of violently twisting the head of an animal until its neck broke. Other cat mummies show evidence of head trauma from a blow. Apparently the sacredness of these animals to the gods did not prevent the priests from doing what was necessary to supply a pilgrim with a mummified animal.

PRIVATE ANIMALS. The third type of sacred animals were members of the same species as the temple animal which were kept in private homes as representatives of the gods. For example, snakes, cats, or dogs were often kept in homes and buried at their deaths. This practice is analogous to the construction of household shrines to allow for domestic worship.

SOURCES

Jaromir Malek, *The Cat in Ancient Egypt* (Philadelphia: University of Pennsylvania Press, 1993).

H. te Velde, "A Few Remarks upon the Religious Significance of Animals in ancient Egypt," in *Numen* 27 (1980): 76–82.

THE KING

DIVINE STATUS. The king of Egypt was the only living person who possessed the status of a *netjer* ("god"). He could be called "the good god," the "great god," or simply "god." Because of the king's special status, he could serve as the link between the world of the gods and men. The king was the only mortal who could directly approach the gods. The temples throughout Egypt show only the king performing the rituals. This was a polite fiction, because in reality the king commissioned the priests to act in his stead. The king's "divinity" (for lack of a better word—"netjer-hood" would be more appropriate, but is too cumbersome), however, is different from that of the gods. The king's divinity was an acquired status, bestowed when he ascended the throne. Beginning with his coronation, and extending throughout his reign, the king participated in rituals designed to reinforce and strengthen his divine status.

DESCRIPTIONS. The Egyptians had many ways of describing the king's unique nature. He could be called a god, the son of a god, the image of a god, or he was described as like a god. For example, one text describes Merneptah (r. 1213–1204 B.C.E.) as "the good god that lives on Maat … son of Kheperi [a form of the sun], descendant of the Bull of Heliopolis [probably a reference to Amun, Re, or Atum], … born of Isis." A text describes Redjedef (r. 2560–2555 B.C.E.), the third king of the Fourth Dynasty and the successor of Khufu, as the first king to be called the Son of Re. From this point on, every king has a "Son of Re" name, usually his birth name, which was one of the king's two names enclosed in a cartouche (an oval or oblong figure enclosing the king's names). This king's status as the son of a god is explained in the text called *Khufu and the Magicians*, where the first allusion to the myth of the king's divine birth are found. The text contains references to Ruddedet, the wife of a priest of Re, who was impregnated by Re himself. She gave birth to triplets who grew up to be the first three kings of the Fifth Dynasty (2500–2350 B.C.E.). Later, in the Eighteenth Dynasty, Hatshepsut (r. 1478–1458 B.C.E.) had a set of reliefs carved in her temple at Deir el Bahri depicting the myth of her divine birth. The myth relates that the god Amun, in the guise of her father Thuthmosis I, visited her mother one night. As a result of their union, Hatshepsut was conceived. The myth of the divine birth of the king was not confined to only Re

and Amun. An inscription from the time of Ramesses II (1279–1213 B.C.E.) states that Ptah engendered the king in his form of Banebdjed, a ram god.

HORUS. The king could be equated with any number of deities when he was said to be fulfilling the function of those gods. From the earliest periods of Egyptian history, the king was thought to be the embodiment of the ancient sky god Horus. Amenemhet I (r. 1938–1909 B.C.E.) is described as "driving out evil when he appears like Atum." Sesostris III (1836–1818 B.C.E.) was described as Sekhmet, a fierce lion goddess representing the fiery heat of the sun, when attacking the enemies who trespassed on the borders of Egypt. The *Loyalist Inscription* describes King Amenemhet III (r. 1818–1772 B.C.E.) as Sia (goddess of perception), Re, Khnum, Bastet, Hapi, Montu, and Sakhmet. Here the king was not the incarnation of these deities, but equating the king with these gods described his roles as warrior (Montu), provider (Hapi), protector (Sakhmet), and father figure (Khnum).

FOUR PURPOSES. According to an Egyptian text that scholars call *The King as Sun Priest*, Re established kingship in Egypt for four purposes: "judging men, for making gods content, for creating truth (maat), and for destroying evil (isfet)." The first of these duties, judging men, refers to the king's civil duties as the source of law and justice. The second, making the gods content, refers to the king's responsibility to see to it that temples to the gods were built and maintained throughout Egypt, and that in them the gods received the necessary offerings and the required rituals were performed. The third and fourth duties, creating maat and destroying isfet, go together. Maat has been translated as truth, order, justice, or righteousness. It refers to the order established by the gods at creation, when a space was established in the chaos of Nun for life to take place. It refers to the natural order as well as to the social order, and embraces the concepts of duty, responsibility, social justice, and ethical behavior. It was the way the Egyptians thought things ought to be. It was the king's responsibility to ensure that maat was preserved and that its opposite, isfet (evil, disorder, injustice) was overcome. One of the king's most important duties was to present maat, represented as a small figure of the seated goddess with her legs drawn up, to the gods in their temples daily. In this way, the king reaffirmed that he was fulfilling his duty of preserving maat.

SOURCES

H. Frankfort, *Kingship and the Gods* (Chicago: University of Chicago Press, 1978).

David O'Connor and David P. Silverman, eds., *Ancient Egyptian Kingship* (Leiden, Netherlands: E. J. Brill, 1995).

SEE ALSO *Literature: The Literature of Moral Values; Philosophy: Maat*

KINGSHIP RITUALS

FORMAL TITULARY. The king acquired and maintained his divinity through a series of rituals. The first such ritual the king participated in was his coronation, called in Egyptian *khai*, which means "to arise" and was also used to describe the sun's rising. At this time, the five elements of the king's formal titulary were announced: a Horus name, representing the king as the earthly embodiment of the sky-god Horus; a "Two Ladies" name (the two ladies being the goddesses Nekhbet and Wadjit, the two protective goddesses of Upper and Lower Egypt); the Golden Horus (or simply the Gold) name, the exact significance of which is uncertain; his throne name, assumed at accession, which was preceded by the title "King of Upper and Lower Egypt"; and the birth name which, beginning in the Fourth Dynasty (2625–2500 B.C.E.), was compounded with the title "son of Re." It is the throne name and birth name that were surrounded by a cartouche (an oval or oblong figure that held the king's names).

OPET FESTIVAL. Once inducted into office, the king participated in rituals designed to maintain and renew his divine status. Once a year he traveled to Thebes to participate in the Opet festival at the temple of Luxor. During this festival, which began on the fifteenth or nineteenth day of the second month of the first season known as Akhet (Inundation), the king participated in a procession from Karnak to Luxor temple, where some of the rituals of the coronation were reenacted. The purpose of these rituals was to renew or restore the king's royal *ka* (spirit) and reconfirm his right to rule. Each Egyptian possessed a ka, which can roughly be translated "life force." This was a separate entity that was thought to inhabit the body. The ka was transmitted from parent to child, and embodied the procreative power. The ka represented a bridge between the physical world and the world of the spirit. At his coronation, the king had received the royal ka, the same ka possessed by all the previous kings of Egypt. It was possession of this ka that rendered the king divine. As the vessel of the royal ka, some kings had temples dedicated to their worship built during their lifetimes. Amenhotep III (r. 1390–1352 B.C.E.) erected temples to himself at Soleb, Sedeinga, and

Sesebi. Tutankhamun (r. 1332–1322 B.C.E.) did the same at Kawa and Faras. Ramesses II (r. 1279–1213 B.C.E.) built temples to his own divine form at Gerf Hussein, es-Sebua, ed-Derr and most famously, Abu Simbel. In these temples, the king could even be shown worshipping himself. The king really was not worshipping himself, but the royal ka of which he was only the vessel.

SED FESTIVAL. After about thirty years on the throne, the king participated in a festival designed to restore his flagging powers. This event, called the Sed festival, was named for a very ancient jackal god named Sed. It could be held wherever the king chose. Generally, the festival would be held near the capital. Amenhotep I (1514–1493 B.C.E.) and Amenhotep III (1390–1352 B.C.E.) of the Eighteenth Dynasty held their Sed festivals at Karnak; Ramesses II (1279–1213 B.C.E.) celebrated a Sed festival at the city of Pi-Rameses in the Delta. The exact elements of the Sed festival are uncertain, and the available evidence indicates that the rituals underwent changes over the course of Egyptian history. The two major aspects of the Sed festival remained fairly constant. First, the king sat on two thrones in succession, first wearing the crown of Upper Egypt and then the crown of Lower Egypt. He then paid a visit to each of the provincial gods in their shrines, which had been built for this occasion. Next he ascended the throne to receive visits from these same gods. The king then performed a ritual race or dance in which he strode across a field, crossing it along the two axes formed by the cardinal points. This activity took place between two territorial cairns (piles of stones serving as a memorial markers) designated respectively as the southern and northern boundary markers. During this circuit, the king wore alternately the two crowns of Egypt, a shendyt kilt that was a royal symbol, and carried a flail—a symbol of royal rule—and a document container containing the deed to Egypt. The ritual of crossing the field was intended to symbolize the king's seizing possession of Egypt.

REJUVENATION. The result of completing the Sed festival was the rejuvenation of the king. An inscription from the temple of Sety I (1290–1279 B.C.E.) at Abydos stated of the king that "you experience renewal again, you begin to flourish ... as a young infant. You become young again year after year. ... You are born again by renewing Sed festivals. All life comes to your nostrils. You are sovereign of the whole land forever." After completing his first Sed festival, the king could celebrate subsequent festivals at intervals of two to three years. Amenhotep III celebrated three such festivals, while Ramesses II held fourteen.

NEW YEAR. The third major festival associated with the king was the New Year's festival. This festival began on the last five days of the year, called epagomenal days, because they were added by the Egyptians to their 360-day calendar to bring the year up to 365 days. The festival lasted until about the ninth day of the first month. The festival had three main purposes: protect the king from the ills and dangers which were thought to threaten creation during the five epagomenal days, renew royal power for the coming year, and purify the king and Egypt from the miasmal effects of the end of the year and of the misdeeds of the past year. There were two main parts to the festival: the Ceremony of the Great Throne, and the Rites of the Adoration of Horus who bestows the Heritage.

CEREMONY OF THE GREAT THRONE. During the Ceremony of the Great Throne the king was purified, dressed in new garments, provided with amulets of protection such as the ankh-sign (for life), and anointed nine times as a means of protection. After the last anointing, the following statement is given: "Pharaoh is a god among gods, he is come into being at the head of the Ennead, he has become great in the heaven and eminent in the horizon. Pharaoh is one of the victors who causes Re to triumph over Apophis; he is without wrongdoing, and his obstacles are dispelled." This last line is a quotation from *Book of the Dead* spell 125, the so-called "negative confession" in which the deceased denies any wrongdoing. In a hymn to Isis from the temple at Philae (third century B.C.E.), there is the following inscription: "the evils of the past year that had adhered to [the king] have been repelled. His evils of this year are destroyed. His back is turned to them. ... He has not done anything abominable toward the god of his town. He has not committed any evil. Nothing will be counted against him among the assessors and the scribes of the Two Lands [Egypt]." Here the king is essentially performing two functions: he is making amends for the past wrongdoings by himself, and by extension, the people of Egypt. As a result, the king can claim ritual purity and innocence. The king can claim that he has fulfilled the divine commission to uphold Maat and destroy wrongdoing (isfet), and as a result, he and the people of Egypt are entitled to the blessings and favors of the gods.

RITES OF THE ADORATION OF HORUS. In the Rites of the Adoration of Horus, the king participated in a series of events that renewed his powers through recalling the coronation. The king spent a night in a chapel in the temple (which temple was not significant) during which he received a scepter and had four seals placed on his head, two with the name of Geb, one with Neith, and the other with Maat. The next morning, when the king appeared from the chapel, two birds were sent out

as messengers to proclaim the king's dominion. The king then engaged in the symbolic massacre of Egypt's enemies by cutting off the tops of seven papyrus stalks. Next the king made offerings to all the deceased former kings of Egypt. This last act was related to the concept of the royal ka encountered in the Opet festival. Each king, by virtue of the fact that he was endowed with the royal ka at his coronation, was thought to be a direct descendant of all the previous kings of Egypt. One responsibility of possessing this ka was that of providing for the king's deceased predecessors. In ancient Egypt, one way for the eldest son to ensure his right to the primacy of inheritance was to provide for the burial and continued funerary offerings of his father. By providing his deceased predecessors with the necessary offerings, the king confirmed his right to inherit the throne.

IMPORTANCE. As can be seen from this brief description of the coronation, Opet festival, Sed festival, and the New Year festival, the maintenance of the king's divine status was of great importance in the royal ideology of Egypt. An acquired status can be lost. In order to prevent this from happening, the king participated in several rituals intended to reinforce his divinity and relationship to the royal ka. The king's divinity was essential to the well-being of the country, because without his status of netjer the king could not meet the needs of the gods, nor successfully intercede with the gods on behalf of the Egyptian people. If this happened, all sorts of calamities could be expected. After the Amarna Period (1352–1332 B.C.E.), during which the traditional gods and their temples were neglected, we are told that "the land was topsy-turvy, and the gods turned their backs upon this land." So it was vitally important to the well-being of Egypt that the king's status as netjer be constantly maintained.

SOURCES

Lanny Bell, "Luxor Temple and the Cult of the Royal Ka," *Journal of Near Eastern Studies* 44 (1985): 251–294.

H. W. Fairman, "The Kingship Rituals of Egypt," in *Myth, Ritual and Kingship.* Ed. S. H. Hooke (Oxford: Clarendon Press, 1958): 74–104.

Eric Uphill, "The Egyptian Sed Festival Rites," in *Journal of Near Eastern Studies* 24 (1965): 365–383.

SEE ALSO *Fashion: Crowns*

TEMPLE ARCHITECTURE AND SYMBOLISM

GOD'S HOUSE. One of the king's duties was to build and maintain temples throughout Egypt. The Egyptian word for temple meant "god's house," and temples were designed to be the earthly dwellings of the gods. As such, they included all the elements necessary to provide for the care and feeding of the gods. To meet the needs of the gods a temple needed to control an extensive network of land, livestock, and personnel. All of the elements necessary to conduct the business of the temple were referred to as the *er-per*, or temple estate. There were two main classes of temple in ancient Egypt: the cult temple and the mortuary temple, called by the Egyptians the "House of Millions of Years." The cult temple had as its main purpose to carry out the worship of a particular deity or deities. The mortuary temple was built by the reigning king in order to carry out his cult while living, and to provide for his mortuary cult after he died. Since much that went on in cult temples had to do with the king, and the "houses of millions of years" could have areas dedicated to the cults of the gods, it has been suggested that the difference between the two was a matter of primary focus, the cult temple having as its primary focus the carrying out of the cult of a god, and a mortuary temple having as its primary focus the carrying out of the cult of the divine king, but not to the exclusion of the cults of other gods.

BUILDING MATERIALS. For information on the layout of Egyptian temples modern scholars depend primarily on the large stone temples dating from the New Kingdom until the Roman Period (1539 B.C.E.–395 C.E.). The earliest temples in Egypt were built of perishable materials such as mud brick or reeds. For information on these early structures, scholars rely on archaeological evidence combined with images found on labels, pottery, and other materials. The earliest religious structures built of stone were those intended for King Djoser's (r. 2675–2654 B.C.E.) cult at Saqqara. The use of stone in cult temples did not begin until the Middle Kingdom (2008–1630 B.C.E.), and the only surviving non-royal cultic structures from the Middle Kingdom are the White Chapel of Sesostris I (r. 1919–1875 B.C.E.) at Karnak and the small temple dedicated to Sobek, Horus, and Ernutet built by Amenemhet III (r. 1818–1772 B.C.E.) and Amenemhet IV (r. 1773–1763 B.C.E.) at Medinet Maadi. The White Chapel was dedicated to Amun at Karnak, and served as a place for the priests to rest the barque (sailing vessel) of Amun when the god was out in procession. The only reason the White Chapel stands is because it was disassembled and used as fill in the Third Pylon of Amenhotep III at Karnak. When archaeologists discovered the blocks during the twentieth century C.E., they carefully reassembled them.

Arts and Humanities Through the Eras: Ancient Egypt (2675 B.C.E.–332 B.C.E.)

227

TEMPLE COMPLEX. The main elements of a temple complex were fairly standard throughout Egypt. The temple area was segregated from profane space by a large brick wall, called a temenos. Entrance into the complex was gained through a gateway called a pylon. The pylon was a pair of high trapezoidal towers flanking a doorway, one on each side of the road leading up to the temple. The only limit on the number of pylons a temple could have was the space available and the resources that the king wanted to expend. Some temple complexes, such as the temple of Amun at Karnak, had ten pylons. For hundreds of years, successive kings would add a pylon to the temple. In front of pylons, tall poles with pennants were raised. Generally four such poles were in front of each pylon, although Karnak had eight. Colossal statues of the king or obelisks could also be set up in front of the pylon. These colossal statues could serve as focal points for the worship of the king. Obelisks were tapering shafts topped with a pyramid-shaped stone called a pyramidion. They were usually made of pink granite, and the pyramidion could be plated in gold. As such, they served as solar symbols, and the pyramidion was perhaps the first and last part of the temple to receive the sun's rays.

GOD'S ROAD. The road to the temple, leading through the pylons, was called the "god's road." This was the path the god took when he left his temple in procession during festivals. Beginning with the reign of Hatshepsut (1478–1458 B.C.E.), this path could be lined with small sphinxes. Smaller gateways, called propylons, could also be built along this pathway. As one passed through the last pylon, one entered the forecourt of the temple, called the "court of the multitude." This open courtyard was as far as the general public could go. Here devotees could gather to participate in the public aspects of temple festivals. Individuals who received the king's permission could erect statues of themselves within this courtyard. These statues, serving as proxy for the deceased donor, allowed the donor to continually enjoy the god's presence and to participate in the offerings donated to the temple.

INTERIOR DESIGN. Passing through the forecourt, one entered the hypostyle hall, called the "fore-hall" or the "great court." This room was filled with gigantic columns spaced close together. The columns took the form of plants such as palm trees, bundles of papyrus, or lotus stalks, with capitals of papyrus umbels or lotus blossoms (open or closed). The hypostyle hall gave way to the offering chamber, a room containing many small tables and stands set up to receive the offerings for the gods. Next was the barque shrine, a room that included a large

platform intended to support the god's boat when not in use. Egyptian gods generally traveled by boat when they left their temples. These boats were carried on the backs of priests and contained a small shrine to house the portable image of the god. Leaving the barque shrine one enters the inner shrine of the temple, the room that housed the god's image. As the visitor proceeded from the hypostyle deeper into the temple, the ceiling became progressively lower, and the floor rose slightly. As a result, the main sanctuary of the temple was the highest point on the ground floor. This room had a low roof and was usually totally dark. It contained a small shrine, called a naos, which contained the image of the god. This image could be made of wood, stone, or gold, and has been estimated to be approximately twenty inches high. This image was the focus of the daily temple ritual. Since more than one deity could be worshipped in a temple, there was usually more than one sanctuary. The hypostyle hall, the offering chamber, the barque shrine, and the inner temple room lay along the main axis of the temple, usually oriented east-west. In addition, a temple had subsidiary rooms used for the various functions necessary to the cult. There could be a laboratory, where incense and ointments were prepared; a treasury where sacred vessels were kept; and a room through which libations entered the temple, sometimes called a Nile room.

HOUSE OF LIFE. The temple proper was often surrounded by auxiliary buildings such as storehouses, granaries, kitchens, administrative offices, workshops and studios for the manufacture and repair of statues and furniture used in the temple, and dwellings for the priests. One such building was called the "House of Life." This structure served as the place where texts were studied, copied, and assembled. Priests in the House of Life would prepare the texts that the lector priests would read during the daily temple ceremony. Papyri containing spells for protection for the living and for the dead (*Book of the Dead*) were also composed there. Medical textbooks and astronomical information were also compiled and copied in the House of Life. Temples of the Ptolemaic and Roman periods (332 B.C.E.–395 C.E.) could include a building that the French Egyptologist J.-F. Champollion called a "mammisi," meaning birth house, and a sanatorium. A mammisi depicted the events surrounding the conception and birth of a god's offspring, such as Ihy, son of Horus and Hathor (found at Dendera). A sanatorium was a building to which the sick could be brought to seek healing from the gods or medical treatment from the priests. Here pilgrims could practice incubation, in which they would spend the night in hopes of receiving a dream detailing the cure for their

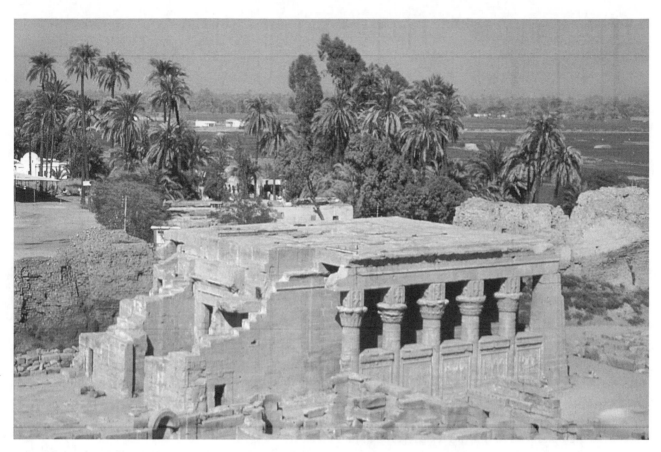

The Mammisi, or Birth House, in Dendera. **PHOTOGRAPH BY CORY LANGLEY. REPRODUCED BY PERMISSION.**

illness or the answer to their problem. A central courtyard of the sanatorium could contain statues covered with magical healing texts, and water poured over these texts was thought to become charged with their power, and was used for drinking or bathing.

SACRED LAKE. Within the temenos of each temple was a sacred lake, usually rectangular, filled with groundwater. This water was thought to originate in Nun, the cosmic water of creation, and it served several purposes. The king and priests would purify themselves in the sacred lake before performing rituals in the temple. This water also served to purify the sacred vessels used in the ceremonies, and was a source of water for libations poured out before the gods. Even the fish in the lake were considered important, and one of the sins the king denied when making his denial of guilt at the New Year's festival was that he had poached fish from the sacred lakes.

MODEL OF THE COSMOS. The architectural design of the temple was intended to represent a scale model of the cosmos, the created world. The bricks of the temenos wall were not laid in straight lines, but in undulating rows, giving the effect of a wave. This wall represented

Nun, the primordial water surrounding the created universe. The temple itself could be called an *akhet* ("horizon"), and represented the place where this world and the world of the gods and the deceased came together. The pylons could also be called akhet, and represented the mountains between which the sun rose and set. The two portions of the pylon could also be called Isis and Nephthys or the two Meret goddesses, who were thought to lift the sun out of Nun daily. The pylons could be decorated with scenes of the king smiting his enemies in battle, or engaging in hunting expeditions, all activities that the Egyptians associated with the role of the king as the champion against chaos and guarantor of order. Similar scenes could be carved on the outer walls of the temple, and served to protect the temple from the evil forces of chaos. The floor of the temple was also associated with Nun's waters, and the large papyrus-shaped columns of the hypostyle hall seemed to grow out of this water. The bases of these columns and interior walls of the temple were frequently decorated with scenes of aquatic plants, papyrus plants, and lilies, as if growing out of the floor of the temple. The ceiling of the temple could be decorated with stars or astronomical texts,

or with winged sun disks or vultures, all elements belonging to the sky. The sanctuary containing the god's image was thought of as both the akhet, the place from which the sun god appeared, and as the sky. The priest opening the shrine each morning was said to "open the doors of heaven." The steadily rising floor had the effect of rendering the sanctuary the highest point within the temple. As such, it represented the primeval hill, the first land to emerge from the waters of Nun on which creation began.

SOURCES

Stephen Quirke, ed., *The Temple in Ancient Egypt* (London: British Museum Press, 1997).

Richard H. Wilkinson, *The Complete Temples of Ancient Egypt* (New York: Thames and Hudson, 2000).

SEE ALSO *Architecture: Earliest Temples and Tombs; Architecture: New Kingdom Temples*

TEMPLE RITUAL

ENSURING PROSPERITY. Fortunately for the modern scholar, the Egyptians decorated the walls and ceilings of their temples with scenes and texts relating to the activities which went on in the temples. A few papyri relating to the temple rituals have also survived, and by putting the two together, scholars have been able to draw a fairly detailed picture of the rituals that went on within the temple. These rituals fall into two main categories: those which were intended to satisfy the god's needs, conducted on a daily basis; and those representing the god's function, either cosmic or political. These were the festivals celebrated during particular times of the year. The Egyptians believed that the well-being of Egypt was dependent on their continued performance of temple rituals. The *Papyrus Jumilhac* states that "if the gifts are poor on its [the sanctuary's] tables, then the same thing will happen in the entire country; life will be poor for the living. If the gifts are multiplied in this place, then abundance will happen throughout the entire country, and every belly will be filled with grain."

CARING FOR THE GOD. The focus of the daily temple ritual was the care and feeding of the god, mediated through the divine image in the naos. This ritual took essentially the same form in every temple in Egypt. It derived from the ritual for the sun god Re at Heliopolis, and represented the rebirth of the sun each morning. At a later date, elements of Osirian belief were incorporated into the ritual, and it also came to symbolize the restoration and revivification of the dismembered body of Osiris. For the purposes of the ritual, the cult-statue was identified as both Re and Osiris. Modern information regarding the sequence of events of this ritual comes from two main sources: temple reliefs that show the king performing the various rituals of the ceremony, and papyri that list the rituals and the hymns which accompany them. Analysis of these various sources has allowed scholars to reconstruct the likely sequence of events of this ritual. Since all of the sources are not in agreement as to the order of events, scholarly reconstructions differ, depending on which source is taken as a guide.

COLORED CLOTHS. Before dawn, two priests filled containers with water from the sacred well of the temple and replenished all the libation vessels of the temple. Priests were busy in the temple kitchens preparing offerings for the gods. The main officiating priest went to "the house of the morning" where he was ceremonially purified, dressed, given a light meal, and prepared to conduct the morning ceremony. The priest approached the shrine containing the god's image, and as the sun rose the bolt was drawn back and the door opened. Since only the king was able to confront the god, the officiating priest declared that "it is the king who has sent me to see the god." Once he had opened the doors to the shrine, the priest prostrated himself before the image. The next step was a ritual purification of the chapel with water and incense in preparation for removing the image from its shrine. At this point, the priest presented a small figure of the goddess Maat to the statue, which symbolized the proper order established for the world at creation. The image was then removed from its shrine, and the clothing and ointment that had been placed on the image the previous day were removed. Priests then placed the deity's image on a pile of clean sand and purified the shrine with water and incense. Next, a priest applied green and black eye paint to the image and anointed it with several oils. A priest dressed the god in four colored cloths: white, green, blue, and red. The white and red cloths protected the god from his enemies, the blue hid his face, and the green ensured his health. The priest then presented the god with various objects such as his crowns, scepter, crook, flail, and collar. Next he anointed the god's face, scattered sand around the chapel, and replaced the cult image in the shrine and bolted and sealed the door. Finally the priest performed the final purifications and exited the sanctuary dragging a broom behind him to obliterate his footprints.

BREAKFAST. At some point during the morning ritual, the offering ritual took place. The purpose of this ritual was to provide the god with his "breakfast." Some reconstructions of the ritual have it occurring before the

final purification of the chapel in preparation for replacing the statue in the shrine, while others would have the offering ritual take place before the undressing and dressing of the statue. In this ritual, the offerings that had been prepared that morning by the priests were presented to the god. Although an enormous meal was prepared for the god consisting of meat, bread, cakes, beer, milk, honey, vegetables, and fruit, only a small part of this repast was actually placed before the statue. An offering formula listing the various items of the offering was recited by the priest, and incense was burned and libations made to purify and sanctify the offerings. Since the god did not actually consume the offerings, but simply partook of their essence, they could be shared with the other deities in the temple. The offerings were also used in the ritual of the royal ancestors, in which the king made offerings to all of his predecessors in office, often depicted in the form of a list of their names. After this ritual, the offerings could then be made to the statues of other individuals found in the temple, and finally they became the property of the priests, who received a share based on their rank in the priestly hierarchy. This reuse of the offerings until they were finally consumed by the priests was called the "reversion of offerings" and was one way in which the priests were compensated for their work.

THREATS TO EXISTENCE. This morning ritual was the main ritual of the day, but less elaborate ceremonies were also held at noon and in the evening. During these rituals, the doors of the sanctuary housing the god's statue were not opened. These rituals consisted primarily of pouring water libations and burning incense before the shrines of the gods. In addition to these offering rituals, certain protective rituals were conducted in the temples throughout the day and night in order to repel the threats to existence, frequently thought of in terms of Seth, the murderer of Osiris, or Apophis, the serpent who tried to stop the daily voyage of Re and thereby bring an end to creation. Singers sang hymns during the twelve hours of the day and night to protect Re from Apophis and keep the solar barque moving along on its voyage. Artists created images of enemies from wax or clay and then destroyed them, thereby bringing about the enemies' destruction through magic.

FESTIVALS. In addition to their daily rituals, temples also celebrated a number of festivals throughout the year. For example, during the reign of Thuthmosis III (1479–1425 B.C.E.), the temple of Amun-Re at Karnak celebrated 54 festival days. Ramesses III's (r. 1187–1156 B.C.E.) temple at Medinet Habu celebrated sixty festival days. Festivals could last from one to twenty-seven days,

and involved large expenditures of food and drink for those participating in or observing the festival. Work records from the village of Deir el-Medina indicate that workers were frequently given days off to allow them to participate in many festivals. During the festival of Sokar, the authorities distributed 3,694 loaves of bread, 410 cakes, and 905 jars of beer. Important festivals included New Year's Day; the festival of Osiris at Abydos, during which the "mysteries" of this god were celebrated; the festival of Hathor, during which the goddess would visit the royal cult complex, as did the god Sokar during his festival; and the Festival of the Coronation of the Sacred Falcon at Edfu. The Beautiful Festival of the Valley was an important occasion during which Amun-Re traveled from Karnak to the temple at Deir el Bahri and visited the royal cult complexes on the west bank of the Nile, particularly that of the reigning king. This was also an occasion for people to visit the tombs of their relatives, where they observed an all-night vigil and shared a feast among themselves and their deceased relatives.

BARQUE SHRINES. The focus of a festival was the gods in their barque (sailing vessel) shrines. Egyptian gods always traveled in boats, either in real boats when traveling by water, or in barque shrines, carried over land on the shoulders of priests. Festivals could involve the procession of the god in his boat within the temple, or the god could leave the temple to visit another deity. These shrines were carried along processional avenues, often lined with sphinxes. At intervals, small altars were built which were essentially open-ended buildings that contained a station on which the priests could rest the barque. When the porters rested, priests performed fumigations and libations and sang hymns to the god in its boat. Such festivals and processions provided most people with their greatest access to the gods, since the furthest most people were admitted into the temples was the open forecourt. Scholars have long thought that the shrine in the barque containing the god's image was closed during the procession, hiding the god's image from onlookers. Recently, one scholar suggested that the doors of the barque shrine were open during such travels, since numerous texts describe the desire of people to see the image of a god during a procession. Egyptians believed that beholding the image of a god during a procession could heal an individual from illness.

ORACLES. It was during such festival processions that people could approach the gods seeking an oracle. The first clear evidence for oracles occurs in the New Kingdom (1539–1075 B.C.E.). The English Egyptologist John Baines, however, argued that evidence for the existence of oracles occurs much earlier, perhaps as early

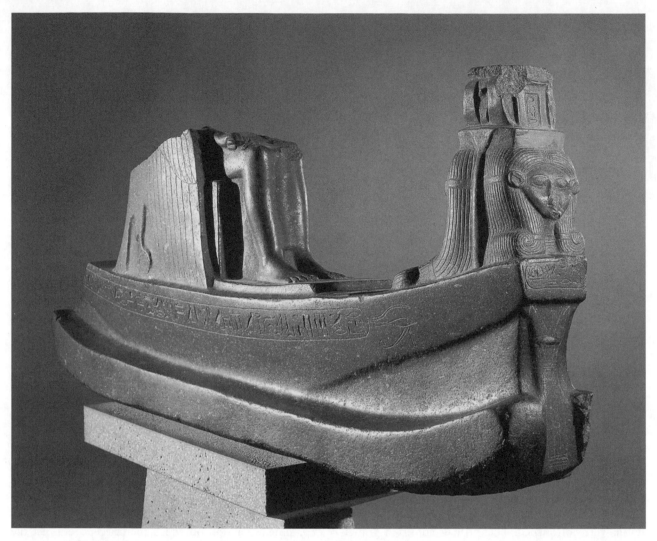

A barque bearing a statue of Queen Mutemwia in the guise of the goddess Mut. Discovered in the floor of the main sanctuary at Karnak, this barque would have been carried by the priests as the god's mode of transportation between temples. © THE BRITISH MUSEUM/TOPHAM-HIP/THE IMAGE WORKS.

as the First Intermediate Period (2130–2008 B.C.E.). During processions, people could approach the god with a yes-or-no question written on small flakes of limestone or on ostraca that would be placed before the god. Surviving examples of such questions include "Is it he who has stolen this mat?", "Shall Seti be appointed as priest?", and "Is this calf good so that I may accept it?" The movement of the barque-shrine as it was carried on the shoulders of the priests indicated the answer, forward for affirmative, backwards for negative.

SOURCES

Byron E. Shafer, ed., *Temples of Ancient Egypt* (Ithaca, N.Y.: Cornell University Press, 1997).

Barbara Watterson, *The House of Horus at Edfu: Ritual in an Ancient Egyptian Temple* (Gloucestershire, England: Tempus Publishing, Ltd., 1998).

TEMPLE PERSONNEL

STAFF. In view of the numerous activities which went on daily in an Egyptian temple, it should come as no surprise that a large staff of priests, priestesses, and other support staff was necessary for the efficient functioning of the temple. For example, the temple of Amun-Re at Karnak employed 81,322 men, while the temple at Heliopolis employed 12,963, and the temple at Memphis a paltry 3,079. Technically, only the king could officiate in the cult before the gods. He was the high priest of all the gods and goddesses of Egypt. In actual practice, the king delegated this responsibility to the priesthoods of the various gods throughout Egypt. Many priestly appointments came directly from the king. Some priestly appointments could be made by local adminis-

trators. Frequently, priestly offices could be inherited. Yet priests could also hold civil offices in addition to their priesthoods.

PRIESTLY FUNCTIONS. There were two main classes of priests. The higher class of priest was the *hem-netjer*, "god's servant." These priests functioned in the cult before the god's statue. The Greeks translated hem-netjer as "prophet," an equation that derived from the priests' role in interpreting oracles. The lower class of priests was the *wabu*, or "pure ones." They carried the god's barque (sailing vessel); poured water for the various libations required during the temple service; oversaw craftsmen, artisans, or scribes; or served as craftsmen themselves, making such sacred objects as the gods' sandals. In addition to these two priestly titles, there was a third, the *it-netjer*, or "god's father." It has been suggested that the title "god's father" was given to senior wab priests who had reached the level of prophet but were not yet formally inducted into that office. One of the it-netjer's functions seems to have been to walk in front of the god's image when it was in procession and sprinkle water on the ground in order to purify the path.

PURITY. Inherent in one of the Egyptian words for priest is the concept of purity. Priests were required to maintain a status of ritual purity while serving in their office. Priests attained and maintained such purity through several means. During the Ramesside Period (1292–1075 B.C.E.), priests had to bathe in the sacred lake of a temple three times a day; the ancient Greek historian Herodotus (fifth century B.C.E.) wrote that in his day priests bathed twice a day and twice during the night. Priests had to cleanse their mouths with natron (a salt-like substance) dissolved in water, and remove all hair from their bodies. Herodotus wrote that they shaved their whole bodies every third day. Furthermore they were circumcised. They also had to abstain from sexual activity for several days before entering their service as priests and during the period of their service. While serving in the temple, they were not allowed to wear wool, and were required to wear white sandals. Priests had to observe certain food taboos, which differed from nome (province) to nome. For example, in the Third Upper Egyptian nome, eating fish was forbidden, and in the Sixth Upper Egyptian nome, honey could not be eaten.

GANGS OF THE SERVICE. Priests were divided into four groups, called "gangs of the service," to which the Greeks gave the name "phyles." Each phyle served one lunar month in rotation, so that during the year each gang served for a total of three months, with three months off between each month of service. This free time allowed individuals to hold priesthoods in several temples. The chief priests of a temple were designated by ordinal numbers; the high priest of the temple was called the first prophet, the next most senior priest was the second prophet, followed by a third and a fourth prophet. The high priests of some gods bore special titles. The high priest of Ptah was called "he who is great at directing the crafts." The high priest of Re was "he who is great at seeing." The high priest of Thoth was called "the arbitrator between the two," while the high priest of Khnum was called the "modeler of limbs." These titles derive from the various spheres of influence or mythological roles these gods played.

SPECIALISTS. In addition to these classes of priests, there were also priestly specialists. The *hery-heb* ("he who carries the festival roll") was responsible for reading the hymns and spells which accompanied many of the rituals in the temple. The *sesh per-ankh* ("scribe of the house of life") was responsible for copying the papyri used in temple and funerary rituals. Women also played a role in the temple priesthood. During the Old Kingdom, women of high social station could hold the office of priestess (*hemet-netjer*) of Hathor or of Neith. Prior to era of the New Kingdom, women served as priestesses in the cult of a god, but only rarely, due to the fact that women had numerous other duties in the culture and were not allowed to hold any job that would detract from these duties. Only select women who never married and dedicated themselves to a life of religion were allowed to serve the cult of a god. This changed in the era of the New Kingdom with the introduction of a professional class of priests, members of which gained title and property. Since women could hold no titles nor own property in ancient Egypt, they were no longer able to serve in the role of priestess. Instead they served mainly as musicians, singers, and dancers in the temple.

SOURCES

Serge Sauneron and Jean-Pierre Corteggiani, *The Priests of Ancient Egypt* (Ithaca, N.Y.: Cornell University Press, 2000).

PERSONAL RELIGION

EVIDENCE. Personal piety is not uniformly attested throughout Egyptian history. Before the New Kingdom (1539–1075 B.C.E.), it is very rare to find a private person depicted on a stele (etched slab of stone) worshipping a deity. Old Kingdom tomb biographies tended to

stress the service the tomb owner had performed for the king, and any mention of his deeds for the gods is largely absent. During the First Intermediate Period (2130–2008 B.C.E.) the first indications of the belief in divinities that would intervene in the lives of individuals can be found on stelae and inside tombs. Such references are few, however, and seem to be outside the norm of general religious experience. Beginning in the New Kingdom, however, the evidence indicates a much greater emphasis on an individual's personal relationship with the gods, and the gods' actions on behalf of the individual. Evidence for such personal piety becomes abundant during the Ramesside period (1292–1075 B.C.E.), and it has been suggested that this is a reaction to the religious upheaval which took place in Egypt during the Amarna period.

ENCOUNTERING THE GODS. A primary locus for the individual's encounter with the gods was the temple. While most of the temple activities were closed to the public, there were occasions when the gods appeared publicly. During festivals, when the gods left their temples in processions, people had the opportunity to present the gods with questions and receive oracular responses. In addition, there were places set aside within the temple complex where people could approach the gods with their prayers. At the rear of some temples, directly behind the sanctuary of the temple, could be found a chapel of the "hearing ear." This could vary between an elaborate chapel to a simple niche with a statue of the main god of a temple, or even only a pair of carved ears, representing the god's ability to hear prayers. There were also places in the gates of the temenos wall (the wall surrounding a temple) where people could make prayers and offering to the gods. The south gate of the temenos wall at Edfu was described as "the standing place of those who have and those who have not, in order to pray for life from the lord of life." Even the relief images of the gods in the accessible parts of the temple could become the focus of prayers and offerings. Some of these figures show evidence that, at one time, structures were built around some reliefs, forming small shrines, with a shelf for offerings and at times a curtain to conceal the relief.

PURPOSES. People would visit a temple for three main purposes: prayer, sacrifice, and dedication of votive offerings. Prayers were generally delivered orally, and began with a low bow, called "kissing the ground." The petitioner would then kneel or stand, with arms raised, to praise the deity and make their requests. Fortunately, visitors sometimes carved their prayers into the temple as graffiti, which preserved evidence of the types of things people prayed for. People could pray to receive the favor of the gods, or to be loved by their gods. Other requests included the opportunity to go on pilgrimages, to avoid evil-doing, to receive the material necessities of life, good health, and a long lifetime of the ideal 110 years. One man left a prayer for potency and a good wife as a companion. Another left a request that he gain favor in the eyes of a certain female singer in the temple of Amun. Letters written by officials of the Ramesside period away on business to their family members back in Egypt made requests for prayers to be offered on their behalf. One such official, Dhutmose, instructed his family and servants to "please call upon Amun to bring me back, for I have been ill since I arrived north and am not in my normal state. Don't set your minds to anything else. As soon as my letter reaches you, you shall go to the forecourt of Amun of the Thrones of the Two Lands, taking the little children along with you and coax him and tell him to keep me safe."

OFFERINGS. Worshippers did not approach their gods empty-handed. When they visited the temples to offer prayers, they frequently brought sacrifices along as an inducement to the god to grant their requests. Common sacrifices included libations of wine, beer, milk, or water. The presentation of bread, fruit or flowers, or the burning of incense or foodstuffs was also common. Most temple visitors brought their offerings with them, but they could also acquire them at the temple. A more permanent type of offering was the votive offering, a permanent memorial of a prayer to a deity. Votives could include stelae, showing the petitioner praising the god, model ears, or stelae with images of ears, intended to induce the deity to hear the petitioner's prayers. Other types of offerings included model phalluses, intended to gain fertility for the donor, or small images of deities or cult objects used in the temples.

PUBLIC CHAPELS. Temples were not the only location at which the worship of the gods occurred. The site of Deir el-Medina has preserved the remains of public chapels dedicated to the gods. These chapels show a fairly consistent design. They consisted of an open forecourt leading to a roofed hall, often with one or two pillars, with benches along each side wall. On the benches were seats, seven along one side of the hall, five along the other. Some seats from these chapels were inscribed with the names of individuals. This may indicate that participation in worship in the chapel was by subscription. Some scholars have used these inscriptions at Deir el-Medina to prove the existence of "cult guilds," in which individuals would enter into a legal contract to band together in the worship of a particular deity. There is written evidence of these guilds in the Twenty-sixth Dynasty (664–525 B.C.E.), but as yet no written evidence of such societies has turned up for New Kingdom Egypt or for the Deir el-Medina. Moving

from the open forecourt, the Deir el-Medina gave way to a small room, called the pronaos, which led to a series of one to three sanctuaries for cult statues, or more probably, stelae (carved or inscribed stone slabs or pillars), to the gods of the shrine. Around the sides of these rooms were subsidiary service rooms or rooms in which the guardian of the chapel could live. The priests who served these chapels were also the workmen who lived at Deir el-Medina and served part-time in the chapel. The chapels were places where worshippers could go to make prayers and offerings, and to receive oracles.

DOMESTIC SHRINES. Houses at Amarna, the capital during the reign of Akhenaten (1352–1336 B.C.E.), have preserved evidence of domestic shrines. These shrines were located in the garden, surrounded by trees and separated from the rest of the garden by a wall. They consisted of a sloping flight of stairs leading up to a platform, on which was a walled room containing an altar of brick or limestone. Found within these shrines were statues of Akhenaten and his family, or stelae showing the royal family worshipping the Aten. Evidence of domestic shrines can also be found at Deir el-Medina, where the hills around the town are dotted with over fifty tiny shrines arranged in rough rows. These shrines consisted of a few rough stones, arranged to form a back, floor, two sides, and a roof. Sometimes stones marked off a miniature forecourt. Inside each shrine was originally a small stele, commemorating its donor's dedication to his gods. Additionally, there were places set aside within the house itself where people could worship their gods. The walls of a house could contain niches in which could be placed a stele of a god. Such niches could be fitted with a wooden door, and could be found in any room of the house. Deities particularly popular in such house shrines were Meretseger (protective goddess of the Theban necropolis), Renenutet (goddess of harvest), Sobek (crocodile-god), Amun, Taweret (goddess who protected women during childbirth), and Hathor (mother-goddess). In addition to the gods, stelae depicting deceased relatives or anthropoid busts of such relatives were erected and served as the recipients of offerings. Deceased relatives were worshipped as *akh aper* ("effective spirits") and were thought to be able to influence the lives of their living relatives. The nature of the cult carried on in these private venues is not well known. From the images on the stelae, it seems that offerings of incense, food, and libations were made to the gods. The ritual involved in these offerings, or their frequency, is unknown. One suggestion is that a smaller, less elaborate version of the daily temple ritual may have been celebrated, but this is just conjecture.

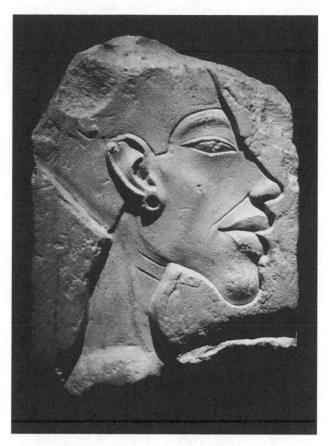

Portrait of Akhenaten, limestone relief sculpture fragment of the New Kingdom. © VANNI ARCHIVE/CORBIS. REPRODUCED BY PERMISSION.

SOURCES

John Baines, "Society, Morality, and Religious Practice," in *Religion in Ancient Egypt: Gods, Myths and Personal Practice.* Ed. Byron Shafer (Ithaca, N.Y.: Cornell University Press, 1991).

Florence Friedman, "Aspects of Domestic Life and Religion," in *Pharaoh's Workers: The Villagers of Deir el Medina.* Ed. Leonard H. Lesko (Ithaca, N.Y.: Cornell University Press, 1994): 95–115.

Geraldine Pinch, *Votive Offerings to Hathor* (Oxford: Griffith Institute, 1993).

Ashraf I. Sadek, *Popular Religion in Egypt during the New Kingdom* (Hildesheim, West Germany: Hildesheimer Ägyptologische Beiträge, 1987).

ETHICS

RELIGIOUS WORLDVIEW. For the ancient Egyptians the matter of ethics was firmly grounded in their religious world view, so much so that one scholar has written that "in the Egyptian's terms, morality and religion

can hardly be separated." At the basis of all moral and ethical behavior in ancient Egypt was the concept of maat, which was also an essential element of kingship. It was every Egyptian's duty to conduct his or her life in accordance with maat (truth), and to avoid committing deeds considered *isfet* ("wrongdoing") or *gereget* ("falsehood"), the opposite of maat. In this way, the continued existence and prosperity of Egypt was assured. Our main source of knowledge concerning what behavior was in accordance with maat is the instruction literature from ancient Egypt. These texts, similar to the biblical book of Proverbs, date from the Old Kingdom to the Roman Period (2675 B.C.E.–395 C.E.), and were used as exercises for student scribes. They are portrayed as books of practical wisdom written by famous sages in which they distilled their lifetime of experience concerning which actions were and were not in accordance with maat. Living a life in accordance with the principles of maat was not only good for Egypt, but also good for the individual, and the instruction texts assured the individual that living a life based on maat was the path to success.

JUDGMENT AFTER DEATH. Maat was not only good for the living, but was also beneficial to a person after death. In *The Eloquent Peasant*, the peasant exhorts his audience (and the reader) to "speak maat, do maat, for it is great; it is important; it is everlasting; its usefulness will be discovered; it will lead (a person) to a blessed state (after death)." The ancient Egyptians believed in a post-mortem judgment of the individual, symbolized as the weighing of his or her heart against the feather, a writing of the word maat. The earliest hints of such a judgment appear in the *Pyramid Texts* (2371–2194 B.C.E.), but the first certain reference of a post-mortem ethical judgment is found in the First Intermediate Period (2130–2008 B.C.E.) text known as the *Teachings for Merykare*, where reads "a man survives after death, and his deeds are laid before him in a heap." In the *Coffin Texts*, it is the balance of Re which weighs the individual against maat. The idea of post-mortal judgment reaches its peak during the New Kingdom (1539–1075 B.C.E.) in the *Book of the Dead*, Spell 125. This spell is accompanied by an elaborate scene, showing Osiris presiding over the weighing of the heart of the deceased against the feather of maat, while the 42 judges watch. The god Thoth is present to assure the accuracy of the balance, and to record the results. Standing nearby is the demon Amemet, who swallows the dead. He gobbles up the heart which fails to measure up to maat, assuring the eternal destruction of the sinner.

NEGATIVE CONFESSION. In order to prevent the deceased from suffering this fate, the scene was accompanied by a text that scholars call the *Negative Confession*. This spell consists of two long lists of denials of wrongdoing by the deceased. One list is spoken before Osiris, the other before the 42 assessor demons/judges. A study of the lists reveals the types of activities the Egyptians believed were contrary to maat. Deeds found in the lists include blasphemy, thievery, murder, damaging offerings to the temples, being dishonest in weights and measures, and stealing cattle from the temple herds. Sexual sins such as adultery, pederasty, ejaculation, and copulation (when in violation of purity regulations) also turn up. Less physical offenses include coveting, lying, sulking, "prattling," and boasting.

HEAVY BURDEN. The negative confession placed a heavy burden on an Egyptian wishing to live a life in accordance with maat. The question has been raised as to what extent the list of offenses in the confession served as a guide to daily life. The purpose of the *Book of the Dead* was to provide the deceased with safe passage to the afterlife, and by including spell 125 the deceased purchased for himself absolution of his sins. In view of the fact that living a life in accordance with maat was thought to lead to success, and that the declarations of innocence were not made only after death, but by the king during the New Year's ceremony and by priests entering temples to perform their duties, it is probable that the lists did serve as a general code of conduct for at least some Egyptians.

GODS' DISPLEASURE. But what happened when someone committed an offense against maat and against the gods? The gods showed their displeasure with an individual by means of a *bau* ("curse"). A person under the curse of a god could be described as being, as in this Rameside inscription, "… the abomination of men. The sun does not rise in his presence, while the inundation does not flow for him. He is a mouse surprised by the inundation; he cannot find a place to rest himself. He is a bird caught by the wings by the hand of man; he finds no means of flying away." One sinner, Neferabu, admits in his stele that he swore falsely by Ptah, and as a result he was made to see darkness by day. He described his condition as that of "the dogs of the street." The occasion for dedicating the stele was apparently Neferabu's release from Ptah's "doghouse." Other deeds which are recorded as bringing about a manifestation of the gods' displeasure are stealing, lying, and the most common offense, committed by the hapless Neferabu, swearing a false oath in a god's name.

APPEASEMENT. Once under a manifestation of a god, a person had to appease the offended deity to have the

236

Arts and Humanities Through the Eras: Ancient Egypt (2675 B.C.E.–332 B.C.E.)

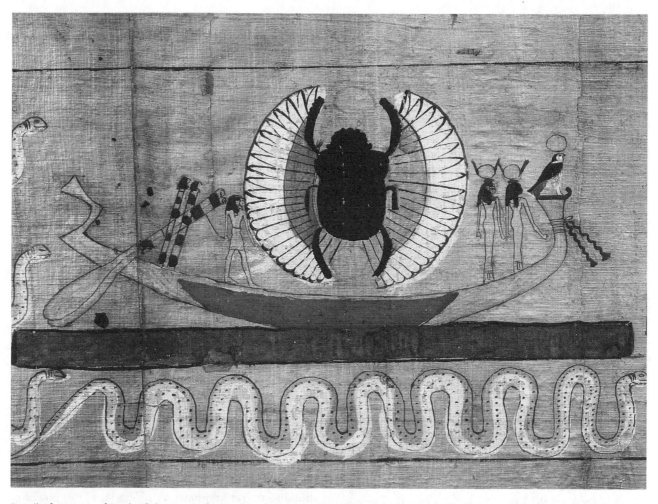

Detail of papyrus of Book of the Dead of Hirweben showing a winged scarab being transported on a solar barque. From Thebes, 21st Dynasty. THE ART ARCHIVE/EGYPTIAN MUSEUM OF CAIRO/DAGLI ORTI.

manifestation removed. This involved confession, as on Neferabu's stele, making offerings of incense, and perhaps dedicating a votive stele to the god recording praise to the god and promising that the infraction will not occur again. There were occasions, however, when a person fell under the manifestation of a god without knowing what the offense was. In that case, the Egyptian could consult a "wise woman" in his village. One New Kingdom ostracon (inscribed potsherd) from Deir el-Medina records the visit of an unnamed individual to the wise woman who told him "the manifestation of Ptah is with you" because of an oath sworn by his wife. How exactly a wise woman arrived at her information is not recorded. Demotic texts from the Ptolemaic and Roman period record various methods of divination, but whether they were practiced as early as the New Kingdom is unknown.

REWARDS AND PUNISHMENT. The ancient Egyptians had several inducements to live a life in accordance with maat. Those who attended school were taught that the path to success lay in keeping maat. The reward for living a life according to the principles of maat was a pleasant existence in the next life. Finally, those who chose to violate the norms of maat stood in danger of incurring the wrath of an offended god, which could result in blindness or any number of other misfortunes.

SOURCES

Joris F. Borghouts, "Divine Intervention in Ancient Egypt and its Manifestation (baw)," in *Gleanings from Deir el-Medîna*. Eds. R. J. Demarée and J. Janssen (Leiden, Netherlands: Nederlands Instituut voor het Nabije Oosten, 1982): 1–70.

MAGIC IN EGYPTIAN RELIGION

DEFINITIONS. The English word "magic" is the accepted translation of the Egyptian word "heka." The extent to which the two terms are synonymous, however,

has been a subject of much discussion. The English term "magic" tends to carry pejorative connotations that the Egyptian term does not. Frequently "magic" has been opposed to "religion," the one seen as somehow a debased form of the other. At various times, scholars have seen magic as unauthorized, abnormal, illegal, or as deviant behavior. None of these connotations is present in the Egyptian term. The association of "magic" with "heka" is not an invention of modern scholars, however. Coptic, the last stage of the Egyptian language, written with the Greek alphabet, used the equivalent of heka to translate the Greek terms for magic or magician.

ORIGIN. The Egyptian *Coffin Texts* state that the creator god Atum created *heka* ("magic") first of all his creations in order to protect all he had ordained. In the *Teachings for Merykare*, the king is told that the god had created magic as a weapon for mankind to ward off the blows of events. In view of these Egyptian statements regarding the purpose of magic, Egyptologists have tended to focus on the protective nature of heka in trying to define it. One such definition involves Egyptian heka as actions involving human contact with supernatural/divine powers in order to exploit these powers to deal with specific, unforeseen events. Such events include sickness, scorpion sting, snakebite, safety during childbirth, and threats from a living or dead enemy, evil spirit, or demon. Certain times, such as nighttime during sleep, and the end of the year, were considered particularly dangerous, and required the use of magic as a means of protection. Magic could also be used to induce love.

PRACTITIONERS. Practicing magic in ancient Egypt required reliance on the written word, so magicians had to be literate. Most magicians belonged to the ranks of the priesthood, and bore titles such as "Prophet of Heka," "Chief of Secrets," or "Lector Priest." The manuals necessary for the practice of magic, consisting of compilations of spells and instructions on their use, were composed, compiled, and stored in the temple scriptorium called the "House of Life." While most magicians would have been men, texts from the workmen's village at Deir el-Medina preserve mention of a "wise woman" who may have functioned as a seer.

MAGICIANS IN LITERATURE. Egyptian literature does preserve accounts of famous fictional magicians and their incredible deeds. In *Khufu and the Magicians*, the Old Kingdom king Khufu (2585–2560 B.C.E.) is entertained by his sons with tales of the deeds of great magicians. The lector priest Webaoner was said to have fashioned a crocodile out of wax and brought it to life in order to avenge himself on the townsman who had cuckolded him. The magician Djadjaemonkh performed a feat that would later be duplicated by the biblical Moses when he recited a magic spell to part the waters of a lake. In the Egyptian's case he performed this feat so that one of the female rowers of the king's boat could retrieve a pendant she had dropped overboard. The magician Djedi was able to reattach a severed head through the use of a spell. When the king, anxious to see such a fantastic deed, asked for a prisoner to be brought as a test subject, Djedi refused, preferring to perform his feat on a goose rather than a human.

METHODS OF THE MAGICIAN. These literary tales serve to highlight the methods used by the magician. The primary tool of the magician was the magic spell. These spells frequently associated the problem at hand with an event or element in the divine world in order to bring about the desired result. A sufferer from scorpion bite would be equated with the infant Horus, who had suffered and been saved from a similar fate. Spells to hasten childbirth equated the mother with Isis, and the infant with Horus. Such spells could be recited over the sufferer, but there were other ways in which a person could make use of a written text. Healing stelae known as *cippi* had their surfaces covered with magical images and texts and were set up in temples, houses, or tombs. Frequently such stelae were accompanied by basins, and individuals availed themselves of the power of the texts and images by pouring water over the stela and then drinking it. Yet another way of ingesting the power of the written word was by washing off the ink of an inscribed papyrus in a liquid such as water or beer and drinking it or by licking the ink off an inscribed object.

MANIPULATION OF OBJECTS. In addition to written spells, objects also played a role in Egyptian magical practices. Protective wands made of ivory and decorated with images of deities wielding knives served to protect women during childbirth. The names of enemies could be inscribed on images of bound captives known as execration figures or on red pottery and then smashed to bring about the destruction of the enumerated enemies. Images of such enemies could also be drawn on the sockets of doorposts, on the bottoms of sandals, or on footstools, so that every step or opening of a door caused the enemy to suffer. As in the story of Webaoner, figurines of animals could be fashioned out of wax in order to accompany a spell. A spell against scorpions involved the fashioning of a scorpion of clay, and another required the creation of a wax cat, presumably an enemy of the scorpion. From the Ptolemaic and Roman periods, a spell for the summoning of Thoth involved the creation of a wax baboon.

SOURCES

Joris Borghouts, *Ancient Egyptian Magical Texts* (Leiden, Netherlands: E. J. Brill, 1978).

Geraldine Pinch, *Magic in Ancient Egypt* (Austin: University of Texas Press, 1994).

Robert Ritner, *The Mechanics of Ancient Egyptian Magical Practice* (Chicago: University of Chicago Press, 1993).

SEE ALSO *Literature: The Egyptian Literary Canon; Philosophy: Alchemy*

FUNERARY BELIEFS AND PRACTICES

MISCONCEPTION. So much of modern knowledge of the ancient Egyptians derives from material recovered from tombs that the misconception that the Egyptians were obsessed with death is common. We are indeed fortunate that the Egyptians decorated their tombs with scenes of daily life, that they included objects from everyday life in their burials, and that they buried their dead with texts of all types, from funerary texts intended to smooth the transition into the next life for the deceased, to literary and even administrative texts. Since the Egyptians buried their dead in the desert west of the Nile, avoiding wasting the scarce arable land, arid conditions have preserved this wealth of material.

THE KA. The ancient Egyptians viewed the individual as the sum of component parts, some of which came into existence at birth and coexisted with the individual throughout life, while others came into existence only at death. The Egyptians were not consistent in their description of these different entities, and it is not always possible to distinguish them clearly from each other. In Egyptian mythology, Khnum the potter god was responsible for the physical creation of the individual. Contemporaneous with the molding of the body, the god also fashioned a double for a person, called a ka. The ka is the life force, the difference between a living and a dead person. It was transmitted from parent to child, and represented that aspect of the deceased individual that was capable of making use of the numerous offerings of food and drink. Prayers accompanying offerings or taking the place of offerings were frequently addressed to the ka of the deceased. A statue of the deceased could serve as an image of the ka, and was placed in the tomb as insurance against the destruction of the body. In the event that occurred, the statue could serve as a stand-in and conduit to transfer the benefits of the offerings to the deceased.

THE BA. After death, the mummified body was placed in the tomb, where it was meant to stay for all eternity. In order to allow the deceased to leave the tomb and visit the world of the living and the gods, another element of the individual was necessary. This was called the ba. The ba was frequently depicted as a jaribu stork, occasionally with a human head. At death, the ba was said to fly away from the deceased. This separation was not permanent, however, since the ba must return to the mummy every night. The image of a person's separation from his ba came to be used as a description for the condition brought about by drunkenness, or the losing of one's wits in a stressful situation. The ba provided the deceased with two necessary capabilities: movement, signified by the wings of the ba-bird, and transformation. In order to make the transition to the next life, avoiding the pitfalls that awaited, the deceased often found it useful to transform him or herself into different forms. Spells in the *Book of the Dead* transformed the deceased into a falcon, lotus, snake, crocodile, or swallow, just to name a few of the forms assumed by the deceased. The ba also provided the dead with the ability to continue to enjoy sexual activity beyond the grave.

THE AKH. A third aspect of the deceased individual was the *akh*, frequently translated as glorified or effective spirit. This was the aspect of an individual that achieved a glorified and exalted status in the next life. It was the spirit that could get things done, as shown by the letters preserved between living Egyptians and their dead relatives. These letters were written on papyrus or in bowls that would have contained offerings to entice the deceased to grant their requests. The letters could ask the dead to cease troubling the living, or to intercede with other spirits in the afterlife on behalf of the living to either bring about or cease a certain activity.

TOMBS. An important aspect of preparing for the afterlife was the construction of the tomb. Tombs could take many forms, including the elaborate pyramid complexes of the Old Kingdom kings; rectangular, box-like constructions called mastabas; and tombs cut deep into the rock, known most famously from the Valley of the Kings. The construction of the tomb began as soon as a man had the means to do so. The *Instruction of Prince Hardjedef* gives this advice: "When you prosper, found your household, take a hearty wife, a son will be born to you. ... Make good your dwelling in the graveyard, make worthy your station in the West [another euphemism for the land of the dead]." Whatever its form, the tomb had two main purposes: to house the body and to provide a place where the cult of the deceased could be carried out. This cult took the form of regular offerings and special rituals carried out during particular festivals. The two main parts of the tomb correspond to

Arts and Humanities Through the Eras: Ancient Egypt (2675 B.C.E.–332 B.C.E.)

239

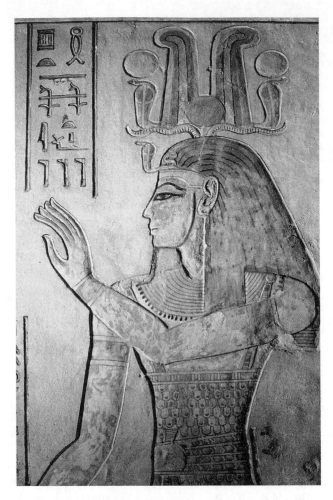

Painted relief of a god, in Egyptian tomb, Valley of the Kings, Luxor, Egypt. © BOJAN BRECELJ/CORBIS. REPRODUCED BY PERMISSION.

these two functions. The burial chamber, usually located below ground, housed and protected the body. Above ground was the superstructure, the chapel, which served as the public part of the tomb and was accessible to priests and visitors.

BURIAL CHAMBER. The burial chamber frequently contained the equipment necessary for a proper burial and a pleasant afterlife. Inside the burial chamber was the coffin, four canopic jars (containing the liver, lungs, stomach, and intestines, which were removed at mummification), shawabti figures (figurines designed to act as stand-ins whenever the deceased was called upon to do any work in the afterlife), amulets, and texts. Objects of daily life that were thought necessary for the comfort of the deceased were also included in the burial chamber. These objects included food containers, furniture, tools, games, clothing, and any other object the deceased could have used. The walls of the burial chamber could

be left plain, or be decorated with scenes from daily life, offering scenes, or scenes of the deceased in the afterlife.

CHAPEL. The chapel could also take different forms. It could be as simple as a stele erected above the burial; wealthier individuals could have a chapel of many rooms, usually—but not necessarily—above the burial chamber. The focal point of the chapel was a stele called a "false door" by Egyptologists, since it represented a door carved in stone. This door, usually located directly above the burial chamber, was thought to be the place where the ba of the deceased could leave and enter the burial chamber. In front of the door could be found a stone table on which offerings could be left. The sides of the door were frequently engraved with the text of the offering formula, and it was thought that if any passersby would stop and recite the formula on behalf of the deceased, he would be magically provided with nourishment.

CHAPEL DECORATIONS. The walls of the chapel could be decorated with many types of scenes. Some scenes depicted activities associated with agriculture, such as plowing, planting, and harvesting of crops, and the herding of animals. Scenes showing the processing of foodstuffs include those of brewing beer and making bread. Scenes of daily life include such activities as fishing and fowling, boating and boat-jousting matches, and the manufacturing of goods such as jewelry, chairs, beds, coffins, pottery, or cloth. Other tombs have representations of the funeral procession with mourners. During the First Intermediate Period, chapel walls were rarely decorated with such scenes. Rather, small wooden models depicting the same types of activities were included in the burials. The purpose of the scenes and models was the same: to ensure the deceased a steady supply of those goods he would need in the afterlife.

MUMMY. The focus of all this effort and activity was the mummy (embalmed remains) of the deceased. The English word derives from the Persian word *mumia*, meaning pitch or bitumen. The word was used at least since the Renaissance to describe the embalmed remains of the Egyptians because they appeared to be covered with pitch. The practice of mummification may have arisen because of the natural drying property of the Egyptian sand. The earliest Egyptian burials, from the Predynastic Period, were simply shallow pits on the desert's edge. The heat combined with the sand served to dry out the body's tissues before they could decompose, leaving a considerably lifelike appearance. With the introduction of more elaborate tombs, however, the body was no longer buried in the sand, and as a result quickly decomposed. Consequently, various attempts

240

Arts and Humanities Through the Eras: Ancient Egypt (2675 B.C.E.–332 B.C.E.)

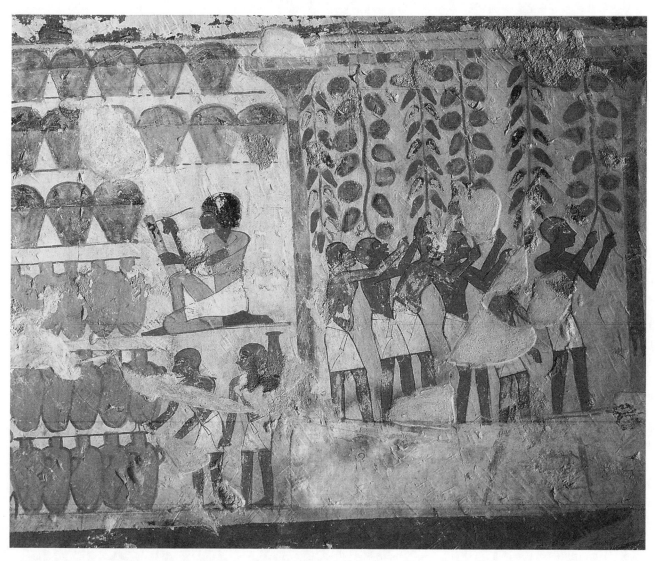

Scenes of agricultural life and food preparation, such as this fresco showing the treading on the grapes in a wine vat and the counting of wine jars, often decorated tomb walls as a way of magically providing for the deceased in the afterlife. © GIANNI DAGLI ORTI. CORBIS. REPRODUCED BY CORBIS CORPORATION.

were made to preserve the body. The mythological justification for the process of mummification derives from the myth of the god Osiris. After Osiris had been dismembered by his brother Seth, Isis traveled throughout Egypt gathering up the pieces of his body. The god of embalming, Anubis, then reassembled the pieces and rejuvenated the body of Osiris to allow him to sire a son with Isis. Each deceased Egyptian was thought to become an Osiris, and by reenacting the same mummification process, to gain renewed life, as Osiris did.

METHODS OF MUMMIFICATION. The earliest example of mummification dates to the Fourth-dynasty (2675–2500 B.C.E.) burial of Queen Hetepheres, the wife of Sneferu (2625–2585 B.C.E.) and mother of

Khufu. Throughout Egyptian history, several different methods of mummification were used, depending on what the deceased or his family could afford. An elaborate mummification could have proceeded along the following lines. First, the corpse was taken to the *Per-Nefer*, the House of Mummification, where it was placed on the embalming table. This table was supposed to resemble the one on which Osiris had been placed after his death. The table is frequently shown with lion's feet. Next, the brain was removed through the nose and thrown away. The Egyptians did not recognize the significance of the brain, and thought it of no use. The embalmer, known as the *ut*-priest, made a cut in the left side of the abdomen of the mummy and removed the liver, lungs, stomach, and intestines. The organs were

Arts and Humanities Through the Eras: Ancient Egypt (2675 B.C.E.–332 B.C.E.)

241

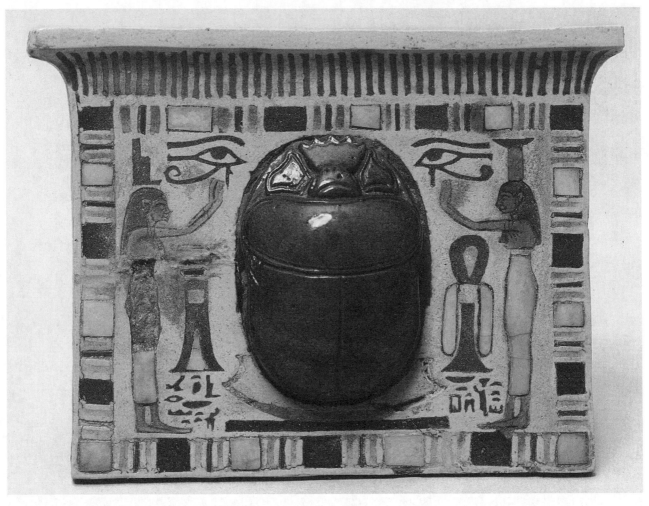

Heart scarab amulet of Ptahemheb. The amulet was placed in the mummy bandages above the human heart to prevent the heart from testifying against its owner in the underworld. Nineteenth Dynasty. **THE ART ARCHIVE/BRITISH MUSEUM/JACQUELINE HYDE.**

wrapped separately and each one was placed in its own jar. These jars were buried in the tomb with the mummy, often in a special chest. At times, the heart was removed and carefully wrapped and returned to its place. At other times, it was simply left in place. Near the heart the embalmer could place a "heart scarab," an amulet containing a protective spell. The body cavity was packed with linen and other stuffing material. The body was packed and covered with dry natron, a salt-like compound used to dry out the body. This process took about forty days, after which the natron was removed and the body cavity was packed with linen bags of sawdust or myrrh soaked in resin. Then the abdominal incision was sewn shut. Priests rubbed the body with a mixture of cedar oil, wax, natron, and gum, and sprinkled it with spices. They smeared the skin with molten resin which, when hardened, kept moisture out of the body. The last step was wrapping the body with linen. This could involve the use of hundreds of yards of linen. Beginning in the

Thirtieth Dynasty (381–343 B.C.E.), scribes wrote texts from the *Book of the Dead* on some of the mummy bandages. During the wrapping process, priests included amulets on the mummy to protect it. Throughout the whole process, priests recited the appropriate incantations at each stage of the mummification. Some of these spells have been preserved on papyri. For example, after anointing the head of the mummy with good quality resin, the embalming priest was to recite the following: "Ho, Osiris N [N represents the name of the deceased], resin which came forth from Punt is on you in order to make your odor agreeable as the divine scent. The efflux which comes forth from Re is on you in order to make [your odor] agreeable in the broad hall of the Two Truths." According to the Greek historian Herodotus (fifth century B.C.E.) the process of making a mummy took seventy days, this number deriving from the number of days the star Sirius was invisible. In actuality, the mummification could last anywhere from thirty to over

200 days. Once the mummy was completed, the funeral could begin.

FUNERAL PROCESSION. The funeral began when the coffin of the deceased left his house. It could be carried by pallbearers or drawn on a sledge. The family of the deceased accompanied the procession, and they were said to be in a state of mourning. Tomb scenes show these individuals pulling at their hair, throwing dust on their heads, and collapsing from grief. Men and women mourned separately, men outside, and women inside the home. Two women fulfilled the roles of the goddesses Isis and Nephthys, who mourned for Osiris. The wife of the deceased usually took the part of Isis. Also present were the embalmer, lector priest, and the Sem-priest. Since most Egyptians lived on the east bank of the Nile, and most cemeteries were located on the west bank, a trip to the necropolis required travel by water. The west was also the location of the land of the dead, since the sun set in the west. When the procession reached the river, the mourners placed the coffin on a barge and towed it to the *wabet*, the "place of purification" on the west bank of the Nile. In the wabet, various rituals of purification were carried out. From there, they again placed the coffin on a sledge which was drawn by oxen to the tomb.

OPENING OF THE MOUTH. At the tomb the Sem-priest purified the deceased, and the lector-priest performed the Opening of the Mouth ritual. The Opening of the Mouth ritual restored the vital faculties which the deceased had lost, and allowed him to make use of the funerary offerings. This ritual derived from the statue workshops of Memphis, and was originally used to animate statues of the gods after they were complete. Through a series of ritual passes made with an adze (a cutting tool), the priest opened the eyes, ears, nostrils, and mouth of the deceased, restoring his or her senses and faculties. Priests recited glorification spells in order to help the deceased transform into a glorified akh. The offering ritual involved the presentation of food, drink, incense, and many other goods before the false door of the tomb. The text stresses that the deceased has his own heart. This was essential, since in the final judgment before Osiris it was the deceased's heart that the gods weighed in the balance against the feather of maat. If the heart failed to measure up to maat, it and the deceased would be devoured by the demon Ammit. This is why the heart was often carefully wrapped and replaced in the chest cavity of the mummy. The heart scarab frequently placed inside the chest was engraved with a spell to prevent the heart from opposing the deceased in the tribunal before Osiris. Completion of the rites of mum-

mification and burial are what allowed the deceased to acquire the status of *netjer*, divine being.

FUNERARY FOUNDATIONS. We have seen that at burial the deceased was the recipient of offerings of food and drink. The need for such sustenance lasted far beyond the funeral, however. In order to ensure that he would have a steady supply of offerings to support him in the afterlife, an Egyptian would endow a foundation with land or with the income from a priestly office that he held. Usually, this endowment went to the eldest son of the deceased, called his "beloved son" on the condition that some of the income from the endowment went to provide offerings for the deceased. Such individuals functioned as "ka-priests" for the deceased. Such offices could be bequeathed to descendants of the ka priest for generations. During the New Kingdom, an individual who had royal permission could set up a statue of himself in the temple precincts, and through the intermediary of this statue share in the prayers and offerings which went on in the temple.

a PRIMARY SOURCE *document*

TWO STELE DESCRIBING FUNERARY RITES

INTRODUCTION: Two stele from the New Kingdom preserve a description of the funerary rites. They come from the tombs of Amenemhet in Thebes and the joint tomb of Djeheuty and Intef. This is a rare Egyptian description of a ritual.

A goodly burial arrives in peace after 70 days have been completed in your embalming house. [You] are placed on a bier pulled by four sound bulls, the path being sprinkled with milk until you reach the door of your tomb. Your grandchildren are assembled together weeping with loving hearts. Your mouth is opened by the lector priest; you are purified by the Sem-priest. Horus has adjusted your mouth for you; he has opened your eyes and ears for you. Your flesh and bones are complete (as) that which belongs to you. The spells of glorification are recited for you. The offering ritual is performed for you. Your own heart is with you, the one you had upon earth. You have arrived in your former appearance, as on the day in which you were born. Your beloved son is presented to you while the attendants give reverence. You enter the land which the king provides, into the area of the West. It is done for you as was done for the ancestors. The Muu dancers come to you rejoicing.

Translated by Stephen Thompson.

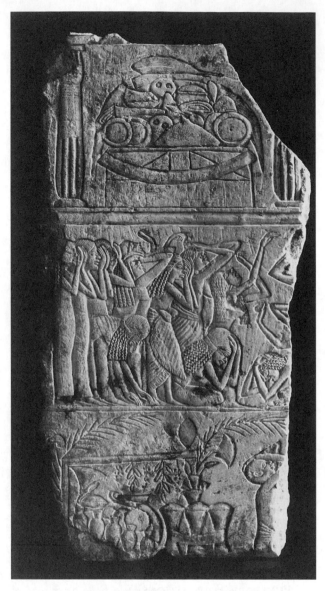

Relief carving depicting mourners at a funeral and table of food offerings, Eighteenth or Nineteenth Dynasty. PUBLIC DOMAIN.

SOURCES

Sue d'Auria, et al., *Mummies & Magic: The Funerary Arts of Ancient Egypt* (Boston: Museum of Fine Arts, 1988).

Salima Ikram and Aidan Dodson, *The Mummy in Ancient Egypt* (London: Thames and Hudson, 1998).

A. J. Spencer, *Death in Ancient Egypt* (Middlesex, England: Penguin Books, 1982).

SEE ALSO *Dance: Muu-Dancers; Dance: Funeral Dances*

THE EGYPTIAN AFTERLIFE

DESTINATIONS OF THE KING. Information concerning the Egyptian ideas of the hereafter comes from the texts buried with the dead and the illustrations found on tomb walls. As with so much in Egyptian religion, there was no single destination, but a multiplicity of destinations, all of which an Egyptian wished to reach after death. The earliest postmortem destination was celestial, and in the *Pyramid Texts* it was the deceased king's goal to ascend to the sky to live as a star among the circumpolar stars which never set. In Spell 1455 and 1456, the king states "I am a star which illuminates the sky; I mount up to the god that I may be protected, for the sky will not be devoid of me and this earth will not be devoid of me for ever. I live beside you, you gods of the Lower Sky, the Imperishable Stars. ..." In addition to ascending to the sky as a star, an Old Kingdom pharaoh also wished to ascend to the sky to assume a seat in the barque (sailing vessel) of the sun-god Re. Re was thought to travel throughout the sky in his solar barque by day, and through the underworld at night. By taking a seat in the solar barque, the deceased king was allowed to participate in the eternal, rejuvenating voyage of the sun. Yet another destination for the deceased king was the underworld kingdom of Osiris. Osiris, after his death at the hands of his brother Seth, became the ruler of the Egyptian underworld. As a result of undergoing the ritual of mummification and burial, the dead king becomes identified with Osiris, and as such became the ruler of the underworld.

PRIVATE INDIVIDUALS. After death, the private Egyptian expected to continue to enjoy a life very much like that which he had experienced on earth, judging from the types of burial goods included in the tombs, and the scenes found on tomb walls. Towards the end of the Old Kingdom (2675–2170 B.C.E.), however, the formerly exclusively royal prerogatives of the afterlife became available to private individuals as well. During the First Intermediate Period (2130–2008 B.C.E.) and

FAMILY MEMORIALS. Although the dead were buried in the necropolis, they did not cease to form part of an Egyptian's family. During certain religious festivals, the dead received special offerings. During the New Kingdom, at the "Feast of the Valley," families would cross over to the west bank of the Nile to visit the tombs of their relatives, and hold picnics within their chapels. Within the home, busts of deceased relatives as "effective spirits" could be set up, and were the focal point of prayers and offerings. According to Egyptian thought, the deceased still influenced the lives of the living, hence the necessity to make sure that their needs were satisfied.

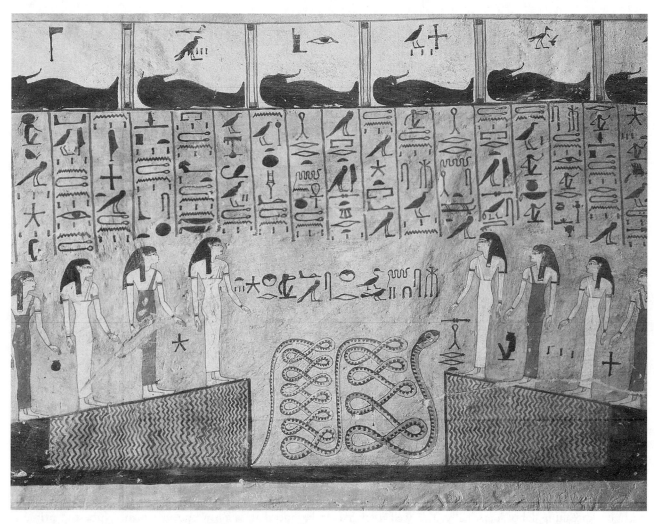

An illustration of one of the entrances to the Egyptian afterlife, from the *Book of Portals*. The soul had to know the proper spell to get past the snake. © GIANNI DAGLI ORTI/CORBIS. REPRODUCED BY PERMISSION.

Middle Kingdom (2008–1630 B.C.E.), the idea of a post-mortem life in the underworld realm of Osiris became more prominent, but was not the exclusive goal of the deceased. The New Kingdom (1539–1075 B.C.E.) *Book of the Dead* placed even more emphasis on the Osirian hereafter.

DANGEROUS JOURNEY. The journey to the realm of Osiris was fraught with danger. The paths of the underworld were guarded by knife-wielding demons that lay in wait for the unprepared dead. At times these demons guarded gates through which the deceased had to pass. In addition, these gates could be guarded by encircling walls of flame. During the New Kingdom, the number of gates through which the dead had to pass was variously given as seven (*Book of the Dead* Spell 147) or twenty-one (*Book of the Dead* Spells 145 and 146). The key to safely negotiating these dangers was a knowledge of the names of the demons and obstacles which one was

likely to encounter. Knowing their names rendered them unable to harm the deceased. Such knowledge was available in the texts buried with the deceased.

FIELD OF REEDS. After finally reaching the Hall of Osiris, the deceased had to undergo the final judgment and the weighing of his heart against the feather of maat (truth) in the presence of Osiris and the 42 judges of the afterlife. If the applicant passed successfully, he was admitted to the paradise of Osiris, referred to as the "Field of Reeds" or "Field of Offerings." This realm was modeled on Egypt itself. The land was crisscrossed by irrigation canals, and the deceased was responsible for such agricultural tasks as plowing, sowing, and reaping. Since this was paradise, the fruits of such labor were much greater. Wheat was said to grow to a height of five cubits (2.29 meters), with ears two cubits (.91 meters) in length. Barley grew seven cubits (3.2 meters) high, with ears of three cubits (1.37 meters). In order to avoid performing

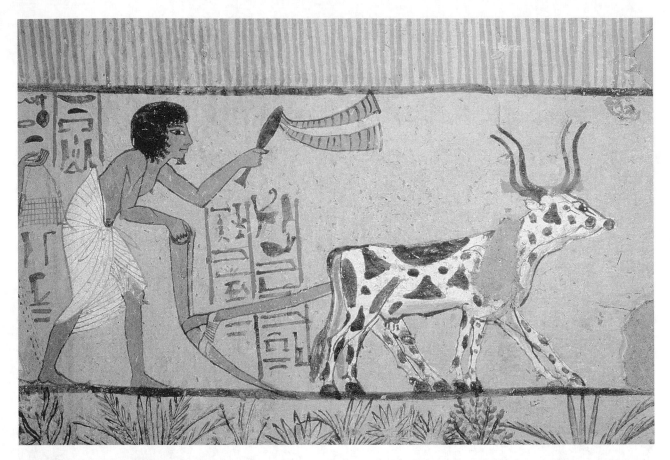

Depiction in a tomb of the tomb owner performing certain tasks in the Field of Reeds in the company of the gods. © BOJAN BRE-CELJ/CORBIS. REPRODUCED BY PERMISSION.

such backbreaking labor personally, the well-prepared Egyptian was buried with a number of shawabti-figurines, which responded for him or her when the deceased was called on to do manual labor in the afterlife.

BEGINNING OF A NEW DAY. Although the idea of spending the afterlife in the company of Osiris was prominent in the *Book of the Dead*, the idea of spending eternity in the solar barque (sailing vessel) with Re had not disappeared. Beginning with the Eighteenth-dynasty tomb of Thuthmosis I (r. 1493–1481 B.C.E.), a new type of funerary text made its appearance, the so-called *Underworld Books*. Included in this category are such works as the *Amduat* ("That Which is in the Underworld"), the *Book of Gates*, the *Book of Caverns*, and the *Book of the Earth*. These works describe the sun's journey through the underworld, which begins at sunset and concludes with the sun's rise from the waters of Nun, rejuvenated and ready to begin a new day. The underworld was divided into twelve sections, corresponding to the twelve hours of the night. During this time, Re, as the sun, bestows his life-giving rays on the dead who inhabit the underworld. Re travels through the underworld in his

barque that sails on the waters of Nun, the primeval ocean. At times, hostile creatures try to stop the barque, but due to the efforts of Re's entourage, they fail. At sunrise, Re successfully completes his journey through the underworld, bringing life and light to its inhabitants, including Osiris, and begins the new day rejuvenated.

THE DAMNED. Not all the dead, however, were allowed to share in the life-giving rays of the sun during the night. The lowest level of the underworld was reserved for the damned, those who had not successfully passed the final judgment. These unfortunate individuals become identified with the enemies of Osiris and Re, and are consigned to the *Hetemit* ("Place of Destruction"). There they suffer decapitation and dismemberment, including removal of the genitals and heart. They are suspended upside down, with their severed heads between their feet. Other scenes show them being boiled in cauldrons heated by fire-breathing snakes, or being incinerated directly by such serpents. They are doomed to spend eternity submerged in the "Lake of Fire." Perhaps worst of all, not only are their bodies subject to torture and destruction, but so are their bas. Scenes from the under-

world depict the bas of the condemned dead, represented by the ba-bird hieroglyph, being boiled in cauldrons. Through these means these unfortunate Egyptians, whose crimes are not known, were consigned to oblivion.

SOURCES

Werner Forman and Stephen Quirke, *Hieroglyphs and the Afterlife in Ancient Egypt* (Norman, Okla.: University of Oklahoma Press, 1996).

Erik Hornung, "Black Holes Viewed from Within: Hell in Ancient Egyptian Thought," in *Diogenes* 42 (1994): 133–156.

————, *The Valley of the Kings: Horizon of Eternity* (New York: Timken Publishers, 1990).

SIGNIFICANT PEOPLE
in Religion

AKHENATEN

Before 1352 B.C.E.–1366 B.C.E.

King
Founder of a New Religion

BEGINNINGS. Akhenaten was the second son of King Amenhotep III (r. 1390–1352 B.C.E.) of the Eighteenth Dynasty and his wife Tiye. When his older brother Thutmose died young, Akhenaten became the crown prince. It is possible that Akhenaten served for a time as co-regent (co-king) with his father, but the evidence for a co-regency is disputed. When his father died around 1352 B.C.E., he ascended to the throne as Amenhotep IV. He was married to the beautiful Nefertiti, as his Great Royal Wife. She may have been his cousin, although this is uncertain. He was also married to a woman named Kiya, who may have been a Mitannian princess from a region north of modern Iraq. With Nefertiti, Akehnaten had six daughters, three of whom died in infancy. It is also possible that he was the father of Tutankhamun (born Tutankhaten), but, as with so much from this period of Egyptian history, the evidence is inconclusive.

ATEN. In the fifth year of his reign, the king signaled a new religious direction for his kingdom by changing his name to Akhenaten, "He who is effective for the Aten." "Aten" was the Egyptian word for the physical disk of the sun. In the same year, the king began construction of a new capital for Egypt. At a vacant site in Middle Egypt he built the city of Akhetaten, "the horizon of the sun-disk." In the sixth year of his reign, Akhenaten moved his family and administration into his new capital.

NEW RELIGION. Akhenaten introduced a new religion to Egypt. Akhenaten worshipped only one god, the light that was in the sun. This light was believed to grant the world life, and to keep it alive. This new god was depicted as a sun disk emanating rays that ended in hands. These hands were frequently directed towards Akhenaten and his family, and could be shown offering the breath of life, symbolized by ankh-signs, to their noses. In order to worship the Aten, Akhenaten had a new type of temple constructed, reminiscent of the sun temples of the Fifth Dynasty (2500–2350 B.C.E.), nearly 1,000 years earlier. These temples consisted of a series of open courts oriented towards the east, centering on an altar. Such temples were built at Thebes, Memphis, Heliopolis, and of course, Akhetaten. In these temples, even the doorways had broken lintels, to allow the sun's rays to reach all parts of the temple.

ROYAL FAMILY. While Akhenaten and his family worshipped the Aten, the people of Egypt, especially those living at Akhetaten, were to worship the royal family. Akhenaten was considered to be the son of the Aten, and it was through him that the Egyptians were to worship the sun. Egyptian homes at Akhetaten contained stelae (carved or inscribed slabs of stone) showing the royal family worshipping the Aten. These stelae served as the focal point of the cult of the Aten within their homes. One official, Panehsy, praised Akhenaten as "my god, who built me, who determined good for me, who made me come into being and gave me bread."

AFTERLIFE. Even the traditional conception of the afterlife underwent a drastic change. No longer did the dead live on in the underworld in the company of Osiris, or journey through the sky in the barque of Re. Essentially there was no longer a world of the beyond. Both the living and the ba-spirits of the dead continued to live here on earth, under the sun's rays. At sunrise, the bas of the justified dead traveled to the Great Temple of the Aten in Akhetaten to receive the sun's life-giving rays and to participate in the offerings made to Aten in his temple. Justification no longer meant being found innocent in the tribunal of Osiris, but was a status reserved for those who were loyal to the king during life. Akhenaten, as Aten's sole representative on earth, was the dispenser of provisions to the dead.

AMUN. Not only did Akhenaten promote the worship of a new deity, he went so far as to close down the

temples to the other gods of Egypt, particularly the temples of Amun. Also in his fifth year, Akhenaten sent workmen throughout Egypt to remove the names of Amun, his consort Mut, and even the plural term "gods" from the monuments of Egypt. Akhenaten referred to the Aten as a god of whom "there is no other but him." Aten had no consort, no children (other than Akhenaten), and no opponent. Akhenaten may have been the world's first monotheist. After his death, however, Tutankhamun soon restored the full Egyptian pantheon. Akhenaten's revolution was short-lived and unsuccessful.

SOURCES

Cyril Aldred, *Akhenaten King of Egypt* (London: Thames and Hudson, 1988).

Erik Hornung, *Akhenaten and the Religion of Light* (Ithaca, N.Y.: Cornell University Press, 1999).

Donald Redford, *Akhenaten: The Heretic King* (Princeton, N.J.: Princeton University Press, 1984).

AMENHOTEP, SON OF HAPU

1479 B.C.E.–1353 B.C.E.

Royal Scribe
Priest
Overseer

SPECIAL STATUS. Amenhotep, son of Hapu, was born during the reign of pharaoh Thuthmosis III in the town of Athribis, in the Delta. His father was Hapu, and his mother was Itu. As a young man, he attended the temple school and learned "the words of Thoth" (hieroglyphs). Amenhotep served as an official under King Amenhotep III (r. 1390–1352 B.C.E.) of the Eighteenth Dynasty. He was first appointed as a royal scribe and priest in the temple of Horus-Khentikheti. He was later promoted to the office of "Scribe of Recruits," where he was responsible for organizing the manpower of Egypt for the king. From there he rose to the position of "Overseer of all the works of the King." In this position he was responsible for the construction of the king's temples at Soleb and Karnak, and for the monumental statues of the king set up at Thebes. As a reward for his services, Amenhotep was allowed to erect statues of himself throughout the processional way in the temple of Karnak. There, he could serve as an intermediary between visitors to the temple and the gods worshipped therein.

REVERED AFTER DEATH. When he died, he was buried at Qurnet Murai on the west bank of the Nile across from Thebes, near his king's funerary temple. He was even given the honor of having his own funerary temple, built near that of his sovereign. From there, the cult of Amenhotep, son of Hapu, grew in renown until he was revered as a local saint at Thebes. A Twenty-sixth-dynasty (664–525 B.C.E.) statue of Amenhotep dedicated by Merit-Neith, daughter of Pharaoh Psammetichus I (664–610 B.C.E.), asks him to heal her of an unnamed affliction of the eyes. By the Ptolemaic Period (332–30 B.C.E.), Amenhotep had entered the pantheon of the gods, and was revered as a god of wisdom and a healer, with major cult centers at Deir el Bahri and Deir el-Medina.

SOURCES

Eric Cline and David O'Connor, *Amenhotep III: Perspectives on His Reign* (Ann Arbor, Mich.: University of Michigan Press, 1998).

Rosalie and Antony E. David, *A Biographical Dictionary of Ancient Egypt* (Norman, Okla.: University of Oklahoma Press, 1992).

Dietrich Wildung, *Egyptian Saints: Deification in Pharaonic Egypt* (New York: New York University Press, 1977).

IMHOTEP

Unknown–c. 2600 B.C.E.

Vizier

DIVINITY. The Egyptian term *netjer* could be applied to a range of entities. In addition to gods, the word could be applied to the king, certain animals, and the dead. Egyptians venerated their deceased ancestors as in some sense divine. There are a few individuals in Egyptian history whose divinity grew to exceed the bounds of their own families, and who eventually came to have a place in the pantheon of Egyptian gods. Two such individuals are Imhotep and Amenhotep, son of Hapu, who both gained the title of netjer in Egyptian writing.

OFFICES. Imhotep served as a vizier (high government official) and architect under King Djoser of the Third Dynasty. He also held the offices of high priest of Re at Heliopolis, and the chief of sculptors and makers of stone vessels. He is credited with designing the king's step pyramid complex at Saqqara, and therefore with inventing monumental construction in stone. He outlived his patron, and his name is found in a graffito on the enclosure wall of an unfinished pyramid started during the reign of Sekhemkhet, the successor of Djoser. Imhotep perhaps died around 2600 B.C.E.

CULT. Imhotep disappears from view until the New Kingdom. Texts from this period credit him as one of the great sages of Egypt, who authored a collection of

proverbs, unfortunately now lost, but revered for their wisdom. Imhotep was considered to be a patron of scribes and intellectuals. Scribes would frequently pour out a water libation to him from their water-pots before beginning to write. By the Twenty-sixth Dynasty (664–525 B.C.E.), Imhotep was considered to be the son of the god Ptah and Khereduankh, his natural mother. Later on, Imhotep was given a wife, Renpet-neferet. Eventually a sanctuary in honor of Imhotep was built at Saqqara. Here in the area of Memphis, Imhotep was considered to be a god with special powers of healing. He was thought to be able to grant requests for wives and children. By the time of Roman domination of Egypt (30 B.C.E.–395 C.E.), the cult of Imhotep had spread throughout Egypt. In addition to being a god of healing and wisdom, Imhotep acquired a reputation as a famous astrologer, and was thought to have the power to bring fertility to the earth.

SOURCES

Rosalie and Antony E. David, *A Biographical Dictionary of Ancient Egypt* (Norman, Okla.: University of Oklahoma Press, 1992).

Nigel Strudwick, *The Administration of Egypt in the Old Kingdom: The Highest Titles and Their Holders* (London; Boston: Kegan Paul International, 1985).

Dietrich Wildung, *Egyptian Saints: Deification in Pharaonic Egypt* (New York: New York University Press, 1977).

DOCUMENTARY SOURCES
in Religion

Anonymous, *Amduat* (c. 1493 B.C.E.)—"What is in the Underworld," a description of the afterlife first found in the tombs of kings beginning with Thuthmosis I, is one of a series of underworld books composed in the New Kingdom.

Anonymous, *Book of Caverns* (c. 1292 B.C.E.)—This work is one of a number of descriptions of the underworld composed for the use of kings in the Ramesside Period (1292–1075 B.C.E.).

Anonymous, *Book of the Dead* (c. 1539 B.C.E.)—Called in Egyptian, the "Book of Going Forth by Day," these texts written on papyrus became popular in the New Kingdom and in the Late Period as guides to the afterlife. They are included in tombs for the use of the deceased.

Anonymous, *Book of Gates* (c. 1322 B.C.E.)—Found first in the tomb of King Ay, this is one of a number of books describing the underworld written during the New Kingdom.

Anonymous, *Book of the Heavenly Cow* (c. 1322 B.C.E.)—First found in the tomb of King Tutankhamun, this work is one of a series of descriptions of the underworld composed in the New Kingdom.

Anonymous, *Coffin Texts* (c. 2130 B.C.E.)—This funeral text found written on the interiors of non-royal people's coffins includes protective spells for parts of the body and other information necessary for the deceased to enter the afterlife. They are popular throughout the Middle Kingdom.

Anonymous, *Contendings of Horus and Seth* (c. 1279 B.C.E. or slightly later)—This is an account of these two gods' struggle to inherit the throne from the first mythical king Osiris.

Anonymous, *Esna Cosmogony* (c. 97 C.E.)—This is the only Egyptian creation story that claims a goddess, Neith, created the world. Other creation myths in Egypt credit creation to male gods.

Anonymous, *Khufu and the Magicians* (c. 1630 B.C.E. or slightly later)—This story describes a succession of professional magicians demonstrating their abilities for King Khufu. The story shows one idea of the Egyptian concept of magic.

Anonymous, *Memphite Theology* (c. 716 B.C.E.)—This version of the Egyptian creation myth stresses creation through the spoken word and is reminiscent of the biblical creations in Genesis and the Gospel of John.

Anonymous, *Pyramid Texts* (c. 2371 B.C.E.)—This is a royal funeral ritual inscribed on the interior walls of the pyramids of the end of the Fifth and Sixth Dynasties.

Anonymous, *Tale of the Doomed Prince* (c. 1292 B.C.E. or slightly later)—This is a story of a prince whose fate is set at his birth and who attempts to avoid it. The end of the story is missing and so it is not clear if he succeeds or not.

Clement of Alexandria, *Title* (c. third century C.E.)—This later description of Egyptian gods shows a misunderstanding of the role of statues in Egyptian religion.

Plutarch, *On Isis and Osiris* (c. first to second centuries C.E.)—This Greek recounting of the story of Isis and Osiris is the only connected narrative of this myth from ancient times.

Arts and Humanities Through the Eras: Ancient Egypt (2675 B.C.E.–332 B.C.E.)

249

chapter eight

THEATER

Edward Bleiberg

IMPORTANT EVENTS
in Theater

All dates in this chronology are approximations (c.) and occur before the common era (B.C.E.).

2500–2170 One of the earliest composed dramas, concerning the battle between the gods Horus and Seth, may have been written during this time period. The text is preserved only on the *Shabaka Stone* which dates to this king's reign (716–702 B.C.E.).

2130–2008 The *Coffin Texts*, which may have been dramatized, are composed during this time. The possible dramatic texts concern the goddess Isis' conception of her son Horus.

1919–1875 The *Dramatic Ramesseum Papyrus*, identified as a drama by the Egyptologist Kurt Sethe, is composed during the reign of Senwosret I. This text contains the burial ritual for a king and the coronation of the new king at the end of his father's funeral.

1836–1818 The earliest account of the *Osirian Drama of Khoiak* is composed. This ritual drama relating the story of the death and resurrection of the god Osiris is the best example of an Egyptian drama.

1539–1075 The *Book of the Dead*, which the Egyptologist Emile Drioton believed was dramatized, is composed. The texts contain spells which enabled the deceased to enter the next world.

1187–1156 The Festival Calendar carved at the temple of Medinet Habu includes the performance of several scenes from the *Osirian Drama of Khoiak* among the events on the calendar. This text helps to determine the proper order of the scenes of the play over the month of Khoiak.

381–362 The *Metternich Stele*, which Egyptologist Emile Drioton believed was a drama, is carved. The text concerns the goddess Isis' ability to cure scorpion stings and snake bites.

332–30 The *Papyrus Bremner-Rhind*, named for its first European owners, is written. It concerns a battle between the god Thoth and the demon-snake Apophis, and may have been a drama.

The *Triumph of Horus*, a drama carved on the walls of the temple at Edfu in Upper Egypt, is performed. The drama concerns the conflict between the gods Horus and Seth and their claims to be the legitimate king.

OVERVIEW
of Theater

EXISTENCE OF THEATER. The primary question in a discussion of ancient Egyptian theater is whether or not it existed at all. Theater in modern American culture is primarily a mode of entertainment, though it can examine political, religious, or social topics. Actors perform theater on a stage, speaking dialogue. If ancient Egyptian culture had included a similar sort of drama, they would have had words for "actor," "theater," and "performance." Yet all of these words are lacking in the Egyptian language. Theater buildings did exist in Egypt during the time period when the Greeks and then the Romans had conquered the country (after 332 B.C.E.), but Greek dramas and Roman comedies were undoubtedly performed in these theaters rather than native Egyptian drama. If Egyptian theater did exist, it must have taken a form different from theater in Greek and subsequent Western cultures.

THE STUDY OF EGYPTIAN THEATER. At least three early twentieth-century Egyptologists claimed to have identified ancient Egyptian dramas similar in form to ancient Greek drama: Kurt Sethe (1869–1934), Emile Drioton (1889–1962), and Herbert Fairman (1907–1982). Though Sethe, Drioton, and Fairman represent three successive generations of Egyptologists, they shared a common desire to represent ancient Egyptian culture as the equal of ancient Greek culture. For them, this equality meant that Egyptian culture had all of the same cultural institutions as the Greeks. Thus they sought to identify the mythology that would have been represented in Egyptian drama and further sought the dialogue for drama in surviving Egyptian texts. All three men were great scholars whose command of the ancient Egyptian language and numerous other contributions to Egyptology won them the respect of their colleagues and of Egyptologists living today. For this reason, their misguided search for a Greek-style drama in Egyptian culture has remained a part of Egyptological literature.

REDEFINING THEATER. Louis Boctor Mikhail, a Swedish Egyptologist, published a study of Egyptian theater in 1983. By redefining theater in Egypt as a ritual drama that was present in the festival of Osiris held during the month of Khoiak (mid-September to mid-October), Mikhail was able to analyze a particular kind of Egyptian theater. This theater was an element of Egyptian temple ritual, took place over many days, and incorporated priests and puppet-like statues as actors. Various locations within the temple served as the stage. Only by accepting Mikhail's definition of drama is it possible to discuss theater in ancient Egypt.

TOPICS
in Theater

DEFINING THEATER

FEW CLUES REMAIN. Egyptian theater has been a mystery to modern scholars. The fact that the Egyptians had no words equivalent to the English words "theater," "actor," or "stage," leads many scholars to believe that Egypt had no theater, as theater is understood in modern times. Yet Egyptologists (experts who have made a special study of Egyptian culture) have recognized that while there is no vocabulary pointing to theater, there are certain ancient Egyptian texts that are dramatic in nature. Many dialogues between gods and kings have survived and much of the music that was recorded on stone walls or papyrus is accompanied by illustrations of people in dramatic poses. There is also a recorded history of Egyptian priests impersonating different gods during ceremonies and festivals. If theater did exist in ancient Egypt it would have occurred during the various festivals held throughout the year, as it mainly did in ancient Greece and Rome in the later centuries before the common era. Even if theater was performed during festival periods, however, Egyptologists concede that it may have lacked many of the major components found in modern theater including entertainment value, professional actors, a stage, action and even an audience since many of the activities considered to be theater took place in small temple areas.

NOT ENTERTAINMENT. It is clear that if Egyptian theater existed, it did not serve as an independent form of entertainment. Instead it functioned within religious rituals as either a teaching method or as an offering to the gods. This type of theater is similar to the function theater played in various other cultures of this time period such as the Japanese Noh drama that took stories from religious myths and presented them both for religious

edification and for education. This designation puts Egyptian theater in contrast to more Western civilizations, such as Greece which developed theater as an independent institution from religion, education, or government, even though these institutions were still heavily influential in determining dramatic content.

NO ACTORS. Because theater was not separate from the institution of religion in Egypt, there were no professional actors or acting troupes. Instead, it was the religious class that performed all acting duties. While priests and, on the rare occasion, priestesses were the main performers in theater rituals, statues also played a large role in the dramatic telling of stories. The best-known example of how these actors and statues functioned in a theater production comes from a surviving Osirian drama most likely performed in the cult center at Abydos. The statues used to represent gods were usually made of stone and thought to be small based on remains that have been found. For instance, the figures of the gods Henty-imentyu and Sokar were approximately 22 inches tall. The coffin for the god Osiris used in the drama was about the same length, suggesting that the figure of Osiris used in the drama was also small. Lesser gods, such as a small hippopotamus that was used to represent the god Seth in the Osiris play, were rendered not in stone, but in bread. Priests also represented gods in this drama and they wore masks that allowed them to impersonate the gods and provide a narrative by reciting a ritual. Priestesses mimed the parts of the goddesses Isis and Nephthys, who performed a mourning ritual. Some reliefs that allude to the Osiris drama indicate that the king, for whom all theater would be performed, would sometimes portray himself during performances. A variety of archaeological and textual materials have revealed many of these details of the Osirian Khoiak festival.

NO STAGE. Since all theater was related to religious rituals and festivals, Egyptian dramatic presentations took place at various venues within a temple. Chapels at the god Osiris' temple in Abydos bore names related to different scenes in the drama and were perhaps the venues for the performances of these different scenes. The priests, however, often presented other scenes on the temple lake within the sanctuary, and at specific stations on the processional way to different temple locations. Hence, there was no necessity for a central theater in ancient Egypt due to the fact that religious rites were mobile.

NO ACTION. Based on the surviving texts thought to be dramatic in nature, action was most often reported rather than performed. The characters were often statues and thus could not be manipulated to perform actions.

Furthermore, the course of the story was never a surprise to the audience. The dramatic presentation was instead the reenactment of a ritual that was most likely performed yearly and would be familiar to all in attendance. While there was little action during Egyptian drama, there were various different elements during a performance that told the story of a myth within the context of a temple ritual. These included song, dance, instrumental music, pantomime, and dialogue.

EVALUATING PERFORMANCES. Though comparisons with ancient Greek or with modern drama can clarify the differences between modern expectations and Egyptian reality, those expectations cannot be used to define or evaluate Egyptian theater. Since all of the stories were centered around the religious rituals which were taken from the myths surrounding the god Osiris, his wife Isis, their son Horus, and Osiris' brother Seth, there was most likely very little originality in the performances. There would not have been one ritual that was more highly favored than any other due to the fact that each ritual honored a different god. Hence, unlike festivals in other cultures where theater was judged and prizes awarded, the Egyptians saw theater more as a necessity and not worth the fanfare.

SOURCES

Louis B. Mikhail, *Dramatic Aspects of the Osirian Khoiak Festival* (Uppsala, Sweden: Institute of Egyptology, 1983).

Paul O'Rourke, "Drama," in *Oxford Encyclopedia of Ancient Egypt.* Ed. Donald B. Redford (New York: Oxford University Press, 2001): 407–409.

SPOKEN DRAMA

DETERMINING TEXTS. Though Egyptologists generally agree that some Egyptian texts were dramatic, there is little agreement on which texts fall into this category. The most commonly identified drama is the *Dramatic Ramesseum Papyrus,* but there are other texts thought by some Egyptologists to constitute dramas, including the *Shabaka Stone,* parts of the *Coffin Texts,* parts of the *Book of the Dead,* the *Metternich Stele,* the *Papyrus Bremner-Rhind,* the *Louvre Papyrus 3129,* and the Horus Myth carved on the walls of the Edfu temple. The lack of agreement on which texts constitute drama leads to difficulties in studying drama as a distinct class of text. The following reviews the evidence that these texts represent dialogue and stage directions for dramatic presentations.

DRAMATIC RAMESSEUM PAPYRUS. The *Dramatic Ramesseum Papyrus* received its name from its first editor, Kurt Sethe, the distinguished German Egyptologist

who worked in the late nineteenth and early twentieth centuries. The English archaeologist James Edward Quibell discovered the papyrus in a tomb near a temple built by Ramesses II, called the Ramesseum, in 1896. The text most probably dates to the Twelfth Dynasty (1938–1759 B.C.E.). The text describes the coronation of Senwosret I, the second king of the Twelfth Dynasty (1919–1875 B.C.E.). The ceremony portrayed in the text is probably even older than Senwosret I's reign. The funeral ceremony for Senwosret's father, Amenemhet I, begins the text. The culmination of the funeral is Senwosret's coronation.

STRUCTURE OF THE RAMESSEUM PAPYRUS. The structure of any Egyptian text must be interpreted by the modern reader. The Egyptians used no punctuation. Thus sentence and paragraph division is sometimes a matter of opinion, though usually no Egyptologist disputes the order in which the lines are read. Sethe believed that the author of the Ramesseum Papyrus had divided it into scenes. Each scene included stage directions, provided as a narrative. The actor's dialogue followed the narrative. The narrative, according to Sethe, describes the actions that the actors perform. It begins with the phrase "what happened was …," but often the second sentence in the narrative is a comment on the religious meaning of the action in the previous sentence. Thus such stage directions would also include religious interpretation. The dialogue always begins with the Egyptian formula, "Words spoken by …," found often at the beginning of Egyptian prayers and magic spells. Sethe called the third section of each scene "scenic marks." The scribe wrote these marks horizontally, in contrast to the vertical columns of the dialogue. The first scenic mark included either the name of a god, the name of a ritual object, a ritual theme, or a ritual action. The second scenic mark gave an earthly equivalent of the divine antecedent in the first mark. The third scenic mark was the name of a place, an action, or a person. The scenic marks seem also to interpret the preceding action and dialogue.

VIGNETTES. "Vignette" is the name Egyptologists give to the illustrations found in a papyrus manuscript. Sethe noted that the vignettes included in the *Dramatic Ramesseum Papyrus* do not relate directly to the texts. Sometimes the vignette combined more than one scene. At other times, the vignette bears no clear relationship to the words found near it in the papyrus. Hence, Sethe concluded that the vignettes were used only for reading the text, not for performing it. This situation is similar to that found in illustrated examples of the *Book of the Dead.*

a PRIMARY SOURCE *document*

DRAMATIC RAMESSEUM PAPYRUS SCENE 3: A TYPICAL SCENE

INTRODUCTION: The German Egyptologist Kurt Sethe believed that the *Dramatic Ramesseum Papyrus* consisted of scenes composed in a regular pattern. The scenes began with stage directions. These directions began with the phrase, "It happened that …" The following sentence was an interpretation of the religious meaning of the stage directions. Then the formula "words spoken by …" followed with the dialogue. Finally, the scenic marks included the names of gods, actions, or places. The following scene, which Sethe numbered three follows this pattern.

It happened that the royal bull burnt-offering was made. Horus is the one who is angry and his eye takes when the (falcon) with the great breast of Thoth comes and when the one who empties the eye during the making of the burnt-offering of all sacrificial cattle. Words spoken by Isis to Thoth: "Your lips are those which have done it." Thoth. Making the burnt-offering and chaining the sacrificial cattle for the first time. Words spoken by Isis to Thoth. "Open your mouth again." Thoth. Slaughtering of the sacrificial cattle.

Translated by Edward Bleiberg.

OTHER THEORIES ON THE RAMESSEUM PAPYRUS. Sethe was not the final word on the *Dramatic Ramesseum Papyrus.* Two Egyptologists working in Germany during the 1960s and 1970s believed that the currently known copy of the Ramesseum Papyrus included both the original script as well as comments made after the composition of the script. According to these scholars, the comments are part of the interpretive comments found in the second sentence of Sethe's narrative stage directions and in the scenic marks. They believed this commentary to be religious in nature and evidence that the Ramesseum Papyrus was a religious ritual. Even Sethe implied such a conclusion because he referred to it as a festival play and emphasized its ceremonial character. Other Egyptologists have debated the proper order of the scenes. Egyptian writing on papyrus is most often arranged right to left. Indeed the individual lines of the Ramesseum Papyrus are arranged in this typical fashion. Some Egyptologists, however, have attempted to arrange the scenes from left to right, while reading the individual lines from right to left. This sort of arrangement is not otherwise known in Egyptian texts. The motivation

a PRIMARY SOURCE document

THE SHABAKA STONE: THE FIRST IDENTIFIED DRAMA

INTRODUCTION: *The Shabaka Stone* was among the first texts which the German Egyptologist Kurt Sethe identified as drama. The text includes both narratives that Sethe understood as stage directions and speeches by the gods that Sethe viewed as dialogue. The major themes of the drama include the battle between Horus and Seth to inherit the right to be king from Osiris and the unity of Horus, the rightful king with the god Ptah. The text was either composed in the Fifth or Sixth Dynasty (2500–2170 B.C.E.) and recopied in King Shabaka's time (716–702 B.C.E.) or composed during Shabaka's time and attributed to ancient history to increase its importance.

This writing was copied out anew by his majesty in the House of his father Ptah-South-of-his-Wall, for his majesty found it to be a work of the ancestors which was worm-eaten, so that it could not be understood from beginning to end. His majesty copied it anew so that it became better than it had been before, in order that his name might endure and his monument last in the House of his father Ptah-South-of-his-Wall throughout eternity, as a work done by the Son of Re [Shabaka] for his father Ptah-Tatenen, so that he might live forever …

[Geb, lord of the gods, commanded] that the Nine Gods gather to him. He judged between Horus and Seth; he ended their quarrel. He made Seth king of Upper Egypt in the land of Upper Egypt, up to the place in which he was born, which is Su. And Geb made Horus king of Lower Egypt in the land of Lower Egypt, up to the place in which his father was drowned which is "Division of-

the-Two-Lands." Thus Horus stood over one region, and Seth stood over one region. They made peace over the Two Lands at Ayan. That was the division of the Two Lands.

Geb's words to Seth: "Go to the place in which you were born." Seth: Upper Egypt. Geb's words to Horus: "Go to the place in which your father was drowned." Horus: Lower Egypt. Geb's words to Horus and Seth: "I have separated you."—Lower and Upper Egypt.

Then it seemed wrong to Geb that the portion of Horus was like the portion of Seth. So Geb gave to Horus his inheritance, for he is the son of his firstborn son.

Geb's words to the Nine Gods: "I have appointed Horus, the firstborn." Geb's words to the Nine Gods: "Him alone, Horus, the inheritance." Geb's words to the Nine Gods: "To this heir, Horus, my inheritance." Geb's words to the Nine Gods: "To the son of my son, Horus, the Jackal of Upper Egypt—" Geb's words to the Nine Gods: "The firstborn, Horus, the Opener-of-the-ways." Geb's words to the Nine Gods: "The son who was born— Horus, on the Birthday of the Opener-of-the-ways" …

Reed and papyrus were placed on the double door of the House of Ptah. That means Horus and Seth, pacified and united. They fraternized so as to cease quarreling in whatever place they might be, being united in the House of Ptah, the "Balance of the Two Lands" in which Upper and Lower Egypt had been weighed.

SOURCE: "The Shabaka Stone," in *The Old and Middle Kingdoms*. Vol. 1 of *Ancient Egyptian Literature*. Trans. Miriam Lichtheim (Berkeley and Los Angeles: University of California Press, 1973): 52–53.

for rearranging the scenes was to make their order more closely resemble the order of some relief sculptures carved in the Tomb of Kheruef, an official of King Amenhotep III (1390–1352 B.C.E.), nearly 550 years after the date of the papyrus. Though the scenes in Kheruef's tomb contain some of the same subject matter as the *Dramatic Ramesseum Papyrus*, no scholar has been able to convincingly argue that the order of the scenes in the papyrus should be read in the same order as the relief scenes.

SHABAKA STONE. Sethe's second example of an Egyptian drama was the *Shabaka Stone*. Egyptologists named this inscribed black slab of slate after King Shabaka (716–702 B.C.E.) who ordered that it be carved. The inscription begins with the note that it is a copy of a papyrus that was written "in the time of the ancestors." Some problems in understanding the text stem from the

fact that millers used the *Shabaka Stone* as part of a millstone at some time. Many parts of the center of the inscription are so worn away that they are illegible. Furthermore, Egyptologists continue to question the true date of this text. The first commentators thought it was a Fifth- or Sixth-dynasty text which would date it to approximately 2500–2170 B.C.E. These scholars saw similarities between the language used in the *Shabaka Stone* and the *Pyramid Texts*, known to be written at that time. Others believe that scribes in the time of Shabaka purposely created a text that sounded old to validate current theological ideas and imply these ideas had an ancient pedigree.

DEBATE OVER TEXT. When Sethe studied the text of the *Shabaka Stone*, he concluded it was a drama, expanding on the ideas of his teacher, Adolf Erman. He

a PRIMARY SOURCE *document*

DRAMA AND RITUAL IN THE COFFIN TEXTS

INTRODUCTION: The French Egyptologist Emile Drioton regarded *Coffin Text Spell 148* as the written evidence for a drama involving the goddess Isis, her child Horus, and the father of the gods, Geb. Scribes wrote *Coffin Texts* on the interiors of Egyptian coffins beginning in the First Intermediate Period (2130–2008 B.C.E.) and throughout the Middle Kingdom (2008–1630 B.C.E.); Egyptologists understand them as part of the funerary ritual. The narrative in Drioton's opinion constitutes stage directions while the speeches represent dialogue. This spell refers to the gods' reaction when Isis learns that she has become pregnant posthumously with Osiris' child. The child Horus was destined to become the next legitimate king of Egypt. This story is basic to the political legitimacy of each Egyptian king. It remains doubtful whether this text was enacted as a ritual drama.

The lightning flash strikes, the gods are afraid, Isis wakes pregnant with the seed of her brother Osiris. She is uplifted, (even she) the widow, and her heart is glad with the seed of her brother Osiris. She says: "O you gods, I am Isis, the sister of Osiris, who wept for the father of the gods, (even) Osiris who judged the slaughterings of the Two Lands. His seed is within my womb, I have moulded the shape of the god within the egg as my son who is at the head of the Ennead. What he shall rule is this land, the heritage of his (grand-)father Geb, what he shall say is concerning his father, what he shall kill is Seth the enemy of his father Osiris. Come, you gods, protect him within my womb, for he is known in your hearts. He is your lord, this god who is in his egg, blue-haired of form, lord of the gods, and great and beautiful are the vanes of the two blue plumes."

"Oh!" says Atum, "guard your heart, O woman!"

"How do you know? He is the god, lord and heir of the Ennead, who made you within the egg. I am Isis, one more spirit-like and august than the gods; the god is within this womb of mine and he is the seed of Osiris."

Then says Atum: "You are pregnant and you are hidden, O girl! You will give birth, being pregnant for the gods, seeing that(?) he is the seed of Osiris. May that villain who slew his father not come, lest he break the egg in its early stages, for the Great-of-Magic will guard against him."

Thus says Isis: "Hear this, you gods, which Atum, Lord of the Mansion of the Sacred Images, has said. He has decreed for me protection for my son within my womb, he has knit together an entourage about him within this womb of mine, for he knows that he is the heir of Osiris, and a guard over the Falcon who is in this womb of mine has been set by Atum, Lord of the gods. Go up on earth, that I may give you praise. The retainers of your father Osiris will serve you, I will make your name, for you have reached the horizon, having passed by the battlements of the Mansion of Him whose name is hidden. Strength has gone up within my flesh, power has reached into my flesh, power has reached...."

" ... who conveys the Sunshine-god, and he has prepared his own place, being seated at the head of the gods in the entourage of the Releaser(?)."

"O Falcon, my son Horus, dwell in this land of your father Osiris in this your name of Falcon who is on the battlements of the Mansion of Him whose name is hidden. I ask that you shall be always in the suite of Re of the horizon in the prow of the primeval bark for ever and ever" ...

Isis goes down to the Releaser(?) who brings Horus, for Isis has asked that he may be the Releaser(?) as the leader of eternity.

"See Horus, you gods! I am Horus, the Falcon who is on the battlements of the Mansion of Him whose name is hidden. My flight aloft has reached the horizon, I have overpassed the gods of the sky, I have made my position more prominent than that of the Primeval Ones. The Contender has not attained my first flight, my place is far from Seth, the enemy of my father Osiris. I have used the roads of eternity to the dawn, I go up in my flight, and there is no god who can do what I have done. I am aggressive against the enemy of my father Osiris, he having been set under my sandals in this my name of ... I am Horus, born of Isis, whose protection was made within the egg; the fiery blast of your mouth does not attack me, and what you may say against me does not reach me, I am Horus, more distant of place than men or gods; I am Horus son of Isis."

SOURCE: "Spell 148," in *Spells 1–354*. Vol. I of *The Ancient Egyptian Coffin Texts*. Trans. Raymond O. Faulkner (Warminster, England: Aris and Phillips, Ltd., 1973): 125–126.

came to this conclusion based on the existence of dialogues through which the gods give speeches and others reply. Again he used the formula "words spoken by ..." to recognize the dialogue. The text also contains some free spaces and squares that Sethe believed divided the text. Other commentary on the *Shabaka Stone*, however, has suggested that the gods' dialogue only reinforces ideas in a philosophical treatise. The major themes of the text concern the gods Horus and Seth quarreling over which is the rightful heir to Osiris, the first Egyptian

Arts and Humanities Through the Eras: Ancient Egypt (2675 B.C.E.–332 B.C.E.)

257

a PRIMARY SOURCE *document*

SEEKING DRAMA

INTRODUCTION: The French Egyptologist Emile Drioton sought Egyptian drama in the rituals of the *Book of the Dead*. Though Chapter 39 has speeches that appear to be dramatic, it is more likely that they were recited in rituals that ensured that the deceased was admitted into the next world.

Chapter for Repelling a Rerek-snake in the God's Domain

Get back! Crawl away! Get away from me, you snake! Go, be drowned in the Lake of the Primordial Water, at the place where your father commanded that the slaying of you should be carried out. Be far removed from that abode of Re wherein you trembled, for I am Re at whom men tremble; get back, you rebel, at the knives of his light. Your words have fallen because of Re, your face is turned back by the gods, your heart is cut out by Mafdet, you are put into bonds by the Scorpion-goddess, your sentence is carried out by Maat, those who are on the ways fell you.

Fall! Crawl away, Apophis, you enemy of Re! O you who escape massacre in the east of the sky at the sound of the roaring storm, open the doors of the horizon before Re, that he may go forth, wearied with wounds. I do what you desire, O Re, I do what is good, I act as one who pleases, O Re, I cause your bonds to fall, O Re. Apophis has fallen to your destruction, the southern, northern, western and eastern gods have bound her bonds on him, Rekes has felled him, he who is over the partisans has bound him, and Re is content, Re proceeds in peace. Apophis the enemy of Re has fallen down, and what you have experienced is greater than that experience which is in the heart of the Scorpion-goddess; great is what she has done against you with the everlasting pains which are hers. You shall not become erect, you shall not copulate,

O Apophis, you enemy of Re. Opposition is made against you, O you whom Re hates when he looks on you.

Get back! You shall be decapitated with a knife, your face shall be cut away all round, your head shall be removed by him who is in his land, your bones shall be broken, your limbs shall be cut off; the earth-god has condemned you, O Apophis, you enemy of Re.

O Re, your crew … may you rest there, for your possessions are there. Bring to the house, bring your Eye to the house, bring what is good; may no evil opposition come forth from your mouth against me, being what you might do against me, for I am Seth, who can raise a tumult of storm in the horizon of the sky like one whose will is destruction—so says Atum.

Lift up your faces, you soldiers of Re, and keep Nendja away from the tribunal for me—so says Geb. Make yourselves firm, O you who are on your seats aboard the bark of Khepri. Take your ways and your weapons which are put into your hands for you—so says Hathor. Take your javelins—so says Nut. Come, drive away that enemy of his, namely Nendja, that those who are in his shrine may come and that he may ferry himself in solitude, even he the Lord of All, who shall not be opposed—so says those primeval gods who circumambulate the Lakes of Turquoise. Come, O Great One whom we worship; save us, O you whose shrines are great, from whom the Ennead came forth, to whom what is beneficial is done, to whom praise is given; may someone report it to you and me—so says Nut—for yonder Happy One—so say those who are among the gods. May he go forth, may he find the way, may he plunder the gods, may he rise early in front of Nut, and may Geb stand up—so says the Terrible One. The Ennead is on the move, the door of Hathor has been infringed, and Re is triumphant over Apophis.

SOURCE: "Chapter for Repelling a Rerek-snake in the God's Domain," in *The Egyptian Book of the Dead*. Trans. Raymond O. Faulkner (San Francisco: Chronicle Books, 1994): 104.

king. Horus, son of Osiris, and Seth, brother of Osiris, each claim to be the next legitimate king. The god Geb judges between them, first giving Horus the north and Seth the south, then finally proclaiming the whole inheritance belongs to Horus. Much of this plot is also known from the Ramesside story, the *Contendings of Horus and Seth*. But in the *Shabaka Stone* the story then places the god Ptah as the chief of the gods. The author describes Ptah as the ultimate creator god who created the world from speech. Memphis, Ptah's home city, is further declared the proper capital of all Egypt. Hence,

many commentators regard these themes as strictly political and religious and do not regard it as a ritual drama.

COFFIN TEXTS. Scribes wrote the *Coffin Texts* on the inside of coffins, beginning in the First Intermediate Period and throughout the Middle Kingdom (2130–1630 B.C.E.). There are many different spells, mostly concerned with the deceased gaining admittance to the next world. The French Egyptologist Emile Drioton believed that spells 148, 162, and 312 represented extracts from dramas. Though few Egyptologists today accept this view, these spells represent dramatic dialogues and monologues

that offer a view of the drama inherent in certain religious rituals for the Egyptians.

COFFIN TEXT 148. Much of Drioton's conjecture comes from the dialogue between the deities Isis, Atum, and Horus in *Coffin Text 148*. According to Drioton, the text begins with a title and the stage directions that Isis awakes, pregnant. She then speaks, describing in outline the conflict between Osiris, her husband, and Seth, his brother. She proclaims that the child within her womb, Horus, will become the next king. Atum first questions her knowledge, but then agrees to protect her after she insists that this child belongs to Osiris. Isis repeats Atum's assurances and describes Horus. Horus himself then gives a speech to the gods, claiming his right to the throne. The action thus is magical and not clearly logical. The inherent drama from this text comes from the audience already knowing the story and making other connections to mythological tales while hearing this recitation. The speeches thus belong to the realm of ritual and could possibly have been acted out by priests during the ritual.

BOOK OF THE DEAD 39. The *Book of the Dead* contains spells designed to enable the owner to enter the afterlife. They replaced coffin texts during the New Kingdom and through the end of pagan Egyptian religion (1539 B.C.E. to the second century C.E.). Some of these spells, such as the one contained in Chapter 39, also resembled drama to Drioton. Chapter 39 bears the title "Repelling a Rerek-snake in the God's Domain," and it contains long speeches made by the god Re and an unnamed speaker, and short speeches made by the deities Geb, Hathor, and Nut. Again the situation is heavily dialogue-based. It concerns saving the god Re from the attacks of a snake. Again the text resembles a typical Egyptian ritual, but unlike the *Coffin Texts*, there is no clear evidence of stage directions or the intention to stage the recitation of these speeches.

METTERNICH STELE. The Metternich Stele received its modern name because it was once in the collection of the early nineteenth-century Austrian prince Klemens von Metternich. An artist carved the stele (a slab with an inscribed or sculpted surface) in the reign of Nectanebo I (381–362 B.C.E.) during the final native Egyptian dynasty. Most Egyptologists today consider the stele a *cippus*, a magical device used to protect the owner from snake bites and scorpion stings. Drioton, however, regarded the story carved on the stele as a drama. The text describes the rescue by the goddess Isis of a rich woman's son from a scorpion bite, and her subsequent curing of her own son, Horus, with the help of the gods when he is poisoned. Though Drioton understood the narrative

a PRIMARY SOURCE *document*

MISIDENTIFICATION IN THE BIOGRAPHY OF EMHAB

INTRODUCTION: Emile Drioton's desire to discover ancient Egyptian drama in some texts also led him to search among Egyptian texts for people who had been actors. Drioton translated the Biography of Emhab in a way that implied that Emhab had been an itinerant actor, rather than a drummer in the Egyptian military. Drioton translated a word that means "followed" as "tour" and a word that means "utterance" to mean "declaim" and thus could interpret the text to mean that Emhab was an actor. Jaroslav Černý, the Czech Egyptologist, retranslated the Biography of Emhab according to standardized meanings of the words and discovered that Emhab was a military drummer.

A boon which the king gives (to) Osiris, lord of Busiris, the great god, lord of Abydos, that he may give invocation-offerings consisting of bread and beer, oxen and fowl, to the spirit of the hereditary noble and favoured count Emhab, called Tamereru, repeating life. He says: I am one who followed his lord in his movements and one who did not fail in (any) utterance which he said. I put all strength and suppleness in (my) two hands. It was said to Hetinet: "Come! He will fight with you in endurance." I beat him with fingers seven thousand (times) in endurance. (I) spent year 3 beating drum every day. I gave satisfaction to my lord in all his affairs, (for) he is now a god, while I am (only) a ruler. He killed and I let live. I reached Miu without counting all foreign countries, while I followed him day and night, and I reached Auaris. My lord acquired Gemishena for Lower Egyptian barley and one pot full of choice oil …

SOURCE: Jaroslav Černý, "The Stela of Emhab from Tell Edfu," *Mitteilungen des Deutschen Archäologischen Instituts, Kairo* 24 (1969): 89.

as stage directions and the magic spells as dialogue, no other Egyptologist accepts this interpretation.

RETURN OF SETH. Drioton draws the drama *The Return of Seth* from the Louvre Papyrus 3129 and the British Museum Papyrus 10252. The Louvre papyrus dates to the Ptolemaic period (332–30 B.C.E.) while the British Museum papyrus dates to the reign of Nectanebo I (381–362 B.C.E.). These texts describe the god Seth's return from banishment after losing his battles with the god Horus. These battles resume upon his return. This story relates to the narrative in the *Shabaka Stone* and,

like the *Shabaka Stone*, it has a mix of dialogue and narrative. Yet no other Egyptologist recognizes these texts as drama.

PAPYRUS BREMNER-RHIND. Drioton also recognized a drama in *Papyrus Bremner-Rhind*. A scribe wrote this papyrus during the Ptolemaic period (332–30 B.C.E.). The story concerns a battle between the god Thoth and the demon-snake Apophis. The papyrus contains neither stage directions nor the formula that introduces speech, the criteria Drioton used to identify drama in other texts. Hence the *Papyrus Bremner-Rhind* is the least convincing of Drioton's examples.

FAIRMAN'S DRAMAS. The English Egyptologist H. W. Fairman believed that the best evidence for drama in ancient Egypt came from the texts and relief sculptures carved on the walls of the temple at Edfu. These texts and reliefs date to the Ptolemaic period (332–30 B.C.E.) and concern the conflict between Horus and Seth. At Edfu, Seth takes the form of a hippopotamus, a theme found also in the Ramesside story that considers the same topic. Fairman advanced the discussion of drama in Egypt by showing concrete proof that drama was most likely connected to a festival. From the reliefs he identified musical instruments included in the performance as well as a chorus of singers and dancers. Fairman also believed that the king participated in the performance from the evidence of the reliefs. Most Egyptologists accepted Fairman's analysis of the scenes as accurate. The question still remains as to whether it represents only a festival ritual or whether that ritual can be identified as a drama.

SOURCES

Hartwig Altenmüller, "Zur Lesung und Deutung des dramatischen Ramesseum Papyrus," in *Jaarbericht van Het Vooraziatsich-Egyptisch Genootschap Ex Oriente Lux* VI (1967): 421–442.

Emile Drioton, "Le théâter dans l'ancienne Égypte," in *Revue de la Société d'Histoire du Théâtre* VI (1954): 7–45.

H. W. Fairman, *The Triumph of Horus* (London: Batsford, 1974).

Kurt Sethe, *Dramatische Texte zu altägyptische Mysterienspiel* (Leipzig, Germany: J. C. Heinrichs Verlag, 1928).

THE OSIRIAN KHOIAK FESTIVAL DRAMA

OSIRIS MYTH. The Egyptologist Louis B. Mikhail argued that the ritual associated with the god Osiris, performed during the Egyptian month Khoiak (mid-September to mid-October) was the best example of a festival drama known to modern scholars. The subject of the drama was the struggle between Osiris and his brother Seth, Osiris' death, and his resurrection. The festival itself lasted for ten days, culminating with Osiris' resurrection at the end of the month that paralleled with the planting of new crops at the beginning of the agricultural year.

THE STORY. No one Egyptian text narrates the story of Osiris' life, death, and resurrection, but the outline of the story can be reconstructed. The good King Osiris ruled Egypt with his devoted wife Isis, a great magician. Osiris' brother, Seth, was jealous and believed he should be the king. Seth murdered Osiris—in this version through drowning—and dismembered his body into sixteen pieces that he scattered around Egypt. Isis gathered together the pieces of Osiris' body and reanimated his body so that they could conceive a child, the next legitimate king, named Horus. Osiris proceeded to the next world where he ruled over the dead. This story and its various elements were dramatized in the Osirian Khoiak Festival.

SOURCES. In order to reconstruct the Osirian Khoiak Festival ritual drama, Mikhail drew on festival calendars inscribed on temple walls, texts on stele, reliefs in temples, and archaeological remains such as the statues of Osiris used in the performance. One problem with these sources is that they originate from widely different time periods. The oldest material dates to the Middle Kingdom (2008–1630 B.C.E.) while the newest sources date to the Ptolemaic Period (332–30 B.C.E.). The sources thus would also reflect variations in the importance of the different parts of the festival at temples widely separated both in time and space. Thus it is not really possible to understand fully the development of the festival, but only to reconstruct it in broad outline.

FESTIVAL CALENDARS. Mikhail drew on festival calendars from temples at Medinet Habu, Edfu, Dendera, and Esna. All these temples are located in Upper (southern) Egypt. They date as early as the time of Ramesses III (1187–1156 B.C.E.) and as late as the end of the Ptolemaic Period (30 B.C.E.). Mikhail reconstructed the scenes of the play that took place between the twenty-first and thirtieth of Khoiak. Each day witnessed a particular festival scene that included purifications, processions, feasts, and erection of obelisks and pillars that symbolized Osiris' resurrection.

PREPARATIONS. Different texts supply different kinds of information about the festival drama. Inscriptions at the Temple of Isis at Dendera supply information about preparations for the festival between the twelfth and twentieth of Khoiak before the festival be-

gan in earnest. These preparations include creating the figures used in the drama. The figures represent the gods Sokar and Khenty-imentyu, two forms of the god Osiris. Priests buried these figures so they could resurrect them later in the festival. It was also necessary to create and decorate a coffin for Osiris and to create a shroud. These preparations also took place on designated days between the fifteenth and twentieth of the month.

ACTIONS. The Dendera texts also record specific ceremonies that took place during the festival drama. On the sixteenth of the month the god Horus, in the form of a crocodile, conveyed Osiris' body to the temple from the water. It is possible that crocodile mummies, known from many temples, actually portrayed Horus at this point in the drama. The priests then held a procession that included the gods Sokar and Anubis, other gods with their emblems, and the obelisk tops called benben stones. They traveled through the temple and the necropolis. This procession marked the divine transformation of Osiris' body. On the twenty-second of the month, 34 boats bearing different gods participated in the search for the drowned remains of Osiris. They searched on the sacred lake within the temple. The boats were small, about 63.5 centimeters (25 inches) long. Though the measurements of the statues of the gods on the boats are not recorded, clearly the statues were also fairly small. It is not clear why the gods continue to search for Osiris if Horus had already conveyed his body to the temple on the sixteenth. Perhaps this ceremony is a kind of flashback. On the twenty-fourth of the month, the figures of Sokar and Khenty-imentyu were shrouded and the procession of the sixteenth was repeated. This time the procession preceded the burial of Osiris' body. On the thirtieth Sokar and Khenty-imentyu were buried under a persea tree.

DETAILS. The overall dramatic qualities of the play cannot be determined from the existing source materials, but certain details emerge. The drama took place over at least ten days and the priests performed only certain episodes on each day. The actors played different gods, but the main character, Osiris, was played by a small statue. The drama thus proceeded as interactions among human actors (priests), statues, in one case possibly a crocodile mummy, and small props such as boats. Thus dialogue was probably much less important than it is in modern drama.

MASKS AND PROPS. Reliefs on the roof of the Dendera temple illustrate scenes from the Osirian Khoiak drama. The reliefs portray a priest wearing a jackal mask, designating him as the god Anubis. Another priest wears a falcon mask, indicating that he plays the god Horus.

Actual jackal masks are known from archaeological evidence. The small statues seem to be made from gold, silver, or wood. They are both props and characters in the drama. Archaeological examples of the Osiris statues are known. They were hollow, made from bitumen, resin, and natron and filled with barley seeds. The seeds sprouted, symbolizing Osiris' resurrection.

SOURCES

E. Chassinat, *Le mystère d'Osiris au mois de Khoiak* (Cairo: L'Institut français d'archéologie orientale, 1966–1968).

Louis Boctor Mikhail, *Dramatic Aspects of the Osirian Khoiak Festival* (Uppsala, Sweden: Institute of Egyptology, Uppsala University, 1983).

SEE ALSO *Religion: Myth of Osiris*

SIGNIFICANT PEOPLE
in Theater

EMHAB

Unknown in the Second Intermediate Period (1630–1539 B.C.E.)–Unknown in the early Eighteenth Dynasty (1539–1514 B.C.E.)

Nobleman
Drummer

MISUNDERSTOOD. Emhab was active during the reign of King Kamose (1543–1539 B.C.E.) probably as a military drummer. Misinterpretations of some common Egyptian words in his biography led to his mistakenly being called an itinerant actor in Egyptological literature by Egyptologist Emile Drioton. He probably accompanied Kamose on a military expedition to Nubia in 1540 B.C.E. It was in the description in Emhab's biography of drumming that Drioton found the announcements of a theatrical presentation. He also translated the common word for travel to imply that Emhab was undertaking a theatrical tour. Finally, Drioton understood a common word for speaking as declamation, making it into a theatrical term.

SOURCES

Jaroslav Černý, "The Stela of Emhab from Tell Edfu," in *Mitteilungen des Deutschen Archäologischen Instituts, Kairo* 24 (1969): 87–92.

Emile Drioton, "Le théâtre égyptien dans l'ancienne Egypte," in *Revue de la Société d'Historie du Théâtre* 6 (1954): 7–45.

DOCUMENTARY SOURCES
in Theater

Anonymous, *Book of the Dead Chapter 39* (c. 1539–1075 B.C.E.)—The rituals found in the Book of the Dead were used as part of the funeral ritual to help the deceased enter the land of the dead. The Egyptologist Emile Drioton interpreted it as part of a ritual drama.

Anonymous, *Coffin Text 148* (c. 2130–1630 B.C.E.)—This ritual text was intended to help the deceased enter the land of the dead. The Egyptologist Emile Drioton interpreted it as part of a ritual drama.

Anonymous, *Dramatic Ramesseum Papyrus* (c. 1842 B.C.E.)—This text contains both a funeral ceremony for the deceased king Amenemhet I and the coronation ceremony for his son Senwosret I. The first editor of the text, Kurt Sethe, understood it as a drama.

Anonymous, *Shabaka Stone* (c. 2500–2170 or 716–702 B.C.E.)—The text dates either to the Old Kingdom or to the reign of Shabaka, when the only preserved copy was carved on basalt. Kurt Sethe thought it was an Old Kingdom drama.

Emhab, *Biography of Emhab* (c. 1543–1539 B.C.E.)—This biography of a soldier who served in the reign of King Kamose was interpreted to be the biography of an actor by the Egyptologist Emile Drioton.

VISUAL ARTS

Edward Bleiberg

IMPORTANT EVENTS
in Visual Arts

All dates in this chronology are approximations (c.) and occur before the common era (B.C.E.).

3800–3500 Earliest fired pottery is decorated with a red body and a black rim.

3500–3300 Egyptian artists draw and model from clay and carve the earliest Egyptian human figures.

3300–3100 Artists carve first animals in relief in ivory.

3200–3100 Narmer Palette is the first Egyptian relief that follows the classic Egyptian style. It represents a stylistic break with pre-historic Egyptian art.

3100–2675 Egyptian artists formulate the basic strategies for their works of art that remain in use for nearly 3,000 years.

The Stela of Wadj is an example of one of the first uses of combined perspective to represent a building from both the top view and the front view.

2800–2675 The statues of King Khasekhemwy represent one of the first attempts to portray a seated king, a common subject for later Egyptian artists.

2675–2170 Old Kingdom artists use guidelines to compose two-dimensional scenes. This system is the source of the grid that will be used in the Middle Kingdom.

2675–2625 Egyptian artists produce one of the first images of a standing male figure, probably a deity.

The statue of Ankhwa is one of the first figures of a seated official.

A head of a king is one of the first colossal statues known from ancient Egypt.

2675–2654 Egyptian artists produce the earliest known life-size image of a king, King Djoser seated on a throne.

2625–2585 A statue of Rahotep, the son of King Sneferu, and his wife, Nofret, is among the first seated pair statues, a typical Egyptian pose.

2555–2532 A series of diorite statues of King Khafre represent a high point in sculptural production.

2532–2510 A standing statue of King Menkaure and Queen Kha-merer-nebu II is among the earliest standing statues of a male and female figure.

2350–2170 A second style in Egyptian art emerges that emphasizes expressiveness and portrays the human figure as more elongated and thinner than previously.

2338–2298 A seated statue of Pepi I represents the clear use of a statue as a hieroglyph.

A statue of Pepi I kneeling is an early example of a royal pose that shows the king making an offering to a god.

2288–2194 A statue of Queen Ankh-nes-meryre II and her son King Pepi II reveals innovative use of Egyptian traditions.

2081–2003 Artists compose scenes with eighteen-square grids, a system that allows them to enlarge figures and still control proportions.

Evidence for regional styles around Thebes and Memphis shows that Egyptian artists had some freedom to develop local ways of making art.

2008–1957 A seated statue of King Nebhepetre Mentuhotep is among the earliest images of the distinctive Theban style.

1957–1945 Artists of the reign of Mentuhotep III strive to combine Theban and Memphis style.

1938–1759 Artists of the Twelfth Dynasty revive the Memphite style of the Old Kingdom.

Block statues become a very popular way of depicting high officials with a cube for the body and only the head, hands, and feet carved.

Cloaked seated figures become a popular way of depicting officials.

1539–1292 Artists re-plot the grid for composing figures, changing the proportions of human figures, making them longer and more elegant. The reason for this change is not understood.

1539–1425 Artists revive stylistic elements of the Twelfth Dynasty in an attempt to restore and refer to the glory of this earlier time.

Some paintings of this period are difficult to distinguish from Eleventh-dynasty work.

1478–1458 Artists strive to adapt traditional forms to represent the female king Hatshepsut.

The high official Senenmut has at least 25 statues and some of them provide innovations used by later officials.

Artists portray new historical subjects such as the Expedition to Punt in Hatshepsut's temple in Deir el Bahri.

1390–1352 More statues of Amenhotep III survive than there are for any other Eighteenth-dynasty king. Amenhotep III is depicted with innovative body types, not restricted to the athlete-king.

Officials are depicted living a more luxurious life than previously.

1352–1336 Radical changes in style—including the depiction of more expressions and emotions—are related to a change in Egyptian religion.

Portrayal of kings in this period are nearly androgynous. King Akhenaten and his wife Nefertiti are portrayed as nearly identical.

Many examples of the royal daughters exist. Some of them stress emotional ties within the family, unlike Egyptian art of any other period.

1332–1322 Art of the reign of Tutankhamun is well-documented because of the discovery of his unplundered tomb in 1922.

1292–1075 Artists of the Ramesside Period revive some early Eighteenth-dynasty styles, avoiding the Amarna style used in the reign of Akhenaten.

1075–332 Art of the first millennium in Egypt reflects revival of older styles and an interest in copying older works. Egyptologists call this tendency archaism.

1075–656 Artists revive Eighteenth-dynasty subjects and style in such detail that it is sometimes difficult to recognize art of this later period called the Third Intermediate Period.

760–656 Artists revise the grid for composing figures using twenty-one squares rather than eighteen squares per figure as previously. This new system results in longer-waisted figures than previously drawn.

Artists copy and imitate many works of the Middle Kingdom.

664–525 Egyptian artists copy and imitate the art of the Old Kingdom during the Saite period.

525–404 Egyptian artists add details from Persian art while the Persians dominate Egypt.

381–343 Artists rely on New Kingdom models during this last period of native rule before modern times.

OVERVIEW
of Visual Arts

ANCIENT VIEW OF ART. The ancient Egyptians had no word that was an equivalent for "visual art," though they clearly created many objects that modern people recognize as art. In the modern world, art is the product of an individual's creative expression. But this view of art is bound to modern, Western culture. An ancient Egyptian artist would not have understood the value of individual originality. For the Egyptian artist, the creator god Ptah had ordained the proper form for representing the world in both two- and three-dimensional art. According to Egyptian myth, these forms had existed since the time that Ptah created everything in the world at the beginning of time. The artist's task was to approximate Ptah's pre-ordained pattern as closely as possible. Egyptian artists could be creative within the confines of the patterns that Ptah had created, but the patterns could not be ignored. Thus the basic representation of a man in two dimensions could not change. But within the basic pattern there was room for artists to exercise creativity in the details.

NATURALISM. Egyptian art mirrors an idealized vision of nature. The art was more or less naturalistic in different periods of Egyptian history, but this naturalism was always restrained within a certain idealism and stylization. The most common Egyptian subject is humanity and all of its activities. Though modern audiences tend to think of colossal Egyptian sculpture as the norm, most statues were rather small. They were usually less than life-size. Relief sculpture of people was usually about twelve to eighteen inches tall (30.4 to 45.7 centimeters). Humanity almost always exists in Egyptian art in an ordered and rational universe. This order is especially apparent in the common scenes of family groups, religious rites, and even in daily activities. Though historical scenes sometimes included the chaos of battle, these scenes are meant to stand in contrast to the orderly, idealized world that the Egyptians believed was governed by *maat* ("correct order").

EGYPTIAN WORLD. The Egyptians viewed the world as a box. The natural world had two axes: the Nile, which ran from south to north, and the sun, which ran the axis from east to west. The sky itself was a canopy supported by poles at either side. The earth was a flat floor beneath the canopy. Egyptians reproduced this worldview in two-dimensional painting and relief. The artist composed scenes in rectangular registers with a clear base on which humans stood and a clear dividing line between what was above and below them.

MOVEMENT. The Egyptian artist had no interest in capturing a transitory moment as did classical Greek and Roman artists. The Egyptian artist aimed to capture an eternal and idealized vision of humans that would be valid for all time. Especially in portraiture, the Egyptian artist tried to create a static world. The artists had no interest in depicting motion or emotion as the important elements in a composition. Though a particular pose might signal walking or even running, Egyptian artists had no interest in depicting the illusion of movement in visual art.

INTEGRATION OF VIEWS AND SYMBOLISM. The pattern that the Egyptians believed that Ptah had created for two-dimensional art integrated more than one view of each object or person. In an Egyptian architectural drawing, the building could be represented as a façade or front view with the plan view attached above it. A hieroglyphic label in the middle of the plan could then identify the specific building that the artist intended to represent. When artists represented people, a similar system for integrating views was nearly always followed. The head was in profile, but the whole eye was visible. This defied visual reality; it would be impossible in life. Both shoulders were visible as if the artist drew from the front, but the torso twisted unnaturally so that a side view of the hips and legs was visible. This representation was a symbol of a man, not an attempt to present visual reality. This style of drawing relates art to hieroglyphs. Each drawing, just as was true for each hieroglyph, was an easily recognizable symbol of the object that the artist wanted to represent. The shapes of most objects in Egyptian drawing also closely resemble the hieroglyph used for writing the word for that object in Egyptian. Perhaps the same need for clear outlines to make hieroglyphs instantly recognizable influenced artists to standardize the outline of most types of figures. This standard outline allows the viewer to "read" a drawing in the sense that each outline symbolizes something already defined in advance. The artist's dependence on a pre-ordained outline for figures and objects led to a stable iconography or symbolic representation. For example, a child nearly

always posed with a forefinger to the mouth, the tongue extended, and wore a side lock of hair. These three features instantly identified the figure as a child, no matter how big or small the figure was in relation to the other figures around him or her. Egyptian artists extensively used conventions like this for particular classes of people and objects. Each drawing represented a type. Men were always either very slender or extremely corpulent. These two variations represented youthful vigor or a later stage of maturity and wealth. Women were nearly always represented as slender and elegant. These women were thus young and fertile. Artists also exaggerated foreigners' ethnic characteristics, showing the ways that they differed from the typical Egyptian. Artists often drew workers with more naturalism, showing deformities and age.

LABELS. The Egyptian work of art often functioned similarly to hieroglyphs. Labels in hieroglyphs often specified the person's name or the particular type of object that the artist had represented. These labels clarify not just that the artist had drawn a man, but which particular man the artist intended to show by including his name. The image itself often acts as the final hieroglyph in the writing of a word, just as each hieroglyphic word has a final sign that places the work in a class of objects. The image is integral to the writing.

MAGIC. Many commentators stress a connection in Egypt between sympathetic magic and artistic representation. Sympathetic magic postulates that an image can hold the power of the object it represents. Yet the Egyptians never wrote their thoughts on this subject. Modern scholars have found clues pointing to the idea that the Egyptians believed that images could possess powers. One of the best clues is the occasional tendency to draw the snake that represents the letter "f" in hieroglyphs with a break in the middle of its body or a knife stuck in its back when it is needed to write a word in a tomb or on a coffin. Scholars explain this break as a means to prevent the snake from having hostile power. Ancient defacing of works of art, especially the eyes and noses of figures, also suggests that ancient enemies attempted to control the powers of the deceased by destroying significant portions of the deceased's face.

ARTISTS' NAMES. Only a few artists from ancient Egypt are known by name. Signatures were rare. Yet the hierarchy of the artists can be deduced by titles preserved in Egyptian documents and in relief scenes that depict artists' workshops. These scenes often depict a supervisor who perhaps was the overall designer for a project. Possibly the High Priest of Ptah served as the master craftsman for the king in the Old Kingdom (2675–2170 B.C.E.). A younger royal son often held this office. Other titles such as "Master of the King's Works" and "Chief of Sculptors" suggest that Egyptian society organized artists in a very hierarchical manner. Such organizations were common in nearly every aspect of life. In the New Kingdom (1538–1075 B.C.E.) even more information on the social structure of the royal artists at the Valley of the Kings is preserved. The men who decorated the royal tombs were divided into two crews, each with its own leadership. In theory, at least, each crew was responsible for decorating one side of the tomb.

INSTITUTIONS. Most artists worked directly for an institution. Scholars assume that the royal workshop could command the best artists. Others worked for the temples or perhaps for the households of individual officials. The artists thus worked under the supervision of royal or upper-class managers for the palace, the temple, or an official. The artist's profession often passed from father to son. The methods employed seem to change very little over 3,000 years, but it is clear that the carving tools improved from the original copper chisels in the Old Kingdom, to the bronze chisels in the New Kingdom, and finally the iron tools made in the Late Period (664 B.C.E. and later).

SPECIALIZATION. Managers divided individual art projects into stages that specialists executed, at least in the ideal. Whether actual work proceeded in an organized fashion is difficult to demonstrate from the unfinished tomb walls that are the only modern evidence for the process. After masons smoothed the wall surface of a tomb or temple, outline artists sketched the scene in black ink. The chief designers made red corrections. Sculptors then carved the scene, following the guidelines made in the drawing. Plaster workers then prepared the surface with a thin coat of plaster, following the outline of the carved relief. The plaster provided a surface for painters who applied the color. In three-dimensional sculpture there might also be a goldsmith who added gilding or a lapidary who added inlay of semi-precious stones, often for the eyes of a statue.

MATERIALS. Egyptian artists worked with materials naturally available in Egypt and with imported wood and stone. The quintessential Egyptian material seems to be stone because it is best preserved from antiquity. But it is important to remember that wood and metal were just as important to the artist in Egypt, even though fewer such objects have survived. Wood is clearly more fragile than stone while precious metals were often melted and reused in antiquity.

STONE. Egyptian artists worked in both hard and soft stones. In addition to easily available limestone granite and basalt, Egyptian artists used slightly more

Arts and Humanities Through the Eras: Ancient Egypt (2675 B.C.E.–332 B.C.E.)

267

rare hard stone materials such as diorite, quartzite, grey-wacke, and Egyptian alabaster, a form of calcite. The sculptor heated the surface of the stone before working. The heat allowed artists to use the flint drill effectively on the hard surface. In the Late Period with the introduction of iron punches, artists could pulverize the surface of hard stone, then shape and smooth it with other stones. The pulverized surface could be polished with quartzite sand. There are also documented cases where an element could be added or perhaps reattached with dowels if it broke. The two most widely used soft stones were sandstone and limestone, which was widely available in the area near Memphis. The most famous limestone quarry was at Tura, east of modern Cairo. Limestone was the whitest and considered the best for building. It is relatively easy to cut in blocks from the quarry bed. The blocks could then serve as the starting point for sculpture. It appears likely that many sculptors' workshops were located near to the quarry to at least allow the sculptor to shape a sculpture roughly before moving it closer to its final destination. This practice made it unnecessary to transport any heavier blocks than necessary.

WOOD. Artists used wood for statues, decorative panels, doors, and shrines. They executed the initial rough work with saws and axes. An adze (cutting tool) and chisel could be used to shape the statue. Artists would often smooth wood surfaces with abrasives before and after they were done sculpting. But much of the surface of a wooden statue was covered with plaster and then the artists applied color. Wood sculptures often reached the highest quality because the materials were imported and expensive. Only the best artists were trusted with these precious materials. Cedar came from Lebanon and ebony from Somalia beginning in the earliest periods. Native acacia and sycamore fig could sometimes be pieced together to form the surface of cheaper statues. Neither of these local Egyptian woods were as good for sculpture as the imported cedar and ebony. However, the addition of plaster and paint often disguised the poor quality of the native wood.

METAL. The Egyptians also created metal statues from copper and bronze. There are two known examples of royal hammered copper statues from the Sixth Dynasty and one royal example from the Twelfth Dynasty. Others must have existed but did not survive. But caste bronze was by far the more common metal statue type. Thousands of caste bronze statues have been preserved from ancient Egypt. Egyptian artists had invented the lost wax method for casting by the Old Kingdom. They demonstrated great skill in nearly every period. First the artist created a model in bee's wax. He then covered the model

with clay and left holes open. The clay and wax were heated until the wax melted and ran out the holes and the clay hardened. Bronze, silver, or gold could then be heated until it was a liquid and poured through the holes in the clay which was now a mould or negative image of the bee's wax model. The clay mould could be removed carefully for reuse. The metal sculpture was usually polished as part of its final preparation.

GRIDS. Grids are a system of horizontal and vertical lines dividing a work of art into regular units. Egyptian artists used grids to create sculpture in two and three dimensions. After the mason had smoothed the stone surface, the artist could apply the grid with a taut piece of string dipped in paint or chalk dust. The grid divided the stone into equally spaced units. In different periods, the proportions of units used for the head, torso, and legs changed, creating differing body proportions. The outline artist worked from the grid, knowing the number of units necessary for each body part. The grid allowed artists to keep the various parts of the body in proportion and to enlarge images over vast areas of wall space.

RELIEF TYPES. Egyptian artists worked in both sunk relief and raised relief. In sunk relief the artist chiseled an outline into the stone and modeled a surface that lay beneath the surface of the stone. In raised relief, the background was carved away leaving a modeled subject raised above the surface of the stone. The Egyptians preferred sunk relief in strong sunlight. With sunk relief, the sun could not create as many shadows as in raised relief. Sunk relief provided a sharper image in bright sun. Raised relief, which requires greater skill to execute, generally was used for interiors. Here low light could emphasize the sculptural forms by allowing them to cast shadows. The Egyptians plastered and painted both raised and sunk relief. They could also use plaster to repair the surface of a tomb or temple wall and occasionally modeled features from plaster.

COLORS. Egyptian artists used a variety of colors including yellow, red, brown, white, blue, and green. The earth tones were made from natural pigments tinted with white. Blue came from a copper-based frit or from copper calcium tetra-silicate. Yellow and blue combined to make green. All colors were mixed in water-soluble gum. Artists applied color with almost no shading, only flat areas of color. Most objects were colored naturally. Herbage was green; mud was black. Water was blue; linen garments were white. When the Egyptians added color to human flesh, however, symbolism often dominated. Though Egyptian men and women must have had similar flesh tones, men are often painted red while women are painted yellow. The red associates men with the sun-god

Re. The yellow associates women with the goddesses who had gold skin. Foreigners such as Nubians had black skin while Asiatics from the modern Middle East had yellow skin. In the New Kingdom artists experimented with different background colors. In the early Eighteenth Dynasty they used light gray and occasionally yellow backgrounds. Later in the Eighteenth Dynasty (1550–1295 B.C.E.) the backgrounds were white. Ramesside artists of the Nineteenth and Twentieth Dynasties used yellow backgrounds primarily.

TOPICS
in Visual Arts

INTERPRETING EGYPTIAN ART

REFLECTION. Art represents the world. But in ancient Egypt, art reflected a very particular worldview. Egyptian art reflected an idealized world and ignored any part of the world that did not fit the ideal. Egyptian art also incorporated certain fictions in order to express a larger truth. For example, Egyptian temple art always showed the king presiding over rituals. Since in reality it was impossible for the king to simultaneously lead every temple ritual in every temple, every day, priests usually substituted for him. Yet such scenes express a larger truth that the king was the only true intermediary with the gods according to Egyptian thought. Though modern viewers cannot always take Egyptian art at face value, it is possible to discover Egyptian conceptions of the perfect world in their art.

GENDER DIFFERENCES. One approach to understanding Egyptian art might be to question its purpose. The main purpose of Egyptian art was to serve the needs of the elite, especially the king and his retainers, both in this life and the next. Thus it might be that many scenes can be interpreted both as what they depict, but also as a way of sending a message to those whose support the king required. The representation of males and females in New Kingdom Egyptian tombs is a clear case where the artist conveys a message other than visual reality. In the typical New Kingdom tomb painting, relief, or statue, males are dressed in kilts with perhaps a shirt, while women wear tight-fitting sheath dresses, probably made from a single piece of cloth wrapped around the body. Yet archaeological examples of ancient Egyptian clothing demonstrate that the most common garment was a bag tunic. This outfit was basically a linen bag with sleeves that fit very loosely. Both men and women wore

it. In art, however, men wear an outfit that suggests freedom of movement while a woman's garment suggests restricted movement. Even without archaeological evidence, the typical female garment depicted in art could never match reality. The dresses are so impossibly tight that a woman could not move, sit, or walk. The real intention behind this representation is to reveal the woman's body. These dresses clearly reveal the overall female form and the pubic triangle. Since the difference between everyday Egyptian reality and the presentation of people in art differ so radically, there must have been a reason for the difference.

ART Terminology

Historians of Egyptian art use the traditional art history terminology in a slightly different manner from historians of the art of other eras. The following definitions help the reader understand these differences.

Artist: Egyptian artists are anonymous. In Egyptian society, artists were craftsmen, usually working in large groups together on a project. There is no concept of the individual genius making art in ancient Egypt.

Iconography: Iconography refers to symbols in art. Egyptian iconography allows a work of art to be read. Since Egyptian writing was recorded in pictures (hieroglyphs), Egyptian art lends itself to a very sophisticated iconography that can be clearly understood.

Patron: The patron traditionally commissions a work of art. He or she is the benefactor who pays the artist. In ancient Egypt, the patron is nearly always the state. Even individual tomb owners credit the king as the person who gave the tomb to the deceased as a gift. Thus Egyptian art always follows the official line. There are no rebellious artists commenting on society in Egyptian art.

Style: Style in art refers to the way the work is made. Egyptian style is largely uniform for three thousand years. Differences in Egyptian style are subtle and require training to understand and notice them. An artist's training in Egypt led him to attempt to follow the rules of style with little deviation. There is little recognizable difference between the work of two Egyptian artists living in the same time period. This situation especially contrasts with the modern world where individual style is valued.

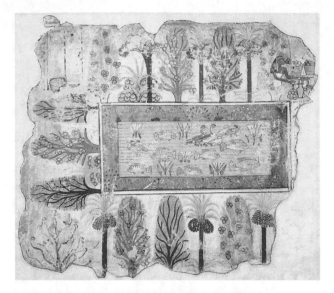

A fragment of a wall painting found in the tomb of Nebamun in Thebes showing a pool full of ducks, lotus flowers, and tilapia fish. These symbols, particularly the tilapia fish, are rich symbols of rebirth and new life. © THE BRITISH MUSEUM/ TOPHAM-HIP/THE IMAGE WORKS.

ROLE OF MEN. Men are generally active rather than passive in tomb representations. In Old Kingdom and Middle Kingdom tombs, the deceased reaches for offerings at the offering table or inspects agricultural laborers or workshops under his control. Artists also often depicted men hunting birds or fishing. They wear loose clothing and are quintessentially the active principal in life. These roles correspond to an Egyptian view of men actively winning a place for themselves in the afterlife.

ROLE OF WOMEN. The importance of women in Egyptian society is often conveyed in artwork found in temples and tombs. The role of the woman in Egypt was that of life-giver and supporter. Hence, the emphasis in art was on their role as mothers. Because of this, women were often depicted wearing little or no clothing. The artist's intention was not to portray eroticism but rather to symbolize reproduction—all people come into the world without clothing, and hence the idea of nudity is connected to that of birth. Due to their connection with birth, women are most often found depicted on tombs, for the Egyptians considered the tomb a means to rebirth into the next world. Yet women represented in tombs could also hold other meanings. When labeled with their name in hieroglyphs, a figure of a woman could represent an individual wife, daughter, or cousin. Many women represented in one tomb could be a means for a man to emphasize his wealth. Both these roles would be important to the deceased in addition to the overall conception of women as the source of rebirth.

DAILY LIFE. In conjunction with how women and men were portrayed individually, much can be learned from the different scenes that artists chose to portray. Daily life scenes of craftsmen and of peasants engaged in agricultural tasks had a deeper meaning than the tasks portrayed. These scenes functioned at a literal level, but also represent a way of structuring life. Artists chose some activities to represent status and wealth in tombs while other activities were left out of art altogether. This selection was purposeful. Craftsmen and peasants were always portrayed at their most productive for the benefit of the owner of the art. Though Egyptologists depend on these scenes for knowledge of all kinds about ancient Egypt, artists had no interest nor intention of providing an illustrated guide to Egyptian life when they decorated temples and tombs. Rather agricultural scenes of peasants working in the fields stress the owner's status and distinction in the physical world. They also provide a permanent supply of provisions for the next world. In addition, they function symbolically to depict the passage of the seasons of the year and thus the continuation of life for the deceased spirit. The flax harvest painted in a tomb suggests an abundance of linen clothing for the deceased. Scenes of manufacturing jewelry guarantee that the tomb owner will have jewelry in the next world.

FISHING AND FOWLING. Scenes of fishing and fowling (bird hunting) in the marsh with the tomb owner and his family in attendance are one of the most common scene types in Egyptian tombs and households. Yet it seems unlikely that these scenes depict only a family outing. Scenes of a nobleman fishing or hunting birds are very ancient, beginning in the Old Kingdom. Both kings and officials included them in their tombs. Usually the male figure actively fishes with a harpoon or hunts birds with a boomerang-like throw-stick. His wife is at his side and usually a child accompanies the family. They are all dressed in their most elaborate linen clothing. Often they are in a small papyrus boat. Their clothing is clearly too elaborate for the activity that engages them. The clothing, thus, must reveal their status rather than a true picture of the way they would dress for a day of fishing or hunting. Additionally, the boat is both too small and too unstable to be the sort of boat used for a family outing. A child could easily capsize it. The boat, the most archaic type of woven papyrus boat, has symbolic meaning of transition and togetherness. The Egyptologist Gay Robins speculated that scenes of fishing and bird hunting represent the deceased as Osiris. In *Coffin Text* 62, Osiris claims he will have thousands of birds available in the next world. Whenever Osiris hunts with a throw-stick, a thousand birds will fall. Since

BIRDS
in Coffin Text 62

Many Egyptian tombs contain scenes of the deceased hunting birds. Usually such scenes include the deceased, his wife, and one child. These scenes probably can be explained by examining *Coffin Text 62*. The *Coffin Texts* are spells recited as part of the funeral ceremony. Scribes recorded them on the interior of wooden coffins during the Middle Kingdom (2008–1630 B.C.E.). *Coffin Text 62* contains the god Horus's description of the next world. Horus is speaking to his father Osiris, the king of the dead: "Waterfowl will come to you in the thousands, lying on your path; you throw your throw-stick at them and it means a thousand are fallen at the sound of its wind." When bird hunting is included in the decoration of a tomb, the deceased is associated with the god Osiris, the desire of every Egyptian.

FISH
as Symbols in Tomb Paintings

Many Egyptian tombs contain scenes of the deceased harpooning tilapia fish. They depict the deceased, his wife, and a child in a papyrus boat. The tomb owner stands with a harpoon in one hand that has a tilapia fish on the end of it. These scenes can be explained by the reference to the tilapia fish in Chapter 15 of the *Book of the Dead*, the papyrus scroll Egyptians started including in their tombs during the New Kingdom (1538–1075 B.C.E.): "You will be summoned into the sun-god's Day-Barque ... You will see the tilapia completely, in the stream of blue."

In Chapter 15, seeing a tilapia fish while in the barque of the sun-god Re is an indication of rebirth. The female tilapia carries her fertilized eggs in her mouth during gestation. At birth, it appears that the offspring swim alive from their mother's mouth. The Egyptians thus regarded the tilapia as a symbol of fertility.

each deceased Egyptian hoped to be assimilated to the god Osiris, king of the dead, such scenes in tombs suggest another means of expressing the same hope for obtaining thousands of birds to eat. Moreover, when a man dominates wildlife he also makes order from chaos in Egyptian thought. This is the role that both the king and Osiris play. Thus the deceased further identifies with Osiris by bringing order to the natural world. Fishing also represents a man dominating nature and thus bringing order to the world. But fishing for the tilapia fish also relates to rebirth. The tilapia fish accompanies the solar barque of Re in the underworld. The tilapia is a symbol of fertility and rebirth because the female carries its fertilized eggs in its mouth. When the eggs hatch, it appears that the offspring are born live from the mother's mouth. In *Book of the Dead* Chapter 15, the deceased is assured that while in the god's barque he will see the tilapia fish. This means that he will experience the rebirth each Egyptian desired into the next world. Thus scenes of family outings in the marshes represent much more than a picnic. These scenes convey ideas about rebirth into the next world by associating the deceased with the god Osiris.

SOURCES

Gay Robins, "Interpreting Egyptian Art," in *Discussions in Egyptology* 17 (1990): 45–58.

Wolfhart Westendorf, "Bemerkungen zur 'Kammer der Wiedergeburt' im Tutanchamungrab," in *Zeitschrift für ägyptische Sprache und Altertumskunde* 94 (1967): 139–150.

SEE ALSO *Fashion: Clothing*

GRID SYSTEMS IN VISUAL ART

EVIDENCE FOR GRIDS. Grids were used to control the proportions of two-dimensional relief sculpture and to line up the sides, back, and front of sculpture in the round. Grids are often preserved in unfinished relief sculpture or in paintings where a finished layer of paint has fallen off to reveal the underlying grid. These remains of grids have provided the data to study how Egyptian artists worked. In the earliest examples from the Old Kingdom, Egyptian artists used a system of eight horizontal guidelines and one vertical line bisecting the figure through the ear rather than a complete grid. Grids marked eighteen horizontal units for each figure and also fourteen vertical lines spaced at the same distance as the horizontals. Thus the grid formed a series of squares. Grids are first preserved from Dynasty 11 (2125–1991 B.C.E.) and continue for nearly 2,000 years into the Roman period.

OLD KINGDOM GUIDELINES. Old Kingdom (2675–2170 B.C.E.) guidelines allowed the artist to divide

the figure in half and/or in thirds. A line at the lower border of the buttocks divided the figure in half. Lines at the elbow and the knee divided the figure into thirds. Artists drew additional lines at the top of the head, at the junction of the hairline and forehead, at the point where the neck and shoulders meet, at the armpit, and at the calf. The base line of the register marked the bottom of the figure's foot. The proportions that were maintained made the distance from the bottom of the foot to the neck and shoulder line equal to eight-ninths of the figure's height. The distance from the bottom of the foot to the armpit was four-fifths of the figure's total height. This series of proportions gave figures their uniformity and most likely aided artists in drawing a figure on a large scale.

GRIDS IN THE MIDDLE KINGDOM. Grids of squares probably developed from guidelines. Grids were certainly in use by the Middle Kingdom (2008–1630 B.C.E.). Eighteen squares separated the hairline from the bottom of the foot in the Middle Kingdom grid. Various body parts also fell on regular grid lines. For example, the meeting point of the neck and shoulders was at horizontal sixteen, the elbow at horizontal nine six squares wide, similar in proportion to Old Kingdom figures. Females were more slender with shoulders between four and five squares wide.

GRIDS IN THE NEW KINGDOM. The proportions of figures changed in the mid-Eighteenth Dynasty (1550–1295 B.C.E.), becoming more elongated. The small of the back rose from gridline eleven to gridline twelve, making the leg longer in proportion to the body. At the same time, the width of the shoulders was reduced from six squares to five squares. This reduction also made the figure more elongated and graceful in the New Kingdom (1538–1075 B.C.E.) than it was previously.

LATE PERIOD GRID. Egyptian artists of the first millennium B.C.E. used a grid with twenty-one horizontal lines rather than the eighteen lines used previously. Though the exact time when the transition from eighteen to twenty-one squares was made is unknown, artists of the Twenty-fifth Dynasty (730–661 B.C.E.) were surely using the twenty-one square grid to lay out relief sculpture. The new grid squares were thus five-sixths of the old grid squares. In the new system the following correspondences were made. Line twenty-one passed through the root of the nose and upper eyelid. Line twenty passed through the mouth. Line nineteen passed through the junction of the neck and shoulders. Line thirteen passed through the small of the back. Line eleven passed near the lower buttocks. Line seven passed

through at the top of the knee. Line zero, the baseline, passed through the sole of the foot. The result of these changes was a slight change in the proportions of the figure. The knees, small of the back, and buttocks are all lower than in figures drawn on the Late Period grids than in the Middle and New Kingdom grids. Thus the torso and upper leg appear longer in proportion to the body as a whole in the Late Period than in the Middle and New Kingdom. This change is clear in figures until the end of ancient Egyptian history. However, the meaning of this change is not clear. The art historian Erik Iverson suggested that the grid changed to accommodate a new measuring system that used a shorter unit of measurement. The Egyptologist Gay Robins convincingly argued that the Late Period system used the same measuring system but regularized the grid to make calculations easier. In the early system the arm length was five grid squares. This distance was the hypothetical value of one cubit. A cubit was divided into six palms. A five-square arm thus equaled grid squares one and one-fifth palm wide and long. The new Late Period grid square used an arm length that was six squares long. Thus in the Late Period grid square each square was equal to the measurement one palm. All calculations would be simpler using grid squares equivalent to one palm rather than equivalent to one and one-fifth palm.

INGENIOUS TECHNIQUE. The grid was an ingenious and simple way to maintain proper proportions for figures no matter how large or small they were reproduced. Artists could maintain the same proportions for a sculpture only twelve inches tall as in sixty-foot tall sculptures in front of temples. This technique is also one element in the tendency of one work of Egyptian art to resemble all others.

SOURCES

Gay Robins, *Proportion and Style in Ancient Egyptian Art* (Austin: University of Texas Press, 1994).

EARLIEST EGYPTIAN ART

STYLISTIC BREAK. The earliest Egyptian art, created during the pre-dynastic period (4400–3100 B.C.E.), exhibits a coherent style that does not continue into historical, dynastic times (after 3100 B.C.E.). All of this art comes from graves that belonged to non-elite, non-governmental people. The objects created for these tombs might be considered folk art. The earliest art is handcrafted pottery with a surface ripple that potters created by running a comb over the surface. This pot-

tery was made during the Badarian period (4400–3800 B.C.E.), named after the village of Badari where archaeologists first found it. The English archaeologist W. M. F. Petrie discovered a nearly complete sequence of objects for the subsequent period at the village of Nagada in southern (upper) Egypt. Thus Egyptologists refer to the different chronological stages of this art as Nagada I (3800–3500 B.C.E.), Nagada II (3500–3300 B.C.E.), and Nagada III (3300–3100 B.C.E.). Nagada III overlaps with Dynasty 0 (3200–3100 B.C.E.), a newly identified period when Egyptian kingship first appears. One very common object of Nagada I is a ceramic jar or cup made from a red polished clay with a black rim. Egyptologists call it black-topped red ware. The black color often extends to the middle of the jar. Potters built these jars by hand with a coil of clay. The potter smoothed the coils once the pot was built. The potter then fired the pot upside-down, producing the black rim. These pots first appear in Nagada I and continue into Nagada II. The emphasis on abstract decoration, though often beautiful, is not typical of Egyptian art in the historical period after 3100 B.C.E. This distinction, however, cannot be used to argue convincingly that a different group of people inhabited Egypt after the historical artistic style emerged.

ANIMAL PALETTES. Artists made some of the most interesting early figures during Nagada II and III. Some figures were animal-shaped palettes resembling fish, turtles, and birds. These were often made from schist, a very commonly used stone in this period. Egyptians used these palettes to grind galena, a naturally occurring mineral, into eye-liner called kohl. Kohl both emphasized the eyes and possibly protected them from the glare of the sun. The Egyptians also believed it protected the eyes from disease. Some of the shapes of these palettes, such as the fish, represent symbols of fertility and rebirth. The tilapia-fish, for example, carries its fertilized eggs in its mouth. It thus appears that the offspring are born alive from the mouth rather than hatched from eggs. The Egyptians thus included the tilapia among their fertility symbols.

HUMAN FIGURES. Sculptors in Nagada II and III also concerned themselves with human figures. Among the first human figures were the female figurines that the archaeologist Henri de Morgan discovered in the village of Ma'mariya in 1907. Found in graves, her face appears beak-like. She wears only a long white skirt that covers her legs completely. Her bare arms extend upward in a graceful curving motion. Though these figurines are among the most famous pre-historic sculptures from ancient Egypt, it is impossible to determine with certainty whether the figure represents a priestess, a mourner, or

Black top vase. BROOKLYN MUSEUM OF ART, 09.889.557, CHARLES EDWIN WILBOUR FUND. REPRODUCED BY PERMISSION.

a dancer. Furthermore, it is completely unknowable whether she is a goddess or a human. The generally abstract style used in this sculpture, with each part of the body reduced to a simple organic outline, does not continue into the historical period. Yet very similar female figures occur painted on pottery contemporary with the figurines. The female figures painted on pots are prominent in river scenes that include a boat with two cabins, two male figures, and palm fronds on the shore. Some examples depict mountains beyond the riverbank abstracted to triangles. The female figure is the largest element in the composition, suggesting, as was true in historic times, that she was the most important figure. The figures, boat, palms, and mountains are in red paint on a light buff clay, typical of the Nagada II period. Though the abstract style is not typical of the later period, subject matter such as river scenes were popular throughout ancient Egyptian history. If this is indeed a religious scene, it would be an early example of a common Egyptian subject for art.

ANIMAL RELIEF CARVING. Animal relief carving on ivory began at the end of the pre-dynastic period. One fine example of a knife handle, carved from elephant ivory, includes 227 individual animals. Not only are most of the species identifiable, but also the sculptor arranged the animals so that they are facing in the same

Arts and Humanities Through the Eras: Ancient Egypt (2675 B.C.E.–332 B.C.E.)

273

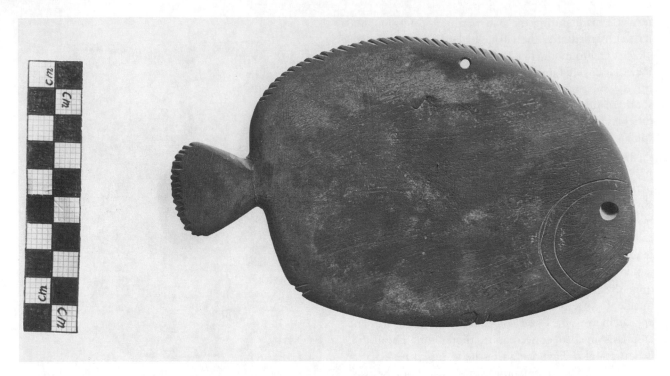

Fish-shaped palette. BROOKLYN MUSEUM OF ART, 07.447.611, CHARLES EDWIN WILBOUR FUND. REPRODUCED BY PERMISSION.

direction in ten horizontal rows. These rows suggest the first hint of the compositional device called a "register" in historic Egyptian art. A true register includes a ground line that gives the figures a place to stand. Here the sculptor only arranges the animals without providing a ground line. Yet the attention he pays to depicting the animals in a recognizable form along with the organized composition hints at the future of Egyptian art.

SOURCES

Winifred Needler, *Predynastic and Archaic Egypt in the Brooklyn Museum* (Brooklyn, N.Y.: The Brooklyn Museum, 1984).

A. Jeffrey Spencer, *Early Egypt: The Rise of Civilization in the Nile Valley* (London: British Museum Press, 1993).

NARMER PALETTE

COMMEMORATION. The Narmer Palette commemorated King Narmer's victory over ten enemies of Egypt some time during Dynasty 0 (3200–3100 B.C.E.). Though scholars disagree on the precise details, the narrative would have been clear to viewers contemporary with Narmer. The Narmer Palette also represented a turning point in artists' experiments with carving in relief on stone. It is the earliest known example of the mature Egyptian style. It exhibits all of the major char-

acteristics of the Egyptian relief style that artists used for the remainder of ancient Egyptian history, over 3,000 years. It thus represents a break with a 1,400-year old tradition of art-making during the pre-dynastic period. Moreover, its subject matter—the triumphant king—remained an important theme throughout ancient Egyptian history.

COMPOSITION. The composition of the Narmer Palette, the manner that different figures and objects are arranged in the picture, utilized baselines and registers. Baselines are horizontal lines at set intervals across the entire area that is decorated. The baselines create a frame for the action in each register. They give each figure a place to stand. The sequence of actions in a narrative is also clear and logical because of the baselines and registers. The obverse (front) of the palette shows Narmer defeating his enemy in the central register. His sandal bearer accompanies him as he strikes the enemy on the head with a mace. The god Horus, depicted as a falcon, symbolically restrains the enemy as the god perches on the flowers that represented Lower (northern) Egypt. In the bottom register, defeated enemies either flee Narmer or lie prone. On the reverse, a bull representing Narmer attacks a city in the bottom register. In the center, two servants restrain an animal that is part leopard and part snake. A third register depicts Narmer inspecting the enemy dead who lie with their severed heads between their legs.

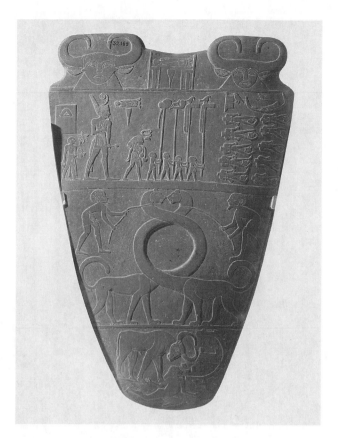

Back of the Narmer Palette, showing scenes of a triumphant Narmer. In the bottom register, he is a bull attacking a city; in the top register he inspects the headless bodies of his dead enemies; and the middle register shows two servants restraining fantastic beasts who represent Upper and Lower Egypt. THE ART ARCHIVE/EGYPTIAN MUSEUM CAIRO/DAGLI ORTI.

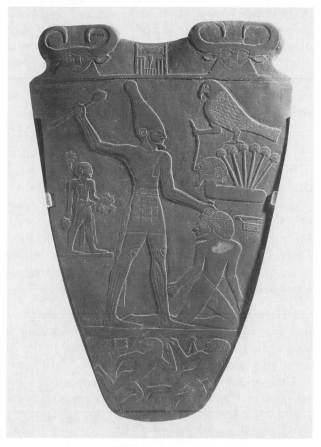

Front of the Narmer Palette, showing Narmer with upraised mace, defeating an enemy. This is a pose of the king which became traditional in Egyptian art. THE ART ARCHIVE/EGYPTIAN MUSEUM CAIRO/DAGLI ORTI.

FIGURE STYLE. The figures of Narmer and the other individuals were carved in the typical Egyptian style, integrating more than one perspective into one representation of a figure. The viewer "sees" a figure from more than one angle at the same time. The head was carved in profile, as if the viewer sees it from the side. Yet the eye was carved frontally, as if the figure and viewer are face to face. The shoulders were also carved frontally, but the torso, legs and feet are shown in profile. It is physically impossible to see this combination of body parts in reality. However, the artist's aim was not to present visual reality but rather an idea of what a person is. Thus Egyptian style is described as conceptual rather than visual because it meant to convey a concept or an idea rather than an image.

CANON OF PROPORTIONS. The Narmer Palette also used a canon of proportions for the figures. The proportions of each figure were standardized in Egyptian art so that every figure could be plotted on an imaginary grid. Actual grids only survive from Dynasty 11 (2081–1938

B.C.E.) and later. Yet this figure has proportions similar to later representations. In a standing figure, such as Narmer found on the obverse, the grid would have contained eighteen equal units from the top of the head to the bottom of the foot. Particular body parts were then plotted on the grid in a regular way. Counting from the bottom of the representation, the knee fell on grid line six, the lower buttocks on line nine, the small of the back on line eleven, the elbow on line twelve, and the junction of the neck and shoulders on line sixteen. The hairline was on line eighteen. The same ratio of body parts would have applied to Narmer's standard bearer. The individual units would have been smaller in this case since the overall figure is about one-quarter the size of Narmer. This standardized ratio of body parts gave uniformity to Egyptian representations of people. Seated representations used a grid of 14 squares.

HIERATIC SCALE. Though individual bodies all had similar proportions, the scale of figures varied widely even within one register. On the reverse of the palette

Arts and Humanities Through the Eras: Ancient Egypt (2675 B.C.E.–332 B.C.E.)

275

in the second register, Narmer was portrayed double the size of his sandal bearer and prime minister. The standard bearers are half the size of the sandal bearer and prime minister. The scale of any one person was based on his or her importance in society rather than actual size. This method of depicting figures is called "hieratic scale."

ICONOGRAPHY. The Narmer Palette uses standard iconography for the king for the first time that we know of in Egyptian history. On the obverse the king wears the cone-shaped White Crown of Upper Egypt. He also wears a bull's tail and a false beard that were associated only with the king. On the reverse the king wears a similar costume, but this time with the Red Crown of Lower Egypt. Many commentators have associated the wearing of each crown on the palette with the unification of Egypt about 3,000 B.C.E.

HIEROGLYPHIC LABELS. Narmer's name appears in hieroglyphic writing at the top of both sides of the palette. It is also written in front of his face on the reverse. Hieroglyphic labels also identify the sandal bearer and the prime minister. These labels personalize these images, which otherwise could represent any king, prime minister, or sandal bearer. Hieroglyphic labels were a standard feature of Egyptian art.

SOURCES

Cyril Aldred, *Egyptian Art in the Days of the Pharaohs* (New York: Thames and Hudson, 1985): 33–36.

EARLY DYNASTIC PERIOD ART

FORMULATED LONG-STANDING STRATEGIES. During the Early Dynastic period (3100–2675 B.C.E.) and the Third Dynasty (2675–2625 B.C.E.), Egyptian artists formulated basic strategies for their works of art that their descendents continued to utilize for the next 3,000 years. Objects such as stelae with relief carving, seated statues of kings, standing deities, and seated private officials assumed a form in art that remained quite static. Yet Egyptologists notice significant differences in style and in the details that distinguish this period from later works of art. Continuity and change of this sort is a defining characteristic of Egyptian art.

STELA OF WADJ. King Wadj, who ruled Egypt some time in mid-Dynasty One (3100–2800 B.C.E.), erected two stelae in front of his tomb in Abydos in middle Egypt. The stelae marked the place where worshippers made offerings after the king's burial. The relief on the two stelae emphasizes the centrality of the king to Egypt-

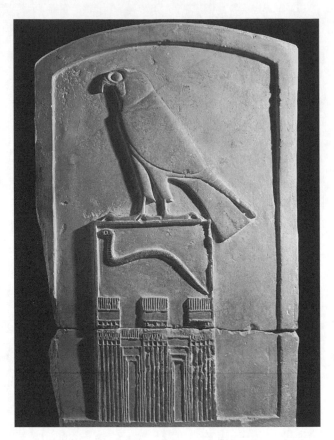

The Stela of Wadj. THE ART ARCHIVE/MUSÉE DU LOUVRE PARIS/DAGLI ORTI.

ian society and the king's link with the gods. In the relief, a falcon, the hieroglyphic writing of the god Horus's name, perches on a rectangle. Within the rectangle is an image of a cobra, the hieroglyphic writing of Wadj's name. Below the snake and completing the rectangle are three tall towers with niches forming the gateway to Wadj's palace, called a *serekh*. Conceptually this composition conveyed that when Wadj was in his palace, he was the earthly incarnation of the god Horus. This theme would be constant in Egyptian art, though later artists found other ways to portray this idea. Here the artist used the fact that hieroglyphs are pictures to portray this idea in a clear but also beautiful way.

MULTIPLE VIEWS. Wadj's stela also illustrates the Egyptian method of portraying multiple views of both animals and buildings in two-dimensional art. Though the Horus falcon is in profile, his tail twists unnaturally into a top view to reveal the square tail that helps a viewer identify him. The artist also combined a frontal view of the palace façade, a profile of the cobra, and a top view of the rectangular plan of the palace into one continuous whole. Thus the artist can portray all of the important identifying criteria of an object with one relief.

SEATED KING. Two limestone statues representing King Khasekhemwy, the last king of the Second Dynasty (2800–2675 B.C.E.), are among the first statues of a seated king. This standard theme in Egyptian art varied only in the details for nearly 3,000 years. Khasekhemwy sits on a simple chair-like throne with a low back. He wears the tall, conical White Crown that proclaims the king's power over Upper (southern) Egypt. He also wears a cloak that Egyptologists can associate with the *heb-sed*, the royal jubilee festival. The king looks straight ahead, establishing that the frontal view of the statue was the main view. The king's left arm crosses his abdomen, while his hand holds the cloak closed. The right arm extends from his waist to his knee on the right thigh, the hand in a fist. Perhaps the hand originally held a scepter or some other indication of the Khasekhemwy's royal status. This arrangement does not conform with later statues. In most later royal, seated statues, the king's left hand reaches toward offerings. This detail indicates that this statue was carved before the conventions became rigid. The king's feet rest on the base in front of the chair. Near his feet the artist carved Khasekhemwy's name in hieroglyphs oriented toward the figure of the king, rather than to the viewer. This arrangement is found on other early statues, though later the hieroglyphs will be oriented to the viewer, making them more legible. On the front and sides of the base of the statue in sunk relief is a representation of defeated enemies. The enemies are naked and arranged in awkward, prone positions. The artist carved the number 47,209 near some prisoners wearing lotus flowers on their heads. The lotus is the traditional symbol of Lower Egypt. Clearly the statue refers to a war or series of battles in which the king defeated this large number of enemies, perhaps from Lower Egypt.

DJOSER. A seated statue of King Djoser of the Third Dynasty (2675–2625 B.C.E.) is one of the first known life-size images of a king. Archaeologists discovered it in a shrine at the base of his pyramid. Ancient artists positioned the statue so that it faced a blank wall with two holes carved through it at the statue's eye level. Priests could thus view the statue through the wall, and the statue could see the offerings brought to it. Djoser wears a heavy wig that divides the hair into three parts. Since gods also wear this hairstyle, it identifies Djoser as fully assimilated to divinity and thus already deceased. Over the wig, Djoser wears an early form of the Nemes kerchief, the blue and gold striped cloth restricted to kings. By the Fourth Dynasty (2625–2500 B.C.E.), the period subsequent to Djoser's time, the Nemes will fully cover the king's hair. Here the lappets of the Nemes rest on the

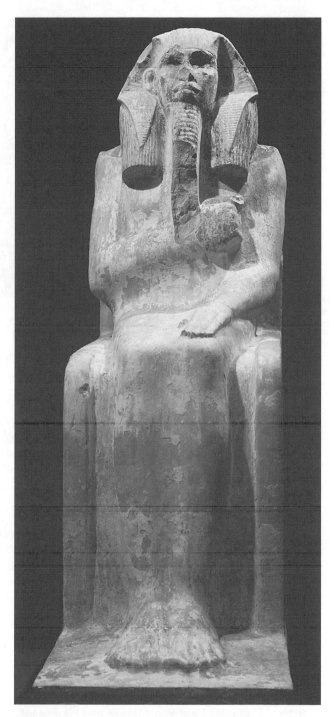

Seated statue of Djoser (Zoser) in Cairo Museum. © **ARCHIVO ICONOGRAFICO, S.A./CORBIS.**

hair but do not cover it completely. Djoser also wears the same heb-sed cloak that his predecessor Khasekhemwy wore in his statue. Yet the position of Djoser's hands reverses the hands in Khasekhemwy's sculpture. Here the king's right hand holds the cloak closed while his left arm is placed on his lap. The hand is flat and rests in this statue on his lap. Similar representations of kings

Large knife. BROOKLYN MUSEUM OF ART, 09.889.119, CHARLES EDWIN WILBOUR FUND. REPRODUCED BY PERMISSION.

in relief show that this gesture should be read as the king reaching for offerings with his left hand. The Egyptian sculptor did not leave negative space between the arm and the lap for fear of creating a weak point in the sculpture. In general, Egyptian sculptors in stone preferred to preserve the shape of the stone block overall and not to free the limbs from the block. Djoser's throne closely resembles the low-backed chair that Khasekhemwy occupies in his sculpture. The inscription on the base gives Djoser's throne name, Netjery-khet. The carving is oriented toward the viewer. Though Djoser's statue shares characteristics with Khasekhemwy's statue, the position of the hands and the inscription's orientation point toward the commonly observed conventions of subsequent Egyptian history.

DEITY. A Third-dynasty (2675–2625 B.C.E.) statue of a deity is among the earliest preserved freestanding statues of a god from ancient Egypt. The god wears a rounded, short wig. The facial characteristics found here resemble other Third-dynasty figures. The artist paid little attention to the eyes, but carved a prominent nose and full lips with rounded corners. The god wears a long divine beard. The shoulders are broad and the artist has modeled the chest and arms to suggest musculature. In his right hand, the god holds a broad, flat knife that associates him with the god Onuris. This god also can be associated with the penis sheath that he wears here. This statue thus is another early example of the way that artists could communicate the identity of a figure through attributes, a system that Egyptologists call iconography. Onuris stands with this left leg forward, a pose meant to suggest walking

forward. Egyptian standing male figures conventionally depict the left leg forward. In spite of the facial features which connect this statue to the earlier periods, the pose, torso, and use of attributes such as the knife look forward to the broader conventions of Egyptian art.

ANKHWA. The seated statue of the Ankhwa represents a shipwright whose name Egyptologists formerly read as "Bedjmes." Bedjmes, a reading of the word for shipwright, was formerly thought to be his name. This statue represents a standard Egyptian type, the seated official. But it also exhibits features related both to the subsequent standardization of the type and other features which do not become part of the standard. Ankhwa sits on a stool without a back. On the sides of the statue, the sculptor carved in relief the curved braces that held the stool together. This feature of Ankhwa's statue will disappear in subsequent periods and thus is indicative of the Third-dynasty date. The other feature of Ankhwa's statue that is typical of earlier statues is the positioning of the hands. Ankhwa reaches for offerings with his right hand while his left hand holds the adze, a symbol of his profession. Later such statues of officials will depict the left hand reaching and the right hand holding an attribute that refers to the subject's profession. These distinctions, though very small, are important for deducing the date of statues in Egypt. The style of the statue places it firmly in the Third Dynasty. The face displays eyes with only the upper lid carved. In contrast the mouth is portrayed in more detail with broad lips with rounded corners. The head is large and attached almost directly to the torso with short neck. The artist here was avoiding a possible

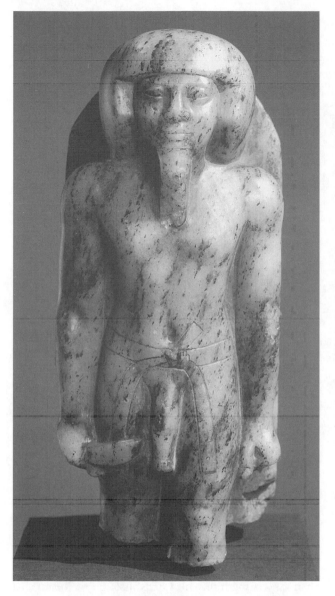

Statuette of a male deity. BROOKLYN MUSEUM OF ART, 58.192,
CHARLES EDWIN WILBOUR FUND. REPRODUCED BY PERMISSION.

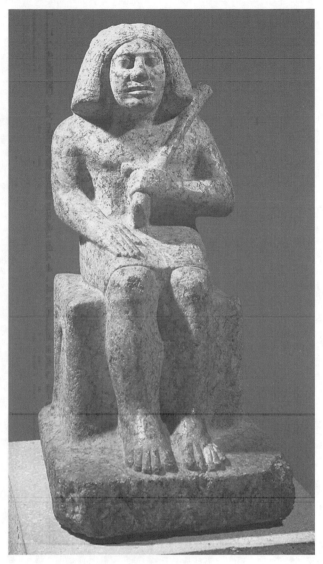

Statue of Ankhwa, the ship-builder. © THE BRITISH
MUSEUM/TOPHAM-HIP/THE IMAGE WORKS.

weak point in the sculpture. Finally, the artist carved the
inscription on Ankhwa's lap rather than on the base as
would become more typical in later periods.

COLOSSAL HEAD OF A KING. A colossal head of a
king without inscription to identify it is closely related
to the art of the Third Dynasty. The head is larger than
life-size, measuring over 21 inches in height and made
of red granite. The king wears the white crown. The
shape of the crown, especially the depiction of the tabs
around the ears resembles the shape of the crown in the
seated statue of Khasekhemwy. This king's eyes are also
carved in a manner that resembles the eyes on the stand-
ing statue of Onuris and Ankhwa. Only the upper lid is

carved. The lips are broad and curved at the ends. These
facial features also recall Onuris and Akhwa and suggest
that the king's head also dates to the Third Dynasty.
Enough of the line of the cloak is preserved at the statue's
neck to suggest that the king wore the heb-sed cloak as
seen in Khasekhemwy's and Djoser's statues. This statue
is also a good example of the way Egyptian artists used
monumentality, overwhelming size, to stress the king's
power to the viewer.

SOURCES

Metropolitan Museum of Art, *Egyptian Art in the Age of the
Pyramids* (New York: Harry N. Abrams, Inc., 1999).

Edna R. Russmann, *Eternal Egypt: Masterworks of Ancient Art
from the British Museum* (New York: American Federa-
tion of Arts, 2001).

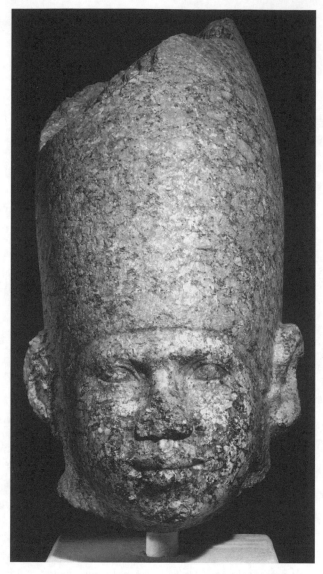

Head of a king. BROOKLYN MUSEUM OF ART, 46.167, CHARLES EDWIN WILBOUR FUND. REPRODUCED BY PERMISSION.

SEE ALSO *Architecture: The North/South Pyramid Complex: King Djoser's Complex at Saqqara*

THE OLD KINGDOM

HIGH POINT. Egyptian art of the Old Kingdom (2675–2170 B.C.E.) reached a high point of accomplishment which scholars often associate with a strong central government. Clearly the royal workshop had the means to command the best artists and supply them with the most costly materials. Though political weakness or strength does not necessarily determine the quality of the art of the times, the Old Kingdom was certainly a period when political strength and artistic accomplish-

ment overlapped. The art created in this period portrays the king, the bureaucracy, and the workers according to a set of conventions developed in this period and followed throughout ancient Egyptian history.

KHAFRE. The statue of King Khafre (2555–2532 B.C.E.) portrays the builder of the second pyramid at Giza and patron of the Great Sphinx. The statue illustrates the intersection of skilled craftsmanship and rare materials resulting in superior work. It also exemplifies Old Kingdom artists' approach to portraying the king as an all-powerful, godlike ruler. The statue is one of several of this king from his mortuary temple, attached to his pyramid. The sculptor carved this statue from diorite, a very hard stone that takes a high polish. Though the gray-green color of the stone would have been disguised by the paint Egyptian artists added to statues, the stone's quality allowed the sculptor to model details in a way that would not have been possible in a softer stone. Moreover, the Egyptians imported this diorite from Nubia, making it rare and expensive. This statue is also an early example of the standard interpretation of the seated king as a conventional subject. Khafre sits on a lion throne, a royal chair with legs carved to resemble lions. The side panels of the chair display the hieroglyphic sign that proclaims that Upper and Lower Egypt are united into a single political entity. Other seated statues of Khafre include the unification motif, but not on lion thrones. The king wears the Nemes kerchief—the blue and gold striped cloth restricted to kings—with a Uraeus—the figure of the sacred serpent, an emblem of sovereignty depicted on headdresses—also standard for seated, royal statues. The king wears a square beard, indicative that the statue represents him in life rather than associating him with Osiris through the beard that curves upward at the end. Perched on the king's back is a Horus falcon, representing the god protecting the king with his wings. The falcon on the king's back might be compared to relief sculptures of the king with a falcon hovering above him. This, indeed, might be the way that the artist intended for viewers to interpret the falcon, indicating that the king is the living Horus on earth. The artist has sensitively modeled the king's face with wide open eyes, a broad nose, philtrum, and sensitive lips. The artist has also exploited the quality of the stone to carve the king's broad shoulders, muscular arms, and modeled chest. The king reaches for offerings in the now standard way with his left hand and probably held some object associated with his office in his right hand. The hieroglyphs carved on the statue base are oriented to the viewer and identify the king by name following the standard convention. Overall, the statue conveys a sense of

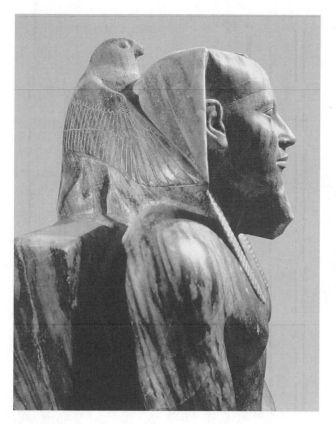

Statue of Khafre, wearing the nemes headcloth and false beard, with the falcon of the god Horus protecting him. **THE ART ARCHIVE/EGYPTIAN MUSEUM CAIRO/DAGLI ORTI.**

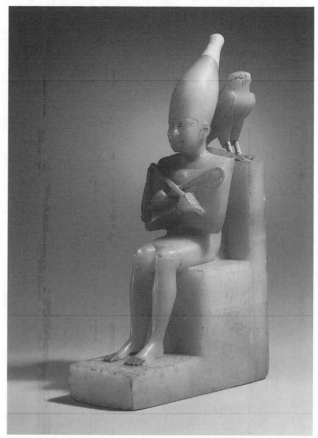

Small seated statuette of Pepi I with Horus falcon. **BROOKLYN MUSEUM OF ART, 39.120, CHARLES EDWIN WILBOUR FUND. REPRODUCED BY PERMISSION.**

overwhelming power and majesty both through the skillful carving and forceful presentation of the king.

PEPI I. The calcite seated statue of Pepi I (2338–2298 B.C.E.) recalls the seated statue of Khafre but also demonstrates the kinds of changes which occurred in art between the earlier king's reign and the Sixth Dynasty (2345–2181 B.C.E.). Few other statues from Egypt so clearly read like a hieroglyph as does this one. The king sits on a throne that is shaped exactly like the hieroglyph for the word throne. He wears the white crown that identifies him as the king of Upper Egypt. He also wears a cloak that scholars recognize as the same costume the king wears during the heb-sed (jubilee). The king's arms cross his chest and he holds the crook and flail. These two objects identify the king with the god Osiris. An inscription on the base identifies the king and is oriented to the viewer. Perched on the back of the throne is the falcon that represents the god Horus. The bird's pose recalls the profile view of the falcon in two dimensions found on the Stela of Wadj. Just as was true on Wadj's stela, beneath the falcon the king's name is written within a serekh. The back of the statue thus stresses the living king's association with the god Horus on earth. The

king's facial features differ from Khafre's face. His eyebrows are broad, arch over his eye, and extend back toward the ears. The cosmetic line, the representation of the kohl applied like eyeliner that encircles the king's eye, also extends parallel to the eyebrow toward the ear. The king's lips are thick, and the mouth is shaped in an oval without any pointed corners. The small scale of this sculpture allowed the artist to carve the negative space of the legs, freeing them from the block.

PEPI I KNEELING. A small schist statue of Pepi I kneeling is an example of another typical Egyptian royal statue type. It portrays the king kneeling and holding a jar in each hand. The king is making a liquid offering to a god. This statue is the oldest complete example of a royal kneeling statue, but there is a fragment of a similar statue from the reign of Khafre known to Egyptologists. The king wears a Nemes kerchief. A Uraeus, probably fashioned from precious materials, once filled the hole over the king's forehead. The king also wears a shendjet kilt, a garment worn only by kings that thus helps to identify him. His facial features are typical of

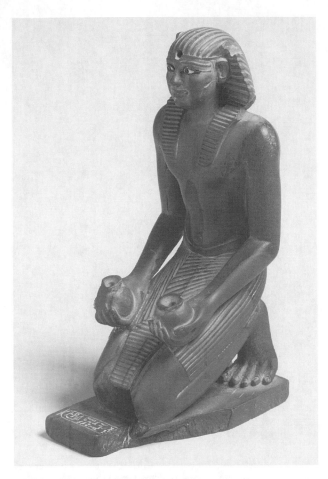

Kneeling statuette of Pepi I. BROOKLYN MUSEUM OF ART, 39.121, CHARLES EDWIN WILBOUR FUND. REPRODUCED BY PERMISSION.

the Sixth Dynasty. The broad but gently arched eyebrow extends nearly to the ear. The eye, like many statues in ancient Egypt, is made from precious materials and inlaid. The pupil is obsidian, while the white is calcite. These materials are held in place by a copper armature that represents the cosmetic line around the eye. The cosmetic line then extends in stone toward the ear, running parallel to the eyebrow. The nose and cheeks are full. The philtrum is modeled. The king's mouth has broad lips and is shaped like an oval, without corners. The king's torso and arms are elongated, not as muscular as Khafre's body. This body type represents a second style in Egyptian art, identified by the art historian Edna R. Russmann. It contrasts with the more muscular and robust body of Khafre, for example, portrayed earlier and later in Egyptian history. This second style seems more expressive, and Egyptologists believe its source was religious. In common with the seated statue of Pepi I, the negative space between the arms and the king's torso is carved. Again this is probably due to the small scale of this work.

ANKH-NES-MERYRE II AND PEPI II. The calcite statue of Queen Ankh-nes-meryre II and her son Pepi II (2288–2194 B.C.E.) reveals further Sixth-dynasty innovations in royal sculpture while still relying on ancient conventions. The statue portrays a small, adult-looking king sitting on the lap of a woman who is much larger. The fact that Pepi II ascended the Egyptian throne at the age of six explains the difference in size between the figures. Taken alone, the small statue of the king resembles most seated royal figures. The king wears a Nemes kerchief and Uraeus over his forehead. He also wears a shendjet kilt, another symbol of royalty. The king's left hand reaches for offerings in a conventional way, while his right hand holds a piece of linen, an offering he has already accepted. The sculptor placed this conventional statue at a ninety degree angle to a seated statue of the queen. The queen sits on a low-backed throne. She wears the vulture-headdress that indicates her status as a royal woman. The vulture further identifies her as the royal mother since this bird is also the hieroglyph for the word "mother." The hole above her forehead probably once held a vulture head in some precious material. She also wears the tri-partite hairstyle, a traditional style for both women and goddesses. She wears a tight fitting dress with straps that pass over her breasts. Both the king and queen bear similar, Sixth-dynasty facial characteristics including the broad eyebrow, long cosmetic line, and oval-shaped mouth with no corners. Though most Egyptian statues are frontal, meant to be viewed from only one direction, clearly this statue has two fronts. But the queen here must be the major figure because she is so much larger than the king. Usually in Egyptian art, the king appears to be the smaller figure only in the presence of a deity. Thus many Egyptologists understand this statue to represent the king and his mother in the guise of the goddess Isis caring for her child Horus, the divine manifestation of the living king. Here the mythological interpretation most probably overlaps with reality since the six-year-old Pepi must have relied on his mother to rule Egypt during his minority.

STANDING ROYAL SCULPTURE. The standing sculpture of King Menkaure and Queen Kha-merer-nebu II is a masterpiece of Egyptian sculpture and illustrates the Egyptian conventions for representing a standing king and queen. The sculpture is just under life size, 54¾ inches tall. The sculptor used greywacke, a hard gray stone that the Egyptians prized. The archaeologist George Reisner discovered the statue in 1910 in the valley temple of this king's pyramid at Giza. This sculpture clearly illustrates the main conventions of Egyptian

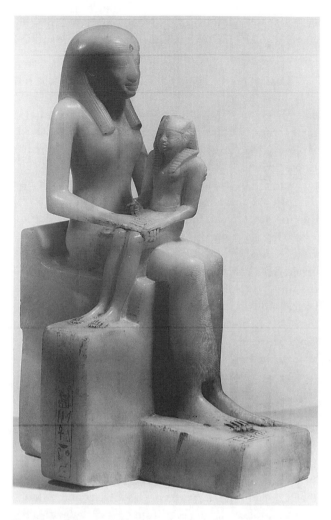

Statuette of Queen Ankhnes-meryre II and her son Pepi II.
BROOKLYN MUSEUM OF ART, 39.119, CHARLES EDWIN WILBOUR
FUND. REPRODUCED BY PERMISSION.

standing royal sculpture. The sculptor placed Menkaure on the viewer's left and the queen on the right. The ancient viewer would have recognized immediately that Menkaure was the more important figure of this pair. The viewer's left is always the place of honor in Egyptian representations. The king and queen were also conventionally dressed to communicate their rank in Egyptian society. Menkaure wears the Nemes kerchief, worn only by the king. This headdress was made from cloth, folded to form triangular shapes framing the king's face. Two lappets hang from the triangles over the king's chest. The back of the cloth was twisted around a braid of hair. Though the headdress covered most of the king's hair and head, his sideburns and ears are visible. In examples where the artist used color, the Nemes is striped blue and gold. The king also wears a rectangular false beard. The false beard was leather, attached by straps that would have tied under the Nemes. This beard, worn only by

the king, contrasts with the longer beard that ended in an upward twist worn only by the gods. The king's chest is bare. He wears a distinctive kilt called the shendjet, worn only by kings. The kilt features a belt and a flap that was placed centrally between his legs. The king holds a cylinder in each hand, usually identified as a document case. The case held the deed to Egypt, thought to be in the king's possession. This statue also shows some conventions of representing the male figure used for both nobles and kings. The king strides forward on his left leg, a pose typical for all standing, male Egyptian statues. The traces of red paint on the king's ears, face, and neck show that the skin was originally painted red-ochre. This was the conventional male skin color in statuary, probably associating the deceased king or nobleman with the sun god Re. The statue of Queen Kha-merer-nebu II also exhibits the conventions for presenting women in Egyptian sculpture. Unlike kings, queens did not have their own conventions separate from other noblewomen. The queen's wig is divided into three hanks, two draped over her shoulders and one flowing down her back. There is a central part. The queen's natural hair is visible on her forehead and at the sideburns, another common convention. The queen wears a long, form-fitting dress. The fabric appears to be stretched so tightly that it reveals her breasts, navel, the pubic triangle, and knees. Yet the length is quite modest with a hem visible just above the ankles. The queen's arms are arranged conventionally with one arm passing across the back of the king and the hand appearing at his waist. The queen's other hand passes across her own abdomen and rests on the king's arm. This pose indicated the queen's dependence on the king for her position in society. In pair statues that show men who were dependent upon their wives for their status, the men embrace the women.

STYLE AND MOTION. The conventions of Egyptian art make it easy to stress the similarity of Egyptian sculptures to each other in the Old Kingdom. Yet details of the style of sculptures such as the Menkaure statue often make it possible to identify specific royal figures such as the king. All of his sculptures show distinctive facial features. His face has full cheeks. His eyes bulge slightly. The chin is knobby while the nose is bulbous. His wife resembles him, probably because the king's face in any reign became the ideal of beauty. In almost every period, everyone seems to resemble the reigning king. Another aspect of style that remained constant through much of Old Kingdom art was the purposeful avoidance of portraying motion. Unlike ancient Greek sculptors, Egyptian sculptors aimed for a timelessness that excluded the transience of motion. Thus even though Menkaure and

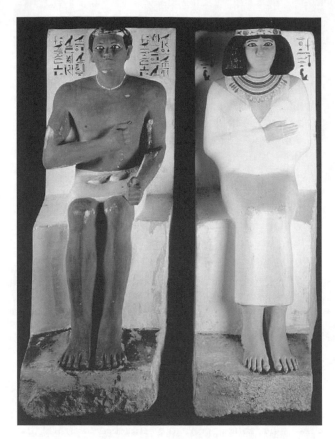

Seated statues of Rahotep and his wife Nofret. SCALA/ART
RESOURCE NY.

the statue was not finished. Finished sculpture almost always included a hieroglyphic inscription that identified the subject.

RAHOTEP AND NOFRET. Rahotep was a king's son who lived early in the Fourth Dynasty (2615–2492 B.C.E.). He was probably a son of King Sneferu and the brother of Khufu, builder of the Great Pyramid. His wife, Nofret, held the title "One Whom the King Knows," indicative of her high rank. Statues of this couple were discovered in their tomb in 1871 C.E. Because the paint on these statues is fully preserved, they reveal the pristine, original appearance of Egyptian sculpture. They are fully painted. The colors are almost surely symbolic. Rahotep's skin is painted a dark red derived from ocher. This color associates the deceased Rahotep with the sun god. Nofret's skin is painted yellow/gold, symbolically linking her skin with a goddess's skin. An alternative, frequent suggestion for the difference in skin tones between men and women is that men spend more time in the sun than did women in ancient Egypt, and so they were portrayed as lighter in color. This explanation, however, assumes that Egyptian artists fixed on this one detail as important enough to include visually in a sculpture. Since Egyptian art is largely conceptual, conveying ideas rather than visual reality, it seems likely that the color is symbolic rather than a representation of visual reality. The eyes on both statues are inlaid rather than carved from the same stone as the rest of the statue. The sculptor carved the eyes from rock crystal with a flat back. On the back, the iris and white have been added in paint. A hole drilled in the center, also painted black, represents the pupil. The front was highly polished, resembling the cornea of a living eye. The crystal was surrounded with a metal frame and placed in the socket carved in the statue. The effect is amazingly life-like. These crystal eyes must have been quite valuable in ancient times. They are only rarely preserved in statues, usually the loot of ancient tomb robbers who often left a statue behind without the eyes. The seated statue was also a common pose for high officials. These statues are very early examples, thus they do not preserve the later conventional hand gestures. Rahotep and Nofret both place the right arm across the chest. He holds the right hand in a fist while she lays it flat against her body. Rahotep's left arm stretches on his lap toward his knee. The left hand is positioned as if it held some insignia of his office. Her left arm and hand are hidden behind her cloak. Later in the Old Kingdom, both men and women will reach forward with the left arm for offerings in the conventional pose for three-dimensional sculpture.

Kha-merer-nebu II were portrayed walking, the sculptor did not attempt to depict the weight shift in the hips and the stretch of the muscles that would create the illusion that the statue could move. This attitude toward depicting motion is a fundamental difference between ancient Egyptian and Greek art.

STRUCTURAL SUPPORTS AND INSCRIPTIONS. Egyptian sculptors relied on back pillars and the avoidance of negative space to support their sculptures. The back pillar in standing sculptures, such as the Menkaure statue, forms a slab that reaches to the shoulders of the figures. In statues of individuals, enough of the block of the stone was removed so that the back pillar would cover only the spine of the figure. In some cases, the entire back of the figures disappears into the remaining block of the stone. The negative space, the area between the arms and torso or between the legs was not carved. Unlike most sculptures of the Old Kingdom, the statue of Menkaure lacks the inscription that is usually found on the base and on the back pillar. Instead the artist relies on the idea that Menkaure can be identified from his facial features and the find spot of the statue in a temple built by Menkaure. The absence of an inscription indicates that

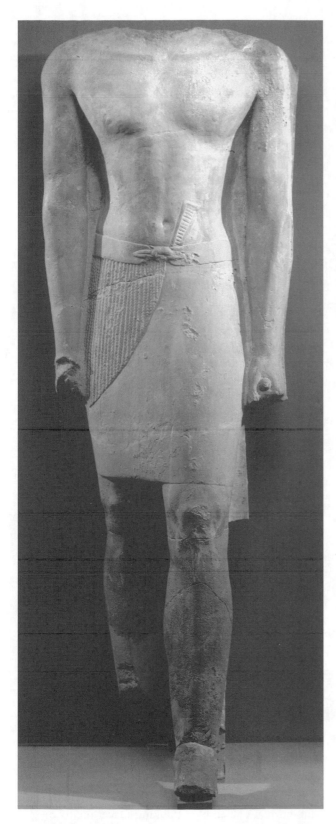

Standing statue of Ity-sen. BROOKLYN MUSEUM OF ART, 37.365, GIFT OF EVANGELINE WILBOUR BLASHFIELD, THEODORA WILBOUR, AND VICTOR WILBOUR HONORING THE WISHES OF THEIR MOTHER, CHARLOTTE BEEBE WILBOUR AS A MEMORIAL TO THEIR FATHER, CHARLES EDWIN WILBOUR. REPRODUCED BY PERMISSION.

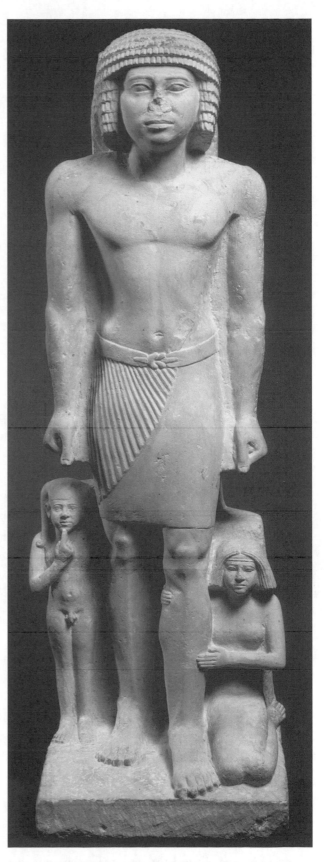

Statue of a family group. BROOKLYN MUSEUM OF ART, 37.17E, CHARLES EDWIN WILBOUR FUND. REPRODUCED BY PERMISSION.

Arts and Humanities Through the Eras: Ancient Egypt (2675 B.C.E.–332 B.C.E.)

285

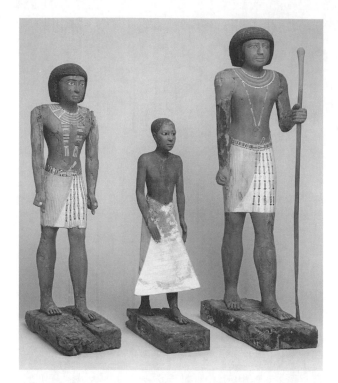

Three statues of Metjetji. BROOKLYN MUSEUM OF ART, 50.77, 51.1, 53.222, CHARLES EDWIN WILBOUR FUND. REPRODUCED BY PERMISSION.

PORTRAYALS OF OFFICIALS. In addition to royalty, another large class of Egyptian sculpture portrays the officials who ran both the secular and religious institutions. These men and women were often younger sons and daughters of the royal family in the Fourth Dynasty, but later in the Fifth and Sixth Dynasties included self-made commoners who somehow developed a relationship with the king and thus rose in society. Egyptian artists developed a set of conventions for portraying these officials during the Old Kingdom. The standing statue of Ity-sen is an excellent example of the conventions for a standing statue of an official. Originally it was part of a group of three figures. Ity-sen stands with both arms at his sides. His hands hold peg-like objects that might represent offerings of cloth. His left leg strides forward, indicating that Ity-sen is walking forward to receive his offerings. His upper body is youthful with careful modeling of the pectoral muscles and the clavicle. He wears a simple kilt with a pleated apron. The muscles around the knee are modeled as well as the bones of the knee. The overall effect is a youthful and vibrant man in the prime of life. This effect was the artist's usual intention. Statues like this functioned as containers for the deceased's soul and allowed the deceased to continue life after death eternally young.

GROUP STATUE. A family group of statues which represents an official, possibly named Irukaptah, his wife, and son, illustrates Egyptian use of hieratic scale—size based on importance—in three-dimensional sculpture. Irukaptah is a conventional standing male official roughly three times larger in scale than his wife and son. This difference in scale points to the Egyptian convention that the main figure of a group can be presented on a completely different, larger scale than the less important figures. Irukaptah wears a heavy but short wig. His facial features suggest a date in the Fifth Dynasty. His eyebrows are straight, and his eyes are wide open. There is no cosmetic line. Though the nose is damaged, it is still possible to see that the sculptor carefully modeled the area where the nose met the cheeks. His mouth is set in a somber expression with carefully modeled lips that end in a point. He has a strong, rounded chin. The upper body is carefully modeled with a clavicle, pectoral muscles, and a groove that runs through the center of the abdomen to the navel. The muscles of the shoulders and arms are also carefully modeled. Irukaptah wears a simple wraparound kilt with a pleated apron. His legs display careful modeling of the knees and the muscles surrounding them. His wife kneels at his left. She wears a short wig that reveals some of her natural hair at the forehead. She wears a tight dress that reveals her youthful breasts and also the pubic triangle. She crosses her left arm over her abdomen and holds Irukaptah's left calf with her left hand. Irukaptah's son stands on his right. The portrayal of the son follows Egyptian conventions for representing a child. His hair is gathered in a side lock that curls at the end. He holds his right hand up with his index finger pointing to his mouth. He is also nude. These conventions would have conveyed to the viewer that the subject is a child, even though he is larger than his mother. Though the expected inscription was never carved on this statue, the conventions of scale, dress, and pose make it easy to interpret.

SECOND STYLE. Three wooden statues of Metjetji illustrate both the conceptual nature of Egyptian sculpture and the emergence of a second style in Egyptian art in the later Old Kingdom. Though all three statues bear inscriptions identifying the subject as Metjetji, a high official of the late Fifth or early Sixth Dynasty, the facial features are not at all similar. Egyptian artists individualized a statue by adding a person's name in hieroglyphs to the base or on the statue itself. The facial characteristics normally resembled the king's face, the living god on earth. With such a "portrait" an official could merge his personality with that of the god and enter into the afterlife. Thus the three statues, though different in appearance, represent only the concept of the man Metjetji.

286

Arts and Humanities Through the Eras: Ancient Egypt (2675 B.C.E.–332 B.C.E.)

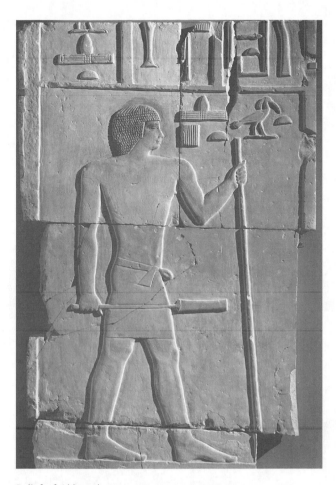

Relief of Akhety-hotep. BROOKLYN MUSEUM OF ART, 57.178, CHARLES EDWIN WILBOUR FUND. REPRODUCED BY PERMISSION.

The three statues also represent the emergence of a second style in addition to the idea of the youthful and idealized standing male figure. The three statues seem to portray Metjetji at different stages of his life. The statue of Metjetji holding a walking staff is most like other conventional images in style. It resembles, for example, the standing statue of Ity-sen in basic conception. The statue depicting Metjetji in the most conventional pose with both arms at his sides also begins to exhibit characteristics of the second style. The figure is much less robust looking. His arms, torso, and legs are elongated. His body is slimmer and less muscular. The facial features are more exaggerated and less idealized than in the more conventional style of Egyptian art. Finally, the statue with the open palm pose is very much more elongated and expressive in its facial features. Some scholars have considered it an individualized portrait. The face, arms, torso, and legs are even more attenuated and slender than in the previous example. From the Sixth Dynasty until the end of ancient Egyptian history, artists used the idealized, traditional style alongside the attenuated second style in

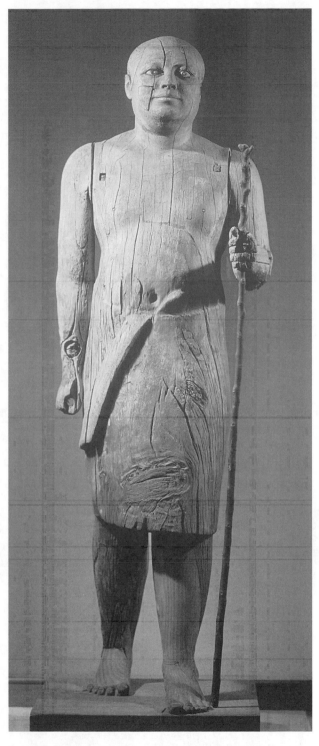

A wooden statue of the dignitary Ka-aper. His corpulence was a sign of wealth in the Old Kingdom. © ROGER WOOD/CORBIS. REPRODUCED BY PERMISSION.

certain period. Many scholars have suggested that the motivation behind the development of this second style was religious. Yet the details of how and why it developed have not been explained.

Arts and Humanities Through the Eras: Ancient Egypt (2675 B.C.E.–332 B.C.E.)

287

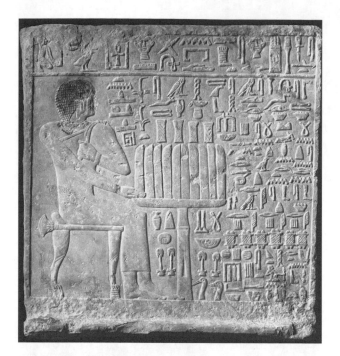

Offering scene of Setjau. BROOKLYN MUSEUM OF ART, 37.34E, CHARLES EDWIN WILBOUR FUND. REPRODUCED BY PERMISSION.

RELIEFS OF OFFICIALS. Old Kingdom artists carved reliefs of officials on their tombs' walls. These representations were also conventionalized, using standard poses for standing and seated officials. Reliefs could be either raised or sunk, depending on placement in the tomb. In raised reliefs, the artist cuts away the background, leaving behind an image raised above the surface of the stone. Sunk reliefs cut the image below the surface of the stone. Raised relief in Egypt was most effective in dark interior spaces where it caught the diffused light. Sunk relief was more visible in bright, outdoor spaces where the intense light of the Egyptian sun was brightest. All relief was painted.

STANDING POSE IN RELIEFS. A relief of the official Akhety-hotep is a conventional standing figure of an official. Akhety-hotep stands with a staff in his left hand and a scepter in his right hand. The staff is a simple, tall walking stick which only men of authority carried. The scepter is also a hieroglyph for the word "power." The fact that Akhety-hotep holds this scepter conveys the basic message that he is a high official. The pose portrays Akhety-hotep's face in profile with a frontal view

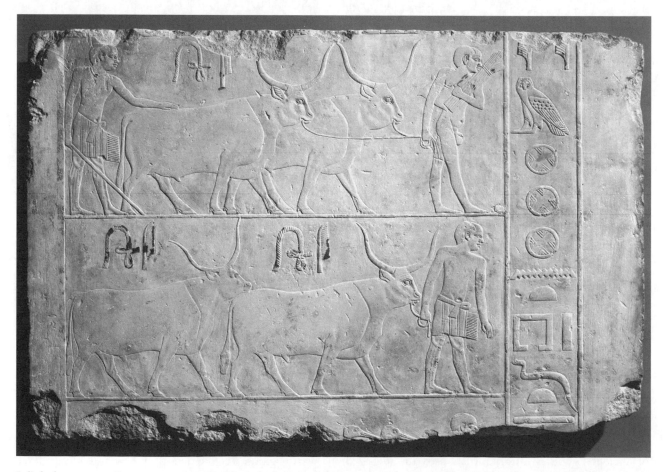

Relief of men presenting oxen. BROOKLYN MUSEUM OF ART, 49.62, CHARLES EDWIN WILBOUR FUND. REPRODUCED BY PERMISSION.

of his eye. His shoulders seem to twist to a frontal view while his torso violently twists back to a profile. Only his nipple remains in the frontal view. From his waist to his feet, the view of Akhety-hotep is in profile. The artist, however, has given him two left feet, also a convention of Egyptian relief. Both feet display the arch and the big toe as closest to the viewer. This view should only be possible of the left foot. Finally, the hieroglyphs directly in front of his face spell his name, thereby individualizing this conventional image as one particular official. In fact the image of Akhety-hotep is properly a hieroglyph. In hieroglyphic writing, the final sign in a name is an image of a man or of an official if a man had achieved that status. Thus the image acts as the final hieroglyph in the writing of his name.

SEATED OFFICIAL IN RELIEF. The relief of Setjau illustrates a typical offering scene with a seated official. Reliefs of seated officials before an offering table were placed above the false door in a mastaba tomb. Here the priests offered food, drink, cosmetics, ointments, ritual oils, and clothes to the deceased during the ritual. This relief depicts Setjau receiving these gifts that he needs in the afterlife while sitting on a stool carved with animal legs. Even through the damage, it is possible to see that his face is in profile, except for the eye that the artist has carved frontally. The shoulders twist to a frontal view while the torso, legs, and feet are in a profile view. Setjau holds a ritual object in his clasped left hand. His right arm reaches forward with an open hand touching the offerings on the table. This gesture suggests he has received the offerings that the priests made. This hand, as is commonly the case, appears to be a left hand too, though it is attached to the right arm, nearer to the viewer. The thumb is at the bottom rather than the top, the place the viewer would expect it if this relief were a version of visual reality. Setjau is surround by hieroglyphs. The top horizontal line contains his titles and name, individualizing this conventional image. The hieroglyphs around the offering table enumerate the offerings that Setjau can expect to receive for eternity.

WORKERS. Workers appear in scenes of farm life and manufacturing in Old Kingdom tombs. In the relief called Men Presenting Cattle it is clear that the same conventions governing portrayals of kings and officials did not apply for agricultural workers, or indeed any workers in Egyptian society. The three workers are all balding, not anything like the idealized kings and officials. Though the basic conventions can be found in Egyptian representations of workers, the man at the upper right side of this relief might represent a comic view of workers. This man is balding and nude. In gen-

eral Egyptian artists only portrayed nudity for the children of the upper classes. Rather than having an idealized body, this man displays a pot-belly. Moreover, his right foot is forward as he walks rather than the conventional left foot. Though such a detail might seem minor, viewed against a background of hundreds of examples from Egyptian art, this is a major deviation from the conventions. Egyptian artists could exercise much more freedom in their depictions of workers than they could when portraying kings and officials. This freedom also stems, in part, from the fact that the scenes of daily life required more complicated poses in order to depict certain actions.

SOURCES

Metropolitan Museum of Art, *Egyptian Art in the Age of the Pyramids* (New York: Harry N. Abrams, Inc., 1999).

Edna R. Russmann, *Egyptian Sculpture: Cairo and Luxor* (Austin: University of Texas Press, 1989).

———, "A Second Style in Egyptian Art of the Old Kingdom," in *Mitteilungen des Deutschen Archäologishen Instituts Abteilung Kairo* 51 (1995): 269–279.

SEE ALSO *Architecture: Fourth-Dynasty Architecture and History*

THE MIDDLE KINGDOM

NEW TRENDS. The visual art of the Middle Kingdom (2008–1630 B.C.E.) displays both regional styles and development through time. The art created during the Eleventh Dynasty (2008–1938 B.C.E.) displays a distinct style that originated in Thebes, the home of Nebhepetre Mentuhotep, the king who reunified Egypt and founded the Middle Kingdom. In the Twelfth Dynasty (1938–1759 B.C.E.), Memphis was once more the Egyptian capital. Artists drew inspiration from Old Kingdom (2675–2170 B.C.E.) models found in this area. They reestablished this older art as the official style. Yet they also continued to develop within this older tradition. Representations of kings remained the most common and most important subject for Egyptian artists during the Middle Kingdom. Statues of kings conveniently illustrate the regional differences in Egyptian art during the Middle Kingdom as well as developments through time.

NEBHEPETRE MENTUHOTEP. King Nebhepetre Mentuhotep (2008–1957 B.C.E.) reunited Egypt after nearly 150 years when local princes ruled small provinces after the collapse of the Sixth Dynasty (c. 2170 B.C.E.). Mentuhotep's family had been the local princes of Thebes,

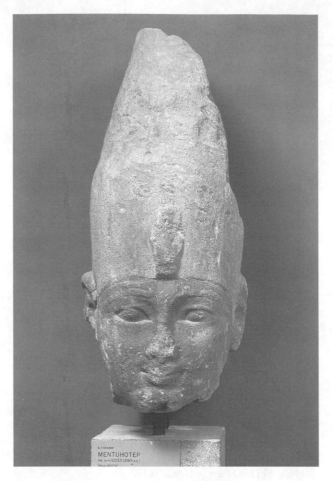

Sandstone head of Mentuhotep. **SCALA/ART RESOURCE NY.**

kings conventionally wore the Uraeus with the Nemes kerchief—the blue and gold striped cloth restricted to kings. Thus this is a new combination. This statue also preserves the red paint used for male skin in Egyptian art. Red associates the king with the sun god Re and probably also with the idea of the sacred. The ancient Egyptian words for sacred and for red contain the same consonants (dj-s-r) and thus red skin for a king was a visual pun for the word sacred. The facial features found in this statue are also typical of the Eleventh-dynasty style. The eyebrows extend in a flat line over the eye and then continue back toward the ear. The lower inner corner of the eye dips downward while the eye is wide open. The cosmetic line extends toward the ear parallel to the eyebrow. Though the nose of the statue has been damaged, the accentuation of the muscles at the base of the nose is clear. There is a sharp ridge around the mouth consisting of broad lips. The edges of the lips form a flat line meeting the cheek. All these characteristics are typical of Eleventh-dynasty sculpture and distinguish it from the more idealizing features of Old Kingdom kings.

ROYAL RELIEFS. Royal reliefs in the Eleventh Dynasty also display a distinctive style and high quality. A good example of this type of carving comes from Neb-hepetre Mentuhotep's mortuary temple. In the section devoted to Queen Neferu, his wife, there is a scene of hairdressers preparing her coiffure. One fragment represents the hairdresser Inu curling the queen's hair or wig. Inu's representation is personalized through the inscription with her name just to the right of her face. Otherwise she bears the facial features found in typical Eleventh-dynasty relief in the Theban style. Her long, flat eyebrow and flaring, extended cosmetic line place her firmly in this tradition. She also displays the artist's interest in the intersection of the nostrils and the cheeks, the broad lips with a ridge around the mouth, and the vertical line marking the corner of the mouth. Finally, the oblique placement of the ear and the emphasis on long, active fingers all are part of the Theban style. After Nebhepetre Mentuhotep's reign and the unification of Egypt, artists combined the Theban and Memphis styles to create a new synthesis.

MENTUHOTEP III. A relief of Mentuhotep III and the goddess Iunyt, wife of the war god Montu, shows the gradual combination of the Theban and Memphis styles. In this reign, Theban artists would have traveled to Memphis and seen the art of the Old Kingdom in places like Giza and Saqqara. Two representations of the king are included. On the left he wears the red crown of Lower Egypt. On the right he wears the Nemes kerchief with a Uraeus. The goddess wears the vulture head-

the area now occupied by Luxor in Upper (southern) Egypt. By conquering Lower Egypt, Mentuhotep established the Eleventh Dynasty and the Middle Kingdom. The artists working at Thebes had a distinctive style in both sculpture and relief. This style became the official style of the Eleventh-dynasty kings. Though it drew on traditional symbols and poses already developed in the Old Kingdom, the way these symbols and poses were carved was distinctive. The sandstone head of Mentuhotep is a good example of how these artists worked. This head comes from a statue discovered in the king's mortuary temple at Deir el Bahri. The king wears the tall white crown, an ancient symbol that proclaimed that he ruled Upper Egypt. Other statues from the same site portray the king in the red crown, the symbol of ruling Lower Egypt. Thus by this series of statues, the king communicated the reestablishment of central rule of all Egypt by one king. Mentuhotep also wears the Uraeus snake. This is an early example in which the Uraeus was combined with the white crown. The snake protects the king by attacking his enemies. In the Old Kingdom,

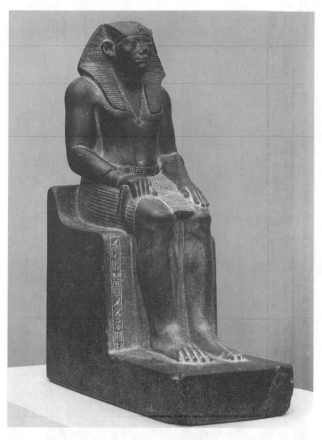

Senwosret III. BROOKLYN MUSEUM OF ART, 52.1, CHARLES EDWIN WILBOUR FUND. REPRODUCED BY PERMISSION.

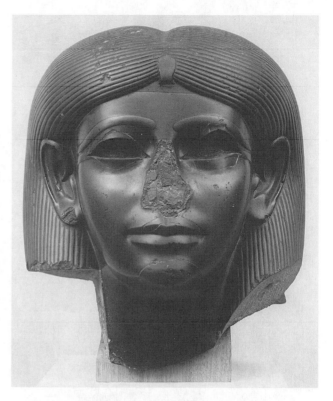

Head from a female sphinx. BROOKLYN MUSEUM OF ART, 56.85, CHARLES EDWIN WILBOUR FUND. REPRODUCED BY PERMISSION.

dress that associates her with maternity. In style, the synthesis between Theban and Memphis traditions are clearest in the eye and the ear. The eyebrow and cosmetic line are still extended and ribbon-like. But the eyeball itself seems to swell behind the eyelid in a more life-like way than was found in earlier Theban work. This is a clear Memphis influence. The ear also is placed more naturally than in other Eleventh-dynasty relief. The lips remain broad but do not end as bluntly at the corners. This relief points toward the revival of the Memphis style during the Twelfth Dynasty.

TWELFTH DYNASTY. Kings of the Twelfth Dynasty (1938–1759 B.C.E.) restored the capital to the area around Memphis in Lower Egypt. Their artists also resided in the new capital. Artists now had direct access to the Old Kingdom cemeteries of Giza and Saqqara and others for inspiration. The results of this inspiration are clear in royal statues of this period. The seated king, in a style reminiscent of the Fourth-dynasty statue of Khafre from his mortuary temple, once again was a common subject. A black granite statue of Senwosret III follows this ancient pattern while also drawing on artists' new

interest in portraying the subject's inner life. The king sits on a low-backed throne with his arms resting on his lap. The left hand is open and reaches for offerings. The right hand is curled in a fist and holds a piece of linen, a common offering. The king wears the Nemes kerchief with a Uraeus protecting him, the conventional headgear for a seated royal statue. The heart-shaped pendant that the king wears suspended from a chain around his neck is typical of Middle Kingdom jewelry. The king also wears the pleated shendjet kilt so often seen in seated royal statues. Finally the king wears an animal tail that is visible between his legs, carved in relief on the block of the throne. The king's thick legs and feet rest on top of nine bows that represent the weapons of Egypt's traditional enemies. With the king's feet on top of them, the enemies are disarmed and rendered harmless. The king's torso also recalls the idealized and muscular bodies of Old Kingdom kings. The artist has carefully rendered the pectoral muscles, the groove over the abdomen to the navel, and the muscles of the arms. Once again the king represents Egypt's strong and idealized protector. Yet the king's face, as is true of many sculptures of Senwosret III, suggests an attempt at conveying the king's psychological state. Many commentators have suggested that the carefully carved bags under the king's

Arts and Humanities Through the Eras: Ancient Egypt (2675 B.C.E.–332 B.C.E.)

291

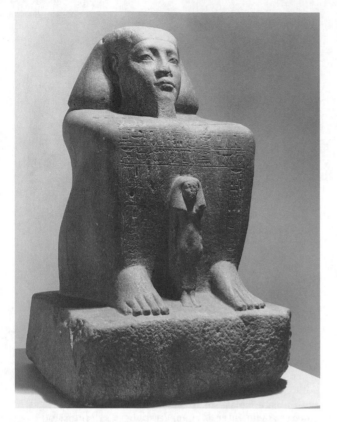

Block statue of Senwosret-Senbefny. BROOKLYN MUSEUM OF ART, 39.602, CHARLES EDWIN WILBOUR FUND. REPRODUCED BY PERMISSION.

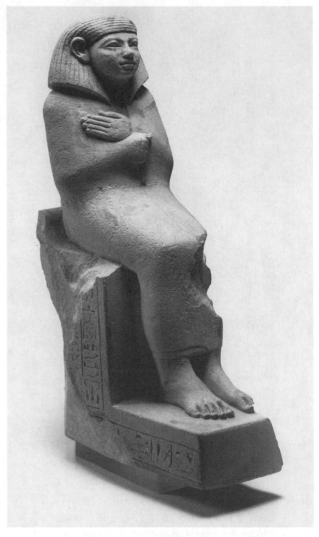

Statue of a cloaked official. BROOKLYN MUSEUM OF ART, 41.83, CHARLES EDWIN WILBOUR FUND. REPRODUCED BY PERMISSION.

eyes, the drawn muscles of the cheeks, and the drooping corners of the king's mouth suggest the heavy burden borne by kings who take proper care of their people. The large, protruding ears, though possibly a family characteristic, might also signify that the king hears his people's prayers. This tradition is found in the literature of the period. The inscription carved on the front of the throne identifies the king and is oriented to the viewer as in classic Old Kingdom royal statues.

PRINCESS. The artists of the Twelfth Dynasty also produced extremely high quality and innovative work. A head of a princess carved from chlorite exemplifies the highest standards of Egyptian art and a new convention, the female sphinx. Even in its damaged condition the head reveals the expressiveness that Egyptian artists could achieve while working within strict conventions. The planes of the face are modeled so delicately that the youthful freshness of the sitter becomes obvious. The princess wears a heavy wig that reveals some of her natural hair above the forehead in the conventional way. A small Uraeus over the forehead indicates that she is royalty. The eyebrows arch over the eye and extend back toward the ear. The eyes were once inset, undoubtedly

made from precious materials. The nose is damaged but the expressive lips are carved with great subtlety. The chin, though repaired in antiquity, is also extremely delicate.

BLOCK STATUE. Block statues possibly began in the Old Kingdom but became very popular in the Middle Kingdom. They represent an individual squatting on the ground, usually wearing a cloak. The pose is common today among Egyptians. It is not unusual to see workers squatting on the back of their heels during a break. The artist preserves the shape of the original stone block with only the head emerging from the top and the feet revealed at the front. In the case of the block statue of Senwosret-Senbefny, the subject's wife is presented on a small scale between his feet. Senwosret-Senbefny wears a wig tucked behind his large, protruding ears. His face resembles the king, Senwosret III for whom he was

named, though he is only a "steward of the reckoning of the cattle." The eyebrow ridge is carved without detailed carving of the eyebrows themselves. Perhaps originally the artist added them in paint. The eyes are placed squarely in the face. The nose is flat with carefully modeled muscles joining it to the cheeks. The mouth with its slight downturn at the ends greatly resembles Senwosret III. The chin with its short, square beard rests on his hands. The feet are much less carefully modeled, appearing thick and clumsy. The block shape of the statue creates additional space for inscriptions. The fact that the funerary god Ptah-Sokar is named in the inscription suggests that this statue came from Senwosret-Senbefy's tomb.

CLOAKED FIGURES. Late in the Twelfth Dynasty artists started to represent officials in full-length cloaks. They could be seated on chairs or on the ground. "Statuette of a Cloaked Official" is an example of a seated male figure in full-length cloak. The subject's body is entirely draped. Only his hands, ankles, and feet emerge from the cloak. Scholars have speculated about the meaning of this popular new way of portraying officials. The contrast between the carefully modeled face and the stark cloak might have had visual appeal for artists. The cloak might also echo the mummy bandages that totally wrap the god Osiris and thus help to equate the deceased official with the god. The cloak is also the garment associated with the king's jubilee (heb-sed). When artists portray a deceased official wearing such a cloak, it might imply rejuvenation for the deceased.

FEMALE FIGURES. Female figures in the Middle Kingdom resemble Old Kingdom models yet illustrate the Egyptian artist's tendency to give all people the king's features. A female figure in the Brooklyn Museum depicts a woman in a tight, v-necked dress and a tri-partite hairstyle. Both of these features resemble Old Kingdom styles. Yet her face reflects the conventions for portraying the king's face and head in the Twelfth Dynasty. She has the same very large ears as the kings of this period. Her eyebrows are relatively straight over wide-open eyes. Her nose is broad and her lips are rounded at the end.

SOURCES

Richard A. Fazzini, *Art for Eternity: Masterworks from Ancient Egypt* (New York: Scala Publishers, 1999).

Jaques Vandier, *Manuel d'archéologie égyptienne, iii, Les grandes epochs: La statuaire* (Paris: A. et J. Picard, 1958).

SEE ALSO *Architecture: Transition to the Middle Kingdom; Architecture: The Pyramids of the Middle Kingdom*

THE NEW KINGDOM

VARIETY. Egyptian art of the New Kingdom (1538–1075 B.C.E.) displays a wide variety of styles within the established artistic tradition, by this point nearly 2,000 years old. The New Kingdom includes the classical images of the warrior pharaoh Thutmose III (1479–1425 B.C.E.) but also the androgynous king, Akhenaten (1352–1336 B.C.E.). It includes relief based on Old Kingdom (2675–2170 B.C.E.) models along with more fluid depictions of both people and places. The variation in size runs from the colossal to the minute. Impassive royal sculptures from the early Eighteenth Dynasty (1539–1425 B.C.E.) contrast with Amarna period (1352–1332 B.C.E.) scenes that seem to represent a loving royal family. Art of the New Kingdom reflects a serious change in Egyptian perceptions of the world from the beginning to the end of the period.

HYKSOS. The Hyksos, a Semitic-speaking ethnic group that ruled northern Egypt from approximately 1630 to 1523 B.C.E., caused a radical change in the way Egyptians thought about the world and Egypt's place in it. The first kings of the Eighteenth Dynasty drove the Hyksos out of Egypt and chased them into the area now known as the Middle East as far as modern-day Iraq. Even after Egyptian victory, kings continued at first to feel vulnerable to the outside world's designs on their country. The kings created a professional army for the first time in Egypt's history. This army was a response to Egypt's new view that broader organization and professionalism was now necessary in public life in order to combat the threat from outside. The civil service was also revived outside the old hereditary nobility, probably copying a Middle Kingdom reform. The military victories celebrated by Thutmose III (1479–1425 B.C.E.) brought to a close the first stage of New Kingdom history and its associated art.

COMFORT AND LUXURY. Beginning with the reign of Thutmose IV (1400–1390 B.C.E.) Egyptian art reflects the comfort and luxury that came with Egyptian victory over its rivals both in both Asia and in Africa. Egyptian artists' contact with the outside world yielded an interest in the vitality of other cultures rather than the pure rejection the Egyptians offered to the Hyksos. A new optimism about their own place in the world allowed Egyptians to appreciate their neighbors in a way that had not been available when the Hyksos were thought to be a threat.

EARLIEST NEW KINGDOM. The earliest art of the Eighteenth Dynasty found inspiration in early models both of the Old and Middle Kingdoms. Clearly artists

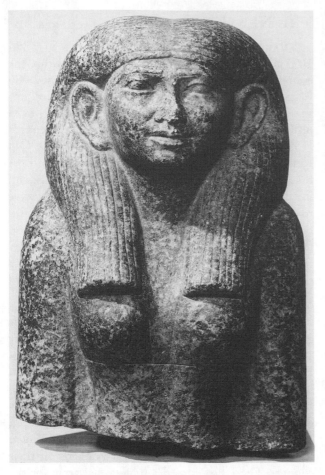

Head and torso of a noblewoman. BROOKLYN MUSEUM OF ART, 59.1, CHARLES EDWIN WILBOUR FUND. REPRODUCED BY PERMISSION.

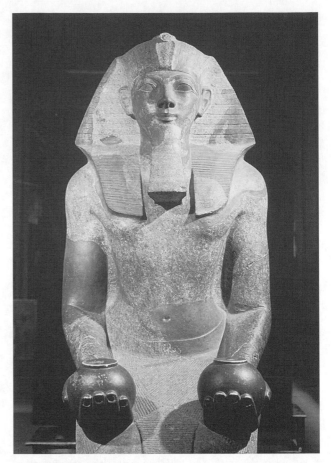

Statue of Queen Hatshepsut holding vases of "Nou" offering. GIRAUDON/ART RESOURCE NY.

depended on models that they found around Thebes, the traditional home of the new royal family that had reunited Egypt and driven out the Hyksos. A head of King Ahmose in a private collection shows the first king of the Eighteenth Dynasty in a white crown with the Uraeus-snake. This head is so similar to Eleventh-dynasty royal sculpture that only the inscription which identifies the king as Ahmose makes it absolutely clear that it was carved in the Eighteenth Dynasty. The carving of the eye depicts it as wide open but slanting toward the middle of the face. This same slant can be found in statues of Mentuhotep II and Senwosret I. Ahmose's eye also bulges naturalistically. It looks three-dimensional because of the grooves around the eyeball that separate them from the lids. The iris and pupil were represented by concentric circles, a technique that began in the Eleventh Dynasty. The cosmetic line is horizontal and long, extending from the corner of the eye to the ear tabs of the crown. The face is broad with full, high, rounded cheeks. The sickle-shaped mouth might be an individual characteristic that truly represented Ahmose's mouth. It is not a feature

found in Middle Kingdom sculpture. In sum, this sculpture of Ahmose closely resembles statues of Mentuhotep II, nearly five hundred years older. Clearly, artists were turning to traditions that for them were already ancient to reestablish an artistic style for the Egyptian state now newly liberated from foreign domination.

HATSHEPSUT. Hatshepsut came to the throne of Egypt in 1478 B.C.E. Officially, she ruled jointly with Thutmose III who had ascended to the throne as a child one year earlier. Hatshepsut was the chief wife of Thutmose II, Thutmose III's father. But Thutmose III was not her son. Thutmose III's mother was Isis, a secondary queen of Thutmose II. Though the details of Hatshepsut's rise to power remain unclear, she certainly presented herself as the ruler until her death in 1458 B.C.E. Only then did Thutmose III assume independent rule of the country. Statues of Hatshepsut in the guise of the ruling king created a challenge for Egyptian sculptors. The traditional image of the king was an athletic male figure that protected Egypt from its enemies. Artists had to develop

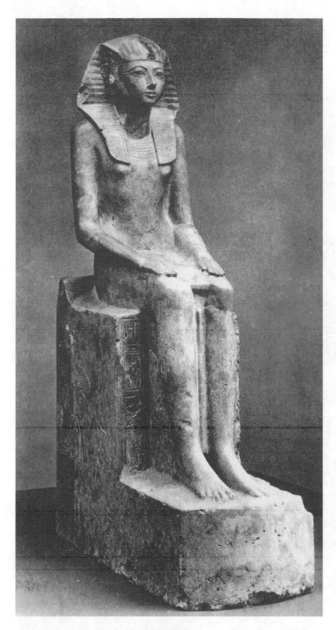

Seated statue of a youthful Hatshepsut, queen of ancient Egypt. © CORBIS-BETTMANN. REPRODUCED BY PERMISSION.

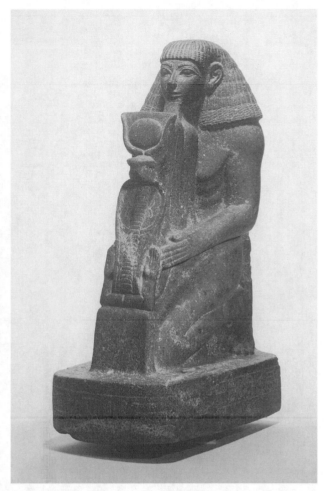

Kneeling statue of Senenmut. BROOKLYN MUSEUM OF ART, 67.68, CHARLES EDWIN WILBOUR FUND. REPRODUCED BY PERMISSION.

ways of presenting Hatshepsut as a female king, but still convey the same message of strength that Egyptians expected in representations of their ruler. One solution was to present Hatshepsut in traditional royal poses, regardless of her gender. Thus one statue of Hatshepsut shows her as a seated king comparable to the seated statues of Khafre made in the Fourth Dynasty or of Senwosret III made in the Twelfth Dynasty. Hatshepsut's torso is more slender than her royal predecessors, but she sits on a similar throne in a Nemes kerchief and wears the same shendjet kilt. A statue in Cairo shows Hatshepsut kneeling with two jars, the same pose that Pepi I took in one statuette. Again she wears the Nemes kerchief and the shendjet kilt. When she wore traditional clothing or posed in a traditional manner, she evoked for ancient viewers the timeless traditions of royalty. Hatshepsut's artists also portrayed her as a sphinx. This tradition had been popular in the Twelfth Dynasty and helped artists avoid the difficulties of portraying her body since they needed only to show her face attached to a lion's body. Hatshepsut's face was characterized by arched eyebrows that gave her a slightly surprised facial expression. Her eye dipped slightly at the inner corner. A flat, long cosmetic line that she often wore resembles her Eleventh-dynasty predecessors. Her nose was aquiline, and she pursed her lips in most of her statues. These facial characteristics were repeated in statues of Thutmose III, her co-ruler and later the sole ruler after her death. Since it is clear that they were not related by blood, it is significant that artists presented both of them with a nearly identical face. Though one or another facial characteristic might have

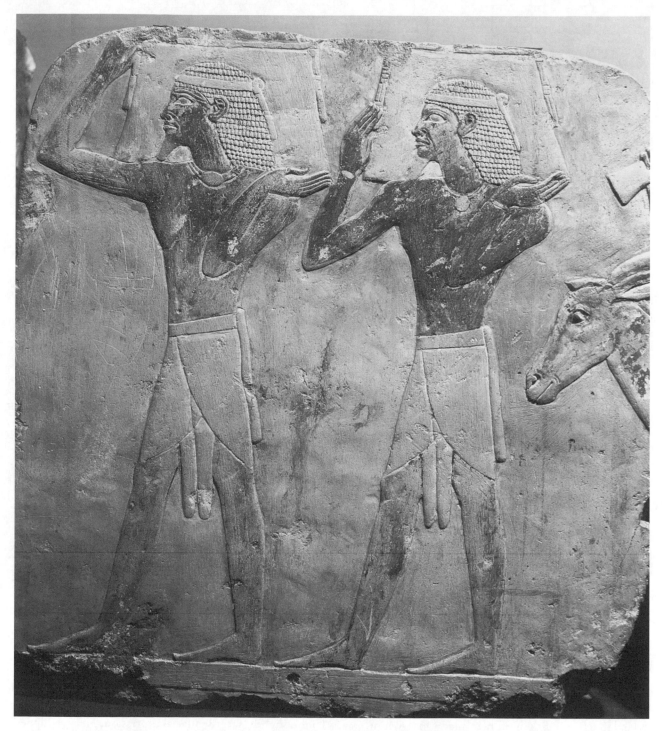

Relief showing the expedition to the Land of Punt, on the wall of Hatshepsut's mortuary temple. © GIANNI DAGLI ORTI/CORBIS. REPRO-DUCED BY PERMISSION.

actually been recognizable on Hatshepsut's face, this portrait represented an ideal king rather than an individual. Many of the individual characteristics portrayed in the face were similar to rulers of the distant past who also were not blood relations. Rather, by repeating certain characteristics the artist conveyed the clear message

that this particular ruler was part of a line of legitimate rulers who protected Egypt from its enemies.

SENENMUT. Senenmut was a powerful official during Hatshepsut's reign. He served both as prime minister and a high official of the god Amun, the chief god of the Egyptian pantheon. Thus he was able to commis-

sion at least 25 statues of himself. They represent a great variety of poses, demonstrating that artists in this reign began to exercise their creativity in the statues they made of officials as well as coping with the artistic problems created by portraying a female queen. They showed Senenmut with Hatshepsut's young daughter, Neferure, on his lap. This statue imitates the poses assumed by Queen Ankhnes-meryre II and Pepi II in one statuette. Artists also created a cube statue of Senenmut that included Neferure's head emerging from the top of the cube. The Brooklyn Senenmut comes from a temple of the god Montu. Senenmut kneels, holding a divine symbol. The symbol includes a sun disk enclosed in cow horns, a cobra, and a pair of human arms ending in flat hands that face the viewer. This symbol probably is a hieroglyphic writing of Hatshepsut's name. Thus Senenmut is offering her name to the god Montu. This is one of the earliest temple statues that portray a non-royal individual making such an important offering to a god. Previously only a king would be shown in such a pose. Senenmut's face is nearly identical to Hatshepsut's face, though again they were not relatives. His eyebrows are arched in the typical manner for this period. His eyes dip slightly at the inner corner. His nose curves slightly in an aquiline shape. His lips are pursed. Officials wanted to be represented with faces that resembled the royal portrait because they hoped to become divine, as the king was, in the next world. A statue's face in the guise of the king helped an official achieve this goal.

AHMOSE-RURU. Other officials commissioned traditional statues during the reigns of Hatshepsut and Thutmose III. Ahmose-Ruru, who lived in Thutmose III's reign, commissioned a statue in a cloak, a style that had been popular in the Twelfth Dynasty. For example, the "Statuette of a Cloaked Official" from the earlier period shows a very similar pose. Here Ahmose-Ruru sits on a block-like throne. Only his hands and feet emerge from the garment. His left hand rests on the right side of his chest. His right hand is curved into a fist and rests on his lap. The hands seem too large for his body. An inscription down the center of his cloak identifies him as a high official. His face, however, resembles his ruler's face or his fellow official Senenmut's face. The arched eyebrows are a defining characteristic of the period. His eye also dips slightly at the inner corner. He wears a long cosmetic line that parallels the end of his eyebrows. His nose is aquiline and his lips are pursed. Ahmose-Ruru also wears the short, square, chin beard worn by high officials. This face places the statue squarely in the early Eighteenth Dynasty, but it is also clearly inspired by the traditions of the Middle Kingdom.

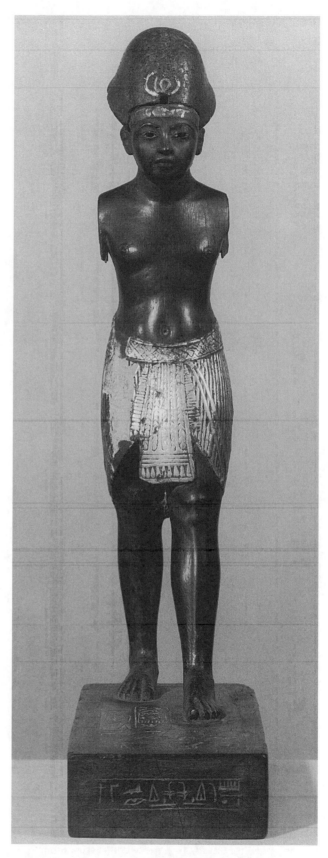

Amenhotep III in blue crown. **BROOKLYN MUSEUM OF ART, 48.28, CHARLES EDWIN WILBOUR FUND. REPRODUCED BY PERMISSION.**

Arts and Humanities Through the Eras: Ancient Egypt (2675 B.C.E.–332 B.C.E.)

297

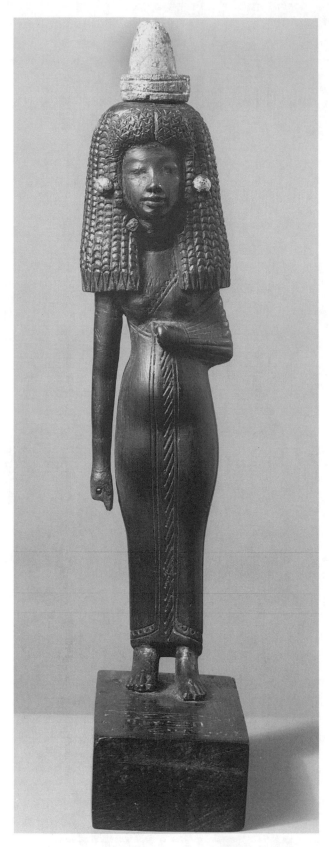

Standing statuette of Lady Tuty. BROOKLYN MUSEUM OF ART, 54.187, CHARLES EDWIN WILBOUR FUND. REPRODUCED BY PERMISSION.

RELIEF SCULPTURE. Relief sculpture of the early Eighteenth Dynasty followed Middle Kingdom models yet changed certain proportions in a way that makes it possible to recognize them as products of the later period. The Funerary Stela of Senres, for example, depicts the deceased Senres with his wife Hormes, seated before an offering table. The pose dates to the Old Kingdom. Senres' short hairstyle with rows of curls and his ear at an odd angle are based on Middle Kingdom models. Hormes wears a simple hairstyle that divides her hair into three sections arranged over the back and on either side in the front. This so-called tri-partite hairstyle is very ancient, dating at least to the Old Kingdom. He wears a simple wraparound kilt with an apron. She wears the sheath dress with a strap. Their faces also reflect Middle Kingdom models. The forms of their mouths, with squared ends, particularly are reminiscent of earlier periods. The proportions of their bodies, however, place the stela firmly in the Eighteenth Dynasty. Their torsos are long and slender as are their arms. These characteristics are typical of the later period.

NEW SUBJECTS. Hatshepsut's Mortuary Temple at Deir el Bahri contains relief with innovative subject matter created in the same style that recalls the Middle Kingdom. Hatshepsut ordered an expedition to Punt (modern Somalia) to bring back incense that the Egyptians used in religious rituals. In her temple, the various stages of the expedition were illustrated in a series of reliefs. They include scenes of sailing on the Red Sea, arrival in Punt, the people of Punt, the unusual housing elevated on stilts, cutting trees that produced incense, and potting them to return to Egypt. Artists must have accompanied the expedition where they recorded many details that found their way into the reliefs. This is the earliest preserved example of an historical subject in Egyptian art. Such historical reliefs were later included in temple decoration, though the subject matter in the later temples was war.

EARLY NEW KINGDOM PAINTING. Painting revived in the early Eighteenth Dynasty along with the other visual arts. During the previous Hyksos period, there are no good examples of painting. Artists drew inspiration from the Middle Kingdom in painting just as they had in sculpture and relief. A fragment called Painting of a Woman represents the difficulties in distinguishing Middle Kingdom painting from early Eighteenth-dynasty examples. A woman kneels before a table holding a lotus flower. She wears her hair in the tri-partite style and wears a wraparound dress with one strap. Only the details of her face help in dating this fragment. Like many Middle Kingdom faces, she wears an extended cosmetic

line that parallels her eyebrow. Her mouth, outlined in red, is square at the corner rather than round. Her ear tilts at an odd angle, also a Middle Kingdom characteristic. Yet her eye is quite elongated, as is her mouth. These characteristics make it more similar to early Eighteenth-dynasty paintings. Yet the dependence on the earlier models is clear.

LATER EIGHTEENTH DYNASTY PAINTING. By the reign of Thutmose IV (1400–1390 B.C.E.) painting style had changed and new subjects were introduced. By this point Egyptian artists knew the work of Middle Eastern and Minoan Greek artists from increased trade contacts following the wars of Thutmose III. The drawing is now more fluid than the stiff and slightly archaic drawing found in the early New Kingdom. Artists began to expand the color palette to include more colors. The difference from the earlier Eighteenth Dynasty is clear in the depiction of female musicians. The musicians in the tomb of Rekhmire from the reign of Thutmose III are fully clothed. The artist made no attempt at depicting movement. In contrast the musicians in the tombs Nebamun play for two nude dancing girls. The dancers strike exotic poses reaching into the air and bending at the waist. Their feet hover in the air as they dance to the music. Artists also attempted to use more impressionistic brush strokes rather than flat areas of color as they had previously. The more lively drawing and additional colors applied in a rapid way create a noticeable change in painting style.

AMENHOTEP III. By the time that Amenhotep III ascended the throne in 1390 B.C.E., his immediate ancestors had extended Egypt's borders into Iraq and south through Sudan. The country was richer than ever before because of the expanded tax base. The art created in Amenhotep III's time reflects a much richer and more peaceful society than the art of the early Eighteenth Dynasty. More statues of Amenhotep III survive from ancient times than any other king of the Eighteenth Dynasty. They range in size from the Colossoi of Memnon, over sixty feet tall, to an exquisite wooden statuette only ten inches high. The large preserved production from this reign means that there are statues in many different stones. They include red and black granite, quartzite, limestone, and sandstone. The art historian Betsy Bryan differentiated a number of different styles of portraying Amenhotep III's face that are related to the material. For example, quartzite is a very hard stone that takes a high polish. In a quartzite statue of Amenhotep III, the artist used different degrees of polish as a technique to differentiate different textures in the crown, the skin, and the hair. The eyebrows are fairly rough in comparison to the

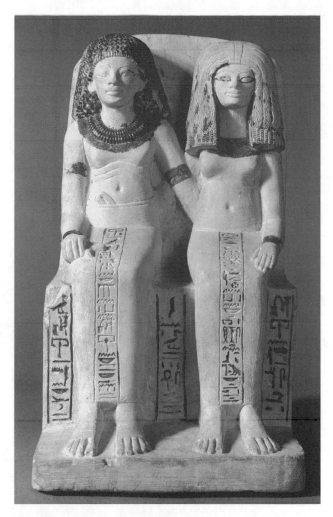

Pair statue of Nebsen and Nebet-ta. BROOKLYN MUSEUM OF ART, 40.523, CHARLES EDWIN WILBOUR FUND. REPRODUCED BY PERMISSION.

skin near the eye. This skin is very highly polished to indicate the smoothness of this skin. The cheeks, where the king would have had a beard, are rougher than the skin near the eye, but not so rough as the eyebrows. These contrasts indicate a sophistication about working the stone that did not exist in previous reigns. Artists also exploited differences in the degree of polish in granite statues that they could also polish to a high shine.

BODY TYPES. Statues of Amenhotep III also display a variety of body types. Some statues portray the traditional athletic royal body that emphasizes the king's role as Egypt's protector. Other statues, such as statuettes made from wood, might represent an older king. His body is fleshy and slack. His pectoral muscles sag, almost resembling female breasts. His belly is rounded and puffy. This representation of a royal body might symbolize the king's wealth. But some scholars understand

a PRIMARY SOURCE document

RARE WRITTEN EVIDENCE OF EGYPTIAN ART

INTRODUCTION: The Inscription of Bak, chief sculptor of King Akhenaten, represents rare inscriptional evidence for art. Bak carved this inscription in the granite quarry near Aswan. A relief shows Bak's father, named Men, seated before a statue of Amenhotep III while Bak himself offers at an altar. At Bak's side is King Akhenaten before his god, the Aten. In this inscription, Bak claims that Akhenaten himself instructed the sculptor in the new style used during the Amarna period. This is rare evidence of how such an official change took place.

Above Men: Offering every good and pure thing, consisting of bread, beer, long-horned oxen, [short-horned cattle], fowl, and all sorts of fine vegetables by the overseer of works projects in the Red Mountain, the chief sculptor in the big and important monuments of the king, Men, son of Baimyu. …

Above Bak: Giving adoration to the lord of the Two Lands and kissing the ground to Waenre by the overseer of works projects in the Red Mountain, a disciple whom his Person [a way of referring to the king] himself instructed, chief of sculptors in the big and important monuments of the king in the House of Aten in Akhet-Aten, Bak, the son of the chief of sculptors Men and born to the housewife Ry of Heliopolis.

SOURCE: William J. Murnane, *Texts from the Amarna Period in Egypt* (Atlanta, Ga.: Scholars Press, 1995): 129.

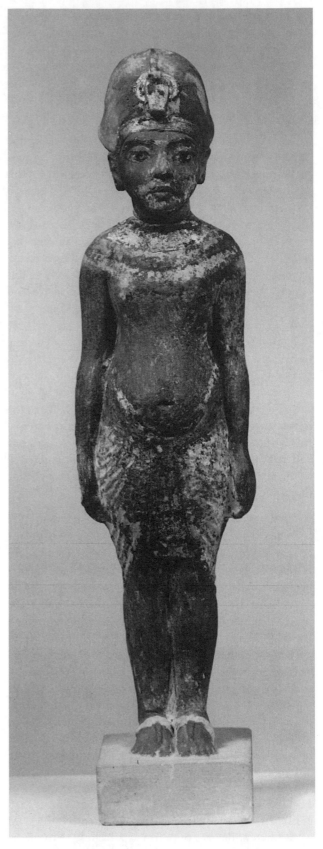

Akhenaten. **BROOKLYN MUSEUM OF ART, 29.34, GIFT OF THE EGYPT EXPLORATION SOCIETY. REPRODUCED BY PERMISSION.**

this version of a royal body as feminized. The meaning of this feminized body would, however, not be negative as it might be in modern eyes. Instead the Egyptian artist could be stressing the king's role in guaranteeing the country's fertility. The king's breast-like pectorals and nearly pregnant abdomen suggest common Egyptian symbols for rebirth and plenty. This version of the king's body would also send an important positive message to ancient Egyptian viewers.

PRIVATE PEOPLE. Increasing wealth throughout Egypt and the resulting opulence during Amenhotep III's reign is clear in art that represents non-royal officials during this period. A pair statue representing the officials Nebsen and Nebet-ta and a tomb painting representing a lady named Tjepu both demonstrate that artists portrayed these members of the elite with increasing numbers of luxury goods. Nebsen was a scribe

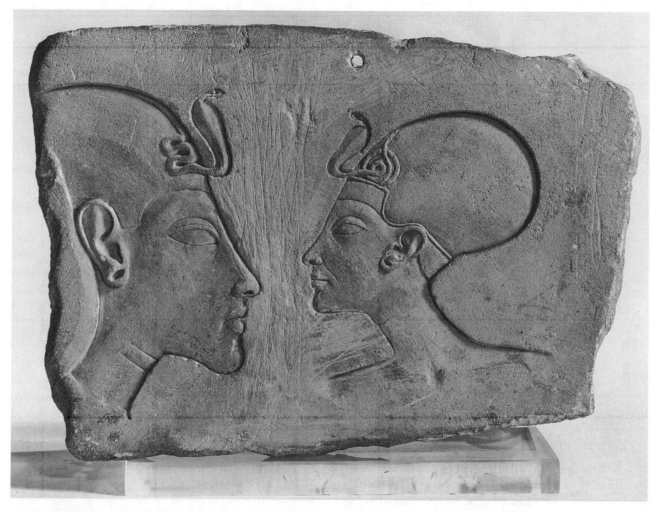

The Wilbour Plaque. BROOKLYN MUSEUM OF ART, 16.48, GIFT OF EVANGELINE WILBOUR BLASHFIELD, THEODORA WILBOUR, AND VICTOR WILBOUR HONORING THE WISHES OF THEIR MOTHER, CHARLOTTE BEEBE WILBOUR, AS A MEMORIAL TO THEIR FATHER, CHARLES EDWIN WILBOUR. REPRODUCED BY PERMISSION.

of the royal treasury. His wife, Nebet-ta, was a singer in the cult of the goddess Isis. In the statue that their son commissioned for them, they are portrayed sitting on a high-backed chair. Nebet-ta wears the elaborate enveloping wig that had become fashionable in this time period. It completely enfolds her shoulders and reaches the upper part of her breasts. She wears a broad collar and bracelets on her wrists. She appears to be wearing a tight dress that reveals her breasts and navel. The pubic triangle is hidden because she is seated with her knees together. Nebsen also wears an elaborate wig that reaches his shoulders. He wears a broad collar and armlets that encircle his biceps. He also wears a wraparound kilt. His chest is fleshy and corpulent, suggesting his wealth and high position in society. Inscriptions on both people elaborate their names and titles for the viewer. Though both of these individuals lived in the reign of Thutmose III, their son commissioned this statue in the current

style during his own lifetime. When compared with the pair statue of Rahotep and Nofret made during the Fourth Dynasty, it is clear that the later New Kingdom artists strove to emphasize the sitter's wealth. Rahotep and Nofret were a prince and princess, yet they do not wear wigs, clothing, or jewelry nearly as elaborate as these non-royal officials wore. Even though both statues share the same pose, the style of the later periods called for a different emphasis. The tendency is noticeable in the painting of Tjepu that comes from her son's tomb. Tjepu stands making a gesture of adoration with her right hand and holding a menat, a piece of jewelry that could double as a musical instrument in her left hand. She wears on top of her wig a scented wax cone that Egyptians of this period wore as deodorant and perfume. Her wig is also adorned with a closed lotus flower and a colorful headband. The wig itself is long and envelops her near shoulder. Due to the conventions of Egyptian art in

Arts and Humanities Through the Eras: Ancient Egypt (2675 B.C.E.–332 B.C.E.)

301

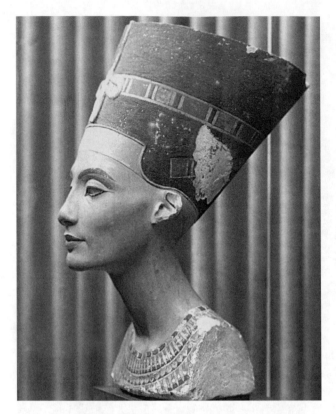

Bust of Nefertiti. © FRANCIS G. MAYER/CORBIS. REPRODUCED BY PERMISSION.

two dimensions, the far shoulder is uncovered, though in reality this hairstyle would have covered both shoulders. She wears an elaborate and colorful broad collar, armlets, and bracelets made from gold, turquoise, and jasper. She also wears a complex linen dress with a shawl. Her coiffure, jewelry, and clothing all convey a message of plenty that seems integral to Amenhotep III's reign. A wooden statue of the Lady Tuty further illustrates the opulence found in Egyptian representations of private people of this period. The wood itself is ebony, a very high-priced material imported from Somalia. The cosmetic cone on her head and her disk earrings are fashioned from gold. She wears an elaborate complex wraparound dress with many pleats. All of these images reflect the wealth of the time period.

NON-ROYAL FACES. As in other periods of Egyptian history, non-royal officials were portrayed with the same facial characteristics as the monarch. The eyebrow arches more gently than in the early Eighteenth Dynasty. The eye is almond-shaped and tilts toward the center of the face. The nose is straight and slightly bulbous at the end, and the cheeks are full. The mouth has full lips with a slight overbite. The chin is round. Viewers can easily distinguish this face from the early Eighteenth Dynasty. But the principle that people could identify themselves

in the afterlife with royalty and thus deities remained true in the later Eighteenth Dynasty.

AMARNA PERIOD. Amenhotep III's son ascended the throne in 1352 B.C.E. as Amenhotep ("Amun is satisfied") IV. But by 1347 B.C.E., five years later, he called himself Akhenaten ("Spirit of the sun disk"). His new name was only a small part of the religious and artistic revolution that he inaugurated. It was the most distinct eleven years in 3,000 years of Egyptian artistic history. As Akhenaten, he banned the worship of all gods except Aten, the physical disk of the sun. He closed Egypt's traditional temples and built new temples first at Karnak, and later at a new city in central Egypt in a place now called Tell el Amarna. The modern name of this place gives its name to this period in Egyptian history. Since Akhenaten built so many new buildings, there remain many fragments of sculptural relief and sculpture that once decorated Akhenaten's new construction. This art is distinctive in style and subject matter.

THE KING. Images of Akhenaten never match the traditional ideal of the athletic young man who protects Egypt from its enemies. Instead, representations of Akhenaten portray him with elongated and thin features. His face is extremely long and narrow with a pronounced chin. His arms are also elongated and skinny rather than muscular. Often his clavicle protrudes through his skin. His chest is flabby and the abdomen is puffy. Very often his hips are wide rather than the traditional slim-hipped figure presented by other kings. Indeed, Akhenaten's form resembles a feminine rather than a masculine ideal. Perhaps this ideal originated in his father's reign with images like the wooden statuette of Amenhotep III. Yet the elongation is much more pronounced in images of Akhenaten. The Wilbour Plaque shows the king in two dimensions where the exaggeration of his portrayals is even clearer. Here the king wears a traditional Uraeus snake over his forehead with a cloth headdress called the afnet. He has only an eyebrow ridge rather than a fully carved eyebrow. His eye is almond-shaped and deeply slanted toward the center. The extreme length of his face is clear in the very long, straight nose. His full lips slant downward at the corners. The chin is strongly pointed. Akhenaten's ear is very naturalistic and includes the slit for earrings. He also has a long arched neck with two grooves. These grooves are characteristic of the period. The king's face contrasts strongly with the normally round, full-cheeked Egyptian ideal in periods before and after the Amarna period.

NEFERTITI. Queen Nefertiti faces Akhenaten on the Wilbour Plaque. She also has an extremely long and narrow face, paralleling many of the characteristics of

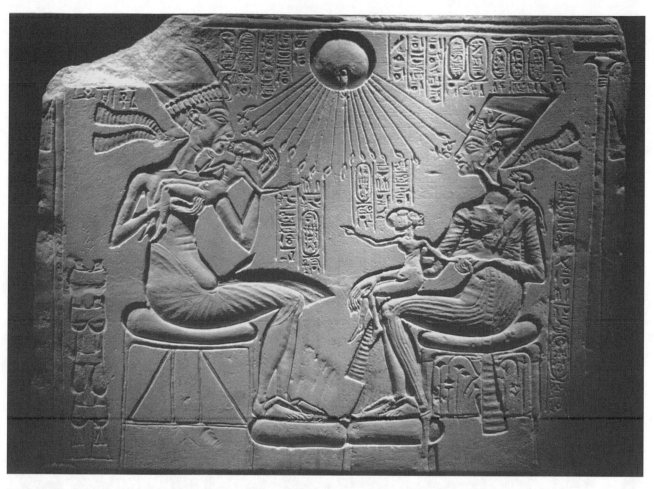

Stela of Akhenaten (left) and his wife Nefertiti holding their children and blessed by the Aten, the sun god, c. 1345 B.C.E Displays of familial intimacy such as Is shown here were unique to the Amarna period. © RUGGERO VANNI/CORBIS.

her husband's face. Her face is distinguished from his by being slightly less long and with a slightly less pronounced chin. There is also a groove carved from the outside corner of her nose extending on the diagonal that distinguishes her face from his. Her long neck has one groove in contrast to his two grooves. Nefertiti wears a Uraeus and cap with a diadem. The Uraeus is one of a few normally masculine characteristics this queen bears. In a relief from Akhenaten's palace, the queen wears the Nubian hairstyle, normally reserved for male soldiers. She also wears the Uraeus snake over her forehead. Her almond-shaped eyes dip toward her nose that is quite long. Her full lips turn downward at the end. Her neck is long and graceful with two grooves. Of course the most famous image of Nefertiti is the plaster bust now in the Egyptian Museum in Berlin. Its long and elegant lines are often compared to a modern fashion model. Yet its ideal of slim elegance could not be farther from the traditional Egyptian view of the ideal woman. Usually women are portrayed with round, full faces and few

angles. The reversal of typical male and female roles during the Amarna Period remains one of its most intriguing characteristics.

PRINCESSES. Another unusual feature of Amarna Period art is its many representations of Akhenaten and Nefertiti's six daughters. They are often included in scenes portraying rituals dedicated to the Aten. In a relief from a chapel in the palace, two princesses play the sistrum in their most elegant linen dresses. The facial characteristics in these reliefs are extremely exaggerated, a fact that places them at the beginning of the period. Another image of a princess depicts her pressing her lips to her mother's lips. Though called a kiss, it is a very rare representation of such an act in Egyptian art. The princess is portrayed as a child with a shaved head and the typical side lock that children wear. She also wears a flat, disk shape-earring. Such scenes of intimacy and familial feeling are extremely rare in Egyptian art in general but are much more common during the Amarna Period.

Arts and Humanities Through the Eras: Ancient Egypt (2675 B.C.E.–332 B.C.E.)

303

Nefertiti and daughter ("The Kiss"). BROOKLYN MUSEUM OF ART, 60.197.8, CHARLES EDWIN WILBOUR FUND. REPRODUCED BY PERMISSION.

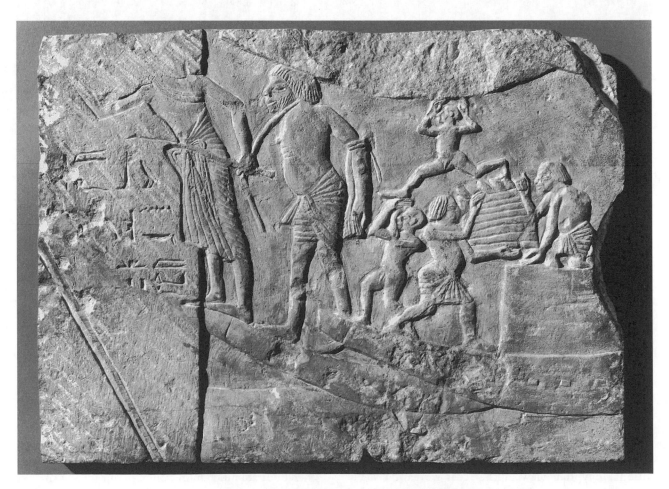

Harbor Scene. BROOKLYN MUSEUM OF ART, 48.112, CHARLES EDWIN WILBOUR FUND. REPRODUCED BY PERMISSION.

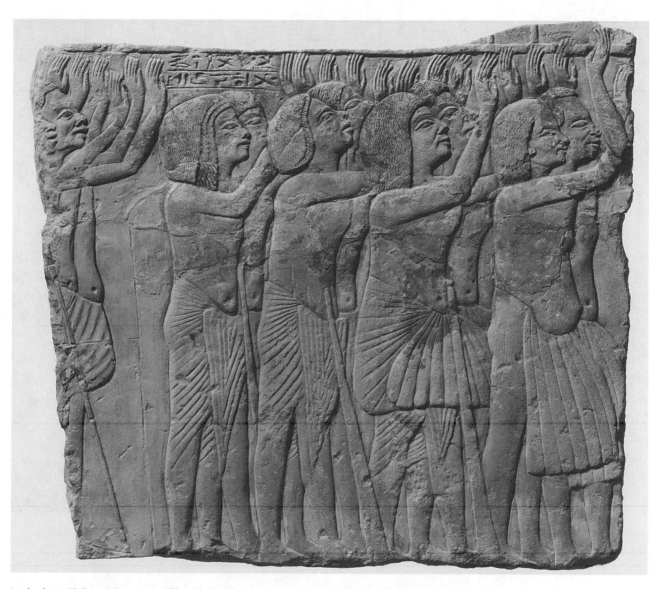

In the later Eighteenth Dynasty officials added scenes from their lives. Here, General Horemheb depicts soldiers he commanded.
BROOKLYN MUSEUM OF ART, 32.103, CHARLES EDWIN WILBOUR FUND. REPRODUCED BY PERMISSION.

LATE EIGHTEENTH-DYNASTY RELIEF. Tomb relief in the late Eighteenth Dynasty included unusual subject matter sometimes related to the tomb owner's profession. The exquisitely carved soldiers from the tomb of Horemheb illustrate men he commanded while he was a general in the army. The varied faces and body types of this row of men indicates a certain freedom in the representation of common people. A harbor scene from an unknown tomb of the late Eighteenth Dynasty shows a harbor scene with a bound prisoner descending the gang plank of a boat. Such scenes that depict the varied activities in a town perhaps were an outgrowth of the Amarna period's willingness to explore new subject matter. This tendency ended with the Ramesside Period which followed.

END OF AMARNA. The Amarna Period ended nearly as suddenly as it began. The details remain murky, however. After Akhenaten's death, he was followed briefly by King Smenkare and then King Tutankhaten. Tutankhaten changed his name to Tutankhamun and restored the traditional gods of Egypt. He also restored the traditional capital at Thebes and abandoned Amarna. Yet Tutankhamun is much better known as the owner of the only royal tomb of this period to be discovered nearly intact. Thousands of works of art found in his tomb reflect both the influence of the Amarna Period and movement back toward more traditional Egyptian art. Tutankhamun's painted chest, for example, preserves a war scene with the king attacking Egypt's enemies with a bow and arrow while he rides in his chariot. Battle

Arts and Humanities Through the Eras: Ancient Egypt (2675 B.C.E.–332 B.C.E.)

305

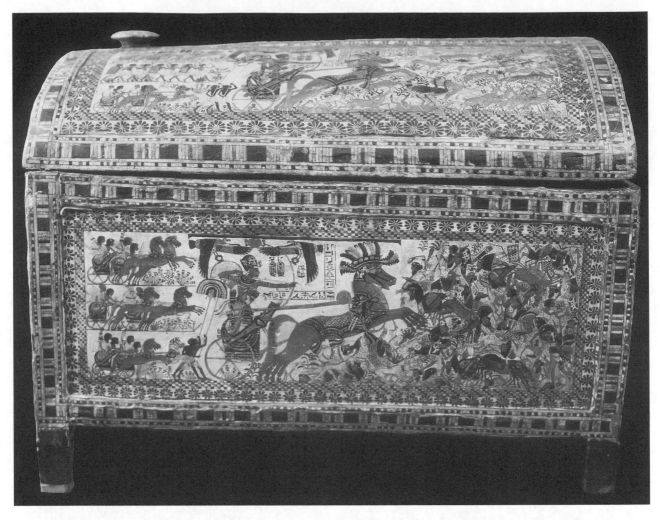

Linen chest of Tutankhamun, showing the king in his chariot, riding into battle and defeating his enemies of the North and South. THE ART ARCHIVE/EGYPTIAN MUSEUM CAIRO/DAGLI ORTI.

scenes of this sort represent a return to the king's traditional role as Egypt's protector.

RAMESSIDE PERIOD. In 1292 B.C.E., General Ramesses ascended the throne and founded the Nineteenth Dynasty. The royal family of the Eighteenth Dynasty had died out with Tutankhamun. Until 1075 B.C.E. through the Twentieth Dynasty, kings reverted to the old ideal. Kings such as Ramesses II created vast amounts of art that both looked back to the early Eighteenth Dynasty for inspiration but also bore the influences of more recent Egyptian art. A relief depicting Ramesses II combines features of kings such as Thutmose III with Amarna details. The king wears a Nemes kerchief with a Uraeus snake over his forehead. His eyebrow arches similar to early Eighteenth-dynasty models. His eye is wide but still tilts slightly toward his nose, much as was true of Amenhotep III's sculpture. Yet the cosmetic line is long and parallel to the extension of the

eyebrow as found at the beginning of the Eighteenth Dynasty. His nose is slightly aquiline. His sensitively carved lips curve down slightly, reminding the viewer of the Amarna period. Yet the chin is round. Though his neck is muscular it still has the grooves carved in it that first appeared in the Amarna period. Thus through a combination of characteristics, Ramesses II's artists created an image of the king that provided some continuity with the recent past but still recalled the glorious early Eighteenth Dynasty and its warrior kings. This message must have been reassuring to his contemporaries who had witnessed many violent changes in policy during their lives.

TOMB OF SENEDJEM. The paintings found in tombs during the Ramesside period differ from Eighteenth Dynasty and earlier tombs because the subject matter is more clearly religious. Rather than scenes of fishing and fowling that must be interpreted to find their religious meaning, Ramesside artists portrayed the next world

TUTANKHAMUN'S Tomb

The English archaeologist Howard Carter discovered Tutankhamun's tomb in 1922. The subsequent publicity made Tutankhamun one of the most famous of ancient Egyptian pharaohs. This king was little known before his tomb was discovered. Ironically, the tomb itself has not yet been fully studied eight decades after its discovery.

Tutankhamun came to the throne as a child and ruled roughly ten years from 1332 to 1322 B.C.E. He officially presided over the god Amun's return to power after King Akhenaten (1352–1336) attempted to suppress the worship of all gods except the Aten (sun disk). Tutankhamun's inscription restoring Amun's temples provides evidence of this important event.

The tomb's discovery was the single most spectacular and most highly publicized event in Egyptian archaeology of the twentieth century. So far, it remains the only unplundered pharaoh's tomb from the Valley of Kings known today. As a result, unlike the rest of the royal tombs that were robbed and emptied in antiquity, thousands of objects were discovered still neatly packed in their ancient wrappings and boxes. Three major traveling exhibitions of artifacts from the tomb to Europe, Great Britain, and the United States in the second half of the twentieth century added to this king's fame. Yet scholars have studied only a handful of objects from the tomb. These include the thrones and the sarcophagus (coffin). Interestingly, these objects once belonged to the king's predecessor, Smenkare, who ruled less than three years. The splendor and wealth of the tomb revealed in the exhibitions makes Tutankhamun a figure of fascination for many.

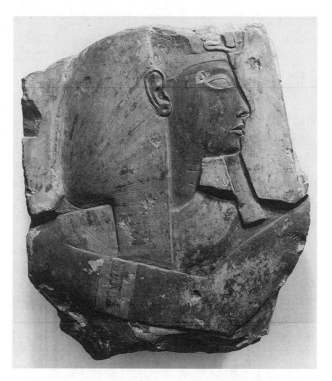

Relief of Ramesses II. **BROOKLYN MUSEUM OF ART, 11.670, MUSEUM COLLECTION FUND. REPRODUCED BY PERMISSION.**

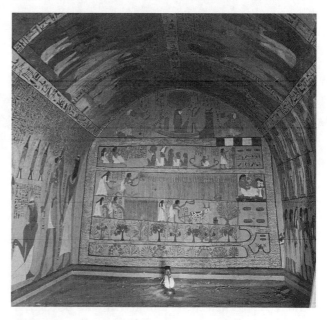

A chamber in the tomb of Senedjem. The painting on the end wall depicts him and his wife performing ritual acts of plowing, sowing, and reaping crops in the Field of Reeds. © **WERNER FORMAN/ART RESOURCE, NY.**

with its gods neatly arranged in rows. The god Osiris, king of the dead, is the first image the visitor to Senedjem's tomb would see on entering it. To the left the visitor would see Senedjem and his wife Iyneferti worshipping thirteen gods of the underworld arranged in two rows. They include Osiris at the head of the top row and Ra at the head of the lower row. Above them are two images of the jackal god Anubis, guarding the entrance to the tomb. On the end wall to the visitor's right is a scene of Senedjem and Iyneferti harvesting flax in the next world. Dressed in their best clothing, they plow and then harvest the flax that they can later use to make linen clothing. The text included in the scene comes from

the Book of the Dead where the deceased are promised the ability to plow, reap, eat, drink, and copulate in the next world. The scene is another way of guaranteeing that Senedjem and Iyneferti will have a successful afterlife.

SOURCES

Ariel Kozloff and Betsy Bryan, *Egypt's Dazzling Sun* (Cleveland: Cleveland Art Museum, 1992).

Arpag Mekhitarian, *Egyptian Painting* (New York: Rizzoli International Publications, 1978).

LATE PERIOD

HEIR. The Late Period of Egyptian history from the end of the New Kingdom (1075 B.C.E.) to the beginning of Greek domination (332 B.C.E.) was heir to over 2,500 years of nearly continuous artistic production. This long native tradition· also interacted with foreign influences during times of Egyptian political weakness. Kushites from the Sudan, Libyans, Persians, and Greeks all influenced artistic production in Egypt at this time. One of the most salient characteristics of Late Period visual art is archaism. In visual art, Egyptologists define archaism as a deliberate attempt to reproduce a style of sculpture, painting, or relief from an earlier historical period. Archaism requires a conscious and purposeful effort to imitate particular styles or scenes. It is a much more literal borrowing than adopting aspects of a style. Artists of the early Eighteenth Dynasty borrowed from the Middle Kingdom, but they did not copy whole scenes. Ramesside artists revived aspects of early Eighteenth-dynasty style, but art historians can distinguish a statue of Ramesses II from a statue of Thutmose III. In the Late Period, however, scholars face greater difficulties in distinguishing old and more recent works. Though there are isolated examples of archaism in the Old, Middle, and New Kingdoms, in the Late Period archaism is often a fundamental aspect of the visual arts.

THIRD INTERMEDIATE PERIOD. The Third Intermediate Period (1075–656 B.C.E.) followed the New Kingdom and witnessed political instability. Kings looked to Eighteenth-dynasty (1537–1292 B.C.E.) models for inspiration for their artists, probably in an effort to link themselves to this glorious era. Some works from this period copy works of Thutmose III's time (1479–1425 B.C.E.) so carefully that scholars have trouble distinguishing the two periods. A gold statuette of Amun that once belonged to the Carnarvon Collection fooled the Egyptologist Howard Carter into identifying it as the work of Thutmose III's artists. The art historian Cyril Aldred showed, however, that it dates to the Twenty-second Dynasty (945–712 B.C.E.) over five hundred years later. Some other works from this period echo art from the Old and Middle Kingdom. Only the smallest details have allowed experts to recognize the differences between original works of the earlier period and copies from the Third Intermediate Period.

COLLECTING
Egyptian Art

The ancient Romans were among the first to collect Egyptian art. The emperor Hadrian (ruled 117–138 C.E.) brought art from Egypt to his country villa in Tivoli, Italy. He built a model of the Nile and arranged Egyptian statues around for his pleasure. In the eighteenth and nineteen centuries, many English and European aristocrats continued the tradition of collecting Egyptian art along with the art of Greece and Rome.

The late eighteenth and the nineteenth centuries witnessed the birth of public collections of Egyptian art in Europe and Britain. The great American public collections went on view in the twentieth century in New York, Brooklyn, and Boston. The British Museum in London, the Louvre in Paris, and the Egyptian Museum in Berlin were among the early and important public collections. The greatest of all public collections is the Egyptian Museum in Cairo. These collections inspired scholars to study Egyptian art and create the field of Egyptology.

In the early twenty-first century, both private and public collectors face pressure and even censure because of the political conditions prevailing when these collections were formed. Between 332 B.C.E. and 1952 C.E., foreigners ruled Egypt. Thus the period when Egyptian collections were formed corresponds to the period when Egypt was under foreign rule. The present government of Egypt has sought restoration of key monuments to Egypt that left the country while it was under foreign rule. Yet the legal and ethical issues involved are complex. There are no easy answers to questions raised by the long years of collecting and current Egyptian aspirations.

KUSHITE ART. The Kushite kings of the Twenty-fifth Dynasty (760–656 B.C.E.) originated in Sudan. They sought to identify themselves with kings of earlier periods through their art. They modeled many sculptures on work produced during the late Middle Kingdom (1938–1630 B.C.E.). In fact scholars still dispute which works rightly should be assigned to the Twenty-fifth Dynasty and which are products of the Middle Kingdom. The tomb of the high official Harwa, certainly built in this time period, demonstrates considerable copying from the Old Kingdom (2675–2170 B.C.E.). Much of the original Old Kingdom material was in the northern capital in Memphis, but Harwa's artists reproduced it for his tomb in Thebes.

SAITE PERIOD. The Twenty-sixth Dynasty (664–525 B.C.E.), called the Saite Period because of its king's origins in the town of Sais in the Delta, looked for inspiration in the New Kingdom once again. A remarkable tomb belonging to the governor of Upper Egypt, Montuemhet, spans both the end of the Kushite Period and the beginning of the Saite Period. This tomb contains elements from the Kushite Period imitating the Old Kingdom as well as Saite Period work imitating the New Kingdom. The Theban tomb of a man named Ibi that dates to this period was highly influenced by the Memphite tomb of a man with the same name who lived in the Old Kingdom. Later in the Twenty-sixth Dynasty, artists drew on New Kingdom models for inspiration.

PERSIAN PERIOD AND THIRTIETH DYNASTY. The Persians conquered Egypt in 525 B.C.E. Artists blended Persian artistic traditions with traditional Egyptian art. A statue of the Treasurer of the god Ptah, Ptahhotep, blends typical Egyptian elements with Persian details. The frontality, back pillar, and stance that Ptahhotep assumes in the statue all date back thousands of years in Egyptian history. Yet Ptahhotep wears a Near Eastern costume consisting of a shawl and high-waisted kilt that would be more at home in Persia than Egypt. He also wears a Persian necklace ending in typically Persian mountain-goat shaped forms. Under the necklace, he wears a typical Egyptian chest ornament. In statues such as this, artists were able to accommodate foreign tastes but also rely on Egyptian models. The Thirtieth Dynasty (381–343 B.C.E.) was the last period of native Egyptian rule in antiquity. Artists of this period relied on New Kingdom models. The tomb of the official Zanofer incorporates a blind harpist and female offering bearers that would be at home in the Eighteenth Dynasty.

DISPUTES. This brief survey of Late Period art only scratches the surface of the complications that remain to be studied. Scholars still dispute many of the details, sometimes unable to agree on whether key works belong to the earlier or later periods. In spite of considerable progress in the last forty years, much work remains to be done to provide an understanding of this period.

SOURCES

Cyril Aldred, "The Carnarvon Statuette of Amun," in *Journal of Egyptian Archaeology* 46 (1960): 3–7.

Bernard Bothmer, *Egyptian Sculture of the Late Period: 700 B.C. to A.D. 100* (Brooklyn, N.Y.: Brooklyn Museum, 1960).

Richard Fazzini, *Egypt Dynasty XXII–XXV* (Leiden, Netherlands: Brill, 1988).

J. A. Josephson, *Egyptian Royal Sculpture of the Late Period, 400–246 B.C.* (Mainz, Germany: Verlag Philipp von Zabern, 1997).

SIGNIFICANT PEOPLE
in Visual Arts

NEFERTITI

Unknown–Unknown near the end of the reign of Akhenaten (1352–1336 B.C.E.)

Queen

CHIEF QUEEN. Nefertiti's parents are not known. Scholars assume she was born to a high-ranking family. She first appears in history already the wife of Akhenaten and with him worshipping the Aten. By the fourth year of Akhenaten's reign about 1348, Nefertiti was the subject of a series of extraordinary reliefs in the new temples that the king built in Karnak. Here Nefertiti behaves like a king, smiting Egypt's enemies with a mace. Nefertiti's face in representations of her worshipping with the king and their six daughters is indistinguishable from the king's face. Nefertiti also wore other kingly symbols in art depicting her. She wore the Uraeus snake over her forehead and also wore several different crowns. In one relief she wore the Nubian hairstyle usually worn by male soldiers. Artists also depicted Nefertiti receiving life with an ankh sign from the god Aten. The only other person who held this honor was the king. All of these royal representations provide the only evidence for understanding her role in history.

SOURCES

Dorothea Arnold, *The Royal Women of Amarna* (New York: Metropolitan Museum of Art, 1996).

Ray W. Smith and Donald B. Redford, *Akhenaten Temple Project I: Initial Discoveries* (Warminster, England: Aris and Philips, 1976).

SENENMUT

Unknown–1466 B.C.E.

Chief Steward of the god Amun

HIGH RANKING COMMONER. Senenmut was the son of Ramose and Hatnofer, who were commoners. Several of his earliest titles link him to the town of Armant, perhaps his birthplace. His career probably began in the reign of Thutmose II (1481–1479 B.C.E.) when he became the tutor of Princess Neferure, daughter of the king and his chief wife, Hatshepsut. When Thutmose II died, he was succeeded by his son Thutmose III,

a child. One year later Hatshepsut declared herself co-king. Senenmut's relationship with the princess must have helped him secure new positions with the new co-king. He held many positions, the most important being Chief Steward of the god Amun. In the course of his career, he was an important patron of the visual arts. His two tombs are unusual because artists decorated them with the *Book of the Dead*, an unusual practice for non-royal officials in the Eighteenth Dynasty. He also commissioned at least 25 statues, many of unusual types. His statues with Princess Neferure draw on the tradition of the Old Kingdom statue of Ankhnes-meryre II and Pepi II. A cube statue of Senenmut depicts the princess's head emerging from the top. Senenmut was also the first commoner to commission statues depicting him making offerings, formerly a royal pose. For example, one statue depicts him offering Hatshepsut's name in the form of a royal standard to the god Montu. In fact scholars' interpretations of Senenmut's role in history depend on his tomb depictions, his statues, and the inscriptions on them. Many scholars have speculated that his relationship with Hatshepsut might have been romantic since his works of art suggest he had privileges denied to most commoners. These theories remain unsupported speculation. Senenmut disappeared from history in Year Sixteen of Hatshepsut's reign. His end remains unknown other then his death date of 1466 B.C.E.

SOURCES

Peter Dorman, *The Monuments of Senenmut: Problems in Historical Methodology* (London: Kegan Paul International, 1988).

Peter Dorman, *The Tombs of Senenmut: The Architecture and Decoration of Tombs 71 and 353* (New York: Metropolitan Museum of Art, 1991).

DOCUMENTARY SOURCES

No written documentary sources survive from ancient Egypt to discuss the visual arts. Listed here are some major monuments of the visual arts from ancient Egypt that represent "firsts" or high aesthetic achievements. Since artists were anonymous, no listing is included for the artist.

Colossal Head of King, BMA 54.3 (c. 2625 B.C.E.)—This head may be the oldest known over life-size head of a king, coming from what must have been one of the earliest colossal statues in Egyptian history.

Female Figurine, BMA 07.447.505 (c. 3500–3300 B.C.E.)—This figurine of a woman with a beak-like face is one of the earliest figures of a human.

Kneeling Statue of Pepi I, BMA 39.121 (c. 2338–2298 B.C.E.)—This early example of a statue of a kneeling king making an offering is a type that continued to be made for 3,000 years.

Narmer Palette (c. 3100 B.C.E.)—This is the first known Egyptian work of art to follow typical Egyptian style.

Seated Statue of King Djoser (c. 2675–2625 B.C.E.)—King Djoser commissioned the first known life-size statue of himself.

Seated Statue of King Khasekhemwy (c. 2800–2675 B.C.E.)—King Khasekhemwy commissioned the first known seated statue of a king, a type that continued to be made for over 3,000 years.

Seated Statue of Pepi I (c. 2338–2298 B.C.E.)—This is an early example of a statue that reads like a hieroglyph, taking the images and treating them as hieroglyphic signs.

Statue of a Deity, BMA 58.192 (c. 2575–2625 B.C.E.)—This statue of a deity is the first known standing statue of a god, showing the pose of striding forward with the left leg for the first time. This pose will be standard for 3,000 years.

Statue of Ankhwa (c. 2575–2625 B.C.E.)—The shipwright Ankhwa commissioned the first known seated statue of an official from ancient Egypt.

Statue of Khafre (c. 2555–2532 B.C.E.)—This statue first captures the most basic expression of the Egyptian attitude toward the king as the strong, athletic, and serene protector of the country.

Statue of Menkaure and Khamerernebty (c. 2532–2510 B.C.E.)—This masterpiece of Old Kingdom art shows a royal pair statue.

Statue of Rahotep and Nofret (c. 2585–2560 B.C.E.)—This early pair statue showing a husband and wife retains all of its original paint, illustrating the colorful Egyptian ideal for statuary.

Stele of King Djet (c. 3100–2800 B.C.E.)—Djet's stele is an early example of combined perspective, showing both a top and side view of the same object combined into one image.

GLOSSARY

Abacus: Square, flat upper part of a column that connects the capital of the column to the architrave.

Afnet: A cloth head covering.

Akh: The glorified spirit of a deceased person entitled to offerings from his family members.

Amarna: City on the east bank of the Nile midway between Thebes and Memphis built circa 1353–1336 B.C.E. Called Akhetaten, "Horizon of the Aten," it was the capital of Egypt during the reign of Akhenaten.

Amarna Period: The reign of Akhenaten (1353–1336 B.C.E.) centered at the capital city of Amarna.

Amun: God of the air, "the hidden one."

Amun-Re: Chief state god of the New Kingdom and later.

Ankh: Hieroglyphic sign that means "life."

Anubis: God of the cemetery, represented by a jackal or a man with the head of a jackal.

Architrave: Horizontal structural member that connects the columns and door frames to one another. Also carries roof.

Aten: A deity represented by the disc of the sun; also the cult promoted by Akhenaten (1353–1336 B.C.E.).

Atum: The creator god who sat on the "first" hill and created the world. This hill is often represented in Egyptian buildings by a mound of sand or sand foundations.

Ba: Soul of the deceased that was the manifestation of the person that could travel between the afterlife and the mummy. It took the form of a bird.

Barque: A small ship propelled either with oars or sails.

Batter: A receding upward slope of the outer face of a structure.

Battered walls: Walls with a slope at the edges.

Bench marks: Surveyor's levels marked on the ground.

Cataracts: The six rapids in the Nile River between Aswan and Khartoum.

Cavetto cornice: Concave Egyptian cornice.

Chantress: A woman responsible for the music used in the rituals at the major temples. She usually earned a salary independent of her husband or father.

Clerestory: An outside wall of a room or building that rises above an adjoining roof and contains windows.

Coptic: An Egyptian alphabetic script based on the Greek alphabet, with additional letters derived from Demotic signs.

Corbelled blocks: Stones arranged so that each projects beyond the front face of the stone below, reducing the span over a room.

Cornice: Molded projection on the top of a building façade, usually hollow in Egypt.

Cramp: Dovetail-shaped clamp that connects two stones.

Cubits: Egyptian unit of measurement equal to 21 inches.

Dado: Lower part of an interior wall.

Deir el-Medina: A New Kingdom (1539–1075 B.C.E.) village in the hills of western Thebes occupied by workmen who decorated the royal tombs.

Delta: The mouth of the Nile River in Lower Egypt. In antiquity, it consisted of seven major branches and was the site of several important ports and cult centers.

Demotic: An Egyptian script developed around 650 B.C.E. that was more cursive than hieratic.

Desheret: The Red Land; desert.

Divine Adoratrice of Amun: *See* **God's Wife of Amun.**

Divine Booth: A shrine where a statue of a god was kept.

Dynasty: A powerful group or family that ruled Eygpt for a period of time. Egyptian history is divided into thirty dynasties.

Electrum: A mixture of silver and gold.

Ennead: A grouping of nine gods.

Faiyum: A depression or low area in north-central Egypt.

False door: A stone or wood door that does not open. False doors were offering places. A statue of the deceased was usually placed behind the false door but would have been inaccessible.

First Intermediate Period: The era of Egyptian history from 2130 to 1980 B.C.E. when the central government had collapsed and local governors ruled the various provinces.

God's Wife of Amun: Chief priestess from the New Kingdom (1539–1075 B.C.E.) to the Late Period (664–332 B.C.E.); later called the Divine Adoratrice of Amun.

Graffito: (plural: *graffiti*) Writing on a wall.

Graywacke: A hard gray sandstone, composed of quartz and feldspar, that Egyptian sculptors used. In Egyptian, *bekhen*-stone.

Hathor: Goddess of love and music, usually represented as a cow or a cow-headed woman.

Heb-sed: Jubilee Festival that a king celebrates after he ruled thirty years. The festival renews the king's powers.

Hieratic: A cursive script closely based on hieroglyphic writing.

Hieroglyph: A pictorial script used by ancient Egyptians from approximately 3100 B.C.E. until 395 B.C.E.

Hittites: A people living in Anatolia. Between 1400 and 1200 B.C.E. they contested with Egypt for control of Syria.

Horus: God of the sky in the form of a falcon, son of Osiris and Isis, nephew of Seth.

Hyksos: "Rulers of the Foreign Lands," probably Amorites, Semitic-speaking people who ruled Lower Egypt during the Second Intermediate Period (1630–1539 B.C.E.).

Inclination: *See* **Batter.**

Isfet: Evil, disorder, injustice or wrongdoing. The opposite of Maat.

Isis: The goddess associated with the king's throne and great magician, wife of Osiris and mother of Horus. She raised Horus after Osiris' death until he could claim the throne as legitimate king.

Ka: Life force, part of the soul.

Karnak: City on the east bank of the Nile River in Upper (southern) Egypt. The northern section of ancient Thebes. The site of the Great Temple of the god Amun.

Kemet: "The Black Land," cultivated land along the Nile River.

Khat: A kind of cloth head covering.

Kinnarum: A type of lyre popular in the Near East and Egypt.

Late Period: An era of Egyptian history from 664–332 B.C.E. when Egypt was dominated by foreigners including Libyans, Kushites, Assyrians, and Persians.

Leveling Lines: Surveyor's levels marked on a wall.

Lintel: Horizontal member of a door frame, connecting two jambs.

Lower Egypt: Northern Egypt, which is lower in altitude than southern Egypt. It is also called the Delta.

Luxor: City on the east bank of the Nile in Upper (southern) Egypt. Site of a temple constructed by Amenhotep III and Ramesses II.

Maat: The concept of right conduct and right order approved by the gods. The opposite of Isfet.

Mastaba: Bench-shaped tomb that was commonly constructed for the elite. The first pyramid was six mastabas piled on top of each other.

Memphis: City in Lower (northern) Egypt, traditional political capital of Egypt since the beginning of the First Dynasty (3000–2800 B.C.E.). In the city there is the Temple of Ptah. The pyramids of Giza and Saqqara are nearby.

Middle Kingdom: The period of Egyptian history from 2008 to 1630 B.C.E. characterized by a strong central government at Memphis.

Migdol: A small square tower used in fortified positions.

Naos: An inner room in a temple where the statue of the god was located.

Nemes: A royal kerchief worn only by the king.

Netjer: "God"; a term used to refer to a deceased king becoming Osiris, the divine king of the dead.

Netjer Nefer: "Good God" or "Perfect Youthful God"; a term used to describe the king as the god Amun's junior partner.

New Kingdom: The period of Egyptian history from 1539–1075 B.C.E. characterized by territorial expansion as far as Mesopotamia and Nubia.

Nile River: The longest river in the world (4,160 miles long) flowing northward from Uganda, to Sudan and Egypt.

Nomarch: A local governor of a nome.

Nome: Administrative province.

Nubia: Sudan and the southern portion of Egypt.

Obelisk: Single block of tapering stone that ends in a point and represents a form of the sun god.

Ogdoad: A grouping of eight gods in four pairs.

Old Kingdom: The period of Egyptian history from 2675 to 2130 B.C.E. characterized by strong central government and building of massive pyramids.

Opet Festival: An annual event at Thebes to celebrate a king's reign.

Osiris: King of the afterlife, father of Horus, husband of Isis, brother of Seth.

Ostracon: (plural: *ostraca*) A broken piece of pottery or limestone chip with writing or drawing on it.

Palace façade: A paneled motif used on the front of the earliest mud brick palace but used on tombs and sarcophagi to create royal associations for the deceased.

Papyrus: A material used by the Egyptians as a writing surface made from the pressed pith of the papyrus plant.

Pharaoh: "The Great House"; the term used to describe the ruler of ancient Egypt from the reign of Thutmose III (1479–1425 B.C.E.) in the Eighteenth Dynasty and onward.

Phyle: A group of workers who serve the temple or state on a rotating basis, alternating with other phyles. Five existed in the Old Kingdom (Great Phyle, Eastern Phyle, Green Phyle, Little Phyle, and Perfection Phyle). A phyle's name probably referred to its protective deity. The phyles served in rotation, each working for part of the year. By the New Kingdom the system had been reorganized.

Plumb bob: A string with a weight at one end used to determine that a wall is level vertically.

Portcullis: Large stone used to block an entryway to a tomb.

Predynastic Period: Egyptian history before Dynasty 0.

Pronaos: Antechamber to the inner room (naos) of a temple.

Ptah: Creator god and maker of all things; a patron of craftsmen and sculptors.

Ptolemaic Period: The era of Egyptian history from 332 to 30 B.C.E. when the descendants of the Macedonian general Ptolemy ruled Egypt.

Punt: Present-day Ethiopia, Somalia, or Djibouti.

Putlog: A beam used to support a rope used to lower heavy loads inside a shaft.

Putlog hole: The hole in a wall used to support a putlog.

Pylon: Tower in the shape of a cut-off pyramid, used as the entrance to a temple or tomb.

Ramesside Period: An era during the New Kingdom (1539–1075 B.C.E.) when eleven kings named Ramesses ruled Egypt (1292–1075 B.C.E.).

Re: Sun god, major royal deity beginning in the Fifth Dynasty.

Roman Period: Period of Roman rule of Egypt beginning in 30 B.C.E. and ending in 395 C.E.

Sarcophagus: (plural: *sarcophagi*) A stone coffin.

Sed-Festival: Jubilee festival celebrated by king after the first thirty years of a reign and at fixed periods afterwards.

Set Square: A-shaped device for finding ninety-degree angles.

Skid poles: A track made of parallel beams used to transport heavy materials.

Sledge: A sled used on sand for transporting heavy loads.

Stela: (plural: *stelae*) Upright piece of stone with inscription.

Torus molding: Semi-circular or three-quarter circular molding along the edge of a building.

Votive object: Object used as a gift to the gods or to a deceased person.

FURTHER REFERENCES

GENERAL

Roger Bagnall, *Egypt in Late Antiquity* (Princeton: Princeton University Press, 1993).

John Baines and Jaromir Malek, *Atlas of Ancient Egypt* (New York: Facts on File Publications, 1980).

Kathryn A. Bard, *Encyclopedia of the Archaeology of Ancient Egypt* (New York: Routledge, 1999).

————, *From Farmers to Pharaohs: Mortuary Evidence for the Rise of Complex Society in Egypt* (Sheffield, U.K.: Sheffield Academic Press, 1994).

Alan K. Bowman, *Egypt After the Pharaohs 332 B.C.–A.D. 64: From Alexander to the Arab Conquest* (Berkeley: University of California Press, 1986).

James Henry Breasted, ed., *Ancient Records of Egypt* (Chicago: University of Chicago Press, 1906).

Sergio Donadoni, ed., *The Egyptians* (Chicago: University of Chicago Press, 1997).

Alan Henderson Gardiner, *Egypt of the Pharaohs: An Introduction* (Oxford: Clarendon Press, 1961).

Nicolas Grimal, *A History of Ancient Egypt* (New York: Barnes and Noble Books, 1997).

Michael A. Hoffman, *Egypt Before the Pharaohs: The Prehistoric Foundations of Egyptian Civilization* (New York: Knopf, 1979).

Barry Kemp, *Ancient Egypt: Anatomy of a Civilization* (London: Routledge, 1989).

Amélie Kuhrt, *The Ancient Near East c. 3000–330 B.C.* (New York: Routledge, 1995).

William J. Murnane, *The Penguin Guide to Ancient Egypt* (Harmondsworth, U.K.: Penguin, 1983).

Donald B. Redford, ed., *The Oxford Encyclopedia of Ancient Egypt.* 3 vols. (New York: Oxford University Press, 2001).

Jack M. Sasson, ed., *Civilizations of the Ancient Near East.* 4 vols. (New York: Scribners, 1995).

Ian Shaw, ed., *The Oxford History of Ancient Egypt* (Oxford: Oxford University Press, 2000).

Peter Tompkins, *Secrets of the Great Pyramid* (New York: Harper & Row, 1971).

B. G. Trigger, et al, *Ancient Egypt: A Social History* (Cambridge: Cambridge University Press, 1983).

John A. Wilson, *The Culture of Ancient Egypt* (Chicago: University of Chicago Press, 1956).

ARCHITECTURE

Dieter Arnold, *Building in Egypt: Pharaonic Stone Masonry* (Oxford: Oxford University Press, 1991).

————, *The Encyclopaedia of Ancient Egyptian Architecture* (London: I. B. Taurus, 2002).

————, *The Pyramid of Senwosret I* (New York: Metropolitan Museum of Art, 1988).

Alexander Badawy, *A History of Egyptian Architecture* (Giza: Studio Misr, 1954).

————, *Ancient Construction Diagrams in Egyptian Architecture* (Paris: Bureaux de la Gazette des Beaux Arts, 1986).

Edward Brovarski, *The Senedjemib Complex* (Boston: Museum of Fine Arts, Boston, 2001).

Jaroslav Černý, *A Community of Workmen at Thebes in the Ramesside Period* (Cairo: Institut français d'archéologie orientale, 1973).

Somers Clarke and Reginald Engelbach, *Ancient Egyptian Masonry* (Oxford: Oxford University Press, 1930).

Norman de Garis Davies, *The Tomb of Rekh-mi-Re at Thebes* (New York: Metropolitan Museum of Art, 1943).

I. E. S. Edwards, *The Pyramids of Egypt* (Harmondsworth: Penguin Books, 1985).

Walter B. Emery, *Great Tombs of the First Dynasty: Excavations at Saqqara*. 3 vols. (London: Egyptian Exploration Society, 1949–1958).

Uvo Hölscher, *The Mortuary Temple of Rameses III*. 2 vols. (Chicago: Oriental Institute Publications, 1941–1951).

————, *The Temples of the Eighteenth Dynasty* (Chicago: Oriental Institute Publications, 1939).

T. G. H. James, *The Mastaba of Khentika called Ikhekhi* (London: Egyptian Explorations Society, 1953).

Mark Lehner, *The Complete Pyramids* (London: Thames and Hudson, 1997).

The Mastaba of Mereruka (Chicago: University of Chicago Press, 1938).

W. M. Flinders Petrie, *Egyptian Architecture* (London: British School of Archaeology in Egypt, 1938).

George Reisner, *A History of the Egyptian Mastaba* (Cairo: Institut français d'archéologie orientale, 1938).

————, *A History of the Giza Necropolis*. Vol. I (Cambridge: Harvard University Press, 1942).

————, *The Development of the Egyptian Tomb down to the Accession of Cheops* (Cambridge: Harvard University Press, 1936).

Gay Robins, *Mathematical Bases of Ancient Egyptian Architecture and Graphic Art* (New York: Academie Press, 1985).

Ann Macy Roth, *A Cemetery of Palace Attendants: Including G 2084–2099, G 2230–2231, and G 2240* (Boston: Museum of Fine Arts, Boston, 1995).

E. Baldwin Smith, *Egyptian Architecture and Cultural Expression* (New York: D. Appleton-Century Company, Inc., 1938).

A. J. Spencer, *Brick Architecture in Ancient Egypt* (Warminster: Aris and Philips, 1979).

Miroslav Verner, *The Mastaba of Ptahshepses*. 2 vols. (Prague: Charles University, 1977–1992).

Philip J. Watson, *Egyptian Pyramids and Mastaba Tombs of the Old and Middle Kingdoms* (Aylesbury, England: Shire Publications, 1987).

DANCE

Robert Anderson, "Music and Dance in Ancient Egypt," *Civilizations of the Ancient Near East*. Vol. 4 (New York: Charles Scribner's Sons, 1995): 2555–2568.

Lynn Green, "Words for Dancers and Dancing," *The Ancient World, Egyptological Miscellanies* 6 (1983): 29–38.

Jonathan van Lepp, "The Role of Dance in Funerary Ritual in the Old Kingdom," *Aktes des vierten Internationalen Agyptologuen-Kongresses* 3 (1985–1989): 385–394.

Irena Lexová, *Ancient Egyptian Dances* (Mineola, N.Y.: Dover Publications, 2000).

Lise Manniche, *Music and Musicians in Ancient Egypt* (London: British Museum Press, 1991).

Greg Reeder, "The Mysterious Muu and the Dance They Do," *KMT: A Modern Journal of Ancient Egypt* 6 (1995): 25–50.

Curt Sachs, *World History of the Dance* (New York: W. W. Norton and Company, Inc., 1937).

Emily Teeter, "Female Musicians in Pharaonic Egypt," in *Rediscovering the Muses* (Boston: Northeastern University Press 1993): 68–91.

FASHION

N. Adams, "Meroitic High Fashions: Example from Art and Arachaeology," *Meroitica* 10 (1988): 747–755.

John Baines, "Ankh-sign, Belt, and Penis-sheath," *Studien zur Altägyptischen Kultur* 3 (1975): 1–24.

Robert Bianchi, "Not the Isis Knot," *Bulletin of the Egyptological Society* 2 (1980): 9–31.

B. M. Carter, "The Dress of the Ancient Egyptians," *Bulletin of the Metropolitan Museum of Art* (1916): 166–171, 211–214.

H. Carter and A. C. Mace, *The Tomb of Tut-Ankh-Amun.* 3 vols. (London: Cassell and Co., Ltd., 1927–1933).

W. D. Cooke "Creasing in Ancient Textiles," *Conservation News* 35 (1988): 27–30.

G. M. Crowfoot and N. de Garis Davies, "The Tunic of Toutankhamon," *Journal of Egyptian Archaeology* 27 (1941): 113–130.

G. M. Crowfoot and L. Ling Roth, "Were the Ancient Egyptians Conversant with Tablet-weaving?" *Annals of Archaeology and Anthropology of Liverpool* 10 (1917): 7–10.

G. M. Eastwood, "Egyptian Dyes and Colours," *Dyes on Historical and Archaeological Textiles* 3 (1984): 9–19.

Egypt's Golden Age: The Art of Living in The New Kingdom 1558–1085 B.C. (Boston: Museum of Fine Arts, Boston, 1982).

R. Englebach, "A Peculiarity of Dress in the Old and Middle Kingdoms," *Annales du Service des Antiquités de l'Égypte* 29 (1929): 31–32.

———, "An Ancient Egyptian Dress Bow," *Annales du Service des Antiquités de l'Égypte* 29 (1929): 40–46.

R. E. Freed, "Costume," in *Egypt's Golden Age: The Art of Living in The New Kingdom 1558–1085 B.C.* (Boston: Museum of Fine Arts, Boston, 1982): 170–172.

R. Hall, "A Pair of Linen Sleeves from Gurob," *Göttinger Miszellen* 40 (1980): 29–38.

———, "The Cast-off Garments of Yesterday: Dresses Reversed in Life and Death," *Bulletin de l'Institut français d'Archéologie Orientale* 85 (1985): 235–245.

———, "Crimpled Garments: A Mode of Dinner Dress," *Discussions in Egyptology* 5 (1986): 37–45.

———, *Egyptian Textiles* (Aylesbury, England: Shire Publications, 1986).

———, "Fish-net Dresses in the Petrie Museum," *Göttinger Miszellen* 42 (1981): 37–43.

———, "Garments in the Petrie Museum of Egyptian Archaeology," *Textile History* 13(1) (1982): 27–45.

———, "The Pharaonic *mss* Tunic as a Smock," *Göttinger Miszellen* 43 (1981): 29–37.

R. Hall and L. Pedrini, "A Pleated Linen Dress from a Sixth Dynasty Tomb at Gebelein Now in the Museo Egizio, Turin," *Journal of Egyptian Archaeology* 70 (1984): 136–139.

M. G. Houston, *Ancient Egyptian, Mesopotamian & Persian Costume and Decoration* (London: A. & C. Black, 1954).

S. Landi and R. Hall, "The Discovery and Conservation of an Ancient Egyptian Linen Tunic," *Studies in Conservation* 24 (1979): 141–152.

E. Mackay, "The Representation of Shawls with a Rippled Stripe in the Theban Tombs," *Journal of Egyptian Archaeology* 10 (1924): 41–43.

W. Needler, "Three Pieces of Unpatterned Linen from Ancient Egypt in the Royal Ontario Museum," in *Studies in Textile History* (Toronto: Royal Ontario Museum, 1977): 238–251.

J. R. Ogden, "Studies in Archaic Epigraphy VII: On the Long-Sleeved Dress Logogram and Its Phonetic Values," *Göttinger Miszellen* 68 (1983): 81–83.

L. Pedrini, "Observations on the Cloaks Worn by Private Men During the Old, Middle, and New Kingdoms," *Göttinger Miszellen* 87 (1985): 63–68.

T. E. Peet, "The So-Called Ramesses Girdle," *Journal of Egyptian Archaeology* 19 (1933): 143–149.

E. Riefstahl, "A Note on Ancient Fashions: Four Early Egyptian Dresses in the Museum of Fine Arts, Boston," *Bulletin of the Museum of Fine Arts* 68 (1970): 244–249.

———, *Patterned Textiles in Pharaonic Egypt* (Brooklyn: Brooklyn Museum, 1944).

W. K. Simpson, "A Protocol of Dress: The Royal and Private Fold of the Kilt," *Journal of Egyptian Archaeology* 74 (1988): 203–204.

W. S. Smith, "The Old Kingdom Linen Lists," *Zeitschrift für ägyptische Sprache und Altertumskunde* 71 (1935): 134–149.

G. M. Vogelsang-Eastwood, *Pharaonic Egyptian Clothing* (Leiden: E. J. Brill, 1993).

H. E. Winlock, "Ancient Egyptian Kerchiefs," *Bulletin of the Metropolitan Museum of Art* (1916): 238–242.

LITERATURE

James Allen, *Middle Egyptian: An Introduction to the Language and Culture of Hieroglyphs* (Cambridge: Cambridge University Press, 2000).

Ricardo A. Caminos, *Late-Egyptian Miscellanies* (London: Oxford University Press, 1954).

J. Černý, *Paper and Books in Ancient Egypt* (London: H. K. Lewis for University College London, 1952).

W. V. Davies, *Egyptian Hieroglyphs* (London: British Museum Publications, 1987).

Adolf Erman, *The Ancient Egyptians: A Sourcebook of Their Writings* (New York: Harper Torchbook, 1966).

R. O. Faulkner, *The Ancient Egyptian Book of the Dead* (London: British Museum Publications, 1985).

John L. Foster, *Ancient Egyptian Literature: An Anthology* (Austin, Tex.: University of Texas Press, 2001).

————, *Echoes of Egyptian Voices* (Norman: University of Oklahoma Press, 1992).

————, *Hymns, Prayers, and Songs: An Anthology of Ancient Egyptian Lyric Poetry* (Atlanta: Scholars Press, 1995).

————, *Love Songs of the New Kingdom* (New York: Charles Scribner's Sons, 1974).

————, "The Shipwrecked Sailor: Prose or Verse?" *Studien zur Altägyptischen Kultur* 15 (1988): 69–109.

————, *Thought Couplets in the Tale of Sinuhe* (Frankfurt am Main: Peter Lang, 1993).

Michael Fox, *Song of Songs and the Ancient Egyptian Love Songs* (Madison: University of Wisconsin Press, 1985).

Miriam Lichtheim, *Ancient Egyptian Literature: A Book of Readings.* 3 vols. (Berkeley: University of California Press, 1973–1980).

Antonio Loprieno, *Ancient Egyptian Literature: History and Forms* (Leiden: E. J. Brill, 1996).

Richard Parkinson, *Voices from Ancient Egypt: An Anthology of Middle Kingdom Writings* (London: British Museum Press, 1991).

E. A. E. Reymond, *A Contribution to a Study of Egyptian Literature in Graeco-Roman Times* (Manchester: Manchester University Press, 1983).

L. D. Reynolds and N. G. Wilson, *Scribes and Scholars* (Oxford: Clarendon Press, 1974).

Nili Shupak, *Stylistic and Terminological Traits Common to Biblical and Egyptian Literature* (Göttingen: Vandenhoeck und Ruprecht, 1983).

————, *Where Can Wisdom Be Found? The Sage's Language in the Bible and in Ancient Egyptian Literature* (Göttingen: Vandenhoeck & Ruprecht, 1993).

W. K. Simpson, *The Literature of Ancient Egypt* (New Haven: Yale University Press, 1973).

MUSIC

Robert Anderson, *Catalogue of Egyptian Antiquities in the British Museums III, Musical Instruments* (London: British Museum Press, 1976).

————, "Music and Dance in Ancient Egypt," in *Civilizations of the Ancient Near East.* Vol. 4 (New York: Charles Scribner's Sons, 1995): 2555–2568.

A. J. Arkell, "The Use of Nerita Shells in Early Times," *Annales du Service des Antiquités de l'Égypte* 50 (1950): 6–10.

James Blades and Robert Anderson, "Clappers," *The New Grove Dictionary of Musical Instruments.* Vol. I (New York: Grove's Dictionaries of Music Press, 1984).

James Blades, *Percussion Instruments and Their History* (New York: F. A. Praeger, 1970).

Henry George Farmer, "The Music of Ancient Egypt," in *The New Oxford History of Music.* Chapter VI. (Oxford: Oxford University Press, 1957).

Bo Lawgren, "Music," in *Oxford Encyclopedia of Ancient Egypt.* Vol. 2 (New York: Oxford University Press, 2001): 450–454.

Joseph Leibovitch, "The Statuette of an Egyptian Harper and String Instruments in Egyptian Statuary," *Journal of Egyptian Archaeology* 46 (1960): 52–59.

James W. MacKinnon and Robert Anderson, "Sistrum," in *New Grove Dictionary of Music and Musicians.* Vol. III (New York: Grove's Musical Dictionary Press, 1984).

Lise Manniche, *Ancient Egyptian Musical Instruments* (Berlin: Deutscher Kunstverlag, 1975).

————, "The Erotic Oboe," in *The Archaeology of Early Music Cultures: Third International Meeting of the ICTM Study Group on Music Archaeology* (Bonn: Verlag für Systematische Musikwissenschaft, 1988).

————, *Music and Musicians in Ancient Egypt* (London: British Museum Press, 1991).

————, "Symbolic Blindness," *Chronique d'Égypte* 53 (1978): 13–21.

Marleen Reynders, "Names and Types of the Egyptian Sistrum," in *Proceedings of the Seventh International Congress of Egyptologists, Cambridge, 3–9 September 1995* (Leuven: Peeters, 1998).

Curt Sachs, *The Rise of Music in the Ancient World: East and West* (New York: W. W. Norton and Company, 1940).

Emily Teeter, "Female Musicians in Pharaonic Egypt," in *Rediscovering the Muses* (Boston: Northeastern University Press, 1993): 68–91.

PHILOSOPHY

Garth Fowden, *The Egyptian Hermes: a Historical Approach to the Late Pagan Mind* (Cambridge: Cambridge University Press, 1986).

Erik Hornung, *Conceptions of God in Ancient Egypt: the One and the Many* (Ithaca, N.Y.: Cornell University Press, 1982).

———, *Idea into Image: Essays on Ancient Egyptian Thought* (New York: Timken Publishers, Inc., 1992).

———, *The Secret Lore of Egypt: Its Impact on the West* (Ithaca, N.Y.: Cornell University Press, 2001).

Miriam Lichtheim, *Maat in Egyptian Autobiographies and Related Studies* (Göttingen: Vandenhoeck & Ruprecht, 1992).

Emily Teeter, *The Presentation of Maat: Ritual and Legitimacy in Ancient Egypt* (Chicago: Oriental Institute of the University of Chicago, 1997).

RELIGION

Cyril Aldred, *Akhenaten, King of Egypt* (London: Thames and Hudson, 1988).

Jan Assmann, *Akhanyati's Theology of Light and Time* (Jerusalem: The Israel Academy of Sciences and Humanities, 1992).

———, *Egyptian Solar Religion in the New Kingdom: Re, Amun and the Crisis of Polytheism* (New York: Columbia University Press, 1995).

———, *Magic and Theology in Ancient Egypt* (Leiden: E. J. Brill, 1997).

———, *Moses the Egyptian: The Memory of Egypt in Western Monotheism* (Cambridge: Harvard University Press, 1997).

———, *Semisois and Interpretation in Ancient Egyptian Ritual* (Leiden: E. J. Brill, 1992).

C. J. Bleeker, *Hathor and Thoth: Two Key Figures of the Ancient Egyptian Religion* (Leiden: E. J. Brill, 1973).

J. Černý, *Ancient Egyptian Religion* (London: Hutchinson's University Library, 1952).

Henri Frankfort, *Ancient Egyptian Religion: An Interpretation* (New York: Columbia University Press, 1948).

Lucia Gahlin, *Egyptian Religion* (London: Southwater, 2002).

George Hart, *A Dictionary of Egyptian Gods and Goddesses* (Boston: Routledge & Kegan Paul, 1986).

Dmitri Meeks, *Daily Life of the Egyptian Gods* (Ithaca, N.Y.: Cornell University Press, 1996).

S. A. B. Mercer, *Egyptian Religion* (New York: Alma Egan Hyatt Foundation, 1933–1936).

Dominic Montserrat, *Akhenaten: History, Fantasy, and Ancient Egypt* (New York: Routledge, 2000).

Siegfried Morenz, *Egyptian Religion* (Ithaca, N.Y.: Cornell University Press, 1973).

Stephen Quirke, *Ancient Egyptian Religion* (London: British Museum Press, 1992).

Donald B. Redford, *Akhenaten: The Heretic King* (Princeton: Princeton University Press, 1984).

———, *The Ancient Gods Speak: a Guide to Egyptian Religion* (New York: Oxford University Press, 2002).

C. N. Reeves, *Akhenaten: Egypt's False Prophet* (London: Thames and Hudson, 2001).

Alan Wynn Shorter, *The Egyptian Gods: A Handbook* (London: K. Paul, Trench, Trubner and Co. Ltd., 1937).

Angela Thomas, *Akhenaten's Egypt* (Aylesbury, England: Shire Publications, 1988).

———, *Egyptian Gods and Myths* (Aylesbury, England: Shire Publications, 1986).

Vincent Arieh Tobin, *Theological Principles of Egyptian Religion* (New York: Peter Lang, 1989).

THEATER

Jaroslav Černý, "The Stela of Emhab from Tell Edfu," *Mitteilungen des Deutschen Archäologischen Instituts, Kairo* 24 (1969): 87–92.

H. W. Fairman, *The Triumph of Horus* (London: Batsford, 1974).

Louis B. Mikhail, *Dramatic Aspects of the Osirian Khoiak Festival* (Uppsala, Sweden: Institute of Egyptology, 1983).

Paul O'Rourke, "Drama," in *Oxford Encyclopedia of Ancient Egypt* (New York: Oxford University Press, 2001): 407–409.

VISUAL ARTS

5,000 Years of Egyptian Art (London: The Arts Council, 1962).

Cyril Aldred, *The Development of Ancient Egyptian Art, from 3200 to 1315 B.C.* (London: Academy Editions, 1973).

———, *Egyptian Art in the Days of the Pharaohs, 3100–320 B.C.* (New York: Thames and Hudson, 1980).

Ancient Egyptian Art in the Brooklyn Museum (Brooklyn: Brooklyn Museum, 1989).

Lawrence Michael Berman, *Catalogue of Egyptian Art: the Cleveland Museum of Art* (Cleveland: Cleveland Museum of Art, 1999).

Bernard V. Bothmer, *Egyptian Art: Selected Writings of Bernard V. Bothmer* (New York: Oxford University Press, 2003).

Janine Bourriau, *Pharaohs and Mortals: Egyptian Art in the Middle Kingdom* (Cambridge: Fitzwilliam Museum, 1988).

Jean Capart, *Egyptian Art* (Oxford: Clarendon Press, 1942).

Whitney Davis, *The Canonical Tradition in Ancient Egyptian Art* (New York: Cambridge University Press, 1989).

Egyptian Art in the Age of the Pyramids (New York: Metropolitan Museum of Art, 1999).

Egyptian Art in the Egyptian Museum of Turin: Paintings, Sculpture, Furniture, Textiles, Ceramics, Papyri (Turin: Edizioni d'Arte Fratelli Pozzo, 1964).

The Eternal Image: Egyptian Art from the British Museum (New York: American Federation of Arts, 1999).

Richard A. Fazzini, *Ancient Egyptian Art* (Ivoryton, Conn.: Hollycroft Press, 1979).

———, *Egypt Dynasty XXII–XXV* (Leiden: E. J. Brill, 1988).

———, *Images for Eternity: Egyptian Art from Berkeley and Brooklyn* (Brooklyn: Brooklyn Museum, 1975).

Erik Iversen, *Canon and Proportions in Egyptian Art* (Warminster: Aris and Phillips, 1975).

Jaromir Malek, *Egyptian Art* (London: Phaidon, 1999).

Hans Wolfgang Müller, *Egyptian Art* (New York: McGraw-Hill, 1959).

Vagn Poulsen, *Egyptian Art* (Greenwich, Conn.: New York Graphic Society, 1968).

Gay Robins, *The Art of Ancient Egypt* (Cambridge: Harvard University Press, 2000).

———, *Proportion and Style in Ancient Egyptian Art* (Austin, Tex.: University of Texas Press, 1994).

James F. Romano, *In the Fullness of Time: Masterpieces of Egyptian Art from American Collections* (Seattle: University of Washington Press, 2002).

Edna R. Russmann, *Egyptian Sculpture: Cairo and Luxor* (Austin, Tex.: University of Texas Press, 1989).

Heinrich Schäfer, *Principles of Egyptian Art* (Oxford: Clarendon Press, 1974).

David Silverman, *Ancient Egypt* (New York: Oxford University Press, 1997).

Stephen Spurr, *Egyptian art at Eton College: Selections from the Myers Museum* (New York: Metropolitan Museum of Art, 1999).

MEDIA AND ONLINE SOURCES

GENERAL

The British Museum: Ancient Egypt (http://www.ancient egypt.co.uk/)—The British Museum's website on ancient Egypt. The site includes a section on writing that shows examples of hieroglyphs and information about where and when writing was used. The Shabaka Stone, on which is preserved what may have been the earliest Egyptian drama, is also featured on the site, but the term Shabako must be used in the search instead of Shabaka.

Brooklyn Museum of Art (http://www.brooklynmuseum .org/visit/permanent_collections/ancient-egypt/)—This site examines the reconstruction of an Old Kingdom mastaba as well as other aspects of Egyptian art and language such as using statues in Brooklyn to explore statue types and a tomb relief to explore Egyptian depictions of the human form and information on reading a stele.

The Coptic Museum (http://www.sis.gov.eg/egyptinf/culture/ html/copt001.htm)—The website of the Coptic Museum in Cairo includes many illustrations of clothing.

Egypt: A New Look at an Ancient Culture (http://www.upenn .edu/museum/Exhibits/egyptintro.html)—This site, based on the Egyptian collection of the University of Pennsylvania Museum of Archaeology and Anthropology, Philadelphia, includes online exhibits of many aspects of Egyptian culture, including daily life, writing, funerary practices, and gods and goddesses. The site also has a section on several of the University of Pennsylvania's Egyptian excavations.

Egyptian Museum (http://www.egyptianmuseum.gov.eg/)—The Egyptian Museum in Cairo's website includes a virtual tour of the museum, which houses thousands of artifacts from various tomb sites and includes jewelry, art, and sculpture, among other things. The museum is also home to nearly 2,000 objects from Tutankhamun's tomb, and there is a link that allows the site visitor to view samples from the Tutankhamun exhibit.

The Metropolitan Museum of Art (http://www.metmuseum .org/works_of_art/department.asp?dep=10)—The Metropolitan Museum of Art's Introduction to Egypt site includes 50 artifacts featured from the museum's collection in approximate chronological order. There are links to exhibits and special web resources for learning about Egyptian art and culture.

The Museum of Fine Arts, Boston: Explore Ancient Egypt (http://www.mfa.org/egypt/)—The *Explore Ancient Egypt* website of the Museum of Fine Arts, Boston, includes many illustrations of clothing, a section on hieroglyphs and information on excavating Egyptian art, scenes of daily life, and Egyptian artistic style.

ARCHITECTURE

David Macaulay's World of Ancient Engineering: Pyramid, PBS, 2000—Excellent animated graphics demonstrate methods used while building the pyramids.

The Giza Plateau Mapping Project (http://www-oi.uchicago .edu/OI/PROJ/GIZ/Giza.html)—This website from the Oriental Institute at the University of Chicago contains

the most recent research on the pyramids at Giza, the Sphinx, and the ancient towns near the pyramids.

NOVA Online, Mysteries of the Nile (http://www.pbs.org/ wgbh/nova/egypt/textindex.html)—This website explores major architectural sites of the Old Kingdom and New Kingdom including Giza, Karnak, and Luxor.

Theban Mapping Project (http://www.thebanmappingproject .com/)—The project's website records major monuments of the west bank of the Nile at Thebes, including tombs and temples. It also includes an atlas of the Valley of the Kings.

This Old Pyramid, WGBH Boston, 1992—Archaeologist Mark Lehner builds a pyramid using ancient techniques.

Virtual Kahun (http://kahun.man.ac.uk)—This site contains a virtual reconstruction of the Middle Kingdom town of Kahun based on the collections of The Manchester Museum and The Petrie Museum of Egyptian Archaeology.

DANCE AND MUSIC

Washington State University (http://salc.wsu.edu/fair_f01/ FS20/mdpage.htm)—A brief but accurate description of dance and music in ancient Egypt with photographs of instruments and dancers.

VISUAL ARTS

Ashmolean Museum, *A. C. Mace's Account of the Opening of Tutankhamun's Burial Chamber* (http://www.ashmol .ox.ac.uk/gri/4maceope.html)—A. C. Mace was present at the opening of Tutankamun's tomb. This site posts his diary from the period when he observed the opening of the tomb in 1922. The diary describes in detail the artifacts and artwork found within the tomb. Tutankhamun's tomb was the major discovery in Egypt of the twentieth century. It remains one of two intact royal tombs ever discovered in Egypt and the only one from the New Kingdom.

ACKNOWLEDGMENTS

The editors wish to thank the copyright holders of the excerpted material included in this volume and the permissions managers of many book and magazine publishing companies for assisting us in securing reproduction rights. We are also grateful to the staffs of the Detroit Public Library, the Library of Congress, the University of Detroit Mercy Library, Wayne State University Purdy/Kresge Library Complex, and the University of Michigan Libraries for making their resources available to us. Following is a list of the copyright holders who have granted us permission to reproduce material in this publication. Every effort has been made to trace copyright, but if omissions have been made, please let us know.

COPYRIGHTED EXCERPTS IN ARTS AND HUMANITIES THROUGH THE ERAS: ANCIENT EGYPT WERE REPRODUCED FROM THE FOLLOWING BOOKS:

Ani, Miriam. From *Ancient Egyptian Literature A Book of Readings: Volume II: The New Kingdom.* University of California Press, 1976. Copyright © 1976, by The Regents of The University of California. Reproduced by permission.—Anonymous. From "Hymn to Osiris," in *Ancient Egyptian Literature: An Anthology.* Translated by John L. Foster. University of Texas Press, 2001. Reproduced by permission.—Anonymous. From "The Doomed Prince," in *Ancient Egyptian Literature: A Book of Readings.* Edited by Miriam Lichtheim. University of California Press, 1973. Copyright © 1973, by The Regents of the University of California. Reproduced by permission.—Anonymous. From "Chapter for Repelling a Rerek–Snake in the God's Domain," in *The Egyptian*

Book of the Dead. Translated by Raymond O. Faulkner. Chronicle Books, 1994. Reproduced by permission.—Anonymous. From "Songs and Hymns," in *Ancient Egyptian Literature: The Old and Middle Kingdoms.* Translated by Miriam Lichtheim. University of California Press, 1973. Copyright © 1973 by The Regents of the University of California. Reproduced by permission of the publisher.—Apuleius of Madauros. From *The Isis–Book: Metamorphoses, Book XI.* Translated by J. Wyn Griffiths. E. J. Brill, 1975. Reproduced by permission.—Eicholz, D. E. From *Pliny Natural History.* Cambridge, Mass: Harvard University Press, 1962. Copyright © 1962 by the President and Fellows of Harvard College. All rights reserved. Reproduced by permission of the publishers and the Trustees of the Loeb Classical Library.—Faulkner, R. O. From *The Ancient Egyptian Coffin Texts: Volume I, Spells 1–354.* Aris & Phillips Ltd., 1973. Reproduced by permission.—Foster, John L. From *Thought Couplets in The Tale of Sinuhe: Verse Text and Translation, With an Outline of Grammatical Forms and Clause Sequences and an Essay on the Tale as Literature.* Peter Lang, 1993. © Verlag Peter lang GmbH, Frankfurt am Main, 1993. All rights reserved. Reproduced by permission.—Herodotus. From *The History.* Translated by David Greene. University of Chicago Press, 1987. © 1987 by The University of Chicago. All rights reserved. Reproduced by permission.—Lichtheim, Miriam. From *Ancient Egyptian Literature: A Book of Readings.* University of California Press, 1976. Copyright © 1976, by The Regents of the University of California. Reproduced by permission.—Lichtheim, Miriam. From *Ancient Egyptian Literature A Book of Readings, Vol. I: The Old and*

Middle Kingdoms. University of California Press, 1973. Copyright © 1973, by The Regents of the University of California. Reproduced by permission.—Lichtheim, Miriam. From *Ancient Egyptian Literature A Book of Reading: Volume II: The New Kingdom.* University of California Press, 1976. Copyright © 1976, by The Regents of the University of California. Reproduced by permission.—Lichtheim, Miriam. From *Ancient Egyptian Literature.* University of California Press, 1973. Copyright © 1973 by the Regents of the University of California. Reproduced by permission.—Manniche, Lisa. From "The Hymn to the Aten" in *Music and Musicians in Ancient Egypt.* British Museum Press, 1991. © 1991 Lisa Manniche. Reproduced by permission.—Nefer–seshem–re. From the "Autobiography of Nefer-seshem-re" in *Moral Values in Ancient Egypt.* Edited by Miriam Lichtheim. University Press, Fribourg, Switzerland, 1997. © 1997 by University Press, Fribourg, Switzerland/Universitatsverlag Freiburg Schweiz Vandenhoeck & Ruprecht Gottingen. Reproduced by permission.—Parkinson, R. B. From Voices from *Ancient Egypt: An Anthology of Middle Kingdom.* University of Oklahoma Press, 1991. © 1991. Reproduced by permission.—Parkinson, R. B. From *Voices from Ancient Egypt.* University of Oklahoma Press, 1991. © 1991. Reproduced by permission.—Van Lepp, Jonathan. From a master's thesis "The Dance Scene of Watetkhethor: An Art Historical Approach to the Role of Dance in Old Kingdom Funerary Ritual." Reproduced by permission of the author.

INDEX

Page numbers in italics indicate photographs. Page numbers in boldface indicate biographies. This index is sorted word by word.

A

Abu Roash, Pyramid Complex at, 23–24

Abydos, tombs at, 7–8

The Admonitions of Ipuwer, 129, 141, 192

Afterlife, beliefs about, 174–175, 187, 244–247, *245*

Ahmose-Ruru, sculptures of, *102,* 297

Akh, 239

Akhenaten, 172–174, *235,* **247–248,** *301,* 302–303, *303*

Akhenaten temple in Karnak, *176*

Alchemy, 200–201

Amarna Period
art, 302–306
music, 172–174

Amenemhet (high official), 55

Amenemhet III's pyramid complexes, 41–42

Amenemhet I's Pyramid Complex at Lisht, 39–40

Amenhab Mahu, **179**

Amenhotep, son of Hapu, **59, 248**

Amenhotep III, 299–300

Amun, 49–52, 219–220

Ankhsheshonqi, 201

The Annals of Thutmose III, 122–123, 133

Anonymity in literature, 121–123

Any, 66, 201

Apis bull, 222–223, *223*

Aprons, 91

Ar Risala al-falakiya al kubra, 200–201

Archaic wraparound, 93

Archaism in art, 308–309

Art. *See also* Relief sculpture; Sculpture; Wall paintings
Amarna Period, 302–306
animals in, 270–271, 273–274, *274*
archaism, 308–309
collecting, 308
dance in, 66–68
Early Dynastic Period, 276–279, *276–280*
gender representation in, 269–270
grid systems, 271–272, 275
hieratic scale, 286
inscriptions, 284
interpretation of, 269–270
lack of motion in, 283–284
Late Period, 308–309
Memphis style, 289–291
Middle Kingdom, 289–293
New Kingdom, 293–302
Old Kingdom reliefs, 288–289
Old Kingdom sculpture, 280–287
portrayals of officials, 286–289
pre-Dynastic Period, 272–276
proportion in, 271–272, 275
Ramesside Period, 306–307
religious images in, 306–307
structural supports, 284
Thebes style, 289–291
wealth, portrayals of, *287,* 301–302

Astrology and astrologers, 198–199

Atum, 188, 214

Authorship, 121–123, 191

Autobiographies, 126–128, 133

B

Ba, 239

Bag tunics, 95–96

Banquet music, 166–167, *167*

Barque shrines, 231, *232*

Bent Pyramid, 17–19

Bes, *79,* 170

Biography of Emhab, 259

Blind harpists, 174–175, *177*

Book of the Dead, 139, *237,* 258, 259

The Book of the Heavenly Cow, 142, 197

Building techniques
mud brick construction, 37
pyramid layout, 39
stone quarrying, 52–54, 55
transporting materials, 54, 56–58, 59

Burial customs. *See* Funeral customs

C

Call and response songs, 161–163

Ceremony of the Great Throne, 226

Champollion, J.-F., 116

328

Arts and Humanities Through the Eras: Ancient Egypt (2675 B.C.E.–332 B.C.E.)

Arts and Humanities Through the Eras: Ancient Egypt (2675 B.C.E.–332 B.C.E.)

329

Deleted